Art Nouveau
1890-1914

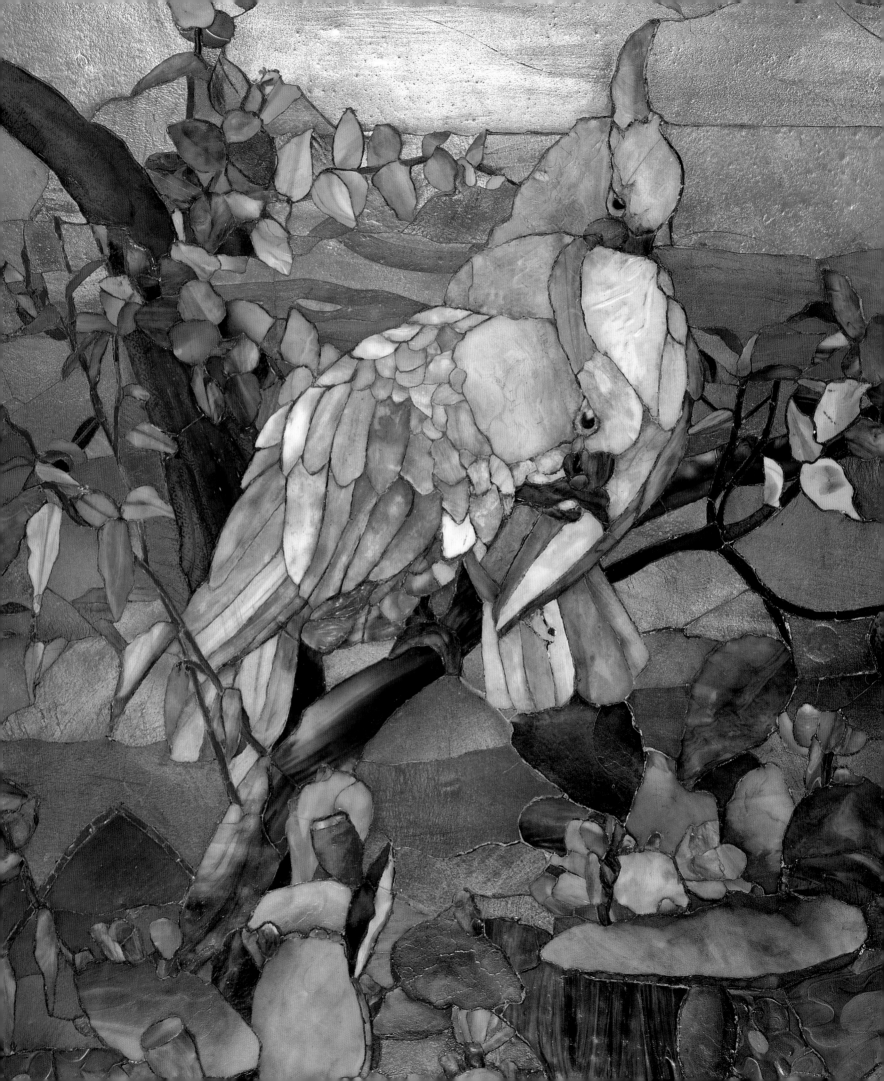

EDITED BY PAUL GREENHALGH

Art Nouveau
1890-1914

HARRY N. ABRAMS, INC., PUBLISHERS

The members of the V&A Research Department

dedicate this book to the memory of Professor Clive Wainwright

Book design: Harry Green
Jacket design: Judith Michael
Photography by Mike Kitcatt and Pip Barnard,
V&A Photographic Studio

Library of Congress Cataloging-in-Publication Data
Art nouveau: 1890–1914/edited by Paul Greenhalgh.
 p. cm.
 Includes bibliographical references and index.
 ISBN 0–8109–4219–4 (Abrams: cloth)—
 ISBN 0–8109–2922–8 (book club: pbk.)—
 ISBN 0–89468–279–2 (museum: pbk.)
 1. Decoration and ornament—Art nouveau—Exhibitions.
2. Decorative arts—History—19th century—Exhibitions.
3. Decorative arts—History—20th century—Exhibitions.
4. Exposition universelle internationale de 1900 (Paris, France)
5. Decorative arts—England—London—Exhibitions.
6. Victoria and Albert Museum—Exhibitions. I. Greenhalgh, Paul.

NK775.5.A7 A785 2000
709'.03'4907442134—dc21
 00-28027

First published by V&A Publications, London, 2000

 Harry N. Abrams, Inc.
100 Fifth Avenue
New York, N.Y. 10011
www.abramsbooks.com

Every effort has been made to seek permission
to reproduce those images whose copyright does
not reside with the V&A, and we are grateful to the
individuals and institutions that have assisted in this
task. Any omissions are entirely unintentional and
details should be addressed to the publishers.

ILLUSTRATIONS

TITLE PAGE Detail from Sulphur-Crested Cockatoos
Mosaic, Tiffany Studios. Glass. American, c.1908.
Haworth Art Gallery, Accrington.

FRONTISPIECE *La Libellule* (The Dragonfly), E. Gallé.
Carved and applied glass. French, c.1904. © Christie's
Images, 2000.

PART I OPENER Detail of stonework, V. Horta.
See plate 18.10.

PART II OPENER Detail of a vitrine, I. Canepa. Wood.
Italian, c.1900. Private Collection.

PART III OPENER Detail of carved glass, P. Wolfers.
See plate 13.11.

PART IV OPENER Detail of writing desk, K. Moser.
See plate 20.6.

PART V OPENER Cast iron number, H. Guimard.
See plate 17.7.

PLATE AT TOP OF CHAPTER 24 Zsolnay plate,
J. Rippl-Rónai. Hungarian, c.1898. Private Collection.

Contents

Directors' Foreword 7

List of Contributors 8

List of Lenders 10

Acknowledgements 11

PART I
INTRODUCTION

1 The Style and the Age 14
Paul Greenhalgh

PART II
THE CREATION OF MEANING

2 Alternate Histories 36
Paul Greenhalgh

3 The Cult of Nature 54
Paul Greenhalgh

4 Symbols of the Sacred and Profane 72
Ghislaine Wood and Paul Greenhalgh

5 The Literary Heritage 92
Philippe Hamon

6 Orient and Occident 100
Anna Jackson

7 Arabesques: North Africa,
Arabia and Europe 114
Francesca Vanke

8 *Le Style Anglais*: English Roots
of the New Art 126
Paul Greenhalgh

PART III
THE MATERIALS OF INVENTION

9 The Age of Paper 148
Ghislaine Wood

10 Moulding Wood:
Craftsmanship in Furniture 164
Gabriel P. Weisberg

11 The New Textiles 178
Linda Parry

12 The New Ceramics:
Engaging with the Spirit 192
Jennifer Hawkins Opie

13 The New Glass: A Synthesis
of Technology and Dreams 208
Jennifer Hawkins Opie

14 Modern Metal 220
Helen Clifford and Eric Turner

15 Jewellery and the Art
of the Goldsmith 236
Clare Phillips

16 The Concentrated Essence of a Wiggle:
Art Nouveau Sculpture 250
Alexander Kader

6

PART IV
THE METROPOLIS
AND THE DESIGNER

17 The Parisian Situation:
 Hector Guimard and the Emergence
 of Art Nouveau 264
 Gabriel P. Weisberg

18 Victor Horta and Brussels 274
 Françoise Aubry

19 Munich: Secession and Jugendstil 286
 Gillian Naylor

20 Secession in Vienna 298
 Gillian Naylor

21 Glasgow: The Dark Daughter
 of the North 310
 Juliet Kinchin

22 Louis Sullivan and
 the Spirit of Nature 322
 Lauren S. Weingarden

23 Barcelona: Spirituality
 and Modernity 334
 Ignasi de Solá-Morales

24 Budapest: International Metropolis
 and National Capital 346
 David Crowley

25 The New Art in Prague 360
 Milena Lamarová

26 Helsinki: Saarinen
 and Finnish Jugend 374
 Jennifer Hawkins Opie

27 Moscow Modern 388
 Wendy Salmond

28 Louis Comfort Tiffany
 and New York 398
 Alice Cooney Frelinghuysen

29 Turin: Stile Floreale,
 a 'Liberty' for Italy? 412
 Wendy Kaplan

PART V
CONCLUSION

30 A Strange Death 428
 Paul Greenhalgh

Notes 437

Bibliography 441

Object List: Art Nouveau
1890–1914 Exhibition,
National Gallery of Art 449

Name Index 487

Subject Index 493

Directors' Foreword

Exactly a century ago, the Victoria and Albert Museum made the decision—controversial at the time—to purchase a body of Art Nouveau works from the Paris *Exposition Universelle* of 1900. Many of those works, now considered masterpieces, are included in this exhibition and catalogue. These vibrant explorations of materials and techniques were also deliberate attempts to transform the urban, industrial world.

The V&A, or South Kensington Museum as it was known, was a key resource for Art Nouveau designers. Émile Gallé, Victor Horta, and Ödön Lechner, for example, visited the Museum and were inspired by its collections. The Museum's numerous publications on the principles of ornament and the resources of the National Art Library also had a great impact on the style. Like museums and public galleries, mass publications on art and design were just becoming established features of cultural life. Art Nouveau was thus quintessentially modern in that it was informed by and created through contemporary means.

The Art Nouveau style was also self-consciously international, drawing upon sources throughout Europe and the rest of the world. American artists, architects, and artisans in New York, Buffalo, Boston, Cincinnati, and Chicago readily adopted the new style. Some American practitioners, notably Louis Comfort Tiffany, were commercially successful abroad, and Americans garnered their share of medals at the *Exposition Universelle* in Paris in 1900. As interpreted by architects and artists such as Frank Lloyd Wright, the movement in America set the stage for a modernism that in turn had a great influence on progressive art and architecture in the United States, Europe, and Japan.

Art Nouveau, 1890–1914, the exhibition accompanying this book, will travel from the V&A in London to the National Gallery of Art in Washington. The exhibition is made possible at the National Gallery by the generous support of DaimlerChrysler Corporation Fund. Additional support is provided by the Terra Foundation for the Arts, Robert P. and Arlene R. Kogod, Eleanor and Donald Taffner, and The Fund for the International Exchange of Art. Although the core of the exhibition comes from the V&A's own vast collections, numerous international lenders, public and private, have provided works. We are grateful to all who have helped create this publication and exhibition, celebrating the astonishing creative achievements of the last *fin de siècle*.

ALAN BORG
Director
Victoria and Albert Museum

EARL A. POWELL III
Director
National Gallery of Art

List of Contributors

PAUL GREENHALGH is Head of Research at the V&A, and curator of the major exhibition *Art Nouveau 1890–1914*, in Spring 2000. Formerly Head of Art History at Camberwell College of Art and tutor at The Royal College of Art, his publications include *Ephemeral Vistas* (1988), *Modernism in Design* (1990), *Quotations and Sources from Design and the Decorative Arts 1800–1900* (1993).

FRANÇOISE AUBRY has been the director of the Musée Horta, Brussels since 1981. Publications include *Bruxelles, Saint-Gilles, Musée Horta* (1990) and *Victor Horta à Bruxelles* (1996). She is co-author of *Art Nouveau en Belgique: Architecture et intérieurs* (1991), *Bruxelles fin-de-siècle* (1994) and *Le XIXe siècle en Belgique: architecture et intérieurs* (1994).

HELEN CLIFFORD is a member of the V&A's Research Department, teaching on the joint V&A/RCA MA in the History of Design. She has curated major exhibitions on historic and contemporary silver, as well as contributing articles on aspects of design history to the *Burlington Magazine, Apollo, Studies in the Decorative Arts* and the *Journal of Design History*.

DAVID CROWLEY is tutor in history of design at the Royal College of Art, London. His publications include *National Style and Nation-State* (1992), *Design and Culture in Poland and Hungary, 1890–1990* (1993) and 'The Propaganda Poster', *The Power of the Poster* (V&A Publications, 1998). His most recent published work was as editor of *Socialism and Style: The Material Culture of Post-War Eastern Europe* (1999).

ALICE FRELINGHUYSEN is curator of American Decorative Art at the Metropolitan Museum of Art, New York. Her published work includes *American Porcelain 1770–1920* (1989) and the catalogue for *Louis Comfort Tiffany at the Metropolitan Museum of Art* (1999). This was the most recent of many exhibitions and installations that she has curated. She has also contributed to *Tiffany's Chapel for the 1893 Worlds Exposition* (2000).

PHILIPPE HAMON studied Literary Theory and 19th-Century Historical Literature at the Sorbonne Nouvelle (Paris III). Publishing chiefly on French naturalist and realist authors, his recent publications include: *Expositions, littérature et architecture au XIXes* (1989) and *L'ironie littéraire, essai sur les forms de l'écriture oblique* (1996).

ANNA JACKSON is a curator in the V&A's Far Eastern Department. Her research interests include the cultural relationship between Japan and Europe in the late nineteenth and early twentieth centuries. Publications include *Japanese Country Textiles* (V&A Publications, 1997). She also edited the museum guide: *V&A: A Hundred Highlights* (V&A Publications, 1996).

MILENA LAMAROVÁ studied at Charles University, Prague and the Royal College of Art, London. She is a curator of the Museum of Decorative Arts in Prague. Publications include *A History of Czech Modern Art 1890–1938* (1998). Awarded the Prize of Czech Academy of Science. She has contributed to many exhibition catalogues, including *Czech Cubism – Design and Architecture* (1991–92).

ALEXANDER KADER is Head of the European Sculpture and Works of Art Department at Sotheby's, London. A graduate of the Courtauld Institute and formerly a curatorial assistant in the Sculpture Collection of the V&A, his publications include articles and essays on English Neo-classical and Pre-Raphaelite sculpture, and on Frederic Leighton.

WENDY KAPLAN is associate director of exhibitions and cultural affairs at The Wolfsonian-Florida International University. She is co-author or editor of many titles on nineteenth- and twentieth-century design, including *The Arts and Crafts Movement* (1991), *Designing Modernity: The Arts of Reform and Persuasion* (1995), *Charles Renee Mackintosh* (1996) and *'The Art that is Life': The Arts and Crafts Movement in America* (1998).

JULIET KINCHIN is Honorary Reader at the University of Glasgow and lecturer at the Glasgow School of Art. She established the Christie's Decorative Arts Programme, University of Glasgow, and in 1999 was Visiting Professor at the Bard Graduate Center for Studies in the Decorative Arts. Publications include *Glasgow's Great Exhibitions* (1988); chapters in *Charles Rennie Mackintosh* (1996) and *E.W.Godwin: Aesthetic Designer and Architect* (1999).

GILLIAN NAYLOR is Visiting Professor in the History of Design at the Royal College of Art, London. She has published books on the Arts and Crafts movement, Hector Guimard, the Bauhaus and William Morris, as well as many articles on nineteenth- and twentieth-century design, including 'Domesticity and Design Reform' in *Carl and Karin Larsson: Creators of the Swedish Style* (V&A Publications, 1997).

JENNIFER HAWKINS OPIE is Deputy Curator in the V&A's Ceramics & Glass Department. Specialising in 19th- and 20th-century studies, publications include *Art & Design in Europe and America 1800–1900* (1987) and *Scandinavia: Ceramics & Glass in the 20th Century* (V&A Publications 1989). She was a contributor to *William Morris 1834–1896* (1996) and *A Grand Design: the Art of the V&A* (V&A Publications 1999).

LINDA PARRY is Deputy Curator of the V&A's Textile and Dress Department. A leading authority on British nineteenth-century design, she edited *William Morris* (1996), the comprehensive catalogue accompanying the V&A's major William Morris retrospective. Her other books include *William Morris Textiles* (1983) and *Textiles of the Arts and Crafts Movement* (1988).

CLARE PHILLIPS studied at Birmingham University and the Royal College of Art in London. Her publications include *Jewelry* (1996), as well as contributions to *The Illustrated History of Textiles* (1991) and *Silver* (ed. Philippa Glanville, V&A Publications 1996). She is a curator in the Department of Metalwork, Silver and Jewellery at the V&A, and lectures regularly.

WENDY SALMOND is Associate Professor in the Art Department at Chapman University, Orange CA. Her publications include *Arts and Crafts in Late Imperial Russia* (1996) and *Russian Icons at Hillwood* (1998). She is co-editor of the forthcoming *The Uncommon Vision of Sergei Konenkov, Russian Sculptor* and editor of a special *style moderne* issue of *Experiment* (Spring 2000).

IGNASI DE SOLÀ-MORALES I RUBIÓ is Professor at the Architectural School of Barcelona. Publications include *Rubió y Bellver y la Fortuna del Gaudinismo* (1975), *Eclecticismo y Vanguardia. El caso de la arquitectura moderna en Cataluña* (1980), *Gaudí* (1983), *L'Exposició Internacional de Barcelona 1914–1929: Arquitectura y Ciutat* (1985), *Fin de Siecle Architecture in Barcelona* (1992) and *Architecture Guide: Spain 1920–2000* (1998).

ERIC TURNER is a curator in the Department of Metalwork, Silver and Jewellery at the V&A. His particular expertise concerns the collections of post-1880 metalwork and Sheffield plate. He has contributed to many publications on these subjects, including *Art and Design in Europe and America, 1800–1900* (1987), *Silver of a New Era* (1992), *Liberty of London* (1992), *Silver* (V&A Publications 1996) and *Pewter* (V&A Publications 1999).

FRANCESCA VANKE has recently completed her PhD thesis on nineteenth-century British cultural and aesthetic responses to Islam and its decorative arts. She is now undertaking post-doctoral research, working at Camberwell College of Arts, London.

LAUREN S. WEINGARDEN is Associate Professor of Art History, Florida State University. Her published work includes *Louis H. Sullivan: The Banks* (1987), *Louis H. Sullivan: A System of Architectural Ornament* (1990), and numerous contributions to conference proceedings and exhibition catalogues, including *Chicago Architecture 1872–1922: Birth of a Metropolis* (1987).

GABRIEL P. WEISBERG is Professor of Art History at the University of Minnesota. He has published widely in the area of Art Nouveau, including *Art Nouveau Bing, Paris Style 1900* (1986) and *Art Nouveau, A Research Guide for Design Reform in France, Belgium, England, and the United States* (1998).

GHISLAINE WOOD is assistant curator of the major exhibition on Art Nouveau (Spring 2000) curated by Paul Greenhalgh. She is author of *Art Nouveau and the Erotic* (V&A Publications, 2000), published to coincide with the Art Nouveau exhibition.

Art Nouveau, 1890–1914

Victoria and Albert Museum 6 April–30 July 2000
National Gallery of Art 8 October 2000–28 January 2001

The Art Institute of Chicago

Mr Victor Arwas

Collection Barlow Widmann

Bibliothèque Forney, Paris

Birmingham Museums and Art Gallery

Brighton Museum and Art Gallery

Carnegie Museum of Art, Pittsburgh

Charles Hosmer Morse Museum
of American Art, Winter Park

Chicago Historical Society

The Chrysler Museum, Norfolk

Cincinnati Art Museum

Cooper-Hewitt National Design Museum,
New York

Cornell University, Ithica

Dalva Brothers

David and Alfred Smart Museum of Art,
University of Chicago

Delaware Art Museum, Wilmington

Martin Eidelberg

Everson Museum of Art, Syracuse

Frye Art Museum, Seattle

Mrs Patricia Gebhard

Glasgow Museums

Glasgow School of Art

The Hearn Family Trust

The State Hermitage Museum, St Petersburg

High Museum of Art, Atlanta

Joseph Holtzman, New York

Houghton Library, Harvard University,
Cambridge

Hungarian National Gallery, Budapest

Mr and Mrs Herbert Irving

Kunstindustrimuseet, Oslo

Mr and Mrs Jean-Louis Lamot

Mr Michael Levitin

The Library of Congress, Washington

Lillian Nassau Gallery, New York

Los Angeles County Museum of Art

The Menil Collection, Houston

The Metropolitan Museum of Art, New York

The Minneapolis Institute of Arts

Mucha Trust

Munch Museet, Oslo

Münchner Stadtmuseum

Musée d'Orsay, Paris

Musée de l'Ecole de Nancy

Musée de la Mode et du Textile, Paris

Musée des Beaux-Arts, Nancy

Musée des Beaux-Arts, Reims

Musée Gustave Moreau, Paris

Musée Horta, Brussels

Musée National de Céramique, Sèvres

Musées Royaux d'Art et d'Histoire, Brussels

Musées Royaux des Beaux-Arts
de Belgique, Brussels

Museo Municipale di Treviso

Museu Calouste Gulbenkian, Lisbon

Museum für Kunst und Gewerbe, Hamburg

Museum of Applied Arts, Budapest

Museum of Fine Arts, Boston

The Museum of Modern Art, New York

National Gallery of Art, Washington

The Nelson-Atkins Museum of Art,
Kansas City

The Newark Museum

Norwegian Folk Museum, Oslo

Osterreichisches Museum für angewandte
Kunst, Vienna

Mr and Mrs Sam G. Perkins

Seymour H. Persky

The Art Museum, Princeton University

Jack Rennert

Mr and Mrs Joel B. Ruby

The Saint Louis Art Museum

Steven Schmidt

The Birkenhead Collection

Smithsonian Institution Libraries,
Washington

Mr Eric Streiner

Donald and Eleanor Taffner

The Toledo Museum of Art

Town of Clarence, NY

Unity Temple Unitarian Universalist
Congregation

University Museum, Southern
Illinois University

University of East Anglia

Victoria and Albert Museum, London

Villa Stuck, Munich

Virginia Museum of Fine Arts, Richmond

The Wolfsonian-Florida International
University, Miami Beach

Private Collections

Acknowledgements

There are a lot of people to thank. A book and exhibition of this kind can only happen with the help of a wide range of supporters, inside and outside the V&A museum. First of all, the Assistant Curator of the exhibition Ghislaine Wood, apart from making such an important contribution to the exhibition and text, did the picture research which makes the book what it is. Ghislaine and I worked alongside Tina Manoli, the exhibition organiser, whose unfailing efforts likewise have made this entire enterprise possible.

Many international scholars gave their time freely, private lenders and institutions provided advice, images and objects, and a huge team of experts contributed their knowledge to assist both the exhibition and the book. I am extremely grateful to them all. I apologise now for any I fail to acknowledge here.

The contributors to the book also offered extensive advice on the exhibition; their details appear overleaf. I am also extremely grateful to the generous support and assistance provided by: Susan MacMillan Arensberg, Victor Arwas, François Aubry, Lucille Audouy, Kenneth Barlow and Albrecht Widmann, Karola Bakonyi, Marc Bascou, Patrice Bellanger, David M. Blackburn, Roselyne Bouvier, Alison Bridger, Stephen Cadwalader, Garth Clark, Pete Clark, Simon Cook, Monique Crespin, Graham Dry, Ralph Esmerian, François Feyens, Pascale Lacroix Green, Alain Gressier, Rupert Harris, Paul and Ellen Josefowitz, Samuel Josefowitz, Timo Keinänen, Pekka Korvenmaa, Jean David Jumeau Lafond, Mark Leithauser, Caroline Mierop, Sarah and John Mucha, Paul Nassau, Francis Van Noten, Jean Luc Olivié, Sickan Park, Earl A. Powell III, Penny Proddow, Naomi Remes, Jennifer Rennie, Béatrice Salmon, Annamarie V. Sandecki, John Scott, Jacqueline Soyeur-Delvoye, Eric Streiner, Arlie Sulka, Paul Tauchner, Valerie Thomas, Dodge Thompson, Peter Trowles, Gábor Újfalusi, Vera Varga, Johanna Walker, Monsieur J. Weiser, Gilbert Weynans and Monsieur Meurrens, Joyce and Erving Wolf, and Madame Baeyens Wolfers.

At the V&A, many colleagues have contributed to both the exhibition and the production of the book, for which I am of course most grateful. Many thanks are due to Jane Buller, Antony Burton, Juliette Dugat, Edgar Harden, Jane Pavitt, Katrina Royall, the late Clive Wainwright, and assistants Susan Barry, Eleanor von Heyningen, Lisa Hockemeyer, Helen Jones and Kati Price, all of the Research Department, and Karen Livingstone of the British Galleries team. All contributed to the research effort. Linda Lloyd-Jones, Head of the Exhibitions Department, has been ceaselessly supportive. Francis Pugh, Anna Salaman and Amanda Sharkey (Education Department), and Ruth Barker and Georgina Cope (Press and Marketing Departments respectively) have made the whole thing known. The exhibition designers Brian Griggs, Andy Feast and Cate Hall have worked wonders. I am most grateful to Michael Cass and all his colleagues at V&A Enterprises for adding to the allure of the exhibition and book. The V&A Photographic Studio, and especially Mike Kitcatt, Pip Barnard and the late Danny McGrath deserve thanks for their patience and professionalism, as do the team at V&A Publications: Mary Butler, Miranda Harrison, Rosemary Amos, Harry Green, John Noble, Geoff Barlow, Clare Davis, Claire Sawford, Nicola Evans and Mary Wessel.

Thank you to all my friends and family – and indeed, friends and family of all the contributors – for their immense patience and unfailing support. Finally, I thank Jack and Alex Greenhalgh, who have a way of continually providing inspiration.

PAUL GREENHALGH

PART

Introduction

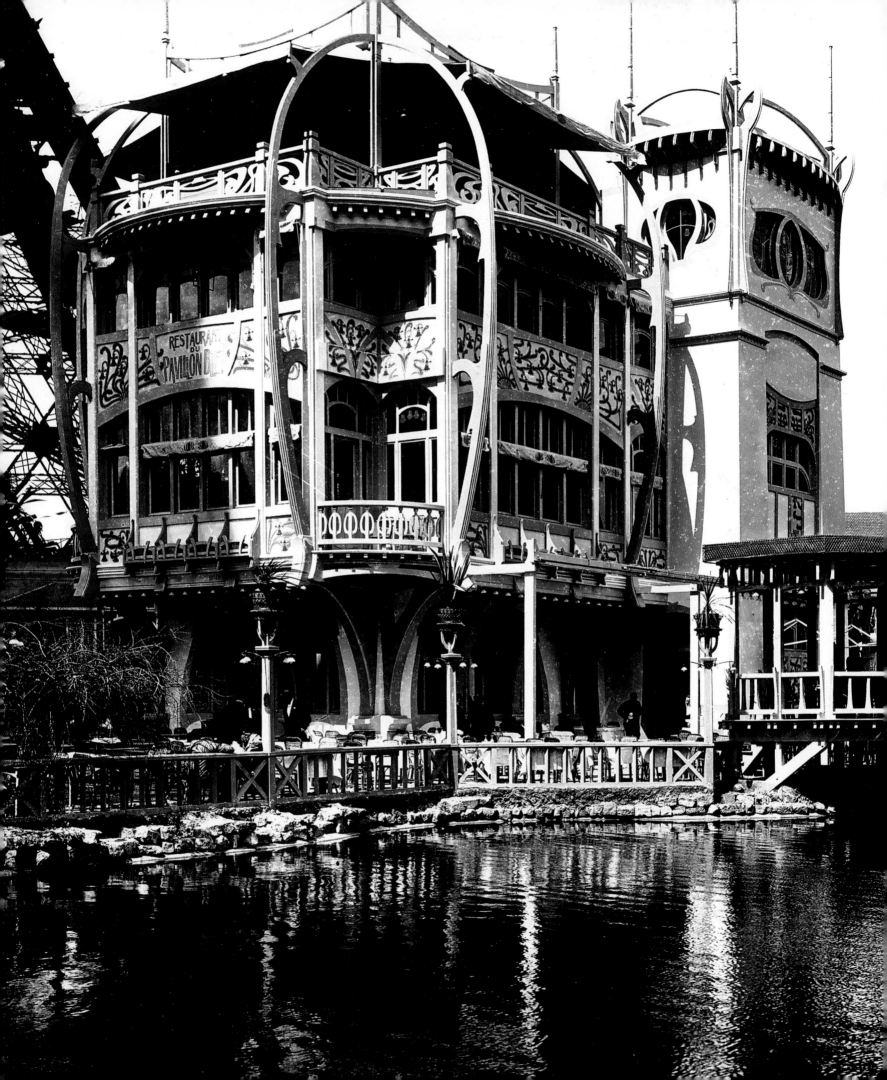

Paul Greenhalgh

The Style and the Age

I believe that art is destined more and more in the future to play a great role,
that it is a force we have at our disposal to create a social harmony,
a unity of humanity that never previously existed. (Gustave Geffroy, 1905)[1]

1.1 Gustave Serrurier-Bovy,
Pavillon Bleu Restaurant.
Exposition Universelle. Paris, 1900.
Photo: Roger-Viollet, Paris.

'The dominant characteristic of an époque of transition like ours is spiritual anxiety', Adolphe Retté told his readers on 1 March 1898. 'It is not surprising', he went on, 'we are living in a storm where a hundred contradictory elements collide; debris from the past, scraps of the present, seeds of the future, swirling, combining, separating under the imperious wind of destiny'.[2] The theme of his column, in the French magazine *La Plume*, was the condition of contemporary society, but his words also described a phenomenon in the visual arts of which he and his colleagues at *La Plume* were aware, and had helped to create: Art Nouveau.

Art Nouveau was the result of intense and flamboyant activity in the visual arts by individuals wishing to change the character of European civilization. It began in the ateliers, workshops and galleries of the art world, but quickly moved out beyond these to become a commonplace that could be detected – but not directed – on all levels of *fin-de-siècle* culture. In the first decade of the new century it was everywhere (plate 1.1). It was simultaneously vulgar and élite, loved and hated. It could be found proudly decorating new and noble museum buildings, State monuments and official architecture (plate 1.2), as well as giving garrulous form to biscuit tins (plate 1.3), bill-posters, menu cards and children's toys. It inspired moral manifestos dedicated to the future good of society, while providing the imagery of erotic theatre and pulp pornography. It was hailed as a visual Esperanto by internationalists, and claimed as their own by Gauls, Slavs, Latins, Celts and Teutons.

Yet all this loudness, pomp and popularity has not helped the historical process much. In the nine decades since its decline, there has been no real agreement as to what Art Nouveau looked like, when it started or finished, where precisely it happened, or even what its politics and ideas meant. Commentators both for and against it have contradicted one another in successive attempts to position it within the larger scheme of European visual culture. There has been no consensus, for example, on whether it was a style or a movement.[3] Usually depicted as a sudden flourish of activity immediately around 1900, it has also been seen as a far lengthier event: 'the span of Art Nouveau must be seen as ranging from 1870 to 1914'[4] and it has even been disputed that it actually occurred in this period at all: 'it has been identified, wrongly, as an aspect of the *belle époque*'.[5] Some have believed that 'there is not a single Art Nouveau style, but that it comprises a number of varied and conflicting movements',[6] whereas others have preferred it as a very specific visual development, a 'style of art which … has as its main theme a long, sensitive, sinuous line that reminds us of seaweed or of creeping plants'.[7] It has been seen as a phenomenon of the French- and possibly German-speaking countries only, but also as 'a European-wide invasion'.[8]

Its intellectual underpinning has been understood in strikingly varied ways. A classic text on the subject is entitled *The Anti-rationalists* (1973) and, in this spirit, many have seen it as a consciously mystical and illogical continuation of the Romantic tradition. By contrast, others believe that it constituted 'a *logical* opposition with a *rationalist* foundation',[9] firmly rooted in the scientific achievements of the nineteenth century. Its ethical constitution has been stretched across the emotional range, from being a dark, immoral reflection of a corrupt world: 'do not such pleasures signal the decline, if not in fact the end, of the civilization for which the First World War tolled the knell?'[10] to being a moral beacon, heralding a new morality: 'Art Nouveau was consciously and hopefully launched in the 1890s as a concrete expression of social conscience'.[11] Condemned as being centrally concerned with 'interiority', or the turning inward – materially and psychologically – of a decadent and capital-driven bour-

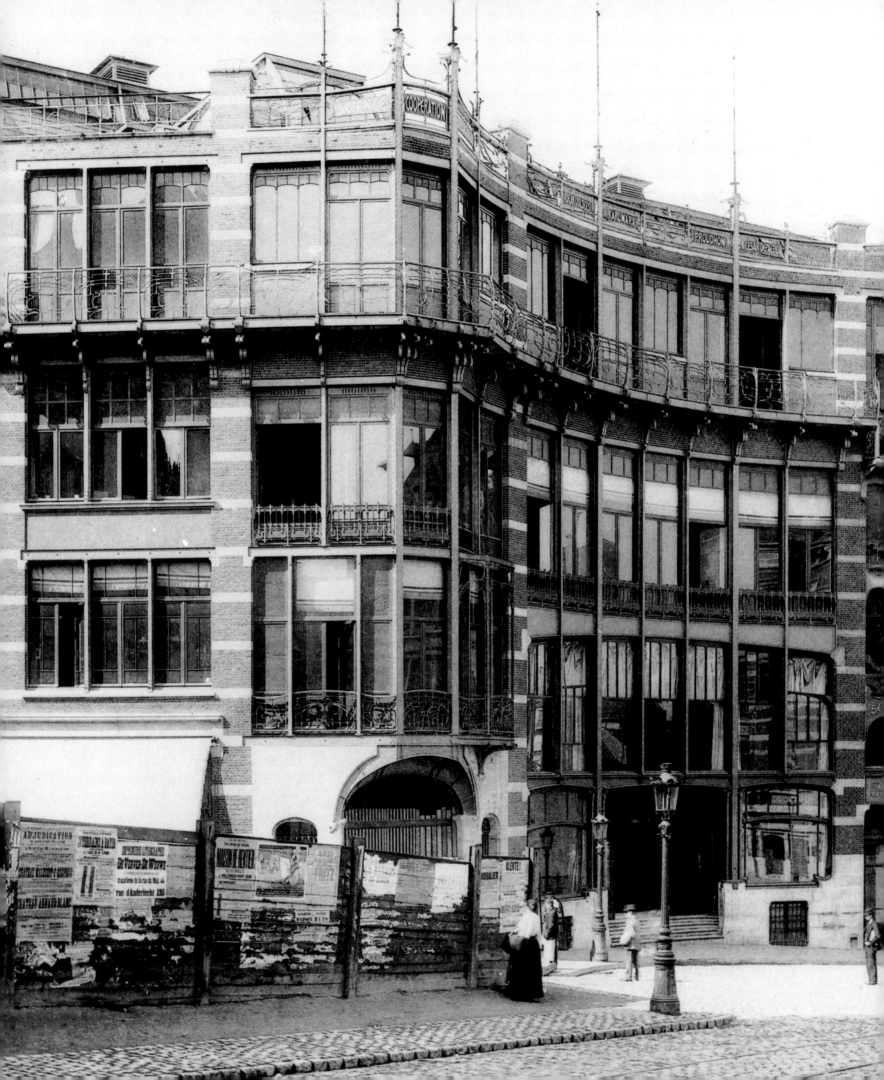

1.3 Biscuit tins made for the Co-operative Wholesale Society. Offset lithography, printed and embossed. English, *c.*1903. V&A: M.112–1983.

1.2 Victor Horta, Maison du Peuple, Brussels, 1896–99. Photo: Musée Horta, Brussels.

geoisie, it has also been heralded as a style centrally concerned with public life.[12] It has been exposed simultaneously as a government-based, pragmatic money-making strategy[13] and as a non-conformist artistic revolt intent on 'defeating the establishment order'.[14] It has been pictured as an idealist crusade, composed of a number of international styles,[15] and as a movement peopled by 'artists and their institutional sponsors [who] shared a contemporary nationalist ideal'.[16]

These varied visions are not to do with the failings of scholarship or the subjective fickleness of taste. They all reflect some aspect of Art Nouveau. Rather, they point to the fact that this was a multi-faceted, complex phenomenon that defied – then and now – any attempt to reduce it to singular meanings and moments. Indeed, under the reductive scrutiny of art-historical scholarship, Art Nouveau has tended to disappear altogether. What we can say, however, is that through the collision 'of a hundred contradictory elements', to use Retté's words, many disparate things cohered into a style which became, despite contemporary rivals, the *style of the age*.

Nevertheless, definitions are important. In this volume, 'Art Nouveau' is the name given to a style in the visual arts that was a powerful presence in Europe and North America from the early 1890s until the First World War. The style emerged from the intense activity of a collection of movements, manufacturers, public institutions, publishing houses, individual artists, entrepreneurs and patrons, located all over the urban, industrial world. It existed in all genres, but the decorative arts were centrally responsible for its invention and its fullest expression. It had diverse roots, meanings and results, but its many parts were held in proximity by a number of shared ideas and sources. Indeed, there was one defining characteristic that held Art Nouveau together, an ideal bestowing the many movements and individuals with a vision that, regardless of different aesthetic solutions and national cultures, meant they all flowed in the same direction. This defining characteristic was modernity. Art Nouveau was the first self-conscious, internationally based attempt to transform visual culture through a commitment to the idea of the modern.

A key motivation behind the drive for modernity in the arts was the recognition that the world was changing, that technical, economic and political developments were transforming the physical environment. Art Nouveau artist Alexandre Charpentier spoke for many when he asserted that 'the face of the world has undergone more change during the last hundred years than it underwent in the previous eighteen centuries'.[17] This implied that the uses of art had changed too and, in the words of Art Nouveau intellectual Julius Meier-Graefe, 'if the uses of art change, art itself must change'.[18] This shift in material conditions carried a sense of drama. Historian Clive Trebilcock has observed that 'symbolically, the European civilization of 1914 could be represented as precisely by the steam-hammer or the steam warship as it had been by the cathedral spire or the knightly banner'. He notes how the pace of development after 1870 was striking:

> There were engineering works in Spezia and Tsaritsyn,
> automobile factories in Vienna and Milan, Dreadnought
> yards in Fiume and Ferrol. … And at St Étienne,
> Hayange and Décazeville, the French industrialists
> had created a handful of manufacturing installations which
> could rival any then in existence. To the casual glance,
> it might appear that industrialisation had overtaken Europe
> from the Mediterranean to the Baltic, from the Channel
> to the Danube.[19]

In commercial and imperial terms, the last third of the century was one of frenzy. On the trade front there was a shift from British monopoly to pan-national competition, as the British lost their grip on the production and sale of industrial commodities. Old rivals came to understand the motor forces of the modern world and younger nations, most notably Germany, the United States and Japan, asserted themselves. Trade simultaneously became more international and more aggressive, as nations fought each other in the factory and the market place. This competitive energy fired the so-called 'New Imperialism', in which nations scrambled not only for trade, but also for territory. The Europeans occupied and to a considerable extent asset-stripped the globe. As they did so, they voraciously consumed the cultures of the world and made them their own.

But while the processes of economic, imperial and industrial modernization occurred everywhere, everywhere was not the same place. Historian Sidney Pollard, for example, has noted that 'Europe was a continent made up of many variegated and contradicting economies'. The geography and demographics of European countries, their traditional infrastructure, the type of government and wealth controlling them, together with the brand of entrepreneur introducing change, all had a bearing on the rate and type of change achieved.[20] The complexity and variety of *cultural* modernization, of which Art Nouveau was the most expressive and successful example, is thus partly explained. The style was as it was, not simply because of the subjective visions of artists and designers (as important as these were), but because of the nature of the world they were born into. When artists and designers in urban, industrial centres began to express a desire to be modern, they invariably found themselves reconciling cosmopolitan ideas with the immediate conditions in which they found themselves. This fusion of universal and local sources is at the heart of the Art Nouveau style, and mirrors reconciliations and tensions evident in all spheres of life.

The concept of the 'new' did not simply imply novelty or relative change, but the transformation of culture through a process of evolutionary development. In 1902 Gabriel Mourey commented:

> This change is taking place. Here and there, in every
> country, men with willing minds are endeavouring to
> hasten it. Will they succeed? Why not? What right have
> we to fix the limits [of] human progress? And even if we
> had enough foolish pride to do so, would that prevent
> what is destined to happen from coming to pass?[21]

Thus, the New Art was to be a vehicle to radicalize established practices in art and design, to effect permanent change. As commentators said at the time, it was to 'enrich the old patrimony with a spirit of modernness',[22] and to

place itself 'in the opposite camp from the prose of old art, which is a rehash of ancient things'.[23] Many in this opposite camp believed, like designer August Endell in 1897, that 'we are not only at the beginning of a new stylistic phase, but at the same time on the threshold of the development of a completely new art'.[24] They felt they must break decisively with the past, a past that implied not only formulations of art that had become dominant and resistant to change, but that had also created institutions which taught, promoted and protected the old ways.

The driving passion behind all these ideas stemmed from the belief that art and life were synonymous. The artist's creative spirit was believed to be a force through which the life of the community could be generally improved. Individuality was a key component in the new thinking, as Charles Rennie Mackintosh espoused: 'the focus will eventually prove to be the work of the individual worker … will prove to be the emancipation of all artists from stupid forms of education – which stifles the intellect, paralyses the ambition and kills the emotion'.[25] The individual was the vehicle of change: through him or her, the spiritual transformation of the whole of society could be achieved: 'the time has come; the idea of love will be communicated to all men; art will return to the light in a new form. The earth has been worked from which the new flower will rise; but we will not see this rise before the complete obliteration of the present.' (Henry van de Velde, *Déblaiement d'art*, 1894.)

Powerful as these poetic statements were, however, they were essentially rhetorical. They gave few recipes and less guidance as to what the stuff of this modern world should look like. If the word 'modern' were to mean more than simply 'now' (or denote the period commencing with the Enlightenment), if it were to suggest a fundamental shift, then artists and designers faced the problem of producing objects which somehow expressed this. It was an obvious requirement that modern objects looked modern: artists and designers had to do something that changed the look of things.

The first and most important position to help achieve this change was the idea that the new style was to exist in all media, and would aim at the creation of *Gesamtkunstwerk* ('total' works of art). A term first used in the *fin-de-siècle* context in relation to the music of Richard Wagner, *Gesamtkunstwerk* implied equality among the arts and their orchestration into unified ensembles. This determination to render the arts equal, in an effort towards cultural renewal, was not new to the period. It was widely held among European intellectuals by 1860 that the visual arts

had become divided against themselves, and were configured within a hierarchy that was more to do with economics and bureaucracy than with creativity. The great divide was between the fine arts – of painting and large-scale sculpture – and the so-called lesser, decorative arts. Major thinkers, such as Gottfried Semper in Germany, Eugène Emmanuel Viollet-le-Duc in France and John Ruskin in Britain, argued consistently against the segregation of the arts which they understood as happening on both a practical level, among practitioners and patrons, and on an institutional level, in museums, universities and government ministries. By arguing from historical precedent, that decoration had formerly enjoyed an all-embracing role in the creation of all art, Ruskin was particularly persuasive: 'There is no existing highest-order art but is decorative. The best sculpture yet produced has been the decoration of a temple front – the best painting, the decoration of a room. Raphael's best doing is merely the wall-colouring of a suite of apartments in the Vatican.'[26]

Mainly via the Arts and Crafts movement in England and Symbolism in France (see chapters eight and four), the unity of all arts became a key debating point in *fin-de-siècle* culture in general, and Art Nouveau in particular. Ruskin's Arts and Crafts followers saw division in the arts as directly analogous to social division, which tinged their discussions with politically motivated anger. Leading designer C.R. Ashbee was typical in asserting that 'we are dealing with Art as a whole, and not with picture-painting … with decorative Art, in which the painting of a picture is of minor importance'.[27] Albert Aurier – the celebrated critical supporter of the Parisian Symbolist group the 'Nabis' – developed the idea that in order to achieve its full spiritual potential, art should have no artificial barriers separating its various spheres of activity. Following Ruskin's line, he argued from history that decorative art had formerly dominated, and that art had been divided into classes only under the weight of commerce: 'Decorative painting is, strictly speaking, the true art of painting … . The easel-picture is nothing but an illogical refinement invented to satisfy fantasy or the commercial spirit in decadent civilizations.'[28] Julius Meier-Graefe also pointed to the commercial underpinning of the fine arts: 'Sales are effected as on the Bourse, and speculation plays an important part in the operation.'[29] He confessed to 'a strange kind of fury' at the thought of large private collections of paintings acquired for investment, and 'a silent longing to destroy the whole lot. Who would be the loser if this were actually done?'[30]

The first Art Nouveau designer to articulate the position

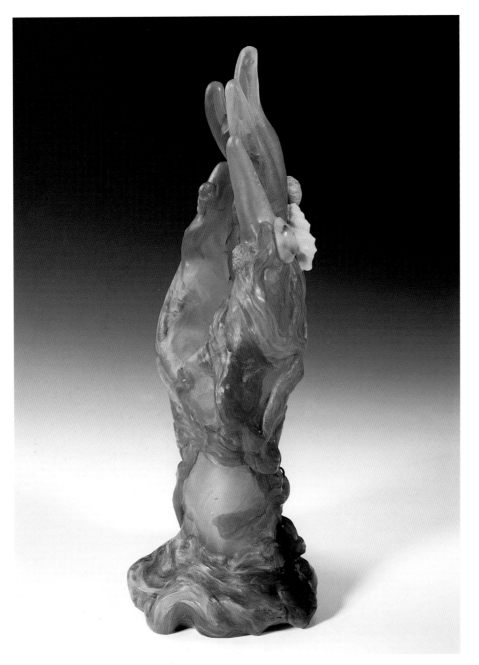

1.4 Émile Gallé, *Hand*.
Hot-worked glass with patination.
French, 1904.
Musée de l'École de Nancy.

one agrees to them. However, this does not imply that these terms are just or that the situation they describe really means anything. We can't allow a split which aims at single-mindedly ranking one art above the others, a separation of the arts into high art and a second class, low industrial art.[31]

French designer Émile Gallé was concerned particularly with the effect of the hierarchy on practitioners: 'Let us not tire of saying over and over again that there are no castes among the artisans of art, that there are no mean and plebian arts.'[32] There was also anxiety about the detrimental effects of the separation of the arts on the general public. Equality of the arts was widely seen as an important pre-condition to making them available to a wider audience. There could be no spiritually uplifting *Gesamtkunstwerk* while the arts were divided. When the group *Les Six* (formerly *Les Cinq* and latterly *Les Huit*) exhibited in Paris in 1898, their advertisements made this clear: 'It is necessary to make art part of contemporary life, to make the ordinary objects that surround us into works of art.'[33] The harmonious ensemble of equal arts, they believed, would surround and transform the audience.

By 1900 Art Nouveau was recognized as the style that had made attack on the existing hierarchy of the arts a main motivation. Practitioners in the style in many countries enjoyed reputations as 'ensembliers', orchestrators of complete interiors known for their ability to design for various media. The ensemble had become the main aesthetic vehicle of the style, and decoration was positioned as the central, expressive force.

At the time, Art Nouveau faced a considerable amount of highly articulate, hostile criticism. Indeed, styles in the visual arts have often been most concisely summarized by those who loathed them most. In 1911, J.H. Elder Duncan, an undistinguished English writer on household design, recognized Art Nouveau's territorial triumph – 'the chaos in design has spread all over France, Germany, Austria and Italy, upon which countries the creed of "L'Art Nouveau" lies heavily' – before advancing his ideas with examples:

Metal is twisted into the most weird and unnatural shapes. Chairs appear as clumps of gnarled tree roots; twisted boughs conspire to form a bedstead; electroliers appear to be boxes suspended by innumerable strings; walls show trees with their roots in the skirting boards, and foliage on the ceiling; sea serpents chase each other around the walls

fully was the Belgian Henry van de Velde. He too believed that the existing nomenclature of the arts was a recent invention and was politically and economically motivated. He campaigned aggressively to change the situation:

Suddenly they were called arts of the second rank, then decorative arts, and then the minor arts … and last, industrial arts … . None of [the arts] had been independent, they were held together by a common idea which was to decorate … . Who or what has the power over these arts? … It is important to note that all terminology, like low art, art of second rank, art industry, decorative art and arts and crafts are only valid as long as

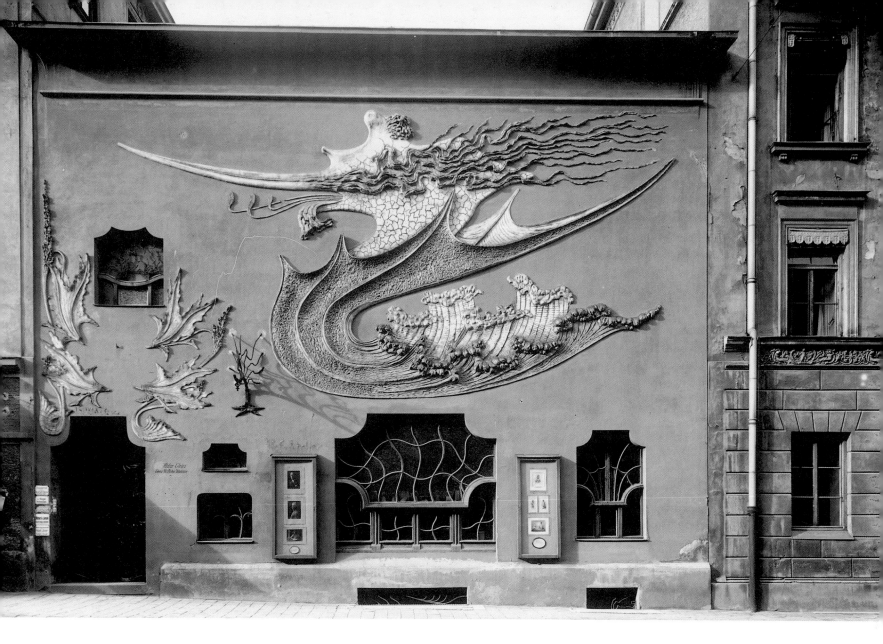

and entrance doors are guarded by appalling dragons … .
The electric lights must masquerade in pools under the
eyes of a nymph; … snakes twisted into ingenious knots
for stair balusters threaten you as you ascend; the door
knocker becomes a grinning satyr, and even the carpet
casts a malevolent eye at you as you traverse it.[34]

Accepting the writer's frenzied venom, his analysis of the
scope of the style is surprisingly perceptive. He deliberately
collectivized the various approaches, making the strategies
used all over Europe and the United States into a common
cause, and he recognized that the look was eclectic (a com-
bination of sources from many diverse places). The
'gnarled' trees, 'boxes', 'strings', 'appalling dragons' and
'grinning satyrs', for example, acknowledged imagery that
was being used in France, Belgium, Scotland, Spain,
Norway and Austria. He understood that the use of this
range of imagery could result in objects that were
extremely complicated or disarmingly simple, but that nev-
ertheless held something in common.

The sources made use of in Art Nouveau emanate from
particular areas of *fin-de-siècle* cultural experience. There
were three types of source at work: these can be identified
as natural, historical and symbolic. While this typology was
hardly new to the history of art, the way in which the three
were used certainly was. Each was re-explored, either indi-
vidually or in combination, so that they could be used to
generate an overtly modern idiom. Nature, history, symbol-
ism: chapters are dedicated to each of these in this volume,
but suffice it to say here that, while the three were com-
bined to create what was the first self-consciously modern
style to embrace the whole of visual culture, they too were
subjects of modernization by forces both within and
beyond themselves. Indeed, a main reason they were used
as an agent of transformation in the arts was because they
themselves were transformed.

Nature was the most important of the three sources. It
inspired the creation of the most archetypal products of
the style, and was the key element in ensuring that the style
itself was a genuinely international phenomenon (plates
1.4 and 1.5). In the context of the rapid urbanization of

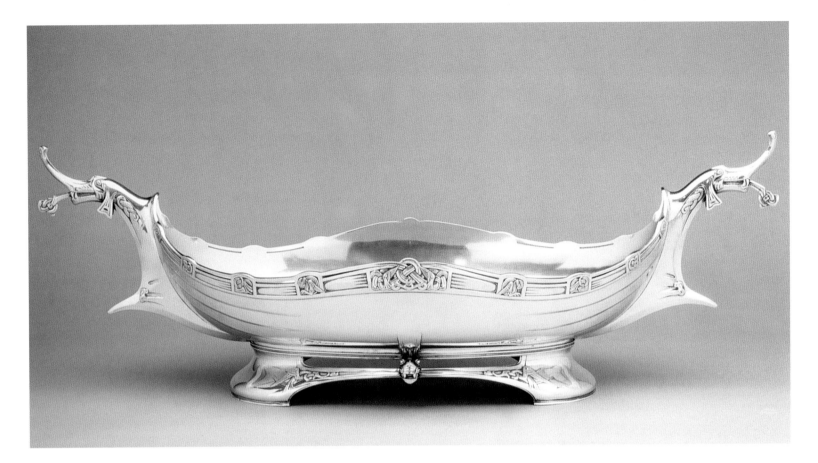

1.6 Henrik Bull, Dragon ship jardinière. Silver. Norwegian, 1899–1900. Kunstindustrimuseet, Oslo.

the European and North American Continents during the later nineteenth century, it aquired new cultural meaning as a wild and unruly determinant outside of normal lived experience. Nature also had a revolution from within, in the form of evolutionary theory, exemplified by the work of Charles Darwin. Humankind was made firmly part of the natural process, and nature itself appeared to acquire its own sense of direction.

It is a truism that history is not the same as the past – history is the past that a society creates for itself. Societies that are stable and unchanging, or that communicate little with the outside world, have relatively little use for history as their past is agreed and omnipresent. But history is extremely important to societies that perceive themselves to be changing, or are being changed by outside forces, or are in constant contact with others who don't share their past. Thus, history became an extraordinarily important phenomenon during the course of the nineteenth century as nations and communities were transformed. By the *fin de siècle*, history was a site of constant contention, a struggle to impose alternative visions of the past in order to gain control of the future. For those committed to the New Art, history was a key tool for the creation of modernity (plate 1.6). Ironically, but inevitably, the modernizing forces

eliminated the past were simultaneously utilized to set up the machinery of history. Trade, industry and empire facilitated the creation of the plethora of publications and archives upon which the profession of history depends, as well as that great invention of the first modern age, the public museum.

During the second half of the nineteenth century, there was a general surge in interest in spiritualism, caused in part by the changes in the material condition of life. The relationship of subjective to objective perception, myth, religion and the supernatural were important themes among those keen to free themselves from the perceived drudgery of normative existence (plates 1.7 and 1.8). Symbolist activity in the arts was part of this wider determination to explore the metaphysical realm. Symbolist literature and painting developed powerfully and came to influence the generation of designers who created Art Nouveau (plate 3.15).

J.H. Elder Duncan and others at the time identified and condemned this particular use of nature, history and symbolism in Art Nouveau. It was not only his taste that was offended. His anger was fired by what is best described as the flouting of normative values. He could see that this was no conventional use of historical style, symbolic iconogra-

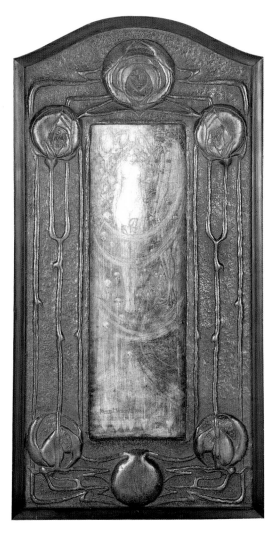

1.8 Frances Macdonald, *Autumn*.
Pencil and gouache on vellum with
beaten-lead frame. Scottish, 1898.
© Glasgow Museums: Kelvingrove
Art Gallery & Museum.

1.7 Eugène Grasset and Maison
Vever, 'Apparitions' brooch.
Gold, enamel, ivory, and topaz.
French, 1900.
Musée d'Orsay, Paris.
© Photo: RMN-Jean Schormans.

phy or nature study; the writing forms and confusing geometry of these objects were not concerned simply with utility or the pleasing of the eye. He sensed an altogether other desire for gratification and a larger ideological agenda. All these sources had been dragged violently out of the haven of legitimate sources of mainstream practice and transformed into the fodder of subversion. He recognized an attempt to question received opinion, to change established norms in accordance with a new vision of life. He felt the modernity of it all, and he didn't like it.

The identification of 'first' objects and artists of a style is a complex and usually fruitless business. A style is more than a movement or a school of thought, more indeed than simply the sum total of the objects with which it is identified. A style has to become aligned with wider lifestyles and patterns of behaviour within the society in which it was created. It has to represent that society in some way. A style is not founded simply by artists and designers making objects in the appropriate idiom. A *work*

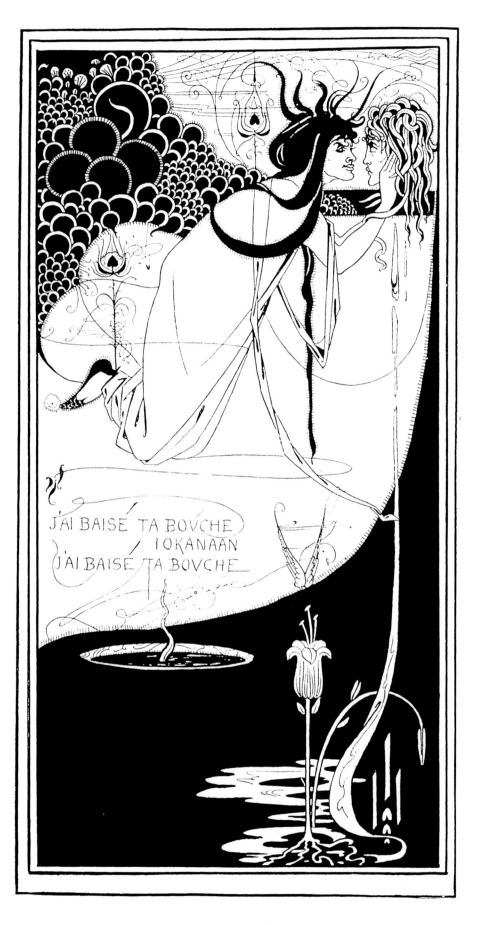

J'AI BAISÉ TA BOVCHE
IOKANAAN
J'AI BAISÉ TA BOVCHE

of art can be made in isolation, a *movement* might comfortably survive only on the admiration of its own members, but a *style* has to be consumed before it can be said to have been produced.

Several factors make the beginnings of Art Nouveau difficult to discern. Many artists, designers and thinkers before 1890 anticipated its objects and ideals without being part of it. The forebears are often wrongly taken for the thing itself. Many key Art Nouveau designers had long careers in related styles before they became involved in Art Nouveau itself. And as Part IV of this volume shows, the style occurred in many different centres, each having 'first moments' to add to the complex international picture. Nevertheless, a pattern of development is discernible. Art Nouveau is most easily understood as having three phases.

In the initial period (1893–95) the first fully mature works emerged from a myriad of related activity in London, Brussels and Paris. Individual artists and designers began to produce consistent bodies of work in the style, and the intellectual agenda was thoroughly worked out. Most important perhaps, an infrastructure for presenting and selling objects and ideas was put in place. Four creative moments stand out as seminal and can serve therefore as a summation of these three years. The first occurred in London. In March 1893 the work of a startlingly young illustrator, Aubrey Beardsley, was featured in the first issue of a new journal, *The Studio*. This was the first public presentation of his work and it catapulted him immediately into the milieu of the European avant-garde. One of the published illustrations, *J'ai baisé ta bouche Iokanaan* (later published as *The Climax*) for Oscar Wilde's play *Salome*, was the first fully mature image in the Art Nouveau style (plate 1.9). The second seminal moment also occurred in 1893, in Brussels. Most certainly in ignorance of Beardsley's efforts, but inspired by much the same things, the Belgian architect Victor Horta completed a commission from his patron, the industrialist Émile Tassel, for a terraced town house in the St Gilles district of the city. The house was the first fully developed exercise in Art Nouveau architecture and interior design (plate 1.10). The third, in 1895 and also

1.9 Aubrey Beardsley,
J'ai baisé ta bouche Iokanaan.
English, 1893. Design for
The Climax from Oscar
Wilde's *Salome* (1893).
V&A: E.456–1899.

1.10 Victor Horta, Hôtel Tassel
(Tassel House). First-floor landing
with view towards the staircase.
Brussels, 1893.
Photo: C.H. Bastin & J. Evrard,
Brussels.

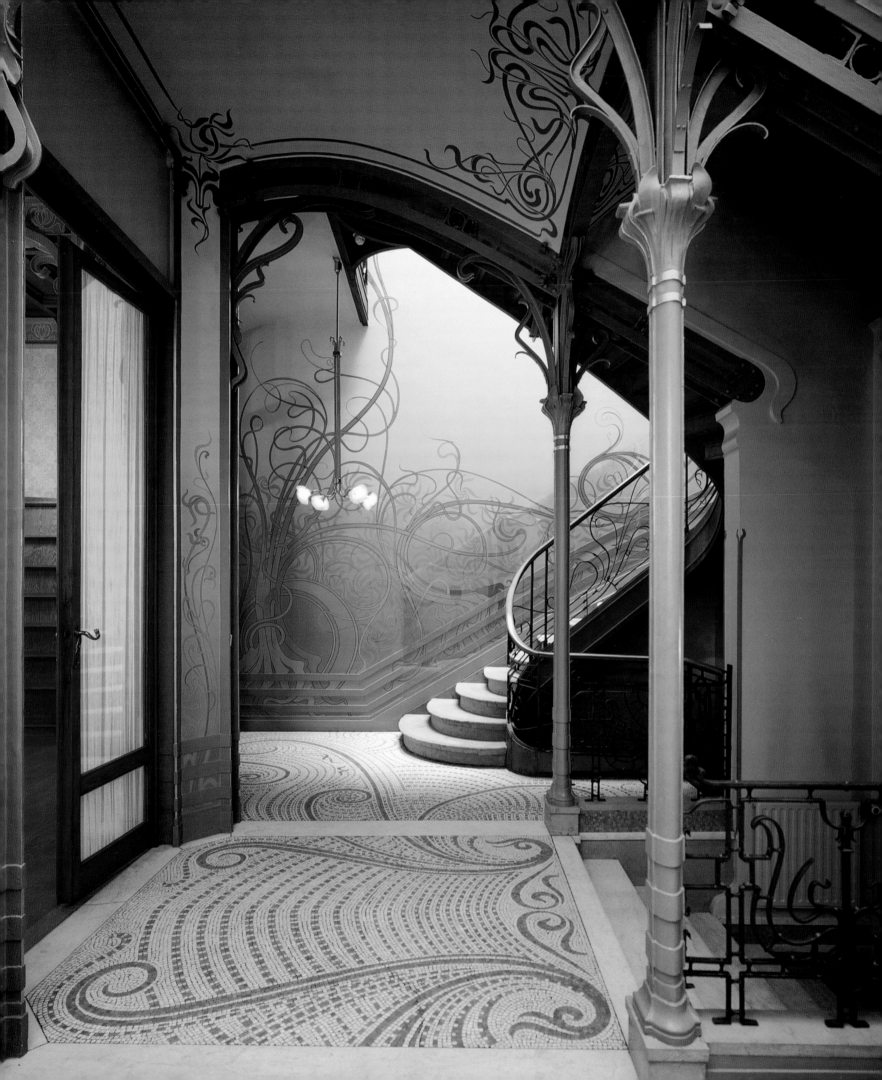

1.11 Entrance to Siegfried Bing's gallery, L'Art Nouveau. Paris, 1895. Photo: Fonds Louis Bonnier.

in Brussels, saw the Belgian Henry van de Velde publish, in pamphlet form, *Déblaiement d'art* (*A Clean Sweep For Art*). Brilliantly abrasive, *Déblaiement d'art* (quoted here, on page 19) was the first in a long line of manifestos for the new generation. Art Nouveau was to be well explained in print by many hundreds of writers, but none was more explosive or persuasive than van de Velde. Finally, in Paris in December 1895, the German-born French entrepreneur Siegfried Bing opened a new gallery, and shop on the rue de Provence in Paris. The gallery, subsequently expanded to include workshops and ateliers, was named 'L'Art Nouveau' (plate 1.11). The style thus acquired one of its most active centres of distribution and its most enduring and widely used name.

A mass-produced print, a bourgeois town house, a polemical pamphlet and a shop: objects, ideas and outlets. Beardsley, Horta, van de Velde and Bing were the most important individuals in the first phase of the style and,

taken together, these things they made describe the parameters of Art Nouveau well. This was to be a style born of international communication, commerce and entrepreneurialism; a style concerned with mass as well as high art, with industrial patronage, urban life, the domestic interior, the ensemble and with the politics of production.

Stylistically, the years of this first phase were most important for the development of the archetypal Art Nouveau line, to the extent that this could be described as the 'linear' phase. A development of the arabesque, Art Nouveau line was a sinuous, tensile abstraction of natural form, that constantly looked as though it were about to burst out of some invisible force that held it under constraint. Coupled with self-consciously asymmetric composition and a certain exoticism, the line lent objects an explosive elegance. Designers following hard on the heels of the first pioneers consolidated the initial achievements and expanded the repertoire to embrace organic form and dramatic colour. Hermann Obrist in Germany, Charles Rennie Mackintosh in Scotland, Émile Gallé in France, Louis Comfort Tiffany in the United States and others were beginning to arrive at definitive statements in the style. Obrist's 'whiplash' embroideries were among its most famous early icons (plate 1.12).

In the second phase, from 1895 to 1900, the style spread to many urban centres in Europe and North America. The 13 cities identified in Part IV of this volume give a fair sense of its distribution, but they were not the only ones. Considerable bodies of work were produced, for example, in Amsterdam, Antwerp, Berlin, Darmstadt, Milan and Riga. The style itself diversified as these various centres adapted it to their needs. Historical sources were used with – and in some cities instead of – natural form. In the hands of some designers, nature revealed itself capable of becoming intensely organic. The metaphysical dimension became powerfully evident as Symbolist ideas asserted themselves. In some cities (notably Antwerp, Brussels, Berlin, Chicago, Milan, Nancy, Prague, Paris and Turin), Symbolism and nature fused in the creation of some of the most flamboyant objects and images of the nineteenth century. In Glasgow, Vienna and, to an extent, Munich, the style acquired a distinctly geometric dimension, in which historical sources were stripped and ordered by tense line, and nature was conventionalized to the point of complete artifice. In other cities, such as Amsterdam, Budapest, Copenhagen, Helsinki, Moscow and Oslo, stylistic sources of particular local relevance came to the fore. The repertoire of ideas and forms culminated in the Paris *Exposition Universelle* of 1900.

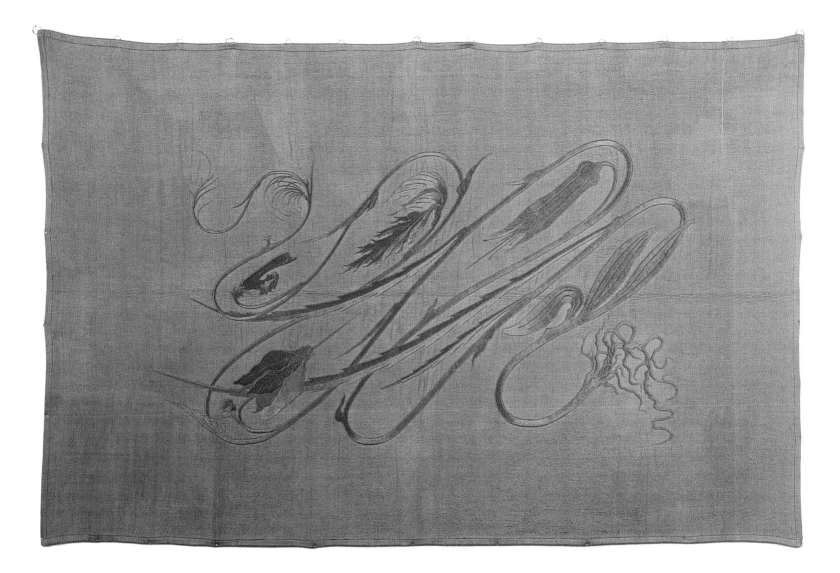

1.12 Hermann Obrist, *Peitchenhieb* (*Whiplash*). Wool with silk embroidery. German, *c.*1895. Stadtmuseum, Munich. Photo: Wolfgang Pulfer.

This phase of Art Nouveau was marked by an extraordinary blossoming of entrepreneurial activity. It should never be forgotten that before they denoted individual artists or movements, the names Daum, Gallé, Iris, Lauro, Liberty, Loetz, Majorelle, Zsolnay and others were those of successful companies. This volume will show that, among the entrepreneurial spirits of the age, Siegfried Bing and Arthur Lasenby Liberty famously stand out,[35] but they were far from unique. Examples abound: the Belgian Octave Maus was a vitally important writer and exhibition organizer. He founded the magazine *L'Art moderne* (1881) and the cosmopolitan exhibition groups *Société des Vingt* (1884) and *La Libre esthétique* (1894). His activities were absolutely essential for the rise not only of Art Nouveau, but also of radical practice generally in Belgium. The German Julius Meier-Graefe ceaselessly promoted the cause of modernity. An editor of the magazine *Pan*, he founded the gallery La Maison Moderne in Paris in 1898. The Belgian Gustave Serrurier-Bovy, quite apart from being a key architect-designer, provided vital links between England, France and Belgium through his correspondence and travel, and his shop in Liège was one of the earliest retail outlets for advanced English and Belgian design.

The interaction of youth and maturity facilitated the entrepreneurial spirit and goes some way towards explaining the ferocious growth rate of Art Nouveau. Using 1895 as a benchmark, two distinct career groups can be discerned. The first consisted of practitioners of around 40 years of age and over in that year. In many cases they were already running successful businesses and had become respected trade names. They were often accomplished in previous styles and had produced a range of products, executed buildings, published, exhibited and travelled on the international circuit. They did not 'invent' Art Nouveau, rather they engaged with it and developed their own versions of it. Most importantly, they lent it credibility. This

Horta and van de Velde, as key initiators, were not quite so young (at 32 and 29 respectively) when they made their breakthroughs, but Beardsley was an astounding 21 years of age when *The Studio* published the *Salome* prints. Many designers producing their signature works in the period 1895–97 were under 30 years of age. These included: Peter Behrens (26), Will Bradley (27), František Bílek (23), Otto Eckmann (30), August Endell (24), Ödön Faragó (26), Georges De Feure (27), Akseli Gallen-Kallela (30), Jan Kotĕra (24), Hector Guimard (28), Josef Hoffmann (25), Charles Rennie Mackintosh (27), Julius Meier-Graefe (28), Hermann Obrist (26) and Eliel Saarinen (22). The machinery of commerce and publicity was made available by the older generation and then exploited brilliantly by the younger. Collectively, these designers had the skills not only to create the new design, but also to establish it fully. Thus Art Nouveau succeeded through the presence, on an international basis, of a tantalizingly rare phenomenon: professionalized radicalism.

With the third phase, from 1900 to 1914, the style became a widely known, practised and discussed phenomenon, an omnipresence on the international cultural scene, and subject both of loud celebration and condemnation. In 1902, the *Prima Esposizione d'Arte Decorativa Moderna*, an International Exhibition held in Turin, showcased Art Nouveau more completely and dramatically than any other event in its history. Dozens of pavilions and thousands of objects celebrated the style as an international phenomenon. It had become mainstream, a trade standard that could be applied to any kind of object to bestow it with the cachet of modernity. Of course, this was hardly the modernity of idealist socio-cultural transformation, but nevertheless, to the millions who consciously consumed it, it still stood for the thrill of contemporary life. Inevitably, the extent of its dissemination led to the rejection of its more popular mannerisms in circles of advanced taste. Thus, the last phase of Art Nouveau saw it widely accepted while being gradually dropped by some of the designers, writers and gallery owners who had initially created it. A simpler and perhaps more rationalist aesthetic – which had entailed a more utilitarian approach and which had always been an element in the thinking of many designers – came to the fore in several schools. It was most evident in Vienna, Munich and Helsinki, and in the work of leading individual designers elsewhere. Hector Guimard in Paris and Gustave Serrurier-Bovy in Liège, for example, deliberately simplified and rationalized their approaches to the design process in the first years of the new century (plate 1.13).

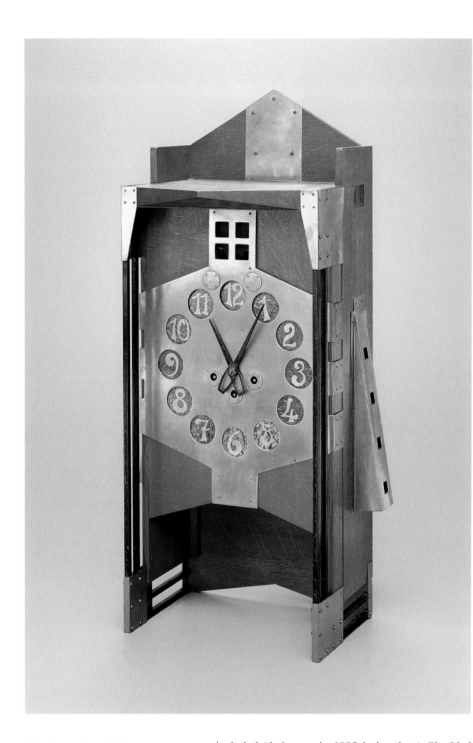

1.13 Gustave Serrurier-Bovy, clock. Oak, brass, iron and miscellaneous materials. Belgian, 1900–10. Collection of Marsha and Jeffrey Miro. Photo: © The Detroit Institute of Arts / Dirk Bakker.

group included (their ages in 1895 in brackets): Siegfried Bing (57), Carlo Bugatti (40), Alexandre Charpentier (39), Raimondo d'Aronco (38), Auguste Daum (42), Frantz Jourdain (48), Émile Gallé (49), Antoní Gaudí (43), Ödön Lechner (50), Octave Maus (39), Gerhard Munthe (46), Fyodor Shekhtel (39), Louis Sullivan (39), Louis Comfort Tiffany (47), Émile Verhaeren (40) and Vilmos Zsolnay (57).

The second group was remarkable for its youth. This gaggle of 'unknowns', barely out of training, invented the look of the style in a frenzy of aggressive enthusiasm.

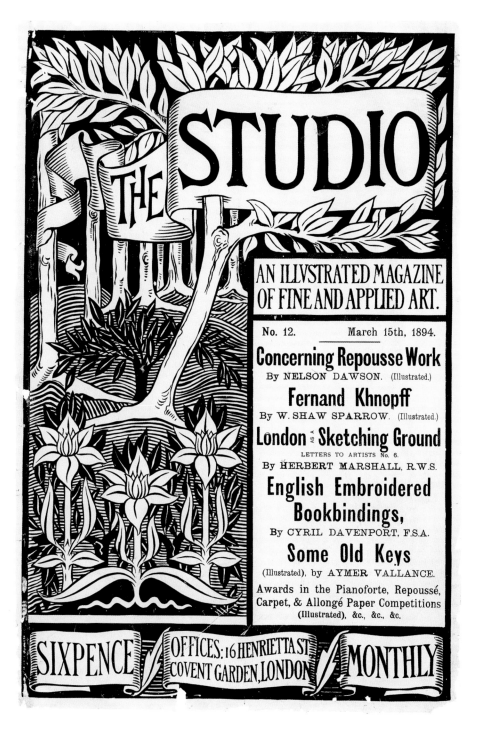

1.14 Aubrey Beardsley, poster
for *The Studio*. English, 1893.
V&A: E.407–1921.

In 1902 Siegfried Bing reported that he 'received by mail from America a prospectus issued by the inventor of a new machine – *viz.*, "a machine for making Art Nouveau"'.[36] In his mirth, he didn't describe this machine, but the article carried a buried irony in that he himself – and others – had indeed invented a machine for making Art Nouveau, in the form of the mechanisms for displaying, marketing, publicizing and selling it.

The speedy expansion after 1880 of all types of display and retail outlet, and especially department stores (the new citadels of luxury consumption), had a direct impact on the dissemination of Art Nouveau. Perhaps more significant, however, was the dramatic growth in the same period of the art-related press. Some publications were famous sources of inspiration, including: Siegfried Bing's *Le Japon artistique* (founded in 1888, Paris), Octave Maus' *L'Art moderne* (1881, Brussels), Léon Deschamps' *La Plume* (1888, Paris), Arthur Heygate Mackmurdo's *Hobby Horse* (1884, London), Shannon and Ricketts' *The Dial* (1889, London) and *The Studio* (1893, London; plate 1.14). Some journals provided a forum for non-partisan debate, including: *L'Émulation* (1874, Brussels), the *Revue des arts décoratifs* (1880, Paris), *Der Architekt* (1895, Vienna), *The Architectural Record* (1888, New York) and *The Craftsman* (1901, New York). Others offered Art Nouveau prolonged periods of overt support: *L'Art décoratif* (1898, Paris), *Art et décoration* (1897, Paris), *Kunst und Handwerk* (1898, Munich), *Kunst und Kunsthandwerk* (1898, Vienna), *Der Moderne Stil* (1899, Stuttgart) and *Das Interieur* (1900, Vienna). Finally, some journals were not so much presenters as examples of the New Art. The German-speaking countries were especially prominent in this area: *Pan* (1895, Berlin, plate 1.15), *Die Jugend* (1896, Munich), *Simplicissimus* (1896, Munich), *Dekorative Kunst* (1897, Munich), *Deutsche Kunst und Dekoration* (1897, Darmstadt) and *Ver Sacrum* (1898, Vienna).

The willingness of the State to become part of the machinery of commerce was a marked feature of the period. State-supported organizations, including public museums, schools of art and design, official exhibitions, ministries and government agencies, were established all over the industrialized world, with the express purpose of developing the quality and status of commodities. All were predisposed to support the cause of modernity if and when it appeared to advance their interests, and to attack it when it did not. The first and most consistent motive was economic. In competitive markets, good design could stimulate sales. In the last third of the century, visual culture was additionally used to promote national identity. Large nations used art and design to consolidate their image of

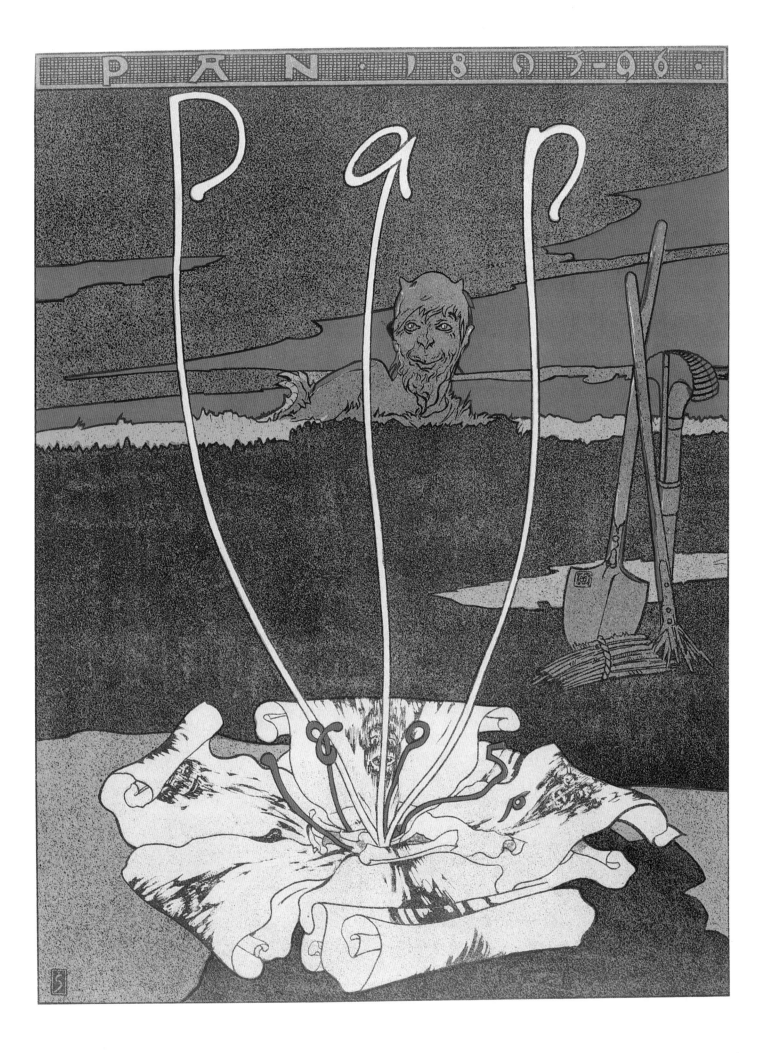

1.15 Joseph Sattler, cover for *Pan*.
Colour lithograph. German, 1895.
V&A: E.3099–1938.

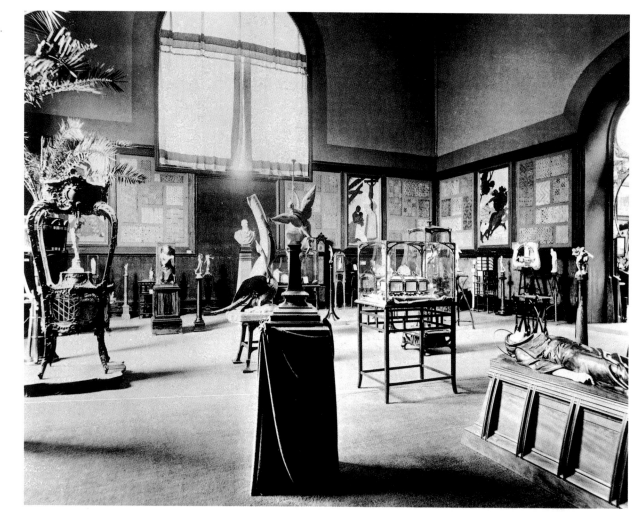

1.16 Paul Hankar, Salon
d'Honneur, interior.
Exposition Universelle, Tervuren,
Brussels, 1897.
© Archives d'Architecture
Moderne, Brussels.

themselves and to promote internal cohesion; small nations used it as a political weapon in the struggle to differentiate and separate themselves from rivals and overlords. Indeed, to the Finns, Norwegians, Hungarians, Irish and others, the achievement of a distinct cultural identity was synonymous with the embracing of modernity. Both implied change.

The greatest product of the machinery of enterprise to be exploited by Art Nouveau was the International Exhibition. The medium (variously known as *Expositions Universelles*, Worlds Fairs or Great Exhibitions) was fired by commercial pragmatism, imperial megalomania and taxonomic obsession. They attempted to display, in their specially constructed facilities, every aspect of human civilization. After 1851, when the first one was held in London at the legendary Crystal Palace (plate 8.2), they became the single most important vehicle for the dissemination of material culture in the industrial and imperial world. The 50 most important International Exhibitions between 1873 and 1915 were attended by 305,000,000 people. Of these, more than 170,000,000 attended the

nine Exhibitions which had the greatest representation and significance for Art Nouveau, at an average of just under 19,000,000 visitors per Exhibition.[37] Through special issues of newspapers and magazines published throughout Europe and North America, an even wider audience could explore the exhibits at distance. Quite apart from presenting their work, designers were powerfully influenced by what they saw at the Exhibitions, including the art of those nations outside Europe.

The progress of Art Nouveau can be traced through International Exhibitions. At the Paris *Exposition Universelle* of 1889 and the Chicago Columbian Exposition of 1893, the older-generation designers and architects exhibited their pre-Art Nouveau works. Émile Gallé and Louis Comfort Tiffany, for example, showed in Paris; Tiffany showed again at the Chicago Columbian Exposition of 1893; and Louis Sullivan designed the Transportation Building in Chicago (plate 22.8). In 1897, on the Tervuren site of the Brussels *Exposition Universelle*, Art Nouveau proper could be found for the first time in the displays and pavilion architecture. Henry

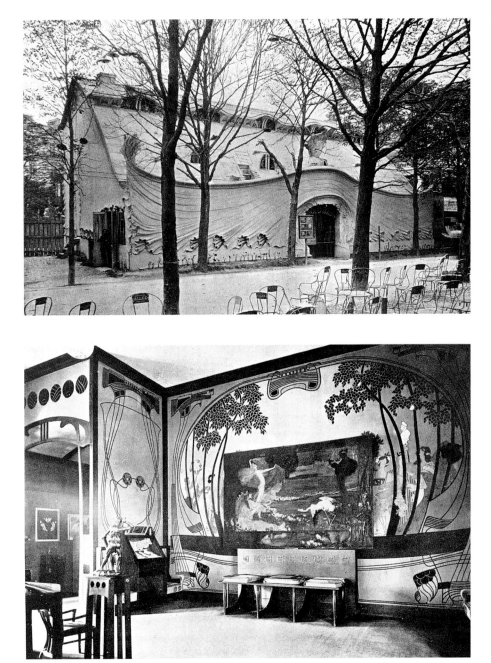

1.17 Henri Sauvage, Loïe Fuller Pavilion. *Exposition Universelle*, Paris, 1900.

1.18 Josef Hoffman and Erwin Puchinger, exhibit of the Imperial School of Decorative Arts, Vienna. *Exposition Universelle*, Paris 1900.

cise in that nation's version of the style. Inside the official and private spaces of the exhibition, the style was well represented. The Union Centrale des Arts Décoratifs, the Pavillon Bing and the spaces dedicated to the department stores Le Louvre, Le Bon Marché and Le Printemps were among the prominent private initiatives. Many of the national pavilions housed examples of the style, and the Decorative Arts Pavilions sited along the Esplanade des Invalides contained hundreds of examples (plate 1.18). The pavilions and objects of the 1902 *Prima Esposizione d'Arte Decorativa Moderna* in Turin were predominantly Art Nouveau. The main site architect, Raimondo d'Aronco, created flamboyant buildings in the style (plates 29.2, 29.3 and 29.4), and many nations were represented by key exponents. This event saw Art Nouveau at its peak of international influence.

After Turin, the style continued to be regularly and healthily represented at International Exhibitions, but it never appeared again in such quantity. At the St Louis Worlds Fair of 1904, the German Section offered a consummate exploration of Art Nouveau (plate 1.19) – one that was to prove deeply influential on American design – and the Czech Section, designed by Jan Kotěra, was the most complete essay in the style they ever sent abroad. The Liège *Exposition Universelle* of 1905 showed, in several of the official buildings, the extent to which Art Nouveau had become a recognized public style (plate 1.20); the major Belgian designers were all present in force, and the French sent a powerful Art Nouveau contingent. At the Franco-British Exhibition of 1908 in London, the largest number of French Art Nouveau objects ever to be exhibited in England appeared in the Pavillon Collectivité André Delieux (plate 1.21). By the end of the decade, however, Art Nouveau ceased to be an Exhibition phenomenon. At the Brussels *Exposition Universelle* of 1910 and the Glasgow and the Turin Exhibitions of 1911, for example, it was conspicuous by its absence. Around 1910–11, its role as a modern style in individual nations had largely come to an end and its commercial viability, as a style that could sell goods, was in steep decline. Art Nouveau was not killed during the First World War. It had slid from grace already.

Yet just as it had many forebears from disparate places, so the aesthetic and intellectual achievements of the style in turn influenced virtually every (disparate) modernist effort in the decades that followed. It informed the rationalist visions of Le Corbusier; the dreams of André Breton and the Surrealists; and the decorative hedonism of all those committed to Art Deco. Two decades of vibrant and brilliant activity had changed the visual and intellectual climate of urban culture.

van de Velde, Gustave Serrurier-Bovy and Paul Hankar created some of the interior spaces, fittings and furnishings of the exhibitions of colonial produce (plate 1.16). Art Nouveau was a powerful presence at the Paris *Exposition Universelle* of 1900. While the site as a whole was dominated by neo-Rococo, neo-Baroque and exotic styles, there were notable Art Nouveau structures: the Pavillon Bleu Restaurant by Serrurier-Bovy (plate 1.1), the Loïe Fuller Pavilion by Henri Sauvage (plate 1.17), and the Pavillon Bing. Visitors who arrived at the site via the new Metropolitan railway could enjoy Hector Guimard's spectacular station entrances. The Finnish Pavilion showed itself to be an accomplished exer-

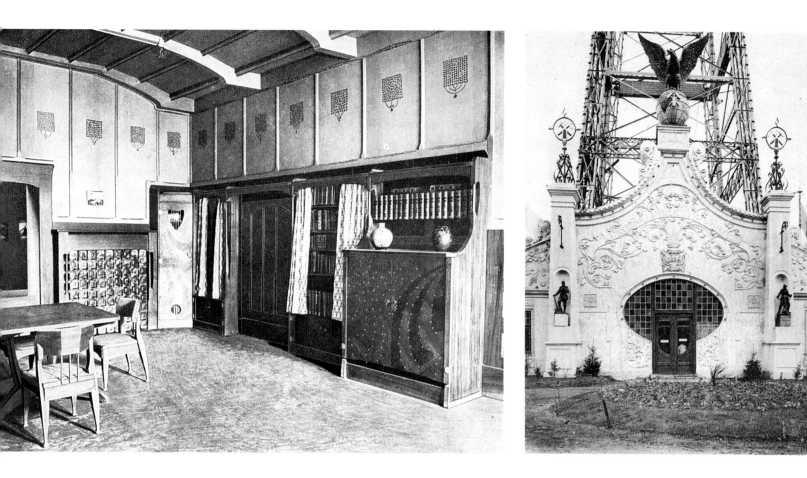

1.19 Richard Riemerschmid,
Munich interior. International
Worlds Fair, St Louis, 1904.
© DACS, 2000.

1.20 The base of the Tour Forage.
Postcard. *Exposition Universelle*,
Liège, 1905.
Collection: Paul Greenhalgh.

1.21 Interior by Sauvage and
Sarazin in the Pavillon Collectivité
André Delieux, Franco-British
Exhibition (London, 1908).
Collection: Paul Greenhalgh.

PART II

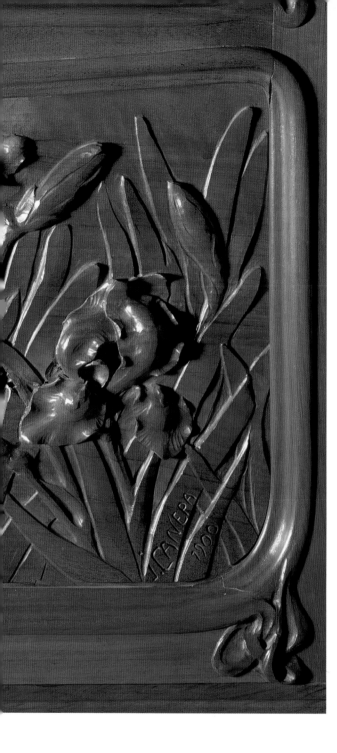

The Creation
of Meaning

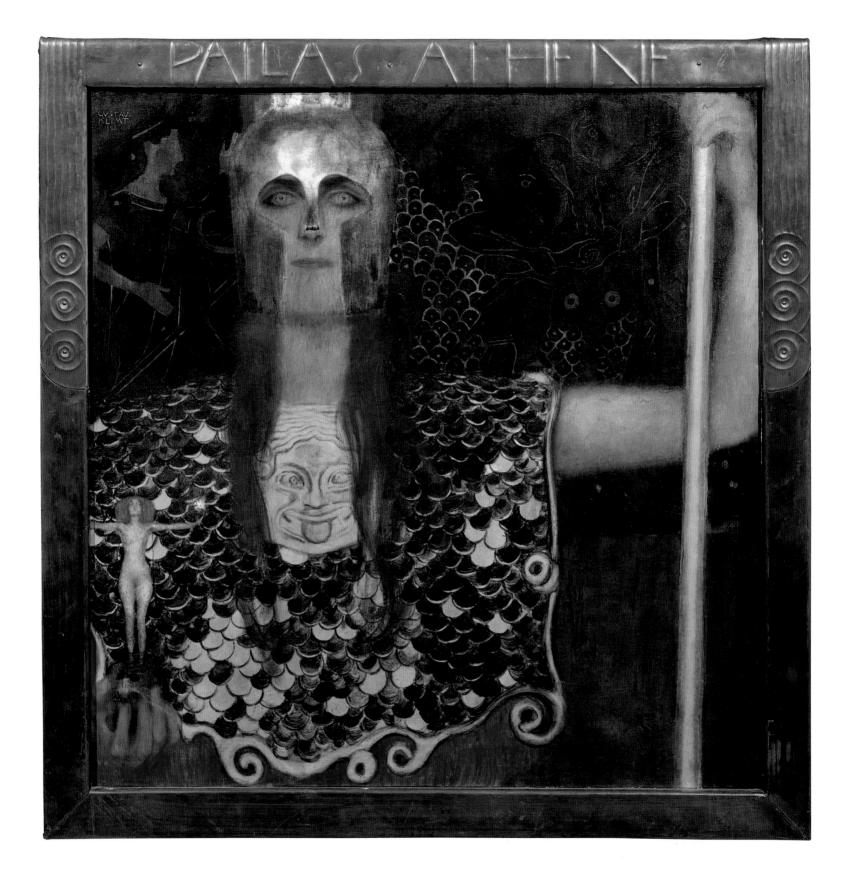

Paul Greenhalgh

Alternative Histories

All around there was busy movement and constant progress, due to the quickening effect
of a thousand scientific discoveries and the shake-up caused by social innovations of the
most radical kind. Amidst this universal upheaval the decoration of the day continued
to be copied from that in vogue in previous centuries, when different habits and different
manners were current. What astonishing anachronism! (Siegfried Bing, *L'Art Nouveau*, 1902)[1]

2.1 Gustav Klimt, *Pallas Athene*.
Oil on canvas. Austrian, 1898.
Museen der Stadt Wien, Vienna.

As its name implied, Art Nouveau was based on the idea of the new. Exponents of the style openly proclaimed themselves to be of the modern world, and most contrasted their modernity with the reactionism they perceived all around them. Therefore, there would seem to be something contrary in the fact that so much was owed to a number of previous historical styles. The different movements contained within the Art Nouveau style used a variety of sources – the mixture in any one school, or indeed in any one object, was as eclectic as anything the nineteenth century had previously seen. Most objects had many debts. Thus there appeared to be much pondering on the past within a style purporting to anticipate the future. As a result of this, many later commentators – and especially historians of international Modernism – have portrayed it as reactionary and confused. It was neither. But its use of history was complex: its eclecticism was born not of a desire to exercise antiquarian skills or pay homage to tradition. Rather, its practitioners were attempting to reformulate the idea of style to enable them to deal with issues in the present and the anticipated future. Stephan Tschudi Madsen, a pioneer historian of Art Nouveau, noted that 'Art Nouveau had the force of an "anti-movement", and was filled with reaction against previous generations'.[2] It was the desire to provide alternatives, to move on, that characterized the whole and held its varied groups and individuals in proximity.

The strategy of those most involved in this reaction was not to copy, but to recover, reorient and even invent histories that had been pushed to the periphery of established practices, that celebrated the unusual rather than the normal, signified different forms of society, and that set precedents for a new European culture. The sources used tended toward the unorthodox, the compromised and the impure; they were drawn from outside the boundaries of normative expectation. This was history at the service of modernity.

Most regions added local ingredients to the stylistic mix that was Art Nouveau. The Dutch made use of Indonesian forms and the Belgians came to embrace Africa, both becoming available through imperial expansion. The Germans and the Austrians made use of the Biedermeier style. Traditional baronial architecture inspired the Scots. Archaeological discovery brought ancient forms into vogue: the Norwegians and several other Nordic nations made use of Viking art, while various British, Irish and American designers were inspired by the Celts. These inflections gave variety to the style. There was, however, a core of historical sources that served Art Nouveau across national boundaries. From within the European tradition, practitioners drew on Classicism, the Baroque, Rococo and Gothic Revival styles and folk art. From outside, the art of the Islamic nations, China and Japan were brought to bear.[3]

The use of Classicism provides an interesting example of the determination to take control of history. The Classical heritage dominated the education of most practitioners in the humanities, and lent the bulwark of meaning to establishment life. Artists, designers, architects, writers, musicians and philosophers arrived at maturity having gone through a rigorous initiation into the antique; and they generally expected to spend their lives working within that idiom. Art Nouveau practitioners opposed this norm by *de-* and *re-*constructing Classicism in two distinct ways. First, they addressed the meaning of Classicism from within itself. They rehabilitated and lauded the darker side of antique art, mythology and philosophy which was previously ignored and even reviled by academics. Second, artists and designers subverted accepted notions of Classical proportion, composition and language. Both strategies were capable of being consciously ironic.

There were powerful precedents from related disciplines for the intellectual and artistic reorientation of the

antique. Friedrich Nietzsche had attacked the Greece of Socratic and Platonic idealism with sacrilegious verve: 'Socrates was rabble … Socrates was the buffoon who got himself taken seriously'.[4] In France, Joris-Karl Huysmans debunked the great canons of Roman literature through the person of Des Esseintes, the hero of his novel *A Rebours*: 'the Latin language, as it was written during the period which the academics still insist on calling the Golden Age, held scarcely any attraction for him',[5] preferring what he termed the 'Decadence' of late Roman culture. In similar vein, the British commentator Gilbert Murray observed a general drift from Classical and neo-Classical values:

> The serene and Classical Greek of Winckelmann and
> Goethe did good service … in his day, though now we feel
> him to be mainly a phantom. He has been succeeded … by
> an aesthetic and fleshy Greek in fine raiment, an abstract
> Pagan who lives to be contrasted with an equally abstract
> early Christian or Puritan.[6]

Of all rehabilitations, it was Oscar Wilde's which was most complete. Developing an almost mystic vision of the earlier world, in which the material and mythic smoothly blended into one another, Wilde lived his life as a character in an antique fresco of his own making. Under cross-examination at his (second) trial for gross indecency in 1895, when famously asked by his prosecutor, Lord Edward Carson, what he understood by the term 'the love that dare not speak its name', he inevitably cited Plato in his defence: 'The love that dare not speak its name in this century is such a great affection of an elder for a younger man … such as Plato made the very basis of his philosophy.'[7] Sadly, his interpretation of the king of philosophers did not save him.

This reoriented Classicism became evident in the work of artists and designers all over Europe after 1870. The Classical world became altogether more dreamlike, mystical and sensual. Historian Victor Beyer commented that 'the antiquity [Art Nouveau] refers to – is it not that of Medusa and Pan? Is it not first of all Dionysian Greece as opposed to Apollonian Greece, to borrow Nietzsche's language in *The Birth of Tragedy*?'[8] Indeed it was. Artists and designers took control of the decadent Classicism of their immediate forebears and made it a central ingredient in their vision of modernity (plate 2.1).

The second strategy employed by Art Nouveau practitioners, namely the assault on Classical proportion and language, was ultimately more significant. Classical composition was not dispensed with, rather it was challenged, reordered and subverted by manipulating and negating Classical form and space. New compositional

methods were introduced – most famously those borrowed from Japan and China. Architects and designers at the *fin de siècle* maintained a relationship with Classicism while nurturing new forms of symmetry and asymmetry in order to express the new. In many ways, this was analogous to the method of various Impressionist painters – most notably Degas – who developed a dialectical relationship with Classical composition in order to maintain allegiance with the heritage of painting, while embracing modernity.

Victor Horta's Hôtel Tassel in Brussels, the first full expression of Art Nouveau in architecture, offers an interesting example. Completed in 1893 in the rapidly developing St Gilles area of the city, where Horta, Paul Hankar, Paul Saintenoy, Gustave Strauven and others produced some of the finest Art Nouveau houses, the Hôtel Tassel was a tall, narrow unit in the middle of one of the many new and crowded terraces (plate 2.2). Although there had been some Gothic Revival activity in Brussels, the architectural world was dominated by *beaux-arts* Classicism and an inflated neo-Baroque. The latter was typified by the work of Joseph Poelaert, whose Palais de Justice (1866–83) was one of the largest buildings to be built anywhere in the world at the time. These two Classical vocabularies, recycled endlessly in miniature along the squeezed, stretched and queue-like terraces, provide the context to Horta's brilliant subversion of his Classical upbringing. The Hôtel Tassel is a symbolic recognition and subversion of inherited Classical values.

The house has symmetrical fenestration centred on a first-floor oriel, framed by all the Classical accoutrements: columns, capitals, frieze, lintels, metopes and triglyphs. However, all of these are twisted, stretched and rounded into novel forms, pulled out of the shape (and therefore out of the meanings) that the viewer is used to. The house is sheathed in masonry that admits no division and prevents us from allocating an ordered significance to the parts. The surface appears as a taut skin, broken only where functional elements of the building push through it. The capitals and bases of the row of columns across the first-floor window are melted into, or creep over, the iron beams. The beams disturb the organic naturalism in order to take on the function of frieze, replacing references to Attica with those of the Industrial Age. The combination of plants and rivets would subsequently appear all over Europe as a signifier of modernity; a unity of industrialism and naturalism simultaneously celebrating progress and evolution and heralding the coming of the new movement and, indeed, a new age. Quite literally, the orders were thrown into chaos.

2.2 Victor Horta, Hôtel Tassel.
Brussels, 1893.
Photo: C.H. Bastin & J. Evrard,
Brussels.

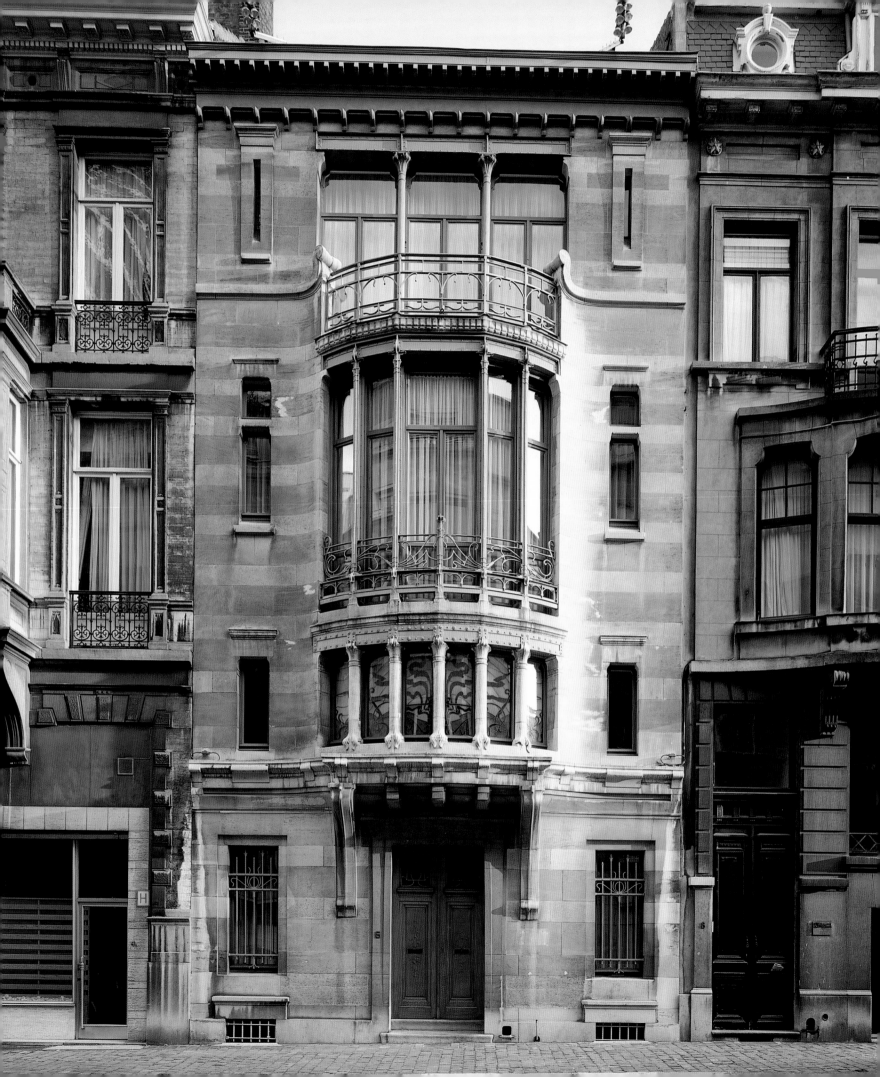

Of all Art Nouveau centres, it was Vienna that most completely explored the Classical idea to create an art of modern life. The work of Josef Hoffmann, Josef Maria Olbrich, Koloman Moser and Gustav Klimt, for example, loses much of its meaning unless read as an ironic exploration and reorientation of Classical form. Josef Olbrich's Secession House of 1897 contains the imagery of Greek theatre and decorative art, as well as variants on the more usual architectural language of cornices, pilasters, frieze and dome (plate 20.1). The building echoes and parodies the Classical and Baroque buildings close by. It contains contrary messages by deliberately juxtaposing physical and symbolic weight and lightness. In its atmosphere it hangs between a place of worship and of pleasure, between whimsy and seriousness. The compositional strategies of Hoffmann and Moser are often less overt than those of Olbrich, but ultimately perhaps they are more fundamentally Classical. Classical symbolism can be found in the use of figures and symbols: lyres, laurels, acanthus, athletes. But more interesting is the manipulation of compositional principles. The Golden Section is constantly teased into novel proportions and relations. Paintings on the antique theme by Klimt, like the work of his colleagues, explore tensions within the human psyche by making use of the Classical world in order to relate sensuality and pleasure to melancholia and tragedy.[9]

2.3 Antoní Gaudí, furniture from the Palacio Güell. Catalonian, 1889. Collection Pedro and Kiki Uhart, Paris.

The Baroque and Rococo styles were popular with Art Nouveau designers all over Europe. The Baroque essentially grew out of sixteenth-century Mannerism, and was a dramatic and extrovert development of Classical language in all the visual arts, based on dynamic manipulation and exaggeration of Classical form. It spanned the late seventeenth and early eighteenth centuries. In many countries during the first part of the eighteenth century it was superseded by the Rococo. This was a delicate and sensuous development of the Baroque, with emphasis placed on asymmetry, gentility and natural form. The distracted, aristocratic world of the Rococo was violently brought to a close by the French Revolution. Both styles were revived in the nineteenth century and so were known to Art Nouveau designers both in original and reinvented form.

In the second half of the nineteenth century the neo-Baroque functioned principally as a grand architectural style for buildings that demanded drama and pomp. The Paris Opera House of Charles Garnier, built between 1861 and 1874, and Poelaert's Palais de Justice were famous examples of what, by 1890, was a Europe-wide idiom. The extrovert curves and weighty dynamism of these buildings clearly had an effect on many Art Nouveau architects when they designed on a large scale. Baroque form was an important element in furniture design, as witnessed by the bulbous dynamism of Antoní Gaudí's designs (plate 2.3) and the Latin grotesques of Ernesto Basile. Combined with the stately simplicity of the Biedermeier style, it provided Bernhard Pankok with inspiration. The Baroque spirit was also, when joined with Symbolism and/or Pre-Raphaelitism, a significant element for makers of figurines and small-scale sculpture. British sculptor Alfred Gilbert was a key forebear for Art Nouveau sculptors. His dramatic *Epergne* of 1887 uses Baroque form to frame a distinctly Symbolist scene, the swirls and cartouches moving towards the organic naturalism that would soon become a hallmark of Art Nouveau (plate 2.4).

The Rococo was more widely and obviously used than the Baroque. Its delicate curves were appropriated by sculptors, graphic artists, furniture and interior designers everywhere. It was used with the greatest significance, frequency and success by the French, who often combined it with the Baroque in a regal collectivity known simply as the Louis' (the styles current in the reigns of Louis XIV, Louis XV and Louis XVI). The Louis' were absorbed into the framework of references of French Art Nouveau furniture and interior design so completely that without them it is impossible to understand the meaning of many designers' work. The High Rococo style of the Louis XV era, and its various

2.4 Alfred Gilbert, *Epergne* (centrepiece). Silver, patinated and gilded, rock-crystal and shell. English, 1887–90. The Royal Collection © 2000 Her Majesty Queen Elizabeth II.

aggressively abandoned during the Revolutionary and Napoleonic years, it regained ground during the Restoration; Louis-Philippe effectively made it the court style on his accession in 1830. After this, the Louis styles went on to enjoy international acclaim. '*Louis Seize*' was acknowledged at the Great Exhibition of 1851 in London as being the most significant 'modern' style, although few professed the ability to tell one Louis from another, and the Louis' went on to enjoy great popularity across Europe and North America as a sign of luxury. Rocaille forms were stamped, pressed, moulded and stencilled onto middle-class domestic objects everywhere. Along with such levels of consumption came the inevitable accusation that the Louis' had become debased and vulgar.

After the debacle of the Franco-Prussian War, however, they were once again rescued for use as the official style of the French nation. This was most evident at the *Expositions Universelles* staged in Paris. At the *Exposition* of 1878, the Louis' dominated the French decorative arts industries and provided the style of virtually every French building on the site, most noticeably the Palais de Trocadèro. From this date through to the Second World War, despite shifts in fashion and ideology, the Louis' were rarely absent from major presentations of the French State. They ornamented the dramatic engineering structures of the *Exposition Universelle* of 1889, were a dominant presence in the decorative arts and architecture of the *Exposition Universelle* of 1900 (plate 2.5), and remained a source long after this for the creators of the *Exposition Universelle* of 1925.[10] Far less grand promoters of the Rococo than the French State, but nevertheless highly significant, were the de Goncourt brothers, who passionately promoted, collected and presented the Rococo style. Novelists, art critics and collectors, Edmond and Jules owe their lasting fame both to their journals and to their publications on artists of the Rococo period. Historian Debora Silverman has noted that: 'the Goncourts' house, collection, and writings reconstituted systematically for the first time the splendour of mid eighteenth-century craft arts. Through their scholarship and their model home, the Goncourts offered primers of Rococo design principles to the nineteenth century' (plate 2.6).[11] They effectively rescued eighteenth-century culture from vulgarization and institutionalization. More significantly in the present context, 'they re-created its charms so that it became, as it were, part of the peculiar mythology of the *fin de siècle*, part of its special stock of imagery'.[12]

Many of the Parisian designers, such as Paul Follot or Maurice Dufrène, achieved an Art Nouveau style by combining the Rococo with a taut, organic naturalism. When

reincarnations throughout the nineteenth century, was especially significant. Its asymmetric, curvilinear profile, use of cabrioles, ovals and floral detailing were a constant presence, especially in furniture, ceramics and glass.

The Rococo was complex. The languid curves and ovals carried a variety of symbolic meanings for the *fin-de-siècle* generation. First and foremost, when allied to the Baroque, it was used throughout the nineteenth and early twentieth centuries as a French national style. Indeed, although it was technically a revival style, it barely disappeared from view long enough to merit this description. Having been

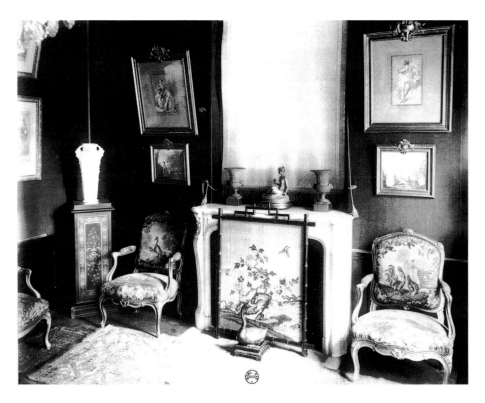

Art Nouveau went into decline, both designers pioneered an historicism based on the Louis', which would later be identified as Art Deco. Perhaps the most successful of the Parisians to embrace the Rococo was Georges De Feure. In an extremely long and entrepreneurial career, De Feure produced a prodigious number of prints, pastels and paintings. Many of them combined the delicacy and detailing of Fragonard, the flat-patterning and asymmetry of Japanese graphic art and the realism of Toulouse-Lautrec. His greatest success was as a designer of furniture, textiles and interiors. Most famously, he produced an interior for the Pavillon Bing at the Paris *Exposition Universelle* of 1900. The gold-leafed furniture and textile furnishings, conceived in a style that hung between Louis XV and Louis XVI, received wide acclaim and the ultimate official recognition of a gold medal (plate 2.7).

The Rococo was reassessed and reused most effectively in France by artists and designers based in the region of Lorraine, in the city of Nancy (plate 2.8). Developed into a grand city during the eighteenth century, Nancy came to full prominence once again in the *fin-de-siècle* period as

2.6 The Grand Salon of the de Goncourt brothers' house. Auteuil, after 1868.
Bibliothèque Nationale, Paris.

2.7 Georges De Feure, gilded furniture and silk wall-covering. French, 1900. From the sitting room in L'Art Nouveau Bing, *Exposition Universelle*, Paris, 1900. Danish Museum of Decorative Art, Copenhagen.
Photo: Ole Woldbye, Copenhagen.

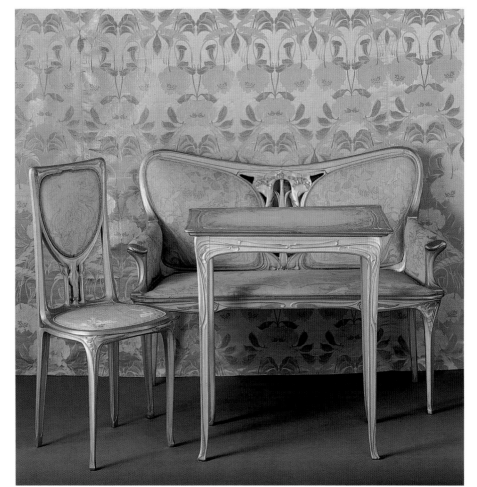

2.8 Jean Lamour, detail of Place Stanislas gates. Wrought iron with parcel gilt. Nancy, *c*.1755.
Photo: Paul Greenhalgh.

2.5 Women's Pavilion, rear elevation. *Exposition Universelle*, Paris, 1900.

in industry. Its first President was Émile Gallé, with Louis Majorelle, Auguste and Antonin Daum and Eugène Vallin acting as Vice-Presidents. Other prominent members of this artistic community included Victor Prouvé, Émile André and Jacques Gruber. These were among the most important practitioners in the Art Nouveau movement as a whole. The École de Nancy was in many ways the heart of the French effort. A consolidated group of practitioners committed to the idea of a modern style, and all that it implied for modern life, the School generated a staggering number of masterworks in all media over a 20-year period.

Émile Gallé was the most important and probably the most eclectic of the designers working in Nancy. His glass and ceramics of the 1880s made use of medieval, Islamic, Chinese, Japanese and Classical sources, often on the same object. However, the Rococo was the form he used most persistently (plate 2.9), and it remained an underlying element in his work from his earlier historicist period through to the high-point of his naturalist experimentation in the late 1890s. The furniture of Louis Majorelle is quintessentially French. His company on its own guaranteed the continuation of the tradition of *ébénisterie* (cabinetmaking) and *menuiserie* (carpentry) into the twentieth century. He incorporated the key features of eighteenth-century form (the oval back, cabriole leg, the floral motif and the taut, curvilinear profile) in a sophisticated journey around the French furniture tradition. This was combined with a dynamic and radical vision of nature (plate 2.10).

It would be a mistake, however, to assume that the artists and designers of Nancy considered themselves to be historicist. In the catalogue for an exhibition of the School held in Paris in 1903, the anonymous writer acknowledged the significance for the designers of both the eighteenth century and, more generally, the 'national heritage of our country'. However, he also affirmed that both these had been challenged:

> Renouncing the pleasures of reproducing eighteenth-
> century models and the erudition of historical styles, our
> decorators, potters, glassmakers, enamellers, furniture-
> makers, silversmiths, leather workers and sculptors of
> Lorrain have seen themselves, over the last 30 years, as
> liberating taste from the imitation of old styles by a new
> principle, that is the observation of living models.[13]

History was not to be copied. It was there to be manipulated, reinterpreted and, where other models provided better solutions, rejected.

Apart from the beauty and grandeur of its forms and its

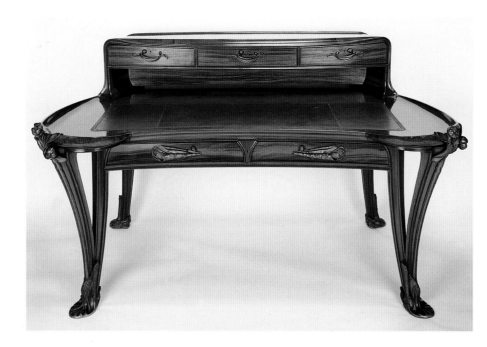

2.9 Émile Gallé, vase. Glass, wheel-cut and acid-etched with silver-gilt metal mount. French, 1889. V&A: C.1212–1917

2.10 Louis Majorelle, *Nénuphars* (water-lilies) desk. Mahogany, leather, gilt and bronze. French, 1900. Musée de l'École de Nancy.

a major centre for the manufacture of modern decorative arts. By 1901, these were so closely identified with the city that the key practitioners felt able to form the 'École de Nancy', a society dedicated to the promotion of the arts

historic associations, there was another, far more subversive, side to the Rococo (plates 2.11 and 2.12) which was well understood by all who used it at the *fin de siècle*. Pioneer historian of Rococo decorative art, Roger de Félice, described it as:

> The perfect expression of a frivolous and voluptuous
> period marked by a passion for pleasure – all pleasure,
> from the most delicate and intellectual and social delights
> to unalloyed debauchery – a period in which moderation
> was by no means the ruling virtue. No seat could be more
> suggestive of love and idleness than a sofa of 1750.[14]

The widely acknowledged hedonism, even eroticism, of Rococo design was inevitably identified by Huysmans in *A Rebours*:

> Visions of the eighteenth century haunted him: gowns
> with panniers and flounces danced before his eyes;
> Boucher Venuses, all flesh and no bone, stuffed with pink
> cotton-wool, looked down on him from every wall … . [It]

is the only age which has known how to envelop a woman in a wholly depraved atmosphere, shaping the furniture on the model of her charms, imitating her passionate contortions and spasmodic convulsions in wood and copper.[15]

The Rococo carried a dangerous air of promiscuity with it. As with the late Roman and Hellenistic worlds that Art Nouveau designers found attractive, it was a style engrossed in self-conscious melancholia and the decadence of a culture about to fall. However, by 1890, successive State interventions had made it into a key element in the French national identity. Thus, through the Rococo, sensuality and even decadence were imported into perceptions of Frenchness. Although the image was a questionable one for many aspects of official national cohesion, it was one which manufacturers and merchants in the luxury goods trades were keen to preserve and in which Decadents revelled.

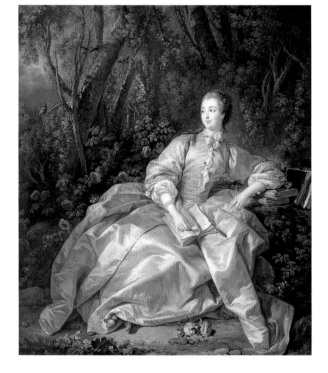

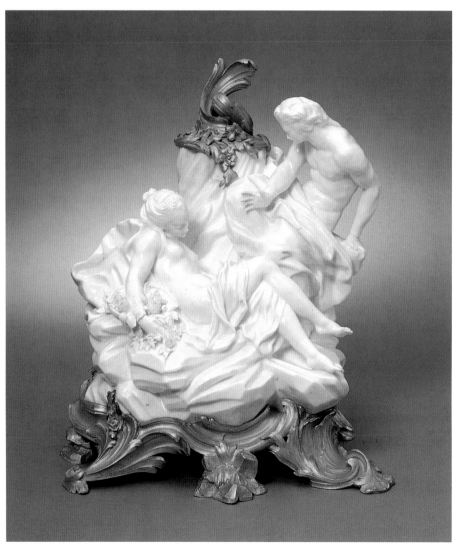

2.11 François Boucher, *Portrait of Madame de Pompadour*. Oil on canvas. French, 1758. V&A: 487–1882.

2.12 Vincennes manufactory, *Venus and Adonis*. Biscuit porcelain with gilt metal mount. French, 1750–55. V&A: C.356–1909.

Art Nouveau was not the first attempt to oppose the moribund dominance of established Classicism. The Gothic Revival constituted an attack upon the ideological complacency of the Classical design heritage. The contribution of the Gothic Revival to Art Nouveau was significant, contributing principally to the realm of ideas rather than specific visual forms. Gothic Revivalists throughout Europe were committed to an agenda that saw style not simply as an aesthetic exercise, but as something linked simultaneously to the condition of society and to the actual building process. Gothic Revival architects such as A.W.N. Pugin and Karl Schinkel did not wish to use the

2.13 Eugène Viollet-le-Duc, illustration of architectural ironwork. Page from *Entretiens sur L'Architecture*, Vol. 11 (1872). V&A: II-33.B.43.

Gothic for antiquarian study, but as a starting point to create a style for the age. Schinkel neatly described the motivation: 'Every major period has established its own architectural style, so why do we not try to establish a style for ours?'[16]

The understanding that style was a signifier of the age was accompanied in most schools of thought by an anti-historicist vision of the origins of style itself. Eugène Emmanuel Viollet-le-Duc, belonging broadly to the Gothic camp, developed a rigorous rationalism that had a major influence on the ideas of all those interested in modernity. Viollet-le-Duc dispensed with the cultural and symbolic

justification for the study of history in favour of analysis of principles of construction. The aesthetic dimension, for him, was a natural result of appropriate methods of building. He viewed the Gothic cathedral architects as brilliant engineers. Thus, he rejected the idea of style as a decorative skin intended to ennoble a building. For him, it arose from the essential logic of construction:

> Our aim then should not be to know what relative proportions the Ancients or the Moderns have thought proper to give to the 'Orders'; how an architectural member requires to be treated … . We should make it our chief endeavour to explain how reason should dictate architectural forms, whatever be the phase of civilization.[17]

Historicism, therefore, was rejected in favour of a controlled exploitation of the knowledge that could be gained from the past. John Ruskin, hardly a Rationalist, was equally fervent in his rejection of antiquarianism. For him, the Gothic was a universal form that provided a template for contemporary art and society:

> Gothic is not an art for knights and nobles; it is an art for the people; it is not an art for churches and sanctuaries; it is an art for houses and homes; it is not an art for England only, but an art for the world: above all, it is not an art of form or tradition only, but an art of vital practice and perpetual renewal.[18]

Viollet-le-Duc and Ruskin had a powerful and direct effect on Art Nouveau architects and designers all over the world, including Antoní Gaudí, Hector Guimard, Frantz Jourdain, Ödön Lechner, Richard Riemerschmid, Eliel Saarinen, Louis Sullivan and Henry van de Velde. They provided a philosophical template for the development of a contemporary humanist architecture, which attempted to consider the needs of society. Following their lead, Gaudí summed up the Gothic as being: 'sublime but incomplete; it is only a beginning, stopped outright by the Renaissance … today we must not imitate, or reproduce, but continue the Gothic, at the same time rescuing it from the flamboyant' (plate 23.10).[19] Perhaps the spirit of Viollet-le-Duc is most evident in the work of Victor Horta and Hector Guimard. In some respects, one could view Horta's Maison du Peuple (plate 1.2) as the result of Viollet-inspired building logic. Ornamentation and engineering design are fused in an exercise in modern Gothic. In similar spirit, the canopies for the Paris Metro stations and the angled columns of the École du Sacré Coeur (1895) in Paris, by Guimard, not only follow the older Rationalist's ideas, but their forms are heavily based on his published drawings (plate 2.13). The historian Yvonne Brunhammer has noted that 'Viollet-le-Duc is, in the eyes of Guimard, the father of the new architecture'.[20]

Art Nouveau designers embraced styles they perceived to be outside normative values. As with the Modernists who came after them, they identified non-European art to be 'other' in this sense. However, there was outsider art within the boundaries of Europe, in the form of the vernacular tradition. It would be no exaggeration to assert that for many concerned with modernity in literature, music and the visual arts between 1890 and 1914, folk art was the most consistently important stylistic source. For a rare moment in its timeless history, the vernacular was at the core – not the periphery – of European culture. Hungarian historian Katalin Keserü

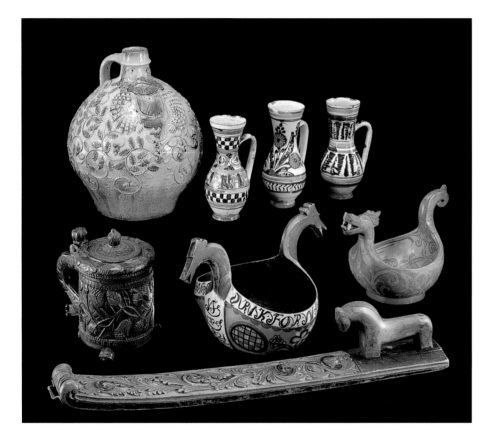

2.14 Vernacular artefacts in the collections of the V&A. Jug, stoneware: German, *c.*1550; vases, earthenware: Hungarian, *c.*1900; tankard, bowls and mangleboard, wood: Norwegian, 18th and 19th century.
V&A: 4610–1858; C.820-3–1917; W.62–1910; W.104–1926; 570–1891; 599–1891.

has noted that it was: 'not a provincial variation of a great style, school or workshop, but for the first time in history, regionalism itself became a style … . It signalled a real renaissance – by recognizing and discovering unknown local artistic values … and through them altering the characteristics of mainstream art.'[21]

The use of folk culture was not new in 1890; the peasantry had been depicted and mimicked throughout history, whenever class and wealth had generated the appropriate social divides. When Marie Antoinette dressed as a peasant girl to amuse herself and her courtiers, she was utilizing an already well-established set of archetypal images. What

made the *fin de siècle* different was that the 'folk' were no longer simply the subject-matter for cultural superiors to identify with or differentiate themselves from. Folk social structures, folk art, folk customs and folk psychology became exemplars of ways of living and making for those in search of alternative social and cultural forms. The motivation behind its use, therefore, was not only aesthetic but moral, political and racial also.

All this activity took place in an international environment. Local ethnic rivalries and tensions could be a creative spur – Meier-Graefe recognized with German Art Nouveau, for example, that a 'sturdy flower grew up out of the personal hostility between North and South' – but among early moderns, the vernacular was used in the knowledge of a wider, modern, cosmopolitan context.[22] When the Norwegians sailed a Viking ship across the Atlantic to the Chicago Columbian Exposition of 1893, or when leading architects and designers took part in the epoch-making Catalan Assembly of 1892, which approved the *Bases de manresa* (the demand for independence), or when the Czechs organized the enormous Ethnographic Exhibition to explore folk culture in 1895, or when the Finns published their national folk legends *The Kalevala* in 1849, the motivation was not to return to the past, but to use it as a way of moving into the future. The modern, urban context was a vital component, therefore, in this use of the vernacular. Writing of the Hungarian avant-garde, the historian John Lukacs asserts that: 'Bartók and Kodály may have been tramping through the villages in the far valleys of Transylvania; but they returned to Budapest and it was in Budapest that their discussions, exhibits and performances took place'.[23] Some nations were thought to have a purer vernacular than others. The Austro-Hungarian and Russian Empires, and various of the Nordic countries, for example, were widely acknowledged as having many uncontaminated folk communities. The Breton, Catalan and Celtic races were also credited as having preserved pure vernacular forms. Materials from all these countries and regions began to be collected and exhibited at the end of the century (plate 2.14). The first and most direct appeal of folk culture was visual. Strong, bold patterns covered objects made with simple, confident directness. Cottage architecture, polychromed and carved furniture, woven and embroidered textiles and hand-painted pottery offered aesthetic solutions to design problems that seemed to possess an integrity absent from the perceived sophistry of court and castle. The simple techniques also appealed to those artists and designers who had come to the decorative arts without the normal

arduous apprenticeship. The world of painted furniture was an easier one to enter than that of *ébénisterie*.

The vernacular first received systematic intellectual attention in the eighteenth century. Thinkers then, through their exploration of the nature of civilization, positioned what were considered simpler forms of society, including peasant communities, ancient and so-called 'primitive' cultures, in relation to contemporary society. Perhaps the single most significant proposition to emerge was that non-urban, 'primitive' societies were 'purer' or less corrupted than modern equivalents. French philosopher Jean-Jacques Rousseau famously developed this line of thought in his *Discourses* (1750):

> Before art had moulded our behaviour, and taught our passions to speak an artificial language, our morals were rude but natural … . Human nature was not at bottom better then than now; but men found their security in the ease with which they could see through one another, and this advantage, of which we no longer feel the value, prevented their having many vices.[24]

This lack of artifice meant, for those who followed Rousseau, that the peasant mind was closer to fundamental values and intrinsically more spiritual.

Philologists contemporary with and immediately after Rousseau dedicated themselves to the study of societies through language and religion. Prominent in this field was J.G. Herder, a German scholar who developed the idea of national character as a phenomenon created by and expressed through language. He believed language to be 'a mirror, which reflects the images that form the soul of a people', and described national character as being a kind of collectivized psychological profile of the population.[25] He was one of the first to identify the *Zeitgeist* (spirit of the age). Alexander von Humboldt went on to strengthen this vision by adding a biological dimension, highlighting the role of environment, and hence locality, in the formation of cultures. Historian William Brock has described his biologism as a 'type of environmentalism [which] interpreted the art of nations as ultimately a function of vegetation, temperature, soil, mountains and rivers'.[26] At the end of the eighteenth century, the integrity of pre-industrial, pre-urban and even pre-Enlightenment communities became central to Romantic Utopian thought. The apparent authenticity of such communities appealed greatly to the poet William Wordsworth, for example, who proposed that literature – and, by implication, all art forms – was a product of indigenous communities rather than individuals. This intellectual heritage pointed powerfully to the unchanged,

vernacular communities of Europe as being the true preservers of culture. Thus, by the beginning of the nineteenth century a powerful formulation of vernacular life existed within the European intelligentsia, positioning the qualities of morality, simplicity and creativity at the centre of a vernacular psyche; a psyche which was perceived to be the 'natural' result of ethnic groups continually inhabiting a single place.

There were two main intellectual threads underpinning the use of the vernacular within Art Nouveau and early Modernism throughout the arts. The first followed the line of 'original innocence' and treated peasant communities in a quasi-religious or mystical way, as holders of lost civilization and self-knowledge. Those artists and designers gathered under the aegis of Symbolism characterize this vision. Painters of the Pont-Aven and Nabis groups used folk culture to search for truths about the human condition. Paul Gauguin and Émile Bernard, as leaders of the former and forebears of the latter, actively sought out communities where they perceived a mode of existence that encouraged a communal spiritual purity. They found this in Brittany, Gauguin openly celebrating what he considered to be the spiritual barbarity of the Bretons: 'I love Brittany: I find the savage, the primitive, there'.[27] He later went to look for it in Tahiti. A carved wooden corner cabinet, on which both artists worked, exemplifies their attempt to commune with the value system of the Breton people, and through this to achieve a more primordial understanding of the human condition (plate 2.15). The powerfully direct method of both artists, and the depiction in their art of what they saw as an uncomplicated allegiance to God and nature in the Breton peasantry, was transmitted directly into the art of the Nabis. Maurice Denis, Paul Sérusier, Paul Ranson, József Rippl-Rónai and many others 'communed' with the Breton peasantry in much the same manner (see chapter four). The logic was clear for Denis: 'All the feeling of a work of art comes unconsciously, or nearly so, from the state of the artist's soul … . He who wishes to paint Christ's story must live with Christ … .'[28]

The second intellectual thread was largely developed by Utopian thinkers of the Arts and Crafts movement. It focused on the virtue of peoples living in harmony in their homeland. Emphasis was on accrued histories and traditions, and the communal spirit that resulted. Arts and Crafts practitioners closely associated what they considered to be the ethics of folk art with its aesthetics. Non-illusionistic patterning, simple use of materials, respect for local traditions and environment were to do with politics as well as appearances. This connection owed a great deal to John

2.15 Émile Bernard and Paul Gauguin, Bretonnerie corner cabinet. Carved and painted wood. French, 1888. Private Collection.

Ruskin and William Morris. Although Ruskin and Morris had radically different solutions to society's problems, they shared the view that those problems were caused by industrial capitalism (see chapter eight). Ruskin believed artisanal culture to be the force behind the creative process. In his writings he often targeted those he felt had been most responsible for the exploitation and destruction of this culture, namely the industrial wealthy:

> You are likely to be maintained all your life by the labour
> of other men You will build houses and make clothes
> for no-one, but many a rough hand must knead clay,
> and many an elbow be crooked to the stitch, to keep that
> body of yours warm and fine. Now remember, whatever
> you and your work may be worth, the less your keep costs
> the better. It does not cost money only. It costs
> degradation. You do not merely employ these people.
> You also tread on them.[29]

In his Utopian novel, *News from Nowhere* (1890), Morris presented the well-fed, absolutely democratized vernacular community as the ideal social form. For him, folk art, together with nature, was a weapon in the war against what he saw as the pretentiousness and tyranny of high-art production: 'a pot of flowers will ornament the parlour of an old English yeoman's house far better than a wagon-load of Rubens will ornament a gallery in Blenheim Park'.[30] The vernacular inspired much of his practice. He made use of folk sagas in his poetry – going as far as to translate Icelandic epic poems – and he introduced folk forms into his design more effectively than anyone before him.

Carrying these sentiments forward, the English Arts and Crafts movement was the principal agent in making folk art into a major component in *fin-de-siècle* culture all over the world. By 1895, the work and writings of designers such as Walter Crane, C.F.A. Voysey, Thomas Cobden-Sanderson and C.R. Ashbee were known all over Europe (see chapter eight). The messages sent out were clear: 'We want a vernacular in art, a consentaneousness of thought and feeling throughout society. ... No mere verbal or formal agreement, or dead level of uniformity, but that comprehensive and harmonizing unity with individual variety, which can only be developed among a people politically and socially free.'[31] But while the sentiment of Arts and Crafts thinkers was essentially Utopian socialist, the association of the vernacular with the land, ethnic groups and traditional political boundaries made it a vehicle for the expression of an overtly national culture after 1890. It served a distinctive role, for example, in nations as diverse as the United States, Britain, Germany, Hungary and Russia. It was especially important, however, for those

ethnic groups marginalized or controlled by larger powers. In these places, the urge to form a new, independent culture and economy, and to generate a sense of nationhood, merged into a single drive toward modernity. Several of the Nordic countries and many Middle and Eastern European nations, for example, were engaged in such struggles. In these countries, Art Nouveau and what has become known as 'National Romanticism' were closely related, and even became synonymous.

When a vocal and proud ethnic group was concentrated in a large, urbanized city, the vernacular could provide inspiration for spectacular developments. Spain, Finland and Hungary provide striking examples of this. Antoní Gaudí in Barcelona combined the rich heritage of Catalonian folk art with a spiritual vision of the Gothic (see chapter twenty-three); Eliel Saarinen in Helsinki brought the raw power of Nordic indigenous building forms together with a lighter, international Arts and Crafts ethic (chapter twenty-six); and Ödön Lechner in Budapest joined the bright polychrome forms of the Hungarian peasantry with a range of exotic forms, most noticeably Islamic (chapter twenty-four). All three used histories in an eclectic way in order to create a modern style that would resonate with its ethnic surround.

Very much following the vernacular spirit, the period witnessed a revival in interest in the art of various ancient cultures. Principal among these were the Celtic Revival in parts of Britain, Ireland and the United States and the Viking or Dragon style in the Nordic countries. Archibald Knox, a designer mainly in silver and pewter, was chiefly responsible for the Celtic Revival. His Cymric ware from 1899 and Tudric ware from 1902, both made for Liberty & Co., proved popular all over Europe. His Celtic motifs had an organic sinuousness which placed them well within the canon of Art Nouveau (plate 2.16). Louis Sullivan introduced Celtic and Gaelic imagery to the Chicago Style. His drawings and some of the pattern-forms in his architectural decoration reveal the debt.

In Norway, ethnic identity became central to the struggle for political independence. When archaeologists discovered Viking ships in 1867, 1880 and 1904, artists and designers seized on these ancient forms as a source for the creation of an independent modern style. Henrik Bull (plate 1.6), Gerhard Munthe (plates 2.17 and 2.18), Lars Kinsarvik (plate 2.19) and others pioneered what became known as the Viking or the Dragon style. The imagery and linear pattern-forms of Viking art were combined with other internationally available styles, most notably Arts and

2.16 Archibald Knox, cigarette box. Silver on wooden carcass and opals. English, 1903–04. V&A: M.15–1970.

2.17 Gerhard Munthe, table.
Painted wood. Norwegian, 1896.
From the Fairytale Room,
Holmenkollen Tourist Hotel.
Norsk Folkemuseum, Oslo.

2.18 Gerhard Munthe, armchair.
Painted wood. Norwegian, 1896.
From the Fairytale Room,
Holmenkollen Tourist Hotel.
Norsk Folkemuseum, Oslo.

2.19 Lars Kinsarvik, armchairs.
Painted pine. Norwegian, 1900.
V&A: 4–1901; 5–1901.

2.20 Doorway with two jambs
and a pillar from 11th-century
church at Urnes, Norway.
Late 19th-century plaster cast.
V&A: Repro.52–1907.

Crafts and the Japanese. Bull, Munthe, Kinsarvik and others were internationally acknowledged by 1900 as having created a Nordic version of the new style. Viking art itself also generated interest across Europe. Swedish historian Hans Hildebrand noted in 1892 in a British publication that:

> The archaeologists of the north have been able to show
> that these men, who seemed to their victims to have only
> one interest – war, murder, rapine – really possessed also
> industrial arts of a kind so characteristically developed that
> even we, men of the era of engines and steam, have a great
> deal to learn from them.[32]

The art and architecture of the Vikings was widely disseminated in the form of electrotype copies and replicas of major works, and plaster casts of parts of buildings (plate 2.20), which were commissioned by museums and exhibition organizers. Similarly, Celtic, Gaelic and early Medieval cultures were brought to the world in the form of design manuals (plate 8.1), facsimile volumes and metal replicas.

Art Nouveau offered a radical eclecticism which was fired by the commitment to a sense of *difference*. The implication was that history was not there to be followed, but to be questioned as part of the process of the creation of the future. Paramount in all this was the power of the individual designer. More than any previous style, Art Nouveau was consciously charged with the subjective desires of the designers themselves. The writer of the École de Nancy's catalogue of 1903 described this as '*ornamentation personelle*'.[33] Indeed, the subjective vision of the designer often seemed to transcend the design process and become part of the subject-matter. The bravura of the combinations of sources is a testament to the keenness of designers and their patrons to express a sense of self.

Perhaps a final example will explain this alternative use of history. In 1897–99, the artist-designer Charles Rennie

Mackintosh designed a high-backed chair for Mrs Cranston's tearooms in Glasgow (plate 2.21). Versions of the chair were widely published and exhibited immediately after, most famously at the Vienna Secession Exhibition of 1900. It became an icon of the New Art.

The chair is alive with understated sources. Its extreme height and linearity have a sense of the Gothic; the delicate curves and the use of the oval echo the eighteenth century; the way in which the vertical elements of the back cut through the oval form are reminiscent of Japanese compositional ploys; the plainness of the slats and struts shows respect for the vernacular, sifted through the filter of the Arts and Crafts movement. Yet there is far more in this design than a compendium of other histories. The back is too high for the accepted norm of a nineteenth-century chair. It has deliberately moved out of the confines of the Golden Section and away from Victorian Classical proportion. While acknowledging the history of chairs, the heights and widths of this geometry deliberately negate the expectations of the Victorian sitter. The oval is on its side, not its end; it rests oddly on the top of the back bars and cuts incongruously through the outer bars; it is pierced through with a form that might be a frown, an eclipsed moon or a bird in flight. Thus, the chair is a denial of convention and a subversion of normative value. It is a subjective work that tests the artistic potential of domestic furnishings and makes references to nature and the human body. The chair is an exercise in the alternative use of history, and as such, it is a typical product of the Art Nouveau style.

2.21 Charles Rennie Mackintosh,
chair. Oak with re-upholstered
seat. Scottish, 1897–1900.
V&A: Circ.130–1958

Paul Greenhalgh

The Cult of Nature

You have made your journey from worm to man, and much in you is still worm.

Once you were apes, and even now man is more of an ape than any ape.

But he who is the wisest among you, he also is only a discord and a hybrid

of plant and of ghost. (Friedrich Nietzsche, *Thus Spoke Zarathustra*, 1885)

3.1 Ernst Haeckel, Plate 49,
Actiniae. German. Print from
Kunstform der Nature (Leipzig and
Vienna, this edition, 1898).
V&A: L.1075–1941/49.A.33.

Across the spectrum of activity that was Art Nouveau, nature was the single most unifying factor. Stated so baldly, it would appear that this might be one aspect of this many-headed phenomenon that could be readily understood. Nature, however, was not a simple matter in nineteenth-century culture. There were many views on the meaning of nature within the Art Nouveau style, and not a little antagonism between them. In the various schools of thought it might stand for nationalism or cosmopolitanism; progress or reaction; eroticism or innocence; individuality or collectivity; conservatism or anarchism; science or mysticism; social movement or stasis. Underpinning all this variety, however, was one common meaning. Wherever it surfaced in Art Nouveau it signified modernity, and in several instances it anticipated future modernisms.

The ability of nature to provide these varied representations related closely to the transformed vision of it within natural science itself. During the nineteenth century, improved communications and new technologies brought natural life from all over the world into view in ways not previously possible. Still more significant, from the late Enlightenment onwards, major thinkers, culminating with the work of Charles Darwin, changed the very nature of nature. Darwin provided the scientific framework which allowed for the full development of the theory of evolution. By 1890, the work of evolutionists all over Europe led to a new vision of nature which came to act powerfully on the cultural sphere, and not least upon the decorative arts. The professional worlds of decorative art and biology – indeed, of arts and sciences in general – encountered each other far more in the nineteenth century than is the case today. Knowledge was a far less divided thing. The relative elasticity between disciplines, and the less specialized types of language used within them, allowed individuals in the arts to accrue surprisingly impressive levels of knowledge

in fields quite different from their own. For example, John Ruskin, Christopher Dresser, Hermann Obrist, Eugène Grasset and Émile Gallé were all either formally qualified, or had been accorded public acknowledgment from professionals, in the field of botany.

An increase in the number of illustrated publications on botanical and biological subjects from the later eighteenth century spread such knowledge. Many of these volumes entered schools and academies of art and design across Europe, to be thumbed by generations of students seeking to copy natural imagery. Superbly illustrated volumes by P.J. Redouté, published in Paris at the turn of the nineteenth century, or *Curtis's Journal*, produced in London between 1785 and 1865, were full of large-format coloured images of flora and fauna.[1] By 1860, a truly international and exotic range of plant imagery was available. Books on the travels of eminent botanists, such as Alfred Wallace in the Malay Archipelago and J.D. Hooker in the Himalayas, allowed enthusiasts to discover the plant life of most regions of the Earth without venturing farther than a library or bookshop (plate 3.2). Likewise, sea life from the deepest and most distant oceans became a commonplace of the printed page. This geographic breadth was accompanied by microscopic depth. Volumes containing magnified illustrations of cellular life, famously exemplified by the books of Ernst Haeckel, published continuously from the 1860s, presented organic life to a wide public for the first time (plate 3.1). Nor was illustration limited to two dimensions. Consummately produced wax, ceramic and glass models, for use as teaching aids in universities, demonstrated the aesthetic potential of realistic, organic and microscopic forms. By their very manufacture, these books and objects guaranteed the presence of technologically enhanced images of natural form in the artistic studios and workshops of Europe.

Exotic nature was also a major source of urban pleasure.

Plate II.

J.D.H del. W Fitch lith.

Vincent Brooks imp.

HODGSONIA HETEROCLITA, Hook. fil. et Thoms.

FEMALE PLANT.

The number of conservatories and hot houses in the public parks of Brussels, London, Paris, Vienna and other cities dramatically increased in the second half of the century. In an interesting prelude to Art Nouveau, the confident exoticism of tropical plant life met the technology of iron and glass in the context of modern, urban life.

3.2 J. D. Hooker, Plate II, *Hodgsonia Heteroclita* (Female Plant). English. Print from *Illustrations of Himalayan Plants* (London, 1855). V&A: 48.E.408.

As flamboyant and symbolically varied as the use of nature in Art Nouveau was, it is possible to discern a limited number of aesthetic strategies at work. These principally concern the decorative and design arts, although at key moments they also involve developments in painting and mainstream sculpture. The strategies were not in any sense wholly separate from each other – some designers employed several simultaneously and most of them at different points in their careers. Nevertheless, it is useful to unravel them. There were four strategies, which can be described as 'symbolic conventionalization', 'pantheism', 'metamorphosis' and 'evolutionism'.

The first two of these sat uncomfortably alongside each other within the boundaries of Art Nouveau. This was principally because they had developed in antagonism through the nineteenth century. In fact, the central debate among those who made use of nature in the ornamental arts between 1830 and 1890 could be summed up as being a conflict between Naturalists and Conventionalists. The former, carrying the banner of pantheism, made their mark first. Ralph Nicholson Wornum, a celebrated English writer on design, noted in 1853 that: 'there is a class of ornament which has much increased of late years in England and, by way of distinction, we may call it the *naturalist* school'.[2] The phenomenon he referred to, in fact, was European-wide by then. Catering for the tastes of what another commentator termed the age of 'variety and complication', this Naturalism used historical styles – frequently the Rococo – as a basic framework which could then be saturated with often highly realist naturalist detail.[3] Developing to extreme proportions in many centres by 1850, this high Naturalism encouraged the creation of objects that were completely covered in people, flora and fauna. The approach celebrated the use of nature as a resource without collaboration or approval. Nature was taken possession of, and became a means for the urban wealthy of the Industrial Age to express their sense of abundance. An extreme aspect of this was the extraordinary taste for antler furniture, in which nature was made to play the role quite literally of trophy, the result of sport, rape and cull (plate 3.3). Buried within this triumphant bloodlust, how-

3.3 Armchair. Horns, antlers and teeth with green velvet upholstery. Austrian or German, *c*.1865. V&A: W.2–1970.

ever, was also a pantheism which had reached its peak of influence earlier in the century as part of the Romantic movement. Thus, the brutalization of nature carried within it a worship of the same.

In due course, those of elevated taste came to regard this pantheistic approach to nature – worshipful or not – as uneducated and vulgar, capable of producing 'simply … aesthetic monstrosities, ornamental abominations'.[4] The principal objections were to do with style and utility. The uncritical application of natural form to an object

bypassed the very idea of style, as it was widely understood in the nineteenth century by those committed to tradition and change alike. Utility, both in terms of actual usage and symbolic function, could not, it was felt, simply be dispensed with in order to achieve a certain look. From the mid-century onwards, design manuals and volumes on taste increasingly imparted the message that nature had to be controlled. One author explained in 1895 that:

A mere naturalistic copy of a plant on to an industrial object will not in itself form ornament. It will neither be interesting because of its fitness for its purpose, nor will it be interesting as an expression of human thought and invention. In order to become ornament, natural forms must be arranged in some orderly pattern; they must be

3.4 Eugène Grasset, Plate 32, *Snowdrops in Ornament*. Colour lithograph. French, 1897. From *Plants & Their Applications to Ornament* (London, 1897). V&A: L.149–1897/48.E.48.

attached. This was, in effect, a process of abstraction, mostly using plant forms. One started with observable elements and subjected them to a process of aesthetic filtration (simplifying, geometricizing and harmonizing) to arrive at a finished image or object which, although derived from nature, was not meant to imitate it directly. The French artist-designer Félix Bracquemond eloquently expressed the idea in his volume *On Drawing and Colour* of 1895: 'Ornament does not necessarily copy nature, even when it borrows from her all the elements that go to make it up. It modifies and transforms nature, subjects her to its conventions … .'

The process was not simply about appearances. Exemplified by developments in advanced design circles in England, conventionalized nature carried an understated social purpose. It was intended to reassure, not to attack. It represented stability, rationality and reliability. Ordered so as to be civilized, made cultural, as it were, through cultivation, nature was symbolically domesticated. It was tamed so as to aid the central aim of the object, namely to be useful. It was configured into an ornamental, benign support to humanity and a moral educator (plate 3.4).

There was a strong Rationalist aspect to the conventionalization of nature. Some designers perceived in nature not simply a source for ornament, but also a system of construction. The designer of the Crystal Palace, Joseph Paxton, famously claimed to have designed his glass buildings following the structural organization he observed in the Victoria Regia Lily. Designers and architects, such as Christopher Dresser, Henri Labrouste and Eugène Emmanuel Viollet-le-Duc likewise saw in nature a system of construction. German architect and theoretician Gottfried Semper developed his concept of 'tectonics' by focusing on the nature of materials and by extrapolating Rationalist architectural principles out of what he perceived to be the processes of nature: 'Tectonics is an art that takes nature as its model – not nature's concrete phenomena, but the uniformity and the rules by which she exists and creates. Because of these qualities nature seems to us who exist in her to be the quintessence of perfection and reason.'[6] There was little in the way of pantheist blood lust here.

It would hardly be an exaggeration to suggest that conventionalization became the subject of propaganda, so widely and carefully was it promoted as a system. A great many publications were produced across Europe and North America with the express purpose of promoting the cause. The better-known ones include:

Rupriche-Robert, *Flore ornementale* (1865)

simplified so that their meaning may be easily grasped; their decorative qualities must be expressed in the material in question in the most direct and effective way.

The technical word is *conventionalized*.[5]

For those who believed in convention as a necessary tool in decorative art – and by 1870 all over Europe they had successfully challenged the pantheist spirit in circles considering themselves to be of advanced taste – nature had to be rendered flat, formed into regular pattern and shaped to complement the contours of the object to which it was

F.E. Hulme (ed.) *Art-studies from Nature as Applied to Design* (1872)

E. Bléry, *Guide industriel dessiné d'après nature* (1878)

K. Krumbholz, *Das Vegetable Ornament* (1879)

A. Seder, *Die Pflanze in Kunst und Gewerbe* (1886)

J. Habert-Dys, *L'Ornement practique, documents d'après nature* (1886)

V. Cherbuliez, *L'Art et la nature* (1892)

Lewis F. Day, *Nature in Ornament* (1892)

F. Luthmer, *Blütenformen als Motive für Flächenornament* (1893)

M. Meurer, *Pflanzenformen* (1895)

G. Brenci, *Esercizi Graduati di Disegno Proprietà Artistica* (c.1895)

Midgely and Lilley, *Plant Form and Design* (c.1895)

Musées Nationaux de France, *Encyclopédie de la fleur, les fleurs et les fruits photographiés et groupés d'après nature* (c.1896)

A. Trenter, *Pflanzen Studien* (1899)

E. Grasset, *Plants & Their Applications to Ornament* (1897)

M.P. Verneuil, *Étude de la plante, son application aux Industries d'Art* (1900)

A. Keller, *La Décor par la plante. L'Ornement et la végétation: Théorie, décorative et application à industrielles* (1902).

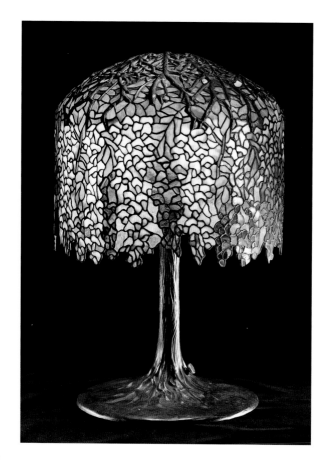

3.5 Tiffany Studios, 'Wistaria' table lamp. Pattern-leaded glass and bronze. American, *c.* 1902. Lillian Nassau, New York.

Conventionalization was the most widely used strategy among Art Nouveau designers. Indeed, many Art Nouveau architects and interior designers used the textiles and wallpapers of conventionalizing forebears. The wallpapers of William Morris, C.F.A. Voysey and Walter Crane, for example, were sold all over Europe (see chapter eight). A critic noted of the work of Victor Horta (who often used Morris wallpapers) that although 'the artist observes nature and is inspired by her … his ambition has never been to do anything which might directly resemble nature'.[7] However, as the various Art Nouveau movements took possession of conventionalized nature, its moral, rational and even respectable demeanour receded, and the method was pushed into altogether new areas. Nature remained as an inspiration, as a starting point and as a vehicle, but was far less the neutral back-drop or the signifier of innocence it had previously been. By 1900, what can be termed 'symbolic conventionalization' put nature at the service of altogether unnatural visions in parts of the Art Nouveau camp.

Symbolic conventionalization developed from mainstream conventionalization, through the influence of several major intellectual forces. Of direct importance was the broad range of painters associated with Symbolism, including those artists breaking free from the strict empiricism of Impressionism and the circle of Paul Gauguin and

the Nabis. In his famous *Ten O'Clock Lecture* (1885), James McNeill Whistler claimed in typical fashion 'that nature is very rarely right, to such an extent even, that it might almost be said that nature is usually wrong'.[8] Shortly after, Gauguin, in developing his notion of Syntheticism, was similarly unequivocal: 'Some advice: do not paint too much after nature. Art is an abstraction; derive this abstraction from nature whilst dreaming before it, and think more of the creation which will result than of nature.'[9] The Symbolist and Decadent movements in literature were, perhaps, ultimately more important than the painters. In a letter to Stéphane Mallarmé of October 1882, J.-K. Huysmans wrote of the hero of the novel *A Rebours*, on which he was working, that 'in his comfortable retreat he substitutes the pleasures of artifice for the banalities of Nature'.[10] The celebration of artifice became a key element of Decadent art in the last two decades of the century. Des Esseintes, the hero of the novel, loudly proclaimed artifice to be 'the distinctive mark of human genius'.[11] Artifice was a prerequisite for the activities of the Aesthetic movement in England.[12] When Oscar Wilde declared in 1894 that 'the first duty in life is to be as artificial as possible', he was acknowledging a well-established view in art as well as manners.[13]

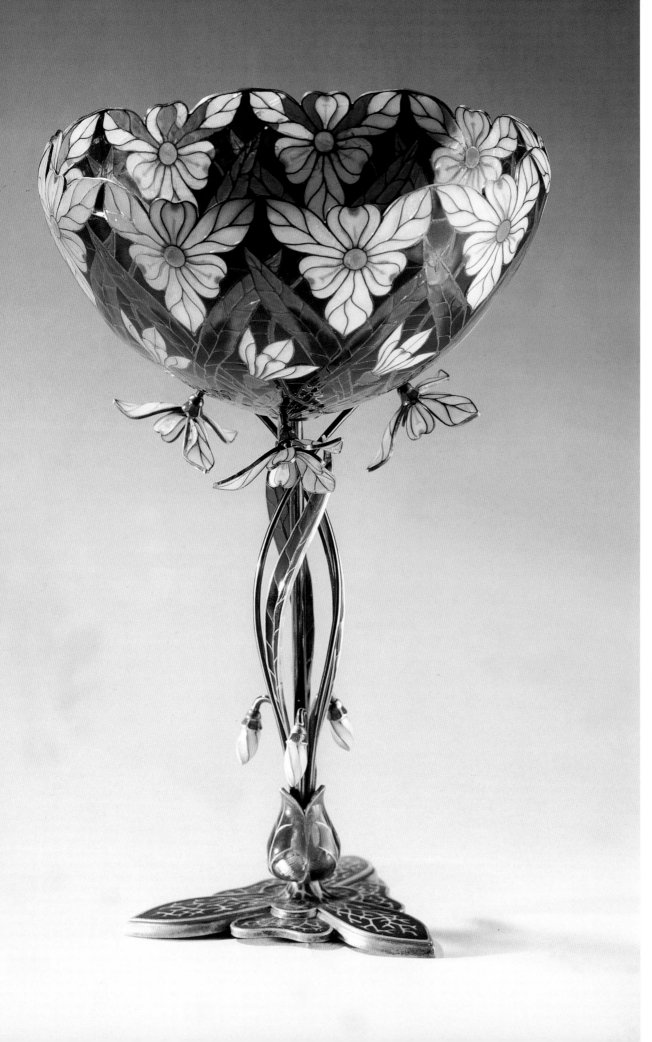

3.6 Thorolf Prytz, cup.
Plique-à-jour enamel.
Norwegian, *c.*1900.
Kunstindustrimuseet, Oslo.

3.7 Thorvald Bindesbøll, vase.
Earthenware, incised and painted.
Danish, 1893.
Danish Museum of Decorative
Art, Copenhagen.
Photo: Ole Woldbye.

Many Art Nouveau pattern-forms are a result of nature being coaxed into the realm of artifice. Symbolic conventionalization allowed the poetic imagination to be expressed through natural form without strictly following the natural world. Unlike previous conventionalist forms, these new shapes might be used to subvert rather than support a sense of stability; they could be used to celebrate individuality, flux or wantonness as easily as conformity or stasis. The depraved arabesques of Aubrey Beardsley (plate 1.9), the mystical geometry of Charles Rennie Mackintosh, the opulent sophistication of Louis Comfort Tiffany (plate 3.5), the writhing modernity of Eugène Gaillard (plate 10.6), the breathtaking delicacy of Thorolf Prytz (plate 3.6), or the gestural abstraction of Thorvald Bindesbøll (plate 3.7), were all achieved through the combination of a conventionalized nature with a symbolic vision. The method, of course, was not employed exclusively by those principally concerned with individualist expression. The curves of Louis Majorelle combined nature with the Louis' (see chapter two) so completely as to defy any attempt to discern where one began and the other ended, lending his work a Gallic confidence that proclaimed a style that was simultaneously new and French (plate 3.8).

3.8 Louis Majorelle and
Daum Frères, pair of magnolia
lamps. Gilt bronze and carved
glass. French, c.1903.
Private Collection.

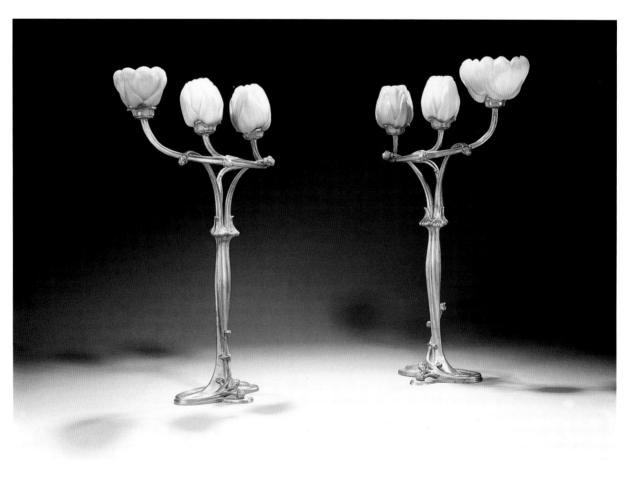

3.9 Philippe Wolfers, *Civilization and Barbary*. Ivory, silver and onyx. Belgian, 1897. Private Collection, Brussels.

Pantheism, the second of the two strategies within Art Nouveau naturalism, was essentially a return to the full-blooded use of nature, unconventionalized and realistic, but given the added inflection of *fin-de-siècle* symbolism. It revealed a revived interest in nature as a mysterious agent, carrying a sense of awe and fear. There was a distinct recognition that nature was ultimately unknowable.

The development of a Rational vision of nature under the guidance of the Darwinists had inevitably encouraged – as a reaction – an exploration of spheres beyond the material. Indeed, many of the Darwinists themselves became interested in mysticism. Alfred Wallace, one of Darwin's key collaborators, became a theosophist; and Ernst Haeckel, the greatest German evolutionist, had a powerfully mystical side to his character. In 1869, in the first issue of the journal *Nature*, T.H. Huxley quoted Goethe's *Aphorisms*, which tellingly outlined the limits of a rational analysis of nature: 'She is incessantly speaking to us, but betrays not her secret … . The one thing she seems to aim at is Individuality; yet she cares nothing for individuals … . She is the only artist.'

Pantheism used the bestial to create a sense of mystery. Animals, reptiles and insects were often depicted realistically, without the taming element of conventionalization.

French designer Eugène Grasset, despite his conventionalist credentials, relished the thought of a reversion from the gentleness of conventionalized plant life back to an older, more bestial spirit:

> In past times, one saw in the world of ornament the butterfly, the squirrel, the dog and the monkey; at other times an audacious parakeet reached to slide through the foliage, swans curving their necks harmoniously, one even came across grass snakes and hedgehogs … . The moderns have reduced this list and when, through great extravagance, they admit an animal into a work of applied art, it's only on the condition that it is friendly, that is to say without great big eyes, too large a beak or paws! Horrors! No, it is necessary that he is bourgeois and very tame; full of feelings that are gentle, tender, with meek features and in every case sympathetic.[14]

Some designers abandoned conventionalist control completely to express a pantheism that bounded on paganism. Philippe Wolfers, the great Belgian jeweller and metalworker, for example, achieved an extraordinary fusion of mysticism and hedonism in works such as *Civilization and Barbary* of 1897 (plate 3.9). Here nature was absolutely a thing to be loved and feared. The use of ivory by Wolfers and other Belgians symbolized not only the exoticism of

3.11 Louis Majorelle and Daum Frères, *Le Figuier de Barbarie*. Lamp of patinated bronze and carved glass. French, 1903. Musée de L'École de Nancy.

3.10 Rupert Carabin, chair. Walnut. French, 1895. Private Collection.

the empire, but also, as with earlier pantheists, the cruel and extravagant celebration of instinct. French artist-designer Rupert Carabin exemplified the pantheist spirit. His sculpted furniture was often composed exclusively from the conjoined bodies of animals. He revelled especially in creatures of the night – the owl, the cat, the snake – these often interacting with the female form. His work expressed an extraordinary range of qualities and feelings: intelligence, cunning, wit, desire, temptation, cruelty and the instinct to kill (plate 3.10). This was not furniture based on rational conventions or utility, but on the heady celebration and exploration of natural body forms. The sensuality of these works edges towards the dangerous and threatening world of the psyche and the spirit.

The pantheist spirit was widely evident in the city of Nancy, especially in the sphere of glass manufacture. The work of the Daum brothers, for example (trading as 'Daum Frères'), carried a pantheist dimension (plate 3.11; 13.3 and 13.4). Émile Gallé was the most complete Naturalist working within the Art Nouveau style. His work crossed boundaries between the different types of nature outlined in this chapter. He made an aggressive plea for conventionalization with regard to furniture and his vision was often metamorphoric in all media, but his work is perhaps best described as part of the return to the direct depiction of plant, insect and animal life in the pantheist spirit. He combined biological exactitude with Symbolist vision to produce some of the most memorable objects in the style (plate 3.12; 13.1 and 13.2).

M etamorphosis and evolutionism, the third and fourth strategies in Art Nouveau naturalism, were both a result of the incursion of evolutionist ideas from biology. Evolution was far from being a new concept when Darwin published *On the Origin of Species* in 1859. Darwin himself acknowledged Jean-Baptiste de Lamarck as the first major evolutionist. Indeed, Viollet-le-Duc had extensively applied Lamarckian ideas to the history of architecture before *On the Origin of Species* was published. In his seminal work of 1906, the German writer Walther May firmly tied the development of evolution to the Enlightenment.[15] Nevertheless, it was Darwin's compelling empirical evidence, plus the revolutionary idea of natural selection, which solved major problems within evolutionary theory and led to its eventual acceptance by the majority of advanced European and American thinkers. Darwin's *Descent of Man*, published in two volumes in 1871, tied humanity to natural processes and provided a new model for the fashioning of

the past and the future. Natural selection described a world that was not stable, but engaged in the constant turmoil of struggle and transformation, a struggle from which humankind was not exempted: 'Man and all other vertebrate animals have been constructed on the same general model … . It is only our natural prejudice, and that arrogance, which made our forefathers declare that they were descended from demi-gods, which leads us to demur this conclusion.'[16]

By the mid-1880s evolutionism was a commonplace, and had moved from the academic world to all areas of human affairs concerned with developmental issues. For example, a popular series of books on contemporary science established in 1890 included volumes on *The Evolution of Sex*, *The Origin of the Aryans*, *Evolution and Disease*, *Primitive Folk*, *The Evolution of Marriage*, *Education and Heredity*, *The Origin of Invention*, *The Growth of the Brain*, *The Evolution of Modern Capitalism*, and, interestingly enough, *The Evolution of Decoration*. Evolution was the new legitimacy; it was virtually a secular religion and had managed to dispense with any negative connotations. Historian Robert M. Young has observed that: 'what evolution took away from man's spiritual hopes by separating science and theology and making God remote from nature's laws, it gave back in the doctrine of material and social and spiritual progress'.[17]

The third strategy, that of metamorphosis, was the most direct artistic response to the repositioning of humankind implied by evolutionism. Although it had existed in literature and the visual arts as a poetic device since the Classical period, this latest use included the recognition that humankind was synonymous with, not above, nature. It involved the fusion of human, animal and plant in a mystical, yet still material, recognition of the ascent of nature and the descent of man.

Some artists dealt directly with the theme of human beings becoming elements of the landscape. Auguste Rodin, for example, often used the theme of metamorphosis, melting bodies into their landscape surround. Art Nouveau designers were often more literal than this in their fusion of human, plant and animal form. It was a central theme in the work of the French master jeweller René Lalique, for example, who did this most famously perhaps in his *Dragonfly Woman* of 1899 (plate 4.12). The vessel form was often used to express the idea of metamorphosis. American potters Artus Van Briggle and George Ohr teased the vessel into mimicry of human form, often with potently erotic results. Van Briggle would typically wind a female form around the entrance of his vases (plate 4.11), while Ohr pushed and squeezed the clay in a startling

3.12 Émile Gallé, detail of vase. Wheel-cut and acid-etched glass, with applied cabochons over silver foil. French, *c.*1903–04. V&A: C.53–1992

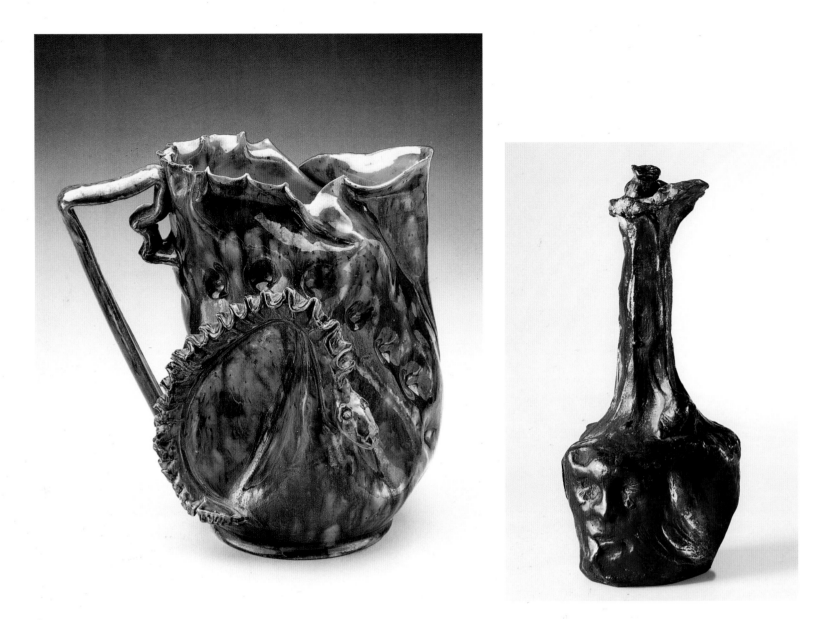

3.13 George Ohr, pitcher with snake. Earthenware. American, c.1895–1900.
Private Collection, New York. Photo: John White.

3.14 Ville Vallgren, vase. Bronze. Finnish, 1893.
Danish Museum of Decorative Art, Copenhagen.
Photo: Ole Woldbye.

suggestion of limbs and genitalia, these often vying for attention with crustaceans and plants (plate 3.13). Finnish sculptor and metalworker Ville Vallgren used the vessel to conjoin heads or the female form with plants, often depicting the process of transmutation in extreme form (plate 3.14). A passage written in 1897, describing his work, captured the way in which metamorphosis was used in many countries:

> Vallgren's decorative ideas emanate from the assimilation of vegetable and human life. He associates flowers with joy or suffering; the forms of flowers have, for him, the forms of women: they flourish together, as it were; and his open chalices he makes brim with these women-flowers, which seem to bloom; stems form their delicate arms … a supple and rigid movement of their narrow hips and their solid chests.[18]

The imagery was not always overtly figural and obvious; designers often used understated metamorphic devices to add to the physical allure of their creations. Organic form could be made to elide from plant to human, and elude the human to become animal or mineral. The hair of the women depicted by Alphonse Mucha, Marcel Bing or Jan Toorop could be the stuff of trees, plants or animals (plate 3.15); Gaudí's facades and objects allude to plants, rock formations and bone structures (plates 3.16 and 3.17); the phallus is buried within the organisms of Hector Guimard (plate 4.24) and the vagina is a sublimated presence in the flowers of the MacDonald sisters (plate 1.8). In thousands of designs the ovular presence of cell life pulls the human into the inhuman, and the organic into the inorganic. Metamorphosis could also have purer intent. Louis Sullivan, for example,

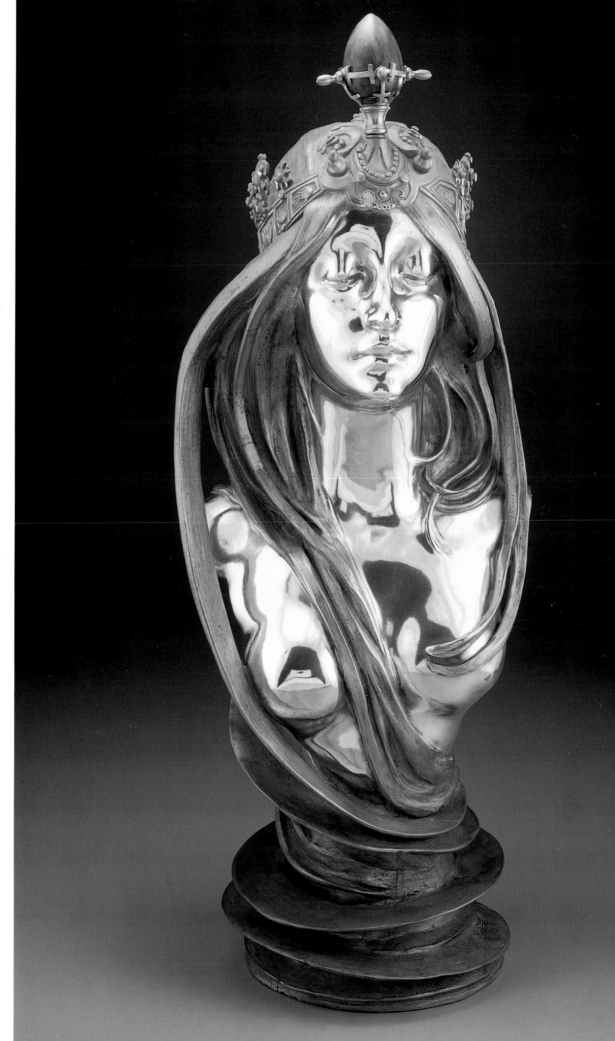

3.15 Alphonse Mucha,
La Nature. Gilt bronze, silver,
marble. Czech, *c*.1900.
© Virginia Museum of Fine Arts.
Gift of the Sydney and Frances
Lewis Art Nouveau Fund.
Photo: Katherine Wetzel.

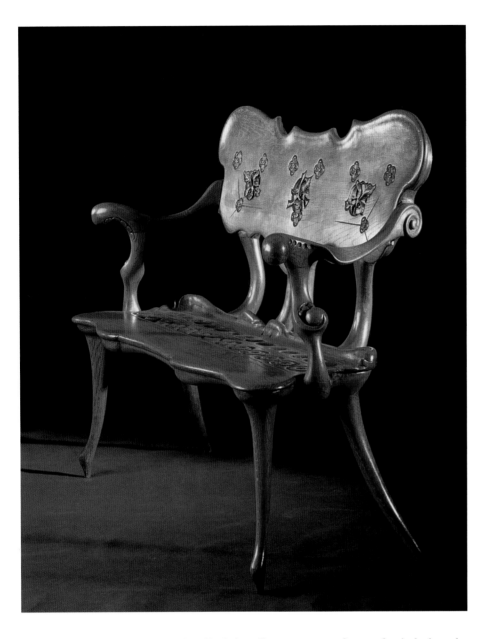

3.16 Antoni Gaudí, bench. Oak. Catalonian, c.1903. Casa Calvet. Collection Pedro and Kiki Uhart, Paris.

3.17 Antoni Gaudí, clock. Gilt wood. Catalonian, c.1909. Casa Milá. Collection Pedro and Kiki Uhart, Paris.

described, in a Rousseauesque frame of mind, the relationship of an early, 'innocent' man to the trees among which he lived:

> Breathing the same air as they, maturing in the same glowing sunshine, sustained by the same satisfying moisture, he and they expand side by side, defining themselves intimately to each other; and the boy, growing always, after a while feels himself to be not only with them but of them. His is a brotherhood with the trees … .[19]
>
> (see chapter twenty-two)

Yet metamorphosis was not simply to do with subject-matter. The fusion of the subjective and objective led to a kind of metaphysical metamorphosis, in which artists and designers made themselves psychologically at one with their total environment and their work. This was described by Friedrich Nietzsche in *Twilight of the Idols* (1889) as being a necessary part of the creative process:

> The essential thing remains the facility of the metamorphosis, the incapacity not to react … . It is impossible for the Dionysian man not to understand any suggestion of any kind, he ignores no signal from the emotions, he possesses to the highest degree the instinct for understanding and divinity, just as he possesses the art of communication to the highest degree.[20]

For Nietzsche, human history could be seen as having lost its position, to have become a mere sequence of events or a gathering of trinkets in the face of giant and timeless continuum. His Dionysian man recognized only the 'will to power', the force that eliminated the abstract niceties of human history in favour of a one-to-one relationship with the actual,

material reality of nature. The burden for the achievement of a higher state lay, therefore, with the individual.

The work of Edvard Munch exemplified the absolute fusion of medium, artist and subject-matter such a metamorphosis demanded. He was indivisible from the subject of his work and the subject of his work was a complete fusion of nature and humankind.

German writer and industrialist Eberhard Freiherr von Bodenhausen attempted to develop the idea of individualism by combining it with evolutionism and Hegelianism. In an article 'Evolution and Aesthetics' (published in 1900 in *Pan*) he made the case for what historian Robert Schmutzler later termed 'biological Romanticism'. Bodenhausen initially recognized that in human beings, 'the fight for survival is refined to a fight towards enlightenment', before dismissing the idea that history, or even learning, could lead to an understanding of art. Art was to be achieved through the complete assimilation of 'the sovereign individual' into nature:

> Not in books, not in exhibitions, not in museums, which so
> often are goals for light and life, can you arouse and widen
> your will to art; just as you can't find God in church if you
> didn't bring him with you … . If you walk out into God's
> free nature and become part of this nature again and listen
> to its voice then heart and senses will become open to it,
> and you yourself will become a bearer and a prophet of
> that force – art – which you couldn't find in the halls that
> bear its name.[21]

This is a call for an anti-historicism based not upon the desire for stylistic novelty or improved commerce, but on the belief that history is a chimera distracting the individual from true self-realization. Developing this idea in an interview of 1902, French designer Alexandre Charpentier expressed the view that the transformation of the world during the nineteenth century, and humankind's position in it, demonstrated that religion had been replaced by individualism:

> The artists of the Middle Ages had religious certainty;
> they have filled our old Europe with perfect
> masterpieces. We shall never know that community of
> enthusiasm and faith in the ideal which vivified the souls
> of the men of those days. In the absence of that, in
> contrast to that, it is in individualism *à outrance*, in
> anarchy – or better, in anarchism – that the artists of
> tomorrow will realise what they have in them and how
> noble is their mission.[22]

By fusing oneself with nature, one rendered human history irrelevant and, thus, was freed from it. Nature became a force in the anarchic quest for modernity.

If metamorphosis was about the passionate and total integration of the human and the natural, evolutionism (the last of the strategies described here) was a rational response to the new biology, whereby evolution was related to material progress in human affairs. In his pioneer study, *The Beardsley Period*, Osbert Burdett affirmed that within *On the Origin of Species*, 'the industrial system found its Bible, and men learnt that the world of nature was also ruled by *laissez faire*'.[23] Darwin himself believed that the technical and economic advances he witnessed in Victorian Britain were part of a natural, evolutionary process; for him 'evolution and utilitarian economics were perfectly tuned'.[24] Through the idiom of progress, evolution implied technological revolution, economic growth, urban development and imperial expansion. There was also a political dimension. Evolution appealed strongly to those in favour of the anti-traditional, *laissez faire* expansionism of classic Liberal mould. The historian Peter Bowler has observed that 'some German scientists, of whom Ernst Haeckel is the best known, were political radicals who saw Darwin's rejection of design as a weapon in the fight against conservatism'.[25] The insistence on material equality and incremental change also appealed to many socialists.

Thus, perversely, the force of nature could be witnessed as being at its most potent in the voracious hearts of Europe and North America's expanding urban centres. Here evolution was at its peak of full-blooded, uncompromised efficiency. The metal tendrils and sepals of Art Nouveau décor, winding around the iron and glass structures of Brussels, Munich or Paris, symbolized absolutely the unsentimental advance of humanity. The tensile, nervous and unstill twists and curves of a million Art Nouveau objects were testament to the fact that all was in a process of change and advance. Moreover, change was not rooted in any one nationality, it was an international style.

In contrast to Charpentier's passionate anarchism, many evolutionists had a gradualist and positivist vision of change. Henry van de Velde, among others, developed what might be termed a socialist functionalism using nature as a model: 'Nature proceeds by continuity, connecting and linking together the different organs that make up a body or a tree; she draws one out of the other without violence or shock.'[26] The process of gradual evolution toward appropriate forms, aided by the determinism of natural selection, could be understood as a struggle towards total improvement. More a philosophical position than an aesthetic strategy, evolutionism could offer artists and designers the certainty that the New Art was not simply a novel fashion, relative to all fashions before it, but

was part of an absolute advance of culture. Some felt that they could help this advance. Hector Guimard, for example, subscribed to the belief that his practice was part of a greater cultural structure, one that could be made to realize change: 'It is upon us architects that falls more particularly the duty of determining, by our art, not only the artistic, but also the civilizing and scientific evolution of our time.'[27] Perhaps the evolutionist idea was subscribed to most strongly in Germany. The dramatic illustrations of nature available in Ernst Haeckel's volumes fused most completely with political views of Haeckel himself. Likewise, the imagery used by Ludwig Vierthaler (plate 3.18), Hermann Obrist, August Endell, Bernhard Pankok (plate 3.19), and others in Munich, was not an innocent utilization of patterns derived from microscopy or from illustrations of the sea-bed. These artists enjoyed the fact that nature was not a stable phenomenon, but a developmental process edging its way irresistibly forwards.[28] The frenetic energy evident in Endell's decoration for the Elvira Studio of 1897–98 and in Obrist's embroideries is dedicated to social and cultural change (see chapter nineteen, and plates 1.5, 1.12, 11.1).

Although they vary in so many ways, the four strategies for using nature at the *fin de siècle* – symbolic conventionalization, pantheism, metamorphosis and evolutionism – held one idea in common, namely the idea of modernity. This was partly because nature could be seen to be outside the conventions imposed by historicism. Primarily, however, Art Nouveau artists and designers took the view that nature, in its reinvented form, pointed as enthusiastically at the future as it did at the past.

3.18 Ludwig Vierthaler, jardinière on stand. Patinated copper with enamel. German, *c*.1906. Private Collection. Photo: Roman Franke, Munich.

3.19 Bernhard Pankok, vitrine.
Stained oak, spruce and glass.
German, 1899.
Stadtmuseum, Munich.
Photo: Wolfgang Pulfer, Munich.

Ghislaine Wood and Paul Greenhalgh

Symbols of the Sacred and Profane

Spiritualism: In philosophy, the state or condition of mind opposed to materialism
or a material conception of things. (Madame Blavatsky, *Theosophic Glossary*, 1892)

4.1 Paul Sérusier, *The Talisman*.
Oil on wood. French, 1888.
Musée d'Orsay, Paris.
© Photo: RMN-Jean Schormans.

As a style premised on narrative, Art Nouveau contained a complex range of symbolic content. This symbolism was not passively acquired, but rather was a pointed appropriation, a search for an iconography of the modern. Nature and history, as chapters two and three have shown, provided much of this meaning. Alongside these two, and overlapping with them, what might be generically termed the 'spiritual world' provided another major source. Art Nouveau articulated widely felt anxiety over the tension between the spiritual and physical realms, often understood at the time as the sacred and profane, or as Octave Uzanne expressed it, 'what the new art sought to depict was the eternal misery of the body fretted by the soul'.[1] The mystical aspect of Art Nouveau was largely acquired through contact with artists and writers associated with the French Symbolist movement. Pioneer Art Nouveau historian Maurice Rheims is unequivocal on the significance of this connection: 'Art Nouveau arose out of Symbolism, and its sources are as diverse and bewildering as those of the parent stream'.[2]

Given that Art Nouveau was only possible because of the material revolutions that transformed the way societies produced and consumed cultural artefacts, it might seem eccentric that many designers in the style were circumspect about the materialism that surrounded them. It was inevitable, however, that an age that was typified (at the time as well as later) as one of frenetic technical progress should also be one of occultism and mysticism. All forces within societies give rise to their opposites. Thus, the nineteenth century was simultaneously the most scientific and the most religious, the most material and the most spiritual. It was an age of engines and of ghosts.

There was a predictable and widely acknowledged tension between those who embraced the quantifiable scientific world and those who sought the metaphysical realm. This was revealed in the great debates between the

Romantics and the Rationalists, in most spheres, and can be witnessed in painting, literature, architecture and the decorative arts throughout the century. After 1880, this material/spiritual dichotomy showed itself most clearly in painting and literature, in the rift between the Realists and the Symbolists. But as chapter five shows, while the conceptual space between Naturalism and Symbolism was clear enough, it was not an absolute divide. In the real world of publishing and exhibiting, Naturalists and Symbolists were often placed alongside one another.

While acknowledging the tension between the material and the spiritual, some individuals attempted to reconcile the world of science with the concerns of spiritualism. This often entailed mutual appropriation of languages and methods: quasi-science could be found everywhere in the *fin-de-siècle* world, bumping into quasi-religion, as a bored and agitated intelligentsia sought new ideals and directions. The combination could lead to spectacular commercial success. The triumph of Bram Stoker's *Dracula* (1897) was in large part due to its fusion of the world of science with that of the supernatural. Stoker used the socio-biological theory of Max Nordau and Cesare Lombroso's theory of criminality to classify Dracula. Jean-Martin Charcot is described in the novel as 'the great' hypnotist. Science was thus used to legitimize the mysterious.

The attempted reconciliation of science, spiritualism and art can be found everywhere among the objects and ideas that are Art Nouveau. Historian Henry F. Lenning's description of Art Nouveau as 'scientific Romanticism' is a useful one, as it implies a conscious fusion of the material with the metaphysical. As a cultural strategy, it would survive Art Nouveau to play a serious role in later twentieth-century activity, including the Modern movement in design and Surrealism.

There was a widespread discontent among intellectuals during the period with organized religion, law and educa-

tion. The more mystical aspects of established religions were pursued, often providing a tremendous impetus for the development of Art Nouveau. Resurgent Catholicism in Barcelona resulted in the Cult of the Sagrada Familia (a key inspiration to Gaudí; plate 23.10), while in Brussels Freemasonry provided patronage, often from within the socialist intelligentsia. Victor Horta benefited significantly from this. Nevertheless Protestantism and Catholicism were generally subjected to aggressive reappraisal in attempts to free them from what was perceived to be their hypocritical and stultifying institutionalization. Much in the way that practitioners of Art Nouveau developed alternative approaches to history, so the spiritualists sought to renew the religious heritage. Alternative religious experience was explored, reassessed and, commonly, reinvented; and forgotten and unacceptable rituals were embraced in order to subvert normative Christian values. In his regular column 'Hermétisme et Spiritualisme' in *La Plume*, one writer identified ancient Egypt, Classical antiquity, the Middle Ages and the early nineteenth century as key periods for the formation of *La Science hermétique*. More worryingly for his readers with an historical sensibility, he also cited Atlantis. The occult – non-conformist religious practices concerned with ancient rituals and miraculous practices – thrived after 1850.[3] The new old faiths included spiritualism, universalism, transcendentalism, hermeticism, Rosicrucianism, Freemasonry and theosophy. Experimentation with Satanism increased markedly.

The academic world was also in a period of agitation and renewal. The emergent disciplines of anthropology, socio-biology, psychology, craniology, sexology and phrenology explored human consciousness and its position in society, using methods that ranged from the respectably empirical through to the new and radical. Things previously thought immeasurable were measured, positioned and classified. Hypnosis, mesmerism, hallucination and other strategies positioned science close to religion, and put both near to magic. F. Castelot Jollivet, writing in *La Plume*, asserted that, 'magic is by no means, as is widely believed by outsiders, the negation of science. On the contrary, magic is science'.[4] For a period of years, psychoanalysis and the seance were seen by many as part of the same world.

A constant theme at the heart of these psychological, spiritual and, indeed, sexual studies, was the role of the individual in the world. Inevitably this had a political dimension. The forces of capital, the collective machinery of science, economy and politics, were openly opposed by deliberately non-material, anti-rational idealists. The self was perceived to be a fragile phenomenon; the motive behind much of the new activity was to combat spiritual alienation and to give an objective role to subjective consciousness. Utopian and universalist ideas on the nature of ideal community were common among artists, writers and designers, who often gave a material dimension to their idealism by becoming involved in political life. Socialism and communism steadily developed through the period as forces to be reckoned with, and both were embraced by a significant number of thinkers and practitioners within the Art Nouveau camp – often influenced by William Morris (a famous early artistic convert to the cause) – who geared their production toward those ends. Much of the Art Nouveau architecture and design produced in Belgium, for example, had socialist motivation. More than having a practical political agenda, however, the movements within Art Nouveau tended to be more idealist and abstract.

In this regard, the rise of Anarchism as a political force in the 1890s is relevant. With its rejection of any form of institutionalized authority and its positioning of the individual at the centre of a localized, communal life, Anarchism appealed to many within radical circles in the visual arts. Coupled with the universalism of spiritualism, it can be recognized within the writings of many Art Nouveau thinkers. Political thought could be poetically translated into a quasi-religious creed, with absolute, universal individual creativity at its core. In keeping with the time, the spirit was millennial.

Spiritualism entered into the arts in the first instance through literature and painting, and Paris played the dominant role in bringing it to the fore as a force in *fin-de-siècle* Europe. The worlds of writing and painting became intimately intertwined, as a spate of new magazines and newspaper columns brought the two together. *La Revue indépendante* (founded in 1884), *La Vogue* (1886), *La Plume* (1888) and *La Revue blanche* (1889), for example, were substantial regular publications with a commitment to modern art in general and Symbolism in particular. Smaller, more partisan publications included *Le Symboliste* (1884), *Le Décadent* (1884), *La Revue Wagnérienne* (1885) and *Le Moderniste* (1889). These interacted with magazines of a similar spirit all over Europe, and so provided vital lines of communication for advanced artistic thought. *The Dial* (1889) and *Yellow Book* (1894) in England, *L'Art moderne* (1881) and *Le Sillon* (1893) in Belgium, and *Pan* (1895) and *Die Jugend* (1896) in Germany regularly covered Symbolist activity in other countries.

4.2 Paul Gauguin, *The Vision after the Sermon: Jacob Wrestling with the Angel*. Oil on canvas. French, 1888. National Gallery of Scotland.

woman, or whatever anecdote, a painting is essentially a flat surface covered with colours assembled in a certain order', was intended to stress not simply the importance of formal values, but also the role of the imagination and the non-visible, mythic life in the creative act.[5] The Nabis were powerfully mystical, their religious vision casting the artist into the role of spiritual leader, a producer of profound decoration that might convert a materially driven society into better ways. Much of the outlook of the Nabis was borrowed from an older generation. The dreamlike visions of Odilon Redon, for example, were important to most of them. However, it was Paul Gauguin who provided them emphatically with a template for their practice.

The seminal event in the formation of the Nabis' consciousness was the meeting between Gauguin and Sérusier in Brittany in 1888, when the former gave the latter a lesson in what he had come to term the Synthetist sensibility. Sérusier painted a small study on a wooden panel directly under Gauguin's tutelage, which, on his return to Paris, he used to explain the abstracted and mystical approach to nature used by the older artist. The panel became known as *The Talisman*, and is the signature painting of the Nabis movement (plate 4.1).

Gauguin was the most important Symbolist artist in *fin-de-siècle* Europe and, for Art Nouveau, the single most influential painter. His mature style provided Art Nouveau designers, both directly and via the Nabis, with a significant part of their aesthetic and symbolic weaponry. Perhaps more than any other artist during the period, Gauguin consciously fused the aesthetic means of expression, whether it be paint, wood or clay, with the subject-matter of the work. For him, the way it was made was part of what it meant. In *The Vision after the Sermon: Jacob Wrestling with the Angel* of 1888 (plate 4.2), for example, the dour spirituality of the Breton peasants – momentarily excited by the vision they see before them – is expressed through the intense red of the landscape. Similarly in his self-portrait of 1889, the colour is part of the symbolism (plate 4.3). This process of abstracting forms down to essentials intensifies the meaning and, for Gauguin, allows the painting to tap universally shared ideas. The universalism of *fin-de-siècle* spiritual thinking powerfully affected Gauguin in his striving towards a unity that would allow the materiality of the art object (its appearance and the stuff it was made from) to commune with the spirituality of the ideas conveyed. The same unity of material and meaning is demonstrated by Denis in his *The Road to Calvary* of 1889 (plate 4.4). The abstracted forms and suffocatingly dark palette are the vehicles through which the inexplicable

The rich social life of literary clubs such as *Les Hydropathes* (founded in 1878) and *Le Chat noir* (1881), together with café culture, provided centres for debate and comradeship. A generation of novelists, poets, editors, critical theorists and reviewers used these vehicles to legitimize the Symbolist cause and, most significantly, to spread it beyond literature into the other arts. These included the novelist and reviewer Joris-Karl Huysmans; Jean Moréas, author of the Symbolist manifesto of 1886; the poet Paul Verlaine; Stéphane Mallarmé, poet and host of a famous weekly Salon; Édouard Dujardin, editor of *La Revue indépendante*; the critic and art theorist Gustave Kahn; and Léon Deschamps, the founder and editor of *La Plume*.

In this milieu, Symbolist painting came to fruition. The most productive and articulate Symbolist group was the Nabis, an idealistic brotherhood formed at the end of 1888. Led by Paul Sérusier and Maurice Denis, with passionate support from the brilliant critic Albert Aurier, the group also included in its ranks Paul Ranson, Pierre Bonnard, Édouard Vuillard, the Hungarian József Rippl-Rónai and the Swiss Félix Vallotton. The work of the Nabis was premised on an intense formalism that aimed to free the imagination to pursue spiritual perfection. The typical Nabis artist would reorganize observed reality into flat, free-form planes of strong colour, intended to convey a heightened, idealized impression of the world. Denis' famous maxim 'that before it is a war-horse, a nude

brutality and tragedy of the scene are conveyed. More than Sérusier, Denis or, indeed, Gauguin himself, Paul Ranson pushed on from Naturalism to the point where his landscape visions owe virtually nothing to observation. His *Nabi Landscape* of 1890, with its cabalistic signs and occultist references described through organic interlocking forms and intense, synthetic colour, anticipated an

approach to representational art that would not become a commonplace for another generation (plate 4.5).

Gauguin and the Nabis did not simply break down barriers between subject and object in the practice of art, they also posited the idea that art was, in itself, no more than profound decoration. Art would achieve its spiritual goal, they believed, through the all-embracing medium of decoration. Gauguin's spectacular achievements in woodcarving, ceramics and printmaking set a powerful precedent for those who believed the decorative and graphic arts to be a vehicle for poetic expression. By aggressively pushing the idea that art was not media-bound, but was an idea, a non-physical concept that could be seen in any kind of object, they provided valuable support to the notion of *Gesamtkunstwerk* embraced by Art Nouveau designers.

The Nabis were not the only spiritually inspired painters in Paris. In 1892, an exhibition, entitled *Salon de la Rose+Croix*, was staged at the gallery of the dealer Durand-Ruel. Surviving until 1897, the Salon was largely

4.3 Paul Gauguin, *Self portrait*.
Oil on wood. French, 1889.
National Gallery of Art,
Washington, Chester Dale
Collection. Photo: Jose A. Navarjo

4.4 Maurice Denis,
The Road to Calvary.
Oil on canvas. French, 1889.
Musée d'Orsay, Paris.
© Photo: RMN-Béatrice Hatala.

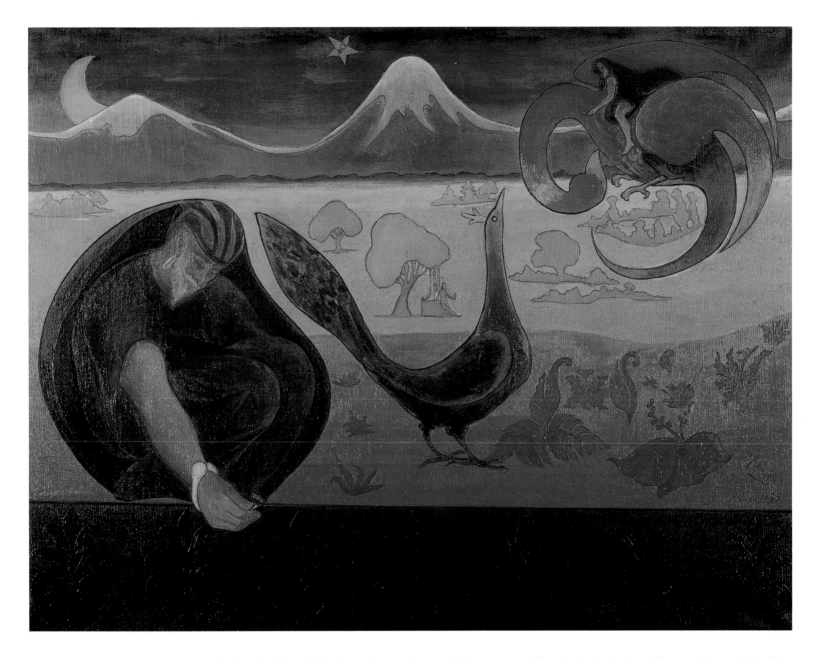

4.5 Paul Ranson, *Nabi Landscape*. Oil on canvas. French, 1890. Private Collection.

organized and selected by the writer and mystic Sâr Joséphin Péladan and represented a wide range of symbolist activity as it stood at the time. Péladan was committed to the revival of Rosicrucianism, a religious sect boasting a lineage back to the Renaissance. Under Péladan, the Salons of the Rose+Croix, in contrast to the Nabis, had no single, unifying agenda, but were surveys of the mystical, alchemaic and the occult as they impinged upon modern visual culture.

Péladan had high aims for the group: 'The Rose+Croix will be, perhaps, the saintly ark in which there will be a refuge for the Abstract and the Beautiful.'[6] He was a passionate follower of the English Romantics and considered himself a key figure in their introduction to France. He especially admired the languid mysticism of the Pre-Raphaelites and the anti-materialist stance of Ruskin: 'If Paris has seen a tentative aesthetic revival, similar to the Pre-Raphaelite movement of Ruskin, Rossetti, Burne-Jones, Watts – in spite of intrusive paintings exhibited through treason – the honour is due to the Rose+Croix.'[7] Indeed, much of the art associated with the Rose+Croix, as demonstrated by the poster for the first Salon, by Carlos Schwabe, was indebted to Pre-Raphaelitism (plate 4.6). Other influences included the heavy mythologizing of Gustave Moreau (plate 7.9), the mysterious Classicism of Puvis de Chavannes and the illustrative Symbolism of Odilon Redon. If Gauguin was the patron saint of the Nabis, then Redon held the same position for the

4.6 Carlos Schwabe, poster
for the first Rose+Croix Salon.
Colour lithograph. French, 1892.
V&A: E.291–1921.

4.7 Odilon Redon,
Portrait of Gauguin. Oil on canvas.
French, 1903–05.
Musée d'Orsay, Paris.
© Photo: RMN-Jean Schormans.

4.8 Georges Seurat, *Young Woman
Powdering Herself*. Oil on canvas.
French, *c*.1889–90.
The Courtauld Institute Galleries,
London.

Rose+Croix. In his work, literary Symbolism joined the occult in order to provide artists and designers with disturbing and dreamlike imagery (plate 4.7). The artists of the Rose+Croix plundered many religions in order to form their individual, subjective world views, this religious plurality being epitomized by the writings of Péladan himself. High morality, religious fervour, sexual desire, horror, awe and joy were interchangeable expressions of the spiritual self. In the hands of Rose+Croix artists such as Alphonse Osbert or Alexandre Séon, the Virgin and Aphrodite

might fuse or ancient deities might take on a modern form to petrify the bourgeoisie in their urban dwellings.

Nowhere in the world of painting did the apparently contrary forces of rational science and mysticism come together more fully than in the Pointillist movement. Invented largely by Georges Seurat, Pointillism, neo-Impressionism or Divisionism, as it was variously known, subjected Impressionism to an array of colour and compositional theory in order to systematize and advance its status as a truly modern art. After the early death of

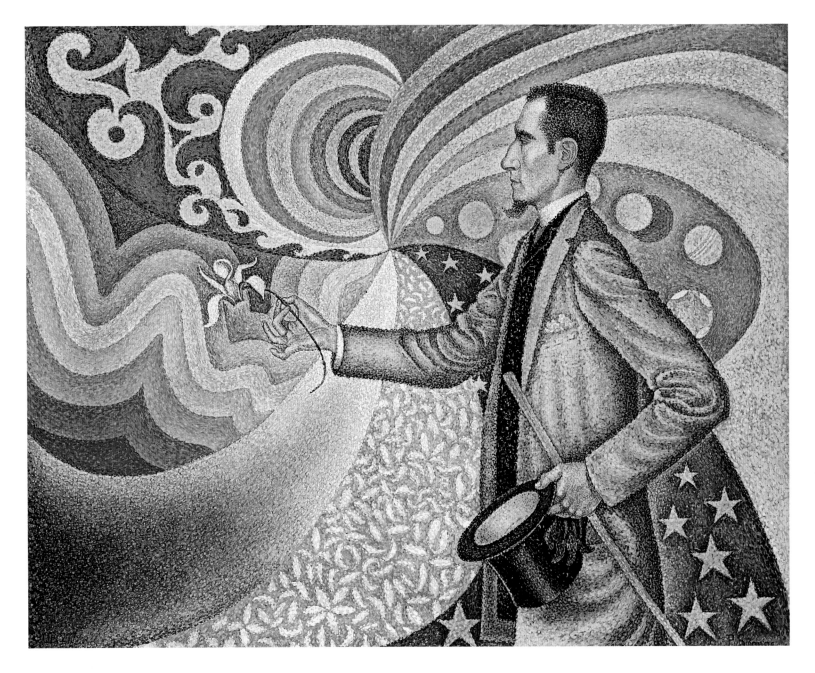

4.9 Paul Signac, *Portrait of Félix Fénéon*. Oil on canvas. French, 1890.
Private Collection, New York.
Photo: Malcolm Varon, 1999.
© ADAGP, Paris and DACS, London 2000.

Seurat, the Pointillist cause was principally advanced by Paul Signac, and became a potent force in Holland, Belgium, Italy and the Nordic countries.

The stylization of nature by the Pointillists into a freckled, gestural geometry of dots, arabesques and planes – a deliberate creation of artifice from natural form while carefully preserving the evidence of nature, frozen and controlled – had a strong influence on Art Nouveau designers. The curves and bends in the work of Seurat and Signac anticipate much of the stylization to come. Seurat's *Young Woman Powdering Herself* (plate 4.8) offers us an intensely urban scene, with nature re-presented to the viewer through the artificial control of modern art. Signac's portrait of the

critic Félix Fénéon pushes the idea of artifice to the extreme, the critic posing amid a kaleidoscope of line and colour (plate 4.9). More important for Art Nouveau than the actual appearance of Pointillist paintings, however, was the *idea* of Pointillism. In a simple and direct sense, Pointillism could be regarded as the intervention of science to achieve progress in art. Indeed, Signac enthusiastically published his Chromatic Circle (a device that allowed a mass public to understand Pointillist colour theory and so improve their aesthetic surroundings), allowing Pointillist ideas to enter into the wider world of design.

However, science as a disinterestedly objective activity was only one aspect of the movement. The motivation

behind the Chromatic Circle (and indeed the whole of the Pointillists' pursuit of scientific objectification) was to tie individual artistic expression – the self – to the outside world. Science was a bridge over which the individual could travel to meet his or her audience. There had been informal connections to spiritualism from the outset (Seurat had had friendships within the Symbolist group), but as the movement developed into the 1890s, a significant number of the Pointillists consciously positioned Anarchism and spiritualism alongside science. Paul Signac, Félix Fénéon, Gustave Kahn and others within the French camp embraced Anarchist ends during the 1890s, without actually committing themselves to Anarchist means, in the

4.10 Jan Toorop, *The Three Brides*. Chalk on paper. Dutch, 1893. Collection Kröller-Müller Museum, Otterlo, The Netherlands.

belief that, properly constructed, art was capable of liberating humankind. It was to become, for them, a weapon in the war to transform universal consciousness.

The concept of art taking on a quasi-political role by fusing the scientific with the spiritual was fed into Art Nouveau by artists and designers who had practised as, or been associated with, Symbolists and Pointillists. Indeed, some artists went through both before arriving at Art Nouveau. For example, Gaetano Previati in Italy, Henry van de Velde and Willy Finch in Belgium (and later in the Nordic countries), and Jan Toorop in Holland were all Pointillists and Symbolists before becoming central figures in Art Nouveau. Of these, perhaps Toorop was the mystic Art Nou-

veau designer *par excellence*. He became a theosophist and used his art as a symbolic expression of his religion. He was part of a milieu that came to inform Piet Mondrian, Theo van Doesburg and other members of the Dutch De Stijl movement, many of whom maintained a balance between theosophy, science and what might be termed 'mystical Anarchism' (plate 4.10).

If Symbolism derived much of its character from Paris, its full development as an international phenomenon and as a major influence on Art Nouveau owed much to the artistic milieu in Brussels. Innovative art activity in Belgium after 1880 was deeply indebted to Octave Maus, with the journal *L'Art moderne* (1881), and the Salons of the *Société des Vingt* (founded in 1884) and *La Libre esthétique* (from 1894) (see chapter one). Apart from being a key forum for Belgian practice, they were also vital for the growth of an internationally based modern art and design. The list of exhibitors, extraordinary for its eclecticism and quality, reveals the extent to which Naturalism and Symbolism were often bedfellows. Exhibitors included the Belgians James Ensor, Charles van der Stappen, Fernand Khnopff, Félicien Rops, Gustave Serrurier-Bovy, Constantin Meunier and Henry van de Velde. A dazzling international array of foreign exhibitors made up the balance, including James McNeill Whistler, Claude Monet, Auguste Rodin, Ford Madox Brown, Philip Wilson Steer, Vincent van Gogh, Paul Cézanne, Georges Seurat, Paul Signac, William Morris, C.R. Ashbee, Paul Gauguin, Maurice Denis, Émile Bernard, Alexandre Charpentier and Jan Toorop. Thus, Brussels provided an international melting pot that facilitated the formulation of the Art Nouveau style.

Perhaps the most prominent area of human experience to receive attention from this mélange of eclectic study, mystical and political belief was sexuality. Sexuality occupied a complex and problematic position within the Victorian moral landscape. Strict moral codes of behaviour were eroded as groups acquired specific identities in the period; feminists, homosexuals and Decadents were openly perceived as threats to prevailing normative values. There were many kinds of sex, and they affected a wide range of human activity. The portrayal of the period as one of unparalleled sexual licence and decadent extravagance was largely dependent on the notoriety of a number of figures in the close-knit and incestuous world of the arts. From Oscar Wilde's tragically exposed activities to the tortuous relationship of Paul Verlaine and Arthur Rimbaud, or the flamboyant figure of Robert de Montesquiou

(inspiration for both Des Esseintes, the hero in *A Rebours* and Baron de Charlus in Proust's *A la recherche du temps perdu*), individuality was an artistic credo which inevitably impinged on sexuality.

As a powerful emotional determinant at the heart of the psyche, sex was a key subject of psychological and spiritual investigation. It was a potent universal force capable of subverting and transforming life, a staple of all societies; it forced recognition of terrifying desires, it refused to acknowledge rank, status or intelligence and it demanded constant satisfaction. Hung irretrievably between the physical and psychic realms, it constituted the unbreakable link between the sacred and the profane.

Fraught with sexual tension, it was Paris that came to signify the sexual nexus of Europe, particularly in those sites that traded on the body – such as the theatre, cabaret, ballet and the café concert. As the de Goncourt brothers observed of the theatre:

> From the stage to the auditorium, from the wings to the
> stage, from the auditorium to the stage and from one side
> of the auditorium to the other, invisible threads criss-cross
> between dancers' legs, actresses' smiles, and Spectators'
> opera glasses, presenting an overall picture of Pleasure,
> Orgy and Intrigue. It would be impossible to gather
> together in a smaller space a greater number of sexual
> stimulants, of invitations to copulation.[8]

The theatre had always been a place of sexual permissiveness and availability, but as consumption patterns changed towards the end of the century so did the way sex was procured and consumed. The street became a place of sexual ambiguity. An increasingly visible female working population employed in the expanding retail trades became disturbingly indistinguishable from the prostitutes who had moved their activity to the new commercial centres of the city. Henry James, reporting for the *New York Tribune*, saw Paris as 'a vast fancy bazaar, a huge city of shop fronts'. When he wrote: 'the Ladies week after week, are treading the devious ways of the great shops – the Bon Marché, the Louvre, the Compagnie Lyonnaise; the gentlemen are treading other ways … ', he simultaneously referenced the 'suspect' morality of the new consumer culture for women and an alternative consumable city, existing beneath the surface, for men.[9]

This ambiguous position of women in society was not only located in their physical availability, but also in their changing social status. The growing urgency of the suffrage movement and the formation in the public consciousness of the *Femme Nouvelle* (New Woman), spawned increasingly divergent attitudes towards women that were articulated in all forms of literary and visual culture. Women increasingly began to free themselves of the home and enter the world of work. The blurring of traditional boundaries delineating male and female spheres – public and private, professional and domestic – created male anxieties that were exacerbated by feminist reform legislation. In France women's right to divorce was re-established in 1884; and the Paris *Exposition Universelle* of 1889 saw the first International Congress on Women's Rights. An increasing number of women's organizations and feminist publications were established between 1889 and 1900.

An article in the literary journal *La Plume* of 1895, entitled 'Le Féminisme et le bon sens', expressed the views of many, attacking the *Femme Nouvelle* and reducing the debate to the familiar and well-worn gender paradigm of nature versus intellect: 'A woman exists only through her ovaries.'[10] The positioning of women within the irrational and instinctive realm of nature, and men in the cerebral and intellectual sphere of culture, took on particular resonance in much *fin-de-siècle* imagery. As chapter three revealed, Naturalist decoration, through the process of metamorphosis, provided a rich area for the depiction of women. The device was both literal and metaphoric. Many Art Nouveau objects and images personified nature as woman, Mucha's *panneaux* series of *The Four Flowers* (1897) and *The Four Seasons* (1900) exemplify a widespread

4.12 René Lalique, *Dragonfly Woman*, corsage ornament. Gold, enamel, chrysoprase, moonstones and diamonds. French, *c*.1897–98. Calouste Gulbenkian Museum, Lisbon.

4.11 Artus Van Briggle, 'Lorelei'. Earthenware vase. American, 1898. Made at Rookwood Pottery. V&A: C.60–1973.

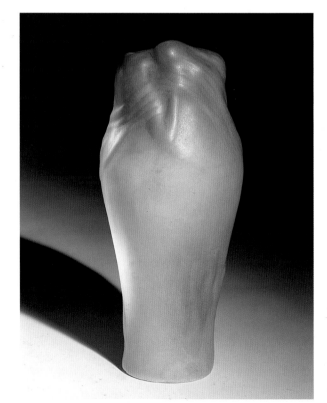

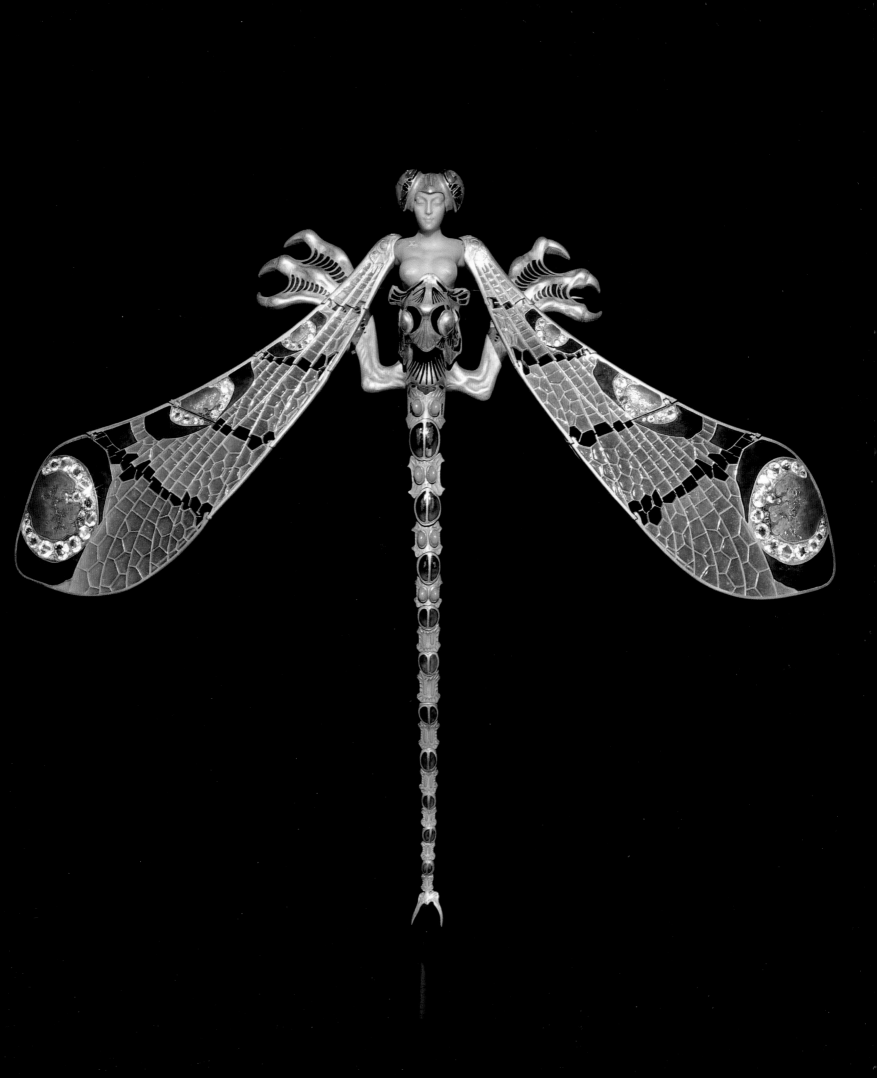

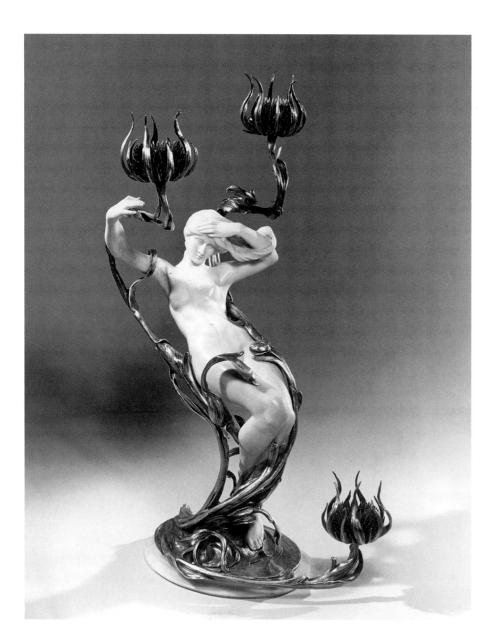

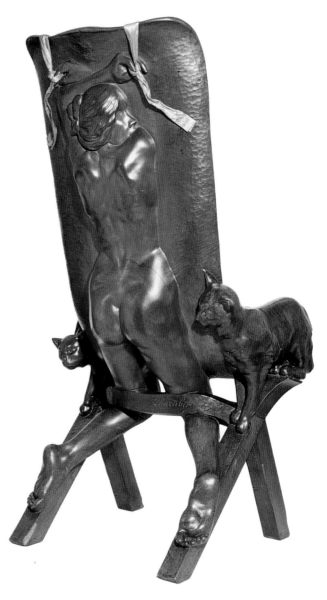

suggests ritual. Overtly erotic, its play with the physical restraint of the body (both the body of the sculpted woman which metamorphoses into the body of the chair and the body of the user positioned within the chair) demands an engagement with the physicality of the object (plate 4.14). At a time when women were redefining themselves psychologically, physically and socially, through changes in dress, home, work and by entering into the world of the professions, Carabin's vision of erotic subjugation is powerfully disturbing. Inevitably, he exhibited with the openly misogynist Rose+Croix Salon.

In much of the imagery of the period, nature becomes the site for erotic or sexual exchange. Georges De Feure's images of degenerate women take up the Baudelairean theme of women as the incarnation of evil (plate 4.15). His predatory lesbians are often placed within the unrestrain-

4.13 Frans Hoosemans, candelabra. Silver and ivory. Belgian, c.1900. Staadliche Museen zu Berlin – Preussischer Kulturbesitz Kunstgewerbemuseum. Photo: Elsa Postel.

4.14 Rupert Carabin, armchair. Walnut. French, 1896. Private Collection.

device, while many artists used metamorphic forms to suggest woman's conflation with nature. American potter Artus Van Briggle not only suggested woman evolving from some primordial matter, but also evoked female genital forms – he literally made woman into vessel (plate 4.11). René Lalique disturbingly conflates woman and insect, while the Belgian designer Frans Hoosemans typically entangled women in a writhing mass of searching stems (plates 4.12 and 4.13).

Often these metamorphic forms were distinctly pantheistic (see chapter three) and promoted a 'cult of the material'. Rupert Carabin, one of the most brilliant sculptors in wood of the period, wrote: 'Wood is the most admirable material that nature gave man. And to keep the cult of the material, there must be priests.'[11] His chair of 1896

4.15 Georges De Feure,
L'esprit du mal. Gouache on paper.
French, 1897–98.
Collection Victor Arwas, London.

4.16 Edvard Munch, *The Vampire*.
Oil on canvas. Norwegian, 1893.
© Munch Museum, Oslo /
Munch-Ellingson Group / DACS
2000. Photo: © Munch Museum
(Svein Andersen / Sidsel de Jong)
2000.

able realm of nature, Eden after the fall. His contemporary Octave Uzanne wrote of his work:

> Woman of a thousand curves, a thousand fascinations, consumed by a selfish love, given to all excesses, the trunk when all the vices spring, the source of all the ills, the soul of every forbidden delight. He sees in these sirens nothing but demons whose mission it is, as St Augustine thought, to increase sin and degrade all vigorous thought. … . Man bearing his cross under the maleficent influence of Woman, perverse, distracting, unconscious.[12]

Much of the debate surrounding the *Femme Nouvelle* centred on her unnatural masculine activities, from wearing trousers and riding bicycles to being sexually avaricious. Anxieties over this proactive female were expressed in a 'veritable iconography of misogyny'.[13] The theme of the libidinous and dangerous *femme fatale* was perhaps most clearly expressed, by the 1890s, in the increasingly prevalent vampire imagery in stories, poems and paintings.[14] A significant development was the 'vampiress': Loïe Fuller metamorphosed on stage from bat to woman, Sarah Bernhardt modelled herself as half bat, and Edvard Munch

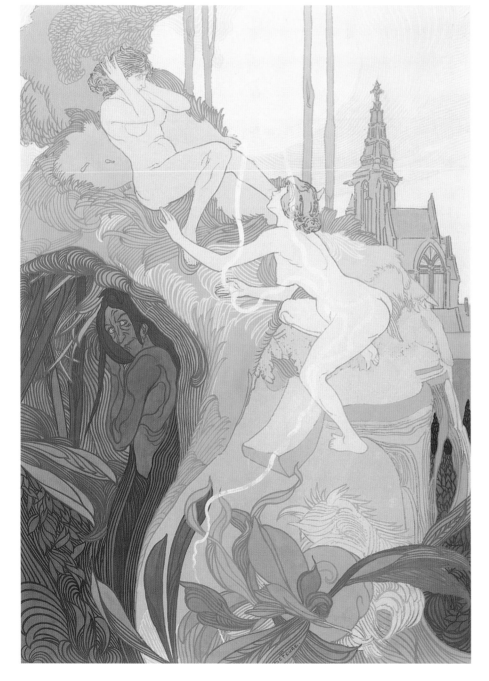

produced a series of paintings and lithographs of the female vampire (plate 4.16). Perhaps the most explicit link between the vampire phenomenon and female sexuality was made in Bram Stoker's *Dracula*, in which the coquettish Lucy Westenra predictably becomes a vampiress, and, in a scene that echoes the wider genre of popular erotic literature of the period, Jonathan Harker, the young lawyer, is seduced by three female vampires.

The vampiress, like the prostitute, signified dangerous female sexuality through her degenerate and infected body. At a time when 'syphilis became an obsessive public crisis',[15] much artistic imagery was based on corruption and disease. Félicien Rops' *Mors Syphilitica* (*c*.1892) explicitly personified the disease as a woman, and Munch's *Madonna* of 1895 suggested degeneration and the dire reproductive consequences of disease with the inclusion of a deformed foetus (plate 4.17). Significantly, the language used to describe Art Nouveau, especially as it drifted out of fashion in the new century, often used the metaphor of disease. It was described as a 'foreign contagion', displaying the 'symptoms of mental disease'.[16] It was attacked as being 'distinctly unhealthy and revolting', and it was

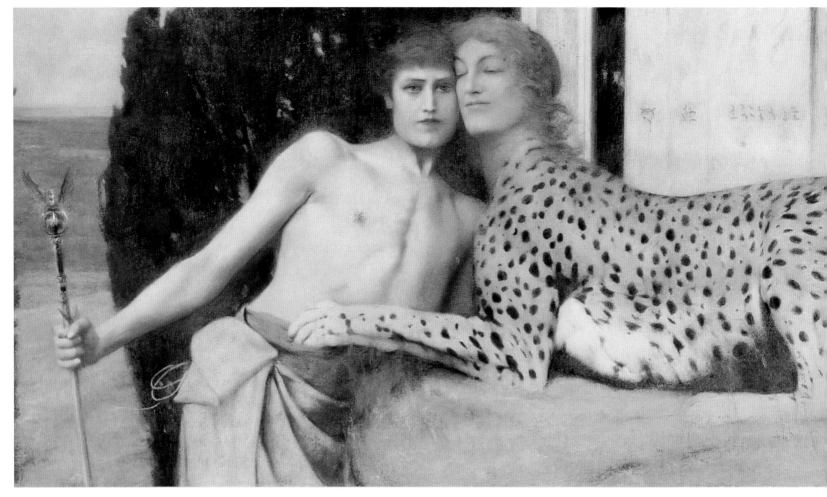

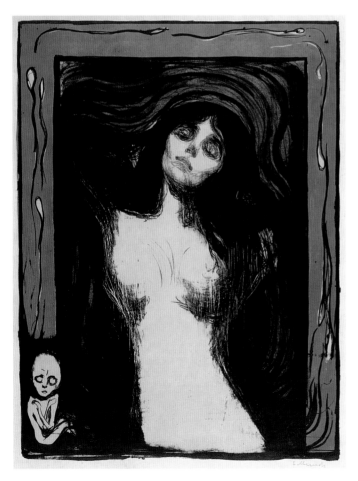

4.17 Edvard Munch, *Madonna*. Colour lithograph and woodcut. Norwegian, 1895. National Gallery of Art, Washington: The Sarah G. and Lionel C. Epstein Collection.

feared that it had come to stay like 'influenza and other unpleasant things'.[17]

Images of women were often mediated via the East. It was an exotic and hedonist realm where women became fantasy creatures, de-clawed and subsumed into alternative religions and practices: the Sphinx, part woman part animal (plate 4.18); Salammbo, the unobtainable high priestess; and Salome, the biblical temptress. Fix-Masseau's adolescent priestess is both chaste and erotic, the box she holds suggesting a ritual that is simultaneously antique and exotic; Pandora's mystery conveyed through the medium of ivory (plate 4.19). For both Fix-Masseau's figure and Charles van der Stappen's *Sphinx mystérieux* (plate 16.7), speech is denied. Gestures of submission, such as the erotic veiling of the mouth or downcast eyes, denote a realm of masculine dominance.

Two of the most popular *femme fatales* were Medusa and Salome, linked through the destructive power of the gaze. Medusa's stare was the most brutal. In Giovanni Buffa's stained-glass roundel, blood pours from the Medusa head to create a viscous sea (plate 4.20). Lévy-Dhurmer's *Méduse* of 1897 (plate 4.21) engages the viewer in a hypnotic gaze. Salome's fatally seductive power derives from her ability to hold men's gaze, as Wilde made explicit in his play *Salome* of 1891: 'You look at her too much. It is

4.19 Félix Fix-Masseau,
The Secret. Ivory and mahogany.
French, 1894.
Musée d'Orsay, Paris.
© Photo: RMN-Jean Schormans.

4.21 Lucien Lévy-Dhurmer,
Méduse or *The Angry Wave.*
Pastel and charcoal on paper.
French, 1897.
Musée d'Orsay, Paris.
© Photo: RMN-Gérard Blot.

4.18 Fernand Khnopff, *Des Caresses.*
Oil on canvas. Belgian, 1896.
Musées Royaux des Beaux-Arts,
Brussels.

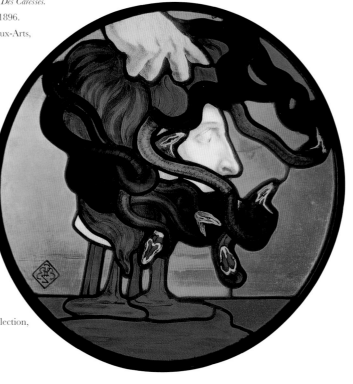

4.20 Giovanni
Buffa, *Medusa.*
Painted stained glass
and painted panel.
Italian, 1901.
Mitchell Wolfson Jr. Collection,
Genoa, Italy.

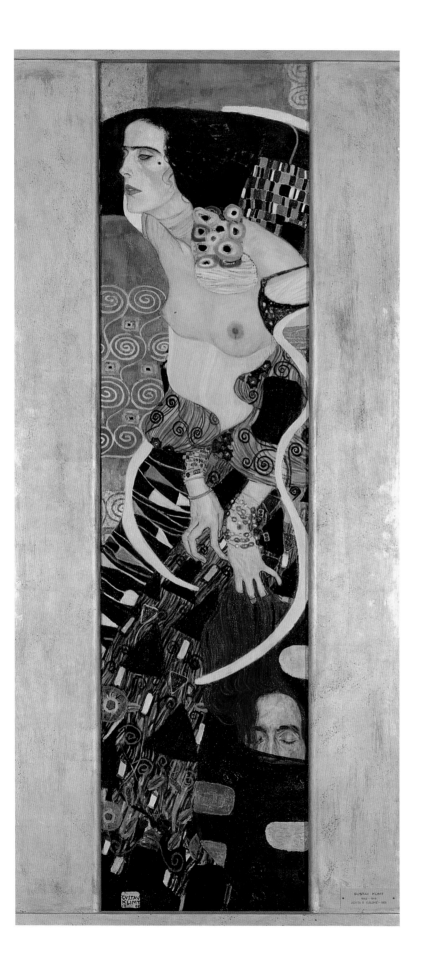

4.22 Gustav Klimt, *Judith II*
(Salome). Oil on canvas.
Austrian, 1909.
Galleria Internationale d'arte
Moderna di Ca'Pesaro, Venice.
Photo: Osvaldo Böhm.

dangerous to look at people in such fashion. Something terrible may happen.'[18] In Beardsley's depiction of his work, Salome stares into the dead eyes of the severed head of Iokanaan, as mannered arabesques of blood gather in a pool below (plate 1.9). The popularity of Salome as a subject can perhaps be explained by its fusion of many of the recurrent themes of the period – dance, desire, death, dismemberment, the Christian, the pagan, the East, and the ultimate *femme fatale*, both virgin and dominatrix. Many artists and writers depicted Salome, including Gustave Moreau (plate 7.9), Franz von Stuck, Gustav Klimt (plate 4.22), Richard Strauss, Mallarmé and, perhaps most memorably, Huysmans: 'She has become, as it were the symbolic incarnation of undying Lust, the Goddess of immortal Hysteria, the accursed Beauty exalted above all other beauties by the catalepsy that hardens her flesh and steels her muscles, the monstrous Beast, indifferent, irresponsible, insensible, poisoning …'.[19]

Huysmans' Salome personifies the worst fears of men over modern women. She is both libidinous and the embodiment of Hysteria, a recently identified condition pertaining principally to women. Eugène Grasset's lithograph *Morphinomane* of 1897 (plate 4.23), one of the most shocking examples of the turn-of-the-century fascination with morphine and opium addiction, clearly depicts not only the physical act of injection, but also the altered mental state of the addict. Octave Uzanne commented that Grasset 'recognizes the element of terror in the phantasmagoria of hallucination; and imparts a *frisson nouveau* into compositions of this kind'.[20] Grasset's image of morphine addiction is explicit, but references to drug-induced changes in consciousness were more usually symbolic. The opium poppy appeared in many Art Nouveau objects and images, as a symbol of sleep and dream.

The nascent fields of psychology and sexology can be seen as empirically based attempts to describe, codify and control sexuality and behavioural systems. Sigmund

4.23 Eugène Grasset, *La Morphinomane*. Colour lithograph. French, 1897. V&A: E.1094–1963.

Many of the artists who exhibited with the Rose+Croix were influenced by Charcot's work, including Osbert, Séon and Schwabe, while Émile Gallé was aware of Bernheim and Charcot's work.[21]

Richard von Krafft-Ebing's *Psychopathia Sexualis* (1876) catalogued erotic deviance and spawned widespread interest in the nature of sexuality and scientific explanations of sexual behaviour. As one historian recently observed, 'the burgeoning new science of sexology created a demand for new forms of venality'.[22] Alongside these developments in the 1890s there was an explosion of pornographic photography and literature which inevitably resulted in this imagery moving into mainstream culture. Publishers such as Charles Carrington catered for the growing demand for erotica with titles such as *Birch in the Boudoir*. Octave Uzanne, among his other activities, was a sociologist of prostitution. In conjunction with the photograph, Japanese prints provided one of the most important visual sources for erotic imagery, consumption being shrouded in the respectability of established connoisseurship. Edmond de Goncourt's book, *Outamaro: Le peintre des maisons vertes* (1891), makes reference in the title to Utamaro's position as the artist of brothel scenes. He produced 34 erotic illustrated books and albums, and a number of artists, including Beardsley, are known to have owned prints (plate 6.5).

Although the female form dominated the sexual vocabulary of Art Nouveau, some artists and designers also experimented with phallic imagery. In many works involving extreme organicism, for example, the phallus is a sublimated presence. Hector Guimard's gate posts on the Castel Béranger (1894–98), the columns on his École du Sacré Coeur (1895) and much of his street furniture contain overtly phallic imagery (plate 4.24). However, it is in print media that phallic imagery is found most commonly. Although Beardsley's illustrations for *Lysistrata* were the most explicitly erotic images of his career, a pervasive strain of sexual ambiguity runs throughout his work. The English decadent writer Arthur Symons underscored the ambiguous morality of Beardsley's art when he wrote:

> In more ways than one do men sacrifice to the rebellious
> angels, says St Augustine; and Beardsley's sacrifice,
> together with that of all great decadent art, the art of Rops
> or the art of Baudelaire, is really a sacrifice to the eternal
> beauty, and only seemingly to the powers of evil … Here,
> then, we have a sort of abstract spiritual corruption,
> revealed in beautiful form: sin transfigured by beauty.[23]

In the work of Félicien Rops, phallic imagery was invariably tied to his obsessive interest in Satanism and prominently displayed in the context of deviant sexual scenes. In

Freud's first major works, published initially in German from 1893, did not gain general currency until well into the new century. Rather, it was the work of Hippolyte Bernheim and Jean-Martin Charcot in France, Richard von Krafft-Ebing in Austria, and Havelock Ellis in Britain that dominated debates. Although Freud had published a paper on male hysteria in 1886, it was Charcot's work on female hysteria that was influential for artists and designers. His appeal lay in his methods of investigation and documentation. Photography used to document the different states of hysteria provided a powerful visual reference for artists, and hypnotism (his method of inducing hysteria) was an ancient practice legitimized and made modern.

impetus for homosexual groups to organize, with journals such as the German homophile *Die Eigene* (established in 1898). By bringing the reality of homosexuality into the public sphere, scandal also made many consciously ambiguous images and objects of Art Nouveau explicit in their decadence.

The realm of Symbolism was centrally concerned with the tension between metaphysical and material experience and, as a corollary to this, with the impact of individual subjective consciousness on society as a whole. The predominance of imagery concerned with sexuality and altered states of consciousness, areas which fuse the physical and the psychic, attests to the power of this *fin-de-siècle* dialectic. The defining tensions within Symbolism also became those of the various schools of thought within the Art Nouveau style. Art Nouveau practitioners, following the logic of the Nabis, took the idea of decoration and pushed it to the point at which it became a vehicle for communal spiritual expression. Thus, via Symbolism, ornamentation became as much a secular religion as a means of changing the look of things.

4.24 Hector Guimard, École du Sacré Coeur, Paris. French 1895. Photo: Roger-Viollet, Paris.

his illustrations for *The Satanic Ones* (plate 4.25) he created what has been described as 'one of the most obscene mythologies in all Symbolism'.[24] Beardsley's work was equally subversive although not nearly as obscene, and his subsequent, respectable positioning as a satirist by critics masks the importance of sexual identity in his work.

Beardsley's androgynous youths are liminal figures, neither adult nor child, male nor female. Androgyny provides a vehicle free from restrictive gender and behaviour codes, allowing different, disturbing and radical messages to be conveyed – from Fred Holland Day's homoerotic photographs of beautiful youths to Khnopff's masculine women or the effete Christ (plate 4.26) of Jeanne Jacquemin (significantly a female Symbolist closely associated with the Rose+Croix Salon).[25] It is unsurprising that Victor Jozé in his attack in *La Plume* on the *Femme Nouvelle* commanded: 'Let there be no ... androgynes!' The homosexual, like the *Femme Nouvelle* or the androgyne, was also perceived as a threat. As historian Richard Dellamora points out 'scandals provide a point at which gender roles are publicly, even, spectacularly encoded and enforced';[26] and the scandals of the 1890s, particularly the trials of Oscar Wilde, did much to consolidate public attitudes to male sexuality. On the one hand, they fired homophobic prejudice, on the other they provided the

4.25 Félicien Rops, *The Abduction* from *The Satanic Ones*. Watercolour on paper. French, *c.*1880. Collection Victor Arwas, London.

4.26 Jeanne Jacquemin,
*La Douloureuse et glorieuse
couronne.* Pastel. French,
1892. Collection Lucile
Audouy, Paris.

Philippe Hamon

The Literary Heritage

All is rotten, all is finished, Decadence is cracking and shaking the Latin foundations … .
Wretched Modernists, your journey into the void is fatal … .You might close down
the Church, but the Museum? The Louvre will rule, if ever Notre-Dame be destroyed.
The artist's noble enthusiasm outlives yesterday's faded piety. (Sâr Joséphin Péladan, Preface To
The *Salon de la Rose+Croix* Catalogue, 1892)

5.1 Carlos Schwabe, cover design for *Le Rêve* by Émile Zola. Pen, ink, watercolour gouache and gold on cardboard. French, 1892. Musée du Louvre, Département des Arts Graphiques, fonds du Musée d'Orsay, Paris. © Photo: RMN-Arnandet.

The primary function of literature is not to create 'fictions' or to invite you to dream but to suggest, in close relationship with the other arts, possible worlds and scenarios for a particular society at a given moment in its history. Such scenarios either reinforce and clarify the dominant cultural trends of the period (this is the consensual, legitimizing and identity-giving function of literature), or they question such trends by proposing 'new' scenarios and new possible worlds (the Utopian, alternative and questioning function of literature). Although it is certainly the innovatory Art Nouveau element that appears to characterize the 1885 to 1900 period of French decadence, the reality is that literary development during this period was far from uniform. In fact, instead of schools of thought following on from, or replacing each other, they tended to co-exist as, for example, did Naturalism and Symbolism. At the same time certain anomalies are evident, and thus the kitch and neo-Rococo architecture of the Paris *Exposition Universelle* in 1900, for example, can seem unrelated to Art Nouveau when compared to contemporary innovation in literature or painting.

Two literary phenomena offer an overview of the trends that influenced and shaped the literary panorama at the beginning of the 1890s. The first was an ambitious series of interviews carried out in 1891 by the journalist Jules Huret in the daily paper *L'Echo de Paris*, in which he interviewed 64 of the most important writers of the time. The creator of the 'interview' style, Huret divided and categorized his interviewees into 'Psychologists', 'Decadent-Symbolists', 'Parnassians', 'Naturalists' and 'Independents'. The main point of debate was to establish whether or not Naturalism – a movement epitomized above all by Émile Zola and Edmond de Goncourt – had come to its end by 1891; and, if so, what had replaced it. With its professions of faith, lively polemics, antipathy, praise, curious inclusions and significant omissions, this survey remains an irreplaceable

snapshot of the literary world of the time. Stéphane Mallarmé, Paul Verlaine and Jules Laforgue are frequently quoted, as are Zola, Gustave Flaubert, and Edmond de Goncourt. Their views reveal both common ground and conflict. The conflict was between Symbolism, which had dominated poetry since the publication of Verlaine's *Sagesse* in 1881 and *Poètes maudits* in 1883, and of Jean Moréas' *Symbolist manifesto* in *Le Figaro* in 1886, and Naturalism, which had dominated the literary novel since the publication of the first of Zola's 20-volume *Rougon-Macquart* series in 1870. The common ground was forged and maintained by prudent publishers: Lemerre with the neo-Parnassians, Kistemaeckers in Belgium with the 'novel of Parisian manners', Vanier with Symbolism and Charpentier, since the end of the Second Empire (1853–71), with Naturalist novels by authors such as the de Goncourt brothers and Zola. Charpentier's large print-runs and trademark yellow covers, which featured in a number of van Gogh still-life paintings, began to swamp European markets.

The second phenomenon related to a particular work, and could be considered the key to studying the complexities of the period. Zola, who was President of the *Société des gens de lettres* (Society of Authors) and whose work was translated into almost every language, had published *Le Rêve* in 1888 (the sixteenth novel in his series *Histoire naturelle et sociale d'une famille sous le Second Empire*). In 1892 he authorized the publishing house, Flammarion, to publish an edition of this novel illustrated by Carlos Schwabe (plate 5.1). Here, the Naturalist endeavour of examining the dreams and psychology of a very young girl, following a strictly physiological type of analysis (hereditary characteristics, the influence of environment, temperament and of reading) is illustrated by a Symbolist artist from the highly decadent and mystical Salon of the Rose+Croix (see chapter four). Schwabe's Symbolism is a world away from the Naturalist aesthetic. What is more, the previous year Zola had

adapted this same work into a 'lyrical drama' for the opera, in collaboration with the Wagnerian musician, Alfred Bruneau. This 'lyrical drama', with its contemporary characters, marked a significant date for *fin-de-siècle* opera, but its rhyming libretto was also far removed from the Naturalist aesthetic.

A wealth of similar examples testify to the fact that Symbolism did not automatically sound the death knell for Naturalism, and that describing dreams is not contradictory to depicting reality. François Coppée, Jean Richepin and Émile Verhaeren introduced Naturalism into poetry and Stéphane Mallarmé's disciple, René Ghil, used a phrase from Zola as an epigraph to his 1885 poetry collection, *Légendes d'âme et de sang*. Francis Poictevin, Sâr Joséphin Péladan and Élémir Bourges introduced typically Naturalist devices into their Symbolist prose.[1] Indeed, Mallarmé wrote enthusiastic letters to Zola, who was utterly deaf to any sort of poetry.

These paradoxical literary relationships and tensions are also detectable at a thematic and stylistic level, particularly with the de Goncourt brothers, who seem to epitomize the contradictions of the period. As Edmond de Goncourt wrote in his *Journal* (entry dated 1 June 1891):

> In *Germinie Lacerteux* I defined the very formula for
> Naturalism … and when I wrote *Les Frères Zemganno* and *La
> Faustin* I was the first to move away from this … precisely
> by way of that which young writers now seek to replace it,
> by dream, Symbolism, Satanism etc. etc., seeking myself,
> the inventor of Naturalism, to dematerialize it before
> anyone else even dreamt of doing so.

Yet de Goncourt – who nevertheless still claimed to be the champion of the Naturalist aesthetic of the 'document of human nature'[2] and, in writing *Germinie Lacerteux* in 1865 claimed to have invented Naturalism before Zola – is the very same person who promoted the *écriture artiste*. This style was highly sophisticated in lexical and syntactical terms, closer to the affected and disjointed writing of Paul Verlaine or Mallarmé than to Naturalism, and was to have a considerable influence on Marcel Proust (Proust had to imitate it in order to liberate himself from it). Novels such as *La Maison d'un artiste* (1881) influenced Joris-Karl Huysmans' seminal work of decadence, *A Rebours* (1884). In *A Rebours* we see an Aesthete dandy meticulously and stylishly arranging the interior of a house which will form his retreat from the vulgar masses outside. With *La Maison d'un artiste*, de Goncourt is playing to the fashion for artist-writers to arrange and style their own interiors and the tendency of poets inspired by Edgar Allan Poe[3] to create 'dream chambers' – elaborately furnished and decorated

rooms over-filled with trinkets (for example, the bedrooms of Charles Baudelaire, Mallarmé, Verlaine and Georges Rodenbach). Similarly, another de Goncourt work, *La Faustin* (1882) is an example of the first 'Decadent' novel. There are white peacocks in vast parks, eccentric Englishmen, neurotic actresses, extreme aesthetisization of feeling, homosexuality and so on. It was de Goncourt, too, who used the term *apporteurs du neuf* (harbingers of the new)[4] to describe all writers and artists of the avant-garde, thus expressing the key notion of the *fin de siècle*: the 'new'.

Yet it is surely with Charles Baudelaire, who was described by Paul Bourget as 'decadent' and who forms the mainstay of the hero's library in that bible of decadence, *A Rebours* (and who himself labelled Manet in the same way), that this religion of the 'new' truly finds expression: 'We wish … /To plunge into the abyss … /To the depths of the unknown to find the new!', he wrote in *Le Voyage*.[5] We are reminded of Arthur Rimbaud: 'Go to the poets and demand the new – in ideas and in form'[6] or from *Une Saison en enfer*: 'I have tried to invent new flowers, new stars, new flesh, new tongues (*Adieu*)'. This word 'new', with all its diverse meanings, was the cornerstone of all avant-garde movements right up to the time of Guillaume Apollinaire, with his *La Phalange nouvelle* (1908) and *L'Esprit nouveau et les poètes* (1917) and Le Corbusier with his magazine *L'Esprit nouveau* (1920–25). The cult of the new produced masterpieces such as Rimbaud's *Illuminations* (which began appearing in print from 1886) and Mallarmé's *Un Coup de dés* (1897). Through their bold form and typography, as well as their obscurity, these texts pushed out the boundaries. Paul Valéry describes this passion for the 'new' in *Degas danse dessin* (1938): 'Whether in politics, economics, lifestyle, entertainment or movement, the speed of modernity is nothing less than that of intoxication. We must either *increase the dose* or *change the poison* – such are the rules. Ever more *advanced*, ever more *intense*, *bigger*, *faster* and always *newer* – these are modernity's demands.'[7] Predictably, it was not long before the 'Art Nouveau' label was seen gracing a shop front, at the Parisian store of Siegfried Bing in 1895 (plate 1.11).

The period between 1885 and 1895 was a time of intense intellectual ferment that witnessed the creation of a number of literary magazines, some with more staying power than others. In France there were *Le Décadent*, *La Vogue* and *Le Symboliste: La Revue indépendante* in 1884; *La Revue Wagnérienne* and *La Revue contemporaine* in 1885; *La Plume* and *La Revue blanche* in 1889 (plate 5.2); and *Le Mercure de France* in 1890. Belgium had *La Jeune Belgique*, *La Société nouvelle* and *L'Élan littéraire*. The movement saw itself

5.2 Pierre Bonnard, poster for *La Revue blanche*. Colour lithograph. French, 1894. Brighton Art Gallery and Museums: The Royal Pavilion.

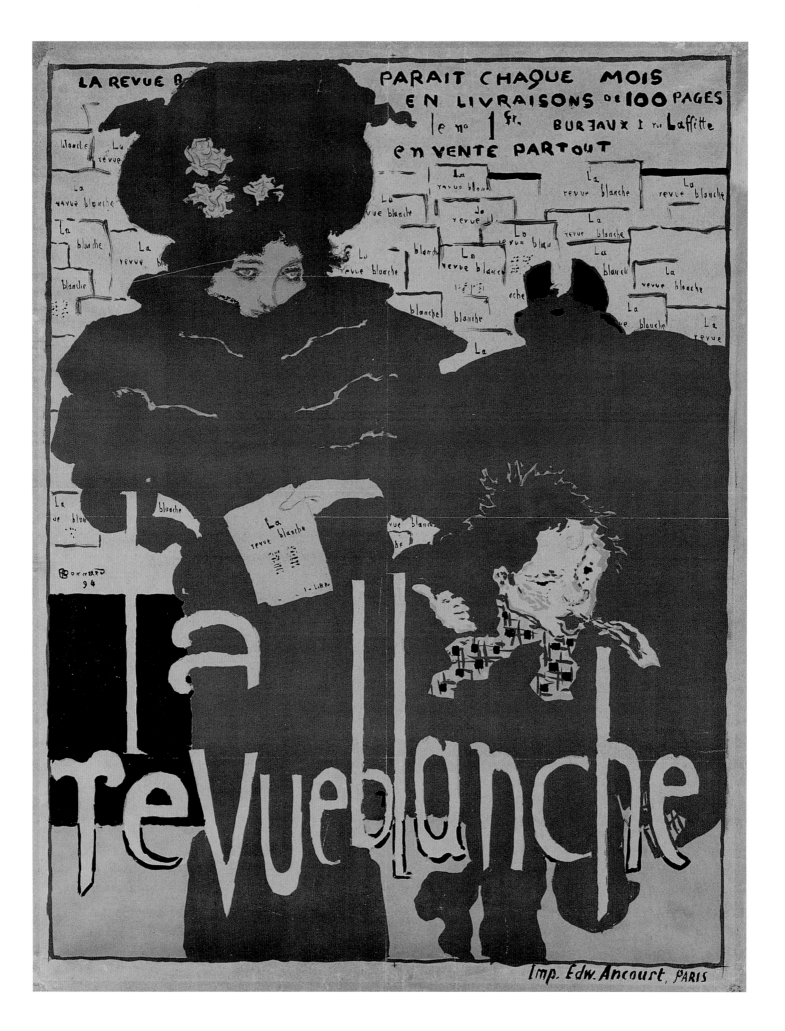

VOYAGE SUR L'OCÉ

AN PATHÉTIQUE

à Henri de Regnier

Prélude

Quand l'amère nuit
de pensée, d'étude et de
théologique extase fut
finie, mon âme qui de-
puis le soir brûlait soli-
taire et fidèle, sentant
enfin venir l'aurore, s'é-
veilla distraite et lassée.
Sans que je m'en fusse
aperçu, ma lampe s'était
éteinte ; devant l'aube

s'était ouverte ma croisée. Je mouillai mon front à la rosée des vitres,

1

5.3 Maurice Denis, title page
for André Gide's *Le Voyage d'Urien*
(Paris, 1893).
V&A: IVRC.A.26.

guin. Verlaine's *L'Art poétique* of 1882 remains the bible of the 'new' poetry. Artists dreamt of 'total art', of the 'total book', of a 'correspondence' (a Baudelairian term) between art and the senses.[8] Different art forms collaborated with, and permeated each other – especially poetry, painting and music – with each art providing the others with new mythologies.

Although it cannot strictly speaking be claimed that the Decadent movement invented any new myths, it certainly questioned existing ones with some force – the optimistic nineteenth-century myths of progress, science, positivism – and it revived and looked afresh at others.[9] The collaboration between myth and art can also be found in music, in the melodies of Maurice Ravel, Claude Debussy and Gabriel Fauré (who worked with Verlaine). In opera, Zola's work was adapted into librettos of rhythmic prose (for example *Messidor* and *L'Attaque du moulin*), and Maurice Maeterlinck's *Pélléas et Mélisande* was scored by Debussy in 1902. Artists such as Odilon Redon, Pierre Bonnard, Victor Prouvé, Camille Martin and Maurice Denis illustrated books produced by quality publishers (plate 5.3). Rodenbach looked to the painter Fernand Khnopff and to photography to illustrate his book *Bruges-la-morte* (1892; plate 5.4).

Three characters dominated literature: the Pierrot (plate 5.5), Salome and Narcissus. They and their variants formed the new pantheon of the *fin de siècle*: the naïve, sarcastic, solitary comic actor, the castrating virgin *femme fatale*, and the figure obsessed with self-love (with its variant, the androgyne, about which Péladan theorized). These obsessive myths of decadence and symbolism were visible in the fields of poetry, prose, painting, opera and the decorative arts, in the work of, for example, André Gide, Albert Giraud, Stéphane Mallarmé, Oscar Wilde, Gustave Moreau, Odilon Redon, Edvard Munch, Richard Strauss, Jules Massenet, Jules Laforgue, Oscar Vladislas de Lubicz Milosz, Jacques Rivière and Georges De Feure.

Meanwhile, in 1889, and very much in the realist vein, Christophe created the first French cartoon, which appeared in *Le Petit Français illustré*. Christophe, using irony, was also giving new life to a mythical figure from the literary culture of the century: the bourgeois (Monsieur Fenouillard). The time when Flaubert would refuse point blank to have his work illustrated was long gone, and the new *fin-de-siècle* myths were not so much literary myths and fables, but rather the myths and fables of literature itself. As such, they would continue to haunt writers well into the next century: the myth of the 'artist'[10] and the myth of the *texte absolu* (as in Mallarmé).

as cosmopolitan, and actively looked for new influences via artistic collaboration and through forging friendships. Kistemaeckers and Camille Lemmonier created a highly active Naturalist communication route between Brussels and Paris, and Georges Rodenbach, Maurice Maeterlinck and *La Jeune Belgique* formed an equally active Symbolist alliance. This opening-out was further encouraged by 'go-betweens', such as Arthur Symons in London with Symbolism, Melchior de Vogüé in France with the Russian novel and Aurélien Lugné-Poe in Paris with his *Théâtre de l'oeuvre* for the Scandinavian theatre. Other 'go-betweens' included Algernon Charles Swinburne (who contributed six poems to Théophile Gautier's *Tombeau* collection of short stories in 1873), Stuart-Merrill and Oscar Wilde.

Good translators (Jules Laforgue translated Walt Whitman in 1886) also helped to bring cultures closer. Literature looked to foreign writing and foreign art (France looked particularly to Wagner) and even to distant cultures such as Buddhism or 'primitive' art, as with Gau-

Above all, the Symbolist-Decadent period of 1885 to 1895 invented new forms. There was fragmentation, discontinuity, heterogeneity, and freedom from the rigid frameworks of genre, Classical metre and narrative structure.[11] Bourget summarized it in his *Théorie de la décadence*: 'A decadent style is one where the unity of the book breaks down to give way to the independence of the page, where the page breaks down to give way to the independence of the sentence, and the sentence to the independence of the word.'[12]

Citing Mallarmé in a chapter of *Aspects*, Adolphe Retté defines the Decadent writer thus: 'Lengthy works seem to him too decisive, too compact. He is the man of the token text, of fragment, of mere essence, of faint tracing of emotions, of the fleeting and mysterious whisper.'[13] From this

came the emotional shifts of the interior monologue (used by Édouard Dujardin in *Les Lauriers sont coupés*, 1888); free verse (introduced by Rimbaud in *Marine* and which the poets Gustave Kahn and Marie Kryzinska claimed as their own); the *sotie* or satirical tale such as André Gide's *Les Caves du Vatican*, 1914); Whitman-influenced verses (taken up by Paul Fort, Paul Claudel, Saint-John Perse); the narrative split into mini-chapters (de Goncourt in *Chérie*, 1884); and the preference for poetic prose and the prose poem (as outlined by Baudelaire in the preface to his *Petits poèmes en prose*, 1869). As if truncated literary forms and critical alienation were meant to go hand in hand, the *fin de siècle* as a whole could perhaps be termed 'ironic'. Paul Adam indicated in *La Morale de Paris* (after 1900): 'Flaubert, Villiers, Verlaine, Laforgue; your knowing ironies speak of every twist of fate in the universe, every unknown rule. With your ordered complications, in perfect equilibrium, you have constructed the rich yet simple harmony of the "*Esprit nouveau*"'.[14]

5.4 Fernand Khnopff,
With Georges Rodenbach: A Dead City.
Coloured crayon and ink on cream
laid paper. Belgian, 1889.
The Hearne Family Trust, New York.

5.5 Aubrey Beardsley, endpaper
from the Pierrot's Library.
Line block print on book cloth.
English, 1896.
V&A: L.5920–1985.

How was writing to be approached after Rimbaud's *Illuminations*, Zola's *L'Assommoir*, Verlaine's *Sagesse* and Mallarmé's *Un Coup de dés*? Guy de Maupassant died in 1893, Paul Verlaine in 1896, Stéphane Mallarmé in 1898, Edmond de Goncourt in 1896 and Alphonse Daudet in 1897. Zola completed his last book in the *Rougon-Macquart*

elements of Symbolism and Decadence. Some reacted by remaining silent for a while (for example, Valéry, after 1892), or by publishing disillusioned accounts of the century (Henry Céard in *Terrains à vendre au bord de la mer*, 1906). Moréas (he who had launched the Symbolist Manifesto) took a 'Romanist' stance and produced *Manifeste de*

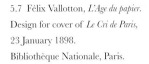

5.6 Front page of *L'Aurore*, with Émile Zola's 'J'accuse', 13 January 1898. Facsimile.

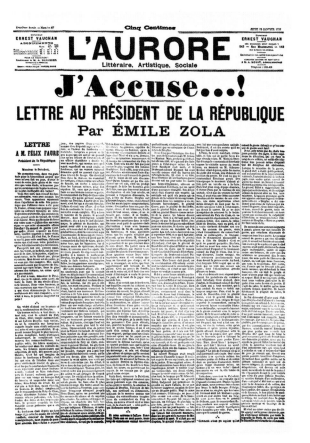

5.7 Félix Vallotton, *L'Age du papier*. Design for cover of *Le Cri de Paris*, 23 January 1898. Bibliothèque Nationale, Paris.

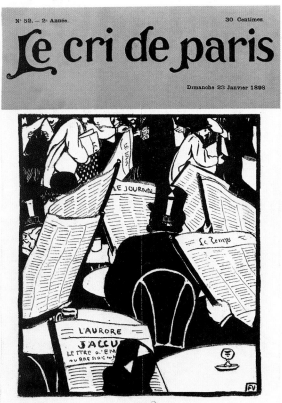

series in 1893. Just as the Golden Age of Naturalism can be placed at around 1880,[15] so the Golden Age of Symbolism and Decadence can be said to have taken place between 1885 and 1895. That said, the two literary currents did continue to co-exist until 1914, feeding into each other, revived and kept alive by original artists. In the Naturalist vein, there was Gustave Geffroy (*L'Apprentie*, 1904) and Charles-Louis Philippe (*Bubu de Montparnasse*, 1901), while Émile Verhaeren provided a blend of Symbolism and Naturalism.

A new literary modernity came to light around 1895 and in Paris, Montmartre and Montparnasse displaced the boulevards and the *Quartier Latin* (home of the literary review, *Lutèce*) as the new homes of modernity. This new modernity was a reaction against the Naturalist idea of literature presenting a 'slice of life' and being an 'ethnographic document', as well as against the quintessential

l'École Romane (1891) as a reaction against the hazy literary influences coming from the North. There was a Catholic reaction against the Republican or atheist language of the Naturalist movement and the neo-paganism of the Symbolists (seen in Francis Jammes, or Paul Claudel's *Cinq grandes odes*, 1910). Sometimes this reaction took the form of derision, parody or irony in the face of the seriousness of the objective, documentary style of Naturalism, favoured by Zola, and the prophetic mysticism of Symbolists such as Péladan and the Wagnerians. This ironic reaction was typical of the poets from the *Cabaret* and *Chat noir* review (1881–97) and the writings of Alphonse Allais and Alfred Jarry in *Ubu roi*. Similarly, Ségalen reacted by turning to the exotic in *Stèles* (1912), as did Pierre Loti with *Les Désenchantés* (1907), while Pierre Louÿs turned to the antique in *Les chansons de Bilitis* (1894) and *Aphrodite* (1896), as did Marcel Schwob in *Mimes* (1894). J.-H. Rosny created

5.8 Pablo Picasso, *Portrait of Guillaume Apollinaire en academicien*, Ink and paper. Spanish, 1905. Musée Picasso.
© Photo: RMN and DACS, 2000.

(1897) was being rediscovered, and Friedrich Nietzche's voluntarist, vitalist philosophy started to replace the pessimism of Artur Schopenhauer. Even Zola, after his 'historical' portrayal of life under the Second Empire, returned to the description of contemporary life with his trilogy *Trois Villes (Lourdes, Rome, Paris)*, 1894–98.

Two things occurred to alter the cultural and intellectual environment in France radically at the turn of the century. The first was the invention of cinema, the new 'dream machine'. Invented and commercialized by the Lumière brothers (at the 1895 screening at the Grand Café in Paris), cinema quickly moved on from the cafés and film festivals to make its home in darkened rooms, showing feature-length films. A new type of spectator was created. There were new dreams, new myths such as the myth of the star, new types of collaboration with literary works being made into films, and a new imagination.[17] The second phenomenon was the Dreyfus Affair, a political and cultural earthquake which shocked the literary world when it broke in 1894, and which culminated in the intervention of a novelist, Zola, via the journal *L'Aurore* in January 1898 (plates 5.6 and 5.7). As a reaction against the élitist and formless intellectualism of Symbolism and Decadence – against the exclusive communication between the *poète maudit* (dandy) and the 'happy few' readers via equally aimless and dreamy heroes, narcissistic sensitive artists, distant princesses, androgynous aesthetes, Salome-like women, and celibate dreams wandering in dead cities – Zola invented a new social actor. The new hero was the 'intellectual', grappling with the realities of life and taking part in the business of the city. Action replaced dream; the quest for 'Truth' (the title of Zola's final novel published posthumously in 1903) replaced the quest for the 'New'. Nature and Life replaced the Idea as absolute values.

By way of a lyrical, Realist, dynamic, non-nostalgic and dreamlike reclaiming of the modern world and the modern city in all its forms (technological as well as ideological, psychological as well as social), and against a backdrop of the rise of Cubism[18] and Futurism[19], the two key writers of pre-1914 modernity emerged. These were Guillaume Apollinaire (plate 5.8), with his *La Chanson du mal-aimé* (1909) and *Alcools* (1913), and Marcel Proust with *Du côté de chez Swann* (1913). The first took up the great musical rythms of Verlaine in a new and unusual way, fusing together Classical culture and Symbolism, irony and sincerity. The second, again in a totally new way, continued the tradition of the supreme *écriture artiste* and the stylistic and psychological ornamentation of the de Goncourt brothers.

an epic, flamboyant 'pre-historical' novel, *La Guerre du feu* (1911), written in the Naturalist vein but as a reaction against the grim depiction of everyday-life found in the Naturalist novel. The 'Naturist' school[16] reacted against the Byzantine excesses of 'artistic' writing by trying to adopt a simpler form of language and to establish a more direct contact with nature. Gide's *Les Nourritures terrestres*

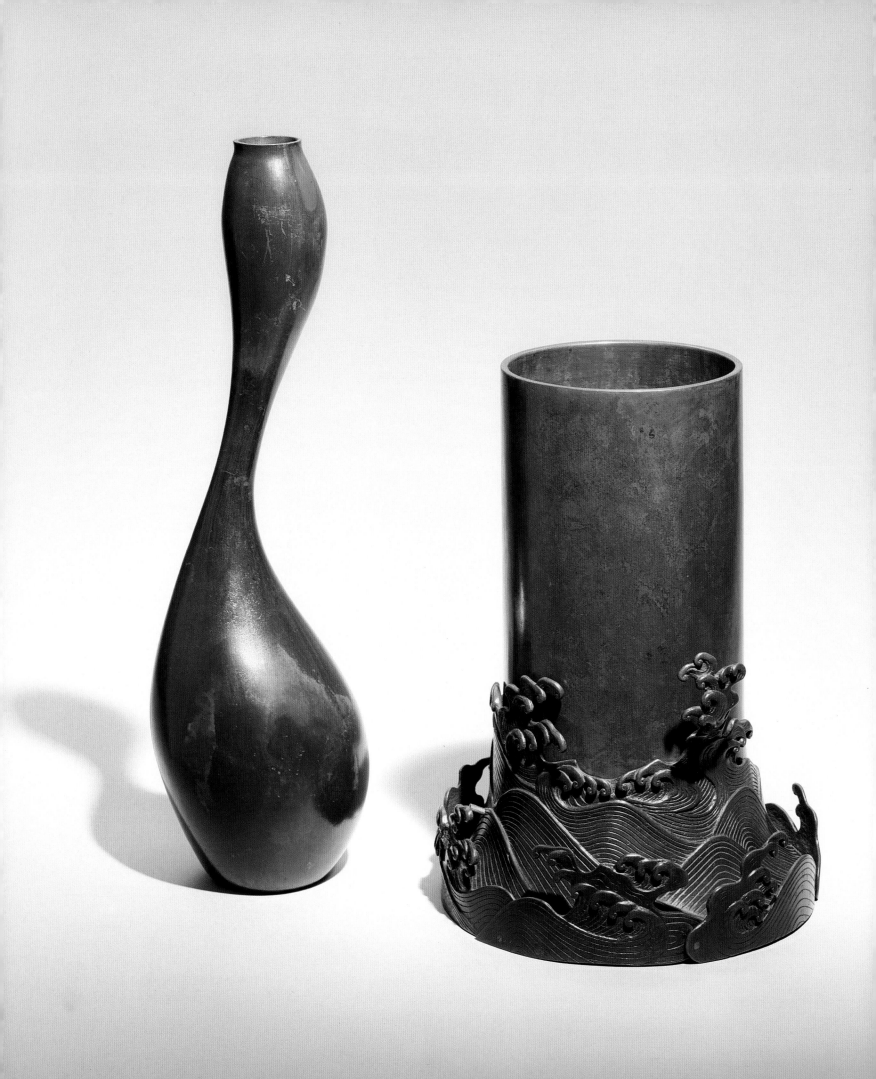

Anna Jackson

Orient and Occident

The whole of Japan is a pure invention. There is no such country,

there are no such people … the Japanese people are simply a mode of style,

an exquisite fancy of art. (Oscar Wilde, 'The Decay of Lying', 1899)[1]

6.1 Two vases. Bronze.
Japanese, c.1800–75.
Bought by the V&A
from Siegfried Bing.
V&A: 85–1876; 148–1876.

The image of the Orient, and Japan in particular, played an important part in Occidental culture in the late nineteenth and early twentieth centuries. For Oscar Wilde the image was the 'deliberate self-conscious creation' of Japanese artists, but his view contradicted, and indeed ridiculed, the common conception that the Japanese people were the living embodiment of their own art. The prevalent Western impression of Japan was that expressed by most travellers to the country, including Isabelle Bird in 1880, who found a world 'so like … pictures on trays, fans, and tea-pots'.[2] Whatever the reality of Japan, there is no doubt that the art of the country had a profound effect on a wide range of painters, designers and craftsmen involved in Art Nouveau. But did Japan merely represent the exotic fantasy of a disillusioned industrial West or did it offer real cultural alternatives and aesthetic solutions?

The art of East Asia was not new to the West in the late nineteenth century. Chinese and Japanese objects were exported to Europe in large numbers from the sixteenth century onwards, and in the eighteenth century the increasing fascination with Asia inspired artists and designers to create their own, extremely fanciful vision of the East. The Rococo style, itself an important source for Art Nouveau, had incorporated Oriental motifs. Those, such as the de Goncourt brothers, who advocated its revival, studied and collected Asian objects believed to have formed part of the eighteenth-century world they sought to recreate.[3]

Although objects from East Asia were exported to the West, the countries from which they came remained something of a mystery. This was particularly true of Japan which, since the 1640s, had operated a 'closed country' policy. This national isolation was brought to an end in 1853 when an American naval squadron arrived off the coast of Japan demanding that the country open its ports

to foreign powers. The 'opening' of this hitherto virtually unknown country aroused enormous interest in the West. The flood of information and goods which reached Europe and the United States led to a craze for all things Japanese, which developed into a major cultural phenomenon known as *Japonisme*. Japanese arts were prominently displayed at the International Exhibitions held in London (1862), Paris (1867, 1878, 1889), Vienna (1873) and Philadelphia (1876). The exhibits shown at these events, and the objects available through a growing number of specialists dealers, had an important influence on artists and designers such as Félix Bracquemond, François-Eugène Rousseau, E.W. Godwin (plate 8.13), Christopher Dresser (plate 8.16), and James Abbott McNeill Whistler (plates 8.14 and 8.15).

By the last decades of the nineteenth century, major collections of Japanese art had been amassed, not only by critics such as Edmond de Goncourt and Philippe Burty, but by many of the major exponents of the Art Nouveau style such as Arthur Lasenby Liberty, Louis Comfort Tiffany and the jeweller Henri Vever. Artists such as Paul Gauguin, Gustav Klimt, Victor Horta and Charles Rennie Mackintosh also collected Oriental art. The most significant figure linking the arts of Japan with Art Nouveau is Siegfried Bing, whose Oriental Art Boutique, opened in Paris in 1875, was an important meeting-place for artists and critics. Bing travelled to East Asia a few years later, returning from Japan 'loaded down with a tremendous booty'.[4] A major supplier of Japanese objects to private clients in Europe and the United States, Bing also sold objects to many European museums (plate 6.1).

The 1880s saw the beginning of more serious attempts to understand Japan and its art. Bing made a major contribution to this new appreciation through his journal *Le Japon artistique*, which was published in 36 issues from 1888 to 1891. Each issue contained an essay on some aspect of

6.2 Katsushika Hokusai, *Kirifuri Fall in Kurokami Mountain, Shimotsuke Province*. Woodblock print. Japanese, *c*.1827. From the series *Going the Round of the Waterfalls of the Country*. V&A: E.653–1901.

6.3 Utagawa Hiroshige, *Awa Province, Naruto Rapids*. Woodblock print. Japanese, 1855. From the series *Views of Famous Places in the Sixty-odd Provinces*. V&A: E.3605–1886.

6.4 Suzuki Harunobu,
*A Courtesan and Attendant on a
Moonlit Veranda.* Woodblock
print. Japanese, *c.*1765–70.
From the series *Genre Poets
of the Four Seasons* .
V&A: E.4368–1897.

6.5 Kitagawa Utamaro, *Lovers Resting by a Tree*. Woodblock print. Japanese, 1788. From the album *Poem of the Pillow*. V&A: E.97–1954.

Japanese art and a number of plates with accompanying information on the technical and stylistic importance of each object illustrated. In the inaugural issue, Bing stated that his publication was addressed: 'Especially to the numerous people who, for whatever reason, are interested in the future of the decorative arts. In the new formulas that come to us from the distant shores of the Extreme Orient … we shall find examples worthy in every respect of being followed.'5 *Le Japon artistique* surpassed all previous publications in terms of its scope and quality. It had a distinguished list of contributors, all of whom were committed to the reform of the arts and crafts. Published in French, German and English editions, it had a far-reaching influence in Europe and the United States that lasted long after the date of the final issue. As late as 1906, for example, Gustav Klimt purchased a complete set of the journal.

Bing organized a number of exhibitions of Japanese prints in London (1890), Paris (1893) and Boston (1894). The most important was the *Maîtres de l'estampe Japonais* held at the École des Beaux-Arts in Paris in 1890. With material drawn from the best collections available, this was a very significant event in the history of Japanese art in the West, not only in terms of the quality and quantity of what was shown – 725 prints and 428 books were displayed in all – but also in scope. Prior to 1890 most people

were familiar only with nineteenth-century Japanese print artists such as Katsushika Hokusai (plate 6.2) and Utagawa Hiroshige (plate 6.3). This exhibition introduced the work of earlier artists, such as the late eighteenth-century masters Suzuki Harunobu (plate 6.4) and Kitagawa Utamaro (plate 6.5).

Over the next two decades numerous small exhibitions of Japanese art were held all over Europe. Japan continued to participate in the International Exhibitions held in Chicago (1893), Paris (1900), Turin (1902) and St Louis (1904). Japanese art began to be shown alongside contemporary European art, such as in the Blanc et Noir print exhibition held in Paris in 1892 which featured prints from Bing and Vever's collections. When Bing opened his gallery L'Art Nouveau in 1895 he continued to show Japanese art alongside work by modern designers. Many of the major art journals published at the turn of the century such as the *Revue des arts décoratifs*, *Dekorative Kunst*, *Pan*, *The Studio* and *The Craftsman* featured articles about Japan and Japanese art. The 1880s also saw the publication of a number of important books on the subject. Louis Gonse's *L'Art Japonais* (1883), which was published to coincide with an exhibition, was the first work to place Japanese art in an historical and aesthetic context and covered the fine and decorative arts from the ninth

century onwards. William Anderson's *Pictorial Arts of Japan* appeared in 1886 and Justus Brinckmann's *Kunst und Handwerk in Japan* in 1889.

For Gonse and many of his contemporaries, the nineteenth-century artist Hokusai (plate 6.2) was the master of Japanese art. However, an increasing number of earlier artists not associated with the woodblock print tradition began to arouse interest. The Rimpa style, with its highly stylized, simplified natural forms, had a particular appeal and many screens, scrolls and examples of lacquerware found their way into European collections (plate 6.6). Ogata Kōrin, the eighteenth-century artist most associated with the style, was given much attention and was praised as one who 'carried to the highest pitch the institution and genius of decoration'.[6] In their appreciation, writers looked to Japanese woodblock-printed books that illustrated Kōrin's designs, as the artist's greatest works could not themselves be seen in the West. The assumption that the political and social upheavals that took place in Japan at the end of the nineteenth century led to the dis-

6.7 *Kesa* (Buddhist priest's mantle). Woven silk. Japanese, *c*.1800–80. V&A: T.140–1927.

6.6 Scroll box, wood with black and gold lacquer. Japanese, *c*.1750–1850. V&A: 701–1901.

persal of the art collections of the great samurai families has proved to be something of a myth.[7] The majority of Japan's most important art treasures remained in their native country and many of the works that reached Europe were contemporary. However, as Gonse's book and exhibition demonstrated, older works were becoming available to private collectors and public institutions. For those able to travel to Japan itself, the possibilities for acquisition were greater. Émile Guimet acquired numerous objects from shrines and temples during his visit in 1876 which formed the basis of the Musée Guimet, first opened in Lyon in 1879 and then in Paris in 1889.[8] Those serving in the diplomatic service in East Asia were also able to acquire religious objects not widely available in

Europe (plate 6.7). Some of the greatest collections were built up by the Americans Edward Morse, Samuel Bigelow, Ernest Fenollosa and Charles Freer.

By the last decades of the nineteenth century, Japan was no longer a novelty in the West, but the information about, and actual examples of, Japanese art that were disseminated in greater and more varied quantity in Europe and the United States were to prove a catalyst for the Art Nouveau movement. Artists and designers looked at Japan afresh in their search for stylistic inspiration and found aesthetic precedents that could be absorbed, abstracted and re-presented. Although the influence of Japan is more apparent in the work of some artists than others, very few painters, designers or craftsmen were unaffected by Japan-

ese art. In the words of one critic in 1900, Japanese art 'set us free and made us bold'.[9]

The asymmetric, undulating, dynamic line that is the principal formal characteristic of Art Nouveau is a distinct feature of much of the Japanese art that was available in the West at the turn of the century. Writing in 1910, Henry van de Velde (plate 10.4) recalled that 'it took the power of the Japanese line, the force of its rhythm and its accents, to arouse and influence us'.[10] The energy of Hiroshige's waves (plate 6.3) can be seen in August Endell's powerful relief for the Elvira Studio (plate 1.5), while the sweeping lines of Utamaro's drapery (plate 6.5) inspired Aubrey Beardsley, who is known to have decorated his bedroom with erotic prints by this Japanese artist. Woodblock prints

and illustrated books were the major, but not the only, source for Western artists. The pattern on the Rimpa-style box (plate 6.6), in which line is abstracted to its essence, is reflected in the architectural decoration of Victor Horta and Hector Guimard (plates 1.10 and 17.3). The ability of the Japanese calligrapher to alter the line of written characters for purely expressive purposes also inspired Art Nouveau artists. Carlo Bugatti used quasi-Oriental characters to decorate his furniture (plate 7.4), while Émile Gallé signed much of his work in the Japanese vertical style. The combination of word and image seen in Japanese prints (plate 6.4) also inspired those producing posters, such as Henri de Toulouse-Lautrec, Alphonse Mucha and Will Bradley (plates 9.3, 9.5 and 9.19).

6.8 Utagawa Kunisada, illustration of a scene from *Genji Monogatari*. Woodblock print. Japanese *c*.1847–52. V&A: E.9492–1886.

Another powerful lesson that Western artists learned from Japanese examples was the ability to use colour for flat-patterning rather that illusionistic modelling. After observing that the Japanese drew 'life outdoors and in the sun without shadows', Gauguin declared that he would 'move as far as possible from whatever gives the illusion of a thing and as shadow is the *trompe l'oeil* of the sun, I am inclined to do away with it'.[11] The strong contours and flat colours of Gauguin's paintings are also seen in works by Eugène Grasset, Georges De Feure and Akseli Gallen-Kallela (plates 4.15, 9.4 and 9.16).

The accentuation of pattern and ground is also a major feature of the work of Gustav Klimt (plates 2.1 and 4.22), who collected Japanese prints and Chinese and Japanese

textiles. Utagawa Kunisada was one of his favourite artists (plate 6.8). The simplification of pictorial space and use of gold ground in his work is also reminiscent of Japanese screens, while the montage-like arrangement of decorative forms can be seen in some Japanese textiles.[12] The combination of curved and geometric patterns in the textile illustrated in the print are another common feature of Japanese art seen in the work of Klimt and others. The circular shapes on the *kesa* (Buddhist priest's mantle) in plate 6.7 take the form of *mon* (Japanese family crests). Such stylistic devices can be seen in Manuel Orazi's poster for Loïe Fuller and in paintings by Georges De Feure, whose women often appear ghost-like as the figure in the print by Tsukioka Yoshitoshi (plate 6.9).

It was not only the curve, but the strong linear design and articulation of space seen in Japanese prints that were influential to artists such as Josef Hoffmann and Charles Rennie Mackintosh (plates 20.10 and 21.8). The uncluttered open-plan, simple furniture, pierced wooden screens and light-coloured plain walls seen in much of Mackintosh's work is derived in part from the Japanese interior architecture found in prints and depicted in Edward Morse's *Japanese Homes and Their Surroundings*, a copy of which Mackintosh is known to have owned.

Above all, however, it was the Japanese use of nature that inspired Art Nouveau artists. The stylization of natural forms seen in Japanese prints inspired artists such as Émile Gallé, who was introduced to the Japanese conception of nature in 1885 by Hokkai Takashima, a botany student at the École Forestier in Nancy. Although Hiroshige depicted the Naruto Rapids as an overpowering organic force (plate 6.3), Japanese artists also depicted nature in intimate detail. Siegfried Bing wrote, in the May 1888 issue of his *Le Japon artistique*:

> The Japanese artist is convinced that nature contains the primordial elements of all things and, according to him, nothing exists in creation, be it only a blade of grass, that is not worthy of a place in the loftiest conception of art.

6.9 Tsukioka Yoshitoshi, *The Ghost of Genji's Lover*. Woodblock print. Japanese, 1886. From the series *One Hundred Views of the Moon*. V&A: 361–1901.

6.10 (right) *Tsuba* (sword guard).
Iron with gold and silver inlay.
Japanese, *c.* 1700–1800.
(left) René Lalique, buckle. Silver,
parcel gilt. French, *c.*1897.
© ADAGP, Paris and DACS,
London 2000.
V&A: M.68–1920; M.111–1966.

6.11 *Inrō* (small container).
Wood with black, gold and brown
lacquer and glazed pottery.
Japanese, *c.*1775–1800.
Signed Mochizuki Hanzan.
V&A: W.419–1910.

This … is the great and salutary lesson that we may derive from the examples which he sets before us. Under such influences the lifeless stiffness to which our technical designers have hitherto so rigidly adhered will be relaxed by degrees, and our productions will become animated by the breath of real life that constitutes the secret charm of every achievement of Japanese art.[13]

One of the most popular flowers in Japanese art, which in turn became one of the emblems of Art Nouveau, was the iris. Otto Eckmann's illustration for *Pan* depicts the iris in a style inspired by Japanese prints (plate 19.5). Insects, particularly the dragonfly, were another common Japanese motif taken up by Art Nouveau artists such as the Daum brothers, Frederick Boucheron and René Lalique. The way in which Japanese artists depicted nature on small items such as *tsuba* (sword guards) and *inrō* (containers for a seal or medicine) was particularly inspirational to Art

Nouveau jewellers (plates 6.10 and 6.11). Henri Vever believed the Japanese to be the 'most artistic race that ever existed', whose love of flora and fauna had led French jewellers 'to re-establish a direct link with nature'.[14]

Japan was not the only Asian influence on Art Nouveau, although it was the most important. Dynamic line and stylized natural forms were also found in Chinese jade carvings (plate 6.12) and French potters, such as Ernest Chaplet, Auguste Delaherche and Pierre-Adrian Dalpayrat, copied Chinese *flambé* glazes (plates 12.3 and 12.5) The dense, organic and flat patterns of Javanese *batik* inspired Dutch Art Nouveau artists such as Chris Lebeau (plate 11.8) and Jan Toorop, whose elongated female attendants in *The Three Brides* recall Javanese puppets (plate 4.10).

Asia did not merely offer stylistic and formal alternatives. Art Nouveau practitioners sought to disrupt established artistic hierarchies and reunite art and craft. In Japan they found a society where, although hierarchies did exist (but were probably not recognized by the West at this time), there was no dichotomy between art and craft.

Kōrin, for example, not only painted scrolls, screens and fans, but also designed lacquerware and kimono. The arrangement of interior and exterior space seen in prints suggested that the Japanese lived in a totally artistic environment in which each element of architectural structure and interior design harmonized to create the total work of art that was the goal of Art Nouveau practitioners (the *Gesamtkunstwerk*). Japan also offered an alternative history that would enable artists to escape from European historicism and established artistic styles. As Bing stated, there were 'lessons to be learned from an art whose origins are so completely independent of our old aesthetic'.[15]

Writers on Japan were attracted not only by the objects, but also by the society that produced them. In 1884 Philippe Burty gave a series of lectures to the Union Centrale des Arts Décoratifs on 'The Pottery and Porcelains of Japan' in which he described the patronage system that had operated in the Edo period (1603–1868), emphasizing the link between the elegance of the objects and the refinement of those for whom they were made. Yet, as historian Debora Silverman has observed, Burty, like most other writers, was describing Japan of the past, not of the pre-

sent. The traditions of another culture, therefore, became a means of freeing European artists from their own; the art of the Oriental past was to be the principal agent of Western modernism.

In the late nineteenth century the arts of the East were being examined as part of the West's colonial possessions. Imperialism is more overt in the case of Islamic and Javanese artistic appropriation, but it should be remembered that attitudes to East Asia reflect the imperialist age in which they were expressed. Chinese art, although collected in the nineteenth century, was generally dismissed. Its supposed inferiority was attributed to the social and political inferiority of the Chinese who were viewed as 'a degenerate race, softened by luxury and by too great a facility for enjoyment'.[16] This image of China was informed by the experience of the Opium War of 1840–42 and by China's continued resistance to trade with the West.

The Western attitude to Japan, which had opened its ports to foreign powers, was far more positive but no less patronizing. Whereas the Chinese national traits were seen to be loose moral fibre and stagnation, the Japanese traits were believed to be their artistic talent and sensibility. The Japanese, it was assumed, were born with a 'feeling for decorative art, assisted and refined by a clear conception of the beauty of nature'.[17] Their apparently emphatic relationship with nature was believed to be due to the fact that they actually experienced it differently. Isolated from the West, the Japanese were 'still in that childish state of development before self-consciousness has spoiled the sweet simplicity of nature' and, therefore, 'artistic perception is … an instinct to which he [the Japanese] intuitively conforms'.[18]

This perception of Japan was not a wholly derogatory one. The country was often likened to the ideal, ancient and primitive society of a mythical Golden Age that could be viewed with escapist longing by those doubtful about certain aspects of life in the industrial West. The union of man and nature, the ties of social deference and the concern with craftsmanship that were commented on by writers on Japan seemed to highlight exactly what the West feared it was losing. However, although aesthetic superiority could sometimes be acknowledged, it was not expressed without an underlying conviction that the West was ultimately superior. Japan's childlike, aesthetic sensibilities were no match for the West's strength of character and imperial power. The notion that Japan was there to be enjoyed and also controlled by a superior West is reflected in the voracious way in which Europe and the United States collected Japan's artistic goods.

6.12 Vase in the form of a lotus. Jade. Chinese, *c.*1760–1840. V&A: 1529–1882.

Japan, however, did not belong to the West. It was subjected to the imperialist gaze, but not to imperialist possession. Nor was Japan a neutral place that Europe and the United States could take inspiration from, and on to which they could map their fantasies. The evolution of Art Nouveau cannot be properly understood without an awareness of the social, political and artistic developments taking place within Japan at the time. The role played by Japanese merchants and artists in the West was also very important. In the wake of foreign intrusion, Japan was constructing its own image of itself *vis-à-vis* the rest of the world, just as the West was constructing its image of Japan. Although Japan sometimes pandered to a Western view that proved good for business, the reality of contemporary Japan bore increasingly little relation to the West's perception.

The arrival of foreign powers in Japan exacerbated growing internal unrest and in 1868 the ruling Tokugawa Shōgun was overthrown and the power of the Meiji Emperor restored. The overriding aim of the new government was the revision of the unequal treaties that had been imposed on Japan, and the building up of armed forces equipped to withstand the military might of the West. An enormous programme of political, economic and social modernization was initiated, so that the country could achieve parity with the Western powers rather than be dominated by them. Although Western scientists, engineers, architects and scholars played an important role in Japan's transformation, the West tended to pour scorn on the 'new' Japan. This attitude was underpinned by the perceived threat posed by the growing assertiveness of the Eastern power. As the country became more like the West, the idea of Japan as a picturesque fairyland was perpetuated and even reinforced. Many writers sought the 'old' Japan or wrote about the Japan of the past. There was also a growing fear that European art was corrupting that of the East. While Albert Aurier suggested that the only hope for Western art was to 'take refuge in the far off countries of the Orient … where art has preserved its integrity and original purity', he feared that it was already too late, as 'the badness of Europe' could have penetrated and 'rotted the fingers of these marvellous artists'.[19] Inherent in such statements is the notion, common in cultural appropriation, that although the West can be inspired by the East, the East should not copy the West but should remain pure and untainted.

In Japan itself the relationship between East and West was complex and ambiguous. The wave of enthusiasm for the West in the 1870s was followed by a strong reaction against what was seen as an uncritical adoption of all things Western. The government slogan 'Japanese spirit and Western technology' expressed the desire for a simple blending of Orient and Occident. Although a hybrid culture did gradually develop, tensions were never far from the surface. The European and American praise for Japanese art, although gratifying to some, did not imply that Japan was accepted as an equal. The image of Japan as delicate and childlike was not appreciated by a country that was rapidly expanding its military and industrial power. After Japan's victory over China in 1894–95 and more especially over Russia, a Western power, in 1905, views did change. Yet in many ways new stereotypes were merely added to those already in existence.[20]

The promotion and export of contemporary art objects formed a crucial part of the Meiji government's efforts to expand industry and increase productivity. The world of the Japanese craftsman changed radically during the Meiji period (1868–1912). Many traditional objects became obsolete, and old systems of patronage disappeared. Skills were turned towards the making of objects for export, and the new government and free enterprise provided backing and sales outlets.[21] The Japanese merchants who traded in decorative art played a vital role in the development of art during the period.

The most famous export company was the Kiritsu Kōshō Kaisha, which was established in 1874. At the Paris *Exposition Universelle* of 1878 the Kiritsu Kōshō Kaisha employed an interpreter called Hayashi Tadamasa. Hayashi stayed on in Europe, and in 1884 he set up an independent trading company with Wakai Kenzaburo, who had been Vice-President of the Kiritsu Kōshō Kaisha. Hayashi lived in Paris to run the shop, while Wakai returned to Japan to purchase objects. The partnership ended after two years, but Hayashi remained in Paris. At this time, French Japanophiles needed someone to provide accurate information on the objects they collected. Hayashi, able to translate Japanese and undertake extensive research, met that need. Much more than a dealer, Hayashi was at the heart of Parisian cultural circles and became the catalyst for the study of Japanese art history in Europe. He is a unique figure in the history of the *fin-de-siècle* cultural interaction between East and West, but he was not the only Japanese person to play such a role. Hiromachi Shugio, Director of the First Japan Trading and Manufacturing Company in New York, and Matsuki Bunkio, who had a shop in Boston, helped introduce Japanese art to the United States. Japanese designers and craftsmen also worked in the West. In 1887 the Rookwood Pottery hired Shirayamadami Kataro as a decorator, and

his talents helped the company to achieve international stature. In 1900 the French jeweller Lucien Gaillard, long fascinated by Japanese metalwork and lacquerwork, employed a number of Japanese craftsmen in his Parisian workshop.

Hayashi Tadamasa's experiences in Europe placed him in a strong position to influence opinion in Japan. Ernest Fenollosa, who lectured at Tokyo University, and his pupil Okakura Tenshin, insisted that the art of Japan should develop from within the context of traditional styles. Okakura became the Principle of the Tokyo School of Art, which was established in 1889. The school taught the separate disciplines of craft, sculpture and Japanese-style painting. However, Hayashi, who collected Impressionist paintings, advocated the study of Western painting in Japan, and in 1898, after the resignation of Okakura, Western-style painting was added to the curriculum of the Tokyo School of Art. Hayashi also believed that craftsmen, instead of copying traditional designs, should create objects inspired by their own artistic vision. He observed that:

> According to the rules of the French art world, truly
> artistic works are products in which the artist employs his
> own philosophy and creativity from the initial idea to the
> finish. Works that are made to other people's designs,
> therefore, are considered to be craft to which art has been
> applied, and their excellence is regarded as craft rather
> than art, however splendid it may be.[22]

By the turn of the century, Hayashi's views were receiving official sanction in Tokyo and he was appointed the Japanese commissioner for the 1900 *Exposition Universelle* in Paris. In addition to contemporary objects, older works that showed the history of Japanese art were displayed in a Japanese-style pavilion. A lavish catalogue was published to accompany this display.[23] In contrast to previous exhibitions, the Japanese entry regulations contained a clause requiring crafts to be made on aesthetic principles, and the individual expression advocated by Hayashi was apparent in the work of a few of the artists. However, despite the Japanese commissioner's efforts and the admiration expressed by critics for the older works on display, the exhibition was something of a failure for Japan. Although praised for their technical virtuosity, contemporary Japanese exhibits were criticized for their poor design. Arthur Lasenby Liberty reported that the ceramics were 'most disappointing. With few exceptions, the specimens afforded no interest on the score of novelty'.[24] The Japanese objects looked stale and old-fashioned beside the exciting Art Nouveau designs.

The Japanese authorities were greatly shocked by this response. The government resolved to learn from the experience and discover something about the new art movement. In 1901 the *Dai Nippon Zuan Kyōkai* (Great Japan Design Association) and the *Nippon Zuan Kai* (Japan Design Group) were established. The former published a journal which introduced Art Nouveau to Japan, while the latter held an Art Nouveau Exhibition in Kyoto in 1902, using material brought from Paris. Design sections were also formed within the Tokyo School of Art and other schools which taught the traditional arts.

Art Nouveau also proved an inspiration for Tsukamoto Yasushi and Takeda Goichi, two Japanese architects who visited the 1900 Paris *Exposition Universelle* and explored the new movement in Glasgow, Brussels and Vienna (see chapters twenty-one, eighteen and twenty). Tsukamoto was so excited by French Art Nouveau that he apparently visited Bing's Pavilion every day from August to November. On his return to Japan, he designed lavish Art Nouveau interiors for Mitsubishi's new ship, the Tenyō Maru. Takeda, who studied in London for a while, was much influenced by the work of Mackintosh and the Viennese Secession. Back in Japan he designed its first Art Nouveau building, the Fukushima House in Tokyo.[25] Both these men taught (Takeda at the Kyoto School of Industrial Art and Tsukamoto at Tokyo Imperial University), and so they were instrumental in introducing Art Nouveau architecture to those who could not see it at first hand.

The introduction of Art Nouveau to Japan demonstrates very clearly the cultural dialogue that took place between East and West at the turn of the century. There is no doubt that without the art of Japan, Art Nouveau would not have developed in the way that it did. Ironically, however, the changes that occurred in Japanese art and art education following the example of the West effectively destroyed one of the great goals of Art Nouveau. It succeeded in dividing, forever, the practices of art, craft and design in Japan.

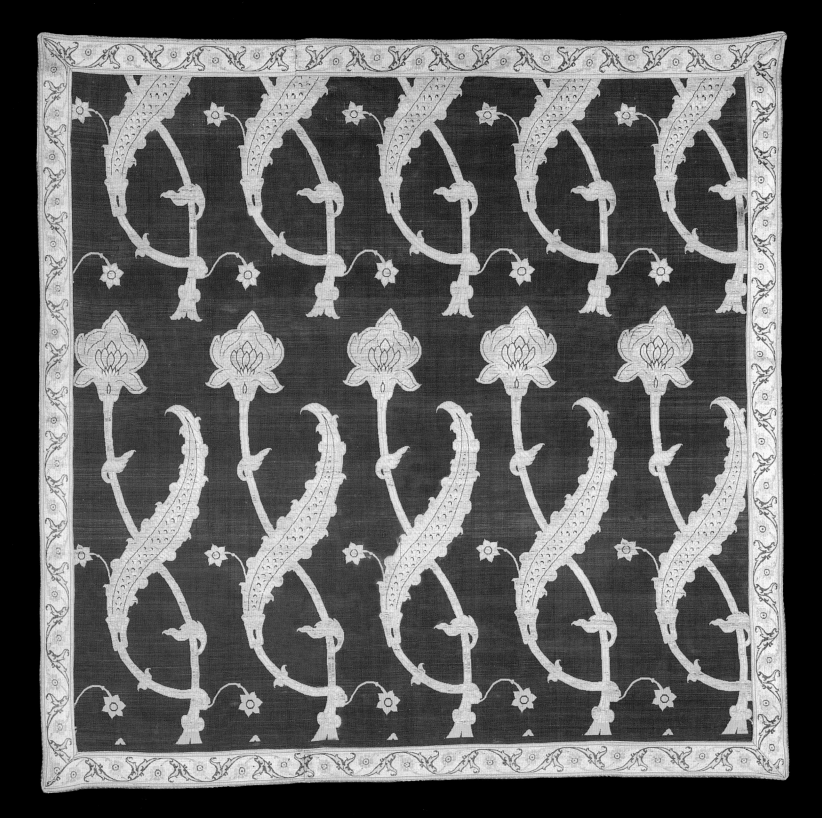

Francesca Vanke

Arabesques:
North Africa, Arabia and Europe

7.1 Woven silk. Persia,
early nineteenth century.
V&A: 18–1903.

Islamic design has been undeservedly neglected in discussions of the stylistic influences upon Art Nouveau, whereas Japan is regarded by most commentators as supplying the only important Oriental input into this complex European style. However, the very visual and ideological complexity of Art Nouveau ensures that its origins are equally convoluted. Debts to Islamic design are, in numerous instances, as discernible as those to the arts of Japan. The role which Islamic art played was protean, more so than that of Japanese art, as it was made to assume several guises and answer many needs. The twists and turns which it traces throughout the genre of Art Nouveau may themselves be described as arabesques,[1] sometimes taking on the nature of a background pattern rather than a central motif, but much in evidence nonetheless. At the same time, the importance of Islamic art in the history of Western cultural responses to non-European civilizations cannot be over-estimated, as this was one of the earliest styles of art to be engaged with on an aesthetic level. This ensured that, although attitudes to Islamic religion and races remained prejudiced and ambivalent throughout the Art Nouveau period, European art did contain forms originally adopted from Islam which had become naturalized over centuries of use and adaptation to European design needs.

The types of use made of Islam by the exponents of Art Nouveau can be divided into two distinct areas. First, in the decorative arts, Islamic forms and motifs contributed to the visual appearance of the finished works, although not necessarily with the same intentions as in their original contexts. Second, in figurative or narrative arts such as painting, sculpture and literature, the Islamic Orient was represented in a more symbolic manner, using contemporary Western interpretations of what 'the East' meant. These ideas pervaded the meaning and ideology of the objects, but did not necessarily affect their actual style.

The emphasis differed depending on individual location and medium, but one or other of these two elements, or sometimes both, can be found at the heart of crucial themes of Art Nouveau, namely nature, exoticism, sexuality and nationalism.

The exponents of Art Nouveau sought to express a new and intense vision of nature, free from historical precedent. The line most typical of the movement is that of the supple 'whiplash curve', which describes natural growth and organic form (plate 1.12). The formulation of this characteristic line can be attributed to many factors, but one of the most important was the interpretation of nature in both Japanese and Islamic art. The stylized curvilinear shapes common to both these artistic traditions proved a tremendous inspiration to Art Nouveau designers. Prior to this period, however, Islamic artistic approaches to nature had proved equally inspirational to William Morris, William De Morgan, Christopher Dresser and others. 'Le Style Anglais' was a vital antecedent to Art Nouveau; via this acivity, Islamic styles were passed to Europe indirectly as well as at first hand.

Morris espoused Japonisme far less than most of his British contemporary design reformers, but did use numerous elements from Islamic sources in his flowing patterns for wallpapers and textiles. He was less enamoured of geometric, abstract and calligraphic forms, but admired and emulated the more figurative Turkish, Syrian and particularly Persian arts. To Morris, works from these traditions embodied perfect principles of decoration and dovetailed exactly with his own aesthetic and theoretical concerns. Patterns were based on nature, but were sufficiently stylized not to appear three-dimensional. Their forms of design enhanced and complemented the surface and type of object they decorated rather than obscuring it. At the same time, the objects were made by expert craftsmen using natural materials and traditional hand

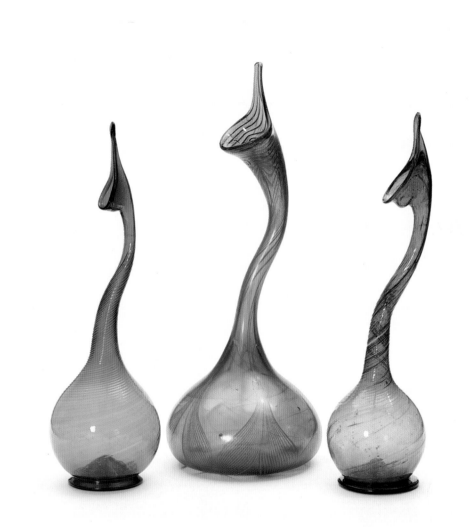

7.2 (left and right) Glass flasks from Persia (Iran). *c.*1885. (centre) Glass flask by L.C. Tiffany & Co. American, 1896. V&A: 921–1889; 903–1889; 512–1896.

7.3 Mosque lamp. Glass, painted in enamels. Egyptian, *c.*1350. V&A: 322–1900.

methods. A wide range of Islamic artworks, including textiles, ceramics, metalwork and glass, was acquired in steadily increasing amounts at the South Kensington Museum, beginning with a large initial purchase of objects shown at the 1851 Great Exhibition. These collections were studied by Morris and other British designers who would later play important parts in the formulation of Art Nouveau, including Christopher Dresser, C.F.A. Voysey and the Silver Studio designers. By the 1890s Islamic design was thoroughly integrated into the visual vocabulary of the British Design Reformers and, along with many other ideas and forms, was exported to Europe and the United States (see chapter eight).

A type of Islamic design most commonly employed in British work, and widely adopted in the Art Nouveau period, is exemplified by Persian textiles (plate 7.1). Persian silks show how similar in appearance the graceful Islamic interpretation of a simple flower and leaf pattern could be

to the characteristic 'whiplash curve' of Art Nouveau. The motif of the tulip and long snake-like leaf known as the *saz* leaf occurs repeatedly in Islamic art and was adapted endlessly by its British interpreters. It had numerous artistic possibilities and was as open to use in a rustic, unflamboyant way to resemble the product of an English country garden, as it was to be fantastically twisted and elongated. Variations in this range of options can be seen in the ceramics of William De Morgan, and the textile and wallpaper designs of Morris, Voysey, Archibald Knox and the Silver Studio. There are extreme distortions of arabesque forms in the works of the revolutionary English illustrators Charles Ricketts and Aubrey Beardsley and it was the wilder interpretations like theirs, never popular in Britain, which were taken up in mainland Europe. Given a further stretch and twist by the addition of Japanese minimalism and asymmetry (not characteristic features of Islamic art), these vital forms were melded into the full-blown Art Nouveau line.

The 'whiplash curve' could also be described in three dimensions. The closest comparison would be the shapes of the eighteenth-century 'swan-necked' Persian glass flasks (plate 7.2; left and right). Little is known of the origins of this design, but it expresses perfectly the strong lines of organic growth and, probably more than any other single type of Islamic artefact, inspired direct copies and adaptations during the Art Nouveau period. The fluid medium of glass was particularly well-suited to display the sinuous form of this design to its best advantage and, although Christopher Dresser had inaugurated the use of the shape in England in the 1880s, the most spectacular examples of the Art Nouveau period can be seen in the *favrile* glassware of Louis Comfort Tiffany (plate 7.2, centre). Many of the elegant forms seen in his glass vessels bear close visual resemblances to Persian originals. Tiffany had encountered Islamic arts through a wide variety of routes. He had not only visited London in the early 1870s, studied the South Kensington collections and met William Morris, but had also travelled in North Africa and Spain where he had painted numerous watercolours of Moorish architecture. In later life, Tiffany collected Islamic artefacts himself, but the collection most influential on his work is that of the noted silver designer and Islamic art connoisseur Edward C. Moore. Famed for his designs based on Islamic metalwork, Moore amassed an extensive Islamic art collection, including enamelled glass mosque lamps (plate 7.3). Unsurprisingly, when Tiffany began his own career, both his glassware and his interior designs showed debts to Islam, in his use of polychrome and gold effects,

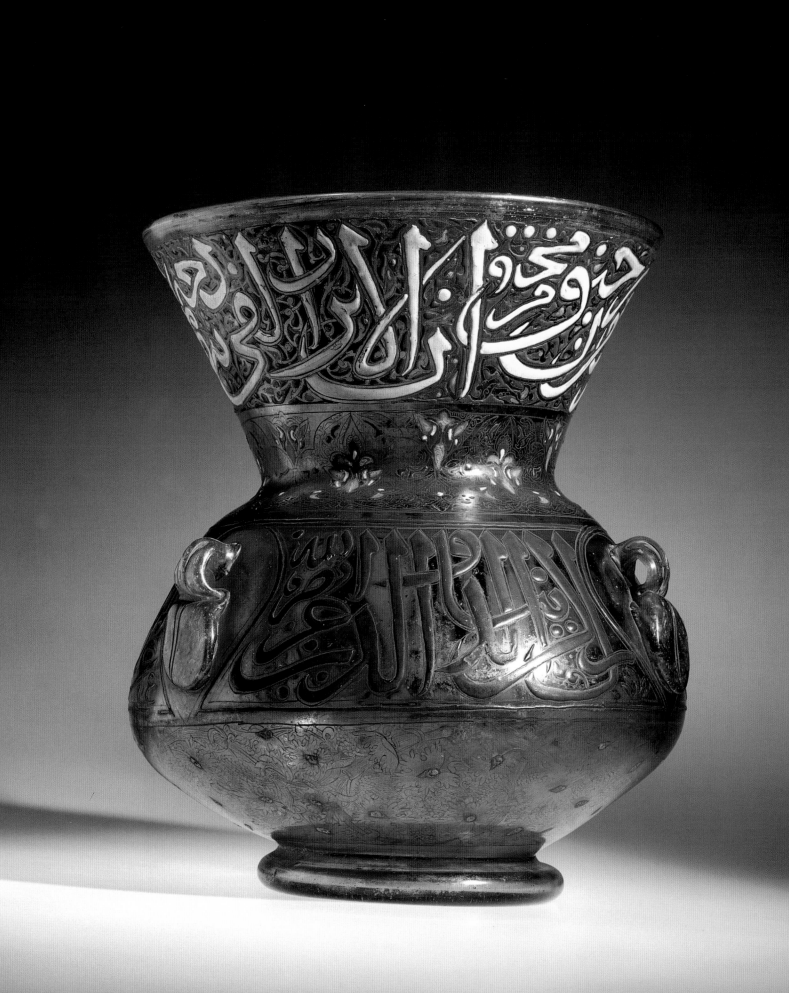

7.5 Eugène Gaillard, printed
cotton velveteen. French, *c*.1900.
Shown at the *Exposition Universelle*,
Paris, 1900.
Musée de la Mode et du Textile,
Paris. Photo: Laurent Sully-Jaulmes.

arabesque patterning and rich and subtle use of iridescent lustre, which serves to enhance the shape of the objects (see chapter twenty-eight).

Other interpretations of this distinctive 'swan-neck' shape were made. The Austrian glassmaker Johann Loetz also produced vessels closely based on this form, as did the Zsolnay ceramics factory in Hungary. An echo of this Persian shape can also be seen in works by Émile Gallé. His main aim was, as for the majority of Art Nouveau designers, the expression of natural form, and the line of the Persian flasks, so eloquently expressing the fusion of art and nature, would have had a universal appeal for all those striving to achieve this goal.

The Italian furniture designer Carlo Bugatti exemplifies how non-European influences could help to create a completely individual style. Bugatti was not part of the mainstream of international Art Nouveau in that his works resembled few of the stylistic archetypes of the period, whether floral or geometric. His work was often considered too bizarre to be copied by his contemporaries, although it was sufficiently admired to win him a first prize at the 1902 *Prima Esposizione d'Arte Decorativa Moderna* in Turin. Despite his idiosyncrasy, he should be considered within the parameters of the style as he was also striving for modernity and for a new and individual means of artistic expression.

Bugatti saw himself primarily as a craftsman, uninvolved with life outside and, unlike most of his contemporaries, he did not travel or collect art himself. He was nonetheless unmistakably influenced by aspects of Middle Eastern and North African architecture, particularly the characteristic 'keyhole' arches and Egyptian *mashrabiyyah* (latticework). He also incorporated unusual materials into his pieces which further enhanced their exotic appearance. He used knotted silk tassels like those on Persian rugs, hand-painted vellum and inlaid abstract decoration which often echoed the forms of Arabic (and Japanese) calligraphy.

Bugatti's table (plate 7.4) borrows from both these Oriental traditions. Made around 1895, it belongs to his later body of work when he pared down his style, but the decoration at the top of the table's legs is suggestive of the *muqarnas* ('stalactite' decoration) on the ceilings of a Hispano-Moresque palace. The discs at each side describe the curve of a Moresque 'horseshoe' arch, but the pewter inlaid decoration which infills each disc and adorns the top of the table is distinctly Japanese in inspiration. However, the overall effect of both this object, and the chair also illustrated, is inventive and original rather than traditional or derivative. Although Bugatti's contact with genuine Oriental forms may have been limited, and he liked to think of himself as one of a kind, he was well aware of

7.4 Carlo Bugatti, table
and armchair. Walnut,
brass, painted vellum, pewter.
Italian, 1895–1900.
V&A: W.10–1968; W.10–1970.

developments in design as he did visit International Exhibitions[2] and exhibit his own work abroad.[3] The fact that so many recognizably Islamic elements found their way into his works shows how multi-faceted a source of inspiration they could be, how prominent Islamic forms must have been in contemporary artistic language and how many purposes they could fulfil. Bugatti's furniture was certainly considered Moresque in character by contemporary commentators, and it is also known that he supplied furniture to the Egyptian royal family.

As Oriental and Occidental decorative forms had become interwoven over such a long period of time, many Art Nouveau designers used aspects of Islamic art without specifically choosing them. The Hispano-Moresque 'horseshoe' arch is the most common example of a form found repeatedly in different interpretations in architecture, interior decoration and furniture. Prominent among those who used this form is the Belgian Gustave Serrurier-Bovy, who cited his greatest influence as the British Arts and Crafts movement, but who incorporated this elegant arch into many of his designs (plate 1.1). Historian Stephan Tschudi-Madsen has noted that the work of key Art Nouveau architects Henry van de Velde, Josef Maria Olbrich and Paul Hankar all contained similar 'horseshoe' arch forms.[4]

Another recurring motif is the 'ogee', a variant on the arch shape formed into a repeating pattern. The textile designs of Édouard Colonna and Eugène Gaillard (plate 7.5), for example, incorporate abstract floral repeating designs not reminiscent of any previously established artistic mode, but which describe a traditional ogee form. This form originated in the Islamic Orient, but had a long pedigree of adaptation for Western textiles, probably because it is one of the simplest and most graceful ways ever devised to create a repeating pattern. Colonna had worked for Tiffany in 1882–83, so he would have encountered Islamic artefacts during that time, and he had also designed furniture with unmistakably arabesque decoration in Canada before he began working for Bing in Paris in the early 1890s.[5] However, overall, Islamic influences featured little in his highly individual stylistic approach, so Colonna's use of the ogee would have stemmed as much from its universality as a decorative form as from his early contact with Islamic art. Other exponents of Islamic forms in Art Nouveau specifically stated the origins of their ideas. For example, the Italian Raimondo d'Aronco, although best known for his innovative architecture for the *Prima Esposizione d'Arte Decorativa Moderna* in Turin in 1902 (plates 29.2 and 29.3), in fact divided his time between practice in Italy and in Turkey. As the official architect to

Sultan Abdul Hamid, his public commissions in Constantinople included mosques and his involvement in restoration work on Santa Sophia Church.[6] When commissioned for the exhibition buildings at Turin, he declared himself so inspired by this famous monument that he was determined to use it to enrich his own designs.[7] The finished buildings for the *Esposizione* in Turin, although entirely modern and original, show unmistakable debts to Turkish Ottoman design, including use of the horseshoe arch. This latter form had a strong influence on the buildings

7.6 *Mihrab* (arched niche). Black shale. Bengal, 15th century. V&A: 3396–1883.

for the *Esposizione d'Arte Decorativa Moderna* in Milan in 1906, its architects using styles from the Islamic East as part of their reaction against Classicism.

This event notwithstanding, Italy as a nation did not acknowledge ancestral links with Islamic arts in the same way as certain other European countries. Although for many individuals and nations during this period, Islamic-derived design supplied the ultimate in *exoticism*, for others the opposite was true – use of the same elements meant the harnessing of indigenous historical styles to create a modern, *national* language of form. In this way, the racial and national origins of the borrowed art forms were as important as their aesthetic appeal. The architects Antoni Gaudí and Ödön Lechner, working in Barcelona and Budapest respectively, both used Islamic-derived stylistic devices which formed part of their national pasts in this manner (see chapters twenty-three and twenty-four.) For Gaudí, a fervent Catalonian nationalist, a use of Islamic architectural forms then current in the mixed Spanish/Moresque style known as *mudejar* reflected his commitment to his region and its history, the Moors having settled in Catalonia in the eighth century. He had studied Oriental architecture as a student[8] and also admired Gothic art; he mingled the sources of medieval, *mudejar*, Moresque tilework and the buildings of the Berber tribes from Morocco to produce works of stunning originality. Gaudí's commissions of the 1880s, such as the Casa Vicens and the Casa el Capricho, are those most undilutedly Islamic in character, combining every conceivable architectural feature, including arches, minarets, *muqarnas* roof ornaments, latticework in wood and metal, tilework, and even glass light fittings modelled on mosque lamps and adorned with calligraphic decoration. The North African *mashrabiyyah* wooden latticework, which combines designs of turned 'spindle' shapes with carved interlocking geometric forms, gives an impression of the complexity and delicacy of effect achieved by the use of this type of decoration on a large scale.

Gaudí's mature style as seen in his most famous buildings in Barcelona had developed far beyond any existing idiom. By this period, between the 1890s and his death in 1926, his work could hardly have been less geometric or symmetric, resembling more a frozen lava-flow of unique natural forms, but the visual traces of Islamic architectural borrowings are clearly discernible. For example, in his asymmetric design for the monumental bench which encircles the Park Güell, Gaudí replicates the colour schemes and patterns of Alhambraic Hispano-Moresque tilework (plate 23.7). At the same time, his use of minaret-like

7.7 Zsolnay factory, vase. Earthenware. Hungarian, 1901. Designed by Tádé Sikorski. The Museum of Applied Arts, Budapest.

structures on the rooftops of the Casa Batlló and Casa Milà (plates 23.3 and 23.5), intricate brickwork on the towers of the Sagrada Familia (plate 23.10) and tiles for interiors all testify to a sustained Islamic influence, albeit one which had broken the confines of its own geometric roots.

Ödön Lechner, the best-known architect of Hungarian Art Nouveau, also used strongly Eastern designs. He sought to establish a distinct Hungarian national language of form by combining the elements, both Oriental and Occidental, which formed the Hungarian identity. The Magyar race had ancient links with the Middle East and Asia, and Hungary had been part of the Ottoman Turkish Empire for centuries. Research by Lechner's contemporary, József Huszka, had made explicit links between Hungarian folk art and Middle Eastern arts. Lechner, aware of this, incorporated folk and Oriental arts into his vision, although he was also inspired by Mughal Indian architecture and the English-generated mixed Indo-Saracenic style used in Indian public buildings. An admirer of English Arts and Crafts principles, he had also visited the South Kensington Museum in London in 1889 to study the Indian artefacts, of which the Museum had a considerable collection by this date, including a fifteenth-century Bengali black shale *mihrab* (plate 7.6). Lechner's Orientalism is most apparent in his first major commission for the city of Budapest, namely the Museum of Applied Arts of 1896. This building centres on a circular court with a glass roof, surrounded on two floors by a series of Islamic Indian cusped arches (plates 24.1 and 24.2).

On many of his commissions Lechner collaborated with the renowned Hungarian ceramics firm of Zsolnay, which supplied decorations for the interior of the Museum of Applied Arts in a similar mixed East-West mode. Zsolnay's designs, although maintaining a floral style reminiscent of folk art, also included Islamic geometric abstract motifs and meandering arabesque patterns. Zsolnay's production was not confined to architectural ceramics, but included domestic wares in the 'Hungarian style'.[9] The overall shape of the 1902 Zsolnay vase (plate 7.7) is sophisticated, bearing more than a passing resemblance to the Persian 'swan-necked' flasks, but the painted design of the onion is simple, almost naïve in style, suggesting inspiration by folk art forms.[10] The illustration also subtly echoes the shape of the vase, and the characteristic 'whiplash curve' is indicated in the curved *saz* leaf design. This vase synthesizes nature and art, but maintains simplicity, containing at the same time the slightest hint of both Eastern and folk origins. Zsolnay also produced lustred ceramics, for which the factory was particularly well-known. For the decoration of these, the potters drew upon the Persian and Hispano-Moresque traditions of lustreware in both glaze, colour scheme and choice of motifs. Nevertheless, as in the work of Lechner, here also Oriental influence was modified and adapted by the need to establish a distinct style which was both individual and national.

In the figurative arts Islam represented different ideas altogether. The 'whiplash curve' was not only the line of nature, but also described the line of a woman's body, hair or drapery. Visual connections were made between femininity and nature in art throughout the Art Nouveau period (see chapter four). By implication, masculinity became more identified with science and the control over nature sought by the Symbolists of the 1880s. Portrayals of Oriental women in particular were seldom free from both erotic and exotic associations. More than any other part of the Eastern world, the Islamic Orient, through the genre of Orientalist painting and literature, had long represented luxury, mystery and an uncontrollable female sexuality. The latter, in an era when issues of sexuality assumed a greater than usual importance, was seen as at once irresistibly attractive and frighteningly repellent. Although in writings by Western women of this period the Oriental

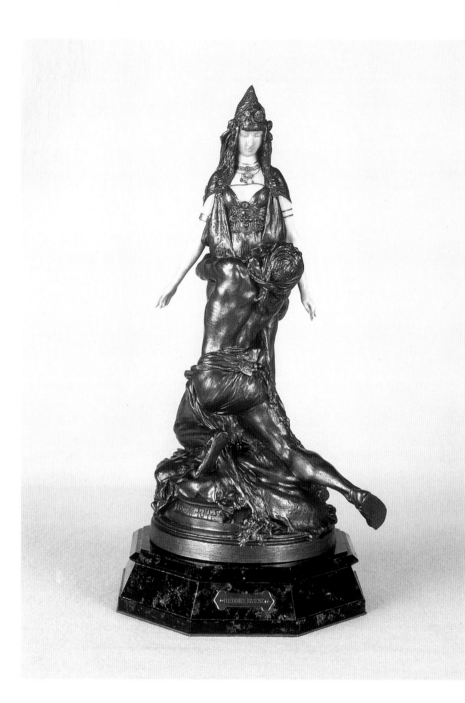

7.8 Théodore Rivière, *Carthage* or *Salammbô chez Matho*. Ivory and bronze painted gold on marble base. French, *c.*1900. Brighton Art Gallery and Museums: The Royal Pavilion.

in word and image at the *fin de siècle* made a major contribution to the vision of woman seen repeatedly in Art Nouveau images. All these figures originated from North Africa and the Middle East, although none of them were Muslims, but they were all imbued with the characteristics ascribed to women of the Islamic Orient. Although the novel *Salammbô* by Gustave Flaubert was written in 1862, the heroine features prominently in the portrayal of women in the Art Nouveau era. Flaubert himself had travelled in Egypt and written extensively in his journals of his encounter with the dancer and prostitute Kuchuk Hanem, who was profoundly influential on his later writings. He viewed Oriental women as forever unknowable and the character of Salammbo in the novel reflects this. Impassive, unattainable and mysterious herself, she unleashes fatal passion in others.

The statuette by Théodore Rivière (plate 7.8), known both as *Salammbô chez Matho* and *Carthage*, is a typical portrayal of the Oriental woman of this period. Simplifying the complexities of the novel, the statuette evokes instead a symbolic surrender of man to the eternal *femme fatale*. Matho, the Libyan captain who eventually dies a terrible death for Salammbo's sake, kneels, grasping her round the waist in his unrequited desire, while she looks down calmly, clad in her exotic regalia. Rivière, like Flaubert and so many other artists and writers of the time, travelled in North Africa for three years and his entire body of work reflects his fascination for Eastern subjects and Eastern women. Interestingly, the figure of Salammbo in this particular context may have a more contemporary relevance than might first be assumed, as, according to one source, it was modelled on Sarah Bernhardt in a scene from the play *Carthage*.[12] The accuracy of this is questionable, as other sources[13] do not confirm that she appeared in a play of this name, but it is possible because Bernhardt herself to an extent partook of the role of exotic *femme fatale* during this era. She was Jewish, therefore of the same Semitic race as the Arabs, her persona was Romantic, flamboyant, larger-than-life, and she was noted for her numerous lovers. As a brilliant actress, she was also adored and came almost to symbolize France itself, but still retained an element of mystery to her public. Thus, the Rivière statuette could represent the worship of both Salammbo and Bernhardt rolled into one.

Oscar Wilde also chose to explore sexuality in the context of the exotic Orient, through the figures of the Sphinx and Salome. Wilde's long poem *The Sphinx* of 1894 visualizes this creature as an 'exquisite grotesque, half woman and half animal'[14] with her 'black breasts … [and] … mouth

woman could symbolize an intellectual and physical liberation,[11] the voluptuous dancer/bather/courtesan of the harem was still the most persistent type of the Islamic female portrayed. This was further borne out by the new translation into French of the *Arabian Nights* (*Le Livre des mille nuits et une nuit*) by Joseph-Charles Mardrus which, although claiming to be an accurate translation from the Arabic, was in fact the author's own adaptation, placing far greater emphasis on sex than the original.

The characters of Salammbo, the Queen of Sheba, Herodias, Salome and the Sphinx all appeared in Symbolist and Decadent art. Portrayals of these legendary women

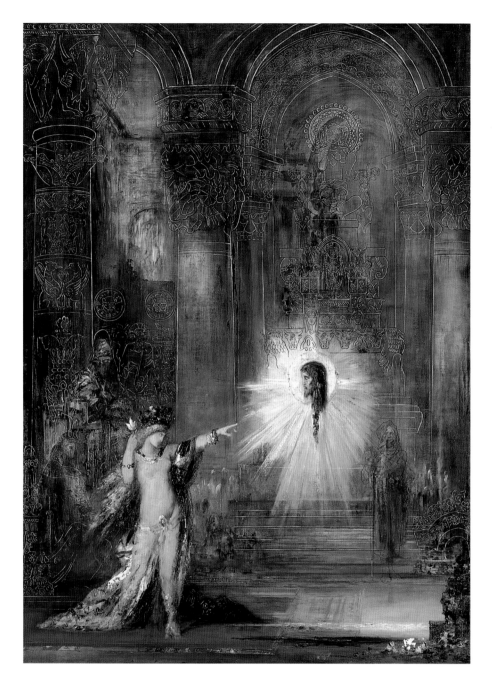

7.9 Gustave Moreau, *L'Apparition*.
Oil on canvas. French, 1876.
Musée Gustave Moreau, Paris.
© Photo: RMN-R.G. Ojeda.

of flame'.[15] She is an ageless mystical figure loved by the pagan gods of Asia, who fascinates but finally revolts the narrator. This work makes explicit the dislike and fear of female sexual power which features in works of the period, the animal nature of femininity becoming literal as well as metaphorical. However, in his notorious play *Salome* of 1892, Wilde expands his vision to equate female sexuality with destruction and death. One of his chief inspirations was Joris-Karl Huysmans' description in *A Rebours* of Salome as portrayed in an oil painting by Gustave Moreau: 'the symbolic incarnation of undying Lust …'. Moreau, inspired by Indian and Persian miniatures for

many of his incandescent paintings, achieved the effect of emphasizing the dangerous seductiveness of Salome by the concentration of glittering colour and the play of light on her jewellery and skin (plate 7.9).[16] Similarly, Wilde wanted his Salome to be 'the cardinal flower of the perverse garden'.[17] The best-known visual images of Salome are by Moreau and Aubrey Beardsley (plate 1.9), the latter being illustrations for Wilde's play. Although these use the Japanese style, with heavy areas of black combined with intricate detailing, the woman portrayed in this fashion is never suggested to be Japanese. Despite the popularity of Japanese art and Beardsley's admiration for erotic *shunga* prints, the over-riding image of Salome is as an Arab belly dancer. Images such as these had their roots in evolving contemporary debates on sexuality and the changing role of women, so it might at first appear incongruous that an Oriental, more specifically Middle Eastern or North African, woman in a mythical setting is so often depicted in this context. The Islamic East and women in general could both represent nature, but the Eastern woman was specially endowed with a combination of mystery and sexuality which made her irresistibly appealing at the end of the nineteenth century. Similar qualities may partially account for the extreme popularity of the dancer Loïe Fuller. Though she was American and not directly associated with the Orient in any way, she was still a highly exotic and mysterious figure on stage. Illuminated by multi-coloured electric lights, she wore diaphanous veils which described an endless succession of arabesque curves as she moved. Her show formed one of the highlights of the *Exposition Universelle* of 1900 in Paris and she was depicted by prominent artists throughout Europe.

The Porte Binet, the monumental entrance to the 1900 *Exposition Universelle*, may be said to bring together all the themes of this chapter. This extraordinary edifice resembled a hybrid between a Moorish gateway and a Mughal Indian tomb, with Persian- and Byzantine-style ceramic decoration in brilliant colours (plates 7.10 and 7.11). Yet despite its lavishness and exoticism, it was also a nationalist statement intended to represent the emergence of France into modern life. It had a statue of a woman representing *La Parisienne* on the top of the dome and, inside, a figure of Salammbo as the personification of electricity. At the time, the whole structure was widely disapproved of as decadent, pretentious and 'too Oriental, Indian or Persian and therefore Colonial rather than cosmopolitan'.[18] The architect René Binet, despite his admiration of Moorish architecture on his travels in Spain and North Africa, had not intended to make a statement of exoticism. His special interest was

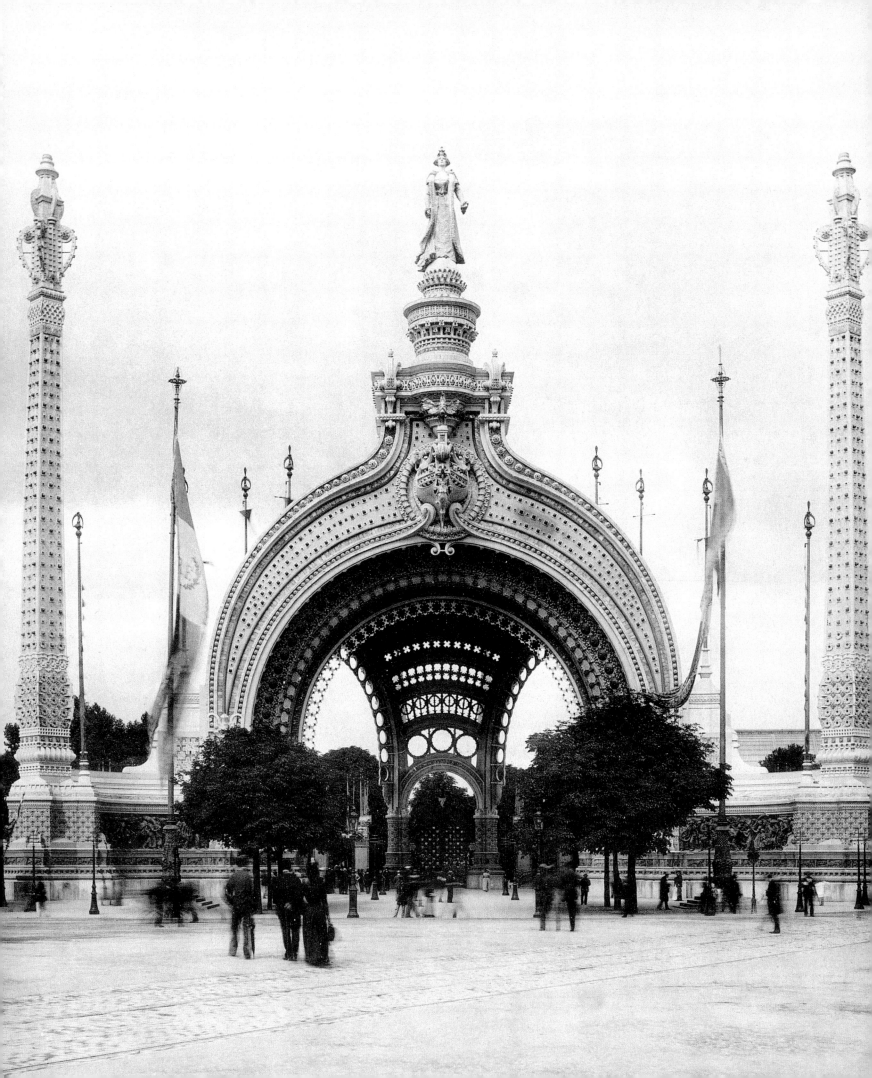

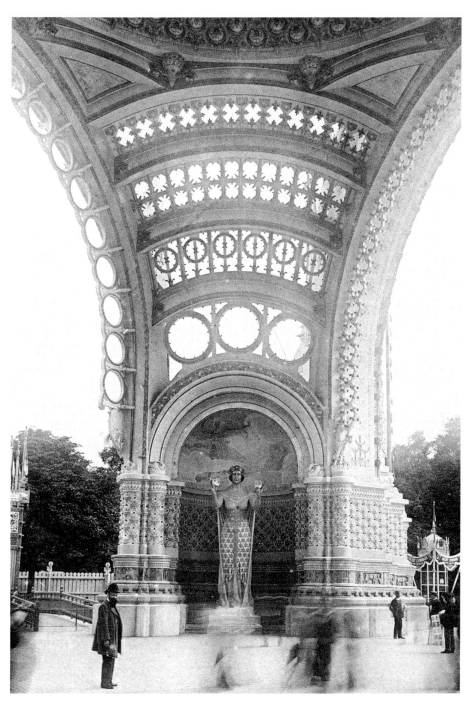

in the structures of nature, and he also wanted to create a celebration of the advance of science, as 1900 was the first time a French International Exhibition had been illuminated by electric light. Like the others discussed in this chapter, however, he chose to express these concerns through an Islamic visual language.

A possible answer as to why Binet considered an Islamic style suitable for the expression of his vision, in this most public and universal of contexts, lies in the fact that although Islamic design was used in some instances as part of a representation of history, it usually had an ahistorical quality. Unlike the other major Oriental culture represented in Art Nouveau, that of Japan (which was seen as more amenable to Westernization), the Islamic countries were still widely viewed at the end of the nineteenth century as being located outside time and, therefore, incapable of 'progress'. It may have been because this perceived quality of timelessness – which led to such eternal concepts as nature, sexuality and mystery being ascribed to Muslim civilizations (quite apart from the genuinely timeless aesthetic appeal of the art and architecture) – answered so many contemporary needs. Could Binet have chosen an Islamic style for the ultimate statement of modernity at the dawning of a new century because electricity, although it represented technology in 1900, also represented mystery and seemed, according to contemporary writers, like a fairytale vision from the *Arabian Nights*?[19] If so, what more suitable style than the Islamic, and what more fitting image than Salammbo, Flaubert's mysterious heroine, who symbolizes nature, danger and beauty?

7.11 Porte Binet, interior
showing Salammbo statue.
Exposition Universelle, Paris, 1900.

7.10 Porte Binet. *Exposition
Universelle*, Paris, 1900.

Paul Greenhalgh

Le Style Anglais:
English Roots of the New Art

It is a sobering fact; Art Nouveau was the first great international style
since the Middle Ages (and the last of course) to which Britain made
any perceptible contribution. (Sir Lawrence Gowing, *Observer*, 5 July 1969)

8.1 Owen Jones,
Plate from *The Grammar of
Ornament* (London, 1856).
V&A: 111.Q.18.

In an essay of 1862, French novelist, poet and artistic commentator Théophile Gautier wrote that 'art in England can scarcely be regarded as a plant indigenous to her soil, but rather as a lately imported and carefully cultivated exotic'.[1] Of all the European schools, he mused, the English was 'the least known' and that within mainland Europe 'scarcely any thought had been bestowed on the number, the talent or the importance, of the artists whom that school comprised'.[2] This scenario of England as an unknown and unloved culture was undoubtedly too harsh. The author (significant in the present context as pioneer of the philosophy of *l'art pour l'art*) was well aware that English fine and decorative art had periodically been fashionable and influential in Europe. Nevertheless, his words rang true at the time he wrote them. There *was* scepticism about the consistency and quality of English art; the Channel *was* believed to be a cultural as well as a natural barrier, not only by mainland Europeans, but also by the English themselves. Gautier noted that the English believed that they had 'naturally and nationally, no kind of aptitude for the fine arts'.[3] Willingness to imitate and patronize foreign – especially French – models was common to all genres. Even Queen Victoria, who might have been expected to stand by British culture through patriotism, if not taste, in 1855 declared a preference for French décor.

The mid-century English were in many ways the cultural outsiders of Europe. Gautier, an anglophile, recognized that they were somehow 'in it' but not 'of it', a race that had always been there but that had not been fully absorbed into the European milieu. Industrialism had, it seemed, simultaneously bestowed wealth, 'otherness' and, perhaps, barbarity. However, by 1890 the cultural outsiders had advanced dramatically. The English had come to enjoy the status of being a leading nation in the visual arts, and particularly in the decorative arts. Their influence became a central feature of most informed schools of thought, with critics and taste-makers – and especially those associated with innovation in design – acknowledging England as a key source of new images and ideas.

The English contribution to the formation of the Art Nouveau style was universally acknowledged. In 1897, for example, in a discussion of Belgian examples of the style, critic Octave Maus sardonically noted that 'it is charming and – a rare thing – it is not English'.[4] At the *Exposition Universelle* in Paris in 1900, the President of one of the juries, George Donaldson, recognized the pervasive presence of 'the New Art movement which commenced in England'.[5] *Le Style Anglais* had become a revered commonplace. In an age when cultural difference was increasingly valued at the radical end of the arts, the 'outsiderness' of the English added to their attraction. The industrial barbarians had seemingly translated themselves into Northern exotics, by producing objects that appeared to move on from the hackneyed use of mainstream historical styles.

Assessing the contribution of England to the New Art, Julius Meier-Graefe, in an essay of 1908, noted that 'English culture … passed into modern materialism more rapidly than that of any other nation'.[6] His point was well made. As the first nation to have an Industrial Revolution, Britain in the opening decades of the nineteenth century experienced what many nations experienced only towards its end. First to exploit fully the possibilities of industrial and economic growth, the British also were the first to discover the consequences (good and bad) of 'modern materialism' on life. It did not lead, for example, to cultural unity. There was a gaping divide in Victorian England between those who supported industrial progress and those who opposed it. The supporters embraced post-Enlightenment Rationalism, while opponents were part of the broad lobby

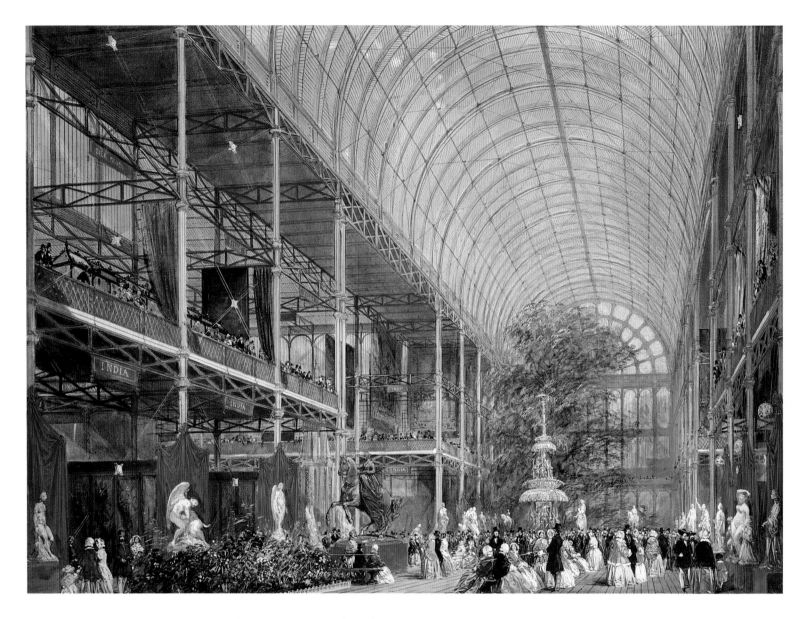

8.2 Joseph Nash, *Interior of the Great Exhibition*. Watercolour and body colour. English, 1851. V&A: 73–1898.

that had inherited the mantle of the Romantic movement of the late eighteenth century. Supporters believed humanity would be reinvented by the machinery of scientific progress, but opponents felt it would be destroyed by it. Both groups were responding to the consequences of modernization and wanted to change the condition of the world for the better, but from radically opposed stances. This divide was a strong mediating force in the world of decorative art.

The Romantics undoubtedly had the most powerful and direct impact on Art Nouveau. Speaking of its origins in 1902, Siegfried Bing confirmed that, 'the initial movement … began in England, under the influence of the Pre-Raphaelites and the ideas of Ruskin, and was carried into practical affairs by the admirable genius of William Morris'.[7] In citing these, he was identifying Art Nouveau

with the oppositionalism of the English Romantic tradition. It would be wrong, however, to discount the significance of the Rationalists entirely, as they created the conditions in which the development of visual culture could properly take place. Those who embraced industry and sought to improve English culture by allying it with art were driven by altruism but also by commercial good sense. It was widely recognized that the improvement of the arts would benefit humankind; it was also believed that good design led to improved trade. Pioneer industrial designer Christopher Dresser explained this belief very simply: 'to the nation it saves impoverishment'.[8] The Rationalists were also driven by educational motives. It was understood that before good designs could be produced, someone had to produce good designers. Sir Robert Kane, musing in 1854 on the issue of international competition in trade and

industry, worryingly acknowledged that: 'even in England, so proud, and so justly proud, of her industrial power, it has been recognized that, to preserve, or to regain, her pre-eminence in many branches of trade, she must have artisans and employers of much higher and more cultivated intelligence than she now has'.[9]

The average industrialist believed design to imply no more than the application of decoration to the surfaces of objects. Technology could be used to stamp, mould or electroplate any number of motifs onto things. These would usually be randomly selected from the history of ornament, the quality of the object being routinely measured by how much could be crammed onto its surfaces. Those concerned with what became known as 'Design Reform' began the drive away from this arbitrary use of historical styles, preaching the virtues of restraint and control in the application of ornament. They believed that historical sources should be applied logically; that colour and pattern should be considered as a unifying element in the object; that natural forms should be used in a restrained and controlled way; and that all ornament should respect the purpose and role of the object on which it appeared.

Design Reformers enjoyed the patronage of major cultural and political institutions, including Parliament, the monarchy and the Civil Service. Most famously, Albert the Prince Consort took a lively interest in the improvement of design and architecture. He was well supported by leading cultural mandarins. Henry Cole (the first director of what was to become the Victoria and Albert Museum) and Richard Redgrave (President of the Royal Academy), for example, embraced Design Reform, and both produced designs of their own and wrote books on the principles of ornament. The achievements of this institutional lobby were considerable. Schools of Design were established and a Museum of Ornamental Art (renamed the Victoria and Albert Museum in 1899) was founded for the education of artisans, designers and the wider public.[10] This was also the great age of publication on design and the decorative arts. A large library of highly illustrated volumes appeared in the second half of the century, preaching the ethos of 'appropriate design'. The most famous, and perhaps the best of these, was *The Grammar of Ornament* (1856) by Owen Jones. In this volume, Jones first set out some 37 General Principles on the 'arrangement of form and colour in architecture and the decorative arts' before providing superb illustrations of the decorative art of all cultures (plate 8.1). The real triumph of Design Reform, however, was the Great Exhibition of 1851 (plate 8.2). This has long and rightly been hailed as a key cultural event in nine-

teenth-century Britain. Staged inside the glittering walls of the Crystal Palace, the Exhibition, despite the confusion of styles evident in many of the exhibits on display, established England as a cosmopolitan player in the world of architecture and design.

The activities of the Design Reformers created an environment that allowed creative design to flourish. It is difficult to imagine the development of a *Style Anglais* – a national design culture of international repute – in its absence. But there were voices that rang far louder than those of the Design Reformers during the period, voices that were utterly opposed to capital-driven technology and the commercialization of art. These voices railed against the idea of art harnessed to industry, and regarded the Crystal Palace as a 'giant cucumber frame'.

The first and loudest of these voices belonged to John Ruskin. For him, art was not a matter of appearances only, it was the basis of civilization. His intense and passionate prose placed creativity, which he believed to be synonymous with the human spirit, at the heart of all civilizations. Art was the manifestation of this spirit in physical objects. He believed that the way in which the mass of people were forced to live and work in industrial England had debased humanity, that the economy had run awry of human needs and that modern life had, to use his word, 'unhumanized' the masses. Following an intellectual trend initiated by Thomas Carlyle, he believed work was the central reason for existence: 'there are three things to which man is born – labour, and sorrow, and joy'.[11] Work was the glue that held societies together, that gave direction to life and the means by which individuals came to know themselves. He believed that the kind of work people did dictated the type of society that resulted. Art, and more specifically craftsmanship, was creative work, and creative work led, for him, to a proper society. He placed craftsmanship at the centre of what he termed 'the political economy': 'Observe that in a truly civilized and disciplined state, no man would be allowed to meddle with any material who did not know how to make the best of it.'[12] He advocated pure and simple design, made in humane conditions for communities that were not inexorably driven by consumerism: 'See that you take the plainest you can serve yourself with – that you waste or wear nothing vainly; – and that you employ no man in furnishing you with any useless luxury'.[13] Simplicity in art and design implied, for him, morality and human dignity.

Ruskin's love of the Medieval period and the societies

8.3 Dante Gabriel Rossetti,
Beata Beatrix. Oil on canvas.
English, 1860–70.
© Tate Gallery, London, 2000.

8.4 William Morris, curtain
with peacock and dragon design.
Woven wool. English, 1878.
V&A: T.64–1933.

Ruskin. In Brussels, a young generation of architects built meeting-halls and schools in the Art Nouveau style, inspired in part by his social idealism. Most significantly, in 1892 the Anglo-Belgian artist-designer Willy Finch introduced Henry van de Velde to Ruskin's writings. Van de Velde went on, in his own writings, to infuse Art Nouveau with a Ruskin-like spiritual communalism that owed a great debt to his English forebear.

In the immediate context of England, Ruskin's intellectual example and critical support was important for the group of young idealists who formed the Pre-Raphaelite brotherhood in 1848, and for a young man who entered into their circle in the 1850s: William Morris. The initial Pre-Raphaelite brotherhood consisted of seven young artists who entered into common cause to improve the quality of British painting and sculpture. These were John Everett Millais, Thomas Woolner, Frederic Stephens, William Holman Hunt, James Collinson, William Michael Rossetti and Dante Gabriel Rossetti. Although the cohesiveness of this original group was short-lived (it slid into disarray by 1852), Pre-Raphaelitism drifted on in many forms throughout the century and was still a force of international interest in 1900. Many other artists, and perhaps most famously Edward Coley Burne-Jones, became associated with the movement after its foundation.

In the context of Art Nouveau, Burne-Jones and Dante Gabriel Rossetti are of most significance. Their combination of Archaism and Symbolism gave much Pre-Raphaelite imagery a mystical and almost alchemic quality, allowing artist and viewer to explore simultaneously shared legends and private dream worlds. These features of their work became a powerful influence on painters associated with Art Nouveau. The 'Pre-Raphaelite woman', a mystical and abstracted vision in which the sensual is held in check by the spiritual (plate 8.3), contributed significantly to the formation of 'Art Nouveau woman'.

Perhaps the main importance of John Ruskin and the Pre-Raphaelites was that they helped form the personality and ideas of William Morris, who was to become the most important artist-designer in nineteenth-century England. It has often been remarked that there was not one William Morris but several, each vying for historical attention. At his death in 1896, his obituaries credited him as being designer, artist, poet, political activist, cultural theorist, conservationist and ecologist. His life's work did indeed merit all of these labels. Morris formed his social and cultural world view during the 1850s. He attended Oxford University from 1853, where he moved

that created the great Gothic cathedrals stemmed from his vision of communities tied by religion and creativity. For him, modern industrial practices (especially the division of labour) had destroyed the possibility of creative work for most people, and in doing this, they had also eliminated the possibility of a proper society or art. Indeed, he perceived the alienation he sensed all around him to have stemmed from the rational exactitude of mechanization. The choice was simple: 'You must make a tool of the creature or a man of him. You cannot make both.'[14] The message was a powerful one, and inspired Art Nouveau architect-designers as geographically and aesthetically diverse as Louis Sullivan, Émile Gallé, Josef Hoffmann, Ödön Lechner and Antoní Gaudí to express their debts to

8.5 William De Morgan, group of three vases. Earthenware with lustre glazes. English, 1888–98. V&A: 860–1905; C.414–1919; C.413–1919.

they demonstrated this in the form of masterworks in most media. William De Morgan, for example, a master potter closely associated with Morris, combined Near Eastern, Medieval and natural sources to create some of the most influential ceramics of the late nineteenth century (plate 8.5). But it was Burne-Jones, more than any other artist of his generation, who successfully carried the imagery developed in his painting across all the arts. His designs for textiles, painted furniture, stained glass, ceramics and book illumination were a key element in the success of the company (plate 8.6).

The immense stature Morris enjoyed in the *fin-de-siècle* world was much to do with the way he combined his artistic skills with a powerful political commitment. Accepting much of Ruskin's social critique as a given, Morris rejected his solutions to society's ills – the older man favoured the establishment of a kind of benevolent monarchy – and committed himself, during the early 1880s, to socialism. This was a socialism which placed individual human creativity at the heart of society and promoted the idea that art belonged to all, and was a necessity of life:

> I do not want art for a few, any more than education for a few, or freedom for a few … . No, rather than art should live this poor thin life among a few exceptional men, despising those beneath them for an ignorance for which they are themselves responsible … rather than this, I would that the world should indeed sweep away all art for a while … rather than the wheat should rot in the miser's granary, I would that the earth had it.[15]

Such statements gave the contemporary decorative arts power and direction, they enabled designers all over *fin-de-siècle* Europe to reinvent themselves as leaders in a revolutionary cause.

Largely through Ruskin and Morris' example, during the 1870s the handicrafts increasingly became a vehicle used by practitioners of all types to express their unease at both the condition of art and design and the state of society. The making of objects was used as a means to demonstrate a rejection of the socio-political order and the artistic practice of the day. The emphasis was on the relationship of art to life, expressed succinctly at the time by the designer Arthur Heygate Mackmurdo: 'I lay stress upon this alliance of art to life, because of the reliance of all art upon life, and of all life upon art in some form.'[16] Practitioners began to meet, then exhibit and publish. Their objects and ideas formed a distinct lobby in English artistic life, and they created organizations to give direction to their efforts. Following the model of the pioneering St George's Guild, established in 1871 by Ruskin and

in the Pre-Raphaelite circle and formed key friendships, most notably with Burne-Jones and D.G. Rossetti. In 1856, he received some architectural training in the London office of the Gothic Revival architect G.E. Street. During this time, he fell deeply in love with the Medieval and Gothic periods, and absorbed the ideas of Ruskin. In 1861, determined to engage fully with the material world, he founded Morris, Marshall & Faulkner, his first company, for the creation of decorative arts. This became Morris & Co. in 1874.

Morris developed into a brilliant designer with the rare ability to orchestrate the work of others. Apart from his love of Medieval art and architecture, he also had a passion for vernacular forms and the arts of the Near East. He combined these with his first and most enduring source – nature. Perhaps his own genius in design was most fully manifested in his two-dimensional pattern-forms. His textiles and wallpapers remain his greatest legacy to art. His organic structuring of nature was a major contribution to the formation of the Art Nouveau style (plate 8.4). He and his circle passionately promoted the idea that art and decoration are synonymous, and

followers, artists and designers mobilized into guilds and companies. The more prominent included the Century Guild, formed in 1882 by A.H. Mackmurdo and others; the Art Worker's Guild, formed in March 1884; and the Guild of Handicraft founded in 1888 by C.R. Ashbee.

Most significant was the creation of the Arts and Crafts Exhibition Society, which opened its doors at the New Gallery in Regent Street in October 1888. Seminal exhibitions, held annually at first and then triennially, consolidated the disparate efforts. Walter Crane, a leading light in the Art Worker's Guild, commented in a lecture in Liverpool in 1888 that:

> I am associated with a movement in London … the
> immediate outcome of which has been an exhibition of
> the Arts and Crafts with the object of ascertaining to some
> degree … our artistic condition in the applied arts, and
> amount of genuine public interest in them, as distinct
> from picture painting.[17]

Thus 'Arts and Crafts', a phrase reputedly invented by Thomas Cobden-Sanderson at an Art Worker's Guild meeting, had become a movement, and, as Crane's telling reference to 'picture painting' revealed, the movement was aggressively committed to the elimination of the divide between fine and applied art. Practitioners believed themselves to be in a class war: 'All art has been rigidly divided into classes, like the society it reflects. We have the arts all ticketed and pigeon-holed on the shelves behind us.'[18] A plethora of organizational activity saw the foundation of workshops, companies, schools and guilds all over the British Isles from the early 1890s. Despite their initiation in the major cities, such as London and Birmingham, all these groups tended to have rural aspirations. In the last years of the century, many craftspeople relocated to the countryside in search of the perfect balance between art, nature and community. The Cotswolds, in the West of England, was a favourite region for such experiments. In

8.6 Edward Burne-Jones, 'Ladies and Animals' sideboard. Deal with oil paint and gold and silver. English, *c*.1860. V&A: W.10–1953.

8.9 C.F.A. Voysey, woollen double-cloth. English, 1897. Woven by Alexander Morton & Co. V&A: Circ.886–1967.

8.8 Arthur Heygate Mackmurdo, title page of *Wren's City Churches*. English, 1883. V&A: 34.E.78.

8.7 Arthur Heygate Mackmurdo, chair. Mahogany and leather. English, 1882. V&A: W.29–1982.

Surrey, the village of Haslemere was virtually reinvented through the influx of craft idealists; several companies and a Peasants Art Society and Museum were founded there.[19]

Arts and Crafts objects had a distinctive appearance, due to the principles that developed around the making process. First, and most significant, was the idea of 'truth to materials'. Makers insisted on using materials only in ways that complemented them. Wood had to be used in a way sympathetic to wood and the finished product had to celebrate wood as a material; similarly metal, glass, ceramic, textiles and graphic work. The inherent qualities of each had to be at the centre of aesthetic expression; illusion and imitation were rejected. Clean profiles, exposed structures, flat planes of colour and rigorous simplicity were the hallmarks in all media. The desire was to make objects that were simultaneously beautiful and 'truthful'. The most important sources at work in Arts and Crafts objects were nature and folk art. The stylization of nature crept into the *oeuvre* of virtually every major designer. Plants, leaves, flower heads, fruit and vegetal forms were transmuted into flat, organic shapes, providing pattern-forms, decorative features and even the overall form of objects. The bold, simple forms of vernacular expression were appropriated for their apparent wholesome honesty (see chapter two). The movement broke cleanly with the reliance on historical styles that dominated nineteenth-century decorative art.

A.H. Mackmurdo was one of the first of the Arts and Crafts designers to develop a mature individual style. His chair of 1882 is a powerful example of early Arts and Crafts values (plate 8.7). Although in overall form it barely broke free of the eighteenth-century models that

still dominated the trade, the back of the chair is a stirring example of free-form use of nature. The lyrical yet energetic flow of the plant forms, which appear to be blown or dragged by wind or water, has been cited by many historians as one of the most important anticipations of Art Nouveau. Similarly, his illustrations for his book *Wren's City Churches* are charged with fluid yet vigorous movement (plate 8.8).

Mackmurdo's significance lay at the start of the Arts and

Crafts movement. The work of C.F.A. Voysey reveals the fully mature style. Voysey's domestic architecture seamlessly fused his vision of nature with forms derived from vernacular building. The elegantly massed triangles and cubes of his houses, poised and balanced in brilliant asymmetry, were widely published in Europe and effectively led to the creation of an international Arts and Crafts domestic architecture. His impact can be witnessed in early Art Nouveau houses all over the world. His brilliance is perhaps most obvious in his flat-pattern designs (plate 8.9). His subjection of plant form to the gentle rigours of geometry allowed him to develop the sense of organic growth, while never losing the grid of the pattern. Nature here is flowing and yet in an ordered tension.

Walter Crane was probably the most active proselytizer of Arts and Crafts values. His numerous illustrated books

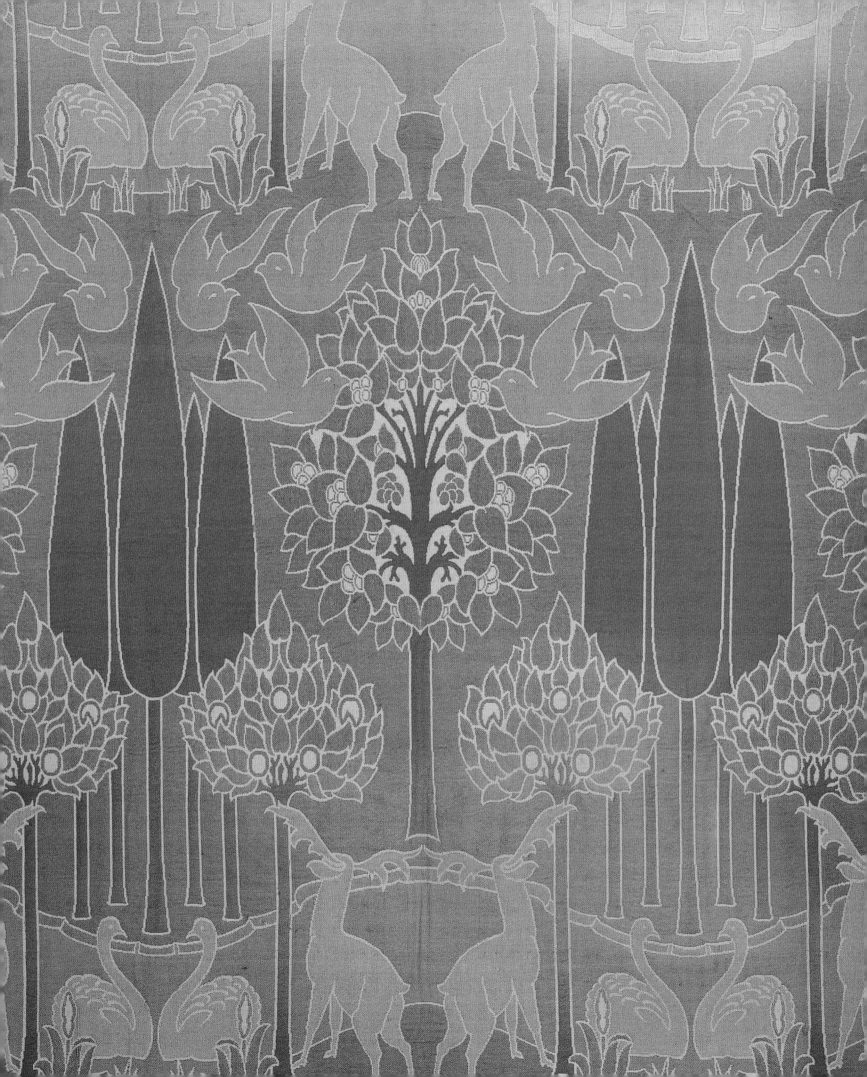

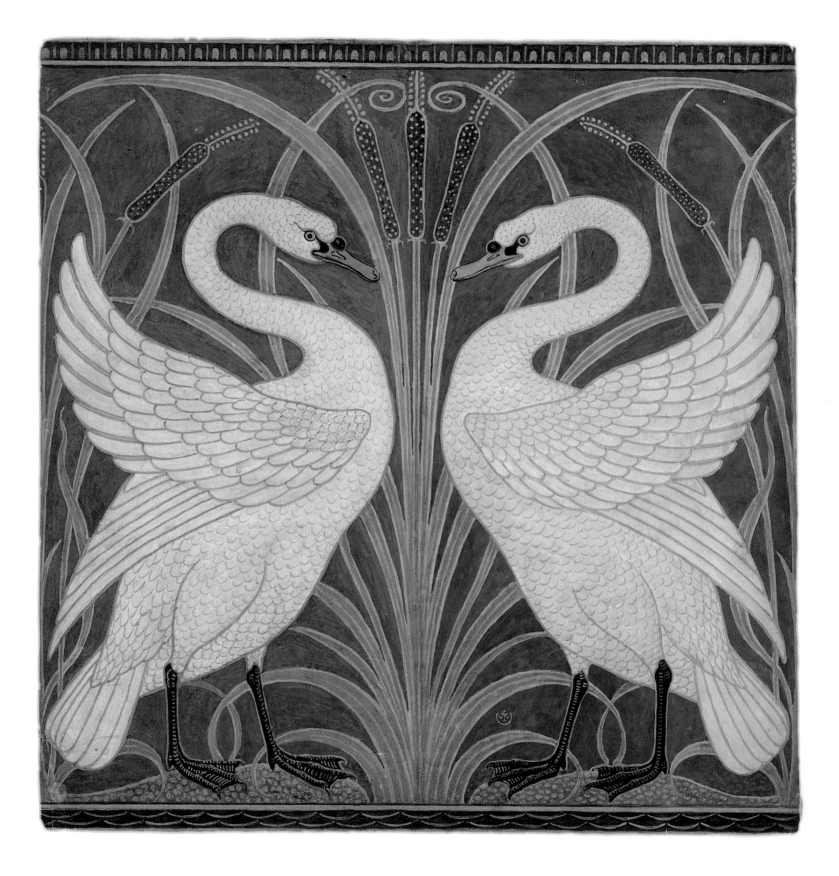

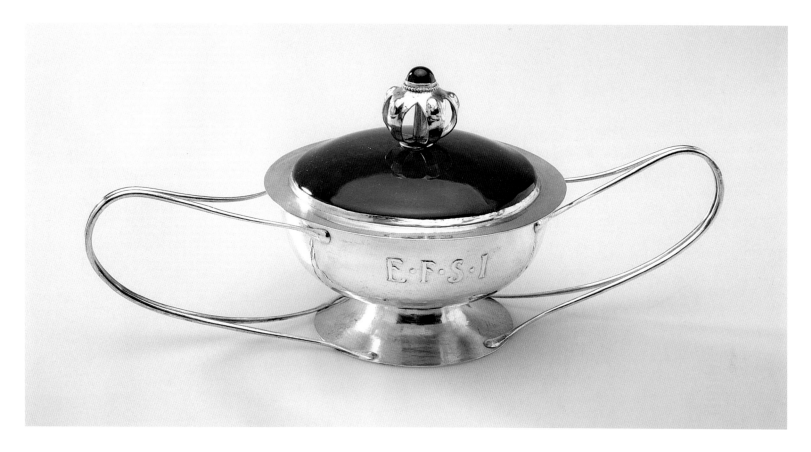

8.11 C.R. Ashbee, bowl and cover. Silver and enamel set with a cabochon. English, 1900–01.
V&A: M.44+A–1972.

8.10 Walter Crane, design for *Swans* wallpaper. Gouache and watercolour. English, 1875.
V&A: E.17–1945.

were widely translated. It was through him as much as through Morris that decorative art and socialism were irrevocably tied. Essentially an illustrator and flat-pattern designer, he became a widely acknowledged designer of surface designs for a wide range of objects, including wall-paper (plate 8.10), books, architectural décor, metalwork and ceramics. At the turn of the century, his reputation in Europe was so pronounced that a huge retrospective exhibition toured Austria, Hungary, Germany and Italy.[20]

C.R. Ashbee, the Director of the Art Worker's Guild, was scarcely less of a polemicist for the movement. He moved his Guild out of London in 1902 to found an experimental community at Chipping Campden, in the rural calm of the Cotswolds. He wrote and lectured extensively, visited the United States in 1901 and met Frank Lloyd Wright. He produced some of the most important Arts and Crafts objects in silver, his mature *oeuvre* exuding an understated calm. A central feature of his work was a simple, eloquently abstracted naturalism, with plain, continuous surfaces occasionally punctuated by a raised feature or attached element (plate 8.11).

The Arts and Crafts movement is probably better described as an attitude rather than a style, an approach to making – and living – that became influential all over the world after 1895. Idealist communities sprang up in places as varied as Finland, the United States, Germany, Hungary and Russia, and many publications were produced, circulated and translated. All this carried the anti-industrial, anti-capitalist ethos of Romanticism into the realm of the decorative arts, and pulled artistic practice into everyday life. More than this, it provided makers with a philosophy that empowered them as individuals to shape their own lives and work.

Long before this triumph, however, as the Arts and Crafts movement was first forming, a volume was published in London in 1882 that described another movement active in London. Walter Hamilton's *The Aesthetic Movement in England* told the story of a loose gathering of intellectuals, poets, writers, artists and designers who had, throughout the previous decade, been styling themselves 'Aesthetes'. Invented more in the Salons and soirées of fashionable, educated London than in the abodes of actual practitioners, the Aesthetic movement was as much concerned with the way art was perceived as with how it was made. In Hamilton's words, Aesthetes were individuals 'who pride themselves upon having found out what is really beautiful in nature and art, their faculties and tastes being educated up to the point necessary for the full appreciation of such qualities'.[21] The

Aesthetic movement grew as a phenomenon through the 1870s, and, by 1880, it was so famous that it had received the dubious honour of being lampooned in *Punch* magazine as well as being the unwitting subject of the Gilbert and Sullivan light opera, *Patience*. Its two most famous – and infamous – leaders were the writer Oscar Wilde (plate 8.12) and the painter James Abbott McNeill Whistler. Despite many of its leading figures' admiration for the products of the Pre-Raphaelites, William Morris and the Arts and Crafts movement, the outlook of the Aesthetic movement was very different.

Aestheticism was essentially a manifestation of the idea of *l'art pour l'art* (art for art's sake). First fully articulated by Théophile Gautier in the preface to his novel *Mademoiselle de Maupin* in 1835, and developed later by Charles Baudelaire, this philosophy crossed the Channel in the second half of the century. It quickly became central to the vision of those artists and writers who believed art to be an end in itself, with no wider social or moral implications. Algernon Charles Swinburne's *Poems and Ballads* of 1866 is generally recognized as the first full blooded expression of *l'art pour l'art* in Britain. Walter Pater, a retiring Oxford don, further developed the position in his volume *The Renaissance* (1873). This was regarded by a generation of Oxford undergraduates, including Wilde, as being a vital text for the unlocking of art. Influenced by German and French writers of the previous generation, Pater placed the individual, and individual experience, at the epicentre of artistic practice. He affirmed that artistic styles were not the product of civilizations but of individuals, and he characterized the role of art as being to do with the absorption of heightened sensations, a kind of disinterested, cerebral hedonism. Affirming that the meaning of life was to be found in 'getting as many pulsations as possible', he provided Wilde and his generation with a clear guide.[22]

Whistler and Wilde, with their dandified mannerisms and frenetic witticisms, embodied the *l'art pour l'art* creed of

Aestheticism. Wilde believed that, 'art has no other aim but her own perfection, and proceeds simply by her own laws'.[23] Having acknowledged their debts to Ruskin, the Aesthetes rejected his belief – shared by Morris and most of the Arts and Crafts designers – that art and morality were fundamentally tied: 'this love of art for art's sake, is the point in which we of the younger school have made a departure from the teaching of Mr Ruskin – a departure definite and different and decisive'.[24] The Aesthetes considered morality and art to be mutually exclusive: 'No artist has ethical sympathies. An ethical sympathy in an artist is an unpardonable mannerism of style.'[25]

Acrimony developed between Ruskinites and Aesthetes. In 1878, Whistler had famously sued Ruskin for libel, for comments Ruskin had made about his painting *Nocturne in Black and Gold: The Falling Rocket*, exhibited at London's Grosvenor Gallery that year. Ruskin said of the painting that he 'never expected to hear a coxcomb ask two hundred guineas for flinging a pot of paint in the public's face'. Whistler won a technical victory; the court case ruined him.[26] Significantly, Burne-Jones supported Ruskin at the trial, asserting in his old friend's defence that 'scarcely anybody regards Whistler as a serious person ... being notoriously without any principle or sentiment of the dignity of his art'.[27] More significant still was William Morris' discomfort with the new hedonism:

> You will find clever and gifted men at the present day,
> who are prepared to sustain as a theory, that art has no
> function but the display of clever executive qualities
> No wonder that this theory should lead them into the
> practice of producing pictures which we might
> pronounce to be clever if we could understand what
> they meant.[28]

He could never accept the validity of a disinterested 'display of clever executive qualities', regardless of the quality of the paint.

The Aesthetic object, be it a painting, a piece of furniture, ceramic, clothing or an entire interior, usually combined a number of sources in a quiet eclecticism, masking a complex mixture of sources behind a veil of simplicity. These might include decorative elements of Attic and Etruscan pottery, Hellenistic and Roman painting, Pre-Raphaelitism, Impressionism, Near-Eastern design, and, most importantly, all things Japanese. Indeed, the archetypal object or image might be defined as a coming together of Japan and the antique. The sources and symbols used were less important, however, than what might be described as the overall sense of charged simplicity. The central aim of the Aesthetic artist or designer was to

8.12 Carte-de-visite of Oscar Wilde. English, late 1880s. Photographed by W&D Downey. V&A: 889–1956.

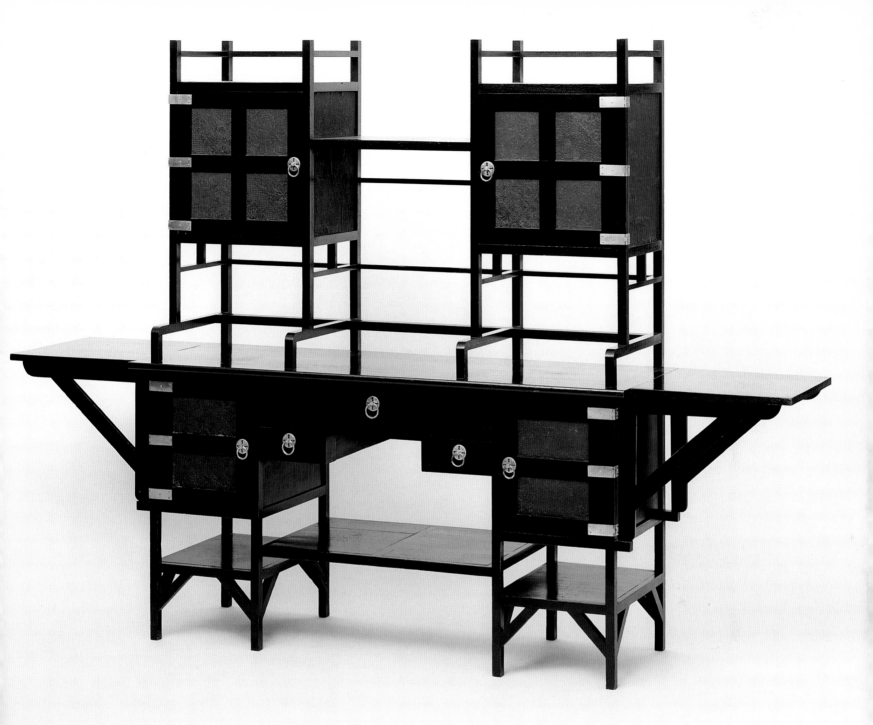

8.13 E.W. Godwin, sideboard.
Ebonized wood and Japanese
leather paper. English, 1867.
V&A: Circ.38–1953.

achieve maximum effect through an absolute economy of means, to exercise restraint in order to achieve opulence.

There was no 'Aesthetic movement' in the sense of a group of unified artists working with common ideals and goals. Instead, artists and designers tended to be critically identified by thinkers like Wilde, whether they approved or not. They would then be absorbed into the Aesthetic canon. Between 1870 and 1890 many diverse practitioners were appropriated in this way. The illustrators Kate Greenaway and Walter Crane; the designers Christopher Dresser, Thomas Jeckyll and Bruce Talbert; the painters, D.G. Rossetti and Albert Moore; the sculptor Alfred Gilbert; the architects Richard Norman Shaw and C.F.A. Voysey, for example, were all herded into the

constellation at one time or another. Some needed no herding, however, and were fully conscious supporters of the ethic. Two of the most unequivocal of these were the architect-designer E.W. Godwin and James McNeill Whistler. Godwin exemplified the aesthetic spirit, especially in his architecture and furniture design. The linear clarity and structural integrity of his famous sideboard, for example (designed at the remarkably early date of 1867) was an example of obsessive restraint (plate 8.13). Masses and voids are juxtaposed and held in place by a balanced framework of horizontals and verticals, as the designer stripped the language of furniture down to its barest syntax. As in so many other products associated with Aestheticism, the Classical and the Oriental are fused in this

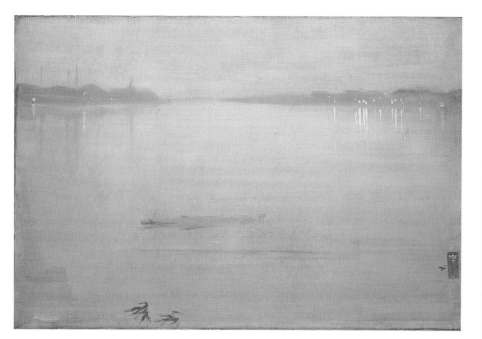

8.14 James McNeill Whistler,
Nocturne in Blue and Silver:
Cremorne Lights. Oil on canvas.
American, 1872.
© Tate Gallery, London, 2000.

8.15 James McNeill Whistler,
Peacock Room for the Frederic
Leyland House. 1876.
Courtesy of the Freer Gallery
of Art, Smithsonian Institution,
Washington D.C.

object. Exhibited widely in Britain, France and Germany, his work had a marked influence on the *fin-de-siècle* generation; in several cases this was decisive. Most pointedly, his poetic geometry affected Charles Rennie Mackintosh in Glasgow and Josef Hoffmann in Vienna.[29]

Whistler had more than art in common with Godwin. They maintained a turbulent acquaintance over many years and even married the same person, Beatrice Philip (Whistler doing so in 1888 after Godwin's death). Whistler became a major figure in London from the early 1870s in advanced circles in art and design. The simplicity of his mature work masked what was a combination of a great variety of sources. He was an early enthusiast of Japanese and Chinese art, was known in Pre-Raphaelite circles and was an admirer of the restrained Classicism of English artists such as Frederic Leighton and Albert Moore. Uniquely, he added to this English concoction a direct knowledge of French Realism and Impressionism, from his years in Paris, counting among his friends Courbet, Manet, Degas and Monet.

Whistler's most unequivocal works were the *Nocturne* paintings from the early 1870s (plate 8.14). These were rigorously emptied out to the point at which their subject-matter was effectively reduced to light and space. Hinted horizons, reflected water, vegetation and figures barely emerge through misted surfaces. Such emptiness shocked Victorian Britain. He was also important as a painter who was interested in decoration. He obsessively controlled the colour schemes of the rooms in which he showed in the Grosvenor Gallery, and he famously designed the Peacock

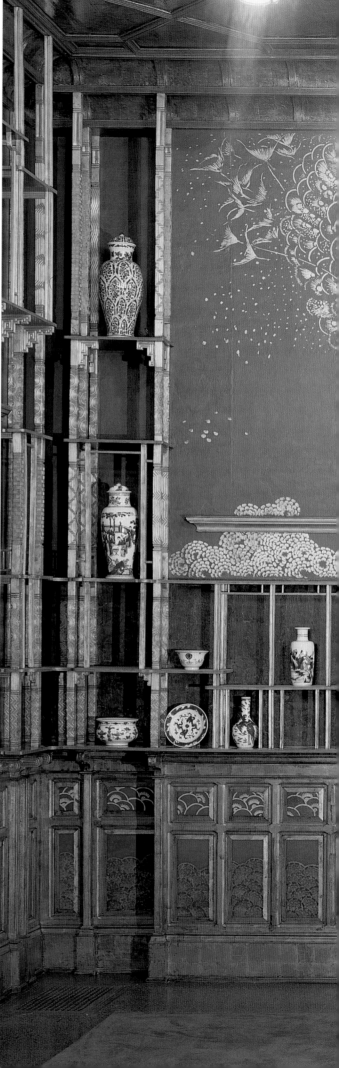

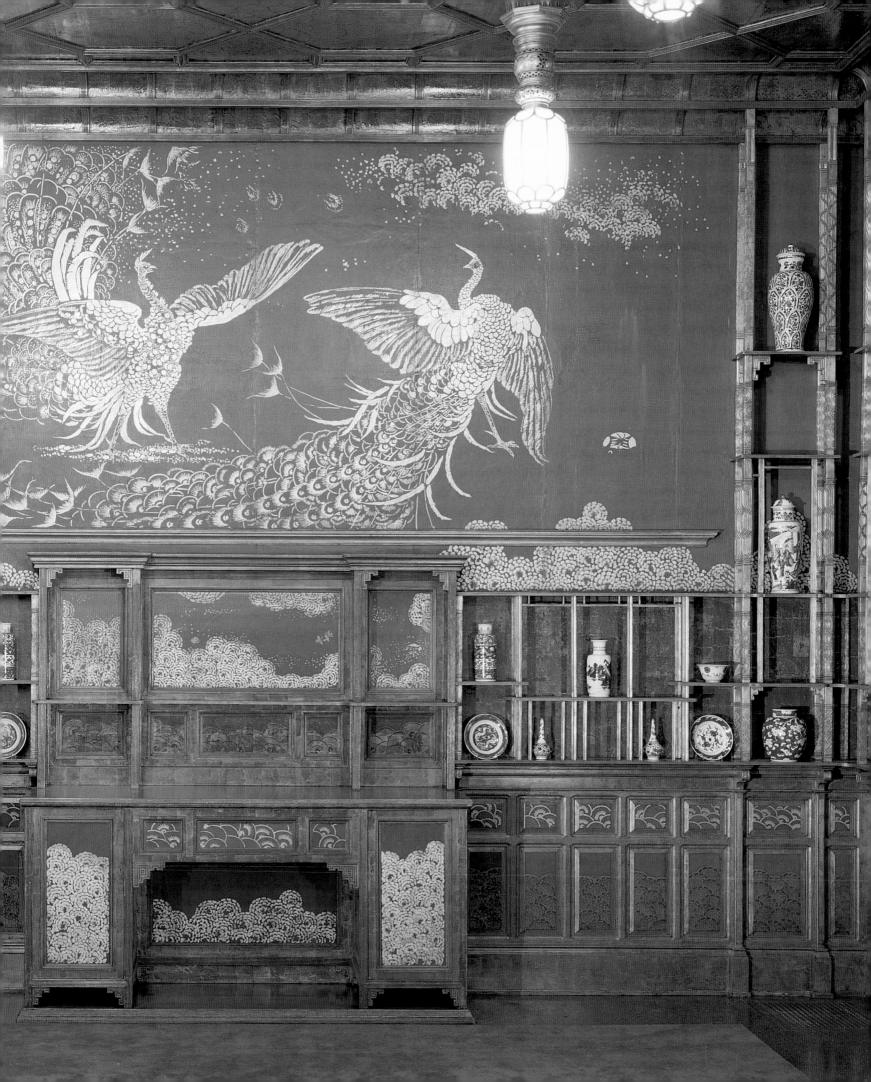

Room in 1876 for the house of his major patron Frederic Leyland (plate 8.15).

However, important as these two artists were, it was Arthur Lasenby Liberty who became the most internationally acknowledged Aesthete and radical influence in the visual arts. The founder of the 'Liberty' department store, this highly successful entrepreneur and trader imported Persian, Chinese, Indian and Japanese artefacts at the *fin de siècle*. E.W. Godwin, who was briefly employed by the company, noted in a review of 1876 (a year after the store was founded), that '218 Regent Street is from front to back and top to bottom literally crammed with objects of Oriental manufacture'.[30] At the end of the 1870s Liberty began to commission textile designs from leading architects, designers and artists, and shortly after that a whole range of decorative arts goods, including metalwork, glass, jewellery, furniture and clothing. The Liberty look – an odd combination of such English things as Pre-Raphaelitism and folk art with the exoticism of the Near East, India and Japan – became synonymous with modernity by the end of the 1880s. The opening of a store in Paris in 1889 consolidated the company's reputation in Europe and bestowed it with a confident cosmopolitanism.

Liberty was an Aesthete and a pragmatic businessman, happy to combine the efforts of industrial Design Reformers, Pre-Raphaelites, the Arts and Crafts and Aesthetic movements or any other that he considered might fit his needs. In his catalogues and stores, designers as diverse as Christopher Dresser (plate 8.16), C.F.A. Voysey and E.W. Godwin appeared together. His entrepreneurialism, as well as his taste, was influential all over Europe.

The languid mysticism of Pre-Raphaelitism, the powerful directness of the Arts and Crafts movement and the eclectic hedonism of Aestheticism sat alongside one another in the art world of London in the early 1890s. All took advantage of the favourable climate brought about by institutional design reform. Between them, they anticipated

8.16 Christopher Dresser, 'Clutha' range vase. Glass with aventurine. Scottish, *c*.1885. V&A: C.52–1972.

most of the essential ingredients of Art Nouveau. Indeed, their combination, brought about by a young unknown illustrator, resulted in the first works in the style.

The short, dramatic *oeuvre* of Aubrey Beardsley – completed between 1893 and 1898 – had the same eclecticism as Liberty's store. He exploded onto the national and international scene when a number of his illustrations appeared in the first issue of *The Studio* magazine in April 1893. His illustrations, for Thomas Mallory's *Morte D'Arthur* and Oscar Wilde's *Salome* (plate 1.9), combined the exoticism of

8.17 William Hutton & Sons, cup and cover. Silver. English, 1900. V&A: M.22–1966.

Japan and Persia, the Pre-Raphaelitism of Burne-Jones, the structural clarity of Morris and the stylized naturalism of Mackmurdo and Voysey. But they were all made into something else by the brilliance of the young illustrator's graphic language. Tensile lines describe a rigorous asymmetrical composition, in which voids are as prominent as solids, and perspective and illusionistic modelling are eliminated. The conventionalization of nature is taken to the point of artifice and stylistic sources exude the decadence of an over-full treasure house. The *Salome* illustrations were the first widely disseminated works in the Art Nouveau style (see chapter one).

Beardsley was the first, but by no means the only English artist, to arrive at the Art Nouveau style. The name 'Liberty' became synonymous with advanced design and the many works he commissioned from British and foreign designers between 1895 and 1914 traced the full development of the style. The impact of Liberty on Belgium, for example, was vital to practitioners there, and there can be no doubt that they regarded the London store not simply as a source, but as part of the modern style proper. It is difficult to imagine the work and entreprenurial activities of Gustave Serrurier-Bovy, for example, in the absence of Liberty. It was natural enough that when it took root in Italy, adherents labelled it the *Stile Liberty*, in an extraordinary tribute to the London storekeeper. Others received international acclaim for their efforts. A lidded cup by William Hutton & Sons, for example, won a prize at the *Exposition Universelle* in Paris in 1900 (plate 8.17). A dramatic peacock sconce by Alexander Fisher did the same at the Turin *Esposizione* in 1902 (plate 8.18). Design companies such as the Silver Studio, textile companies like F. Steiner & Co., glass companies like James Powell & Sons and ceramic companies such as Doulton & Co., were happy to design in the Art Nouveau style, especially for the overseas market. As the century closed, makers and designers such as Archibald Knox and C.R. Ashbee were making objects related closely to mainstream European Art Nouveau (plate 14.4). Meanwhile, in the Edwardian housing boom, shrewd builders were content to fit out houses with fixtures and fittings in the new style when they scented a liberal clientele.

But these individual efforts and shrewd panderings to foreign markets did not cohere into an authentic English movement. Indeed, as the century drew to a close, the critical climate against Art Nouveau grew powerfully. Across the spectrum, English writers on the contemporary arts recognized the influence of the English school on the style, but depicted the latter as a malodorous distortion of the

REVEAL'D·ALL·
THINGS·SHALL·
SOMETIME·BE·
FOR·LIVING·EYES·
THAT·YEARN·TO·
SEE·

AS·BLACK·NIGHT·
SPREADS·HER·
WONDROVS·TAIL·
THE·DARK·SHALL·
FLEE·AND·LIGHT·
PREVAIL

former. Such enlightened designers and educationalists as Ashbee, Crane, Lewis F. Day and Voysey railed against what they perceived to be the decadent and hedonistic dishonesty of the style. It wasn't just the shapes and colours that offended. Art Nouveau inspired an anger, mistrust and fear that went beyond simple xenophobia – it had a distinctly ideological dimension to it.

The England of 1900 was a different place from that of several decades earlier. In an international climate that was still powerfully in the flux of modernization, a complex web of social, political and economic factors had altered England's position in relation to other nations. England was still extraordinarily wealthy, but was no longer the singularly dominant force it had once been. The spirit of progress that had built the Crystal Palace and promoted vibrant change in art and design had given way to a more cautious approach. The English of 1900 had different priorities and needs from their forebears who had created the Crystal Palace. Cultural modernity was a less attractive proposition than cultural consolidation for a nation that sensed that material progress was no longer to its benefit.[31] These nuanced shifts in imperial and economic climate had cultural ramifications that were important to the fate of Art Nouveau.

More important still, however, were perceptions of its moral condition. After 1895 Art Nouveau was closely associated with Aestheticism and literary Decadence, and these were understood to stand not merely for a passive amorality but for an active immorality. Beardsley and Wilde were largely responsible for this. Arthur Symons described Beardsley's work as having 'a diabolic beauty'.[32] An obituary published in *La Plume* was more descriptive:

> His art is morbid and rich at the same time … . His extraordinary fancy takes delight in inversions, in artifice, in audacious paradox. His men resemble women, his women have a virile allure. The expression of his people is always fugitive and equivocal. Life as he understood it, if not life as he wished for it, was a life of complex dream, mystery and perversion.[33]

Beardsley might have been a key initiator of Art Nouveau, but the culture he represented was also a factor in its failure in England.

Wilde's tragic demise was taken as a confirmation of the sinfulness of his art. On 3 April 1895 the first of his three trials opened at the Old Bailey, London. As is widely known, he was ultimately found guilty of acts of gross indecency and sentenced to two years' hard labour. In the first trial his prosecutor, Edward Carson, played heavily on the Aesthetic movement idea that art and morality were unrelated. With questions that might have been prompted by Ruskin himself, Carson doggedly pursued his prey:

> CARSON: … you pose as not being concerned about morality or immorality?
>
> WILDE: In writing a play or a book, I am concerned entirely with literature – that is, with art. I aim not at doing good or evil, but in trying to make a thing that will have some quality of beauty.[34]

The view was not well-received. It seems that the jury felt that what Wilde had depicted in *A Picture of Dorian Gray* was what he had practised in life. He spent two years in prison for his homosexuality. However, his vision of culture – Art Nouveau somewhat innocently included – received a heavier sentence.

By contrast, when William Morris died in 1896, he was immediately re-formed into an icon of English art and ideas. Similarly, the Arts and Crafts movement went from strength to strength, enjoying some of its best moments in the first decade of the new century. The emphasis of the movement steadily shifted, however, away from radical socialism, towards a more openly individualist, comfortable and non-urban vision of England.

Perhaps England's real contribution to international culture in the period was not a set of images or objects – important as these were – but a number of attitudes and ideas. Design Reform set an institutional agenda for what was to become the great age of exhibitions, museums and publications. Ruskin, Morris and the Arts and Crafts movement gave design and decoration an idealistic core. Aestheticism, by fêting individuality, non-conformity and the disinterested pursuit of beauty in the decorative arts, and by pioneering a radical, alternative eclecticism, complicated and enriched this Romantic vision. The various debates on the prevailing issues – industrialism, socialism, individualism and hedonism – would be repeated many times in many national contexts.

By 1910, writers all over Europe and the United States were drafting the obituaries of *Le Style Anglais* and elaborating on its failure to maintain its position in the new century. They unanimously agreed, however, that without it, there could have been no Art Nouveau.

8.18 Alexander Fisher, peacock sconce. Steel, bronze, silver, brass and enamel. English, *c.*1899. V&A: M.24–1970.

PART III

The Materials
of Invention

Ghislaine Wood

The Age of Paper

The crowd is his domain, just as the air is the bird's and water that of the fish.

His passion and his profession is to merge with the crowd ... to establish his dwelling

in the throng, in the ebb and flow, the fleeting and the infinite. ...

Thus the lover of universal life moves into the crowd as though into an enormous

reservoir of electricity. (Charles Baudelaire, *The Painter of Modern Life*, 1863)

9.1 Street in Orléans showing posters advertising Ripolin. French, *c*.1900. Photo: Roger-Viollet.

In his search for the essence of modernity, Baudelaire's hero, the Painter of Modern Life, fed on the frenetic energy of the late nineteenth-century city. The crowd simultaneously produced and consumed his work; the city was a constantly regenerative market where modernity was signified by 'the transient, the fleeting, the contingent'.[1] From the bicycle, car and tram to the dancing of Loïe Fuller and the Ballet Russes, movement became the leitmotif of modernity. The expansion of trade and empire made available a new universe of products. The infrastructure of consumption, shops, galleries, department stores, trade fairs and International Exhibitions presented this world to an ever-growing mass audience. The new idiom of the age – mass advertising – carried the message onto the street and into the home. New printing technologies, from photomechanical reproduction to multiple colour lithography, led to an explosion of print media, consumed by an increasingly literate population. The Painter of Modern Life had, by the 1890s, turned to the print media – posters, prints and books – in his exploration of the new, and in so doing brought élite artistic production and machine mass production into direct conflict.

The poster was perhaps most dramatically transformed. Applied to the surface of the city, it became a sign of the transitory world of the *fin-de-siècle* metropolis. In 1896, in his article 'The Age of the Poster', writer Maurice Talmeyr wrote:

> Nothing is really of a more violent modernity, nothing dates so insolently from today [as] the illustrated poster, with its combative colour, its mad drawing and fantastic character, announcing everywhere in thousands of papers that other thousands of papers will have covered over tomorrow, an oil, a bouillon, a fuel, a polish or a new chocolate.[2]

The impact of the poster on the cityscape was massive.

Many contemporary critics commented on the way it transformed the urban experience: 'Were I the incarnation of the prevailing taste of the day ... I would prohibit the exhibition of M. Chéret's posters on the hoardings. They ruin the uniform sadness and dullness of our streets, now the engineers have demolished the few houses and lanes that interest us.'[3] Huysmans' ironic comment on the replanning of central Paris by Baron Haussman reveals the extent to which, for some, the city had become a backdrop for the poster. The repetition of posters on hoardings (plate 9.1) not only reflected the multiplicity and mass availability of products and entertainment, but also the conscious decoration of the street, just as a repeating pattern in wallpaper or textile decorated the domestic interior. The frequency with which newspapers and periodicals commented on hoardings suggests the importance of these sites within the city.

Many avant-garde artists and designers attempting to create a modern decorative art for both the domestic and public spheres were drawn to chromolithography and its potential to transform the environment inexpensively. The immediacy of the technique – the artist could work directly on the lithographic stone – and the development of more sophisticated and subtle colour techniques, encouraged many artists who had trained as painters to experiment with the medium. The French artist Jules Chéret was the most successful poster designer of the period, and an important influence on the younger generation of avant-garde artists. His use of historical precedents, particularly Tiepolo and Watteau, Japanese stylistic devices (such as the negation of spatial recession and strong delineating outlines) and bright, pure colours, prefigured much Art Nouveau lithographic design. His posters, advertising everything from champagne to cabaret or from gasoline to cough pastilles, were often produced in runs of thousands. From the mid-1880s printing firms such as Champenois,

Lemercier and Charles Verneau (three of the most famous in Paris) not only saw the potential of chromolithography to respond to the demands of advertising, but realized the value of employing artists to design pictorial images that could become highly valued and collected. Chéret's 1893 poster for the famous American dancer Loïe Fuller, the 'idol of the Symbolists' as Oscar Wilde described her, was produced in a series of four colour combinations, a commercial device which encouraged serious collectors to acquire all four (plate 9.2). In an article of 1901 on Japanese art and the artistic poster, critic Raymond Needham defined the essential requirements for a poster to succeed:

> Take any representative Japanese print – a book-
> illustration, a broad sheet or a theatre bill – and it
> will be found to embody all that a good poster should.
> One dominant idea is presented graphically, beautifully.
> The detail does not weaken, but actually enforces the *motif*.
> There is not a superfluous line. The colour-scheme of flat
> tints is fresh and striking, but always harmonious.
> The composition gives an idea of balance and breadth,
> but affords no hint as to how these qualities have been
> obtained … . The general effect is decorative in the highest
> degree, may be humorous and is certainly pervaded by the
> 'hidden soul of harmony'.[4]

This description applies well to Chéret's posters.

Japanese art was the single most important influence on Art Nouveau graphic art; Henri de Toulouse-Lautrec's poster for the small café-concert *Divan Japonais* (plate 9.3) uses Japanese stylistic devices as the basis for a startling modernity. He was fascinated by chromolithography, and by the challenge to generate a modern art form through it. He is often associated with Art Nouveau circles, and held some sources and techniques in common with mainstream Art Nouveau designers. Yet at root, he remained faithful to the Naturalist tradition as it unfolded through Realism and Impressionism. The creation of physical space in *Divan Japonais*, where Yvette Guilbert sings while Jane Avril and Édouard Dujardin observe, ties Toulouse-Lautrec to the Realist tradition. The silhouetted, flat-patterning, asymmetric composition, elongated figures and bold outline all reveal the influence of the Japanese woodblock. The positioning of the action in 'real' space is the antithesis of the Art Nouveau decorative and symbolic space. Toulouse-Lautrec's engagement with modernity is signified in his exploration of the complex sites of the modern world, the crowd, the cabaret, the café or the street, where interchange or dislocation is most visible. Charles Hiatt, the erudite poster historian and editor of *The Poster* magazine, wrote:

> The art of Lautrec is neither moral nor immoral in its
> deliberate intention: like the art of Japan, it is non-moral
> … . It must not be supposed that Lautrec has sought to
> glorify the erotics of the home of the can-can: he depicts
> the frequenters of the place with terrible reality.[5]

The work of Eugène Grasset perhaps best represents the search for a modern decorative style through the appropriation of different sources. Grasset looked not only to Japan, but also to Islamic art (travelling to Egypt in the 1860s) and to Celtic and neo-Gothic styles. His *Histoire des quatre fils Aymon* (1883), the Medieval epic by Montauban,

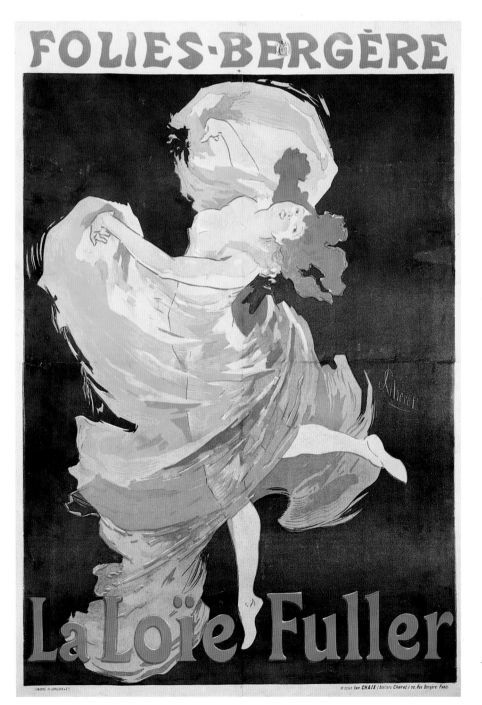

9.2 Jules Chéret, *La Loïe Fuller*.
Colour lithograph. French, 1893.
V&A: E.112–1921.

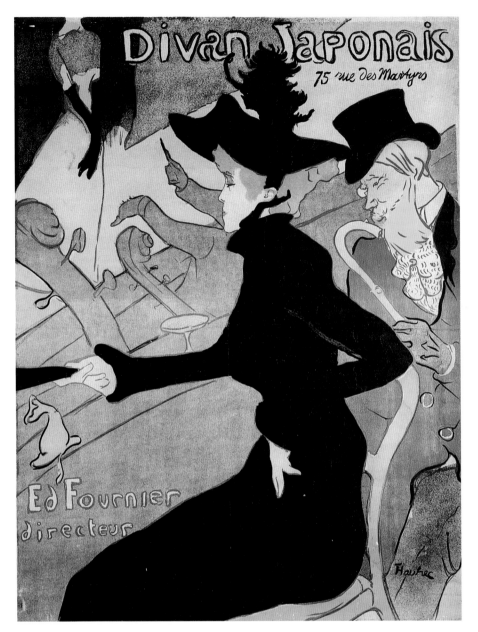

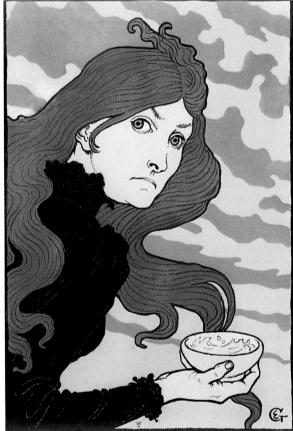

9.3 Henri de Toulouse-Lautrec,
Divan Japonais. Colour lithograph.
French, 1892.
V&A: E.233–1921.

9.4 Eugène Grasset, *La Vitrioleuse*.
Colour lithograph. French, 1894.
Collection Victor Arwas, London.

represents an early attempt in book design to integrate fully text and imagery. Produced by Charles Gillot, the inventor of photo-relief printing, it signalled a revival in art-book printing. In the 1890s he developed a style that depended on powerful delineating outlines derived both from Japan and stained-glass tracery, a medium in which he worked extensively. His *Salon des cents* exhibition poster of 1894 is one of the first embodiments of Art Nouveau woman, here, as so often, inextricably identified with nature. However, Grasset's women were not always benign. *La Vitrioleuse* (1894), produced for the album *L'Estampe originale*, was inspired by the fallen or dangerous women drawn from popular literature of the period (plate 9.4). In an article entitled 'Poster-Neurosis', which refer-

enced the anxiety felt over the new art form, the appearance of this 'unnatural creature' in poster art is marked: 'Just as in modern verse you read not of the nightingale but of the nightjar, so in modern poster art you see, not a buxom rosy-cheeked milkmaid, but an attenuated female with an art green complexion and heliotrope lips.'[6] Both Grasset and his pupil, the poster artist Paul Berthon, stressed the symbolic power of colour and its appropriate use in lithographic design, and both exhibited in the Symbolist Salons of the Rose+Croix.

Alphonse Mucha developed the image of the decorative woman to the pinnacle of refinement. Born in Ivančiče, in South Moravia, he is the quintessential Art Nouveau artist. His commissions from Sarah Bernhardt for the

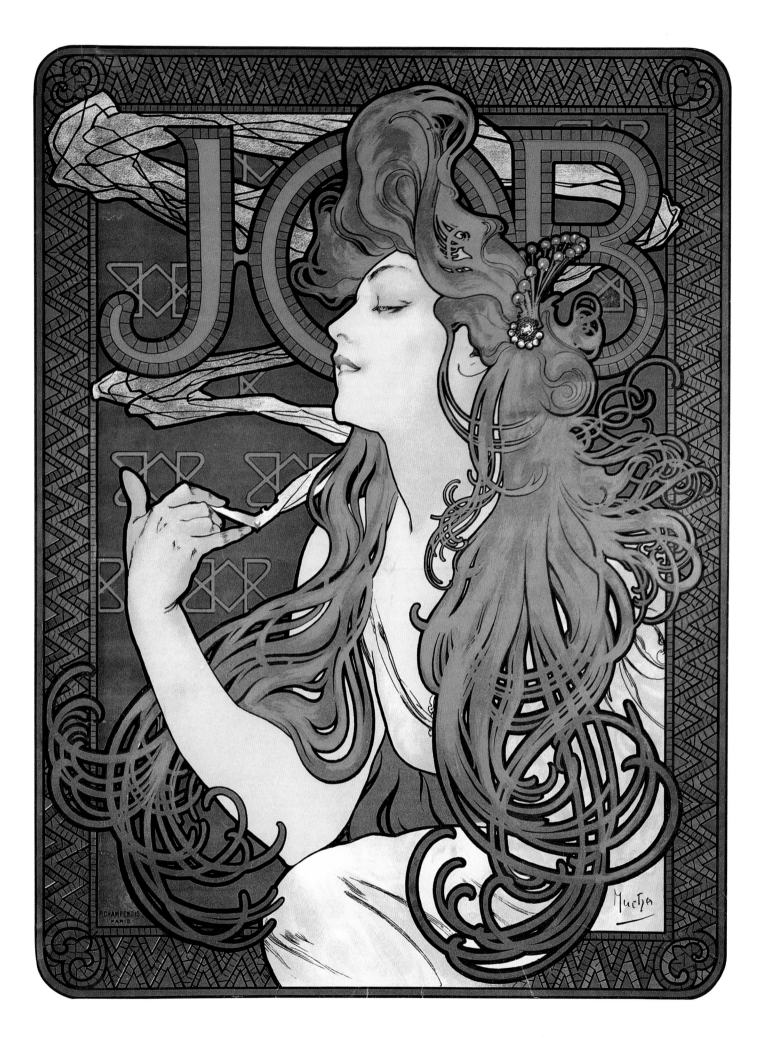

Théâtre de la Renaissance and particularly *Gismonda* (1894), *La Dame aux camélias* (1896) and *Médée* (1898) established a style and format that was endlessly imitated. His sophisticated constructions of colour and decoration, often using Eastern forms and symbols, are the ultimate examples of a symbolic and decorative Art Nouveau. Like many artists of the period, he became immersed in theosophist and occultist practice.

Mucha's volume of ornamental designs, *Les Documents décoratifs*, published in 1902, reveals his versatility as a designer. Although the book is like many produced as teaching aids for designers, it also catered for the print col-

poster designer, and certainly established a template for advertising in the twentieth century.

Much Belgian commercial poster design was indebted to Mucha's vision. T. Privat-Livemont, commissioned to design the official poster for the Brussels 1897 *Exposition Universelle* and considered the leading Belgian Art Nouveau poster designer, combined the tense linear graphic style of Henry van de Velde and Georges Lemmen with Mucha's decorative and exotic woman. Henri Meunier's poster for Rajah

9.6 Henri Meunier, *Rajah*.
Colour lithograph. Belgian, 1897.
V&A: E.440–1939.

9.7 T. Privat-Livemont, *Bec Auer*.
Colour lithograph. Belgian, 1896.
V&A: Circ.604–1962.

lector and enthusiast. Designs range from the more conventional stylization of flower forms for wallpapers and borders, to designs for silverware and jewellery, to images of semi-clad women in exotic settings. With its rich mix of didactic design drawings and hedonistic erotica, *Les Documents décoratifs* represents the complex spectrum of Art Nouveau. Mucha's vision of the decorative Art Nouveau woman has remained one of the most enduring of the style. He, more successfully than any other artist, identified the need to sell an idea rather than a product. Glamorized and feminized women signify pleasure, rather than product, to an increasingly powerful female consumer market. His effective commodification of women (plate 9.5) perhaps resulted in his tremendous success as a commercial

coffee of 1897 (plate 9.6) used a much sparer decorative aesthetic than that of the often ornate style of Privat-Livemont, or of the other leading designers Adolphe Crespin and Fernand Toussaint, but all used the associative power of women and pleasure to sell products. Privat-Livemont's 1896 poster for a brand of incandescent burner, Bec Auer (plate 9.7), demonstrates the difficulty artists often encountered when representing products, especially when new object types demanded new forms of depiction.

New symbols of modernity were everywhere. The car, for example, through its combination of technology and speed, spawned many different forms of representation from the cartoon to the Classical. The Italian poster designer Leopoldo Metlicovitz's *Mostra del ciclo e dell'automobile* of

1905 used the imagery of Apollo's chariot simultaneously to denote movement and power. He frequently used Classical references to position objects within a suitable and accessible frame of reference.

A contributing factor to the mania for poster collecting in the late 1880s and 1890s was the growing historiography of the subject itself. A number of books and periodicals had been published that legitimized poster design as an art form and, therefore, made it worthy of collection. Ernst Maindron's *Affiches illustrées*, published in 1886 (with a subsequent volume covering 1886–95 appearing in 1896), established a canon for the history of the poster. In the same year Roger Marx, a figure of central importance in the project to revitalize the French craft tradition in the 1890s, founded *Les Maîtres de l'affiche*, a monthly magazine entirely devoted to the poster. Each issue consisted of four folio-sized reproductions of famous posters. The first of each month was devoted to Chéret. Marx, one of the founders of *L'Estampe originale* and editor of *L'Image*, argued, through these influential publications and through his role as a senior civil servant, for the equality of the arts and the establishment of a modern decorative style. For his efforts in promoting the educative and social value of art, Anatole France interestingly described him as 'the great apostle of a social art, like Morris in England'.

The campaign to elevate the status of the decorative arts was most closely identified with John Ruskin and William Morris and was most successfully promoted through *The Studio* magazine, a publication of fundamental importance to Art Nouveau designers (plate 1.14). Established in 1893 by Charles Holme and edited by Gleeson White, *The Studio*, with its Arts and Crafts aesthetic and its insistence on the equality of all the arts, became a central conduit for the communication of ideas and style. In its first issue, an article by Joseph Pennell (an influential promoter of the graphic arts) introduced the work of Aubrey Beardsley. For the European and American markets, Beardsley became the latest and perhaps the most brilliant in a line of influential English illustrators which included Morris, Walter Crane and Charles Ricketts. Morris' Kelmscott Press was particularly influential, as Fernand Khnopff's review of *La Libre Esthétique* exhibition in Brussels in 1894 reveals:

> It is with the most lively admiration that connoisseurs are arrested before the beautiful books of William Morris – *The Defence of Guinevere*, *The History of Troy* and *A Dream of John Ball*, of which the frontispiece has been designed by Sir Edward Burne Jones. One recognizes in them the perfection of quality.[7]

English artists before the 1890s had been exploring new forms of expression in the graphic arts as the tense curvilinear design and hand-drawn title of Arthur Mackmurdo's title page for *Wren's City Churches* of 1883 displays (plate 8.8). *The Dial* magazine, established by Charles Ricketts and Charles Shannon, carried this exploration forward into the 1890s, becoming the centre of an artistic circle which encompassed Oscar Wilde. The elision of art and literature and their interdependence in the period is clearly revealed in *The Dial*. *The Studio* wrote in 1894: 'Fantastic, imaginative and bizarre, the illustrations to *The Dial* are firstly art, and almost equally literature.'[8] Although influenced by William Morris, Ricketts developed a more complex and integrated approach to book design. His works were produced by the Vale Press, which was established in 1896 in a house that Whistler had owned. The press produced some of the finest art books of the period. Ricketts' non-literal and symbolic use of line, like Beardsley's, was to be one of the defining features of Art Nouveau style. With his edition of Wilde's *The Sphinx* (plate 9.8), Ricketts tackled the design of all the elements of a book from the typography, illustrations and endpapers to the binding. The restrained but decadent cover in white vellum with gold leaf demonstrates English binding at its most elegant. The

9.8 Charles Ricketts, cover for Oscar Wilde's *The Sphinx*. Gold leaf on vellum. English, 1894. V&A: L.1524–1902.

9.9 Victor Prouvé, *Salammbô*.
Tooled mosaic leather and bronze.
French, 1893.
Musée de L'École de Nancy.

symbolism employed by Ricketts derives in part from his interest in Greek art, but is also clearly part of the Decadent aesthetic of which Wilde and Beardsley were the most famous exponents. Beardsley's illustrations for Wilde's *Salome* eclipsed the design for *The Sphinx*, largely due to the controversy provoked by their 'weirdness and suggestions of horror and wickedness'.[9] One of the earliest Art Nouveau images, *J'ai baisé ta bouche Iokanaan*, published in the first issue of *The Studio*, made Beardsley internationally notorious and perhaps the most imitated artist of the period (plate 1.9).

Fascination with exotic, Classical and biblical subjects, such as Salome, was prevalent throughout the art and literature of the period. One of the finest examples of French bookbinding, Victor Prouvé's *Salammbô* of 1893 (plate 9.9) shows a different Symbolist aesthetic from that of *The Sphinx* with its mix of dramatic action and erotic suggestion. Prouvé, born in Nancy and initially trained in the Gallé workshops, was committed to the unification of the arts. He was instrumental in the foundation of the Alliance Provinciale des Industries d'Art (from 1901

the École de Nancy; see chapter two), which established an integrative approach to the design and production of the decorative arts. The quality of book production in Nancy was acknowledged by Julius Meier-Graefe in his review of Continental bookbindings in Siegfried Bing's exhibition on modern book design of 1896. Having established that book art was 'playing an important part in the art movement of today', he defined two tendencies in modern bookbinding, namely historicism and what he calls the 'modern Japanese fashion':

> Whereas the first ... is essentially one of many limitations
> in respect of reproduction, the followers of the second
> method strive to regard the needs of modern peoples,
> and to develop that which they borrow from their
> predecessors ... taking nothing from Eastern or from
> Gothic patterns, save such things as are in keeping
> with the new decorative ideas.[10]

Although Meier-Graefe praised the quality of the works produced by the Nancy artists, he criticized Prouvé, René Wiener and Camille Martin (the most important of the Art Nouveau binders) (plate 9.10) for creating 'pictures pure

9.10 Camille Martin, *Portfolio,*
L'Estampe originale. Tooled mosaic
leather. French, 1893.
Musée de L'École de Nancy.

and simple'. He reserved the highest praise for van de Velde's bindings which, he observed, used simple linear designs that equalled the best of the '*éditions de luxe*' but were produced at a moderate cost. 'Half a dozen instruments are all he needs for the tooling, whereas the old binders required a hundred to produce the complicated designs of the seventeenth and eighteenth centuries.'[11]

The work of the Dutch artists C.A. Lion Cachet and Gerrit Dijsselhof was also praised by Meier-Graefe for the 'simple excellence of the decorative schemes' and the 'strongly marked national character' of their illustrations and bindings. The development of a modern, commercially successful, national style of central importance to the Arts and Crafts movement was also a governing discourse in the debates surrounding Art Nouveau. In the Netherlands, the influence of flat-pattern design from Indonesia, a Dutch colony, and particularly the technique

of batik, resulted in a distinctive national style seen not only in graphic design, but also in all the decorative arts. In 1894 Jan P. Veth, an artist and critic, adapted Walter Crane's book *The Claims of Decorative Art* (1892) for publication in the Netherlands. *Kunst en Samenleving* (Art and Society), as it was retitled, became highly influential for a new generation of artists and designers and demonstrated a unified approach to design. Dijsselhof designed the binding, dust jacket and woodblock illustrations (plate 9.11). Both Dijsselhof and Lion Cachet experimented with the wax resist technique of batik. The organic, linear and highly decorative patterns created by this technique provided Dutch designers with a new decorative language, a language which reflected the power of the modern colonial state to appropriate other cultures' artistic traditions to create a more complex modern style. Jan Toorop, a Dutch artist born in Java, expressed a more

9.11 Gerrit Dijsselhof,
bookbinding of *Kunst en
Samenleving* (Walter Crane's
The Claims of Decorative Art),
translated by Jan P. Veth.
Dutch, 1903.
The Wolfsonian-Florida
International University,
Miami Beach, Florida:
Mitchell Wolfson Jr.
Collection.

sophisticated understanding of Javanese culture in his art. The personification of the forces of good and evil, so prevalent a motif in his work, suggests a knowledge of Javanese religious iconography. Javanese shadow puppets were the source for his strong linear figures that often metamorphize into pure line. As a founder member of the *Société des Vingt* in 1884, Toorop was deeply involved with the Belgian avant-garde, taking up Symbolism in the early 1890s. Like many of the artists who exhibited at the *Société des Vingt*, he was committed to the idea of a decorative and symbolic art (plate 4.10).

The fusion of symbol and decoration was central to the Nabis, a group of artists influenced by Gauguin. Maurice Denis, a leading member of the group, described Gauguin's influence: 'He had taught … that objects of art must be decorative. And finally, by the example of his work, he had proven that all grandeur, all beauty, is worth nothing

without simplification and clarity, or without a homogeneity of *matière*.'[12]

Paul Ranson, Maurice Denis, Ker-Xavier Roussel, Henri-Gabriel Ibels, Pierre Bonnard, Édouard Vuillard, Félix Vallotton and József Rippl-Rónai all designed decorative arts objects and print media. Both Bing and the dealer Ambroise Vollard encouraged members of the group to experiment with chromolithography. *La Revue blanche* (1891–1903), the anarchic and adventurous journal founded by the brothers Thadée and Alexandre Natanson, did much to promote the Nabis. Bonnard's poster for *La Revue blanche* (plate 5.2) of 1894 is a sophisticated play of positive and negative space, reflecting the Nabis' concern to create images that could be read decoratively as well as symbolically. The legibility of the text has been obscured, while the mass information of the street is evocatively suggested. The figures have become signifiers of 'the crowd'.

A similar engagement with the sites of modern life was sought by Vallotton through the medium of woodcut printing (plate 9.12). Vallotton, who with Edvard Munch and Gauguin had been a principal in the revival of the technique, developed a highly individual and humorous style that depended for its effect on the play of strong decorative contrasts. Bing keenly promoted Vallotton, commissioning him to design the poster for the gallery L'Art Nouveau in 1895 and exhibiting a series of woodcuts in his exhibition on graphic art in February 1896. The entrepreneur also commissioned Hungarian Nabis artist József Rippl-Rónai, in conjunction with Scottish designer James Pitcairn Knowles, to create illustrations and bindings for the Belgian Symbolist poet Georges Rodenbach's *Les Tombeaux* and *Les Vierges*. *Les Vierges*, with its brilliant Art Nouveau palette of acid greens and pinks, is an early example of chromolithographic book design (plate 24.8). However, the artist that Bing most successfully promoted was Georges De Feure. Like Mucha, De Feure developed a sophisticated lithographic technique and style. His subject was usually women. But whereas Mucha's images suggest an erotic fusion of woman and nature, De Feure's Eves are constant reminders of woman's weak and malignant nature. Like other Symbolist illustrators, and most notably Carlos Schwabe, he believed in the moral and cautionary value of art (plate 4.15).

Henri Bellery-Desfontaines, a famous artist-*ensemblier* who worked in both the graphic and decorative arts, produced some of the finest colour lithographs of the period (plate 9.13). Largely ignored in the history of art, after his death he was widely considered as one of the key inventors of Art Nouveau. An article entitled 'Lithography: Its

9.12 Félix Vallotton, *L'Averse*.
Woodblock print. French, 1894.
V&A: E.1558–1926.

9.13 Henri Bellery-Desfontaines,
L'Enigme. Colour lithograph.
French, 1898.
V&A: E.1718–1898.

Artistic Possibilities' in *The Poster* of February 1900 positioned him alongside Mucha, Steinlen, Berthon and Ibels as a leader in chromolithographic design. Between 1897 and 1919 the Victoria and Albert Museum acquired four of his works in a period when relatively little contemporary French graphic art was being bought.

Like much French Art Nouveau, German Jugendstil imagery was powerfully informed by Symbolism. This particular strain of German Symbolism, exemplified by Arnold Böcklin's paintings of mysterious landscapes and Classical ritual, resurfaced in the work of many of the younger generation of artists, including Richard Riemerschmid, Peter Behrens and Bruno Paul. *Pan*, the journal established by Julius Meier-Graefe and Otto Bierbaum in 1895, provided a forum for many of these artists to show their work. Its title positioned the magazine in an hedonist, mythic and even anti-rationalist sphere, reflected in Joseph Sattler's cover for the first issue (plate 1.15). The design evokes the dreamscape of much Jugendstil graphic design, with its mix of Classical allusion, spare Japanese stylistic forms and symbolic nature. Fantasy or fantastical

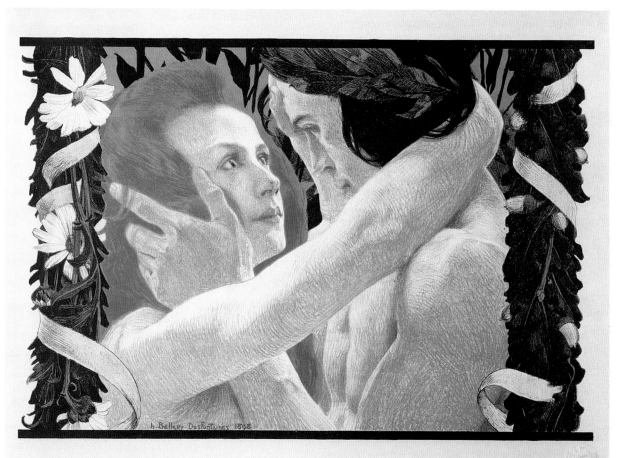

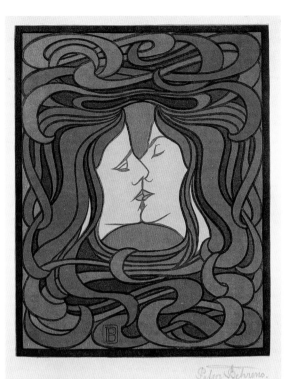

9.14 Peter Behrens, *The Kiss*. Colour woodcut. German, 1899. Private Collection. Photo: Mario Gastinger, Munich.

9.15 Thomas Theodor Heine, poster for *Simplicissimus*. Colour lithograph. German, *c*.1900. V&A: E.408–1939.

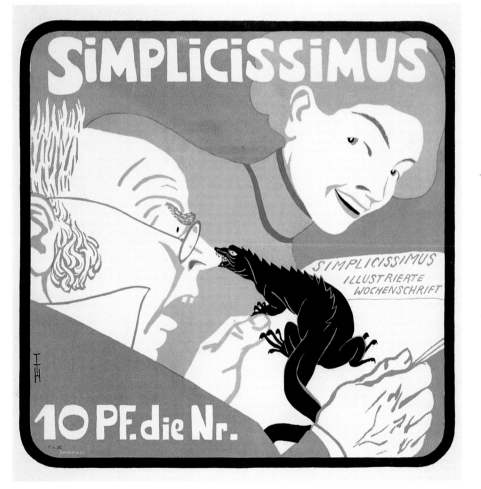

elements were to become central to the style of the publication as it developed. Many artists, including Franz von Stuck, Gustav Klimt and Eugène Grasset, used Classical imagery to denote a pre-Christian and symbolic Aesthetic world whose language could be harnessed in the search for a modern style. Few artists manipulated this vision as effectively as Sattler. *Pan*, following the lead of *The Studio*, was produced to an extremely high quality, which was a factor in its quick demise. Both Otto Eckmann and Peter Behrens (the leading exponents of the colour woodcut in Germany) were commissioned to produce works for the magazine. Eckmann's colour woodcut of irises (plate 19.5) appeared in the first issue in 1895, and Behrens' *The Kiss* appeared in November 1899 (plate 9.14). Both artists also looked to Japanese printmakers for their approach to colour and form.

Die Jugend and *Simplicissimus*, the Munich magazines established in 1896, also became major sources for publishing new graphic work. Designs by Eckmann, Behrens, Ludwig von Zumbusch, Bruno Paul and Fritz Erler all appeared in *Die Jugend*. *Simplicissimus* promoted an aspect of Jugendstil graphic design embedded in tradition – the satirical illustration. A weekly magazine, it combined political and social criticism with lyrical poems and drawings, and infused new life into the established graphic form of the cartoon. Its content was largely determined by Thomas Theodor Heine (plate 9.15). Heine's satirical illustrations and posters parodied the bourgeoisie, the law, the military and the nobility, and his graphic style made him one of the most successful designers in Munich. Bruno Paul, a founding member of the *Vereinigte Werkstätten für Kunst im Handwerk* (United Workshop for Art in Handicraft) in Munich, produced almost 500 cartoons for *Simplicissimus*. Many of these were indictments of German politics and society, but many also showed the artistic milieu of Munich at the turn of the century.

As seen in chapter two, folk culture was often used as a vehicle to express modernity. The graphic arts were no exception. Erler, one of the most regular contributors to *Die Jugend*, often used folk tales as the source of fantasy imagery (plate 19.6). In the 1890s he became interested in the often macabre and violent folk tales of the Brothers Grimm which, like the stories of the American writer Edgar Allan Poe, became for artists a reservoir of the bizarre and fantastic. The use of folk culture to create a modern idiom is clearly seen in the Finnish designer Akseli Gallen-Kallela's *Bil-Bol* poster of 1907 (plate 9.16). Gallen-Kallela had become involved in Jugendstil circles after a visit to Berlin in 1895, where he was taught to

print by Joseph Sattler. The *Kalevala* folk story of the *Snatching of Kyllikki* has been transformed: the sledge becomes a red car and Lemminkäinen, the hero, is a besuited motor-car fanatic. *Bil-Bol* is perhaps one of the earliest advertisements overtly to endow a product with a value that is symbolic, here the promise of sexual fulfilment; a value that has become a mainstay of advertising in the twentieth century. Much Russian Art

of *Ver Sacrum*, Moser's work represents the dual forms taken by Vienna Secession style. He utilized both the curvilinear lines of Jugendstil and Art Nouveau and the more geometric pattern forms used by Viennese designers and the Glasgow school. Moser, like the Glasgow artists, explored the symbolic power of forms and, it could be argued, pushed this to its ultimate extension in his flat-pattern designs based on natural forms.

9.16 Akseli Gallen-Kallela,
Bil-Bol. Colour lithograph.
Finnish, 1907.
Ateneum Helsinki Collection.
Photo: The Central Art
Archives/Petri Virtanen.

Nouveau graphic design also used vernacular culture and forms. Such artists as Elena Polenova and Mariya Yakunchikova-Weber (plate 9.17) utilized ornamental folk patterns and designs as the basis for a graphic style, while simultaneously referencing Western European developments – most notably *cloisonnism*.

The Vienna Secession journal *Ver Sacrum* (1898–1903), expensively produced in a square format, showed the work of the leading Austrian artists Gustav Klimt, Josef Hoffman, Josef Maria Olbrich, Alfred Roller, Adolphe Böhm and Koloman Moser. Initially trained as a painter at the Vienna Academy and responsible for the production

His textile designs for *Die Quelle* (*The Source*) represent some of the most abstracted natural pattern-forms of the period (plate 20.13). Secession artists also did much to develop new typographical styles. Otto Eckmann and Peter Behrens experimented with developing typographies. Eckmann's title page for *Die Woche* of 1900 represented one of the most successful attempts to develop a new typeface appropriate for the printing of books. Moser and Roller took up this lead and experimented with letter forms that ultimately obscured legibility. Roller's *Secession 16 Ausstellung 1903* (plate 9.18) reveals the extent to which lettering could became a decorative

9.17 Mariya Yakunchikova-
Weber, *Mir Isskustva* cover.
Colour lithograph, linoleum cut.
Russian, 1899.
V&A: NAL.

element, showing the tension between the function of
the poster to communicate information and its role as a
symbol of modern design.

In the United States, poster mania manifested itself in
'The Poster Party', which by the mid-1890s had become a
'social fad'.[13] The personification of poster characters is a
recurrent theme in contemporary commentary, a Pyg-
malionism which, by increasing its universality, perhaps
enabled critics to more easily position the artistic poster
in the realm of mass communication and advertising.
Louis John Rhead, Edward Penfield, Ethel Reed and Will
Bradley, the leading American graphic designers, were
influenced by European poster design, especially the work
of Beardsley, the Beggarstaff brothers (brothers-in-law
James Pryde and William Nicholson), Grasset and
Chéret. Rhead, born in England and trained in London
and Paris, produced many posters for New York news-
papers, including *The Sun*, *The New York Journal* and *The
Herald*. Particularly influenced by the Pre-Raphaelites, his
style remained rather static, whereas Bradley developed a
highly organic and linear style. Bradley's posters (plate
9.19) and designs for *The Chap Book* represent the clearest
expression of an Art Nouveau style in American graphic
design. He wrote: 'I think the American Poster has
opened a new school whose aim is simplicity and good

9.18 Alfred Roller, *Secession 16
Austellung 1903*. Colour lithograph.
Austrian, 1902.
V&A: Circ.275–1973.

composition. One can see its effect in all directions, especially the daily papers.'[14] Penfield's designs for *Harper's* magazine, heavily indebted to Toulouse-Lautrec's powerful flattening of space, clearly fulfil Bradley's call for simple and good composition.

Of all paper-based media, posters illustrate with great clarity the divergent strains within the Art Nouveau style. *Tropon* (1898) and *Le Chat noir* (1896) represent the diverse responses to the call for a modern idiom (plates 9.20 and 9.21). Produced by two of the greatest graphic artists of the period, Henry van de Velde and Théophile Steinlen respectively, they exemplify the attempt to create a democratic and social art that reflected an overt moral and political position. *Tropon*, an early example of product branding, perhaps the ultimate tool of modern advertising, heralds the machine aesthetic of the new century. *Le Chat noir*, produced for the Symbolist cabaret of the same name, represents the Art Nouveau marriage of the symbolic with the decorative. Louis Nazzy wrote at the time: 'The walls of Paris have been dignified by the presence of this haloed cat, hieratic, Byzantine, of enormous size whose thin fantastic silhouette hangs high above the crowd in the streets.'[15] As many contemporary commentators recognized, the printed image represented a democratic art accessible to all; it made Art Nouveau the style of the street.

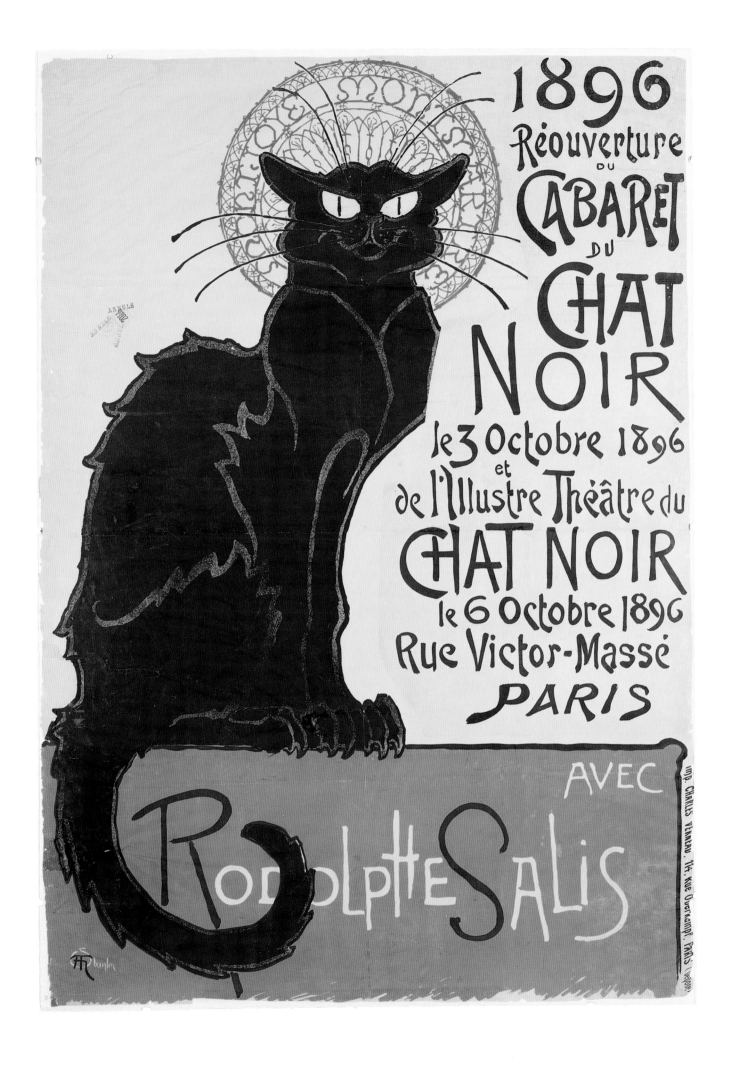

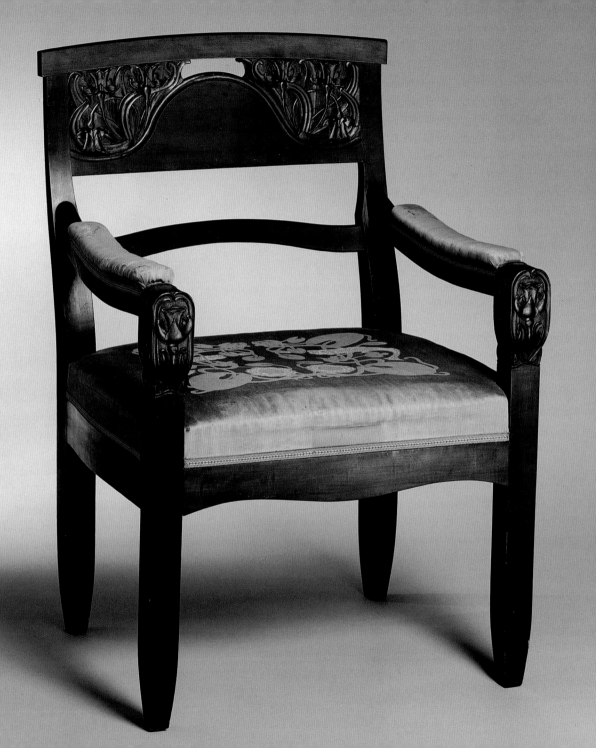

Gabriel P. Weisberg

Moulding Wood:
Craftsmanship in Furniture

10.1 Bernhard Pankok,
armchair. Pear wood with silk
upholstery. German, 1897.
Danish Museum of Decorative
Art, Copenhagen.
Photo: Ole Woldbye.

In design for the home and the decorative arts, the development of Art Nouveau was most prominently found in the area of wooden furniture. Within that arena, designers and craftsmen broke with historical styles to forge a 'new art' that reinforced their battle cry to abandon the tyranny of the past.[1] Creating furniture for model rooms shown at International Exhibitions (plates 1.18, 1.19, 1.21, 10.5 and 10.9), or contriving new forms for modern interiors that were actually installed as part of commissioned architecture, allowed the modern style to be nurtured through the design of furniture.

Critics soon noticed and discussed the revolutionary changes that were occurring within this field. They commented on young designers' creations and elaborated theories on how furniture should complement or enhance an architectural environment, even to the point of furniture serving as part of a wall surface rather than simply as freestanding.[2] Furniture-makers, in turn, were aware of issues that affected all of the applied arts and were inspired by the diverse possibilities of construction that new furniture presented for the modern home. By examining the ways in which designers conceptualized the use of new materials, and by focusing on the ways in which some creators wanted their furniture disseminated, the ability of specific furniture designers to revolutionize home interiors becomes clear. A series of independent pieces, assessed against issues addressed by certain designers, shows how select works expressed the creation of a new style in furniture design.

Art Nouveau designers challenged preconceptions by using traditional materials drawn from nature in innovative ways, such as moulding wood into new shapes or applying a geometric minimalism. Rigid and traditional styles that did not emphasize the pliancy of wood were attacked for being too stultifying and for constraining ingenuity. Designers were committed to using wood in new ways. Outstanding among these designers were Hector Guimard

(plate 10.13), who created pieces for the interior of the Castel Béranger; as well as many other houses and apartment blocks; Bernhard Pankok, whose furniture revived interest in a native German style (plate 10.1); Richard Riemerschmid, whose pieces reflected an innate 'honesty' and practicality (plates 19.10 and 19.11); Tony Selmersheim, who worked on individual pieces for model rooms (plate 10.14); Louis Majorelle, who completed furniture for a larger mass market than usually found in Art Nouveau; Gustave Serrurier-Bovy, whose pieces suggested streamlined sculpture (plate 10.2) and Charles Rennie Mackintosh, who simplified and coloured wood for tea houses in Glasgow (plates 2.21 and 21.8). Their wood creations had more than one purpose, with chairs incorporating shelves to hold glass or ceramics, and beds having head or foot boards with unusual curvilinear forms reminiscent of natural forms. They emphasized imagination, with shapes referring only marginally to naturalistic vines and tendrils, and instead creating something completely novel and abstract. By bending and elongating wood, designers and craftsmen transformed furniture into sculpture that continued the architecture of a room. Since many furniture-makers were also architects interested in functional and structural concerns, their involvement in this field strengthened the interrelationship between furniture design and architecture. Other furniture-makers, such as Rupert Carabin, for example, used sensual female figures that clung to supports for tables and chairs, suggesting that the boundaries between the arts had been reduced (plate 10.3; plates 3.10 and 4.14).

The design of furniture inspired another revolution as well. As several of the most advanced pieces were linked with other areas of creativity, furniture benefited from designers' inherent desire to break free from stifling, age-old routines and time-honoured traditions. Designers who were first and foremost painters, sculptors or architects

now selected their own craftsmen and bypassed employing an *ébéniste*, the master craftsman who had often controlled how furniture was made.[3] In abandoning this practice, designers signalled that traditional methods and ingrained styles were no longer needed. By moving beyond the so-called professional ranks of furniture-makers, designers assumed total control in creating a visually uniform interior that utilized wood in ingenious ways.[4] While the common wisdom was that a room had to be planned in its entirety from the beginning, the notion of an *ensemblier* with an overarching creative vision came into maturity with the Art Nouveau era.[5]

Suites of furniture were soon planned and created from the start. Instead of constructing single pieces of furniture and adding items to a room without a unified approach, designers became concerned with the way each piece related to the next. The appearance of an entire room became crucial – it was to be a 'total' work of art (the *Gesamtkunstwerk*). This new approach was especially clear in the series of interiors for shops or art galleries prepared by van de Velde (plate 10.4), and in the model bedroom and the dining room by Eugène Gaillard (plate 10.5) installed in Siegfried Bing's Pavilion at the *Exposition Universelle* in 1900. Van de Velde's interior for La Maison Moderne in Paris well illustrated how elements of an entire room,

10.2 Gustave Serrurier-Bovy, pedestal. Congolese palissandre. French, 1897. Norwest Corporation, Minneapolis.

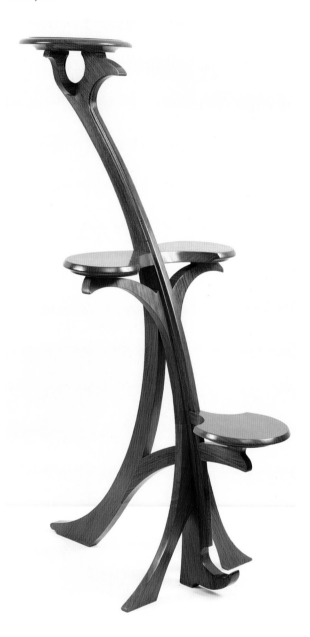

10.3 Rupert Carabin, table. Wood. French, 1896. Private Collection.

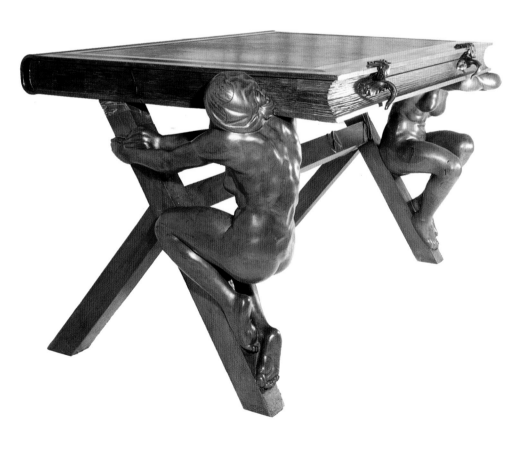

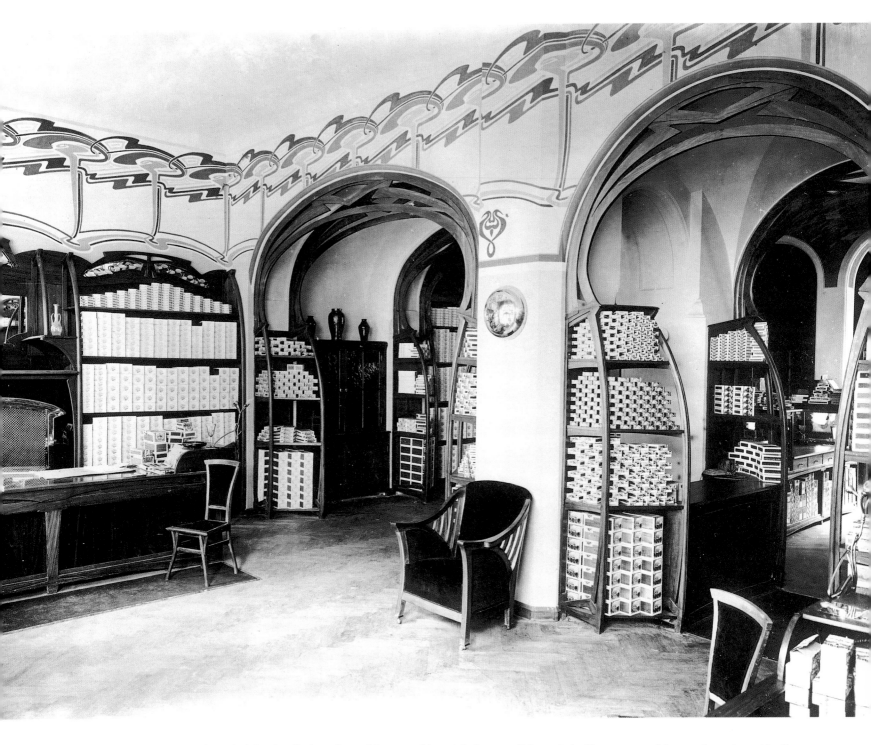

10.4 Henry van de Velde, Havana Tobacco Company, Berlin. 1899. Photo: Bildarchiv Foto, Marburg.

intended for the display of art objects, could work in harmony. Smaller objects, as well as shelves, vitrines, chairs, tables and room dividers, all complemented one another. By following no set rules, furniture-makers attained a greater degree of freedom to express their originality.

As Art Nouveau evolved, it was hoped that this definitive 'new style' would parallel changes occurring in society. Reformers who wanted to improve the 'quality' of life urged that home interiors be constructed to provide more

light and air. Nature entered homes through a wide diversity of shapes and the use of different woods (plate 10.6). Dark, musty rooms gave way to interiors alive with intriguing shapes and colours. Pastel hues enlivened walls, and materials with delicate floral motifs covered chairs and sofas. Windows, some inset with stained glass, were designed to lighten interiors.

Some critics saw these designs as being too radical a break with the past. This was especially apparent in the

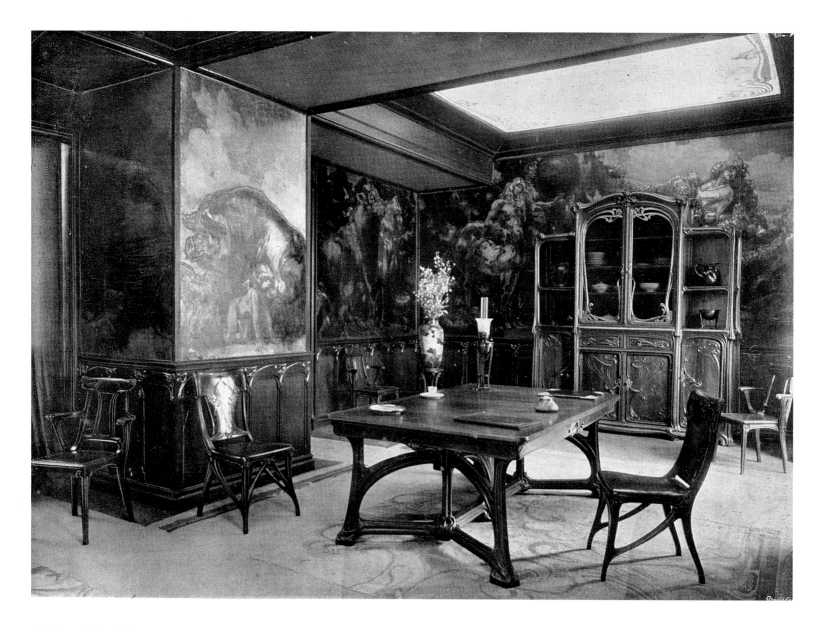

10.5 Eugène Gaillard, dining
room, L'Art Nouveau Bing,
Exposition Universelle, Paris, 1900.

10.6 Eugène Gaillard, cabinet.
Walnut. French, 1900.
Danish Museum of Decorative
Art, Copenhagen.
Photo: Ole Woldbye.

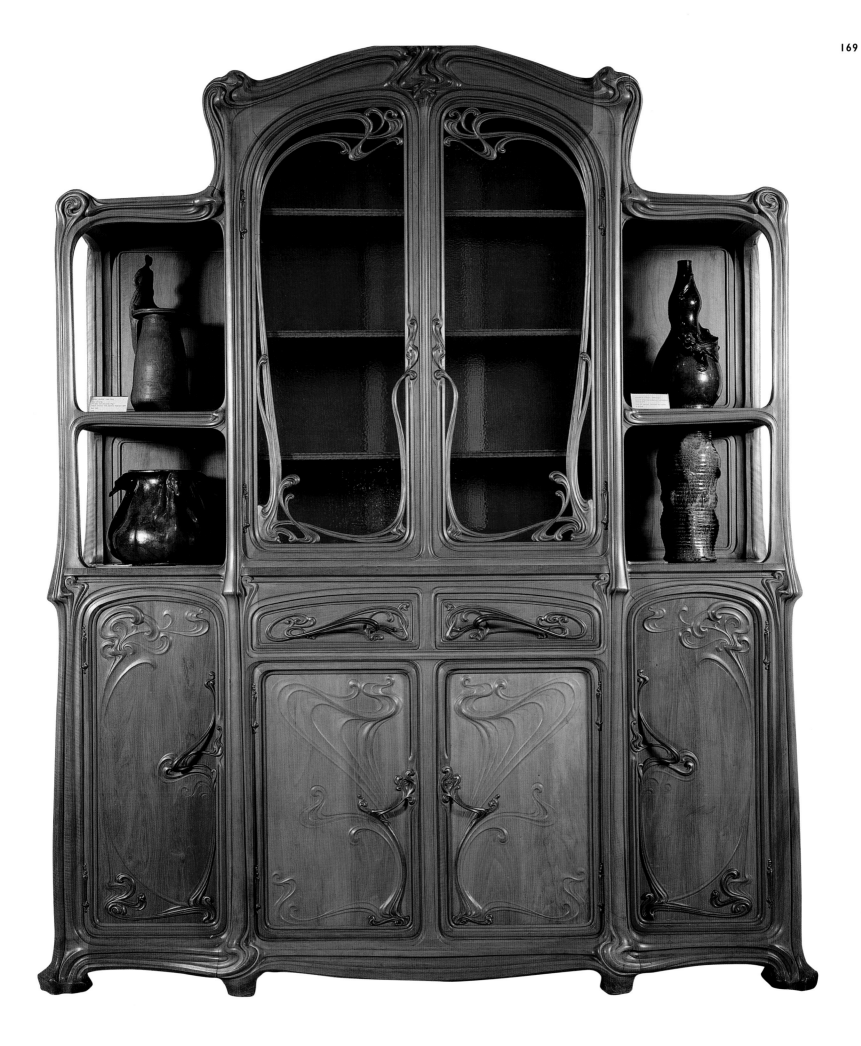

10.7 Josef Hoffmann, adjustable armchair. Steam-bent beechwood and plywood. Austrian, c.1908. V&A: W.28–1982.

simplified furniture produced in Scotland, Austria and Germany. They believed that these designers went too far – as in Charles Rennie Mackintosh's highly eccentric pieces of white furniture decorated with pink or blue accents, or Josef Hoffmann's cabinets and adjustable armchairs (plate 10.7), which created totally new shapes demonstrating a

reliance on the freeing of abstract line. Hoffmann's steam-bent beechwood frame, used in his armchair, built upon the remarkable bent-wood furnishings of August Thonet, experimentation that was well maintained in chairs or settees after 1900 (plate 10.8). A sense of anarchism dominated much of his furniture, critics claimed. These claims were not entirely unfounded: a number of Art Nouveau designers were not simply Aesthetic radicals, but were also interested in political activism.

In addition to shifts in theoretical approach by furniture-makers (and their receiving the recognition of such avant-garde writers as Julius Meier-Graefe), changes also occurred in the production of furniture which stimulated the emergence and eventual dissemination of the Art Nouveau style. Entrepreneurial patrons became more involved in the production of pieces, and there was a greater emphasis on the commercial distribution of furniture.

At his firm L'Art Nouveau, the entrepreneur Siegfried Bing, a leading promoter of the 'New Art', hired the master furniture-maker Léon Jallot to oversee the production of furniture for his gallery/shop. Bing's small workshop was located in an unused storage area behind his Asian art gallery. The jewellery workshop, directed by Bing's son Marcel, was on the top floor. Beneath it were the ateliers in which the furniture was assembled.[6] Georges De Feure, Édouard Colonna and Eugène Gaillard (the young artists 'discovered' by Bing) created the designs. However, Bing personally selected the designs that were transformed into finished pieces. Only a few of the preparatory plans that were submitted to him ever became the pieces of furniture seen in his model rooms at the *Exposition Universelle* of 1900 (plate 10.9; plates 2.7 and 17.9).[7] Although Bing's Pavilion at the *Exposition Universelle* was scarcely mentioned by the Parisian popular press, it did serve as a standard against which designers, collectors and advocates of reform beyond France judged the development and acceptance of this unified approach to interior design.

Given the small space in which Bing's craftsmen created and assembled furniture, only a few sample pieces were likely to have been produced of each model. Documentary

photographs published in a popular Parisian periodical suggest that the construction process was slow. These photographs not only record how the wood was moulded for vitrines by Gaillard and where the different sections of pieces were made (obviously some of the work was jobbed-out, as Bing did with his fabrics), but they also show that just a few pieces at a time were assembled.[8] Some of the completed pieces were put on display in Bing's gallery at 22, rue de Provence, but most were shown in his Pavillon de L'Art Nouveau at the *Exposition Universelle*. Needless to say, his furniture created a stir among the connoisseurs of the applied arts from outside France.

Many of the pieces acquired here or from Bing's gallery were sent to applied arts museums throughout Europe after the closing of the *Exposition Universelle*. Beyond the actual construction of a piece of furniture, Bing's workshop was a very controlled operation. Pieces were not produced until an order came in from a visitor to his exhibition space. If a piece on display did not generate commissions, Bing was willing to sell the model to a museum, with the hope that its form would inspire designers elsewhere.[9] Only a few pieces, such as a desk by Colonna, were produced in a series and entered several collections.

Bing maintained a strong sense of aesthetic quality, similar to that he exercised in collecting and selling prime examples of Japanese art. He refused to be drawn into the mass distribution of applied art. If he did manufacture parts of furniture with outside companies, he did so quietly, for he was not committed to large-scale production. Instead, he promoted the idea of the small workshop in which talented designers and master craftsmen worked together to perfect a small number of pieces. By keeping the workshop in the hands of skilled artisans, Bing hoped to create furniture that reflected the most refined tastes and would be sold for handsome prices. However, by 1904, Bing had liquidated his firm and his remaining models of Art Nouveau furniture.[10] His concept of a contained and controlled workshop had been too costly to maintain, and undoubtedly was considered a financial failure by other artisans and competitors alike.

10.8 August Thonet, settee.
Steam-bent beechwood, stained.
Austrian, 1904.
V&A: W.41–1979.

10.9 Georges De Feure, interior,
'L'Art Nouveau Bing', *Exposition
Universelle*, Paris, 1900.

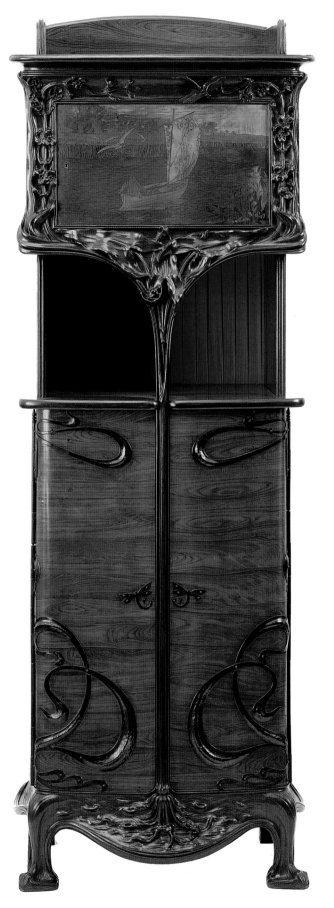

10.10 Louis Majorelle, cabinet. Walnut and oak veneered, enriched with marquetry of various woods, wrought iron. French, 1900. V&A: 1999–1900.

A different and much larger endeavour is associated with the city of Nancy, where Louis Majorelle and Émile Gallé, among others, established effective ways to reach potential clients.[11] Majorelle stressed a high level of creative ingenuity in his works, which he matched with his fervent desire to sell pieces to a large audience. This led him to organize several ateliers in which numerous 'workmen' produced multiple versions of the same piece of furniture.[12] Suites of furniture were produced with almost assembly-line precision, a process that stood in stark contrast to the more traditional craftsman-like approach practised by Bing in Paris.

Although a version of the long-awaited 'modern style' was fostered in Nancy, as it was documented in local newspapers, Majorelle and the entire École de Nancy were not content to have their furniture sold merely in eastern France. They hoped to sell examples in Paris and other European cities, so that Nancy would be recognized as a major centre for the industrial production of lavish furniture, thereby extending the reach of Art Nouveau. The Parisian press frequently singled out Nancy as a city of tremendous vitality, a place where artists displayed a firm connection between art and industry, and thus helped to bring to fruition a basic goal of the Third Republic.[13] Articles extolling the creative ingenuity found in Nancy regularly appeared in daily newspapers. Majorelle in particular benefited from these frequent notices as he acquired clients who were attracted by the publicity surrounding his reputation. Other furniture-makers, such as Eugène Vallin and Émile André, also benefited from the increased attention given to the École de Nancy.

By concentrating on large-scale production, Majorelle's factory system hastened furniture production and made the more popular pieces available to several clients at the same time. No-one had to wait long for availability to meet demand. At the same time, Majorelle's furniture emphasized rich materials – expensive woods were frequently combined with elegant metal trimmings (plate 10.10) – and suggested that only those with considerable wealth could afford them. Prices paid for these pieces showed that this was a luxury trade. With an effective publicity machine at work, Majorelle and many others in Nancy found their furniture appreciated by a large audience. By 1905–06, Nancy was perceived as a centre where like-minded industrialists applied the factory process to the production of furniture and other aspects of the applied arts. By the middle of the first decade of the twentieth century, however, concern arose that aesthetic quality and innovation had been sacrificed in the rush to achieve commercial goals.[14]

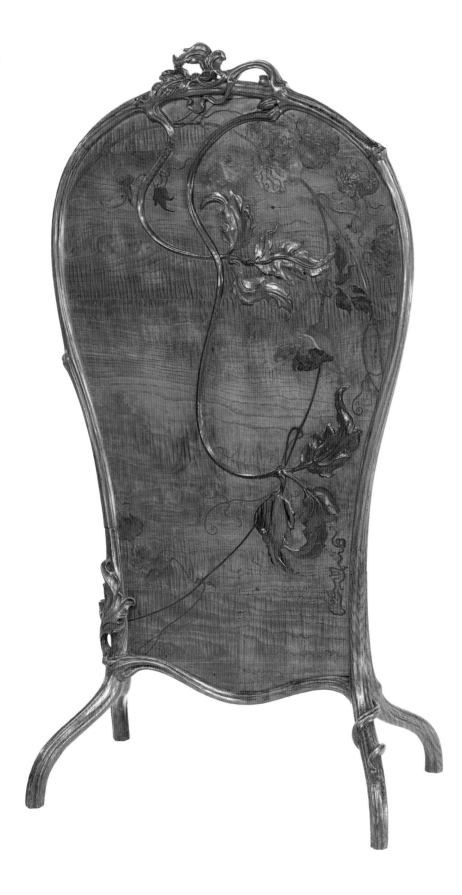

Whether or not the approach of Bing or Majorelle was emulated is of less importance than the realization that the French version of Art Nouveau furniture was being widely discussed and exhibited. Achievements in Paris and Nancy influenced the way furniture was made throughout the world. Paris and Nancy essentially marked the poles of Art Nouveau furniture and affirmed that the 'new style' could be championed in a variety of ways. As furniture-makers tried to break with the past, some explored primitive societies and exotic cultures to find innovative ways to handle materials, especially wood. Others, such as Eliel Saarinen and later Serrurier-Bovy, left the wood unpolished, to allow its rawness to convey an earthy, sensual roughness (plates 1.13 and 26.15). The English Arts and Crafts movement provided a powerful precedent here, with an aggressive commitment to simplicity inspired by folk furniture. In a fashion that seemed to combine the exotic and the vernacular, some designers produced painted furniture. Furniture-makers turned to new sources for inspiration. One such source was the work of the English designer E.W. Godwin from the 1860s, who was one of the first designers to grasp the potential of Japanese art (plate 8.13). His work, shown in France and Germany as well as London, became a model for the creation of a geometric, angular version of Art Nouveau found in pieces by Hoffmann and Mackintosh. The minimalist approach also proved important in Munich, in the work of Richard Riemerschmid. This simple elegance also suggests the role played by the English Aesthetic movement in framing the fundamental interests of furniture-makers (see chapter eight).

Other designers wanted to revitalize aspects of older traditions. An example of this is a suite of furniture created by Georges De Feure for Siegfried Bing (plate 2.7). His sitting room, conceived in 1900, was a modern interpretation of the eighteenth-century Rococo tradition. His use of gilding and the details of flowers in wood and on the fabrics of his chairs and sofa suggested that he did not want to break fully with the past.[15] The Rococo tradition remained alive in France and capable of influencing others – Gallé (plate 10.11) or Majorelle, for example. This strong underlying presence provided a useful counterbalance, so that furniture designs did not become too outlandish.

For other designers who revolted against relying on tradition, furniture had to be structural and functional, with decoration merely added to the surface. Henry van

10.11 Émile Gallé, firescreen. Ash with applied floral decoration and marquetry in various wood, back veneered with maple. French, 1900. V&A: 1985–1900.

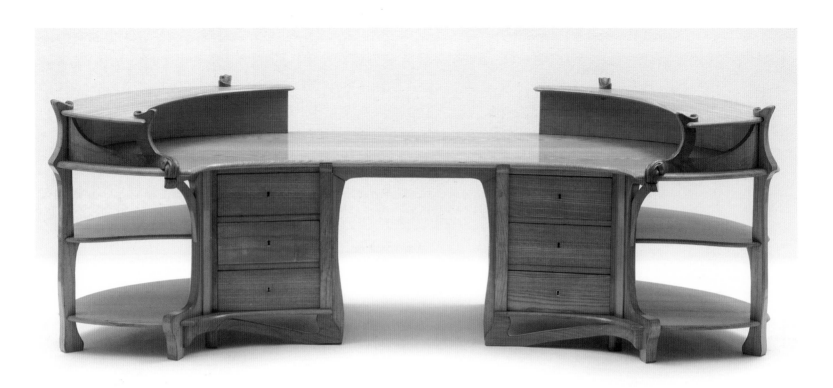

10.12 Henry van de Velde,
desk. Belgian, 1900–02.
MAK – Österreichisches Museum
für angewandte Kunst.

de Velde advocated this approach, and desks created for La Maison Moderne in Paris, and collected by the Decorative Arts Museum in Vienna (plate 10.12) as models to be studied by younger designers, became a hallmark of the era. Van de Velde's ability to counsel collectors, other designers and entrepreneurs such as Bing, helped to move advanced furniture design in the direction of functionality and simplicity. The sweeping sense of curvilinear movement, the challenging way in which forms were streamlined, made van de Velde a role model to follow. Both Guimard and Gaillard learned from van de Velde's achievements. Indeed, critics described Gaillard's furniture as being solid, reasoned and tightly 'constructed'. His pieces were those of an engineer, as their structural members were fully exposed and leather straps for seats were tightly utilized.[16] Guimard also employed a personal sense of architectural functionalism in his furniture designs (plate 10.13).

Some designers, such as Charles Plumet and Tony Selmersheim (plate 10.14) – both associated with the Parisian group *Les Six* – produced ensembles of furniture that visually blended with the room's background decoration. They created simply designed pieces with harmonious colours and restrained forms.[17] Many of their works used plain wood with undecorated surfaces, which convey a minimalist appearance. By emphasizing structure, they underscored the way in which furniture was made. Chairs

and tables made by Richard Riemerschmid (plate 10.15) maintained this tendency, as his shapes suggest interpenetrating planes in space or reveal elongated panels that have been stretched to their limits.

Where furniture was produced without reference to a specific architectural setting, as seen with many pieces created in Italy in keeping with the *Stile Floreale* or with Majorelle's works, emphasis was placed on other aspects. The quality of fittings, the subtle inlay of woods, and the use of rich fabrics drew attention to the tasteful appreciation of lavish details, but they were intended more for commercial exploitation than for aesthetic harmony. The masters of the *Stile Floreale*, including Vittorio Valabrega and Ernesto Basile (plate 29.5), worked with sculpted woods and subtle colourations that provided a lavishness to their pieces (see chapter twenty-nine). Some furniture-makers in the Art Nouveau era followed these directions, but truly innovative designers pursued other courses.

Significantly, furniture-makers used woods (including mahogany, oak and pear) that had not been popular in the years immediately preceding the turn of the century. They polished wood surfaces to create sparkling effects. Lacquered surfaces seemed to shimmer, and drew attention to the fact that room furnishings were changing and evolving constantly. The end-result was that individual pieces of furniture and entire rooms appeared rich and well appointed. Just as consumers wanted, the 'new style' suggested new

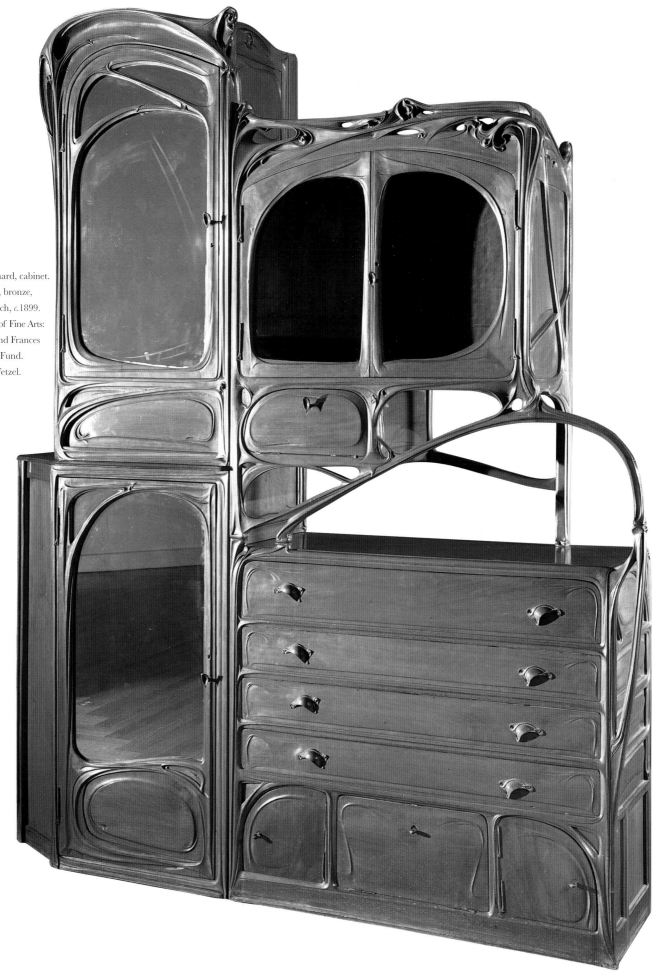

10.13 Hector Guimard, cabinet.
Pear and ash woods, bronze,
mirrored glass. French, *c.*1899.
© Virginia Museum of Fine Arts:
gift of the Sydney and Frances
Lewis Art Nouveau Fund.
Photo: Katherine Wetzel.

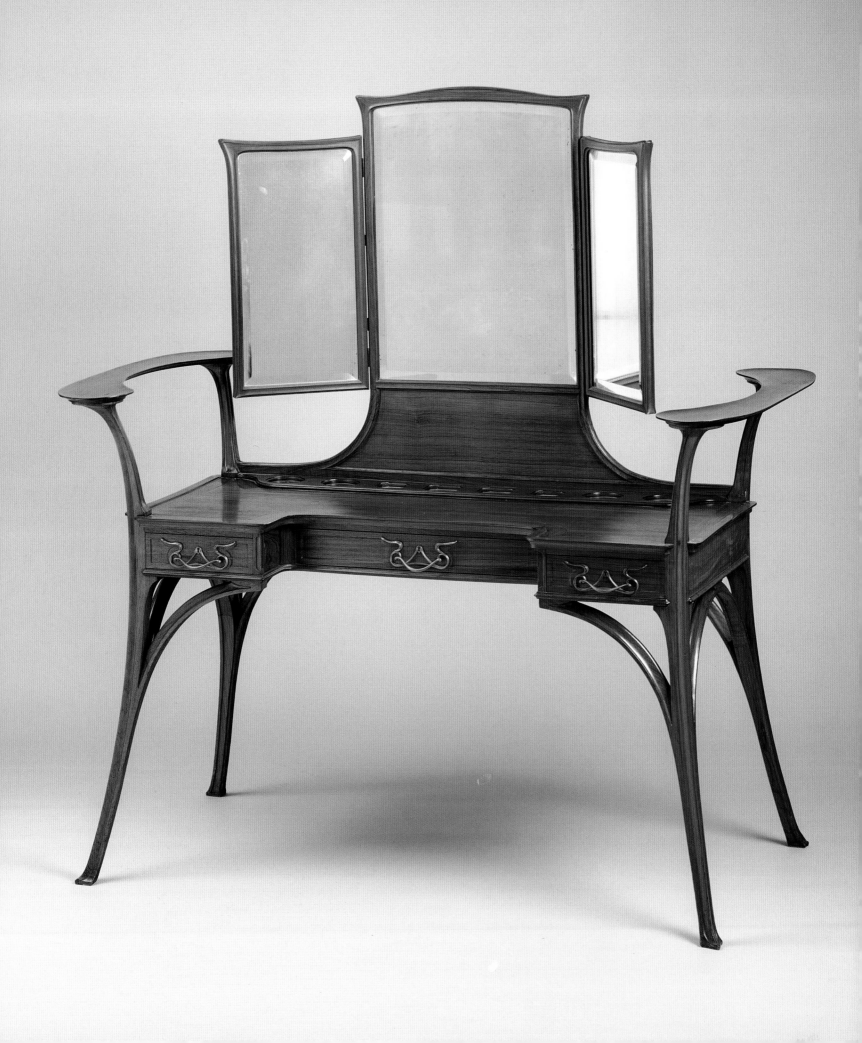

10.14 Charles Plumet and
Tony Selmersheim, dressing table.
Padouk wood with gilt bronze
mounts. French, 1900.
Museum für Kunst und Gewerbe,
Hamburg.

wealth, and along with this, of course, it suggested new power – politically and socially.

Despite public opposition to change and frequent attacks in the press, Art Nouveau furniture designers provided a vision for the future. By eliminating a reliance on the past and on the use of historical styles, designers with engineering instincts and craftsmen with an obvious love of materials produced a vast number of diverse pieces.[18] The ingenuity and sense of imagination that coursed throughout the period are evident in the range of furniture created. This 'modern' style, with its challenging use of wood and innovative forms, marked a distinct rupture with the past and served as a harbinger of the future.

Yet, were all these changes fully accepted? Was the field of design truly modernized by this revolution in design? Did the production of furniture advance at all in the decade that followed the *Exposition Universelle* of 1900? Although these questions are difficult to answer, one writer, a senator intimately connected with the French government, attempted to address these concerns in 1908. Charles Couyba believed that, following the early years of Art Nouveau, developments in furniture design were retarded by the continued dedication to period styles.[19] He also asserted that public taste, rather than the lack of initiative on the part of entrepreneurs and designers, was responsible for this. A reliance on 'past traditions' actually generated an environment that was hostile to modern decorative design. The fact that few independent collectors acquired examples of Art Nouveau furniture was deemed a serious impediment to the successful support and dissemination of modern design. Couyba also chastized individual creators, including furniture-makers, for not following a simple and rational plan. Instead, he claimed, they were

often given over to excess, employing overly finished details and an elaborate use of decoration that appealed to consumers who were wealthy but lacked an innate understanding of true artistic innovation.

Such discussion, appearing when the initial popularity of Art Nouveau furniture was waning, says much about how contemporary styles were interpreted. Somehow, only a few were convinced of the real importance of Art Nouveau. Once these individuals no longer exerted their influence, hardly anyone took their place. Innovators of Art Nouveau furniture lost their supporters just when they most needed them. The style's rapid descent caused many pieces to disappear from public view. The real strength of this revolution in furniture design was only marginally understood well into the 1960s. Yet this was one of the last instances of furniture production being so keenly dedicated to the use of wood. (Perhaps only the Scandinavian moderns of the 1930s maintained such loyalty.) Artisans moulded the best woods to match their inventive imaginations. With the twentieth century came the introduction of new materials such as metal alloys, aluminium and plastics. Although wood remained a popular mass medium, it was relegated to a position of secondary importance among avant-garde designers. The new century also witnessed the rise of composite woods – ply wood, blockboard, chipboard and, ultimately, MDF. The Art Nouveau period was the last time that wood reigned supreme and the creative excesses of woodworking were pushed to the limit. In later years it became obvious that new forms could be more effectively developed using other materials that were less costly to purchase and less time-consuming to produce. The next generation of designers were more intrigued with scientific discoveries and innovative applications of the new materials.

In recent years, as the fascination with synthetic materials has started to fade, admiration for the achievements of skilled craftsmen has grown enormously. Awareness of designers' keen knowledge of wood's capabilities and qualities, as well as respect for artisans' intriguing ability to shape wood in such a way as to animate pieces of furniture with natural forms, has made Art Nouveau furniture seem to be the product of a provocative and highly personal endeavour. Through its ties with nature, such furniture embodies motifs, forms and colours that will never appear insufficient or outdated. By studying *fin-de-siècle* works, we are able to examine the sources of Art Nouveau with an ever clearer vision and to realize that nature remains a solid foundation for the creation of imaginative and breathtaking works of art.

10.15 Richard Riemerschmid,
armchair and table. Walnut and
leather. German, 1898–99.
Chair made by Liberty. Table
made by VWKH, Munich.
V&A: Circ.859–1956; W.1–1990.

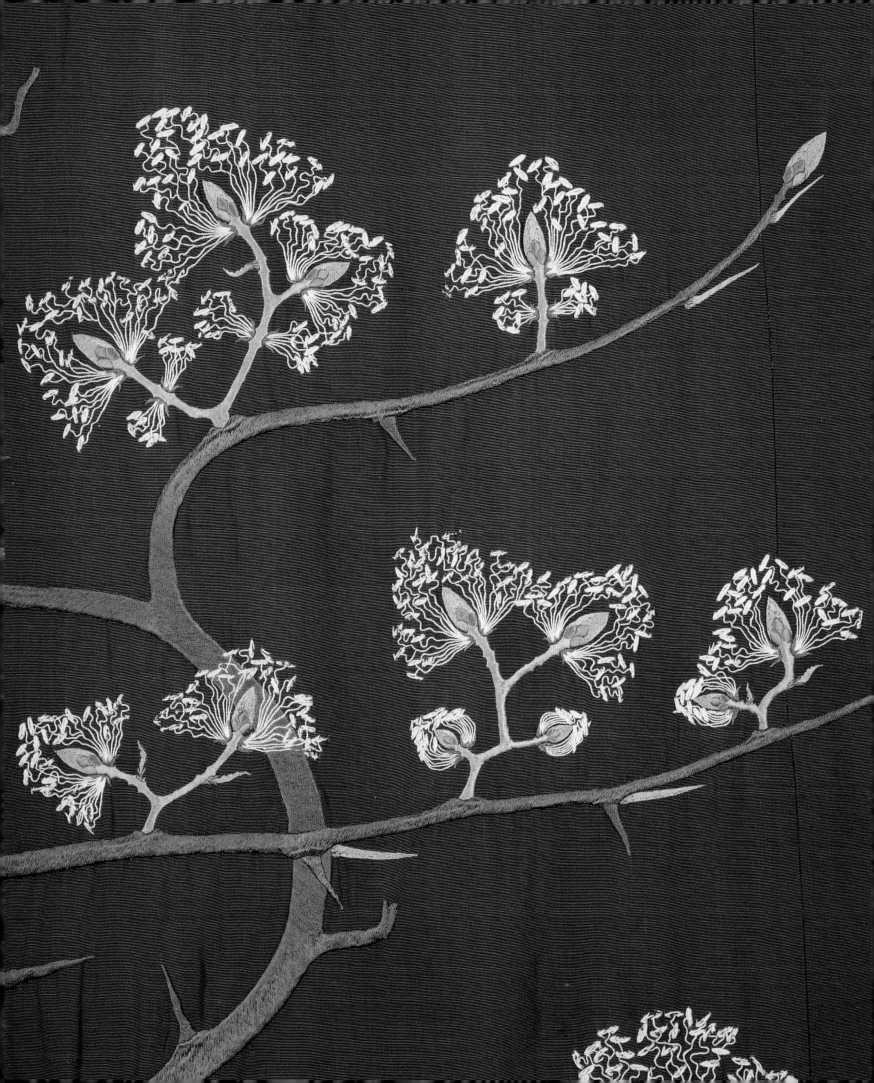

Linda Parry

The New Textiles

11.1 Hermann Obrist, *Grosser Blütenbaum* (Flowering Tree), embroidery. German, 1895. Staatliches Museum für angewandte Kunst, Munich: Die Neue Sammlung.

In 1896, London audiences were able to see for the first time an example of the New Art which was beginning to monopolize the work of European artists and designers. This was Hermann Obrist's *Peitschenhieb* (*Whiplash*) embroidery (plate 1.12) shown at the Arts and Crafts exhibition of that year. It was designed, according to *The Studio* magazine, to show 'the lightning-like flick of a whip – [it] has the endless continuity of line and spring of curve of some fascinating monster orchid'.[1] It represented a shockingly new attitude towards design – forceful, intuitive and lively, at the same time bending all conventional rules on the artistic representation of nature. Today, this embroidery is recognized as one of the most potent icons of the Art Nouveau style. However, the importance of textiles as a whole in helping to create the New Art is much greater than that of any single piece, and this was much more widely accepted at the end of the nineteenth century than it is today. Many leading Art Nouveau architects and furniture designers turned their hands to producing repeating patterns for furnishings and costume decoration, realizing that these would help provide the total fashionable look (the *Gesamtkunstwerk*) that they sought. Subsequently, the style became more comprehensive, and, with the widening of its industrial application, reached a far wider audience than would have been likely otherwise.

As chapter one outlines, the term Art Nouveau has been fraught with problems of definition. Textiles are no exception. This chapter covers designs showing pattern-forms, arrangements and motifs now accepted as characteristic of the style, as well as textiles revealing similarities in ideas and manufacture in the production centres of Europe. Although the stylized and tortuously curving flowers, roots, stems and branches provided the form for many patterns, there is no one continuous artistic development. On the contrary, in a style equally inspired by aesthetic, literary and philosophical sources, strong and quite separate national characteristics appeared in the textiles of the time, and many different types of design and manufacturing methods prevailed. It is this great variety of work which makes Art Nouveau, although short-lived, one of the most fascinating styles to study and assess.

The influence of nineteenth-century British design on textiles in Europe at the turn of the century was strong and has led to the two contemporary styles – namely Arts and Crafts and European Art Nouveau – frequently being confused or simply lumped together as one. This is not just due to ignorance or the coincidence of time, for the exchange of ideas across the English Channel, particularly between Britain, Belgium and France, resulted in individual designers drawing on the characteristics of their foreign counterparts.

Britain had struggled to compete for centuries with the silk, woollen, linen and cotton industries of Italy, France, Holland, Germany, China and India, but by 1890 had established itself as the leading artistic textile manufacturing country in the world. Shown regularly through International Exhibitions and sold in shops throughout the world, these textiles became more popular in mainland Europe than they were at home. Initially it was the textile work of two major English designers, William Morris and C.F.A. Voysey (plates 8.4 and 8.9), which attracted the greatest interest, although a wide range of Arts and Crafts textiles were utilized by European designers and interior decorators. Illustrations in leading French, Belgian and German artistic magazines and trade catalogues of the late nineteenth and early twentieth centuries showed English furnishings used in rooms designed by, for example, Siegfried Bing, Gustave Serrurier-Bovy, Alfred Ginskey, Henri Bellery-Desfontaines and Josef Niedermoser, and on furniture upholstery by Georges De Feure, Victor Horta, Henry van de Velde, Léon Bochons, J.&J. Kohn, the Thonet brothers and Josef Hoffmann, to name but a few.

William Morris' career as a textile designer had already finished when Obrist's work was first exhibited, yet Morris' influence outside Britain was as strong as ever. As early as 1876 he had considered a request to sell his work in Germany[2] and throughout the 1880s a flood of artists, designers and makers from many parts of the world travelled to London to meet him, listen to his views, visit his factory and buy items from the Morris & Co. shop. It was as a result of acquiring his woven and printed furnishings, carpets, tapestries and embroideries that many Europeans were first introduced to his work and ideals. Morris had revitalized an interest in textiles by showing their importance in adding colour and texture to the home, and by demonstrating that tapestry, for instance, could provide one of the highest forms of artistic expression. This helped to persuade artists and designers that the medium was worthy of serious artistic consideration. Furthermore, his working practices attracted the attention of established European manufacturers. They found an unusual situation where, within one small workshop, an enormous range of textiles were produced successfully by traditional means. Although it was impractical directly to emulate such ideas in large purpose-built European factories, it forced a reassessment of industrial practices in an effort both to create the beautiful effects the public sought and to address the needs of workers.

The attraction of C.F.A. Voysey's work was more prosaic, evolving around the originality of his repeating patterns of flowers, animals and birds. Wallpapers from his designs shown in Paris in 1889 greatly impressed van de Velde. Voysey's textile designs, available in a wide range of finishes, were equally admired. Machine- and hand-knotted carpets, printed cottons and linens, woven gauzes and heavier forms of silk, linen and cotton were initially sold through the Liberty shop in Paris, reaching a very wide audience by the end of the century. Although popular in Europe, Voysey was not happy to be associated with Art Nouveau. Famously xenophobic (as were many Arts and Crafts designers), he claimed not to like mainland European design or believe it worthy of study. In an interview published in *The Studio* in 1893 he wrote: 'It is not necessary for artists to be bound merely to tradition and precedent, or be crammed to overflowing with the knowledge of the products of foreign nations.'[3] Some three years later, the same magazine returned to the subject quoting him, more vehemently, as believing that recent foreign developments in the arts had 'brought into our midst foreign styles of decoration totally out of harmony with our national character and climate'.[4] Cultural institutions could be equally narrow-minded. Curators looking after the national collection at the South

Kensington Museum acquired only seven French textiles during the last decade of the nineteenth century, these reproducing seventeenth- and eighteenth-century French and Italian velvets, brocades and damasks, despite clear and widely known evidence of new developments in the industry.[5]

Fortunately, a more congenial relationship existed between the British and European textile trades, despite a history of fierce competition. During the 1890s, when British design was at its most influential, many fashionable Continental shops stocked a wide range. These included Bing's L'Art Nouveau in Paris and Walthers in Frankfurt-am-Main, Hirschwald's Hohenzollern Kaufhaus and Von Burchard Sohne in Berlin, Von Braes in Dusseldorf, Robert Furtwangler in Zurich, Konstantin-Hansen & Bindesbøll in Copenhagen, Steen & Strøm in Kristiana (Oslo) and Eric Folker's Sub Rosa in Stockholm.[6] British dealers, middlemen or 'warehousemen' as they were known at the time, built up strong trading links with French and German textile manufacturers in particular. Not only did they secure orders abroad for British textiles, they also sold original watercolour designs to weavers in Lille, Lyon and Krefeld and to the printers of Alsace. Furthermore, dealers purchased patterns from freelance designers, registered them in their own names and then commissioned French firms to weave or print them for British consumption. For example, leading dealer Richard Stanway followed this process and sold to Liberty or through his own shop at 2 King Edward Street in London. It is possible to trace British designs in the records of the four most influential printing firms: Gros Roman, Koechlin-Baumgartner & Cie, S. Wallach & Cie and Sheurer Lauth & Cie, all based in Mulhouse, the centre of the French textile printing industry. Many are marked with the familiar 'RS' trademark of the importer.[7] The appeal of British patterns sometimes superseded the needs of trade for Frederic Engel-Gros, the owner of Dollfus Mieg & Co. (the largest Alsatian printing factory). He used a wide range of British textiles for the furnishing of his country home, the Château de Ripaille on Lake Geneva, which he restored between 1891 and 1903.

The 1896 Arts and Crafts Exhibition in London proved important in signalling a new change of direction in design and, in the field of textiles, a number of exhibits showed how varied and innovative these effects could be. A settle with a stencilled linen back (now in the National Museum of Scotland) by the young Charles Rennie Mackintosh used a form of decoration which became very popular for upholstery in the furniture of mainland Europe, and the embroideries of Jessie Newbery, a fellow Glaswegian, showed patterns and techniques unfamiliar to English audiences

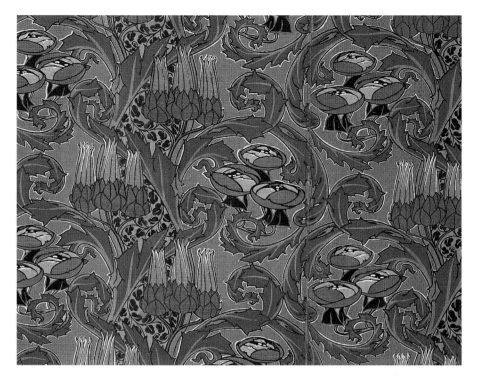

11.2 Silver Studio (Harry Napper), *Convolvulus and Seed Pod*. English, 1898. Block-printed onto cotton by G.P. & J. Baker. V&A: T.53–1953.

(plate 21.3). Newbery had a traditional training, mastering a wide range of stitches through a study of both British and European folk embroidery, which she greatly admired. She had taught embroidery at the Glasgow School of Art from 1894, and while there had developed an experimental style using appliqué with simple stitching. As this technique was quicker, it encouraged more intuitive results. Exploiting the textured linen and fine pastel-coloured silk grounds became as important as the patterns of geometric or stylized floral patterns worked upon them. Her compositions frequently included inscriptions and the repetition of symbolic motifs, especially the now-famous Glasgow rose – her use of which most probably preceded that of her more famous Glasgow compatriots. Newbery's work was much admired by European visitors who recognized in her designs vernacular traditions close to those developing in mainland Europe at that time. Surprisingly, she was guarded in her opinions of this work, believing her simple styling to be a strong reaction against the 'delinquent curves' of Art Nouveau,[8] but clearly recognizing an affinity with traditional northern European aesthetic tastes. Newbery travelled in Germany, where she and her husband Francis had many friends, and her work was published in the popular magazines *Das Eigenkleid der Frau* and *Moderne Stickerein*.[9]

Obrist's work was quite different. He was born in Switzerland and studied in Heidelberg. After travelling to Britain, he developed talents as a decorative artist of some distinction, winning gold medals for furniture and ceramics at the 1889 *Exposition Universelle* in Paris. He established an embroidery studio in Florence which, in 1894, he moved to Munich. His work became extremely popular and Obrist is now seen as the pivotal figure of the Jugendstil movement which developed there. The six embroideries – which included the *Whiplash* and *Grosser Blutenbaum* panels – and one hearth rug, shown in the 1896 exhibition, came from a much larger collection of his work which had been on tour since April of that year, starting in Munich then moving to Berlin before reaching London. Each panel was embroidered by Berthe Ruchet, the manageress of his workshop and one of the unsung heroines of the new textile movement. Worked exquisitely in traditional surface embroidery techniques, these show Obrist's very original designs to perfection. All based on natural forms, they depict roots, stems and flower heads melting into swirling, fluid inorganic patterns. Their intensity and richness is heightened by the use of brightly coloured and gold thread on dark, lustrous grounds (plate 11.1).

In Germany, Obrist's work was heralded as the 'birth of a new applied art'[10] and British designers and craft workers saw, exhibited in their own artistic heartland, evidence of a new spirit of design and decoration that was quickly gathering influence in all parts of Europe. The designers working for the Silver Studio in London, one of the most commercially astute suppliers of patterns to the textile industry, were quick to absorb Continental traits. One novel idea was the use of dead or poisonous plants and weeds, such as dried seed pods, convolvulus, hemlock, thistles and teasels, in their patterns. This conformed with the British view of nature, and, at the same time, showed a guarded interest in the decadent underpinning of the new European style (plate 11.2). These patterns found a ready market outside Britain. 62 designs were sold in 1898 by the Silver Studio to French manufacturers; 40 per cent of designs went abroad by 1906 (the majority bought by two Lille weaving firms, Leborgne and Vanoutryve, the Studio's biggest European customers).[11] Many of these patterns were drawn for the Silver Studio by Harry Napper and Archibald Knox, both of whom worked for a time in the Studio. Napper, in particular, was greatly influenced by developments in France and Belgium and is the closest Britain came to producing its own Art Nouveau textile designer. It is likely that British contractors were also employed in producing goods for the Continental market. A group of printed cottons in the collections of the Victoria and Albert Museum are extravagantly Art Nouveau in style, with strong, bright contrasting colouring.[12] These were printed between 1899 and 1907 by F. Steiner & Co. in Lancashire, and are probably of French or Belgian origin

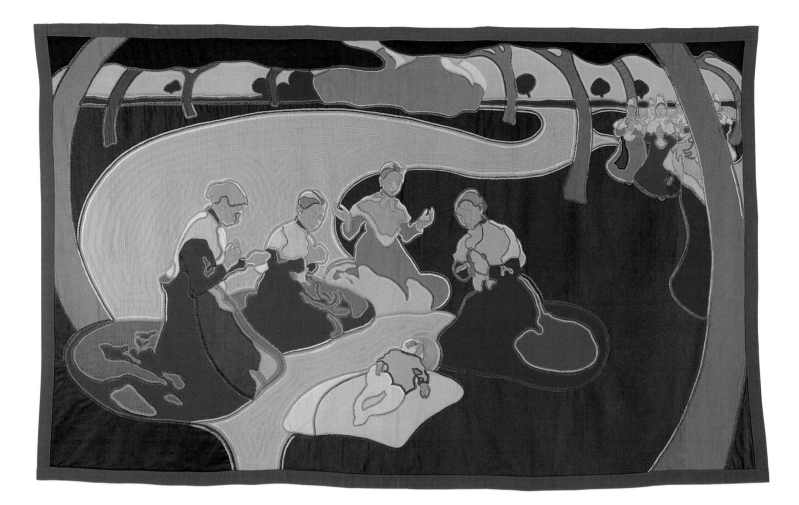

11.3 Henry van de Velde,
La Veillée des anges (Angels Wake).
Wall-hanging of appliqué,
wool and silk. Belgian, 1893.
Museum Bellerive, Zürich.
Photo: Marlen Perez.

(although it is known that the firm purchased British patterns, including the work of the studio of Christopher Dresser). The Art Nouveau patterns would not have appealed to the British market, and the fact that they were all registered with the Patents Office reveals a level of trade protection not normally adopted for the home market.

Art Nouveau textiles show strong geographical and ethnic differences. It is frequently difficult to believe that many were made at the same time, in countries with similar spirits of innovation and common borders. Although mostly produced in urban areas, they cover a wide cultural range from sophisticated machine-woven silks and professional embroideries to hand-crafted needlework and woven panels emulating folk traditions. It was in France and Belgium that stylized floral patterns, with which the style is most clearly recognized, developed. Produced as printed cottons and velveteens, woven silks and luxurious deep-pile carpets, these provided vital sources of colour and texture for the new integrated fashionable artistic interior. This homogeneity demanded that each furnishing conform to a

central theme, either in colour or pattern type, as determined by the architect or designer (frequently the same person). By contrast, designers and crafts workers in a number of countries with strong historical textile traditions, such as Norway, Denmark, Sweden, Finland and Hungary, turned to their own rural artistic heritage for inspiration using indigenous patterns and retelling folk stories in traditional forms of tapestry and carpet-weaving, embroidery and lace. In Holland, Germany and Austria an interplay of these two contrasting developments evolved, crystallizing in the early twentieth century into some of the most original and forward-looking images of all.

For many, van de Velde's enduring legacy rests more on his writings on design and ornament than his own artistic output. However, he was responsible for designing some of the most original and attractive Art Nouveau images. As a textile designer he had few equals. His career can be viewed as a barometer for the style. It both preceded and outlived the period, it included commercial and craft work, and the eclecticism of his patterns shows how thoroughly he absorbed popular stylistic variations. Furthermore, the evolution of significant developments in design from the 1890s

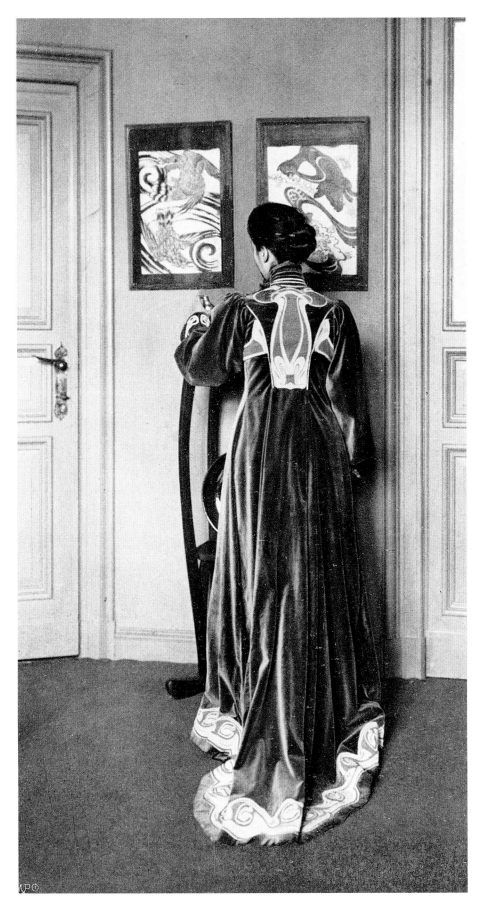

to the 1920s followed his own movements around Europe, from his home town of Antwerp to Brussels, Paris, Munich, and, finally, Weimar. Van de Velde first turned from painting to the decorative arts in 1892. In that year he exhibited an 'ornamental embroidery project' at the ninth Salon of the *Société des Vingt*. The following year, at the tenth Salon, he exhibited the now celebrated embroidered panel *La Veillée des anges* (plate 11.3). Using appliqué techniques with outline stitches to interpret this stylish, Gauguinesque composition, it showed a mastery of the embroiderer's art. This proved to be his most ambitious textile design. It signalled new and exciting directions in embroidery, developing in Glasgow and exploited elsewhere in Europe.

Van de Velde's work shows a fascination for decorative furnishings and clothing, an unusual trait in a male designer, especially one initially trained in the fine arts. He became one of the busiest and most commercially popular textile designers of the late nineteenth and early twentieth centuries, and his patterns were made up into many different types of finishes by manufacturers and workshops in Holland, France and Germany. His patterns were also diverse, ranging from abstraction, influenced by Eastern designs, to geometric and stylized floral repeats. He also produced designs for female clothing. Unfortunately, little of this work survives beyond fragments of embroidered decoration, although original photographs are proof of his interest and innovation in this field (plate 11.4).

Many textiles manufacturers were wary of the new designs arriving on the market, but their conservatism helped to establish some of the most characteristic effects of Art Nouveau textiles. Long-established silk-weaving firms in Lyon, for instance, celebrated for centuries for the high quality of their goods, produced ranges using new patterns but woven in traditional forms, retaining glossy surfaces and fancy grounds. Fashionable clients loved the mixture of new patterns in familiar finishes. It pandered to the need for opulence and, at the same time, accepted an element of change.

These luxuriant furnishings proved ideally suited to the interiors of new buildings being erected in Paris and Brussels, in particular, by architects who were keen to control every feature of their houses. Of these, Eugène Gaillard (plate 7.5), Édouard Colonna (plate 11.5) and Georges De Feure (plate 2.7) working in Paris, and Victor Horta in Brussels, all designed the furnishings used in their interiors. Although restricting his use of textiles to hand-knotted carpets and embroidered trimmings, Horta's characteristic

11.4 Henry van de Velde, dress. Belgian, 1900.

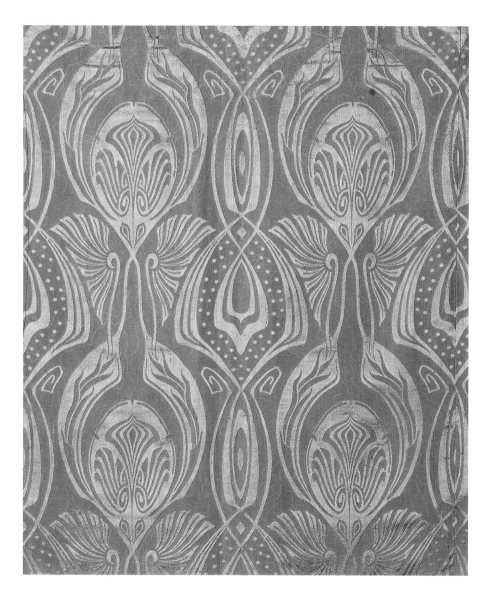

11.5 Probably Édouard Colonna for the Cornille brothers, Lyon, silk-woven curtain. French, *c.*1900. V&A: T.357–1990.

11.6 Paul Ranson, printed cotton. French, 1898. The Museum of Applied Arts, Budapest.

The Paris *Exposition Universelle* of 1900 displayed an enormous range of Art Nouveau textiles. Bing's exhibits showed how strongly his influence on fashionable interior design had become since opening his shop barely five years earlier. Included in his Pavilion were rooms by Colonna and De Feure, displaying sophisticated fabrics (woven for Bing in the three major European weaving centres of Krefeld, Lyon and Lille), carpets, embroidered trimmings and upholstery. Silks by De Feure showed bands of coloured brocading in the eighteenth-century manner in strong contrasting colours, such as lime and lilac (plate 2.7). A number of Colonna's single-coloured textiles had watered grounds, producing a secondary pattern similar to the sub-patterning of his designs for other media, such as the opalescence in glass and wood inlays in furniture. Such exciting effects are likely to have evolved from discussion between the designer, the manufacturer and Bing (as the commissioning retailer).

Although Colonna and De Feure are now recognized as two of the most important French textile designers of the period, their work is known only by a few surviving examples, through contemporary photographs of exhibitions, and by one or two individual decorative schemes purchased by museums directly from Bing. Few house commissions were ever realized, and there is no evidence to suggest that the designers sold textile patterns directly to manufacturers or shops. A number of other French Art Nouveau textile designers were more commercially active. One of the most versatile and prolific was Félix Aubert, who produced designs for many forms of the applied arts as well as *cretonnes* (heavy cotton or linen fabrics with a printed design), printed velvets, silks, damasks, carpets, embroideries and lace. Gabriel Mourey in *The Studio* (1897) described him as one of the few designers able to withstand British influences.

Leading practitioners normally associated with graphic media produced important textile designs. Alphonse Mucha and Eugène Grasset offer good examples of artists who made significant contributions to the genre. Mucha painted a number of watercolours for the well-known commercial design studio, Ateliers C.G. Forrer of Paris. These, like many of his poster designs, show women posed in floral bowers. Printed in two sizes on satin and velveteen, they were intended to be used as screen panels and cushion covers (plate 11.7).[13] Mucha also designed carpets, such as the one exhibited in the Austria Section of the 1900 *Exposition Universelle*, which showed a bizarre mixture of historical styles. Grasset supplied designs for a series of machine-woven pictures and screen panels produced by the firm of J.L. Leclerc of Tourcoing, near Lille. Mass-produced on

designs complement the sinuous curves of his architectural plaster work and monumental furniture. Colonna and De Feure were more adventurous, using woven and printed textiles and embroidery on walls and windows and for upholstery. The importance of Siegfried Bing, who transposed their designs from paper to cloth, should not be underestimated. As well as commissioning manufacturers to produce entire rooms to display in his shop L'Art Nouveau, he also commissioned the textiles used. Bing appreciated the decorative qualities of cloth and used it confidently. One of his first displays, described as an 'English Room', had walls covered with an impractical, yet visually stunning, printed velveteen (plate 11.6). Despite being the most eye-catching detail, the fabric, ironically, turned out to be the only non-British item in the room, as it was a French textile designed by Paul Ranson and printed by Gros Roman in Wesserling.

11.7 Alphonse Mucha, printed velveteen cushion cover. Czech, *c*.1899–1900. V&A: T.317–1965. © Mucha Trust. © ADAGP, Paris and DACS, London 2000.

jacquard looms, the two most popular designs, *Fête du printemps* and *Fête champétre*, provided a comparatively inexpensive form of tapestry for the home and were sold in large quantities through fashionable outlets such as Magasin du Printemps in Paris. Both these designers turned to textiles initially as a means of earning a living, yet this diversion not only provided 'a golden opportunity to thoroughly master different styles',[14] but also showed the diversity of European cosmopolitan decorative artists at the end of the nineteenth century.

Although woven and printed yardage dominated fashionable Art Nouveau interiors, hand-made textiles were also important in defining the style. Exquisitely fine embroidery of the École de Nancy, for example, displayed at an exhibition of the work of the École in Paris in 1903, revealed a specific regional floral form of Art Nouveau, one that could be applied to all media. Although the patterns depicted were new, skills for such work followed traditions developed over centuries. Similarly, rural artistic groups in many parts of Europe revived hand techniques, such as embroidery, lace, tapestry weaving and rugmaking. Despite the traditional techniques, the pieces of work they produced were often extreme examples of the Art Nouveau style. Hungarian tex-

11.8 Chris Lebeau, three-panel screen. Batik on silk with mahogany frame. Dutch, *c*.1904. Stedelijk Museum, Amsterdam.

11.9 Batik workshop in the Hague.

11.10 Gerhard Munthe, *C'est ainsi.*
Woven tapestry. Norwegian, 1898.
Kustindustrimuseet, Oslo.

tile art, for example, such as Hallas lace, combines modernity and tradition in a startling fashion (plate 24.13).

In Holland the technique of batik became popular following the display of Eastern examples at the Colonial and Export Industry Fair in Amsterdam in 1883. Produced for many centuries in Indonesia, part of which had been in the Dutch Empire, it relied on the skilful drawing of patterns onto cloth by dribbling wax through a pointed metal spout. The wax resisted subsequent dyeing, and when melted, left fine crackling lines in the patterns. Multi-coloured designs of infinite fineness were possible with this technique and its individual qualities attracted various designers, including Jan Toorop (who had been born and raised in Java), C.A. Lion Cachet, Jan Thorn-Prikker, Theo Nieuwenhuis and Chris Lebeau. Lebeau's extraordinary designs are the most complex and accomplished, combining the colours and qualities of traditional Eastern work with his own compositions of abstract kaleidoscopes and stylized animals, fish and birds (plate 11.8). They show some of the most original textile images of the age. Although most of Lebeau's batiks were produced in Haarlem and sold through the fashionable Amsterdam shop 't Binnenhuis, the earliest and most celebrated centre was the Arts and Crafts workshop owned by John Uiterwijk in Apeldoorn in The Hague, where 30 women were employed to carry out the work. Wegerif Gravestein, the manageress, had studied wax techniques in Java and 'adapted them to the artistic demands of her own day and country' (plate 11.9).[15] The patterns produced by batik were also imitated by Dutch manufacturers in more commercial production; carpets made by the Deventer fac-

tory from designs by T.A.C. Colenbrander and in textiles by Nieuwenhuis and others woven by Ramaer.

Tapestry weaving is one of the oldest and most esteemed textile techniques. In the past it has been used for a wide range of purposes, from grand pictorial panels woven on looms in large commercial workshops to practical modest furnishings made by individuals using simple equipment at home. European designers working in the late nineteenth century were quick to recognize the value of this ancient technique, not only for its wide artistic appeal but also as a means of reviving long-forgotten traditional skills. Where tapestry has formed no part of the heritage of a particular country or area, it helped form national characteristics which have since become an acceptable part of the history of that region.

Although the royal establishments of Gobelin and Aubusson attempted to modernize the French industry by weaving designs by leading painters of the day, their commercial viability continued to rely on state subsidy as the work, which was both conservative and mediocre, found little favour with the public. Much more innovative both in design and technique were tapestries woven in newly established workshops in Scandinavia and northern Europe. The Norwegian designers Gerhard Munthe and Frida Hansen were foremost among artists who turned to tapestry to illustrate the folklore and patterns of their native land. By 1900, Munthe was described by the jurors of the Paris exhibition as having created 'a truly national style in the modern art of Norway' (see chapter two). His lively multi-figured compositions were clearly influenced by the art of the Nabis (see chapters two and four). A key figure, in several media, of the Viking or Dragon style, he illustrated scenes from Norwegian history and legend in his tapestries, the modernity of his forms bringing the Norwegian heritage powerfully into the twentieth century (plate 11.10). The tapestries were woven by *Det Norske Billedvoeveri* (the Norwegian Weaving Society), which was set up in Kristiania in 1897 by Frida Hansen, an embroiderer turned weaver who had mastered the art of tapestry weaving by working on a series of pictorial panels of her own design. For these she adopted ancient Nordic techniques, closer to those used for *kilims* (Middle Eastern woven carpets) than conventional Western forms of tapestry, in which large bands of colour are interlocked together. Panels such as *The Milky Way* and *The Pentecostal Choir* show her very considerable gifts as a draughtsman and colourist, and her technical prowess in exploiting this rigid and restricting form of the technique to provide more versatile effects cannot be disputed. Her awareness of the newest European art, which she had seen and studied in Paris in 1895, combined with

11.11 Frida Hansen, tapestry woven hanging. Norwegian, 1900. V&A: 1683–1900.

11.12 Otto Eckmann, *Five Swans*. Woven tapestry. German, 1896-97. Museum für Kunst und Gewerbe, Hamburg.

11.13 Josef Hoffmann, woven table cloth. Austrian, *c*.1905. V&A: T.123–1988.

her intense knowledge of the medium, lent her designs a greater sophistication. As well as weaving herself, Hansen also supervised the production of a number of her designs at the Norwegian Weaving Society. This included a series of panels for doorways of floral designs woven in hand-spun and hand-dyed wools with areas of open, gauze ground (plate 11.11).

Tapestries by Munthe and Hansen appeared in a number of European exhibitions and were available for sale through Hirschwald's shop in Berlin.[16] The treatment of tapestry as both picture and furnishing encouraged its much wider use. Carl Larsson, the most celebrated Swedish artist of the day, drew three tapestry designs for the *Hardarbetets Vänner* (Friends of Handicrafts) in Stockholm, an organization already well known for reviving traditional embroidery. Similarly, *Suomen Käsityöu Ystävät* (the Friends of Finnish Handicrafts), which had been set up in 1879 by the painter Fanny Churberg to promote local handicrafts, revived traditional forms of Nordic tapestry and carpet-knotting techniques. Examples of modern design by Akseli Gallen-Kallela, displayed in Paris in 1900, show how innovative this work had become by the turn of the century

(plate 26.8). Frida Hansen's work was also admired in Hungary and influenced the work of Sarolta Kovalszky and the artistic colonies at Nemetelemer and then Gödöllő, near Budapest (opened in 1904; see chapter twenty-four).

Otto Eckmann also designed for tapestry. Trained as a fine artist in Hamburg, Nuremburg and Munich, he turned his back on painting in 1894 to concentrate on a career in the applied arts. His friendship with Friedrich Deneken – a founder member of the *Kunstgewerbeschule* (Arts and Crafts School) at Scherrebek in northern Schleswig (now Denmark), set up in 1896 to encourage the tradition of fine weaving – led him to produce a series of tapestry designs which were woven at the School. The most popular of these was the *Five Swans*, of which approximately 100 versions were woven (plate 11.12). The panel, shown at the 1900 *Exposition Universelle* in Paris, became one of the most recognized and popular Art Nouveau compositions. In 1897, following Deneken's move to Krefeld in Germany to take up the Directorship of the Kaiser Wilhelm Museum, Eckmann began to supply patterns for commercial manufacture in the weaving industry established there. Deuss & Oetker, the Krefeld manufacturers responsible for weaving many of Eckmann's designs over the next few years, also produced the work of other notable designers working in Germany at the time, such as van de Velde and Alfred Mohrbutter.[17] As one of the leading producers of fashionable furnishings at the turn of the century, it is interesting to witness in this work, as with contemporary French textiles, the final flowering of the Art Nouveau style in the first decade of the new century.

However, Art Nouveau as the key modern style in textiles was destined to be superseded. Perhaps more powerfully than in any other medium, the steady development of geometric pattern-form among many Art Nouveau designers signalled the end of the style by 1903, and the tentative beginnings of what would eventually be recognized as the Modern movement. The strong emphasis on abstraction in the textiles produced in Vienna by designers such as Josef Hoffmann (plate 11.13), and by the pioneering German art schools, proved the most abiding influence in the following decades. The work of Richard Riemerschmid offers an interesting example of a mainstream Art Nouveau designer in many media whose textile patterns became increasingly geometric in the new century. For Riemerschmid, and, indeed, for other leading designers such as van de Velde, geometry succeeded nature as an indicator of modernity.

Thus, Art Nouveau in textiles, one of the most original and fascinating decorative styles to have originated in Europe, was put to rest.

Jennifer Hawkins Opie

The New Ceramics:
Engaging with the Spirit

12.1 Taxile Doat, vase. Porcelain made by Sèvres. French, 1900. Danish Museum of Decorative Art, Copenhagen. Photo: Ole Woldbye.

A sense of searching urgency, very much a part of the Art Nouveau spirit, had entered the story of ceramics by the late 1880s. It was the first time in the history of ceramics that makers themselves attracted the title 'artist'. In the hands of this avant-garde circle, although by no means uncommercial, the atmosphere surrounding ceramic production became an intensely emotional undertaking. The spectrum over which the new ceramic art was spread ranges from the discovery and re-deployment of local pottery traditions to the pursuit of the most elusive, demanding techniques in ceramic history. In the name of 'the New', the craft of making with clay, decorating, glazing and firing was pursued with a passion which was both intellectual and sensual, by State manufactories, local workshops and individual artist-potters alike.

For these artists and critics, the imagery drawn from the natural world was a vocabulary for exploring the emotional and intellectual concerns which characterized late nineteenth-century cultural and political life. Others found a deeper meaning in their engagement with the material itself, and the techniques of making and firing, most especially its magical, even mystical, relationship with fire. Pioneering French ceramicist and teacher Taxile Doat was employed by Sèvres for nearly 30 years (plate 12.1), and also maintained his own independent studio and kiln. He made the most exquisite porcelain, skilfully straddling the late nineteenth-century tastes in Classicism and Naturalism. He wrote in 1903 that he was 'unable to resist the passion of the ceramicist … [who] … does not exist without his kiln any more than a violinist without his violin'.[1]

Indisputably, France was the centre for artist ceramics, but in the later years of the century the French were joined by artist-potters of varying skills and ambitions elsewhere. In an official climate of active encouragement of the luxury crafts, French industry pursued the ambitious technical challenges of the *grands feux* (high glazing temperatures), *flamée* (red high-temperature glaze) and crystalline glazes. In this it was rivalled by long-established factories in Denmark, Germany and Sweden. Potteries in Holland made decorated wares from the most elegantly restrained reliefs of Willem Brouwer and stylish graphics of the Weduwe N.S.A. Brantjes company to the most daringly modelled vases and tablewares of Rozenburg. In England, although Art Nouveau was widely resisted, companies such as Maw (with the artist-illustrator Walter Crane), Doulton, Minton and Moorcroft were not immune to its decorative elements. In the United States the potteries of Grueby and Rookwood recognized and drew on the ceramics seen at European International Exhibitions and made their own distinctive contributions to the New Art. In Hungary the Zsolnay works at Pécs, like the Massier pottery in southern France, specialized in painted decoration using lustred glazes.

As with other materials, ceramic production became a new art only after it had endured a period of historicism, but intimately bound up with its rebirth was the change in the hierarchy of porcelain, earthenware and stoneware. Stoneware, formerly the lowliest ceramic medium, was radically reassessed and elevated. By the end of the century, in France at least, the material had achieved a sort of mythical status which recalled the hunt for the perfect porcelain begun some four centuries earlier in Italy. Fired at a high temperature, stoneware is a hard-wearing (as its name implies), watertight and supremely successful material for everyday wares. Traditionally fired once only, thus always susceptible to an element of chance, and glazed simply by the introduction of salt into the kiln during firing, its status was improved somewhat by means of decoration in sixteenth- and seventeenth-century Germany. In England a refined white type was used for the production of thinly potted decorated wares and some figures. However, in France it was almost exclusively used for the production of

12.3 Stoneware vases, with high-temperature glazes and gold: (left) Pierre-Adrien Dalpayrat, French, 1893-1900; (centre) Auguste Delaherche, French, *c*.1890-92; (right) Georges Hoentschel, French, 1895.
V&A: C.60–1972; 1613–1892; 952–1901.

12.2 Jean (Joseph-Marie) Carriès, *Le Faune endormi* (*The Sleeping Faun*). Stoneware, salt-glazed. French, 1885.
Private Collection, Paris.

containers. In the late nineteenth century, the intense interest in traditional crafts made the reassessment of local decorative styles and native, natural materials extremely attractive. With the enthusiasm for certain types of glaze which demanded difficult-to-control, very high temperatures in their firing, it was realized that this useful and still humble material had very special qualities. When refined to a hard, fine texture, detailed modelling was also possible. Thus, stoneware rivalled porcelain, which, initially at least, was rejected for its unnaturalness (as a hybrid material) and its expense. Use of the newly refined stoneware took three directions: first, sculptural; second, as a vehicle for *grands feux* glazes (either the highly prized reds or *flammées*, or the many varieties of crystalline glazes); and, third, as modelled decoration on architecture.

The beginnings of a stoneware revival in France may be traced via the salt-glazed wares of Jules-Claude Ziegler to early work by Ernest Chaplet and then on to Auguste Delaherche, Pierre-Adrien Dalpayrat and their contemporaries. Several of these came to the material through the discovery of local pottery and the traditional simple glazing and incised or painted decoration. However, of all the nineteenth-century potters, Jean (Joseph-Marie) Carriès is the most closely associated with the transformation of stoneware into a true 'art' material, especially in its sculptural form.

Carriès was a curious and romantic figure even to his contemporaries. His life-story has all the essential elements of a martyr to the cause of the New Art – a sense of doom, a struggle against physical odds and an early death resulting from, according to his friends, a reckless commitment to his art. Orphaned at the age of six and apprenticed to a maker of religious statues in his native Lyon, Carriès was a deeply committed Catholic with a morbid imagination prone to fantasy. Having trained as a sculptor, he worked in wax, plaster (both of which he patinated in imitation of bronze) and bronze itself. At the *Exposition Universelle* in Paris in 1878 he saw the brilliantly patinated Japanese bronzes and Bizen and Seto stonewares, and the spontaneity and expressiveness of these came as a revelation – as they did to other French potters. In 1888 he moved to St-Amand-en-Puisaye to concentrate solely on ceramics. He made figures throughout his short career and these included studies of Christ and various saints, mythical beasts, pagan beings, the local street-poor and self-portraits.

Carriès' *Sleeping Faun* appears as though it is in an ecstatic trance, but its particular power comes from his studies of the old and the desperately poor from whom he drew a vocabulary which was often grimly realistic (plate 12.2). His interest in the sinister comedy of Medieval cathedral decoration was extended to an extreme form, involving stages of metamorphosis of man, beast or amphibian, the effect of unease further heightened by a repertoire of earthy, mottled colours.[2] Masks with expressions of various passions were a much-repeated form, and a great number of these depict an intense bearded face that certainly must represent Carriès' own habitual expression of determination. In using the idea of metamorphosis, he explored, in an uncannily disturbing manner, a space between the dreamlike visions of the Symbolists and the harder images of Realism. His Gothic sensibility and intense subjectivity are central to Art Nouveau. He died at the age of only 39, but in those few years of ceramic production he is credited with revolutionizing the status of stoneware. As Taxile Doat commented:

> Without any help from chemists and without financial resources [he] carried to its apogée the *grès cérame* … then ceramicists became legion, everyone wanted to model grès. This *grand feu* stoneware temporarily forged ahead of the porcelain … Carriès, taken away in the midst of his youth and talent, had, like Palissy, numerous imitators, not gifted with the flame of the master.[3]

Carriès was followed by a band of disciples, including his devoted friend Georges Hoentschel, who were just as passionate about *grès cérame* (stoneware) and the Japanese ethic (plate 12.3).

Ernest Chaplet was a far more professional, and indeed successful, potter. In introducing both technical and artistic advances, his direct influence on his contemporaries and succeeding generations was enormous. He was born in Sèvres and trained as a designer at the State manufactory. He became a skilled practitioner, knowledgeable in the clays, glazes and kiln techniques, introducing new methods of painting on earthenware (known as barbotine and associated with the contemporary Impressionist paintings), and of firing successfully impasto decoration at the Laurin factory in Bourg-la-Reine. He was employed by the Limoges manufacturers Charles and Théodore Haviland, with the engraver and entrepreneur Félix Bracquemond at a new studio at Auteuil.

After visiting stoneware factories around Beauvais in 1882, Chaplet was convinced of the material's possibilities. The English company Doulton attracted much praise in the Parisian press for their substantial display of decorated stonewares in the *Exposition Universelle* of 1878, and it is highly likely that Chaplet took note of this. He persuaded the Haviland brothers to re-employ him at rue Blomet, Vaugirard, Paris, to develop stoneware as an art material with commercial possibilities, and it is this which was an innovation in France. Working with the Sèvres ceramicist-decorator Albert Dammouse and artists such as Frédéric Hexamer and Ringel d'Illzach, he made simple country vessels in unglazed brown-red stoneware with incised and applied naturalistic decoration usually of flowers and birds, some in Japanese style. Such realistic country scenes were popular, as the Doulton stoneware artists Hannah and Florence Barlow had already found with their incised decorations of realistically depicted animals. The decoration was part-painted in enamels which were contained within the incised outlines, and sometimes gilded. The simple, strong outlines and clear colours of the English illustrators Kate Greenaway and Randolph Caldecott were much admired by the Chaplet artists as successfully translating this *cloisonné* effect adopted from Japanese woodcuts.

Paul Gauguin entered this pioneering, artistic atmosphere in 1886, as Chaplet took over the workshop from Haviland and became an independent potter. Gauguin, already interested in flat areas of colour contained within strong outlines, immediately responded to the workshop's artistic style. The 70 or more works which Gauguin produced using Chaplet's brown-red stoneware, his coloured

12.4 Paul Gauguin, jug. Stoneware. French, 1886–87.
Danish Museum of Decorative Art, Copenhagen. Photo: Ole Woldbye.

12.5 Ernest Chaplet, vase. Porcelain with high-temperature glaze. French, 1884-88. Musée Nationale de Céramique, Sèvres. © Photo: RMN-M. Beck-Coppola.

each piece himself in its entirety, rather than following the usual path for artists of decorating pre-made forms.

Gauguin's subversion of all the accepted norms of ceramic production, his stated ambition of giving the art of ceramics a new spirit by replacing the thrower with the use of 'intelligent hands which powerfully communicate to the vase the life of a figure',[4] his sometimes violent and certainly symbolic use of Chaplet's richly coloured glazes (especially the red), and his uncompromising production of a complete work of art placed him firmly within the search for a new aesthetic. In the magical colours resulting from a single high-temperature, *grand feu* firing, he believed he had found a harmony which came from nature itself: 'Nature is an artist. The colours achieved in the same firing are always in harmony.'[5] The close interrelationship between Gauguin's ceramics and his painting, in his artistic and intellectual development, is demonstrated conclusively in Merete Bodelsen's study of 1964.[6]

In 1887 Chaplet passed the workshop to Auguste Delaherche. Privately Chaplet began concentrating on porcelain and iron-red *flammée* glazes (plate 12.5). A *flammée* glaze is based on metal oxides, usually copper or iron, once-fired at a high temperature in a kiln in which the atmosphere is dramatically altered at a critical moment by the limiting of oxygen. This results in a violently gaseous condition in the kiln which reacts spectacularly with the oxides and produces rich reds speckled or streaked with a variety of associated effects from green-blue to white. After the highly successful exhibition of his red glazes at the Union Centrale in 1887, Chaplet's reputation soared. His work was purchased by the artistic élite, and in 1896 he presented examples of his best work to the State collections at Sèvres.

Chaplet was by no means alone in this passion. Taxile Doat himself spent his career working with these sumptuous glazes, exceptionally and generously publishing a detailed treatise explaining the method.[7] Delaherche, who took over the rue Blomet workshop from Chaplet, and Dalpayrat both specialized in such high-temperature glazes and were more consistent in their use of the new organic forms than Chaplet, who, in deference to his Oriental sources, was often content to use eighteenth-century Chinese forms. Like Chaplet, Delaherche used the local stoneware, learning the crafts necessary for design and glaze development at small potteries in the Beauvais area, with the added ambition of making inexpensive wares for a wide audience. This ambition rapidly became impracticable as he concentrated on difficult, expensive glazes and was praised by reviewers in the Paris journals. Dalpayrat also aimed to produce reasonably priced stoneware with coloured glazes in collaboration

clay slips and coloured glazes, stand alone in the history of ceramics (plate 12.4). No ceramicist had made anything like them in technique or style, although there are parallels with the Danish painters-turned-potters working in earthenware, such as Joakim Skovgaard and J.F. Willumsen in the 1890s, whom Gauguin certainly knew via his Danish wife Mette-Sophie Gad. From the start, Gauguin's apparently innocent manipulation of the clay was the direct result of his personal artistic ambition, inspired by pre-Columbian artefacts (familiar from his childhood in Peru), by collections in Paris and by his visits to the Pacific islands in the 1880s and 1890s. His solutions are not only unencumbered by formal training or respect for established methods of modelling and construction, but deliberately oppose them. At first, occasionally, he collaborated with Chaplet for the making of more regularly formed wares. Then, he began to model

12.6 Richard Riemerschmid, tankards and jug; Peter Behrens, jug (centre right). Stoneware, salt-glazed and with enamel. German, 1902 and 1903. V&A: C.32-4–1990; C.88–1997.

with the workshops of Alphonse Voisin-Delacroix and then those of Adèle Lesbros. With three sons, the Dalpayrat family was effectively a small workshop of its own. Dalpayrat was a highly professional, commercial maker who also made unique works, including organically shaped vases and small sculptures, perfecting a rich red, green-speckled glaze known as *Rouge Dalpayrat*.

Despite their pre-eminence in this highly specialized field, the French ceramicists were not the only ones in pursuit of stoneware glazes and a New Art. Nor was it confined to the small workshops and independent potters. Architectural stoneware, in which the new glazes were employed in combination with modelled decoration of forms from nature (including flowers, lizards and snails), became a successful industry, as demonstrated by the extensive Greber family of Beauvais and by Alexandre Bigot, who fired the huge reliefs by Paul Jouve for the main entrance to the 1900 *Exposition Universelle* in Paris.

In Germany the development of artistic stoneware took a very different course. In 1902, as a direct result of the critical success of rival manufacturers at the *Exposition Universelle* in 1900, the stoneware companies at Höhr Grenzhausen in the Westerwald district employed the latest generation of architect-designers to inject the fashionable spirit into their production. Technical challenge played

little part in this as these companies used traditional methods, including salt-glazing, which had been theirs for over four centuries. Instead, Peter Behrens, Albin Müller and Richard Riemerschmid were commissioned to update the everyday wares (plate 12.6). Using the traditional method of moulded, raised outlines to contain the painted colour, applied decorative motifs, salt-glazing and pewter mounts, they gave the production of beer mugs and jugs radically new styling. Exceptionally, the Belgian Henry van de Velde designed for both standard and art production. His art wares broke away from the traditional production by using expensive high-temperature red glazes in emulation of those perfected by the French artist-potters. In England Doulton was the centre for industrial art salt-glazed wares, while the eccentric Martin brothers, whose first workshop was nearby in Fulham, produced some of the most extreme and imaginative works. From the 1880s onwards they progressed from fairly mainstream Renaissance-inspired incised decoration to a Naturalism which contained elements of Japonism, Medievalism and fantasy. Around 1900 they were also making organically shaped and exquisitely textured vases for which Edwin Martin is largely credited.

One other type of glaze enjoyed a revival during this period. The rediscovery of the lustre glazes of the Islamic

world had been essential to potters in the 1860s. The first revivals were made in Italy by Ginori and Cantagalli in Florence. The English specialist was William De Morgan (plate 8.5), who in 1892 said that: 'in spite of [the Italian] reproductions, an impression continued to prevail that the process was a secret. I used to hear it talked about among artists, about 25 years ago, as a sort of potters' philosopher's stone.'[8] Romantic, mysterious and glinting, these effects appealed to those artists whose inclinations were for the Oriental and the exotic. Historically, the lustrous finish is the result of glazes incorporating metallic oxides – copper, silver and gold – which are fired at a low heat. At the critical moment, combustible material (usually wood) is introduced into the kiln. As this blazes up, the kiln is sealed and the resulting smoke deprives the interior of all oxygen. This creates what is known as a 'reducing' atmosphere. The effect is to transform the oxides into a metallic state and deposit metals on the surface of the glaze, which then only remains to be polished. There are many variations on this process, and, for those less particular than De Morgan about employing traditional methods and more willing to accept a far less subtle surface, since the end of the eighteenth century ready-

mixed metal-based pigments suspended in oils and known as 'liquid lustre' could be had from wholesalers.

By the 1880s in France, the family company of Massier near Nice, under Clément Massier, were collaborating with the Symbolist painter Lucien Lévy-Dhurmer to produce a range of art ceramics with decoration painted in sombre lustre colours, taking both figurative scenes and motifs from nature. In 1879 the Hungarian architect and designer Ödön Lechner and ceramics manufacturer Vilmos Zsolnay visited London and Paris to study Oriental art. They studied ceramics at the South Kensington Museum and the results were far-reaching. Floral designs in Persian-style colours were followed by lustred ceramics in 1900, to the designs of Sándor Apáti Abt and others and the painter Jósef Rippl-Rónai, rivalling those of Massier in their richness.

Although initially out-paced by the interest in stoneware, porcelain production was hardly neglected. Sèvres, the national manufactory in France, was founded under royal patronage. Consequently, it specialized in production for the luxury market and its stock-in-trade was in expensive porcelain. However, towards the end of the century it also made stoneware, thus taking advantage of the material's

12.7 Agathon Léonard, part of a table setting: *Jeu de l'écharpe*. Porcelain. French, 1898. Made by the Manufacture Nationale, Sèvres. V&A: C.89A-N–1971.

new fashionability, and, a practical saving, the similar temperature to porcelain at which it is fired. The factory was at the forefront of many technical developments and it also adopted a consciously progressive art policy, part of the national move towards regeneration and celebration of French craft skills and design. Perhaps the best known production at this time was a table setting of 15 figures in unglazed porcelain designed by Agathon Léonard in 1898 and first shown in the 1900 *Exposition Universelle* in Paris. Entitled *Jeu de l'écharpe*, it was based on the scarf dance, most popularly associated with the American Löie Fuller, and is an elegant synthesis of static Classical forms and Art Nouveau curves (plate 12.7).

Internationally, exchanges and some competition took place between Sèvres and the Royal Copenhagen Factory over the development of crystalline glazes, combined with porcelain. At Sèvres, the chemists Lauth and Dutailly took the first steps which were then developed by Adolphe Clément in Copenhagen. He began experimenting with crystalline glazes using zinc and quartz oxides in 1886, achieving his first success in 1889 on the Danish hard paste porcelain. From 1891 his work was taken over by Valdemar Engelhardt, and soon coloured crystallines, emulating semi-precious stones, were possible with their decadent associations of alchemy and excess. These pioneering industrial companies were followed closely by the Swedish company Rörstrand and the Imperial Manufactory in Berlin under Hermann Seger. Probably the most extravagantly Art Nouveau forms for the crystalline glazes were provided by Hector Guimard for Sèvres, where they were used on both stoneware and porcelain (plate 12.8). All of these special glazes were highly prized and often further embellished with expensive mounts in precious metals. Technicianship was only one aspect of this work. Most of these chemists were familiar with the Decadent and Symbolist movements and some considered themselves closely tied to them. Clément's library, for example, included works on alchemy and writings by the leading Decadents.[9]

Many of the German porcelain factories at the 1900 *Exposition Universelle* in Paris had been heavily criticized for their outdated and unadventurous displays. One of the few exceptions was Nymphenburg, which had commissioned

12.8 Hector Guimard, jardinière: Vase des Binelles.
Stoneware with crystalline glaze. French, 1903.
Manufacture Nationale, Sèvres. © Photo: RMN.

12.9 Hermann Gradl, part of a fish service. Porcelain. German, 1899. Made by Königlich-Bayerische Porzellan-Manufaktur, Nymphenburg. V&A: C.18-C–1970.

12.10 Alf Wallander, vase. Porcelain. Swedish, 1897. Made by Rörstrand. Danish Museum of Decorative Art, Copenhagen. Photo: Ole Woldbye.

designs for a fish service from Hermann Gradl in 1899 and exhibited it in Paris the following year (plate 12.9). As a direct result of this criticism and under pressure from the government in Berlin, Meissen, like the Höhr Grenzhausen stoneware factories, approached Behrens, Riemerschmid and van de Velde, and they brought curvilinear and geometric patterning and new shapes in the fully established Art Nouveau style to the production.

Denmark and Sweden each had a long history of independence, coupled with European exchange and trade. Consequently, they were both open to ideas from the south, especially from France. Japonism proved appealing to Arnold Krog, Art Director at Royal Copenhagen from 1885, where he introduced underglaze painting often of Danish landscapes mistily rendered in Japanese style. Both Denmark and Sweden specialized in finely modelled porcelain employing motifs from nature, which owed much to Japanese Naturalism. Alf Wallander at Rörstrand (plate 12.10) and Pietro Krohn and Effie Hegermann-Lindencrone at Bing & Grøndahl more than rivalled the exquisite modelling of Taxile Doat at Sèvres. Both the Copenhagen factories were singled out by Alexandre Sandier in his review of the ceramics in Paris in 1900. The

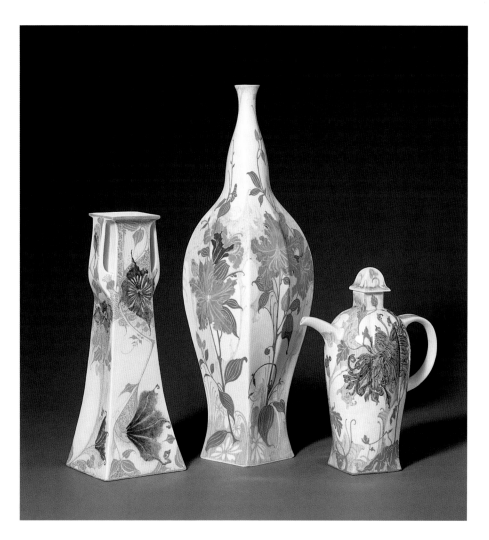

12.11 Designed by J. Juriaan Kok, painted by Samuel Schellink and J.M. van Rossum, two vases and a coffee pot. Eggshell. Dutch, 1903, 1904, 1909. All made by Haagsche Plateelbakkerij Rozenburg. V&A: C.41–1972; Circ.288–1958; C.37–1995.

older company, Royal Copenhagen, had a natural senior-ity. However, Bing & Grøndahl, where the Naturalism had a particularly fleshy vigour, attracted special attention. Perhaps the most exquisite porcelain of all was made in Holland at the Rozenburg factory in The Hague. Intro-duced in 1899 under the Art Director J. Juriaan Kok, the famous 'eggshell' porcelain is unmatched anywhere for its thinness and its daringly flamboyant shapes. The minute delicacy of the patterns is due to the extraordinary paint-ing skills of J.M. van Rossum, Samuel Schellink, W.P. Hart-gring and many others (plate 12.11).

Earthenware was now considered to be at the bottom of the hierachy of ceramic mediums. It is fired at a lower temperature than either porcelain or stoneware and is the least expensive. Therefore, it is the most open to ill-considered design for quick, if small, profit. It is the staple product of many local potteries, and, where these were taken up by the newcomers, forms and decoration could be adapted very simply to conform to the new ideal. Neverthe-less, sophisticated designs were produced. Holland's special

contribution to the eclecticism of Art Nouveau was the use of Indonesian motifs, drawing on their long history of trade and empire in the area. In the earth-enware production at Rozenburg the exotic motifs on Indonesian batiks were translated by Theodor Christiaan Adriaen Colenbrander into extreme, twisted forms and into wild patterns that have no equivalent anywhere. Other Dutch potteries contributed to mainstream Art Nouveau styling – for example, the Weduwe N.S.A. Brantjes company in Purmerend (plate 12.12) excelled in earthen-wares painted with designs which were probably taken from the pattern books of Maurice Pillard Verneuil, a pupil of Eugène Grasset.

In Finland, the Arabia Factory, founded by the Swedish Rörstrand company in 1874 to take advantage of the vast Russian market, launched a new earthenware range enti-tled 'Fennia' in 1902 following an order from an American importer. Its striking geometric printed patterns and

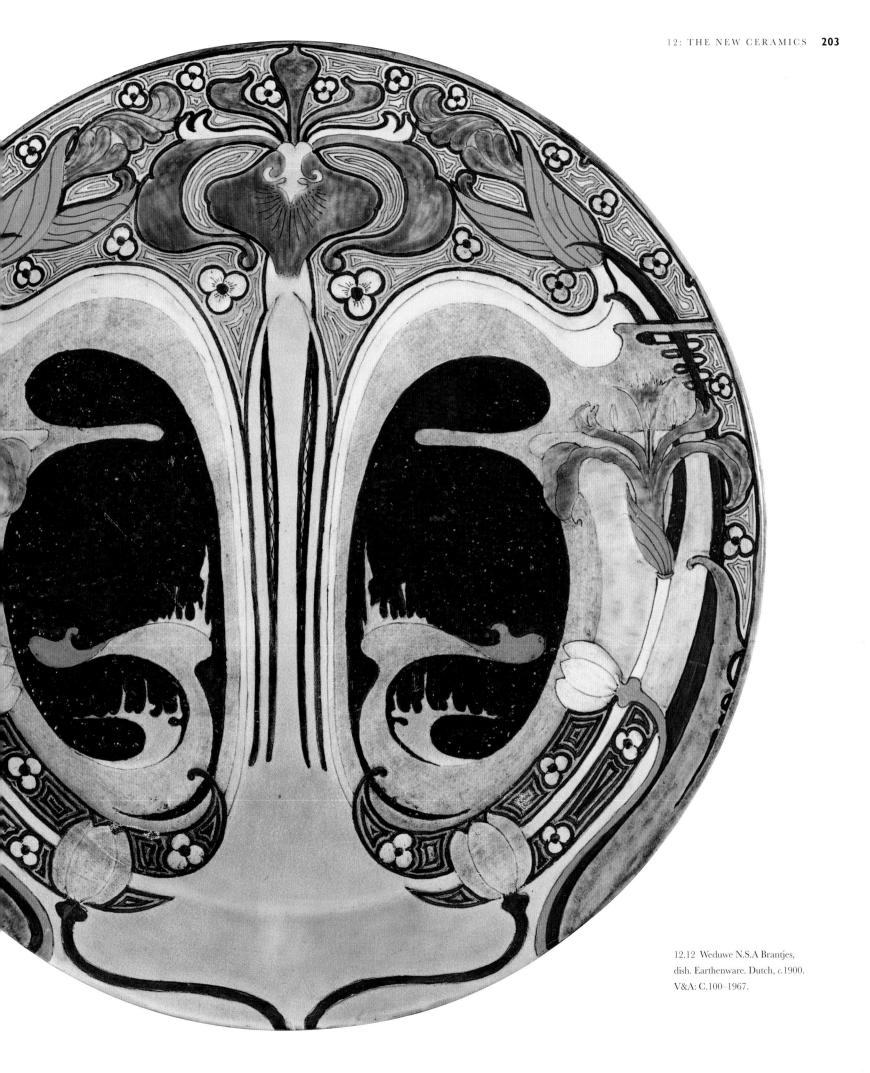

12.12 Weduwe N.S.A Brantjes,
dish. Earthenware. Dutch, *c*.1900.
V&A: C.100–1967.

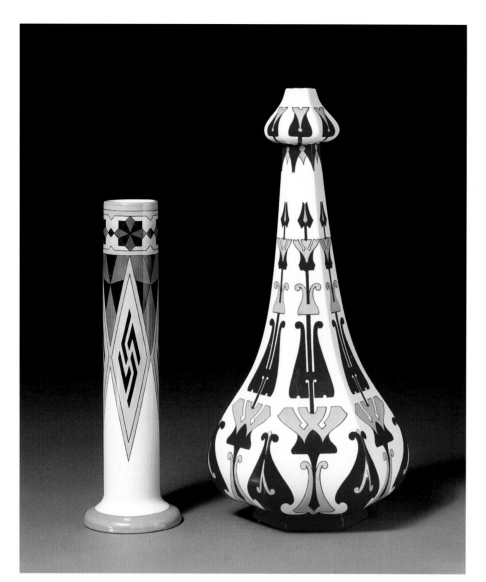

12.13 Arabia Factory, two vases.
'Fennia' range, earthenware.
Finnish, *c.*1902.
V&A: C.29–1990; C.30–1990.

gantly placed spots of white or yellow slip (plate 26.9). These sold through Meier-Graefe's shop La Maison Moderne as well as in Bing's L'Art Nouveau.

Both these shops were useful outlets for many potteries, including the increasing number of small, but commercial, art companies established in the United States in the last years of the century. Some of these acknowledged the direct influence of the French ceramicists. For example, such a debt is clearly owed to Delaherche by the Grueby Faience company of Boston. William Henry Grueby encountered Delaherche's work at the Chicago Columbian Exposition in 1893, and he was keen to emulate the matt and semi-matt glazes in which the European ceramicists excelled. Of the wide range of colours which the Grueby company invented, the most famous was a semi-matt green known as 'Grueby Green' (plate 12.14). Matt glazes also proved important in the production of the American Terra Cotta & Ceramic Company (whose wares were marketed under the name 'Teco'), and to Artus Van Briggle, who established a pottery in Colorado Springs in 1901.

Van Briggle trained in Paris and his ceramics were the most sculptural among American producers. In his best-known works he achieved a dramatic and intense morbidity, unique in the United States and directly allied to European Art Nouveau (plate 4.11). The Rookwood Pottery, Cincinnati (where Van Briggle worked for 10 years), was founded in 1880 by Maria Longworth Nichols (plate 12.15). Nichols had been influenced by Chaplet's barbotine technique in the late 1870s, which she saw when the Haviland workshop exhibited at the Centennial Exposition in Philadelphia in 1876. Rookwood Pottery's speciality was painting in coloured slips on unfired clay with the use of an atomizer, giving a far smoother effect than the more impasto barbotine. In 1887 Kataro Shirayamadani joined the company, bringing a Japanese painting tradition which led to Rookwood's 'Orientalized' decorative style and an unmistakable visual identity which provided a basis for its artistic and commercial success. As retailers, Tiffany & Co. (which also made its own pottery) bought Rookwood ceramics from the start, and in 1882 the Pottery achieved further brief, but equally glamorous, notoriety as the result of a visit by Oscar Wilde.

Among the Americans, the work of two makers in particular stands out as quite unlike anything else produced on either side of the Atlantic. Adelaide Alsop Robineau was one of the most formidable influences in American ceramics (plate 12.16). She was co-editor of the magazine *Keramik Studio*, and, having first published and worked from his treatise on the making of *grand feu* ceramics, she was

distinctive shapes were taken from Karelian sources, especially textiles, and would have been familiar to visitors after seeing the Finnish Pavilion in Paris in 1900 (plate 12.13) The experimental, and for a few years successful, Finnish company Iris, at Porvoo (east of Helsinki) counted ceramics among its most productive lines. The pottery was run by Willy Finch, an English painter raised in Belgium, who was a founder member of the *Société des Vingt* and later a follower of Georges Seurat. He made his first ceramics at Boch Frères in 1890, and, on joining Count Louis Sparre, the founder of the Iris company, he brought a host of contacts including Victor Horta, van de Velde and Julius Meier-Graefe. Employing the local red Finnish earthenware, Finch's designs were a well-balanced combination of traditional vessels richly decorated with powerfully coloured slip-glazes, sweeping wavy-edged patterns punctuated with incised lines and ele-

instrumental in inviting Taxile Doat to the United States in 1910 to act as Director of the newly founded School of Ceramic Art in St Louis. From around 1905, Robineau's work in porcelain was a triumph of meticulously carved and precisely constructed decoration, matched to equally precisely constructed forms and quite independent of European models. Twenty years earlier, George Ohr had been the maverick in American ceramics. Having worked at a number of small potteries, and been dismissed from one as an unsuitable influence, he set up in his home town of Biloxi, Massachusetts, in 1883. An extravagantly skilled thrower, he made vessels with walls so thin they were on the point of collapse, and then ruffled, pinched and frilled them, adding handles so curled and attenuated that they took on a life of their own. His glazes were equally extreme – blistered and speckled like brooding fungus or hot lava. In this apparently manic way, he challenged and subverted ceramic conventions to such a degree that he was virtually dismissed by his contemporaries as the 'mad potter of Biloxi'. In fact his extreme form of Expressionism and his playful use of familiar, daily objects and human body parts anticipated much that was to happen in the twentieth century (plate 3.13).

In Denmark ambitious earthenwares of a very different type emerged. Taking the route that Gauguin had avoided, of decorating thrown forms ready-made to his designs, Thorvald Bindesbøll painted and incised on earthenware with a boldness, conviction and disregard for established conventions that was unprecedented (plate 3.7). Bindesbøll trained as an architect, but his designs for a wide range of media, and above all for ceramics, formed a group style which is unmistakable. Beginning in 1880, he worked largely informally with a number of potteries over 25 years, spending an intensive week or two decorating whenever a sufficient stock of blank vases and dishes had accumulated. He was a leading spirit among the group of Danish artists, including Joakim Skovgaard, who formed the *Kunstnerkeramik* (artists' ceramics group), and whose most important showing was at the Nordic Exhibition of 1888. His designs, incised and thickly painted in coloured slips, range from strictly formalized repeated patterns in the 1880s, through a more expansive yet firmly delineated type, to others which are painted with complete freedom. In the latter he used the vase or dish as a canvas and the

12.14 Grueby Faience company, vase. Stoneware. American, 1898–99.
V&A: 1685–1900.

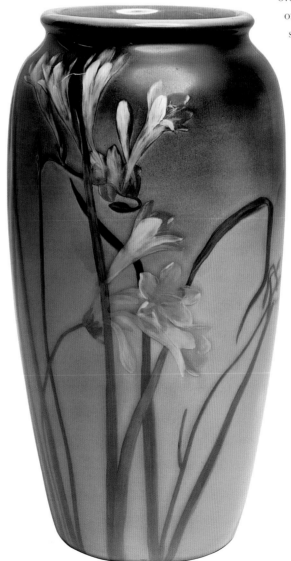

12.15 Rookwood Pottery, decorated by Harriet Elizabeth Wilcox, vase. Earthenware. American, 1900. Purchased by the V&A from Siegfried Bing in 1900.
V&A: 1686–1900.

12.16 Adelaide Alsop Robineau,
Viking Ship Vase. Porcelain.
American, 1905.
Collection of Everson Museum
of Art, Syracuse, New York.

12.17 Maurice Dufrène,
Part of a coffee service. Porcelain.
French, c.1900.
V&A: C.69-L–1989.

brush-strokes as the decoration itself in a manner foreshadowed, but scarcely foreseen, by Chaplet's barbotine technique. Like Gauguin, Bindesbøll used Naturalism in his ceramics as an artifice, a means by which he reached an essentially unnatural world. Skirting the Art Nouveau of conventionalized plant forms, by the late 1880s he had aimed at, and unerringly reached, Abstraction. His well-documented, wide-ranging interests in non-European art (especially Japanese), in primitive arts, in Eastern and Western philosophies and literature led him to a peculiarly personal art for which ceramics merely provided the means of expression.

While artist-potters practised Art Nouveau for a variety of reasons, all over Europe commercial factories produced versions of the style, in a process of rapid dissemination. Maurice Dufrène, later a key figure in the Art Deco manner, designed the archetypal tableware in porcelain (plate 12.17). It was sold through Meier-Graefe's shop, La Maison Moderne, for which Dufrène was chief designer.

The contribution of ceramics to Art Nouveau was extensive. At the most basic level, the decorative techniques involved were accessible to any artist, and for designers there was potential in both its sculptural possibilities and pattern-making. In the late 1880s and 1890s experimentation was positively welcomed by the industry, and, even if this enthusiasm was usually due to commercial competition, the most innovative art directors, chemists and designers were all committed to a fresh and reinvigorated future. Outside the industry, the receptiveness of artists to all forms of craft – indeed, their positive seeking-out of skills which appeared to be 'genuine' and untainted by commercial refinement – made the small workshop and its close-knit team of craftsmen the ideal environment. Whether in the urban or country version, here was the place for experiencing essential spiritual and physical contact, for reinventing the vernacular and, most important, for self-discovery and artistic fulfilment. Forms and decoration were part of an aesthetic strategy which was focused towards an entirely new culture. In the name of Art Nouveau, heroic struggles were made to fire the new glazes successfully and repeatedly. For all of these makers, the arts of clay, glaze and fire were a means of engaging with the new spirit.

Jennifer Hawkins Opie

The New Glass:
A Synthesis of Technology and Dreams

13.1 Émile Gallé, vase. Glass,
wheel-cut, acid-etched, with
applied cabochons of glass.
French, *c*.1903.
V&A: C.53-1992.

By 1890, like most materials, glass had been through a period of retrospection. In glass this was especially productive, as not only were the usual range of past styles plundered for design of form and decoration, but, more importantly in the longer term, historic techniques were researched. This led directly to a renaissance in enamelling (a Medieval Islamic technique), in lustrous, iridescent surfaces (seen on excavated Roman glass, the result of decay during burial), and the invention of *pâte-de-verre* (glass paste). Additionally, glass responds to minute adjustments in its composition and in the last decade of the century the controlled introduction of other materials such as metal foil, of new methods of colouring, of heating and cooling at differing rates within the same work, all widened the possibilities enormously.

By 1890, the palette of the glass artist therefore included clear, opaque and internally crackled effects; applications on the surface, inclusions in the depths of the glass; iridescence, metallizing and a range of cold-working techniques from wheel-engraving to etching with acids. All of these proved vital in Art Nouveau glass, where the aim of the most ambitious artists was no less than the creation of an alternative to nature itself. In the 1880s the artist-designer working with glass, could, metaphorically, embrace the skilled masters, feel the heat of the furnace and partake of the mystery. With the attendant magic of fire and the alchemic transformation from opaque, molten material to glassy translucence, the material offered real possibilities in the search for a new aesthetic.

Unlike ceramics and some of the other craft-based practices, it takes years to learn the skills necessary for the blowing and manipulation of hot glass. Largely because of this, no artist-designers engaged with the physical process of glassmaking or its decoration, even by cold-working methods. There is no equivalent to the ceramics of Carriès, Gauguin or Bindesbøll in the glass world. Eventually, cast-

ing glass proved more accessible, although for over 10 years almost its only practitioner was the pioneering Henry Cros, who laboriously invented the *pâte-de-verre* process in the late 1880s. Artist-designers in the 1880s and 1890s worked with a manufacturer providing designs. Émile Gallé was apprenticed and trained, but once owner of his own glassworks he apparently never made and rarely decorated glass himself. This is true of most of the great men of nineteenth-century glassmaking, who, in the service of art, committed their companies to the development of furnace technology and glass chemistry. In Gallé's case, what we see on the glass is the highly skilled draughtsmanship of craftsmen working from his drawings and ideas, demonstrating the remarkable degree of close understanding between the designer-employer and his workforce.

Gallé is the giant in Art Nouveau glass. His artistry and the technical mastery developed in his factory put him in an overwhelming position. His exploitation of the potential of glass as a multi-layered language makes him the standard against which all others are measured. For the last 15 years of his life he concentrated on the material, using it not only for its sensual and expressive qualities, but also as a way of expressing his commitment to the intellectual and political challenges of his time. As early as 1878 he was incorporating the cross of his native Lorraine in his signature as a protest at the political aftermath of the Franco-Prussian War of 1870, and in the 1890s he was actively engaged on behalf of the Jewish captain Alfred Dreyfus, notoriously accused of treason. Thus, Gallé braved both the national tendency towards anti-Semitism and local antipathy towards the army. He had a passion for literature and he used words as part of the decoration, or to convey a specific poetic or political message, in much of his glass, sometimes celebrating technological and scientific advances. His chief ally in this was the Nancéien artist, designer, poet and teacher Victor Prouvé, whose father was

the ceramic modelmaker for Charles Gallé (Émile's father and founder of the company). Émile Gallé and Victor Prouvé were lifelong friends and Prouvé supplied Gallé with many ideas and models for his glass.

As well as being idealistic, emotional and private, Gallé was also a hard-working, successful businessman and a prominent member of the local business and civic communities, supporting hospitals and the nationally renowned university. Nancy was a thriving city in which a new generation of artists and industrialists had settled, coming from Strasbourg, western Germany and eastern France after 1870. Against this economically flourishing background, the Gallés and their contemporaries were important figures. In the Gallé family house, 'La Garenne' (The Rabbit Warren), surrounded by an extensive garden, Émile was provided with an atelier and his own rooms on his marriage in 1875, when he also became head of the family firm. Within three years he had built a new, large glassworks, surrounded by plant beds. Commercial stability and artistic success came in the mid-1880s, and, by 1890, he had opened shops in Paris, London and Frankfurt. Although his unique pieces attracted most attention, the making of these was only made possible by serial glass production using the quick and commercial technique of acid-etching. At his premature death, he left a thriving and highly productive company. By the 1890s he was mixing in culturally influential aristocratic circles and with the literary and artistic élite – Edmond de Goncourt, Marcel Proust, Sarah Bernhardt and Auguste Rodin. During the 1890s, and even after his death, Gallé's unique glass was chosen for diplomatic gifts between nations, demonstrating the extent to which he had transcended the more usual official preferences for State-owned industrial production and Classicist design. Yet despite these worldly successes, he remained an artist with a genuine passion for the material.

Gallé was a knowledgeable botanist and a skilled draughtsman. His earliest decorations are the result of keen observation of flora and insects, already overlaid with stylish interpretation. Historicism in the form of the Rococo was probably the result of a local faience tradition, but his home city of Nancy is also famed for its central square, the Place Stanislas, with its curling mid-eighteenth-century Rococo ironwork by Jean Lamour (plate 2.8). Japonism soon encouraged the use of Imari-type patterns and a swirling asymmetry which characterized his designs for ceramics, but which he also applied to his designs for enamelling on glass. He followed the pioneering, successful research by Philippe-Joseph Brocard into Medieval Syrian enamel painting on glass. Moving beyond the constraints of formal patterning and

13.2 Émile Gallé, vase, 'Canthare Prouvé'. Glass, acid-etched and wheel-cut, with metal mount. French, 1896. Musée de L'Ecole de Nancy.

calligraphy, Gallé's designs were painted on the glass as freely as watercolours. He adopted the internally crackled and coloured glass of the inventive François-Eugène Rousseau, made at the Appert Frères' Clichy glassworks, which itself was inspired by Chinese carved rock-crystal and jade, Japanese watercolours and lacquerwork. With Gallé's imagination and technical mastery, the possibilities of depth and subtlety and the manipulation of light from within, and on the surface, in the combination of clear, colourless, coloured and painted glass, were explored to the full. He also amassed a range of ways of making glass, using coloured and textured effects within the glass, applying colours and patinating, manipulating and treating the surface to achieve unparalleled, dense and subtle colouring and a mossy translucency (plate 1.4).

Nature is the key to Gallé's work (plate 13.1). The natural world in the form of insects, fish, reptiles and amphibians, and especially plants of all kinds, provided a rich source for all glassmakers. Instead of simply raiding it for convenient motifs, however, Gallé approached it in a far more subjective manner. Although a Christian, Gallé was essentially a pantheist in his reverence of nature; Christianity and nature were central and complementing components in his art. He was also interpretative in his approach – nature took on a special significance. Although nearly every plant, flower, insect or creature is identifiable, and its scientific characteristics accurate, each is given a greater meaning. For him, nature was for worshipping, partly for its mystery and partly because it also held the power to represent his most deeply felt and powerful convictions. He was concerned about the human condition of his time, and, although immensely complex as glass objects, his works radiate a simple ethic of justice, of celebration of human endeavour and aspirations. Glass technology and nature provided the vocabulary (plate 13.2), so that beetles symbolized industriousness; the thistle symbolized Nancy, Lorraine and separation from Germany; the rose symbolized France and the lover; the poppy symbolized sleep and its narcotic powers; and Gallé described the pine tree in 1896 as a 'metaphor of energy in repose'.[1]

Increasingly, however, Gallé's creativity was also driven by a philosophy which demanded not mere depiction but also an evocation of the very spirit of nature, using it to create a powerful sense of an alternative world. In time, Gallé's passionate sensitivity and natural melancholia led him to a gloomy preoccupation with the inevitability of suffering and with dark forces, inexplicable mysteries and threatening forms. These forms included the peculiar and repellent bat (plate 13.1), the alarming and armoured stag

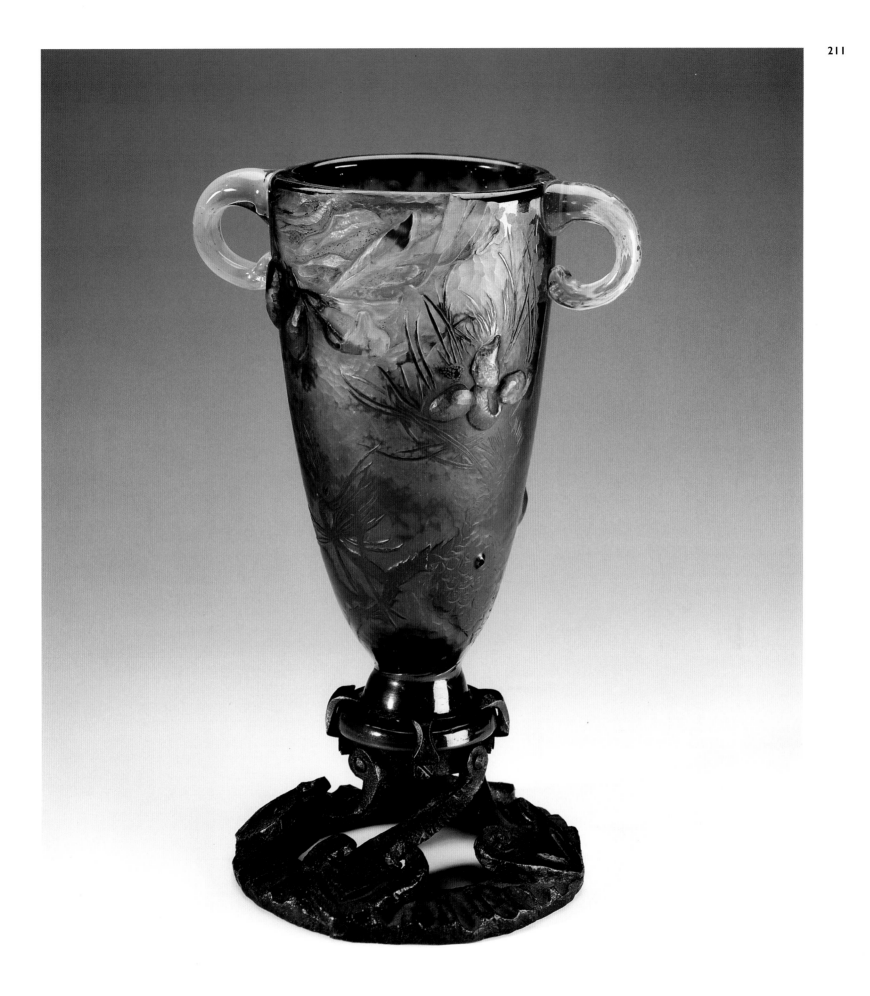

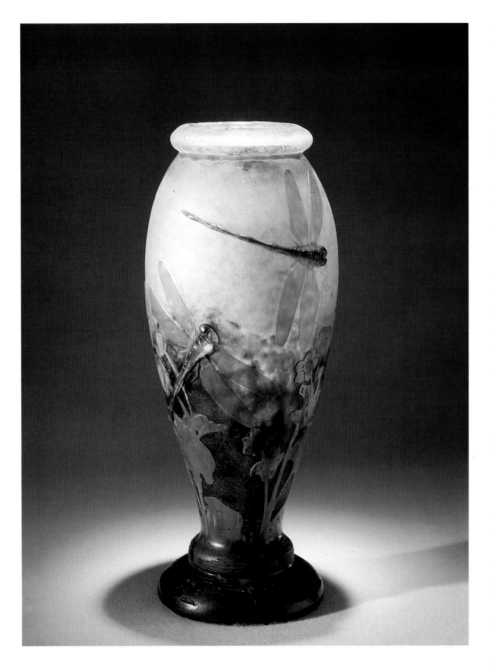

13.3 Daum Frères, vase. Glass, with applications, acid-etched and wheel-engraved. French, 1904. Musée des Beaux-Arts de Nancy.

eight pages to Gallé and a mere paragraph to Daum.[3] Yet elsewhere in the same report, discussing the stained glass of Georges De Feure in Bing's Pavilion L'Art Nouveau, he criticizes the sombre tones and a general aspect of 'Art Nouveau' (his inverted commas), which did not fill him with enthusiasm.[4] He seems unaware that Gallé himself on occasions was accused of too-sombre colours and over-weighty forms.[5]

Gallé was 18 years older than Auguste Daum, the elder of the two Daum brothers. The first to work with his father, Jean, in the family business, Auguste was joined by Antonin around 1890–91. There is no record of formal exchanges or association between the Gallé glassworks and the younger factory, nor any comment by Gallé on what was a rival business in the same city; although the Daum brothers, apparently far more gregarious than the very private Gallé, certainly acknowledged his immense stature within the glass world. Gallé was in the first flush of his fame at the time when they were struggling to establish as commercially viable their production of watchglasses and domestic and restaurant tablewares. Nevertheless, taking their first steps into art glass in the early 1890s under Gallé's influence, they made rapid artistic and technical progress. They exhibited this for the first time at Chicago in 1893. By 1900, showing glass which was distinctively their own, they were prize-winners at the *Exposition Universelle* in Paris. They took special pride in the development of a number of technical advances and in the clarity of their colours. Their artistry was far more straightforward than Gallé's (plates 13.3 and 13.4). The designs were made by Antonin Daum himself, by their Art Director, the painter and modeller Henri Bergé, or by outside artists. One such artist was the sculptor Ernest Bussière[6] who also worked with Majorelle and the ceramic company Keller & Guérin at Lunéville. Amalric Walter, who specialized in *pâte-de-verre*, joined the firm, and, with Bergé sculpting the moulds, from 1905 he introduced a *pâte-de-verre* range before setting up independently in 1920.

Pâte-de-verre was one of many Daum techniques: others included the use of powdered colours on the surface; cased glass skilfully cut in what is known as 'cameo technique'; *intercalaire* (inlays) where differently coloured glass is pressed into the body of the work; and *application* (glass applied in high relief) which was either left in its soft, molten and manipulated form or given more incisive contours by cutting. These were all used in depictions of nature, which, although by no means impersonal, generally did not have the highly charged, intense engagement of Gallé. More significantly, perhaps, they lacked the identification with a

beetle, the unknowable depths of the sea (still a mysterious other-world, despite the newly published drawings by Haeckel of dredged-up creatures and plants), and the menacing and defiant outlines of thistles.

Despite the fact that today Gallé is recognized as the greatest Art Nouveau glassmaker-artist, curiously he was not always associated with the movement by his contemporaries. Jules Henrivaux – writer, chemist and formerly Director of the major glass manufactory of St-Gobain – could appreciate Gallé fulsomely. In his report *La Verrerie à l'Exposition Universelle 1900*, he noted that, at last, Gallé was described by 'les "dillettante"' as 'the incomparable master … the leader of the school'.[2] Later, Henrivaux devotes

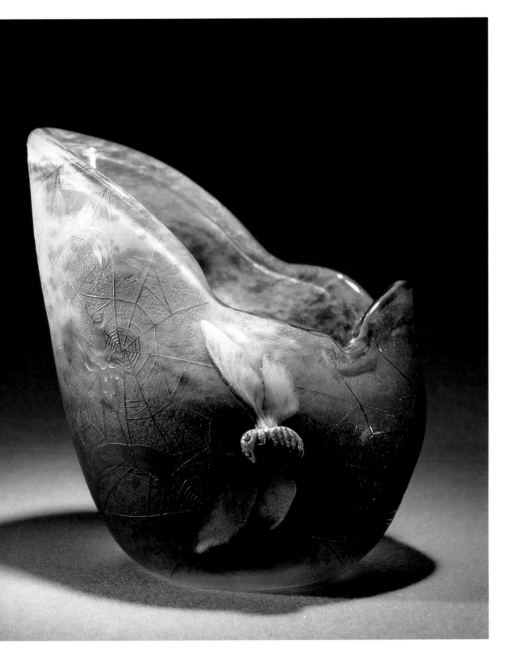

13.4 Daum Frères, cup. Glass, acid-etched and wheel-engraved, with applied glass. French, 1905. Musée des Beaux-Arts de Nancy.

and flowers in powdered colours, applied or layered, and cut glass. Burgun, Schverer & Cie at Meisenthal had well-established connections with the Gallé company. Following the Franco-Prussian War, and deprived of much of their market, Burgun, Schverer & Cie made art glass for Gallé to his designs. Eventually, in the early 1890s they began their own production of art glass under the direction of Désiré Christian. Daum, too, was host to glass artists (in addition to Amalric Walter) who subsequently set up their own business. Charles Schneider, who studied at the École des Beaux-Arts in Nancy, worked freelance for Daum and then entered the factory in 1909. He set up his own glassworks in 1913 at Épinay-sur-Seine and is now best-known for stylish and colourful glass typical of the 1920s and 1930s, which clearly owes a considerable debt – both stylistically and technically – to his early training in Nancy.

The direct influence of French makers (Gallé in particular) was extremely pervasive outside France. In Bohemia the Harrachov glassworks at Nový Svět employed a wide variety of technologies and moved smoothly into production of glass in this newly international style. The Johann Loetz-Witwe works at Klášterský Mlýn in Bohemia made layered and acid-etched glass. In Sweden Gallé's techniques and vision were taken up and transformed into the most lyrical of Nordic glass by the architect-designers Ferdinand and Anna Boberg and by Betzy Ählström for Reijmyre glassworks. In Belgium, at the enormous glassworks at Val-St-Lambert, Philippe Wolfers used bats, salamanders, thistles and orchids in his designs. In Russia the Imperial Glassworks at St Petersburg (plate 13.5) and in Germany Villeroy & Boch (better known as a ceramic company) took up the style. In all of these countries, coloured, layered, etched and engraved glass with decoration of a range of countryside and marine subjects was widespread and recognized to be the new art formula. Of these countries, Italy and Bohemia had a long history of glassmaking, established due to geographical location and access to the essential raw materials. For several centuries, their glass industries had been closely tied to a national identity and re-defining this position was a significant element in the equation.

Italian glass is synonymous with the city of Venice and there, until well beyond 1900, glassmakers chose to stay in a traditional mode both in design, and in the use of traditional Venetian glassblowing skills and the making of coloured glass canes. Blown and elaborately decorated drinking glasses, jugs and flasks in Italian Renaissance style were made, all but indistinguishable from their 400-year-old predecessors. Harking back even further, *millefiori*, a technique

charismatic individual. Consequently, Daum glass has remained in Gallé's shadow.

In the exhibitions assembled by the École de Nancy, under the formal title L'Alliance Provinciale des Industries d'Art, Gallé and the Daum brothers were the main exhibitors of vessel and sculptural glass. Stained glass was represented by the work of Jacques Gruber and Daum's Henri Bergé. The disputed area of eastern France and western Germany, which is today Alsace-Lorraine, was home to many glassworks, several of which had direct or stylistic connections with Gallé or Daum. The St-Louis glassworks at nearby Lemberg and Vallérysthal & Portieux at Vallérysthal both made vessels decorated with insects

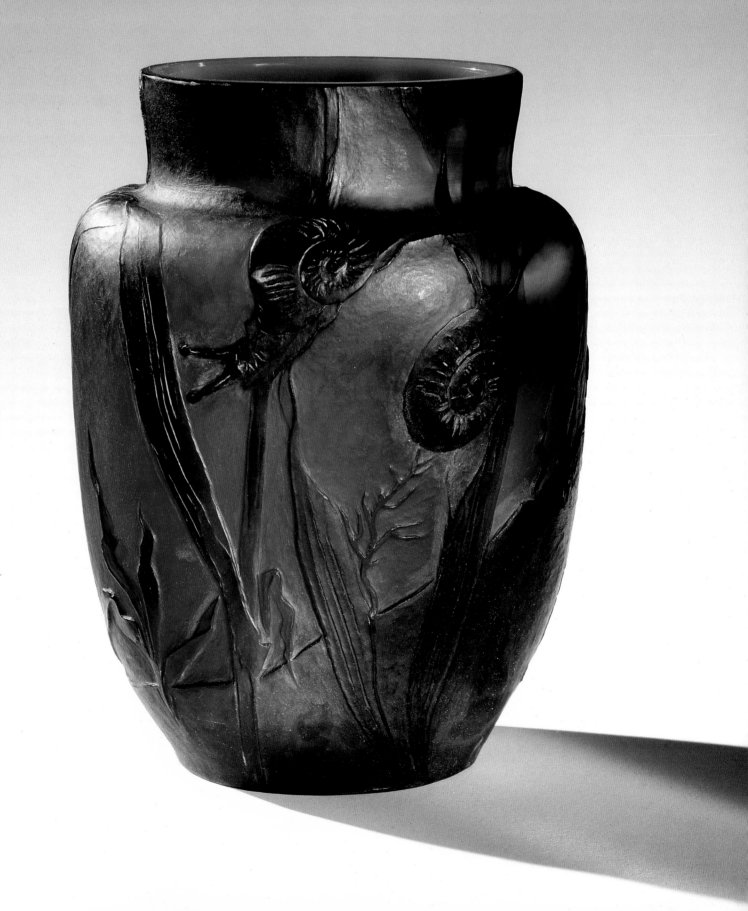

13.5 Imperial Glassworks, St Petersburg, vase. Glass, cased and wheel-cut. Russian, 1904. V&A: C.54-1992.

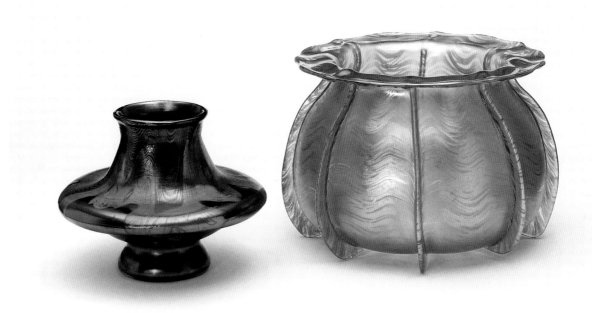

13.6 Johann Loetz-Witwe glassworks, two vases, *Phänomen* range. Czech, 1900. V&A: 1296–1900; 1305-1900.

in which variously coloured and patterned glass canes were cut, assembled and fused in a mosaic, dated back to ancient Mesopotamia and was perfected in Roman antiquity.

At last, the first inclusion of a major modernist in the 1910 Venice Biennale, the painter Gustav Klimt, signalled the breakdown of social and official barriers. It became obvious to Italian artists that the applied arts elsewhere were essential in the 'New Art' and that glass was recognized as an especially expressive medium. Some of the more forward-looking Venetian glassmakers were already receptive to this argument. Fratelli Toso, under Vittorio Toso, invited the Rome-based German designer Hans Stoltenberg Lerche to Murano, where, after failing to master glassblowing skills for himself, he produced a number of designs for the glassworks which employed freely trailing coloured glass lines or images of fish and lizards in coloured glass powder. The painters Vittorio Zecchin and Teodor Wolf-Ferrari, much influenced stylistically by Jan Toorop and Gustav Klimt and probably working with the glassmaker Giuseppe Barovier, produced some highly decorative, pictorial plaques, using glass mosaic as a form of *cloisonné* painting.[7] Late as they were, neither of these developments led directly to the next stage, namely 1920s Modernism in Venice. Nevertheless, they undoubtedly broke through a previously impenetrable resistance to the 'new', and, most especially, to the involvement of the glass industry in the contemporary.

Bohemia's long history of cut and engraved glass was the result of a tradition of princely patronage, which, until the early eighteenth century, was centred on elaborately cut precious and semi-precious gems. Throughout the nineteenth century, glassmakers had adapted to less wealthy circumstances. Individual strengths and skills had developed to suit a more varied market, and by the end of the century regional characteristics were as distinctive in terms of their technology as their artistic style. Probably the best-known Bohemian glassworks was that of Loetz, founded by Johann Loetz-Witwe at Klásterský Mlýn. From 1879, under its Director Max Ritter von Spaun, Loetz moved into the production of historical designs (imitating the shapes and iridescence of excavated Roman glass by the early 1880s) and artistic glass (emulating hard-stones and given such evocative names as 'onyx', 'intarsia', 'octopus' and 'papillon'). These were marketed to a wide audience, combining successful commerce with an ambitious artistic policy. They moved into lustred glass (plate 13.6), following in the wake of the success of the American company of Tiffany.

Loetz' production, called *Phänomen* and launched in 1897, was often spectacular and designed by some of the most avant-garde designers of the day. Josef Hoffmann and Koloman Moser collaborated with the factory for some years from 1899 in production for the Viennese retailers E. Bakalowits & Söhne. This international

13.7 Josef Hoffmann for
J. & J. Lobmeyr, glass from
punch set. Glass, wheel cut.
Austrian, 1910-14.
MAK: Österreichisches Museum
für Angewandte Kunst, Vienna.

Europe. In Vienna after 1900, Josef Hoffmann eventually moved from the lustrous glass of Loetz to the concise shapes and clarity of lead crystal in his designs for J. & J. Lobmeyr (plate 13.7). In Germany, in Munich and Darmstadt, Richard Riemerschmid, Peter Behrens and Albin Müller were commissioned by the progressive glass-works owner Benedikt von Poschinger. Other individual makers and artists in Germany sprang from well-established glass centres, mostly in the east bordering on Bohemia. One of the most distinctive of these individuals was Karl Koepping in Berlin, who designed the archetypal flowers-as-drinking-glasses, apparently simple but with a knowing sophistication. The lampworking technique he employed has an ancient history. It is the making of small glass items by one craftsman, using glass in cane and tube form, a burner and minimal blowing, rather than the full panoply of furnace and glass team of three or four men. In the nineteenth century and into the twentieth century it was the method by which vessels, curved and straight tubes and other glass equipment for use in scientific laboratories were made, traditionally at centres in eastern Germany and western Bohemia, around Thuringia. Training schools there were also surrounded by a local industry devoted to the making of Christmas decorations, buttons and other ornaments.

In the 1890s Koepping adopted the lampworking tech-nique to produce delicate, half-opened buds, curling ten-drils, leaves and stalks (plate 13.8). Koepping was Professor of Design at the Berlin Akademie, an etcher, engraver, painter and chemist. He collaborated with a lamp-glassworker, Friedrich Zitzmann of Ilmenau, in Thuringia, making designs for drinking glasses which were so attenuated, the stalks so extremely thin and twisted and tendrils so fragile as to be totally impractical. Koepping the chemist, with Zitzmann the glassmaker, used a subtle range of nature-inspired pinks, golds and greens, each with a bruised bloom or faint iridescence, effects which were produced by the use of metallic oxides on the glass and the varying degrees of heat and cooling across the glass. In 1896 an engraving of two of these were published in *Pan*, the Berlin Symbolist magazine (of which Koepping was editor from 1895),[8] in a tense com-position with a darkened and cross-hatched background; this image has been reproduced repeatedly as almost more potent than the glass itself. In 1897 he exhibited his drinking glasses at an exhibition at the Munich Glaspalast (Glass Palace), and a review of this in *The Studio* linked his glass with embroideries by Hermann Obrist (plates 1.12 and 11.1) as examples of an 'active interest in the applied

technology, also practised in Britain by Webb & Sons, was balanced by the specifically Bohemian and entirely unworldly designs of Marie Kirschner. A painter from Prague, she co-operated with the Loetz factory between 1899 and 1914, designing a series of vases in coloured and colourless glass which were intended to create a mutual aesthetic between flowers and glass. With their simplicity, their total rejection of Classical form, their acknowledge-ment of a Japanese philosophy and their introspection (the visual results of which are paralleled by the 'Clutha' glass of Christopher Dresser in the mid-1890s in Britain), they break many traditions then regarded as sacrosanct in a cul-ture in which glass had national status.

Glass design was practised in avant-garde centres across

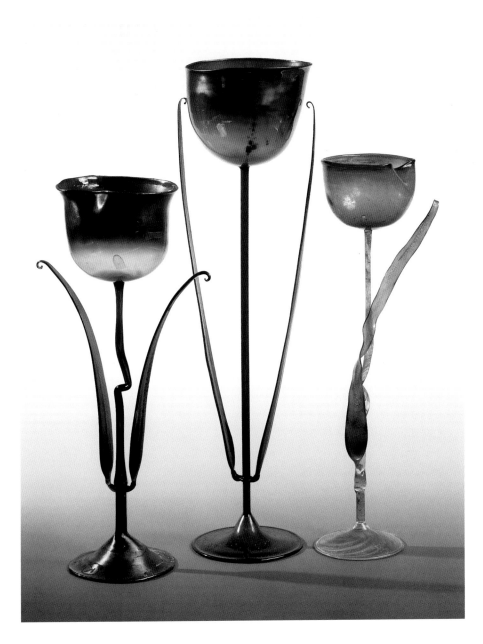

13.8 Karl Koepping,
three goblets. Glass, lampworked.
German, 1895-96.
Danish Museum of Decorative
Art, Copenhagen.
Photo: Ole Woldbye.

nique of *plique-à-jour* as Prytz' artistry (plate 3.6). This technique, of enclosing glass within a fragile metal frame, was a Norwegian speciality at the turn of the century and was practised by other contemporaries, most notably by Gustav Gaudernack for the silver company of David Andersen.

The expansion of artistic ambition and glass technology was married with notable success to one other new technology of the modern world. The dark and glowing colours favoured by these glassmakers responded especially well to an internal or specifically directed light. The invention of electricity and its gradual spread into public and then domestic interiors meant that the design of metal-mounted, glass, electric standing lamps and hanging lamps occupied a significant proportion of most factories' production. Gallé, Daum Frères, Whitefriars and Tiffany all specialized in these, and some of their most spectacular concepts are entirely dependant on the electric light within. Some designs for electricity repeated the format of an oil-containing base and a domed lampshade, but others grasped the opportunity to invent shapes which needed only a stalk or tendril to supply the illumination. Most glassmakers collaborated with independant metalsmiths for the production of lamps, extending this to the supply of mounts for vases, carafes, decanters and tableglass. Whereas French glassmakers tended more exclusively towards wrought iron, the London maker James Powell & Sons at Whitefriars employed iron and copper mounts for lighting, and, for tablewares, fine silver sometimes enclosing semi-precious stones. Under the art direction of Harry J. Powell, the Whitefriars Glassworks made glass in historicist, mostly Renaissance Venetian style (thinly blown, elegant shapes), but the restrained decoration, and especially the mounts, were distinctly Art Nouveau in style. These sold through all of the progressive shops most associated with Art Nouveau, including Bing's L'Art Nouveau, La Maison Moderne, Tiffany & Co in New York, Liberty in London and several shops and galleries in Berlin, Frankfurt, Munich and Brussels as well as from their own premises at Temple Street.[11]

Outside Europe, the American Louis Comfort Tiffany is possibly more famous now for his lamps than for any other branch of his very extensive production. Where lamps and other items required bronze mounts and fittings, they were designed and made by Tiffany's own workshops. Tiffany, like Gallé, is one of the most highly regarded of the late nineteenth-century glassmakers. He developed colours whose glowing richness was without precedence, and more especially, the key to his early success was his perfecting of a vivid, lustrous iridescence. Tiffany was not the first to experiment with metallic finishes. Webb's in England had

arts … striving to create something really new, or at least independent of the old patterns'.[9]

These were the most extreme of Koepping's products. He and Zitzmann parted when the glassmaker appropriated Koepping's design style for his own production, and, following this, Koepping designed and had made more standard glasses which were far less subtle and more glossily iridescent. Despite the suggestion of rarity made by the published etching, Koepping's glass was stocked and sold by Siegfried Bing in his shop L'Art Nouveau, and appeared in exhibitions from 1895 in Paris to 1910 in Brussels.[10] An equivalent in delicacy to Koepping's attenuated glass was designed by the Norwegian Thorolf Prytz for the workshop of Jacob Tostrup in Oslo, as much the result of the tech-

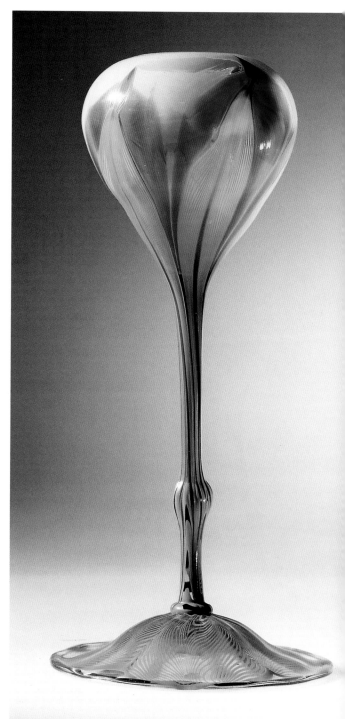

13.9 Louis Comfort Tiffany, bowl. *Favrile* glass. American, 1908. Metropolitan Museum of Art, New York.

13.10 Louis Comfort Tiffany, vase. Glass with applied and marvered colours, combed. American, 1895. V&A: C.58-1972.

exhibited 'bronze glass' in Paris in 1878. Delicate versions were achieved by various European manufacturers, such as the Rheinische Glashütten at Ehrenfeld, near Cologne in Germany, and Loetz in Bohemia. In 1881 Tiffany was able to purchase an existing patent for its manufacture. In 1893 he set up the Corona Glassworks in Long Island, New York, with Arthur J. Nash, a talented glassblower from Stourbridge, England, who brought experience of lustred glass from his time at Webb's glassworks. Within a few years they had not only perfected a richer lustre than any other company (plate 13.9), but were also attracting copyists – possibly the ultimate recognition.

Tiffany had a very wide range of interests and his designs for interiors, which included his glass, drew together ideas gleaned as much from the arts of China, Japan and Arabia as from landscape and nature. His designs for stained glass were woven around naturalistic motifs – the decorative possibilities of dragonflies, vines, magnolia and wisteria were woven into magical and romantic, although largely representational, landscapes. His skill in arranging the elements of the picture and in the creative use of the lead cams was unmatched. He never used the more usual method of painting or etching for the details, instead the textures and variations in the colours themselves created the shadings needed. In his art glass he concentrated on producing an enormous range of different material types which invoked the pitted, bubbled quality of lava or fish or flowers entrapped within layers of water. Every possible glassmaking technique was employed from lustre to *millefiori* (plate 13.10). One of the very few rivals to the Tiffany glassworks' technical mastery of spectacularly iridescent colours was the Aurene glass of the Englishman Frederick Carder, whose first career was with J. & J. Northwood in Stourbridge and then the nearby glassworks of

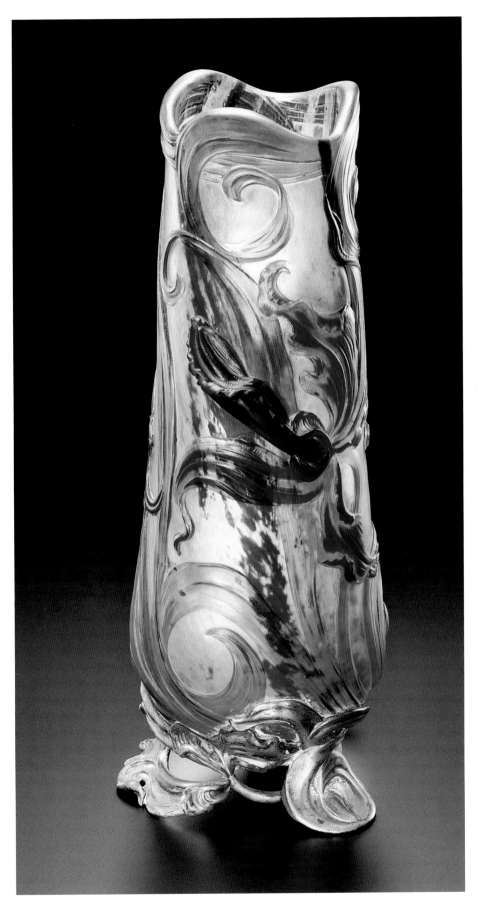

Stevens & Williams. In 1903 Carder moved to Corning, New York, establishing the Steuben Glassworks. Carder brought with him extensive experience of coloured glass in England, and his first American production appeared as early as 1904.

Commercialization of Art Nouveau forms was widespread throughout the glass industry. Glass in the style of Gallé was common, but there was also a vast output with etched or engraved linear design which subscribed to the fashionable asymmetry, curling tendrils and organicism. The glassworks at Val-St-Lambert in Belgium was probably the largest and the most commercially successful company in the world at the end of the century – it employed 5,000 workers and had a daily production total of 160,000 items. It was undoubtedly the largest factory with a reputation for making 'crystal' glass to enter the Art Nouveau field. The company was virtually self-sufficient, as, within the factory, the Frenchman Léon Ledru supplied it with a seemingly endless stream of designs employing just these fashionable characteristics. From outside, Philippe Wolfers (plate 13.11) and Henry van de Velde were invited to contribute designs, although only a small proportion were made.

In the struggle to establish a New Art, glass had an important role. In economic terms, Art Nouveau offered a new start for an industry, which, across Europe, had been in danger of stagnating in a stylistic backwater, trapped in tradition and retrogression. More especially, although machine-made glass was increasingly spread throughout the industry, the glassmakers most committed to Art Nouveau always employed at least some element of hand-making. For these – such as Gallé or Tiffany – hand-making and decorating for their most precious art wares was vital. Craft skills at the end of the nineteenth century were regarded as a means to rediscover local or native identity; they were cleansing and unencumbered by impure commercialism. But glass had particular qualities which offered far more than an alternative route to a New Art. It was especially responsive to the subtle requirements of the Art Nouveau vision. Glass offered an internal depth as well as an external skin. It was possible, within one work, to represent different views of the same subject, and even, in different lights, to change those views. Glass offered the magical, intense and multi-layered experience that artists and collectors were looking for at the end of the century.

13.11 Philippe Wolfers, vase. Carved glass and metal base. Belgian, *c.*1900. Made by the Val-St-Lambert glassworks. Private Collection, Brussels. © DACS, 2000.

Helen Clifford and Eric Turner

Modern Metal

14.1 Gustave Eiffel's Tower of
1889, seen here in a view of the
1900 *Exposition Universelle*, Paris.
Photo: Roger-Viollet, Paris.

In 1847 in *Le Journal de l'architecture* a Belgian architectural critic prophesied that the *ordre metallique* was at hand: 'At last we move under full sail into the metallurgical order, which will present differences sharper than those that distinguish the Tuscan from the Gothic order … . All the architectonic masterpieces of the *Thousand and One Nights*, hitherto relegated to albums and memory-books, are realizable in iron and cast iron.'[1] He shrewdly recognized the potential of iron to create innovative architecture, although he could scarcely have anticipated the developments of the second half of the century, when a generation of architect-engineers created a panoply of extraordinary structures in iron and glass. Conservatories, libraries, museums, railway stations, and, most spectacularly, temporary exhibition buildings confirmed that this was indeed the 'new' material. Alphonse Balat, Henri Labrouste, Joseph Paxton, Eugène Emmanuel Viollet-le-Duc and others contributed ideas and edifices to this new order. Perhaps the most extraordinary structures were built at the *Exposition Universelle* of 1889 in Paris. The Machine Hall by Charles Dutert, and, more famously, Gustave Eiffel's Tower (plate 14.1), dominated what was the greatest Exhibition staged so far. As he looked at the Eiffel Tower on his visit to the *Exposition*, Paul Gauguin determined that 'to the architect-engineer belongs a new decorative art'. He saw the potential for a grand modernity in the new material, a modernity that had no need to disguise itself: 'Imitation bronze statues clash alongside iron. Always imitations! Better to have monsters of bolted iron. Also, why repaint iron so it looks like butter, why this gilding as if in the Opera House? No, that is not good taste. Iron, iron and more iron.'[2]

Such proclamations undoubtedly confirmed the symbolic role of metal as a stridently contemporary material. They are appropriate to the current context because of the extent to which they made iron and glass generally sym-bolic of modernity, and because of the influence they had on the new generation of architects and designers who were about to create Art Nouveau. But while the nineteenth century was a new iron age, the metalsmiths' workshops of Europe tended to cling to traditional techniques and practices. This assured that the heritage of metalworking remained a factor in most objects. Thus, many of the metal objects produced under the aegis of Art Nouveau – in their fabric as well as their form – had elements of both modernity and tradition built into them, and so simultaneously suggested the past, present and future. This chapter explores the world of functional metal, from the architectural fixtures and fittings of the new city to the accoutrements of the domestic sphere.

Metal architecture stood for modernism. Cast iron was employed by Art Nouveau designers and architects for its practical qualities and its aesthetic possibilities. As this volume shows, attitudes to materials in the period were complex. In the world of metal, cast iron was the first artificial building material; it was particularly suitable for the expression of the suppleness and tensile strength of the Art Nouveau 'whiplash' curve. However, not all designers were happy to use it. English Arts and Crafts architects were generally less prepared to experiment with the new materials than their mainland European counterparts and were ambivalent about the use of cast iron as opposed to wrought iron. The idea of creating a form through the casting process that did not intrinsically reflect the nature of the material itself ran powerfully against Arts and Crafts philosophy. Belgian practitioners of Art Nouveau tended to share these suspicions of cast iron, seeing it as 'vulgar' and 'non plastic, that is, without any form of its own or any individual characteristics to guide the imagination and hand of the artist'.[3] In France, Hector Guimard had no such qualms.

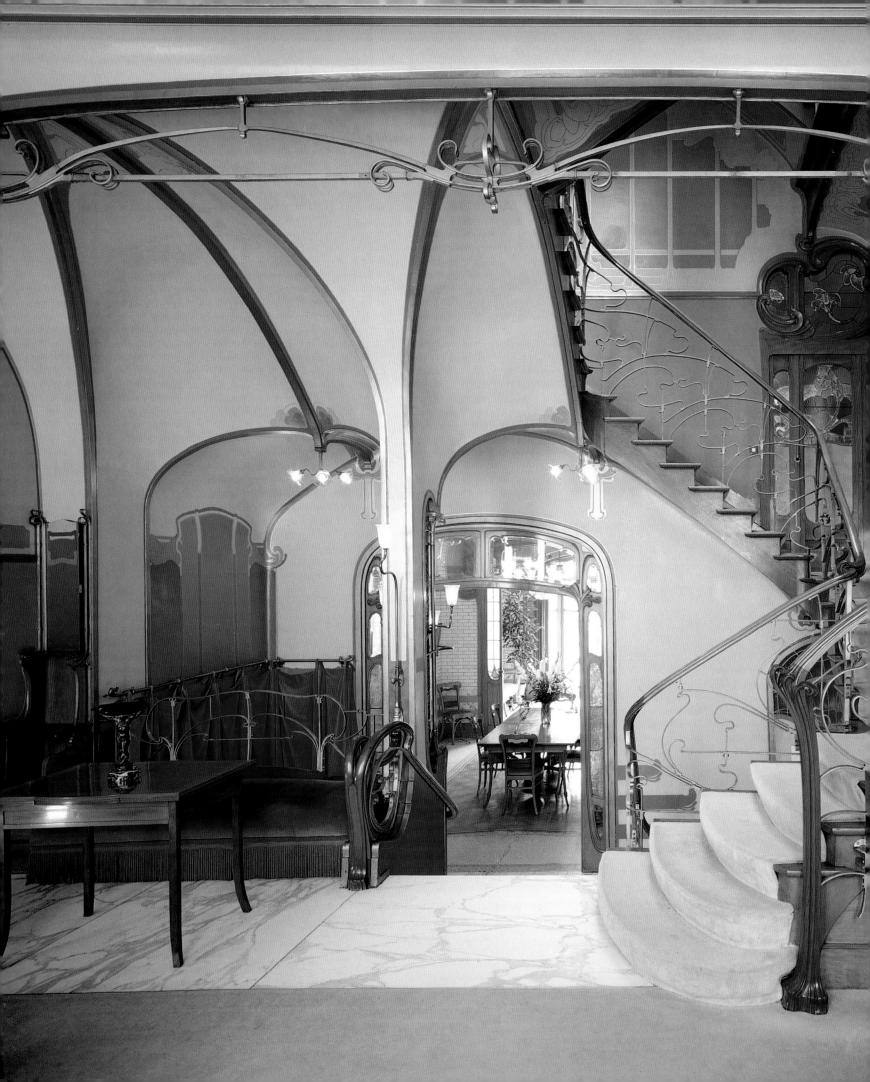

He combined wrought iron with cast iron, producing some of his most imaginative work in the latter. Between 1894 and 1898 he worked on the Castel Béranger, a block of 36 flats for Madame Fournier in the prestigious sixteenth arrondissement of Paris. His client allowed him a free hand to experiment, and, for Guimard, it became a personal manifesto. The facades of this building were an interplay of stone, rustic masonry, brick, cast and wrought ironwork (plate 17.2). In 1901 Henri Franz, writing in the *Magazine of Art*, provided a perceptive analysis of the building: 'We find here none of the decoration in which the artist has adapted natural forms – no flowers, no vegetable types. Line alone is what Mr Guimard relies on; he gets all his effects from the use of line or combination of lines'.[4]

The pivotal point in Guimard's career came with the commission to design a series of station entrances for the new Metropolitan railway in Paris, which were largely opened to coincide with the *Exposition Universelle* of 1900 (plates 17.4 and 17.5). The prize-winning design by Duray, Lamaresquier and Paumier had been selected in 1889, but was ultimately rejected for its feebleness, and André Benard, the Conseil Municipal of Paris and a supporter of Art Nouveau, commissioned Guimard. The brief was to provide a scheme which achieved a fusion of art, design and technology. He was required to design three different types of entrance: open steps, covered steps and railing, and complete pavilions. The materials he selected were glass and cast iron, and the structures were broken down into a modular, standardized range of components which facilitated manufacture and installation. The castings, hardy and interchangeable, were practical and functional while having a fantastical and poetic ambiance. The glass roof panels hovered over the entrance 'like a dragonfly's wings' as the critic George Bans expressed it.[5] Each entrance as a whole was completely different, yet all parts had standardized dimensions. Guimard's experiments with modular construction were supported by the Saint-Dizier foundry, the company that produced most of his cast iron-work. He was interested in the possibilities of standardization, seeing in it the potential for the revitalization of architecture. He developed a range of prefabricated iron-work fixtures and fittings which he marketed through his own catalogue. In the architectural magazine *La Construc-*

14.2 Horta House, view
from the music room towards
the dining room. 1898-1900.
Photo: C.H. Bastin & J. Evrard,
Brussels.

tion moderne he wrote: 'Why condemn architects for using outmoded decorative devices when component manufacturers can only supply Louis XVI models.'[6]

Guimard openly acknowledged his debts to the new Belgian architecture and especially Victor Horta. Indeed, Horta's architecture combined materials within the idiom of Art Nouveau that set precedents for architects all over Europe. It succeeded not simply through the use of iron, but through the brilliant combination of various materials into unified ensembles. Throughout the Art Nouveau phase of Horta's career, marble, brass, ceramic tile, brick, glass, wood and iron were constantly orchestrated. At his home and studio, at the rue Américaine (now the Horta Museum), iron provides the linear elements which frame the space and enable the various materials to relate (plate 14.2). Horta was much influenced by Viollet-le-Duc, whose *Entretiens sur l'architecture* (1863–72) developed the idea of iron construction as a vehicle for rationalist architecture (plate 2.13). Viollet-le-Duc argued for the exploitation of the new and immense resources that were being furnished by manufacturing skill, using them to realize 'architectural forms adapted to our times', instead of disguising them 'by an architecture borrowed from other ages'. In his own house and in the Van Eetvelde House (1897) the central core of the house is an iron cage, fenestrated at the top to allow light to pour down into the building. The Maison du Peuple (1897) and the Innovation department store (1901), which are essentially iron frame buildings, extended this principle.

The Belgian Art Nouveau architects who, alongside Horta, put up hundreds of public buildings and private dwellings, excelled in the use of ironwork. Paul Saintenoy's Old England department store of 1899 used it to complicate, brilliantly, the frame of the building. The municipal buildings of Henri Jacobs played on the pattern of the pre-fabricated metal, the roof spaces of his halls being filled with repeating 'whiplash' motifs. Most dramatically, perhaps, Gustave Strauven surrounded his tall terraced houses and apartment blocks with forests of intertwining stems and sepals, in a pantheistic celebration of the natural world (plate 14.3).

In other leading cities private patrons, companies and government institutions commissioned architects to create architectural elements that became icons of the New Age. In Vienna the second Secession Exhibition of 1899 was held in Olbrich's newly designed Secession House. The most striking feature of the building was the gilded dome of wrought-iron openwork. It instantly became one of the architectural landmarks of Vienna, symbolizing an uncompromising modernity in the middle of the city of the old

14.3 Gustave Strauven, gate. Wrought iron. Brussels, 1900-03. Home of the painter Saint-Cyr. Photo: Paul Greenhalgh.

dios have been split and coiled to create a freely formed helix finial. The fabrication of these finials by the blacksmiths caused a stoppage on the building site, such was the apparent impossibility of the task. Elsewhere in the building, struts and knots of iron cover windows and project from the asymmetric mass of Mackintosh's masterpiece (plate 21.11).

In Barcelona, Antoní Gaudí's key buildings were dramatically enhanced by some of the most spectacularly smithed works in the history of ironwork. Gaudí relied on small local smithing companies, which he consistently patronized throughout the period, forming creative partnerships that allowed extraordinary designs to be realized in three dimensions. The Palacio Güell (1885–89), Casa Batlló (1904–06) and Casa Milà (1906–10), for example, combine the organic microscopy of Ernst Haeckel with a wildly extrovert enthusiasm for all forms of life. Giant clumps of seaweed mingle with spirogyra, cellular creatures, skeletons and abstracted animal and human forms in one of the most extreme expressions of Naturalism in the Art Nouveau style (plates 23.6 and 23.8).

Chicago in the latter part of the nineteenth century saw some of the most spectacular developments in modern architecture (chapter twenty-two). The city was in the process of being rebuilt after the catastrophic fire of 1871. Cast iron as a structural material had proved its vulnerability in the fire. In order to counter this vulnerability, the fireproofed steel frame, which evolved from engineering advances in steel bridge construction and which could carry the entire structural load of the building, was used as the main component. Suddenly, as the contemporary critic Montgomery Schuyler remarked in 1899, 'the elevator doubled the height of the building and the steel frame doubled it again'. The architectural practice of Dankmar Adler and Louis Sullivan was among the most successful in exploiting this new technology. Sullivan evolved a modern ornamental language appropriate to the high-rise frame. The most significant buildings designed and built by the practice, such as the Guaranty Building (Buffalo, 1894–96) and the Schlesinger Meyer department store (Chicago, 1904), articulate the steel substructure clearly (plates 22.6, 22.7 and 22.10). The ornament, a heavily stylized naturalism that fully embraced Art Nouveau in the Schlesinger Meyer building, was in Sullivan's own words, 'applied in the sense of being cut in or cut on, yet it should appear when completed as though … it had come forth from the very substance of the material'.[8] Sullivan could never see any reason why he should resist the use of ornament and his protégé, Frank Lloyd Wright, also followed this

Empire (see also chapters two and twenty). In Glasgow the use of iron, upon which the city's industrial wealth had been made, was particularly pertinent. Historian Juliet Kinchin has suggested that here there was a 'heightened perception of the qualities associated with metal – a material that could be bent, punctured, welded and moulded with great precision' which pervaded the whole Glasgow Style of interiors, with their streamlined, fluid forms and decorative riveting'[7] (see also chapter twenty-one). Mackintosh used exposed, wrought ironwork for the Glasgow School of Art (1899–1909). The end of the 'T' section girders supporting the roof of the basement sculpture stu-

14.4 C.R. Ashbee, decanter. Silver, glass and crysoprase. English, 1904-05. Glass made by James Powell & Sons, Whitefriars. V&A: M.121-1966.

vidualistic production. Although practitioners such as Alexander Fisher and Alfred Gilbert, and companies such as Hutton & Sons and Hukin & Heath, did create master-works considered to be important to the style, Walter Crane's famously disparaging remark that Art Nouveau was a 'strange decorative disease' was a more standard response. Arts and Crafts theories, however, disseminated by practi-tioners such as Crane, Mackmurdo, Henry Wilson and C.R. Ashbee (all of whom produced influential texts) were vital to the intellectual formation of several of the Euro-pean movements. For many contemporary commentators English Art Nouveau metalwork, more than any other craft, represented the triumph of the artist-craftsman. It was seen as the return to the idea of the Medieval and Renaissance workshop (where the designer was involved in manufacture and oversaw production from design to finished object), when art was 'less an effort than a habit'.

Ashbee was the paradigm of the artist-craftsman. An architect by training, he turned to the applied arts and learned the skills of the silversmith to realize the Arts and Crafts ideal. The revolutionary agenda of the Arts and Crafts movement and the radical directions in metalwork design taken by Ashbee and his Guild of Handicraft enjoyed widespread recognition and influence throughout mainland Europe and the United States. Silverware pro-duced by the Guild of Handicraft had its own simple and distinctive style. Purity of profile and a restrained, conven-tionalized use of nature mask eclectic interests in Medieval and Renaissance forms. Towards the turn of the century, the Guild's work took on a more flamboyant appearance, exemplified by the now-famous loop-handled dishes (plate 8.11). In the same spirit, it made a series of wine decanters between 1897 and 1914. The squat, fat-bellied glass bottles made by James Powell & Sons of Whitefriars were based on an Elizabethan sack bottle. Ashbee had uncovered a selec-tion of such bottles when he was excavating the foundations for his house, the 'Magpie and Stump', in Chelsea. Ashbee gave the neck a silver collar and threw a slim cordon of wires around the body without disturbing its contour. As a final flourish, the handles arched upwards and returned inwards in a generous elegant loop (plate 14.4).

Ashbee's reputation and influence in Europe and North America was considerable. This was initially manifested in Belgium, where the links between social change and the applied arts were particularly marked. He was first shown alongside William Morris and others at the Salon of *La Libre esthétiqu*e in Brussels in 1894. Exhibitors and associates were principally painters, sculptors and graphic artists. It was perhaps inevitable then that he became an exemplar of

principle. Though never centrally part of the Art Nouveau story, Wright's ornamentation related closely to Secession-ist geometry, and in many ways anticipated the forms of the following generation.

The production of functional and decorative wares in metal owed a great deal to the English Arts and Crafts movement. As chapter eight reveals, the English did not manage to create a consolidated, intellectually cohesive Art Nouveau style. Instead, Art Nouveau existed there as occa-sional, often commercially pragmatic and invariably indi-

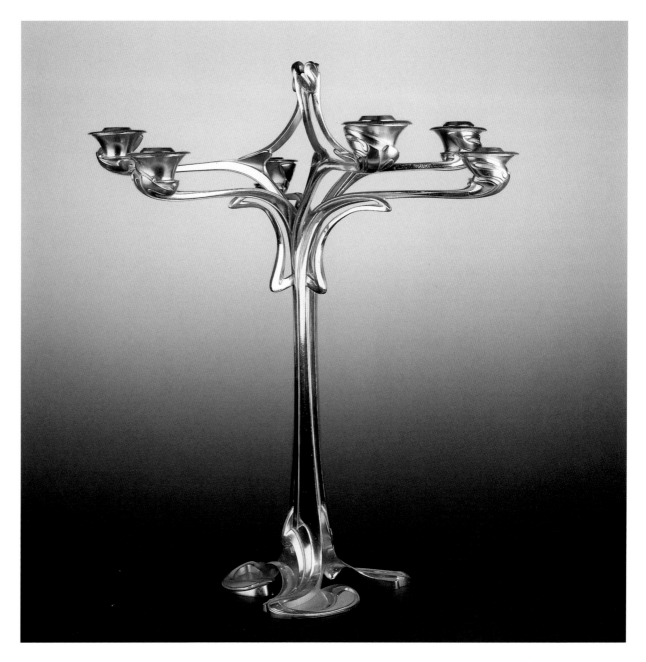

14.5 Henry van de Velde,
candelabra. Electro-plated bronze.
Belgian, 1898-99.
Musées Royaux d'Art et
d'Histoire, Brussels.

modern domestic metalwork. His work was included in an exhibition in Liège the following year and at the Brussels *Exposition Universelle* of 1897. After 1895 Ashbee's work shows his awareness of contemporary developments in Belgium, France and Germany. This is especially clear where the handles of objects show sinuous and serpentine curves. Having influenced the Europeans with his political outlook and his Naturalism, he in turn was influenced by them. In the early years of the new century, as the Arts and Crafts movement in England entered its most consolidated phase, the influence of the Utopian writings and lifestyle of artist-designers like Ashbee reached its peak.

As noted above, other individuals and companies in Britain made a significant contribution to the total sum of Art Nouveau metal. Perhaps the most consistent and widely recognized of these was Archibald Knox. Born on the Isle of Man, he earned his living as a teacher there and in England (in Surrey and later Kingston). He moved in Arts and Crafts and Aesthetic movement circles throughout the 1890s, which ultimately led to his contract with Arthur Lasenby Liberty. Knox's principal importance is found in his exploitation of Celtic linear forms in silver and pewterware for Liberty (plate 2.16). His Cymric ware, from 1899, and his Tudric ware from 1900, both for Liberty, became internationally recognized by Art Nouveau designers and patrons. In Scotland, the Glasgow school produced

a range of works in metal, perhaps the most impressive and characterful of these being the repoussé works of the so-called 'Glasgow Girls'. Designers Frances and Margaret MacDonald, Marion Wilson and Margaret Gilmour, for example, made interesting contributions to the Art Nouveau canon in repoussé tin frames, plaques and dishes (plate 1.8).

Of all the European nations, Belgium produced some of the most vibrant and sophisticated Art Nouveau metalwork. It was the Belgians who came the closest to following Walter Crane's dictum: 'Line is all important. Let the designer, therefore, in the adaptation of this art, lean upon the staff of line – line determinative, line emphatic, line delicate, line expressive, line controlling and uniting.' Henry van de Velde expressed the same idea more succinctly when he stated '*Linie is eine Kraft*' (line is a force). Unlike Britain, Germany or Austria, where many architects and painters designed for silver and other metals, the Belgians tended to confine themselves to their own specialist professions. There were two exceptions to this rule. The first was Serrurier-Bovy, who designed elegant, spartan, geometric hollow ware and household furnishings, in brass and copper. The second, van de Velde (arguably, the most accomplished and prolific designer in Belgium), designed across a whole range of materials (plate 14.5). He founded his own decorating firm and factory at Ixelles, a suburb of Brussels, which produced a few pieces of jewellery and silvered bronze objects. He designed mounts for glass and ceramics for La Maison Moderne, which were executed by the Parisian silversmith A. Debain. In 1900, van de Velde transferred his office to Berlin, with the majority of his designs for silver being for the Weimar court goldsmith, Theodor Müller. Designer and manufacturer collaborated closely to produce silver in a curvilinear, abstract style, often achieved by the most exquisite chasing, and far removed from the naturalistic ornament found in Germany or France.

Fernand Dubois was another highly original and innovative designer of silver. In 1882, he entered the studio of the sculptor van der Stappen who included Octave Maus among his circle of friends. It was probably Maus who encouraged Dubois to submit his work to the first exhibition of *La Libre esthétique* in 1894. Dubois' talents were not exclusively confined to silver; in 1897 he became interested in bookbinding and executed one in embossed leather, incorporating ivory medallions. That same year, he contributed a mag-

14.6 Fernand Dubois, candelabra. Electro-plated bronze. Belgian, *c*.1899. Musée Horta, Brussels.

nificent casket of silvered bronze containing carved ivory panels to the Colonial Exhibition at Tervuren. It is interesting to note that he received advice from Victor Horta for the design of this object. Yet it is his silver candelabra of 1899 (plate 14.6) that demonstrates his talents to the full. His silver work demonstrated three tendencies: motifs which borrowed directly from nature or the human form; an abstract curvilinear style reminiscent of the work of his contemporary, van de Velde; and a very obviously sculptural element. The candelabra is a combination of all three. When compared with the candelabra by van de Velde (plate 14.5), Dubois' version is rather more naturalistic and yet sufficiently distilled into an abstract form to give it an impressive sculptural presence.

Ivory as a material for the applied arts received strong encouragement at the end of the nineteenth century from King Léopold II, who arranged for ivory from the Belgian Congo to be supplied to a number of Belgian artists. His concerns were primarily economic and political, rather than aesthetic. Nevertheless, goldsmiths and sculptors who were given access to this exotic material accepted the challenge of its potential with unreserved enthusiasm. The sculptor Egide Rombeaux carved languid female nudes from the material, and had them entwined in silver mounts supplied by the silversmith Frans Hoosemans. These were exhibited in the Belgian Pavilion at the *Exposition Universelle* in Paris in 1900 and were immediately purchased by European applied arts museums, such as in Hamburg and Oslo (plate 4.13 and 16.8). Yet the most dramatic use of ivory was by the goldsmith Philippe Wolfers. At the Tervuren site of the Brussels *Exposition Universelle* of 1897 he displayed two ivory carvings, which had naturalistic elements carved in relief along the tusk and which were mounted on naturalistic bronze bases, designed by the architect Paul Hankar.

Philippe Wolfers was the son of the goldsmith Louis Wolfers. At the Académie Royale in Brussels he was taught drawing by Isidore de Rudder and met Fernand Dubois and Paul Hankar. In 1875, after completing his studies, he went to work in his father's workshop where he was trained in every aspect of goldsmithing (modelling, casting, chasing, burnishing and stone setting). From 1880 onwards, he designed silver for the firm – first in a neo-Rococo manner, but after 1882 increasingly incorporating Japanese motifs in his work. When his father died in 1892, he became the Managing Director of Maison Wolfers and gave the firm its artistic direction. He was entirely responsible for its Art Nouveau designs, which, unlike those of other Belgian designers mentioned above, were not so much abstract as highly naturalistic (plate 16.6). Studies from nature,

particularly of orchids, irises, wild flowers and lilies, were incorporated into the design of Wolfers' silver from 1890. He exhibited at many of the International Exhibitions and his unexplained absence from the *Exposition Universelle* in Paris in 1900 was widely regretted. His display at the Turin *Esposizione* of 1902 was a triumph. By then his work, both in silver and jewellery, was beginning to show an increasing sculptural emphasis. The organic nature of his purely Art Nouveau designs of the previous decade was already beginning to recede. After 1905, he devoted himself almost exclusively to sculpture. When Philippe Wolfers first joined Maison Wolfers, it was only a factory (although a large one) without any retail outlets of its own. In the Netherlands Wolfers silver was sold by Beeger in Utrecht and Bonebakker in Amsterdam and a considerable quantity of silver was exported to Germany and France. It was only after he became Managing Director that the firm set up its own network of retail outlets in every major Belgian city.

In the Netherlands, the largest and oldest silver manufactory was Kempen & Zoon at Voorschoten. The identity of individual designers on its staff remains obscure because of company policy at the time. The objects designed around 1900 display all the characteristics of international Art Nouveau and are universally of high quality. Liberty's of London had the same policy with regards to the identity of the designers who supplied its metalwork ventures. Nonetheless, it has been established that the most significant designer supplying designs for Liberty's Cymric silver and Tudric pewter ranges was Archibald Knox (plate 2.16).

The use of the vernacular as a source for a modern style was not only evident in Britain, but also in the Nordic countries and Russia. Norway and Denmark, where nationalist movements were particularly strong, drew heavily on a rich vein of motifs from Viking culture to the extent that the silver produced in the first decade of the twentieth century became known as the Viking or Dragon style. Interlaced ornament from early Medieval stone carvings and carved wooden dragon heads found on archaeological sites provided a rich visual vocabulary which was incorporated into coffee pots, candelabra and jardinières (plate 1.6). The most dramatic impact made by Norwegian silversmiths at the *Exposition Universelle* in Paris in 1900 was with their *plique-à-jour* enamelwork. On display were a number of standing dishes in the form of transparent flowers supported on tall and elegant stems. The most important firms producing this enamelwork were J. Tostrup, David Andersen and Marius Hammer.

In Denmark, modernity was expressed in a more natu-

ralistic manner. The first contemporary silver at the end of the nineteenth century was designed by the architect Thorvald Bindesbøll for the well-established Copenhagen silversmiths A. Michelsen. His silver designs tended to use heavy, undulating, abstract ornament which was extensively imitated by the younger generation of Danish artists, including Georg Jensen. Jensen had originally intended to be a sculptor, but was apprenticed to the painter and silversmith Mogens Ballin. By 1904, he had a workshop of his own where he initially made only jewellery. Within two years he had begun to produce hollow ware. At first this was entirely devoid of ornament, but gradually the now-familiar repertoire of stylized finials, feet, stems and handles with bunches of flowers and fruit began to emerge. Jensen's naturalistic ornament always had a formal monumentality. His silver and jewellery quickly became popular and his modest workshop grew into a hugely successful, manufacturing and retail empire.

In France the vernacular was effectively the Rococo form, as distilled through several centuries. Since the eighteenth century, Paris had been the European centre for the luxury trades; silver and jewellery inherited a rich mantle of tradition. The Rococo had first emerged in France in the mid-eighteenth century and was enjoying one of its many revivals in the latter part of the nineteenth century. The studied asymmetry characteristic of the Rococo, in itself a distilled naturalism, provided the perfect framework for the stylized naturalism of the French Art Nouveau designers. In the hands of the most gifted, the silver and jewellery produced was the epitome of the style. One of the most famous and successful jewellers was René Lalique, whose work is discussed in detail in chapter fifteen. Lalique had begun his training in the workshop of Louis Aucoc. Other important workshops were Boucheron, Cardeillac, Keller and the Société Parisienne d'Orfèverie. Maison Christolfe, the biggest silver manufactory in France, tended to be rather more conservative, combining modern floral ornament with traditional forms.

Some of the most technically challenging French metalwork for the luxury trades involved the use of enamel. André Fernand Thesmar was the first to revive the *plique-à-jour* technique in France. He had been trained in the technique of *cloisonné* enamel at the Barbedienne foundry, where he was apprenticed in 1872. In 1902 the designer Félix Bracquemond designed a superb cup and cover with a carved, jade stand for the wealthy banker, Baron Vitta. The gold mounts were the work of Lucien Falize, while the enamelwork was executed by Alexandre Riquet. Eugène Feuillâtre achieved triumphant success with his enamelled

for Art and Industry) bought four metalwork objects for its permanent collections. In 1902 Josef Hoffmann travelled to Britain to visit art schools, and in the following year set up the *Wiener Werkstätte Productiv-Gemeinschaft von Kunsthandwerkern* (workshops modelled on those of Ashbee's Guild of Handicraft). These were backed by a wealthy industrialist, Fritz Wärndorfer. The silver and jewellery workshops were among the first to be established, and the early *Werkstätte* metalwork demonstrates just how sincerely Hoffmann and Moser sought to emulate the Guild principles. The form of the objects was both simple and striking. Coloured, semi-precious stones were used effectively and hammer marks were left on the surface of the metal. In 1905 an *Arbeitsprogramm* was published which reads like an Arts and Crafts proclamation:

> Our aim is to create an island of tranquility in our own
> country which, amid the joyful hum of the arts and crafts,
> would be welcome to anyone who professes faith in Ruskin
> and Morris. … We love silver and gold for their sheen and
> regard the lustre of copper as just as valid artistically. …
> The merit of craftsmanship and artistic conception
> must be recognized once more and valued accordingly.
> Handicrafts must be measured by the same standards
> as the work of the painter or sculptor.

Hoffmann began designing simple table silver as early as 1902, executed by the Vienna goldsmith firms of Alexander Sturm and Würbel & Csokally, and exhibited in Düsseldorf in 1902. The stress was on simplicity; geometric abstraction of design was paramount and choice of material secondary in the *Werkstätte*'s programme. The angular nature of the *Werkstätte* designs became so pronounced that their style was popularly known as *Quadratstil* (square style). The fruit basket designed by Hoffmann around 1904 exemplifies this sophisticated approach to design (plate 14.7). The stress on labour-intensive craftsmanship meant that the *Werkstätte* were often in perilous financial straits. Hoffmann's *magnum opus* as an architect was the commission to design and build the Palais Stoclet in Brussels (1905–11). This commission kept the *Werkstätte* buoyant for the duration of the assignment. Adolphe Stoclet, an extremely wealthy banker of almost inexhaustible means, gave Hoffman virtual *carte blanche* to create the building. The result represented the ultimate in Secessionist architecture – a *Gesamtkunstwerk* – with its organic unity of architecture, decoration and interior furnishing (plate 20.7). The metal elements in the house, from the fences, grills and fittings of the building to the cutlery and other domestic equipment, followed the ethic of unification. The Palais was to prove vital to Belgian architects and designers, most

14.7 Josef Hoffmann, fruit basket. Silver. Austrian, 1904. V&A: M.40-1972.

silver objects in 1898 when he participated in the Salon of the Société des Artistes Français for the first time under his own name. He had previously been employed in the studio of Lalique.

In stark contrast, the Viennese Secessionists developed a powerfully simplified aesthetic. In an attempt to establish more lively contact with developments abroad, they encouraged foreigners to exhibit in Vienna. Thus, British designers became well known there. E.W. Godwin and Charles Rennie Mackintosh were both important for the formation of the Secessionist aesthetic and, inevitably, it was in Vienna that Ashbee was most enthusiastically received. His furniture and metalwork was shown at the eighth Secession Exhibition in 1900 to critical acclaim and his pieces sold well to private and public patrons: the *Österreichisches Museum fur Kunst und Industrie* (Austrian Museum

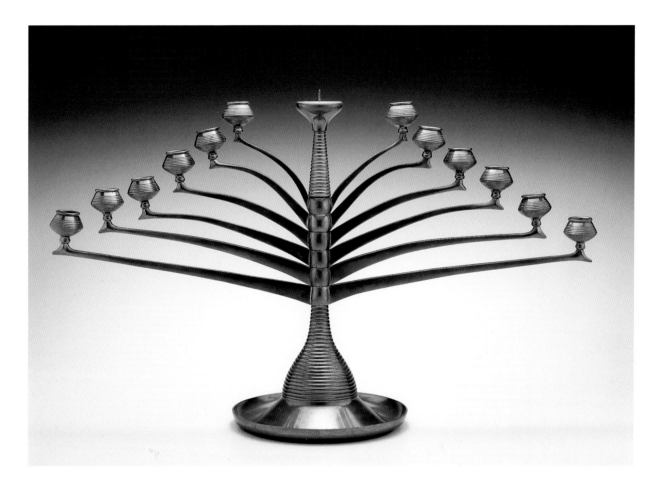

notably Serrurier-Bovy, whose furniture and metalwork acquired a distinctly Secessionist simplicity after 1905.

The Guild of Handicraft was also emulated in Germany, although ideas about training and the relationship to mechanized production differed. From 1897, artists and designers associated with the Secession started Arts and Crafts workshops in Munich. Bruno Paul, who initially trained as a painter at the Munich Academy, was a founder member of the *Vereinigte Werkstätten für Kunst im Handwerk* (United Workshops for Art in Handicraft), which included Peter Behrens, Hermann Obrist, Bernhard Pankok and Richard Riemerschmid. The focus of this group was to achieve a simple domestic style. Paul's monumental brass candelabra of 1901 (plate 14.8), although following English precedents in its simplicity and conventionalization of nature, has an eclectic sophistication which lifts it completely away from its forebears. The composition of the candelabra (as a stylized tree) has a starkly rigorous geometry that hints at Classical precedents without using any single aspect of Classical ornamental language. It was made in several sizes and formed a regular, decorative feature in rooms designed by the *Vereinigte Werkstätten* in contemporary publications.

Richard Riemerschmid was a leading member of the 'functionalist' wing of the Munich Jugendstil movement. He trained as a painter at the Munich Academy, graduating in 1890. It was not until 1895 that he started to produce designs for furniture, which initially showed the influence of folk art, the English Gothic Revival and the Arts and Crafts movement. His scope quickly expanded to include glass, ceramics, metalwork and textiles. He also proved to be an architect and interior designer of considerable verve and originality. His 12-piece silver place setting was developed from a design of 1898. It was exhibited at many International Exhibitions at the turn of the century. In keeping with his pragmatic philosophy, the scimitar blade of the knife is sensibly utilitarian and yet was regarded as the most revolutionary aspect of the set. The handles, fashionably curved, fit snugly into the palm. Another remarkable design from this period is a single socket brass candlestick made by the *Vereingte Werkstätten* in 1898 (plate 14.9). The vegetal source for this design, although obvious, is nonetheless expressed with supreme economy. When it was displayed at the Munich Glaspalast exhibition of 1899, alongside a variety of richly decorated domestic items in wrought iron, copper and brass by such local firms as

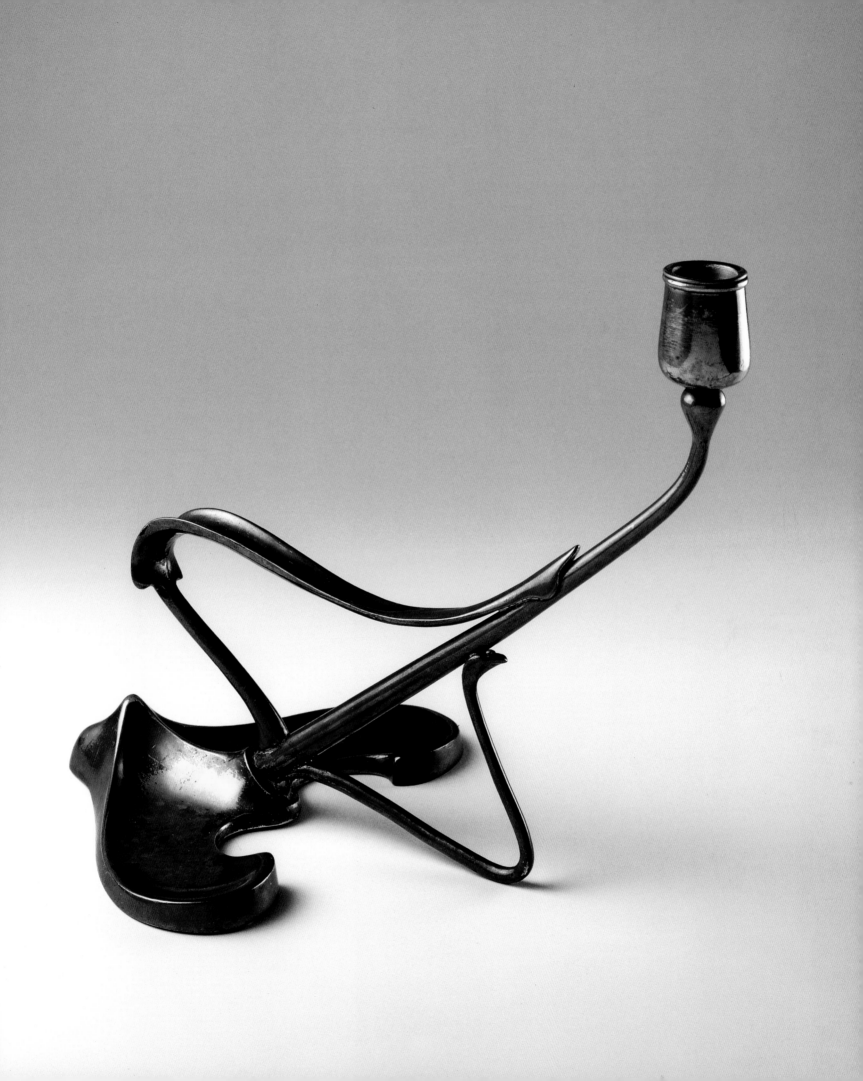

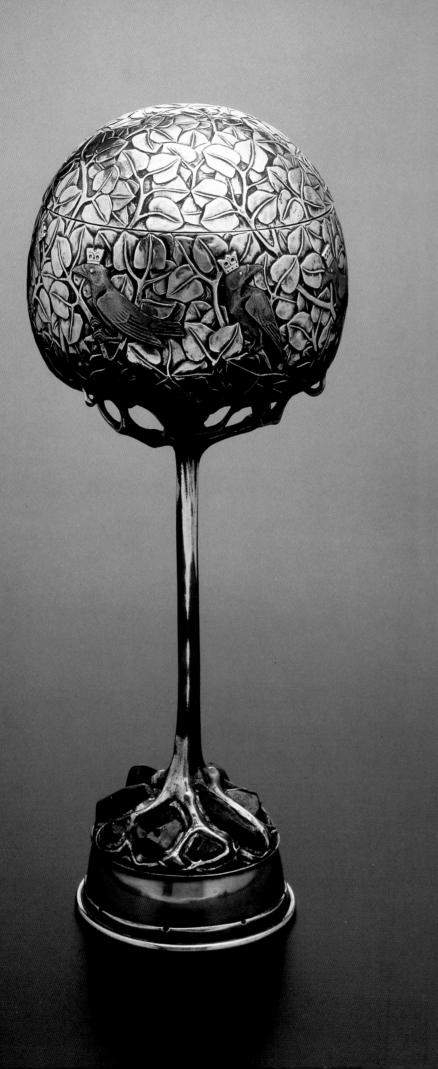

Reinhold Kirsch and Wilhelm & Lind, observers remarked upon the austerity of the design. A reviewer for *Kunst und Handwerk* commented that the candlestick drew attention to itself 'through an almost unnatural restraint in [its] decorative development'. Ten years later, this was no longer a criticism but a virtue.

Ernest Riegel was one of the most significant, but ironically most ignored, German goldsmiths. In 1887–90 he was apprenticed to the silver-chaser Otto Pabst and later became an assistant to the Munich goldsmith Fritz von Müller in 1895. Müller, who at one time had been apprenticed to the London goldsmiths Hunt & Roskell, was the doyen of south German goldsmiths in the closing years of the nineteenth century. He excelled in the production of sumptuous and elaborate centrepieces and his studio was filled with an extensive range of historical prototypes. These undoubtedly influenced Riegel's later designs, but, like Ashbee, he became very successful at treating historical examples in his own thoroughly modern and idiomatic manner. His silver goblet of 1903, partly gilded and with uncut opals mounted on the base, demonstrates this ability perfectly (plate 14.10). Its form recalls the 'apple goblets' of the late Gothic period, and the use of uncut mounted stones is a revival of established south German goldsmithing traditions. Nonetheless, the form representing a tree with pruned foliage and knarled roots has been unambiguously reinterpreted in a contemporary Jugendstil style.

In the United States, great houses such as Gorham and Tiffany realized that in order to march with the times they must employ the artist and designer to help them in their industry. Louis Comfort Tiffany, the son of the founder of Tiffany & Co., is one of the most well-known of all the American contributors to Art Nouveau. While the reputation of both the company and Louis Comfort himself rests heavily on glass production, metal was often used in conjunction with this core material (see chapter twenty-eight). He achieved his unique iridescent colours in glass by exposing the molten glass to the fumes of vaporized metals, and he often designed the metal mounts for the resulting objects himself. Such versatility meant that the physical constraints to the realization of the whiplash and the sinuous curve were few, and the fertile imaginings of designers and makers could be realized with the minimum of restraint.

14.10 Ernest Riegel, goblet.
Silver, silver gilt and uncut opals.
German, 1903.
Stadtmuseum, Munich.
Photo: Wolfgang Pulfer.

14.11 Gorham Silver
Company, ewer and platter.
Silver. American, 1901.
Metropolitan Museum of Art:
gift of Hugh Grant.

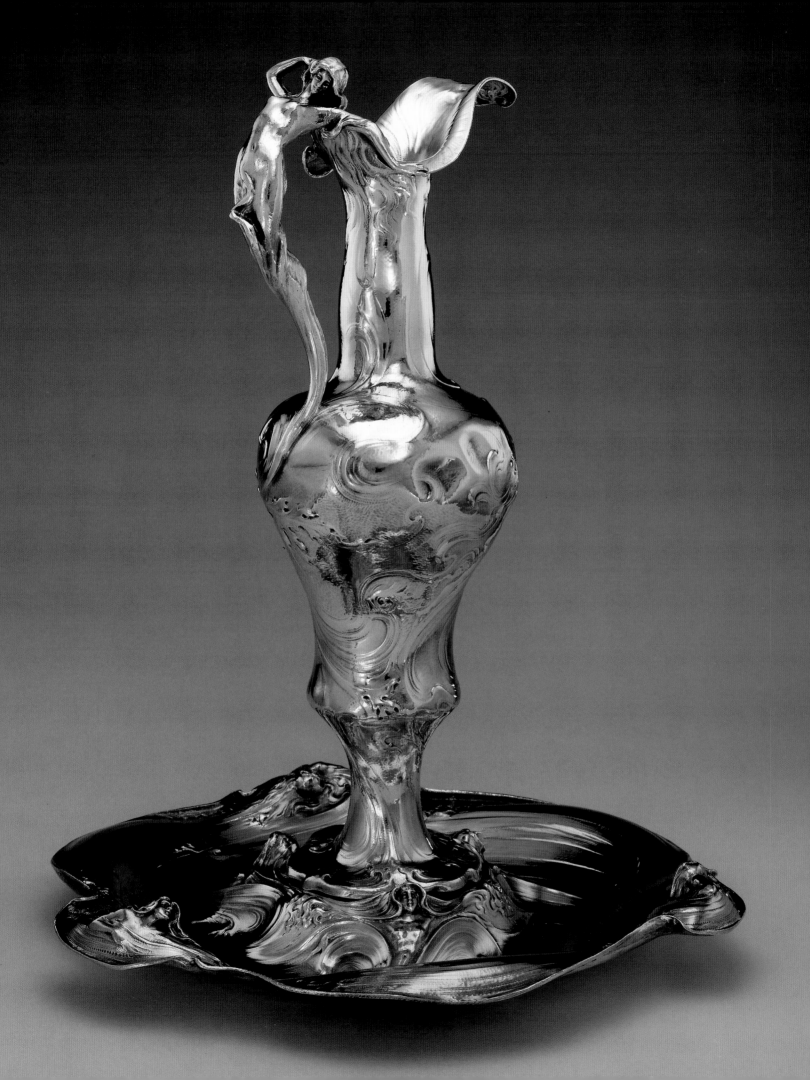

14.12 Georges De Feure, furniture fittings. Electro-plated silver on cast copper. French, *c.*1900. V&A: 2A-N-1901.

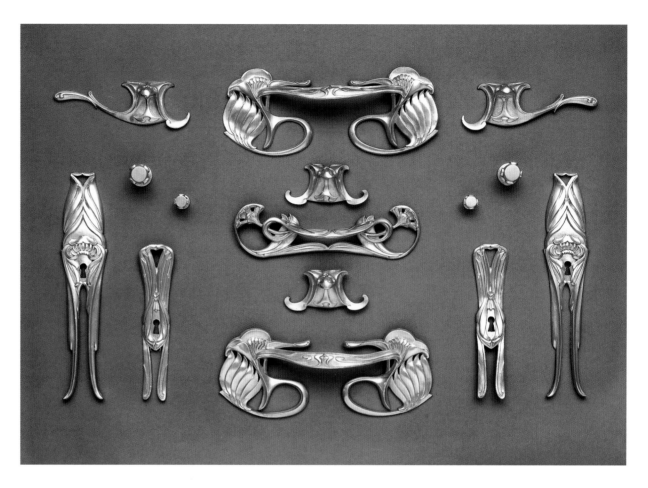

14.13 Paul Follot, teapot and creamer. Silver. French, *c.*1904. V&A: M.105 & A-1978.

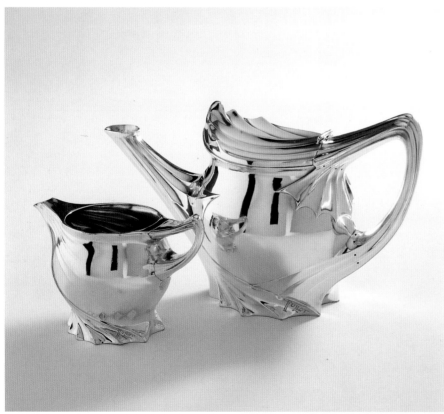

The technical and experimental achievements of Tiffany compare interestingly with the Gorham Silver Company of Providence, Rhode Island, which was the largest silver manufactory in the United States. The company was one of the first to use machinery, but from 1891 under the direction of an English silversmith, William Codman, the company dedicated a workshop to hand-made Art Nouveau silver. The company produced many fine artefacts that can be described as being within the parameters of Art Nouveau. However, these were often just as close to the more mainstream neo-Rococo, the exaggerated curves and bulbous forms masking a more staid historicist conventionalization (plate 14.11).

Art Nouveau architecture and metalwork was expensive. Its very idiosyncrasy ensured that. At its best, it required high-quality draughtsmanship and craftsmanship of the first rank. Those that supplied Siegfried Bing's gallery, L'Art Nouveau, such as Georges De Feure, Édouard Colonna, Eugène Gaillard, Émile Gallé, Louis Majorelle and Daum Frères, produced exquisite masterpieces in the style. The interiors of Georges De Feure, with their delicate curvilinear qualities (exemplified by the metal furniture fittings in plate 14.12, purchased by

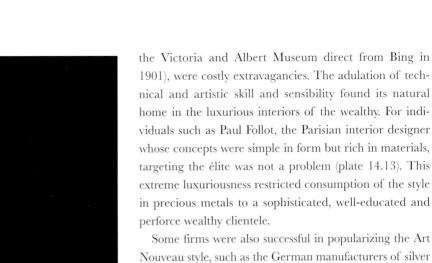

the Victoria and Albert Museum direct from Bing in 1901), were costly extravagancies. The adulation of technical and artistic skill and sensibility found its natural home in the luxurious interiors of the wealthy. For individuals such as Paul Follot, the Parisian interior designer whose concepts were simple in form but rich in materials, targeting the élite was not a problem (plate 14.13). This extreme luxuriousness restricted consumption of the style in precious metals to a sophisticated, well-educated and perforce wealthy clientele.

Some firms were also successful in popularizing the Art Nouveau style, such as the German manufacturers of silver and electroplated tableware, *Württenbergische Metalwarenfabrik* (WMF) of Geislingen, and William Hutton & Sons of Sheffield. The WMF output was particularly prodigious, incorporating both German Secessionist and French and Belgian versions of Art Nouveau which the factory sold all over Europe. In England, Arthur Lasenby Liberty imported pewter from Germany for sale in his Regent Street shop. His principle suppliers were J.P. Kayser Sohn of Krefeld-Bockum, Walter Scherf's Osiris-Metalwarenfabrik für Kleinkunst of Nuremburg, the Orivit-Metalwarenfabrik in Cologne, and the WMF.

Ultimately, the dissemination went much further. Metal was to prove a vehicle for popularization second only to the poster. Boxes and biscuit tins carried the style into the lower middle-class houses of the industrialized world (plate 1.3).

More than any other material, Art Nouveau metalwork allowed the interior and exterior spaces of the urban environment to relate, pulling the private and public spheres of the *fin-de-siècle* middle-class world together. The accoutrements of domestic life (cutlery, clasps, brooches, pins and boxes) complemented the workings of private life (plate 14.14), and through balconies, window grills, doors, balustrades and fences, Art Nouveau was made into a public language. The style thus showed itself capable of being both introspective and loudly theatrical. While all materials boast masterworks in the style, it is the sheer flamboyance of the spread of metal that makes it, perhaps, the most potent idiom of Art Nouveau.

14.14 Prince Bojidar Karageorgevitch,
6 coffee spoons, 1 fruit knife and
2 paperknives. Silver. Serbian, *c.*1900.
V&A: Circ.140, 142-9-1964.

Clare Phillips

Jewellery and the Art of the Goldsmith

The end of the nineteenth century saw an extraordinary revitalization of the jeweller's art, with nature as the principal source of inspiration being treated with unsurpassed sensitivity, complemented by new levels of virtuosity in enamelling and the introduction of new materials. The widespread interest in Japanese art and the more specialized enthusiasm for their metalworking skills, which followed the opening up of Japan to the West in the 1850s, fostered new themes and approaches to ornament. This was complemented by new approaches to history inspired by John Ruskin and Eugène Viollet-le-Duc. For the previous two centuries the emphasis in fine jewellery had been on gemstones, particularly on the diamond, and the jeweller or goldsmith had been principally concerned with providing settings for their advantage. Now a completely different type of jewellery was to burst forth, as jewellers united technical advances with a finely tuned artistic sensibility in response to the new style that was sweeping across the decorative arts (plate 15.1).

Jewellers in many countries shared this reaction against the dominance of the diamond, although this did not herald an international acceptance of the Art Nouveau style. In England Arts and Crafts designers such as C.R. Ashbee provided an alternative hand-wrought look. A sparser, more linear style emerged in Vienna under Josef Hoffmann and Carl Otto Czeschka, while in Denmark Georg Jensen and Thorvald Bindesbøll developed an abstract style in hand-beaten silver. In the United States firms such as Marcus & Co. of New York (plate 15.2) proved highly receptive to Art Nouveau, while Louis Comfort Tiffany (plates 28.12 and 28.13) allowed it to influence his own distinctive style. However, it was the jewellers of Paris and Brussels who created and defined Art Nouveau jewellery, and it was in these cities that it achieved its finest flowering.

Contemporary French critics were united in acknowledging that jewellery was undergoing a radical transformation, and that the French jeweller René Lalique was at its heart. In Paris as early as 1897 the glass artist Émile Gallé had singled out Lalique's work as representing 'a startling regeneration of the jeweller's craft which … lays the groundwork for the ultimate modern bijou'.[1] At the same time they were keen to establish this new style in a noble tradition, and for this they looked back to the Renaissance with its jewels of sculpted and enamelled gold and its acceptance of jewellers as artists rather than craftsmen. Writing on the jewellery shown at the Exposition Universelle in 1900, the curator of the Musée du Luxembourg identified the 1895 Salon, the first public showing of Lalique's work, as the origin of the change 'which has profoundly altered the basic condition and appearance of modern jewellery … from what was merely a brilliant industry to the status of an art'. He was in no doubt that: 'it was Lalique who was the veritable originator, … who threw out encrusted routine and forged a new expressiveness, … who cast all those sinuous lines, … who established the taste for milky cerulean overtones, … who glorified nature in jewellery, inspired by his intelligent encounter with Japanese art.'[2] At the same time, the Belgian jeweller Philippe Wolfers was recognized by many critics as being of equal merit to Lalique, and was even considered his superior by some. Keen competitors in Paris included Eugène Feuillâtre, who was Lalique's chief enameller until 1897, Georges Fouquet, Maison Vever, Lucien Gaillard and René Foy.

Lalique was unusual among the top rank of Parisian jewellers in not being from an established jewellery dynasty. His entry into the jewellery world, in the form of a two-year apprenticeship with the Parisian jeweller Louis Aucoc, had been arranged by his widowed mother when he was 16. This was followed by two years in England, at the art school attached to the Crystal Palace in Sydenham, London. This technical and artistic training was complemented by an informal study of nature which Lalique had

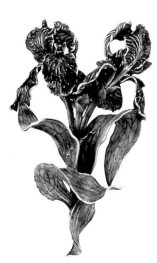

15.2 Marcus & Co.,
iris brooch. Gold and enamel,
American, 1900.
Private Collection, New York.

15.4 Philippe Wolfers,
orchid hair ornament, gold,
enamel, diamonds and rubies.
Belgian, 1902.
V&A: M.11-1962.
© DACS, 2000.

15.3 René Lalique,
iris bracelet. Gold, enamel
and opals. French, 1897.
Private Collection, New York.
© ADAGP, Paris and DACS,
London 2000.

indulged in from early childhood. The jeweller and historian Henri Vever recounted how as a child Lalique 'would spend long hours contemplating the plants, flowers and trees, admiring their elegant forms, their varied colours and exquisite harmony … captivated and deeply moved by the constantly changing spectacle of nature'.[3] This was first manifest in the diamond-encrusted flowers he designed in the 1880s. In 1885 Lalique acquired a workshop and began anonymously supplying fashionable Parisian jewellery houses. He was committed to innovation, initially working in diamonds as convention and his customers expected, but from 1892 with a more radical determination. At this date he began an exhausting programme of technical research principally into enamel and glass. He later explained: 'I had to do my utmost to renounce everything I had accomplished before. I worked relentlessly, drawing, modelling, carrying out technical research and experiments of all kinds, always determined to attain a new result and create something completely new.'[4] By 1897 he had emerged with the distinctive style for which he was to become famous. His work at the Salon that year, including intricately enamelled flowers and jewelled horn combs, was awarded a first-class medal plus the praise 'perhaps never before had an innovator inspired such feverish excitement, so profoundly disrupted the habitual and rejuvenated old traditions'.[5]

Lalique's workshop on the rue Thérèse was described by Vever as bright, full of flowers and decorated with many sculptured figures. In this stimulating environment, and from 1902 when he moved to Cours-la-Reine, Lalique employed about 30 craftsmen. All his jewellery originated in drawings, 300 of which were exhibited alongside his jewellery at London's Grafton Gallery in 1903. Lalique's hand-written annotations on these drawings are the only information on techniques that come directly from him.

His work used a wide range of goldsmiths' skills, including lost-wax casting for solid pieces, saw-piercing gold sheet, enamelling, patinating, engraving, chasing and die-stamping. In addition, he borrowed techniques from other traditions when they suited his needs. His adoption of the medal-engravers' reducing wheel enabled him to capture in a gold miniature the details of a larger sculpted model.

In 1900 Lalique was credited with the ideological victory of having convinced the public that a piece of jewellery 'could by the beauty of its craftsmanship, by the artistic refinement of its form and design, exceed in value the precious materials used in gem-set jewellery'.[6] In other words, the price of a jewel might not relate directly to the size and importance of its gemstones. After centuries of jewellery being thought of as portable and realizable wealth, this was a radical view and was not adopted by the more conservative part of the market who continued to prefer conventional gem-set jewellery. Between the conservatives and the radicals were those jewellers who used massed diamonds to create Art Nouveau forms. While Frederick Boucheron was praised for this, it was Maison Vever that were the acknowledged masters of this style, winning a *Grand Prix* at the *Exposition Universelle* in 1900 for work that combined daring design with close-packed stones. At the same time, Vever balanced this style of work with figurative pieces in enamelled gold designed by Eugène Grasset (plate 1.7).

Although Wolfers, Fouquet, and, on rare occasions, Lalique (plate 15.1), did incorporate important stones in their jewellery, in most of the enamelled work of the period precious stones receded. Diamonds were usually given subsidiary roles, used alongside less familiar materials such as moulded glass, horn and ivory, according to the desired effect of colour and texture. The stone which came to greatest prominence was the opal, loved for its changeable fire and milky iridescence. Readers of *The*

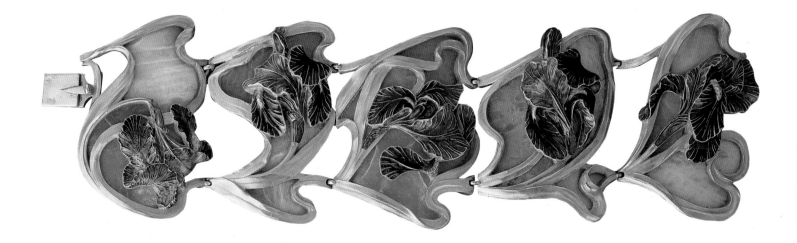

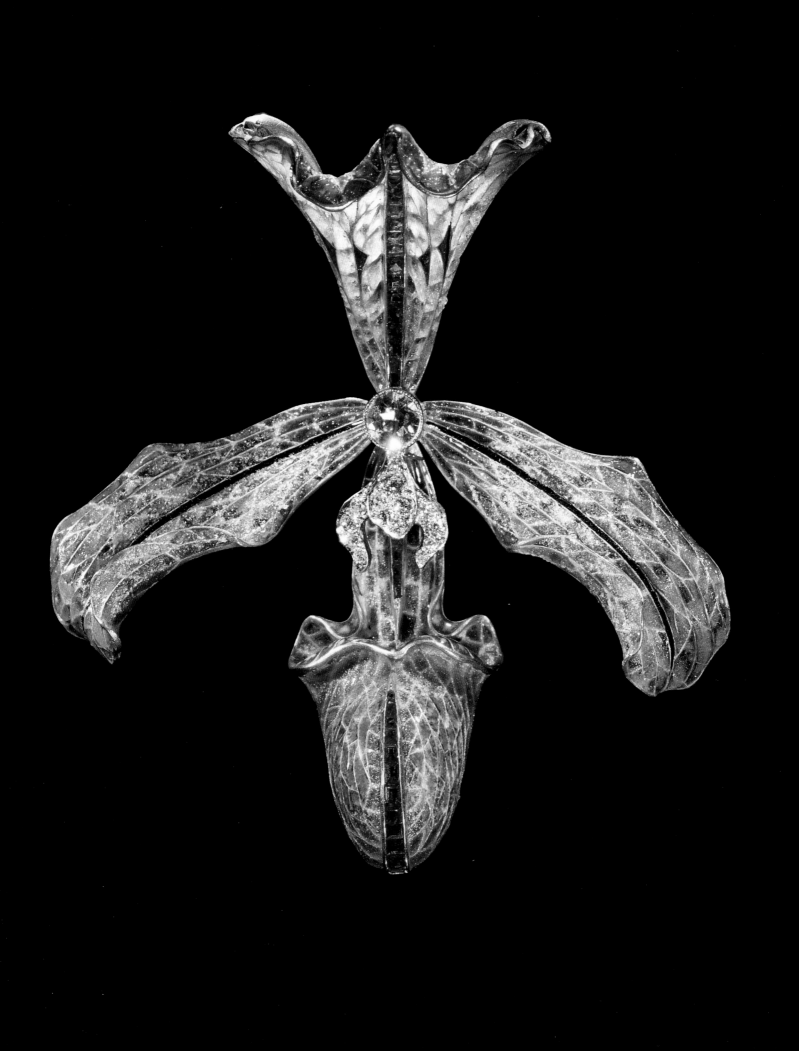

Lady's Realm were told how the visiting French actress Madame Réjane attached 'cheap coral charms against the evil eye' to her chain of opals 'to neutralize the supposed bad influence of the stones'.[7] Sinister superstitions concerning opals were widely held, but despite this (and perhaps partly because of it) they enjoyed a great revival at the end of the nineteenth century.

In the Salon of 1897 Lalique exhibited a bracelet of enamelled irises set against opal panels within curving frames of gold foliage (plate 15.3), and again the following year 'the rainbow highlights of this formerly disparaged stone, veiled by a milky glow'[8] featured in many of his pieces. By 1901 opal was considered such a hallmark of Lalique's work that he was instantly recognized as the 'jeweller of opals enamoured/Whom the purest diamond cannot tempt' in Robert de Montesquiou's poem *The Peacocks*. Lalique used large pieces of opal to create shimmering backgrounds, and showed his technical mastery over this brittle stone in those pieces with carved surfaces. In 1900 an English trade journal responded to Lalique's use of opal with praise tempered by cynicism: 'Thin flakes of opal too thin to be useful … are adapted to excellent effect', adding 'this artist is showing us how to make a capital value out of waste materials'.[9] Fouquet juxtaposed opal mosaic with cleverly shaded and foiled *plique-à-jour* enamel, while many jewellers scattered them as eyes over enamelled peacocks' tails. Whereas most appear to have used opal purely for its colour and texture, Wolfers exploited its sinister reputation in pieces such as his ivory Medusa's head pendant set with blindly staring opal eyes. In gentler mood, opal forms the head or body of various of his insect jewels, or, in a pendant made for his wife in 1899, is carved as a swan and set between writhing gold serpents.

Enamel, which requires the fusion of a vitreous paste to metal under very high temperatures, presents many technical difficulties – not least that of uniting materials which expand and contract at different rates. The exceptional skill of the French enamellers was first made known to the London public in 1898 at an exhibition of modern French enamels at the New Gallery on Regent Street, with work by Feuillâtre, Foy, Lalique, Fouquet and Mabut & Rubé.[10] The review in the *Art Journal* felt that beauty was sacrificed to novelty in many cases, but admired the 'superiority in technique to much that Englishmen think worth exhibiting'.[11] This technical excellence can be traced back to the studio of Louis Houillon, who had taught the difficult technique of *plique-à-jour* enamelling to Feuillâtre, to Fouquet's enameller Étienne Tourette and to Wolfers (plate 15.4). The stained-glass effect of this backless enamel was ideal for the delicate transparency of flower petals and insect wings (plate 15.5). In much the same way that the dancer Loïe Fuller projected electric light through diaphanous silk on stage, so jewellers exploited this translucency, to the delight of the fashion writers who noted that 'with each dress that is worn the effect naturally changes'.[12] An immense range of colours enabled jewellers to capture the subtlety of nature, and a variety of textures from glassy to granular was also possible by varying the conditions in the kiln. Feuillâtre perfected enamelling on silver rather than the simpler gold and copper, while shimmering enamels were created by Tourette who put *paillons* (tiny flakes of gold or silver foil) into the coloured enamel flux.

Glass had featured in jewellery for centuries, but it was almost always as an imitation of something more valuable – either a faceted gemstone or a cameo. Its role was redefined by Lalique, who worked like an alchemist through the early 1890s, exploring the decorative possibilities of moulded glass and its application to jewellery. By 1896, when he exhibited a brooch set with a glass scene of woodland in winter, he had succeeded in achieving magically subtle and painterly effects with this inexpensive and versatile material. Carefully shaded scenes were moulded in shallow relief, while single colours were used for three-dimensional forms such as human heads, berries and birds. Many pieces had a frosted finish, whereas others were given an ethereal shimmer or mottled surface by coating them with an opalescent or vari-coloured enamel. Although glass elements became a typical feature of Lalique's jewellery, they were not widely copied, undoubtedly because of technical difficulties. Wolfers continued to apply the gem-carving skills he had learnt in Bohemia to stones such as tourmalines and garnets, and Vever also preferred carved stone to moulded glass.

During the 1890s there was a revival of interest in working with ivory. This was encouraged by King Leopold II of Belgium, who was keen to promote trade with the Congo. Wolfers was among the first to adopt it in 1892, initially for larger pieces, but by 1895 for jewellery and then hair combs. One of his greatest pieces was the *La Parure* jewel casket of 1905, with ivory sides set with carved medallions of women adorning themselves with jewels (plate 16.6). It is crowned with a silver peacock whose half-open wings and outstretched opal-studded tail cover the lid. In Paris Lalique first used ivory in a binding for Wagner's *Valkyrie* which he exhibited in the Sculpture Section of the 1894 Salon. He went on to incorporate it in many of his jewels, achieving subtle variations of colour by backing thin reliefs with enamelled gold, and incredible delicacy in three-

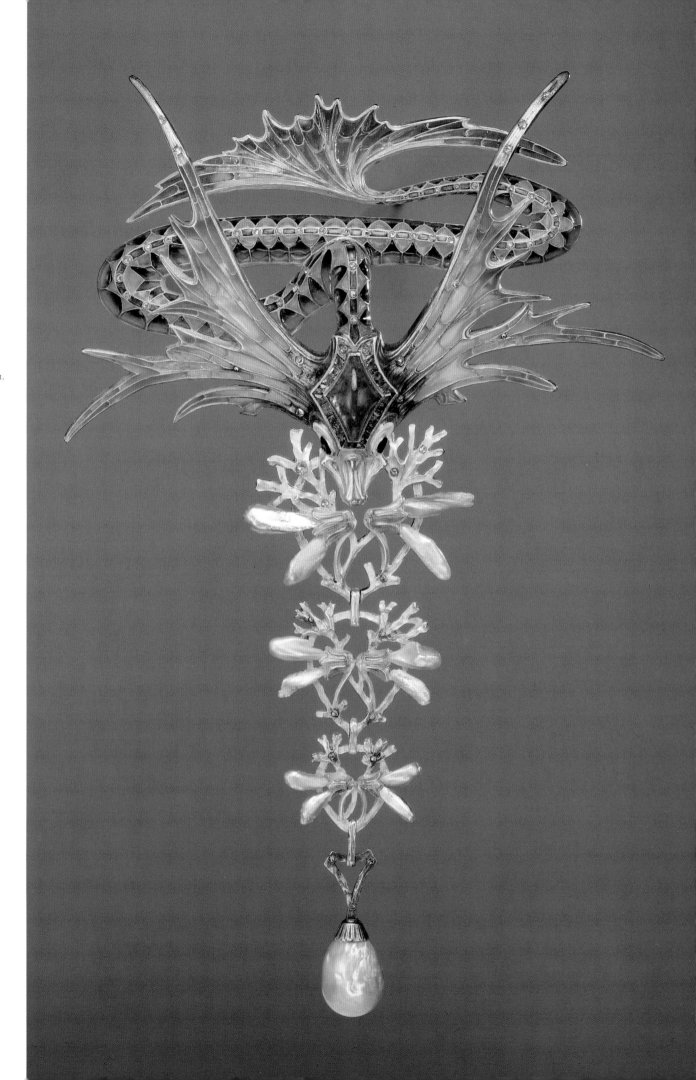

15.5 Georges Fouquet,
winged serpent corsage ornament.
Gold, enamel, diamonds and
pearls. French, 1902.
Private Collection, New York.
© ADAGP, Paris and DACS,
London 2000.

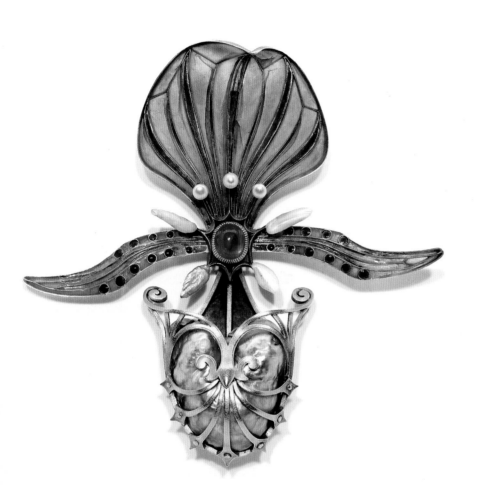

15.6 Georges Fouquet, orchid.
Gold, enamel, ruby and pearls.
French, 1900.
University of East Anglia:
Anderson Collection.

15.7 René Lalique,
sycamore hair comb. Horn
and gold. French, 1902-03.
Bayerischesnational Museum,
Munich.

dimensional carvings, most notably those of orchids. Ivory's colour and silken texture made it ideal for figurative pieces, especially female nudes, and for this it was also used by Fouquet and Vever.

Lalique is credited with introducing horn into the jeweller's repertoire at the Salon of 1896 with a bracelet which won him a second-class medal. Perhaps inspired by its use in Japanese work, Lalique had bought a large white horn from a slaughter house, and from this he sliced a section to make the bracelet. Realizing that its natural properties were similar to those of tortoiseshell, he created a collection of decorative horn combs which he showed at the Salon of 1898. Their elaborate crests were patinated and set with ivory, opals, diamonds and enamelled gold. Although Vever warned that in some cases 'these bas-reliefs in horn become somewhat soft and pasty, taking on the look of embossed cardboard', this modest new material was launched. Vever had reservations too about the practicality of their design: 'Who indeed, however elegant she

may be, can conveniently fasten her hair with any of the combs in this entire display case?'[13] but these worries did not hinder the rapid acceptance of horn and the extravagant honey-coloured combs and hair pins. Some of the most exquisite Art Nouveau combs were made by Lucien Gaillard, whose long-standing interest in Japanese techniques had led him to bring craftsmen from Tokyo to France some time after 1900.

The principal source of inspiration for Art Nouveau jewellery was nature, following in the traditions of mid-nineteenth-century writers such as Ruskin, who had written 'all most lovely forms and thoughts are directly taken from natural objects'.[14] However, it was also influenced by the more recent familiarity with Japanese images of plants and animals. Absolute copying of nature was scorned by all serious commentators, and Ruskin's French contemporary Jules Michelet was among those who warned against too literal an approach. He wrote: 'We must be content to love and contemplate them, to draw our inspiration from them, to convert them into ideal forms Thus transformed, they will become not what they are in Nature, but fantastic and wonderful.'[15] This debate was revived in *The Studio* during Lalique's exhibition at Agnews on Bond Street in 1905. When he took 'purely natural forms, used in design exactly as suggested by their manner of growing', *The Studio* praised him as 'that highest kind of designer by whom the beautiful in nature is always reverently turned to usefulness'. However, when his orchid hat-pins came too close to reality, it considered them counterfeits and regretted 'the time and ingenuity spent on them'.[16] At the Paris Exhibition of 1889 Tiffany had shown a magnificent collection of 25 naturalistic orchids made of gold, painted enamel and diamonds. Although mounted as brooches, these formal depictions of flowers were more like specimen pieces than jewellery, and lacked the fluid charm of the later Art Nouveau flowers. Nevertheless, they generated immense interest and were influential forerunners of the enamelled flowers which followed so soon after.

In 1897 Lalique showed his *plique-à-jour* poppy, which captured with great sensitivity the papery fragility of the petals rather than its exact physical appearance. Similar single flowers were made by Tiffany, whose iris of Montana sapphires was shown in 1900, and Koch of Berlin who used *plique-à-jour* enamel to create a jewelled hibiscus. Exotic orchids were a recurring theme in Art Nouveau jewellery, made in enamel by Fouquet (plate 15.6), Wolfers and Marcus & Co. of New York among others, and in intricately carved ivory by Lalique. Modest flowers such as blossom, pansies and honesty were even more popular.

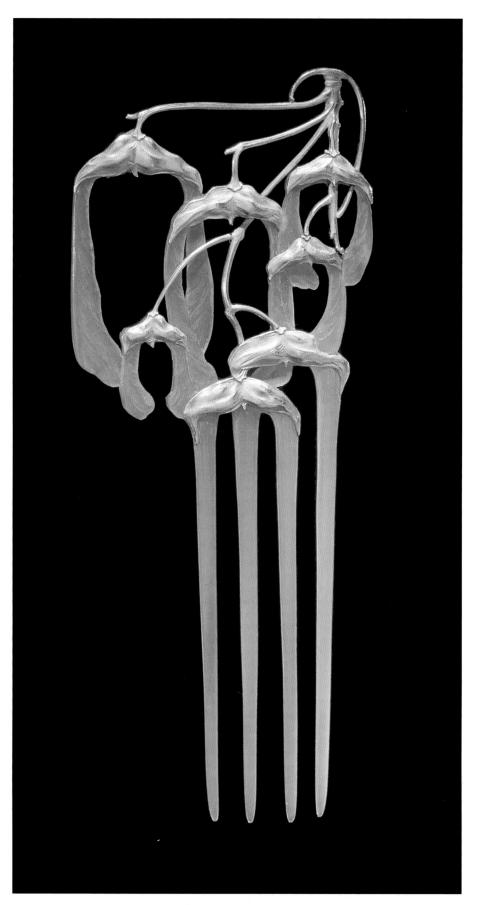

The thistle was the plant most often used by Lalique, the organic geometry of its barbed stem and leaves providing a structure and forming a powerful contrast with the soft petals or thistledown which were usually of moulded and frosted glass. It seemed that no plant was too humble to be considered, with Fouquet and Boucheron even using seaweed. Wisteria and irises were borrowed from Japanese prints, as were, more unusually, bean pods which form the bezel of a ring by Lalique. Japanese influence can also be seen in pieces where there is complete integration of the decorative motif with the form and the function of the object, such as in Lalique's comb of sycamore seeds where the wings of the lower seed pods extend downwards to become the teeth of the comb (plate 15.7). Similarly, on Lalique's iris buckle (plate 6.10) the plant stems curve to frame the central opening, much as they would on a Japanese swordguard.

Typically, Lalique concentrated as much on the individuality of a particular plant as on the characteristics of the species when drawing or designing from nature, and thereby avoided the unconvincing perfection of textbook specimens. Evelyne Possémé has shown that Lalique used photography as well as drawing as part of the creative process, and links black-and-white prints of landscapes and woodlands to particular jewels. She cites notes on one of his pendants which advise 'directly from nature for the/leaves, branches and stalks/the photograph will suffice for/the flowers'.[17] He portrays nature as a cycle, affected by the passing of time. Therefore, his flowers are as likely to be in bud or about to fade and drop their petals as to be at the height of perfection. This realism is taken to its furthest extreme in the anemone pendant in which the uprooted flower has drooped right over and only one petal, drained of colour, remains clinging to the flowerhead (plate 15.8). It is a powerful depiction of decay and the passage of time, and with its carved ivory background of figures entwined in the roots of the dying flower, it extends its message to that of man's own mortality. All the seasons are represented in his work, with spring catkins, summer blossoms, autumn leaves and berries, and, finally, the barren winter woodland scenes.

Art Nouveau's 'whiplash curve' was also expressed in botanical form, with textured gold reeds which curled and flowed in much the same manner as the locks of hair on figurative pieces. At the *Exposition Universelle* in Paris in 1900 it was so prevalent a device that an English critic bemoaned that:

> the Aesthetic designer thinks he can do anything with
> reeds. He can twist and contort them into any form he

15.9 René Lalique, damselflies
necklace. Gold, enamel,
aquamarines and diamonds.
French, *c*.1900-02.
Private Collection, London.
© ADAGP, Paris and DACS,
London 2000.

pleases, frame his pictures with them, make them the
secure foundation for all kinds of weight.

He can entrust valuable gems to their clinging fronds,
and has the strongest confidence in their rigidity, even
when subjected to the severest tensile strain. The faith of
many artists and some jewellers in the power and purpose
of the reed does, in fact, approach the sublime.

Why it is so I cannot say, unless Morris wallpaper design
has spread itself like a mild contagion and affected
metallic construction and ornament alike.[18]

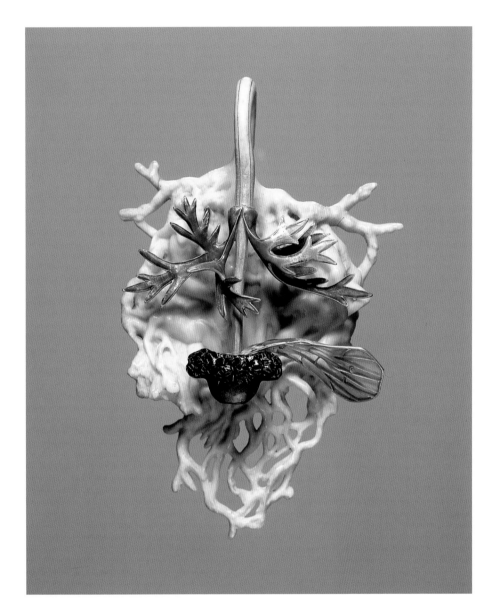

15.8 René Lalique, anemone
pendant. Gold, enamel and ivory.
French, *c*.1900-02.
Calouste Gulbenkian Museum.

Insects were the most frequently used theme from the
animal world. Unlike the eighteenth-century diamond
insects that hovered on springs above clusters of jewelled
flowers, this generation did not require flowers to justify
their presence and they were depicted with great attention

to detail. In 1857 at the height of the Gothic Revival,
Michelet had enthused about entomology as an entranc-
ing and completely unexplored source for designers, and
in particular for the jeweller. In a sharp reference to his
distinguished contemporary, he wrote that, under magnifi-
cation, a horse-fly's eye 'offers the strange faëry spectacle
of a mosaic of jewels, such as all the art of Froment-
Meurice has scarcely invented'.[19] In a passage that
unknowingly anticipates the style of 1900 he describes the
cicindela: 'On the wings, a changeful besprinkling of pea-
cock's eyes. On the fore parts, numerous meanders,
diversely and softly shaded, are trailed over a dark ground.
Abdomen and legs are glazed with such rich hues that no
enamel can sustain a comparison with them.'[20] His writ-
ings appear to have had little impact at the time, but by
1900, allied with the technical advances that had been
made in enamelling, they were inspirational. It is possible
that Lalique knew the French edition of *The Insect*, alter-
natively the English translation (published in 1875) would
have been a fairly new text when he arrived at the art
school attached to Crystal Palace in 1878. That it was
widely known by 1904 is shown in *The Craftsman*, which
refers to the book's 'worldwide currency'.

Dragonflies enjoyed unprecedented favour as a decora-
tive motif in jewellery from around 1900, their delicate
wings being ideal vehicles for the newly fashionable *plique-
à-jour* enamel. Their popularity may be attributed to their
frequent appearances in Japanese art and the remarkable
sequence of Japanese poems celebrating their beauty,
translated into French by Judith Gautier as *Poems de la libel-
lule* in 1885. Lalique's first dragonfly was perhaps that
shown in 1895, its wings scattered with amethysts and
yellow sapphires. Typically, he depicted them in pairs,
facing each other in profile across a central stone.
Although not aiming for strict anatomical accuracy, he
conveys their quivering delicacy and iridescent sheen. In
his magnificent damselfly necklace (plate 15.9), the central
pair are arranged around toning aquamarines, while those
at the sides and back curl around each other, hovering in
an unmistakable, if discreet, mating position. At the *Expo-
sition Universelle* the piece of Lalique most commented on
was the large corsage ornament of a woman metamor-
phosing out of a fantastical dragonfly (plate 4.12). Its size
and subject-matter puzzled its audience – with one Eng-
lish viewer commenting: 'Very remarkable, and startling
to the observer, but is it jewellery?'[21] Meanwhile, on a
neighbouring stand, Vever showed a corsage ornament of
three intertwined dragonflies encrusted with diamonds
and rubies.[22] Examples of dragonflies survive by most of

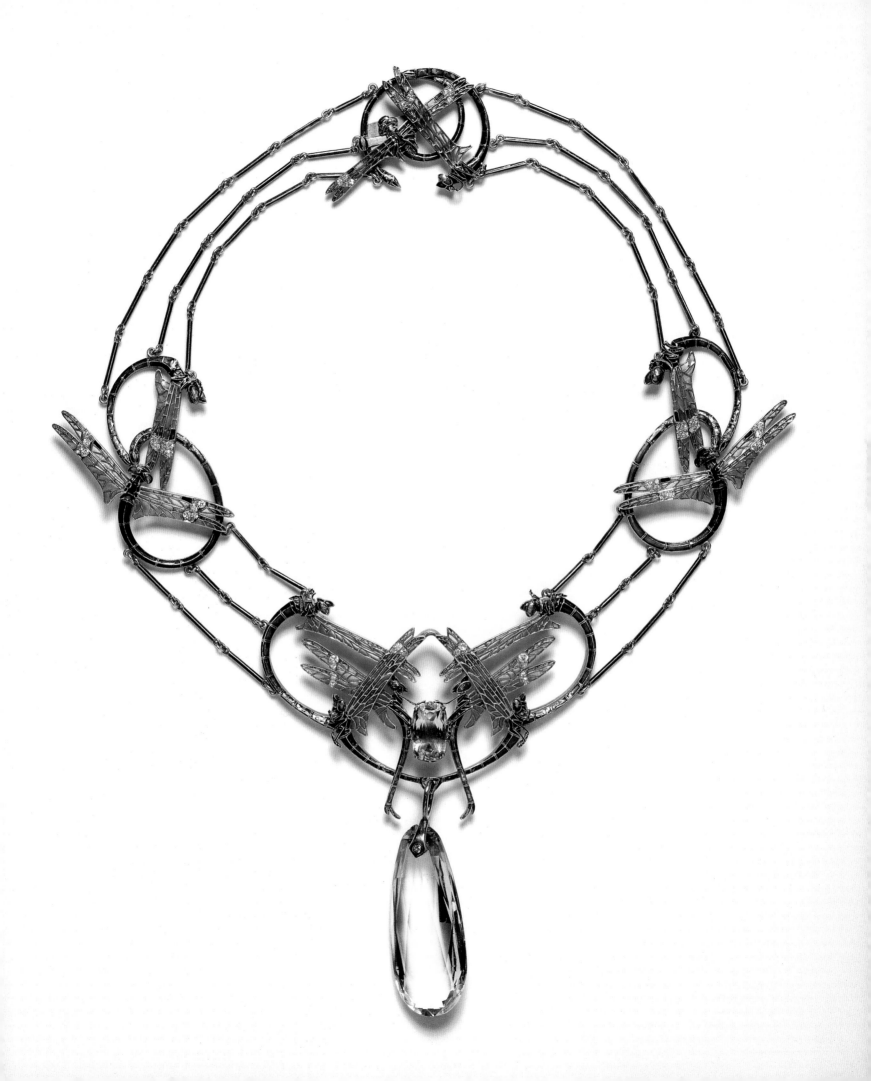

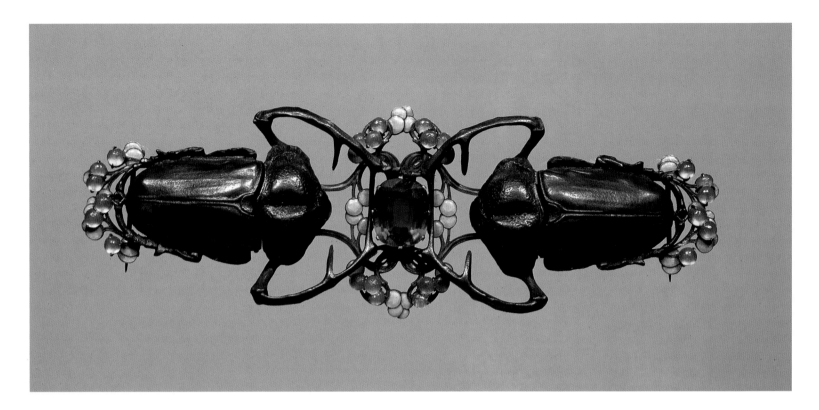

15.10 René Lalique,
blister beetles. Gold, glass,
enamel, silver and tourmaline.
French, c.1903-04.
Calouste Gulbenkian Museum.

the major Art Nouveau jewellers, indicating how popular they must have been. Likewise, the theme of metamorphosis was explored by other jewellers, usually through the more tranquil vision of a woman's face wrapped round with colourful wings.

Butterflies, moths, wasps and grasshoppers all feature in Lalique and his contemporaries' work from the early 1900s. Perhaps the most startling insects of all are the two black-brown beetles that face each other in Lalique's bodice ornament of 1903–04 (plate 15.10). In these substantial creatures of blackened silver Lalique created a hybrid, borrowing the colouring from European beetles and the shape, with its distinctive barbed front legs, from a rare species native to North India called *Cheirotonus parryi*.[23] Their mottled brown and iridescent green markings in real life are shown in Lalique's drawing, which is annotated with instructions for patinating and enamelling – colouring which was abandoned in favour of the more dramatic black. Clearly, although the French countryside was a major source of inspiration for Lalique, he did at times look elsewhere, either to the collections of the Musée National d'Histoire Naturelle or to specialist dealers such as Deyrolle in Paris. That these are life-sized and that their pitted surfaces are rendered so accurately suggests that they may have been cast from nature, and raises the question of whether other pieces, particularly those of cast glass, might also have been. It may be no coincidence that

Lalique was often compared to the sixteenth-century French ceramicist Bernard Palissy, whose naturalistic reptiles and plants were moulded from real specimens.

Although portrayed as a somewhat remote genius, 'an austere hermit',[24] when it came to showing his work, Lalique's style was flamboyant. The spirit that pervades his jewellery also directed his displays, first in 1900 at the *Exposition Universelle*, where surviving photographs and Vever's description give a clear impression of his stand. Most prominent was the patinated bronze grille of five naked winged female figures whose feathers stretch out to form a delicate tracery and a backdrop for the jewels (plate 15.11). With pleated gauze hangings and white moiré fabric, the overall effect was light and airy, despite the bats swooping in the high arch of the central window. In contrast, Vever's stand nearby had dark hangings, perhaps chosen to set the diamonds off to their best advantage. For his London exhibition at the Grafton Gallery in 1903 Lalique stencilled the walls and used showcases with panels of moulded glass flowers. His most complete decorative scheme was that designed for his studio, workshop and showroom on Cours-la-Reine in 1902, which incorporated motifs from pine trees into both the facade and the interiors. The main door was flanked by tree trunks which spread their branches into the masonry above and the glass panels alongside, while ironwork branches complete with pine cones and needles formed the balconies.

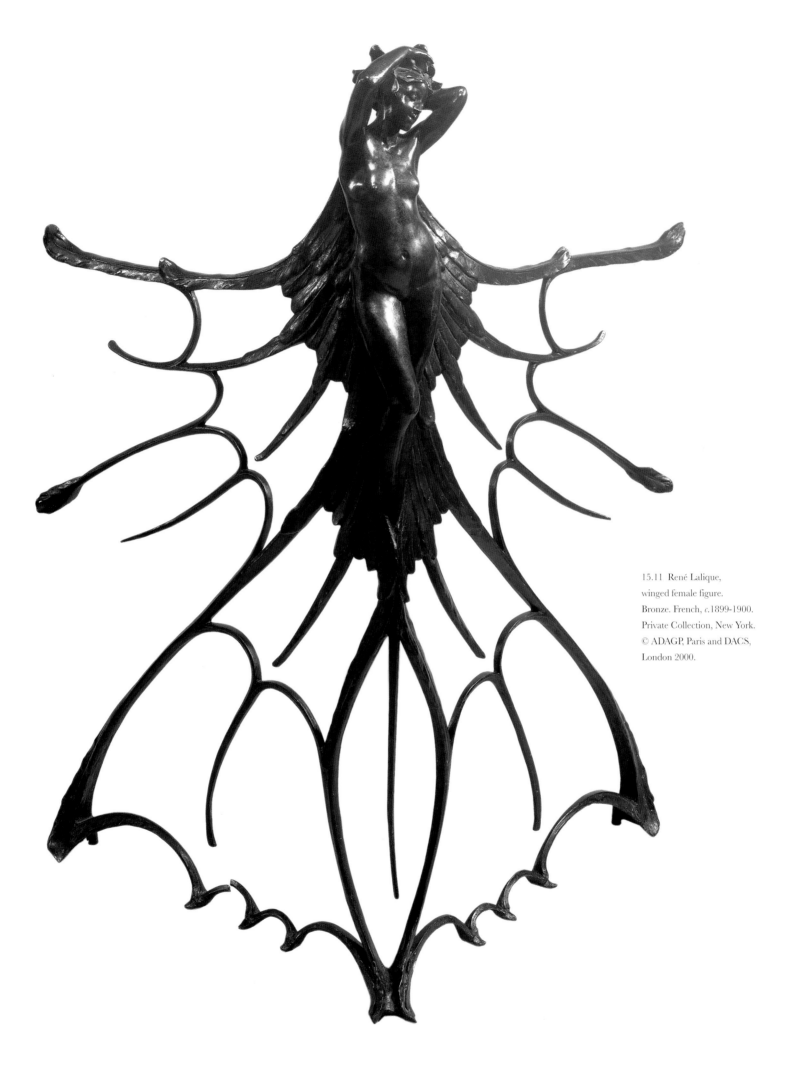

15.11 René Lalique,
winged female figure.
Bronze. French, *c.*1899-1900.
Private Collection, New York.
© ADAGP, Paris and DACS,
London 2000.

Lalique was not alone in creating a distinctive and luxuriant setting for his jewellery. In 1901 Fouquet's opulent new shop, designed by Alphonse Mucha, opened on the rue Royale. The facade was dominated by the bronze panel of a partially veiled female figure wearing a harness-like bodice ornament in the style of Mucha's jewellery, and holding out a second piece consisting of long chains and pendants. This and the row of stained-glass female heads above the windows closely echoed Mucha's poster art. In

Nouveau in collaboration with Alphonse Mucha. This began around 1899 when Sarah Bernhardt, who was depicted wearing extraordinary jewellery on Mucha's posters, commissioned Fouquet to make up one of his drawings of a serpent bracelet. Mucha went on to design many of the pieces Fouquet exhibited at the *Exposition Universelle* in 1900, a distinctive collection which drew closely on motifs in his graphic art and was quite unlike anything shown by anyone else. Vever wrote: 'Although

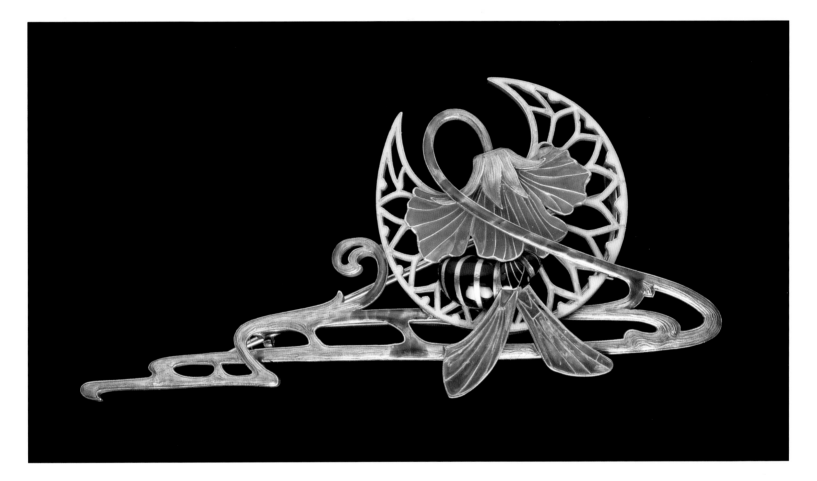

15.12 Georges Fouquet, hornet brooch. Gold and enamel. French, 1901. V&A: 957-1901. © ADAGP, Paris and DACS, London 2000.

1895 Georges Fouquet had taken over his father's business, and by the 1898 Salon was showing Art Nouveau work, including the orchid brooch designed by Charles Desrosiers (plate 15.6). Its subtle colouring and elegant lines are typical of Desrosiers' work, as is the effective choice of *plique-à-jour* enamel for the petals of the flower. His hornet brooch of 1901 (plate 15.12) shows again the 'consistently charming choice of palette'[25] for which Fouquet was praised by Vever, but here a more imaginative treatment of the flower is possible, with the long stem curving back over the flower, criss-crossing with expressive Art Nouveau curves as it recedes into the distance.

Fouquet achieved a more radical realization of Art

thought slightly eccentric, his large and important *parures*, destined to form an integral part of dress, justifiably attracted a good deal of attention.'[26] Contemporary photographs show that these typically consisted of several elements linked by decorated chains which wrapped around the wearer's body or fell vertically, weighted by an assortment of pendants. The larger pendants usually contained a painted miniature of the familiar maiden with long flowing hair. The clusters of small pendants were made up of individually mounted Baroque pearls and pebble-like coloured gemstones, reminiscent of the amulets which had for centuries been a part of Middle European folk jewellery. Of the very small amount of this

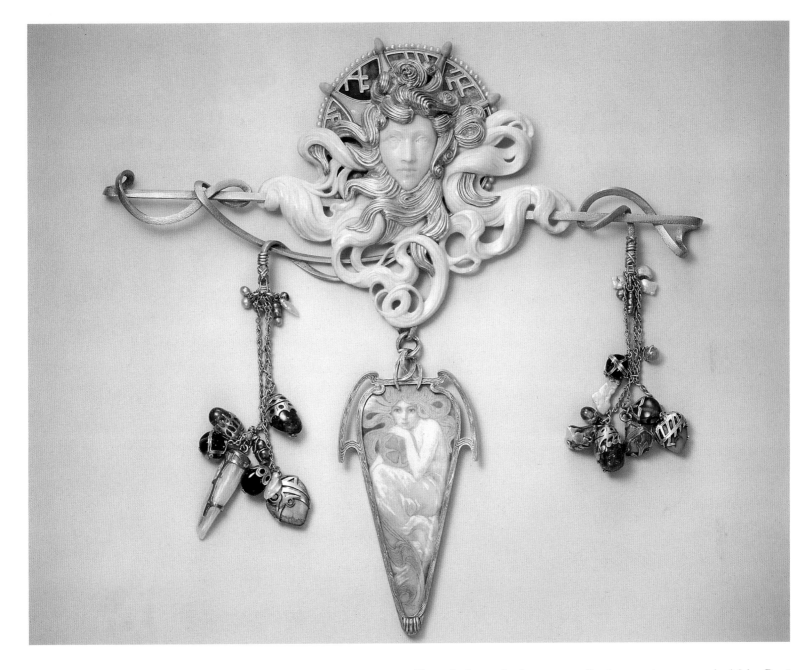

15.13 Alphonse Mucha,
bodice ornament. Gold,
ivory, enamel, opals, pearls,
and coloured gemstones.
Czech, *c.*1900.
Private Collection.
© Mucha Trust / ADAGP, Paris
and DACS, London 2000.

jewellery that has survived, the most magnificent is the bodice ornament crowned with a woman's face in ivory and gold (plate 15.13).

The contemporary reaction to Art Nouveau jewellery was undoubtedly mixed. Many felt that jewellers were creating showcase pieces which were completely impractical. Popular French magazines such as *Femina* might have darting lizards and scaly birds' feet elegantly arranged as illuminated article headings, but their illustrations of contemporary fashions show that such imagery did not generally transfer itself to its readers' clothes and jewellery. At the Folies Bergères in 1903 'La Belle' Otéro preferred her diamond corselet, even though it was condemned as

'barbarous, unrefined, unmodern, unaesthetic' by René Foy.[27] Diamonds continued to be widely worn, but even among those who favoured more conventional jewellery, work by Lalique and his followers exerted a powerful fascination. In 1898 the critic for *Le Journal* wrote of Lalique that: 'when you leave the showcases of the master jeweller you can look nowhere else, everything looks cumbersome, ordinary or stupidly pretentious'.[28] Despite Lalique's great artistic and commercial success, the English critics remained aloof, disapproving of what they saw as a decadence and lack of moral purpose in his work, and wilfully blind to the extraordinary contribution that all the Art Nouveau jewellers had made.

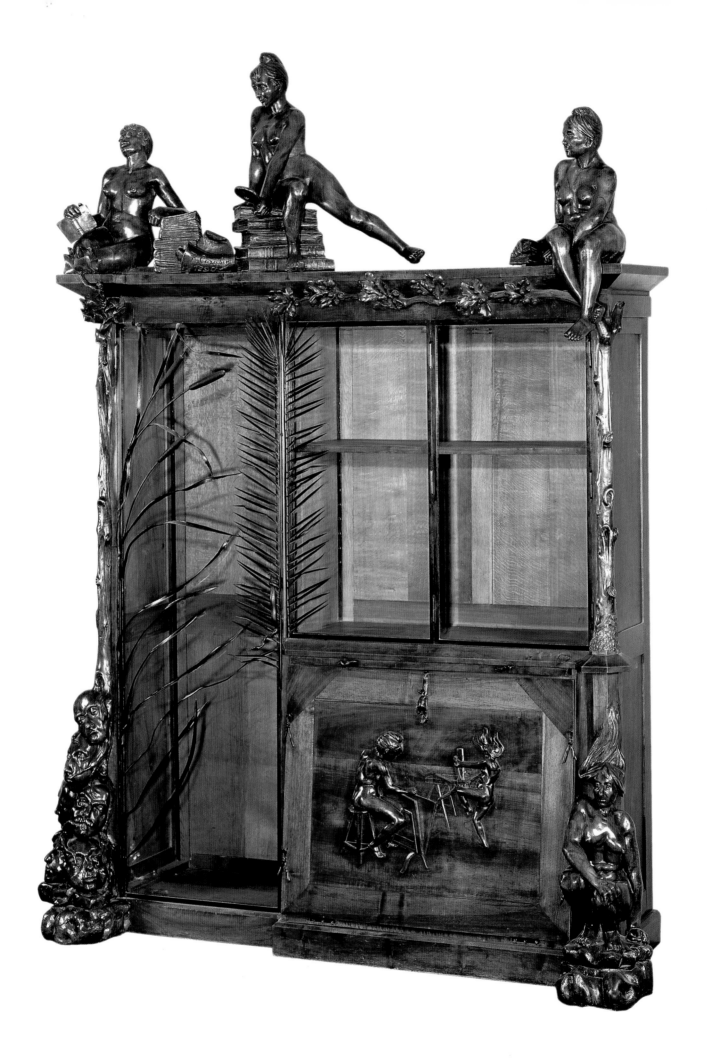

Alexander Kader

The Concentrated Essence
of a Wriggle: Art Nouveau Sculpture

L'Art Nouveau, forsooth! Absolute nonsense! It belongs to the young lady's seminary
and the 'duffer's' paradise. Have I understood L'Art Nouveau rightly, or is it still a matter
of the grave to which I must come, before I understand? (Alfred Gilbert, 1903)[1]

16.1 Rupert Carabin, Montadon
bookcase. French, 1890.
Musée d'Orsay, Paris.
© Photo: RMN-Jean Schormans.

This condemnation of Art Nouveau was voiced by one of England's leading sculptors in 1903 at a symposium entitled 'L'Art Nouveau: What it is and what is thought of it?', attended by British 'painters, designers, architects and sculptors'. It would seem that Gilbert did indeed go to his grave with a wholly negative view of Art Nouveau. After looking at the context of Gilbert's statements, and the importance of his contribution to the new style, this chapter will concentrate on Paris from the reform of the Salon in 1890 to the initiative of Siegfried Bing's L'Art Nouveau five years later. It describes the unprecedented diversification of traditional concepts of sculpture through the campaign for the unity of the arts led by the Union Centrale des Arts Décoratifs, and traces the Art Nouveau style in sculpture in five areas: new materials, medallions and reliefs, *animalier* sculpture, architecture, and images of the famous American dancer Loïe Fuller and the '*femme-fleur*'.

England is widely considered to be the seed-bed of Art Nouveau, but it is also generally accepted that the new style never blossomed there. The opinions expressed at the 1903 symposium reflect a particularly English view which is on the whole negative, deploring the excesses and lack of discipline of the style. Sculptor F.S. Blizard presented 'the challenge on behalf of *L'Art nouveau*', and *The Magazine of Art* published 40 comments from contemporary artists. Walter Crane announced that he had seen the apotheosis of Art Nouveau at the 1902 *Prima Esposizione d'Arte Decorativa Moderna* in Turin, and expressed a common concern about the lack of meaning in the style: 'No style or form of art is of any use unless the designer or decorator has something of his own to say in it.'[2] C.F.A. Voysey was more critical of what he regarded as 'a debauch of sensuous feeling' and felt that it was 'not worthy to be called a style'.[3] Many considered Art Nouveau to be simply a craze; but one or two confessed to some sympathy, and John H.F. Bacon

even acknowledged 'I have been much attracted by it and think it good', but his was a lonely voice.[4]

The 1903 symposium provides an enlightening focal point for a discussion of Art Nouveau sculpture. Several sculptors commented on the subject, including George Frampton, (William) Hamo Thornycroft, William Robert Colton, William Goscombe John, and John Macallan Swan. Goscombe John, for example, took a balanced view, assessing the best as 'a valuable means of expression', but lamenting the 'extravagance and exaggeration' which he felt had developed into a craze.[5] Thornycroft was more perspicacious:

> The movement is an indication of the age in which
> we live – an age of upheavals. Revered canons of art are
> shattered, and the Decorative Art, a crossbreed with a
> good deal of Japanese blood in its veins, has come into
> existence, and with sufficient strength evidently to last
> some time; for the rapidity with which it has spread into
> so many forms of art shows that it has some deep-rooted
> *raison d'être* … . This Art Nouveau appeared concurrently
> with that of freedom from the curbing influence of
> tradition in so many other activities of the human mind,
> it may be considered as an honest expression of the age.[6]

The statement raises issues as to how exactly sculpture was to reflect this expression of the age. In his short proposition on behalf of Art Nouveau, one of the descriptions of the style used by F.S. Blizard was 'the concentrated essence of a wriggle'.[7] The challenge for sculptors who responded to the call of Art Nouveau was, perhaps, how to put the wriggle into sculpture.

The sculptor George Frampton and the painter George Clausen singled out Alfred Gilbert, of all people, as a prime inspiration for Art Nouveau. Frampton observed: 'I trace the present growing advance in decorative art in this country as well as abroad to that Englishman, the greatest master of our time, Alfred Gilbert, R.A.'[8] Clausen considered that

Gilbert's *Eros* (1886–93) in Piccadilly Circus, London, and his *Epergne* of 1887–90 (plate 2.4) exhibited a 'beauty of light playing on developing curves … controlled by a fine taste', which indicated for him the heights to which Art Nouveau aspired.[9] Meanwhile, Gilbert confessed himself 'incapable of understanding what such a movement can mean'. Indeed, despite the clear visual affinity between his furious energy and the swelling, writhing detail of the style, he had little in common with its linear pattern-forms or other stylistic devices. More important than this, he did not share the world view of mainstream Art Nouveau artists and designers. However important, visual appearance is only one element in the formation of a style.[10]

Whether Gilbert acknowledged the importance of Art Nouveau or not (and considering he lived in Belgium from 1901, the public statements of his ignorance of the movement do seem somewhat staged), the *Epergne*, among other pieces of the period, could not but show artists a route by which 'the concentrated essence of a wriggle' could be introduced into sculpture. Gilbert's goldsmith's work in particular, such as his *Presidential Badge* and *Chain for the Royal Institute of Painters in Watercolours* (1891–97), and his ornamental silver spoons (1893–1903), are as fine expressions of the sinuous, asymmetrical organic form and abstract design which define the Art Nouveau style as anything produced by the French or Belgians.

A recent historian has identified Art Nouveau sculpture as 'almost entirely French and, more specifically, Parisian'.[11] Although this blatantly ignores a large body of extremely important and original work worldwide, it is undoubtedly true that the innovations in nineteenth-century art which freed sculptors from, in Thornycroft's words, the curbing influence of tradition, found fullest expression in Paris. This reformation was centred on the campaign to improve the production of the decorative arts launched by the Union Centrale des Arts Décoratifs. Founded in 1865 as the Société de l'Union Centrale des Arts Appliquées à l'Industrie, it was reorganized after the Paris Commune of 1870. Through its journal, the *Revue des arts décoratifs*, first published in 1880, it promoted a revival of eighteenth-century notions of craft and the aristocratic *arts somptuaires*. It also called for a new unity of the arts. It published articles on subjects as diverse as designs for fans,

16.2 Jean (Joseph-Marie) Carriès, mask. Stoneware, salt-glazed. French, 1890-92. V&A: C.60-1916.

lacework and stained glass, bookcovers, mosaic, pre-Renaissance French sculpture and hunting guns, as well as reviews of the Salons and International Exhibitions. The *Revue*'s first editorial clearly stated the convictions on which the Union Centrale was based: 'These principles and these ideas have actually only one formula, as clear as the day and as old as the day: that of the unity of art … .'[12] The Union Centrale's objective was to introduce decorative arts into the annual Champs Elysées Salons.

It was after the 1889 International Exhibition in Paris that tangible reforms began to materialize within the High Art establishment. In 1890 Gustave Geffroy published an article in the *Revue des arts décoratifs*, on a carved bookcase by Rupert Carabin, which highlighted the urgency of reform and focused the debate on sculpture. The year before, Carabin had been commissioned to make a piece of furniture of his own choice by a wealthy businessman called Montadon. For a year, the sculptor worked on the bookcase of walnut and wrought iron (plate 16.1). On the bottom corners at the front, he carved on one side masks representing 'Vanity', 'Greed', 'Intemperance', 'Folly' and 'Hypocrisy' and on the other side the figure of 'Ignorance'. At the top of the bookcase he placed three female figures symbolic of 'Truth', 'Knowledge' and 'Contemplation'. Although Carabin was involved in the formation of the *Société des Indépendantes*, when he submitted his bookcase to this organization for its 1890 exhibition it was refused because it did not qualify as a sculpture. Geffroy's article described it as 'an original piece of work which introduces a new form of art, truly launching Rupert Carabin'. He blamed the work's rejection on the *hiérarchie artistique* which prevailed as much in the *Société des Indépendantes* as in the official Salon, and repeatedly emphasized the novelty of its combination of sculpture and furniture. For Geffroy, Carabin's bookcase, and after this many of his pieces of sculpted furniture such as his desk of 1902, were *causes célèbres* for '*l'idée de l'unité de l'art*'.[13] It exemplified a new way of looking at sculpture; a new formula for sculpture and furniture which rejected traditional definitions of the arts (plates 3.10, 4.14 and 10.3). In his call for unity Geffroy listed the precedents of the Middle Ages, the eighteenth century and Japanese art. Carabin's bookcase was in this sense both new and traditional, and very much in line with the reforms professed by the Union Centrale. Although his sculptural furniture of the 1890s is an important early example of the diversification of sculpture which characterized Art Nouveau, as Carabin's career developed, his increasingly erotic sculptural furnishings were received with disquiet even by contributors to the *Revue*. He ended

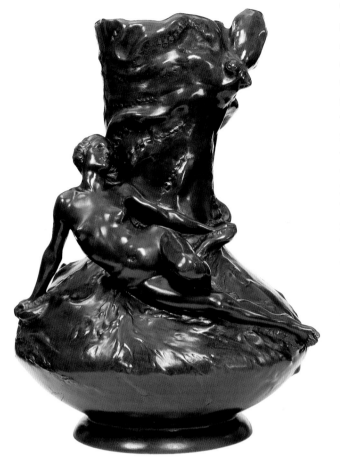

16.3 Auguste Ledru, vase. Bronze. French, 1895. V&A: M.24-1998.

his career as Director of the École des Arts Décoratifs in Strasbourg.

Carabin's redefinition of what constituted sculpture, rather than furniture, was paralleled by the work of Jean (Joseph-Marie) Carriès in the field of ceramics. Carriès made his debut at the Salon in 1875. Over the next 15 years he produced an original body of work which centred on expressive heads and historical portraits (plate 16.2; plate 12.2).[14] By the end of the 1880s he had turned his attention almost exclusively to ceramics. Much of Carriès' work, including his masterpiece, the doorway commissioned in 1889 by the Princesse de Polignac, is Symbolist in character, but his strong emphasis on craftsmanship, both in relation to the casting and patination of his bronzes and his experimentation with glazes, tie his work to Art Nouveau sculpture. Carriès died in 1894, before Art Nouveau was fully developed, but the critic Louis de Fourcaud paid a glowing tribute to his influence in the *Revue* in 1895.[15] The *Gazette des beaux-arts* in 1892 considered his work the most impressive 'fusion' of the decorative arts and sculpture.[16]

The campaign for the integration of the decorative arts into the Salon conducted by the Union Centrale partially achieved its objective in 1890. The solution was a split.

The *Société des Artistes Français* continued to exhibit in the Champs Elysées and a new *Société Nationale des Beaux-Arts* opened in the Champs de Mars. In this way, the decorative arts were admitted into a new section of the official exhibiting system. The key sculptors instrumental in these reforms were Aimé-Jules Dalou and Auguste Rodin. Dalou was admired by many reformers for his sympathy for ornament and his understanding of different materials.[17] He was also one of the major influences on the emergence of the new sculpture movement in England. This movement has many parallels with Art Nouveau, but its affinities with both the Arts and Crafts and Symbolism give it a separate identity – a distinction which had been made very evident by the 1903 symposium. Rodin is universally acknowledged as the greatest French sculptor of the end of the nineteenth century. He rarely features in surveys of Art Nouveau; however it is impossible to ignore his dominating presence.[18] From his early years in Albert-Ernest Carrier-Belleuse's studio, Rodin gained an understanding of the decorative arts and a sympathy for the eighteenth century. He claimed: 'The eighteenth century was a century which designed; in this lay its genius … . The quality of my drawing I owe in large measure to the eighteenth century.'[19] These views were in line with those of the supporters of the Union Centrale. In an editorial article in 1891 entitled 'Les Arts fraternels au Salon du Champs de Mars', the *Revue* illustrated a seated *Bacchante* that Rodin had designed for the Sèvres factory which reflects these sympathies. Debora Silverman has also identified Rodin's *Monument to Claude Lorrain* and his masterpiece *The Gates of Hell* with concerns fundamental to notions of craft modernism promoted by the Union Centrale.[20]

As the new Salon began integrating the decorative arts with the main body of its exhibitions, the *Revue* continued its campaign to change the system in the Champs Elysées Salon. In 1891 Louis de Fourcaud announced: 'the days of aesthetic tyranny are numbered. It is not painting, nor sculpture, which triumph at the Champs de Mars. The laurels according to all those of taste belong incontestably to the masters of industrial design.'[21] Two representative examples of the type of work which de Fourcaud admired were praised by Edmond de Goncourt in the following year: Jean Baffier's tin jugs and Gustave-Joseph Chéret's vases with their figural reliefs. These works illustrate another facet of the diversification of sculpture which has already been noted in the fields of furniture and ceramics – that of sculptural objects. Goncourt identified the Japanese influence and believed them to be the truly original works in the exhibition.[22] Baffier, Chéret, Jules Desbois and

Auguste Ledru (plate 16.3), among many others, made the vase, the candelabra and the jewellery box into vehicles for sculptural expression.[23]

By 1892 the Champs de Mars Salon had established a strong group of exhibitors in the Industrial Arts Section, now fully integrated throughout the display in the Palais des Beaux-Arts. Edmond Pottier, writing in the *Gazette des beaux-arts*, summarized the nature of the diversification of sculpture which characterized the rise of Art Nouveau: 'The association of industry and art happens in two ways. Either the sculptor or painter becomes briefly a jeweller or potter, or the glass or cabinet-maker raises himself to the level of inventor.'[24] This attitude reflects aspirations which date back to the Great Exhibition of 1851, but which were given a new direction through the Union Centrale. Pottier praised two key sculptors who exemplified this diversification of the traditional bounds of sculpture: Jean Dampt and Alexandre Charpentier. These two sculptors worked closely together and in 1896 were founding members of *Les Cinq* (later *Les Six* and finally *Les Huit*), which exhibited at the Galerie des Artistes Modernes. Dampt had a conventional training, first at his local École des Beaux-Arts in Dijon, and then in Paris, where he studied with François Jouffroy and Dubois. He made his Salon debut in 1876 and won various exhibition medals. With the opening of the Champs de Mars Salon, he began to exhibit the full range of his production. Dampt was greatly admired in England. In 1899 *The Magazine of Art* devoted an article to him, noting that 'for many years he has been regarded by most artists, especially in England, as one of the great modern masters'.[25]

Dampt's style does not contain the squirming organic forms so hated by the English arts, but he is a key Art Nouveau sculptor for several reasons. One of the features that defines the progress of Art Nouveau sculpture up to the 1902 Turin *Prima Esposizione d'Arte Decorativa Moderna* is the innovative use of traditional materials (bronze, ivory, marble and wood), and the introduction of new ones (steel, earthenware and tin). Dampt was a superb craftsman and switched fluently between carving in wood or ivory and casting in bronze. He innovated the use of new metals, such as steel, and combined the use of different materials in a single sculpture with fine craftsmanship. Probably the most famous example of this use of material is his *The Fairy Mélusine and the Knight Raymondin*, exhibited at the Salon in 1894 (plate 16.4). While a large body of his work conforms to traditional definitions of Salon sculpture, Dampt had absolutely no reservations in applying his sculpture to decorative objects, chimney-pieces, wooden panelling or furniture. His most progressive contribution to Art Nouveau

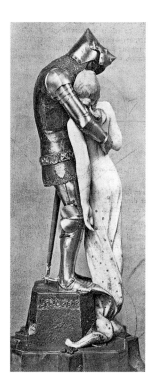

16.4 Jean Dampt, *The Fairy Mélusine and the Knight Raymondin*. French, 1894.

16.5 Alexandre Charpentier, *Armoire à layette*. Sycamore and pewter, French, 1893. Musées Royaux d'Art et d'Histoire, Brussels.

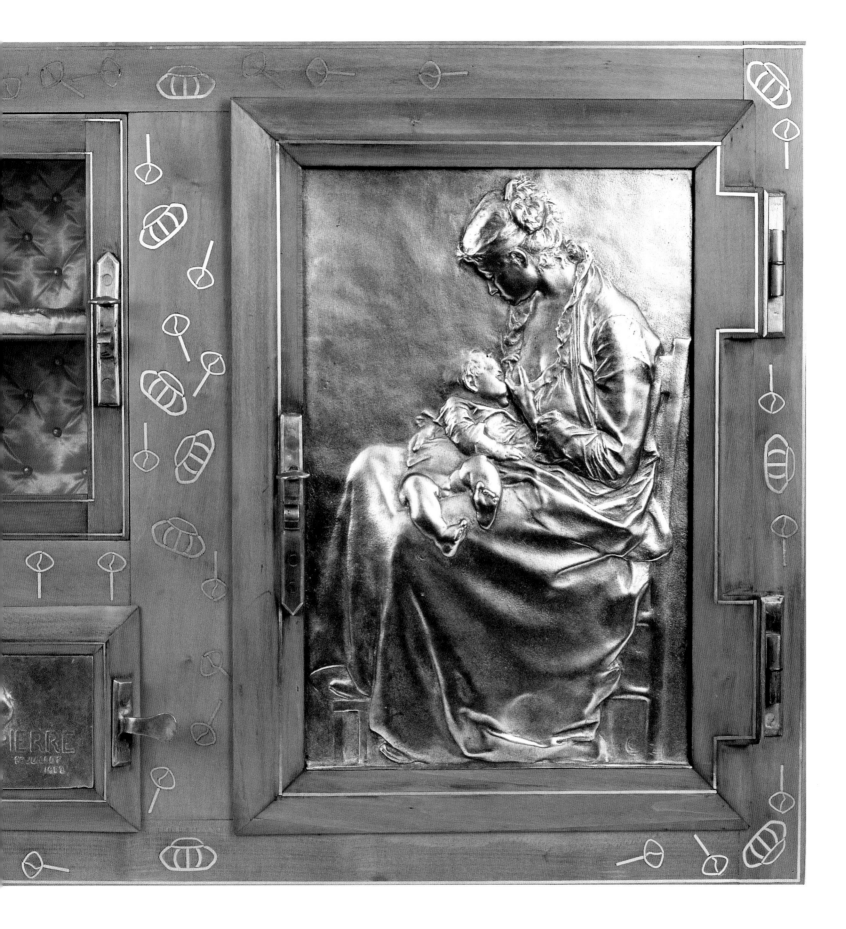

sculpture is his sculpted furniture. At the 1896 Salon, he exhibited his most important piece of furniture, his bed, *Songe d'Or*. Here sculpture merges into furniture with headboard relief panels and pillar figures. De Fourcaud wrote: 'There, before your eyes, is a veritable work of art … nobody could take this captivating piece for a simple industrial product. Relegating it to industry would be perfectly absurd.'[26] In 1892 Pottier admired the influence of Japanese art in Alexandre Charpentier's Salon exhibits, but it is his fusion of sculpture and furniture, and, above all, his medallions and experiments with relief sculpture (discussed below) which underline his importance in the early years of Art Nouveau sculpture. A major work which exemplifies both these features is his *Armoire à layette* of 1893 (plate 16.5). By 1896 Charpentier and Dampt, together with Félix Aubert, Henry Nocq and Charles Plumet, had extended their public profile beyond the Salon and set up their own exhibition venue.

In 1895 Siegfried Bing opened his important initiative in the promotion of the new style, his gallery L'Art Nouveau. Here he presented a broader definition of what constituted Art Nouveau sculpture than the Union Centrale's nationalistic nurturing of craft-modernism. Bing's debut exhibition included 87 sculptures by 15 different sculptors. Although Gabriel Weisberg has observed that the sculpture was collected too quickly and randomly to reflect the harmony Bing achieved in his furnishing and decoration, the selection is revealing as an indication of the diverse range of sculpture which could be associated with the Art Nouveau style at this date.[27] *Animalier* sculptors were represented by the young American Paul Wayland Bartlett (12 works), Charles Cordier (16 works) and Hans Stolenberg Lerche (4 works). Established sculptors, closely aligned to the Salon, included Jean Dampt (who showed plasters for his bed reliefs), Alexandre Charpentier, Charlotte Besnard, Félix Fix-Masseau, Pierre Roche and the Finn Ville Vallgren (plates 3.14, 4.19 and 16.12). Most surprising, however, and revealing the extent to which Naturalist and Symbolist artists were often shown alongside one another, is the inclusion of sculptors such as Émile Bourdelle, Camille Claudel and Auguste Rodin (see chapters four and five). The presence of Bourdelle and Claudel would seem to reflect the affinities between avant-garde sculptors and Art Nouveau created by the new freedom from the curbing influence of tradition, as described by Thornycroft. The final grouping of sculptors who took part in Bing's first Salon is more intimately tied in with Art Nouveau. These sculptors were all from outside France. In addition to Bartlett, there was the Dutch *animalier* sculptor Jozeph Mendes da Costa (3 works)

16.6 Philippe Wolfers, *La Parure*, jewellery box. Silver, enamel, ivory, opals and pearls. Belgian, 1905. Musées Royaux d'Art et d'Histoire, Brussels.

and the Belgian sculptors Victor Rousseau and Constantin Meunier (2 works each).

The inclusion of this final group of sculptors shows how Bing took an international view in his definition of Art Nouveau. His nationalistic colleagues in the Union Centrale mostly disapproved of this move, and Bing in large part revised this approach himself in later years. In the context of sculpture, however, it serves as a reminder that there were important developments in Art Nouveau sculpture beyond Paris. Belgium was a key centre for Art Nouveau sculpture, for example, mainly through the Salons of the association *Société des Vingt*, and later *La Libre esthétique*. It also highlights the relevance of Constantin Meunier to Art Nouveau sculpture. Bing's admiration for the worker figures of Meunier was more than an *ad hoc* arrangement as suggested by Gabriel Weisberg.[28] The second exhibition Bing organized in his Paris venue was in fact a retrospective of 70 works by Meunier. Although Meunier's gritty vision of the worker is at first view quite separate from the dependence on fluid organic forms, Japanese art or the eighteenth century, Bing clearly maintained his close association with the Belgian sculptor, and in 1899 he organized a joint show of Tiffany glass and Meunier bronzes at the Grafton Galleries in London.

The decade which followed the opening of Bing's 1895 exhibition witnessed the full flowering, and the greatest excesses, of Art Nouveau. The innovative use of traditional materials with the introduction of new ones particularly characterizes Art Nouveau sculpture in France and Belgium. This combination led to the development of colouristic effects which were enhanced by intricate goldsmith's techniques.[29] In France, Théodore Rivière's *Salammbô* and Louis-Ernest Barrias's *Nature Unveiling Herself to Science* are often cited as examples of established sculptors of the Champs Elysées Salon, who responded to the new ideas with their combinations of ivory and bronze, often with varied patinas (plate 7.8). The sophistication of these patinas became ever more subtle in the hands of foundrymen such as Siot-Decauville.[30] In Belgium, Charles van der Stappen, Philippe Wolfers (plate 16.6) and the creative partnership of Frans Hoosemans and Egide Rombeaux reflect a more original employment of mixed media. The combination of ivory and metal in particular was taken to the limit of its potential in Brussels. Here, ivory was given prominence and encouragement after the Antwerp *Exposition* of 1894 and the 1897 *Exposition Universelle* in Brussels-Tervuren (plate 1.16). It was both exotic and ancient; it simultaneously represented the antiquity of the craft process and the wealth of the Empire. Narrative was central to the Belgian mixed-media sculptors.

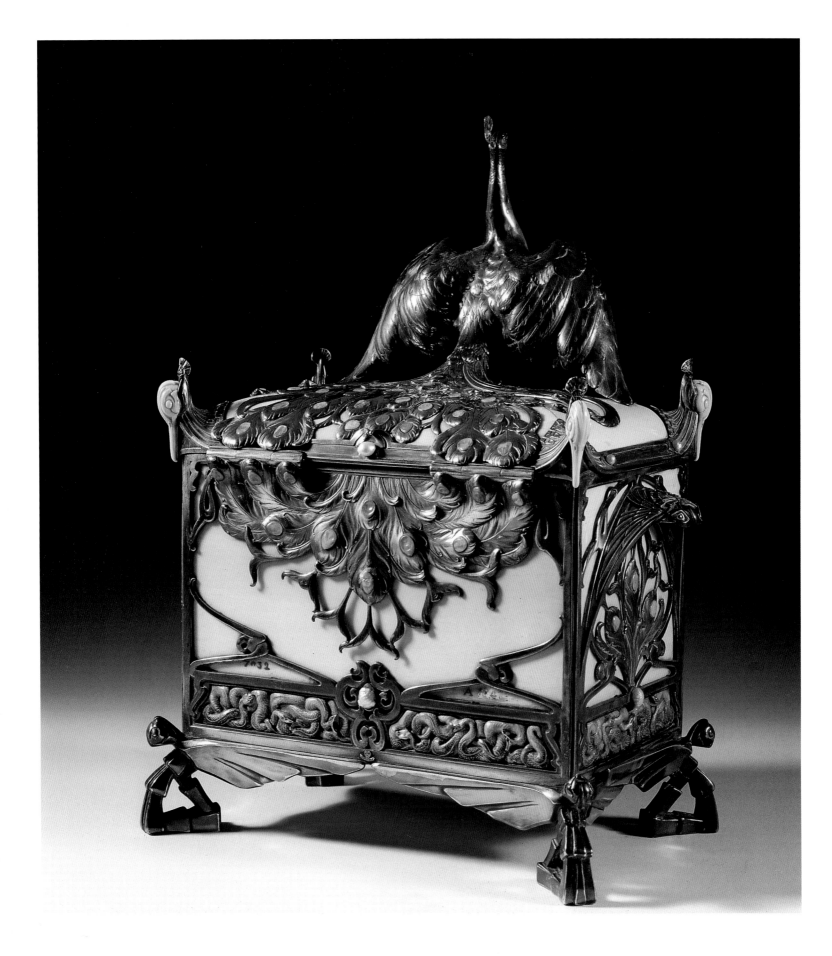

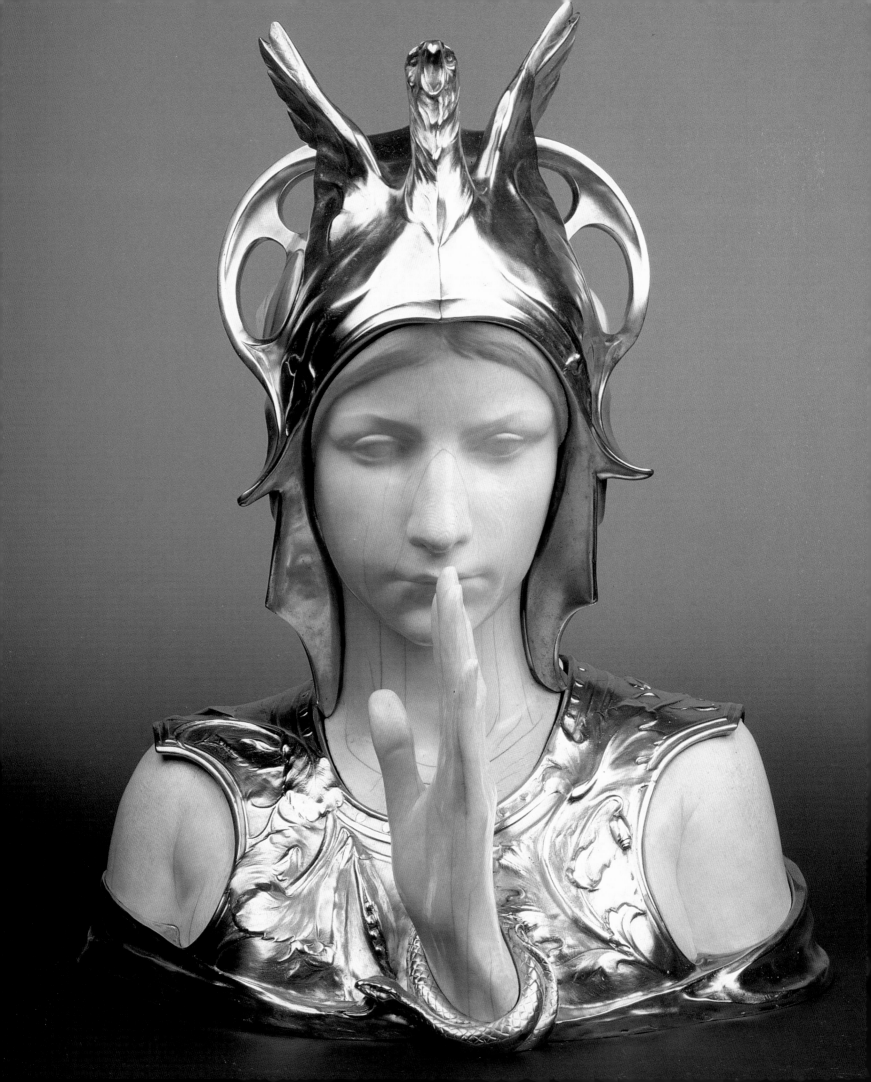

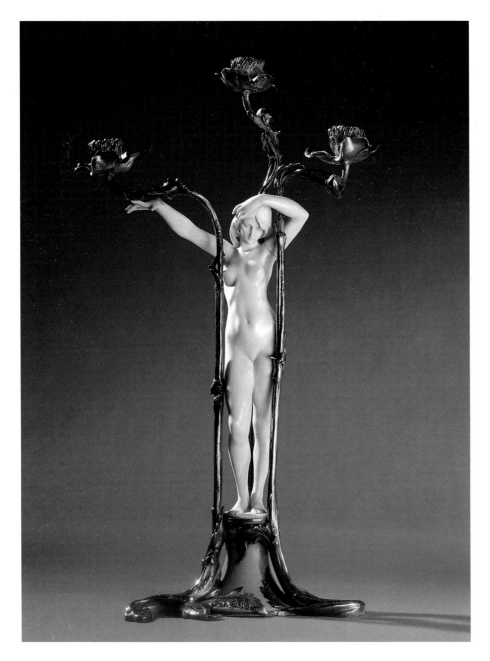

16.8 Frans Hoosemans and Egide Rombeaux, candelabra. Silver and ivory. Belgian, 1899. Kunstindustrimuseet, Oslo.

16.7 Charles van der Stappen, *Sphinx mystérieux*. Ivory and silver gilt, Belgian, 1897. Musées Royaux d'Art et d'Histoire, Brussels.

The influence of French and English Symbolism lend much of this work a haunted expressiveness, while the hedonistic richness of the materials places it close to Huysmans' vision in *A Rebours*. Wolfers' *Civilization and Barbary* of 1897 (plate 3.9) and *Coffre de Mariage* (1905) hang deliberately between jewellery and sculpture, and are among the best examples of mixed-media work of the period. Van der Stappen's large *Sphinx mystérieux* (1897) reveals the lingering influence of Pre-Raphaelitism (plate 16.7), while Hoosemans' images of female sexuality are among the great archetypal images of Art Nouveau (plate 16.8).

One method of putting the wriggle into sculpture (to hark back to the words of F.S. Blizard) was the use of relief

sculpture in which the two-dimensional 'squirming lines and blobs' could be more readily explored. This led to a renaissance in the art of the medallion and *plaquette*. Alexandre Charpentier was at the forefront of this advance, and numerous reviews of his work appear in the *Revue* and other periodicals. His relief work and furniture was exhibited at the Galerie des Artistes Modernes. The greater potential of relief to express the essence of Art Nouveau in sculptural terms is exemplified by the facade decoration of the Georges Fouquet jewellery shop at 6, rue Royale, Paris, designed by Alphonse Mucha. The central element is a dancing *femme-fleur*, which has all the Art Nouveau sense of line and feminine beauty of Mucha's famous posters, and his less well-known but extraordinary sculptural busts (plate 16.9; plates 3.15 and 9.5). This architectural relief serves also to remind us that a significant amount of *fin-de-siècle* architectural sculpture was produced in the spirit of Art Nouveau. Architectural sculpture was a distinct element within Art Nouveau, as was shown by the 1902 Turin *Esposizione*. Raimondo d'Aronco's Central Rotunda and Pavilion of Decorative Arts featured monumental dancing maidens, but in spite of their elegant gestures, their unavoidable massiveness appeared to commentators at the time to be faintly ridiculous. More successful is the type of architectural sculpture made by Jean-Baptiste Larrive in glazed earthenware for Jules Lavirotte's house at 29, avenue Rapp, Paris (1901). Here a lightness and elegance is maintained and a sinuous organic line dominates the design.

During the last decade of the nineteenth century several *animalier* sculptors responded to the example of Art Nouveau. Antoine-Louis Barye, the greatest French *animalier* sculptor, was often cited by proponents of the reforms which led to Art Nouveau as someone who rejected established Salon convention. In works such as *Surtout de Table*, commissioned by the Duc d'Orléans, Barye's approach was seen as a shining example of the unity of the arts. *Animalier* sculpture itself was closely associated with the Salon reforms in the mid-1890s, and featured prominently in Siegfried Bing's first exhibition. Bartlett's animal bronzes were heavily influenced by Japanese art, reflecting one of the key sources of Art Nouveau. Reviewing the Salon in 1900, the writer Jules Rais opened his commentary on the continuing inconsistency in the establishment definition of High and Low Art with a discussion of the *animalier* sculptor Georges Gardet: 'Le Lion tragique' by M. Gardet is a work of sculpture. His *Lions amoureux* appear to belong, according to the catalogue, to the decorative arts. Are we to believe that these categories are established at the mercy of passion?'[31]

In many respects, however, it is the proliferation of

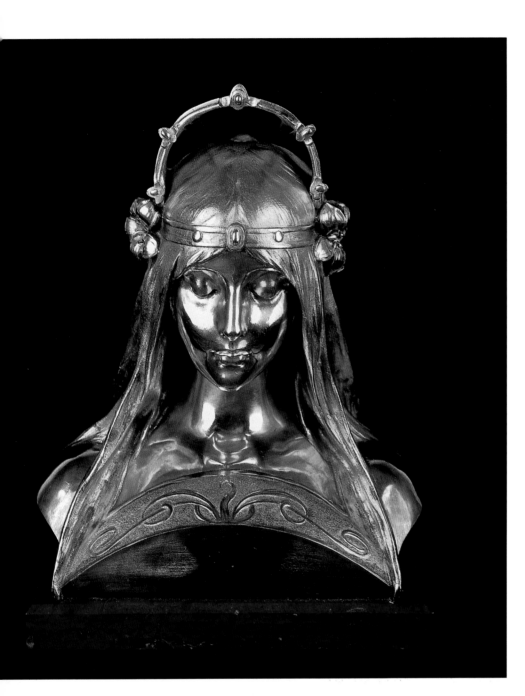

16.9 Alphonse Mucha,
Head of a Girl. Electro-plated silver
and parcel-gilt bronze. Czech,
1900. Statue for the Houbigant
installation at the *Exposition
Universelle* Paris 1900.
© Mucha Trust / ADAGP, Paris
and DACS, London 2000.

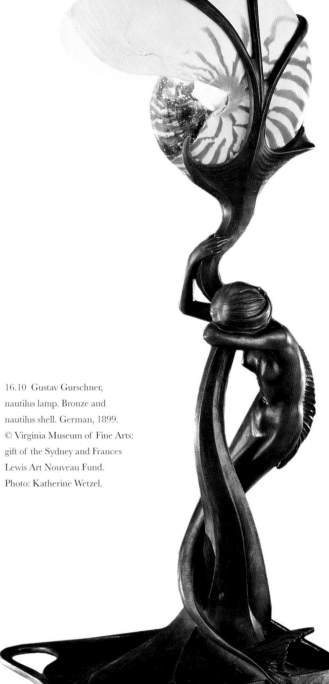

16.10 Gustav Gurschner,
nautilus lamp. Bronze and
nautilus shell. German, 1899.
© Virginia Museum of Fine Arts:
gift of the Sydney and Frances
Lewis Art Nouveau Fund.
Photo: Katherine Wetzel.

images of women, sometimes described as *femmes-fleurs*,
which has become the most immediately recognizable
expression of Art Nouveau in sculpture. A new generation
of sculptors born after the mid-1860s, including Maurice
Bouval, Léo Laporte-Blairsy, Max Blondat, Louis Chalon
and Gustav Gurschner (plate 16.10), exploited this theme
either in traditional formats (exemplified by Bouval's busts
of *Pavot* and *Iris*, exhibited in 1900), or in new contexts,
such as lamps, fruit dishes and desk ornaments. These
sculptural objects were frequently brightly gilded and often
used seashells or glass shades as an integral part of the
design, as in the work of Blairsy or Gurschner.

Perhaps the greatest source of inspiration for this type of Art Nouveau statuette was Loïe Fuller, who arrived in Paris in 1892. Her shows at the Folies-Bergères used electric light and her unique dance style, which created spectacular billowing drapery, was an irresistible draw for artists. In 1897, Louis de Fourcaud's review of the Champs de Mars Salon commented on nine bronze studies of Loïe Fuller. Raoul-François Larche (plate 16.11), Agathon Léonard, Bernhard Hoetger, Hans Stolenberg Lerche, Rupert Carabin and Théodore Rivière all produced statuettes of Fuller, but the greatest sculptural expression of Fuller idolization was Pierre Roche's sculpture for the Loïe Fuller Theatre at the 1900 *Exposition Universelle* in Paris (plate 16.12).

One hundred years later these *fin-de-siècle* fantasies inspired by Loïe Fuller epitomize for many the essence of Art Nouveau sculpture. Their Art Nouveau style is immediately recognizable, and the vitality of its mode of expression is still very much relevant to today's public. It is strange, therefore, that so many people, both contemporary artists and later historians, have had so many problems defining Art Nouveau. George Frampton, who exhibited at *La Libre esthétique* in Belgium, expressed a common dilemma when he said: 'I have nothing to say about l'Art Nouveau, as I do not exactly know what it means. I believe it is made on the Continent, and used by parents and others to frighten naughty children, which I think is a very bad practice.'[32]

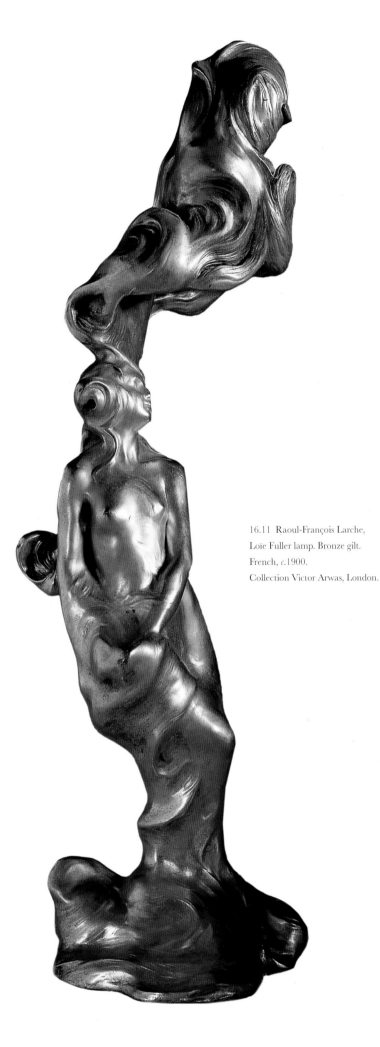

16.11 Raoul-François Larche,
Loïe Fuller lamp. Bronze gilt.
French, *c*.1900.
Collection Victor Arwas, London.

16.12 Pierre Roche,
Loïe Fuller
sculpture, French,
1900. For Loïe
Fuller Pavilion,
Exposition Universelle,
Paris 1900.

The Metropolis and the Designer

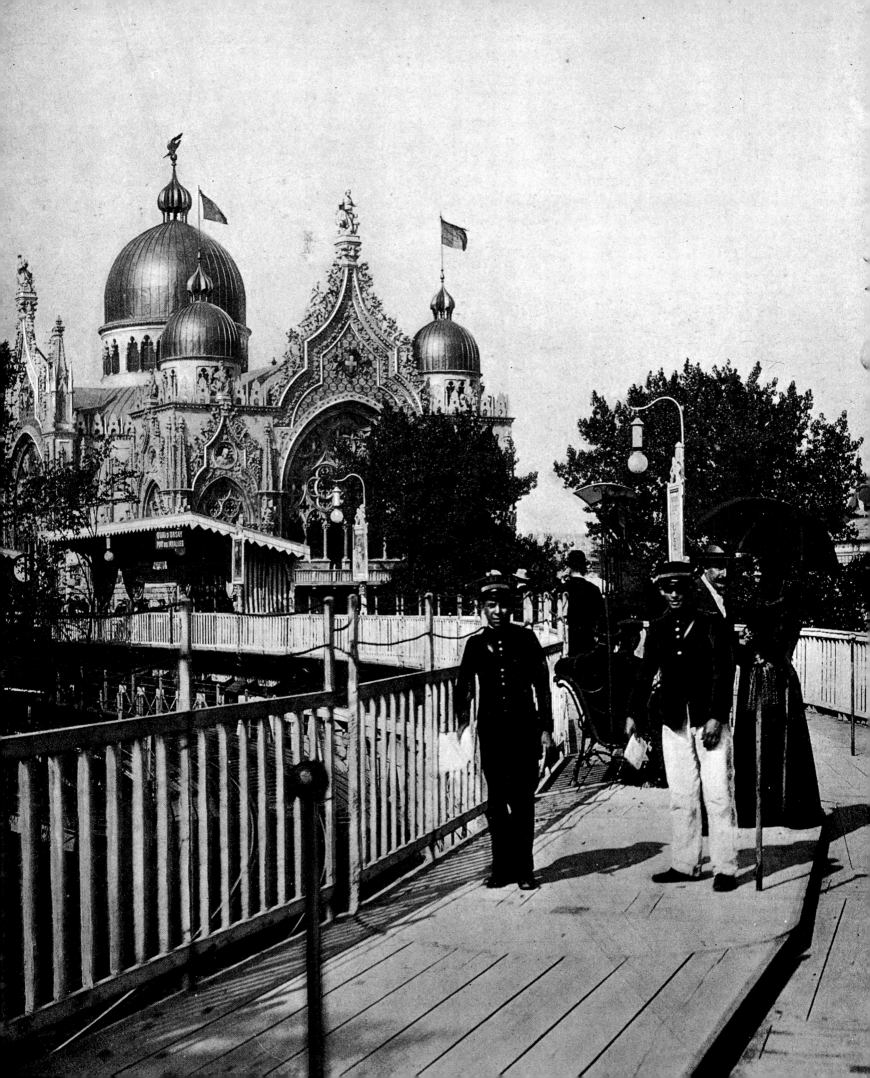

Gabriel P. Weisberg

The Parisian Situation: Hector Guimard and the Emergence of Art Nouveau

17.1 The moving pavement approaching the rue des Nations, *Exposition Universelle*. Paris 1900.

During the 1890s architects, designers and artisans in Paris were increasingly confronted by an inhospitable urban environment, one in which workers in the poorer sections of the city lived in dark, dank and unsanitary living conditions. The arts fraternity also remained committed to continuing the progress that had been made in the creative use of imaginative materials at the International Exhibition of 1889. With the construction of the Eiffel Tower and other advances in industrial design, these leading innovators re-confirmed France's reputation as a country dedicated to artistic ingenuity.[1] Critics applauded the French movement towards creating a new 'living' environment (then under-way in Belgium and other European countries) and implementing improvements in social conditions that would make the Third Republic an ideal community.[2] Those in control of education and the fine arts worked to develop strategies through which France could maintain its reinvigorated position at the end of the century, particularly at a time when many other nations were advancing their own positions as progressive countries.[3] Their discussions centred on the exhibitions to be shown at the *Exposition Universelle* in 1900.

Throughout the 1890s French planners and critics redesigned public and private interior spaces to reflect the growing interest in new materials, plant motifs and imaginative shapes that were propelling architecture and design away from the past.[4] Exhibition systems were modified, including Salons in Paris (notably that of the *Société des Artistes Français* and the *Société Nationale des Beaux-Arts*) to allow all the arts equal representation. Similarly, the decorative arts received revitalized commercial support. Art and industry were recognized as working together, at the same time remaining openly competitive with international advancements. By 1900, when the *Exposition Universelle* was held in Paris, French government and private initiatives were on show (plate 17.1). In many cases these initiatives

successfully reflected the ways in which French designers and architects understood contemporary issues, such as the need to create a 'modern style' that did not borrow heavily from the past.

No other architect comprehended these demands better than Hector Guimard. One of the younger and more revolutionary architects of the period, Guimard focused on a series of pressing problems related to middle-class living. He improved apartments, designed homes that were neither excessively costly nor overly extravagant, created open interior spaces that allowed in more light and were decorated in bright colours, and utilized new shapes that were often standardized through prefabrication, such as the forms of the Metro entranceways. The Castel Béranger (plate 17.2), Guimard's first fundamentally radical design was constructed in 1894–98. It achieved some of these goals with the use of variegated colour on crucial sections of the facade and an interior courtyard that let more light into the apartments. This fusion of architecture and industry within an intricate apartment complex generated considerable discussion among Guimard's fellow architects. Soon established in the forefront of his generation, Guimard became recognized both as an architect who instituted advanced solutions for housing problems and as the creator of ornamental designs that were, in effect, more iconoclastic than his architecture.[5]

With the construction of his buildings and the public exhibition of his models and drawings, Guimard soon found himself at the centre of a heated critical debate. Those linked to academic traditions or trained in architectural ateliers rejected his advancements. Others interested in working independently to invent new forms in interior design saw Guimard's work as visionary. Judging from the debates recorded in the literature of the time, Guimard established himself in the role of a new type of architect-designer. By working alone and isolating himself from the

17.2 Hector Guimard,
Castel Béranger. 1894–98.
From *Le Castel Béranger,
oeuvre de Hector Guimard,
Architecte*
(Paris 1898).
V&A: 101.E.55.

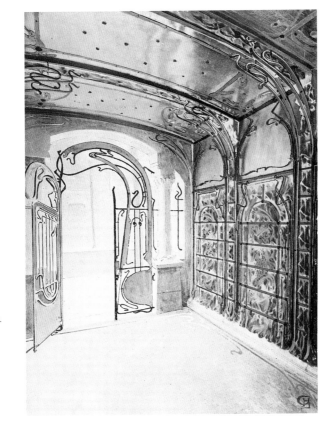

17.3 Hector Guimard, principal entrance to Le Castel Béranger. From *Le Castel Béranger, oeuvre de Hector Guimard, Architecte* (Paris 1898). V&A: 101.E.55.

17.4 Hector Guimard, Metro station, Palais Royal. Paris, *c.*1900. Photo: Roger-Viollet, Paris.

17.5 View of Paris Metro station, showing extravagant Art Nouveau forms. © R.A.T.P., Paris.

masses, he was able to create designs before many others. The Castel Béranger became a heroic statement as Guimard demonstrated how architecture and the industrial arts could be united in one building (plate 17.3). His integration of a wide range of materials and his reliance on various subcontractors to complete different aspects of the building served as models for others to follow. In this way Guimard showed how the arts could work together to create a unified, modern scheme.

Even though Guimard did not participate in the 1900 *Exposition Universelle* in Paris, his presence was evident in the design of the Metro system.[6] He was given official responsibility to create entranceways for the urban rapid transportation system that would transport thousands of people throughout the city in comfort (plate 17.4). As several variations of his Metro stations were constructed, critics began to dub this 'new' approach to design *le style Metro*, thus implying that Guimard was helping to name an entire movement (see chapter fourteen).[7] The great variety of the Metro entranceways ranged from bulbous vegetal forms that were often open to the sky and yet supported electric lights (plate 17.5), to covered stairways and complete pavilions that used frosted glass and other modern materials. A

17.6 Hector Guimard, jardinière.
Cast iron. French, c.1905.
The Birkenhead Collection.

17.7 Hector
Guimard, numbers.
Cast iron. French,
designed c.1900.
Private Collection.

sense of mystery sometimes distinguished these entrance-ways as passengers emerged from the Metro's darkness to be surrounded by vegetal or imaginary shapes created from metal and glass. Guimard's designs were also compared with stations in London, Vienna and other world capitals, providing further evidence that international competition in urban, industrial and interior design existed by 1900.

Although his name was linked with the creation of a truly advanced 'modern style' in 1900, it was not until three years later, when Guimard exhibited his designs at the *Exposition Internationale de l'Habitation* at the Grand Palais, that the term *le style Guimard* came into popular usage. It became another way to recognize those adventur-

ous aspects of architecture and design that were part of Art Nouveau. At the *Exposition* Guimard successfully used personal postcards as a form of self-promotion and a way to spread the new terminology. By this time he had become a master of self-advancement, presenting himself as the principal architect-designer of the new.[8] He cast himself in the role of an entrepreneurial overseer, who directed the work of numerous artisans and craftsmen creating harmonious *ensembles* of furniture and decorative designs. In this way, Guimard supported profoundly original shapes and emphasized the intimate relationship among all the related art industries (plates 17.6 and 17.7). By maintaining this stance, Guimard's work spanned two distinct moments of the modern style and remained a viable movement until after 1910.[9]

The *Exposition Universelle* of 1900 provided one of the most audacious representations of Modernism ever seen in Europe. Having seen the Union Centrale or the Pavillon Bing, many observers left the *Exposition Universelle* feeling bewildered and unable to determine the direction from which the new modern style had come (plate 17.8). An anonymous critic (probably J.H. Morel-Lacordaire), writing for the well-established newspaper *Le National* in August 1900, believed that the *Exposition* was a revelation. In trying to trace the origins of Art Nouveau, he pointed to the United States and then to England. He also noted that if this new 'tendency' was to be accepted in France, it would

17.8 Exterior view of 'L'Art Nouveau Bing', *Exposition Universelle* Paris, 1900.

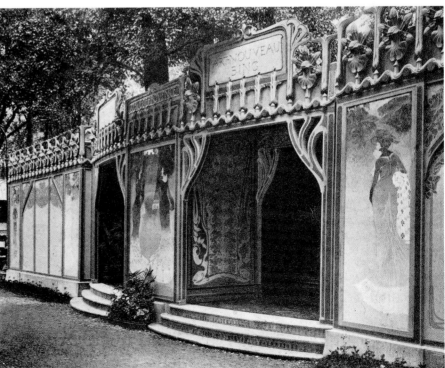

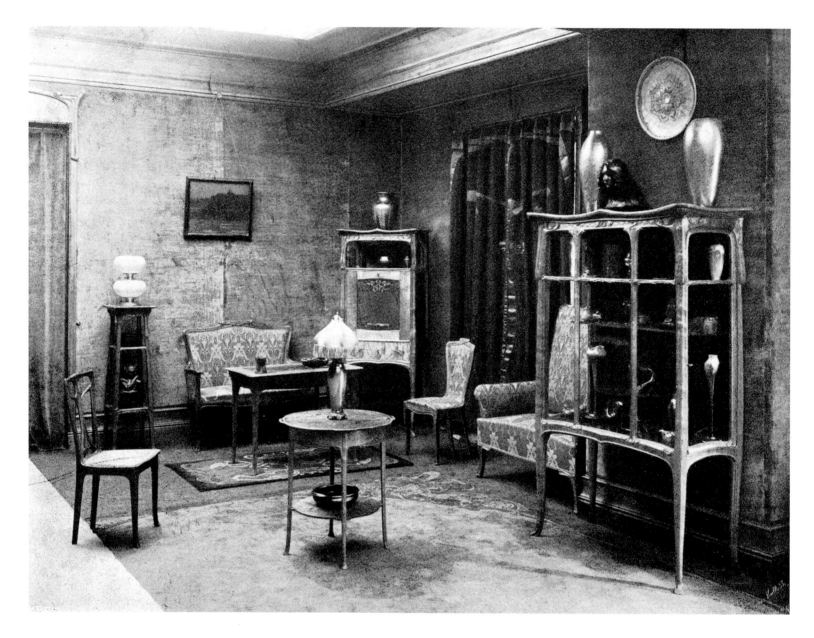

17.9 Édouard Colonna, sitting room from L'Art Nouveau Bing, *Exposition Universelle*. Paris, 1900.

have to modify some of its curvilinear features.[10] The next day a well-argued article by J.H. Morel-Lacordaire appeared in *Le National*. He commented on the expanding role of the architect in providing decorations for both the interior and exterior of homes. He credited Art Nouveau for having been the pretext for this development. Although he found some manifestations of Art Nouveau too extravagant and even comical, he did retain a rather open attitude by calling the style 'interesting' and worthy of further study.[11] If Art Nouveau was well understood, it 'could open a vast field of possibilities. We have the proof of this at the *Exposition Universelle*'.[12] Significantly, Morel-Lacordaire recognized that young architects had created beautiful objects, not only in furniture, but also in ceramics, glass and bronze (plate 17.9).

A third article by Morel-Lacordaire expanded the discussion to include debates surrounding the ways in which architects – ostensibly those designing official buildings for the *Exposition* and elsewhere – had been trained. He noted a controversy between those who had received their training at the École des Beaux-Arts and those who were granted a government licence to practice architecture. Unable to support the more radical architects wholeheartedly, and aware that those trained at the École were essentially experts in construction, the writer remained open to Guimard and other architects who functioned more as decorators. Their contact with woodworkers and other artisans, he realized, made them more practical in their approach.[13] By 22 August, Morel-Lacordaire had moved on to discuss the term 'Art Nouveau' itself. He asserted that

he might not have personally chosen this phrase for the stylistic developments in Paris, as all movements were new when they were first initiated. However, he did believe that these initiatives would last, even though the term '*le style 1900*' might have been more appropriate.[14]

Proclaiming Tony Selmersheim, Charles Plumet and particularly Hector Guimard to be the leaders of the new movement, Morel-Lacordaire largely devoted another article to an interview with Guimard. He recognized the eloquence of Guimard's work and cited the architect as a 'leader' of one new sect of what Morel-Lacordaire called *l'art libre* or *l'art nouveau*.[15] He found Guimard's architecture, as well as his other industrial art designs, to be highly personal in his search for innovative solutions to fundamental artistic issues. Morel-Lacordaire praised Guimard for making his ideas 'accessible' to a greater segment of the public and permitting the 'shock of the new' to be seen as part of a larger, more harmonious *ensemble*.[16] Morel-Lacordaire's article, published in the middle of the series that he was writing on the effects of Art Nouveau at the *Exposition Universelle*, further secured Guimard's position of rank among other independent iconoclasts. In addition, by assessing the various terms under which these new artistic tendencies were being recognized, Lacordaire reiterated the numerous possibilities that were then making design reform issues central to Parisian life.

As much as Guimard played a critical role in the discussions surrounding Art Nouveau, other issues forced the modern style to emerge when it did. It is now clear that the central French government, through the urging and foresight of extremely enlightened administrators, was directing more aid towards the visual arts in 1900 and 1901 than previously.[17] By the turn of the century extremely generous budgets were designated for craftsmen and designers, as well as for the reorganization of museums. Since it was essential for France to compete with other countries, arts administrators assumed responsibility for cultural sponsorship and national leadership. In their desire to improve the lives of the French people, they financed innovations at the *Exposition Universelle* and recognized the educational role that museums could play in reaching individuals.

Charles Couyba, an exceptionally eloquent writer and politician, presented the budget for the visual arts at the 1901 government session in Paris. He argued persuasively that the arts in France could be supported in several ways, with '*l'art libre dans l'état protecteur*' (a free art under State protection) being the path he urged for formal acceptance.[18] This would allow for a greater range of creativity, and the government could work behind the scenes without

controlling or censoring artistic endeavours. In using the term *l'art libre*, Couyba used a slogan that had emerged in the late 1890s, when it was applied to the innovations of Art Nouveau. For the public and government officials of the era, the term also had political implications. In the context of establishing a permanent museum dedicated to the decorative arts – a debate that had been raging for years – Couyba in 1901 applauded the contribution made by the Union Centrale through the 'beauty' and creativity of its pavilion at the *Exposition Universelle*. This installation's success in calling attention to the contributions of French craftsmen confirmed that government 'subvention' had worked. Couyba also stressed that the moment had finally arrived when it was essential that a decorative arts museum receive the 'blessing' of the State, so that private and public initiatives in the decorative arts could be formally recognized under one roof.[19] These statements, following so closely after the construction of innovative buildings at the *Exposition Universelle*, substantially altered the way in which works created under the banner of 'Art Nouveau' were seen.

Couyba was presenting the case, in a preliminary way, for the fact that Art Nouveau might not necessarily be the daring invention of visionaries working outside the system. As the State was moving towards ends similar to those touted by independent curators, and it was also sponsoring the activities of the Union Centrale, many people quickly recognized the importance of creating a totally unified 'new' renaissance that would direct equal attention to State and private initiatives.[20] At the same time as these discussions were taking place, a number of architects and liberal thinkers, including Guimard, grew increasingly committed to reshaping society by using new art forms.[21] They believed that improved hygienic living conditions would combat the escalating problems of urban squalor and overcrowding.

Finding himself in agreement with Roger Marx (the *Inspecteur Général des Musées* and a progressive art critic) and the architect Frantz Jourdain, Guimard participated in the first *Exposition Internationale de l'Habitation*, held in Paris in July–November 1903. The premise of the *Exposition* was quite simple: life in Paris was often dreadful. Many were afflicted with tuberculosis, alcoholism and other diseases and were forced to live in miserable conditions. Even when workers had proper housing, they were crowded into cramped, drab rooms decorated with few bright colours, scant use of nature, and little ingenuity or variety of furniture.[22] One goal, as stated in the *Exposition* catalogue, was to make the home environment healthy and 'pleasant', a

17.10 Hector Guimard, window grill from the Castel Henriette (plate 17.11). Wrought iron. French, 1899.
The Birkenhead Collection; on loan to the V&A.

place where people would want to be, rather than merely a place in which to sleep. Designers and architects proposed to achieve this by making interiors appear lighter with colour and decorations, and by improving the variety of furniture available.

The *Exposition*, which had the support of the government, proved significant as it brought together architects, decorators, industrialists, writers and entrepreneurs. Through the *Exposition*'s different categories, it became apparent that Art Nouveau theories were being incorporated into architectural training. Discussions of new buildings and innovative industrial designs were being introduced into lectures and teaching presentations to broaden the curriculum of young architects.[23] Guimard played an important role in the *Exposition*. Listed in the catalogue not only as a creator, but also as an entrepreneur whose designs were being used to develop furniture and sculpture, Guimard found himself in the company of Henri Sauvage and other controversial creators who were completing similar types of objects for use in low-cost housing.[24] Yet as the *Exposition* strove to present visually harmonious environments in which all furniture and decorations related to each other, it is apparent also that the

principles of the *Exposition Universelle* of 1900 were being put to further use. The strong emphasis on worker 'habitation' and on designs that would affect a broad public heralded the fact that the Art Nouveau practice of designing extravagant and often luxurious objects for 'the few' was passing into history. The *nouvelle société* was to be broadly based.[25]

Closely linked to the *Exposition* of 1903 was the *Société du Nouveau* in Paris. Created in May 1902, this organization published a journal in which the group's various activities were outlined and its members listed.[26] Guimard joined this organization, as did almost all the leading intellectuals and visual artists associated with the evolution of Art Nouveau at the turn of the century. Frantz Jourdain served as President, Roger Marx was Archivist, and the designers Eugène Gaillard, Maurice Dufrène and Alexandre Charpentier played active roles. Having as its primary goal the study of all issues relating to the city of Paris, including any change that would affect its beauty or utility, the group readily discussed what could be done to improve the quality of urban life. Although the group's effectiveness is uncertain, the fact that this organization existed at all and analysed the conditions of the urban environment is quite impressive, as it reveals just how seriously the members perceived the need to create a *nouvelle société*. Since discussing artistic creativity was the group's central mission, along with appreciating individual works by certain members, a revised view of the interrelation of Art Nouveau architects and designers emerged by early 1904. The *Société*'s activities must be placed within a much broader context, one appropriate to all citizens of the Third Republic.

Although the creation of a new society did not occur by 1900, or even by 1904, the emergence of innovative modern design in Paris indicated that considerable advances had been made in both architecture and industrial technology. Through the vital avant-garde movement led by Guimard and others, Paris regained much of the prestige that it had lost to other centres (even to the city of Nancy). One great achievement was that the stranglehold of the past, with its traditional methods of teaching architecture, was finally broken. The independent architect-designer could now visualize many new forms and shapes (plates 17.10 and 17.11), and present himself as an artist working towards a fundamental change, namely to create a total work of art on his own.[27] Whether preparing the Castel Béranger or designing Metro stations, Guimard's originality was realized in his ability to control every aspect of a project. He saw himself as a God-like creator whose

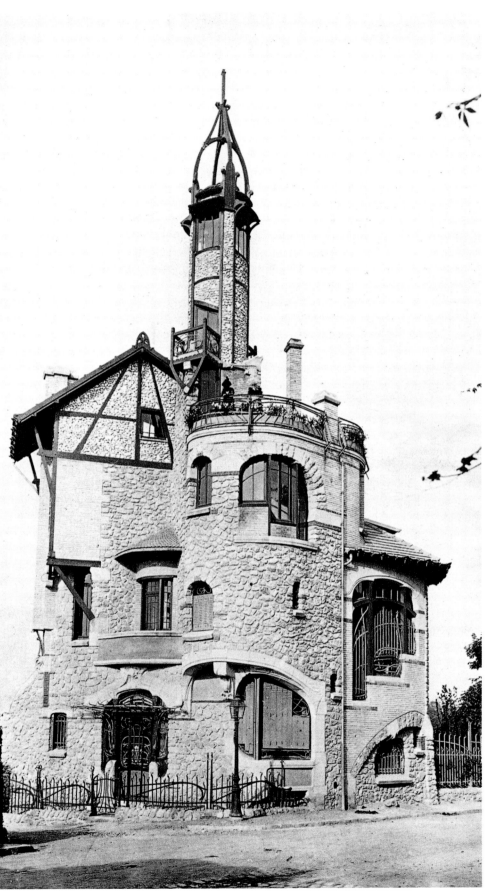

decisions were to be followed by all the artisans working for him. In a sense, he helped promote the architect-designer as a master entrepreneur whose control over a project resulted in almost fanatical commitment to his visionary leadership.

The press debates of 1900 effectively reiterated the achievements of the time and prepared the way for the future innovations of such international figures as Charles Plumet, Henri Sauvage and Frantz Jourdain. Although Art Nouveau did not fully prevail in 1900, Parisian-based Art Nouveau managed a very strong return by 1907, even though it had never really died away.[28] The theories and monuments of the first phase of Art Nouveau had been absorbed by young architectural students and designers, while these ideas remained linked to the highest level of French creativity in a 'modern style'. During the first decade of the twentieth century, French designers and architects were determined to hold their own against German and Austrian influences. At the same time Art Nouveau was regarded by many as a type of quasi-national art intended to assist the middle class. It was seen as a style invented to shatter the constrictions of the past and to provide considerable freedom to Guimard and other creators. Art Nouveau was now perceived as a national style with its birthplace in Paris and its creator in Guimard.[29] The style appealed to latent issues of nationalism and to calls for determining how Paris, and indeed all of France, was going to combat the intense competition of other European countries.[30] Art Nouveau continued the achievements that had appeared by 1900 and served as a creative role model well into the 1920s.

Although other forms of Art Nouveau were visualized in 1900, one lasting variant was that introduced by Hector Guimard, the one artist who himself was reinvented and reappraised by critics and colleagues. What he helped initiate by 1900 exerted a lasting impact that elevated creativity and the prestige of French design prior to the First World War.

17.11 Hector Guimard,
Castel Henriette. Paris, 1899.
Photo: Laurent Sully-Jaulmes.

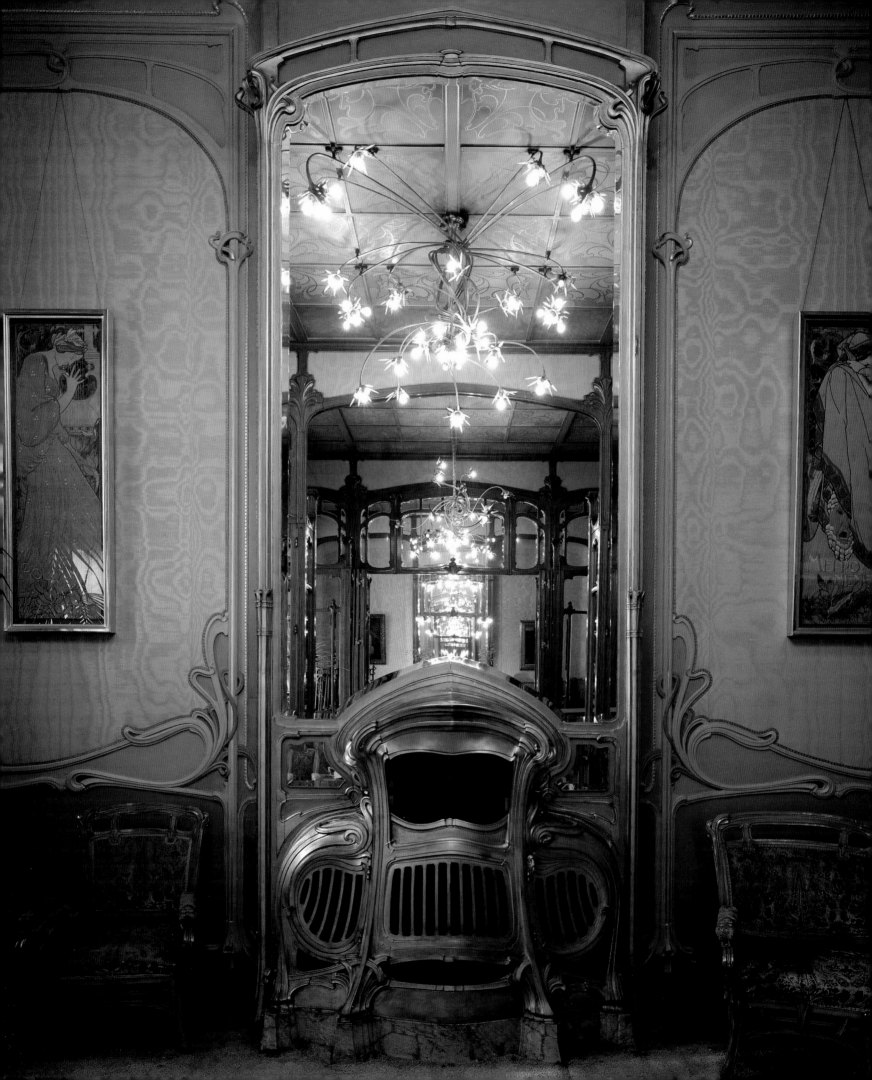

Françoise Aubry

Victor Horta and Brussels

18.1 Victor Horta, Solvay House, reflections of lamps in drawing room mirrors. Brussels, 1894. Y. Oostens-Wittamer, Hôtel Solvay. Photo: Oswald Pauwels © VAL 33.

Victor Horta's architectural flowering coincided with a period of considerable urban redevelopment in Brussels, during the second half of the nineteenth century. When he came to the throne on 17 December 1865, Léopold II had ambitious plans for a capital graced with elegant streets, parks and museums. He even took money from his own pocket to push through the projects which were close to his heart.

The face of the city was transformed in two ways. On the one hand these developments were imposing and monumental: avenue Louise, avenue de Tervuren, avenue de Meise, the royal palaces, the Musée d'Art Ancien, Musée d'Art et Histoire, the Musée du Congo, the King's gardens, and the parks at Forêt de St Gilles, Tervuren and Josaphat. On the other hand, the city's transformation was tied in with the growth of the bourgeoisie and its fondness for private houses. The middle classes had a taste for highly individualized facades, which encouraged the emergence of an extremely rich, eclectic vocabulary.[1] The construction of apartment blocks, modelled on those in Paris along the boulevards (which took place soon after the covering over of the river Senne – the water in the centre of Brussels had become an open sewer), was not particularly successful. The aim was to prevent wealthy families, such as Victor Horta's clients, from leaving the centre and moving into new areas.

Léopold II did not like the New Art. For many years his favourite architect had been Alphonse Balat. After Balat's death, the king commissioned French architect Charles-Louis Girault to design and build the Musée du Congo, to give Ostende a face-lift and to carry out major transformation work on the castle at Laeken.[2] Only once did he decide to adopt the Art Nouveau style for an official display: he commissioned Paul Hankar, Georges Hobé, Henry van de Velde and Gustave Serrurier-Bovy to design the setting for the presentation of products from the Congo for the Tervuren site of the 1897 International Exhibition.[3] He must have thought that the style befitted the exoticism of the objects on show. Moreover, the king knew that his choice of avant-garde designers would attract publicity through the newspaper reviews.

With his reputation as one of Alphonse Balat's most gifted pupils, and his increasing fame during the 1890s, Victor Horta may have hoped to become the next royal architect, but he was not selected. This could have been because he refused to collaborate with other designers. However, thanks to the Secretary of the Independent State of the Congo, Edmond Van Eetvelde, for whom he was constructing a private mansion at 4, avenue Palmerston, Horta was commissioned to design the Congolese Pavilion for the *Exposition Universelle* of 1900 in Paris. Unfortunately the project came to nothing and the architect was left with a far less significant, decorative role.[4]

Horta's bitterness at having been excluded from all major official commissions probably accounts for the determination with which he worked on the renovation, after the First World War, of the Mont-des-Arts area of Brussels, situated between the place Royale and the Grand Place. The only ambitious projects of his to be realized were the Gare Centrale, for which the first plans were drawn up in 1912 (Maxime Brunfaut completed the station, which opened in 1952), and the Palais des Beaux-Arts (1919–28).[5]

Horta thrived through private clients, most of whom chose to move to the new areas such as avenue Palmerston and avenue Louise, where they could find fresh air, light and magnificent wooded views (plates 18.2 and 18.8). The first area was to the north-east, while the second was destined to link the old centre of Brussels to the green areas of Bois de Cambre and the Forêt de Soignes. Léopold II wanted this to be one of the most beautiful avenues in Europe.[6] Horta decided to add balconies and loggias to the four private mansions he constructed in avenue Louise –

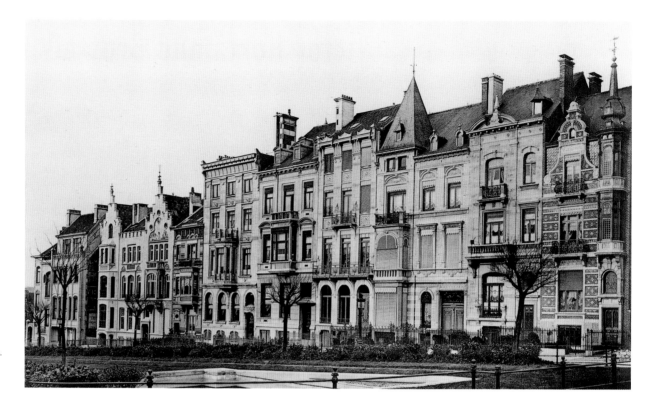

18.2 Avenue Palmerston, Brussels.
The Van Eetvelde House
(plate 18.9) is on the extreme left.

18.3 Victor Horta, Waucquez
department store. 20, rue des
Sables, Brussels, 1906.
Photo: C.H. Bastin & J. Evrard,
Brussels.

Solvay House at 224 (plates 18.1, 18.5 and 18.8), Max
Hallet House at 346, Roger House at 459 and Aubecq
House at 520 – so that his clients could enjoy the elegance
of passers by. He also built the Tassel House a few metres
from the avenue Louise (plate 1.10 and 2.2). In 1898, not
far from there in the rue Américaine, in the St Gilles area,
Horta purchased two plots of land so that he could build
himself a house and workshop.

Horta's first major clients, Eugène Autrique and Émile
Tassel, were friends he had made through the Brussels
Freemasons. Horta had become a member of the Philan-
thropic Friends Lodge in 1888. Both were engineers con-
nected to the Free University of Brussels. At Tassel's
house, Horta met the engineer Charles Lefébure, who rec-
ommended him to another engineer – Camille Winssinger
(whose private mansion he built at 66, rue Hôtel-des-
Monnaies at St Gilles in 1894). Tassel, Winssinger and
Lefébure were all involved in the Solvay Company.
Through them, Horta met the Solvay family, who gave
him a small commission (the monument to Alfred Solvay
in the courtyard of the Couillet factory), before asking
him to undertake the refurbishment of the castle at la
Hulpe (1894) and the construction of the Solvay House
(1894) in avenue Louise (plate 18.8).[7] His other clients
came from the legal world. The first was Maurice Frison,
for whom he built a private mansion at 37, rue Lebeau
(1894), followed by Léon Furnémont, whose house at 149,

rue Gatti de Gamond in Uccle he completed in 1900[8],
then by Max Hallet (1902)[9] and Émile Vinck (a house at
35, rue Washington in Ixelles, in 1903).[10] Furnémont,
Hallet and Vinck were also Freemasons and members of
the Belgian Workers' Party, and went on to have brilliant
political careers. Thanks to his friends on the left, in 1895
Horta was commissioned to design the Maison du
Peuple.[11] 'My friends and I were of the same mind … we
were *reds*.'[12] Philosophically, he was close to the Workers'
Party, and, aesthetically, he was offering a new style that
was quite different from the French royal styles. He
wanted to build 'a house that was light and airy, a luxury
for so long excluded from the workers' slums'.[13] Although
the agenda changed, his initial aims, developed in the pri-
vate mansions he designed, remained the same.

At the turn of the century, businessmen eager to have
their shops brought into line with current tastes
approached Horta, by now a fashionable architect. These
new commissions were on the shopping streets in the his-
toric heart of the city. They include the Innovation (111,
rue Neuve, in 1900), the Grand Bazar Anspach near the
Théâtre de la Monnaie (rue de l'Évêque, 1903), the Wauc-
quez department store (20, rue des Sables, 1906, plate
18.3) and the Wolfers shops (11, rue d'Arenberg, 1909).
These streets led off the boulevards that had been created
after the completion of the railway junction between the
Gare du Midi and the Gare du Nord. Initial funding was

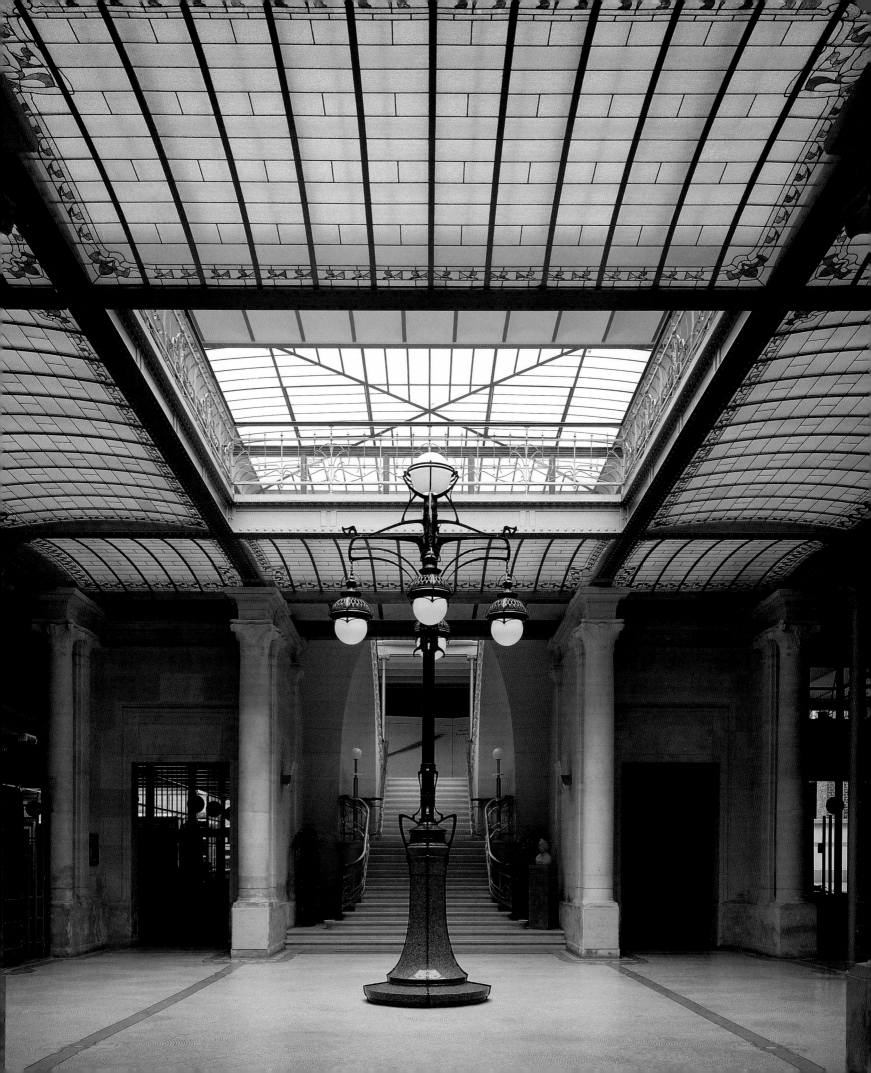

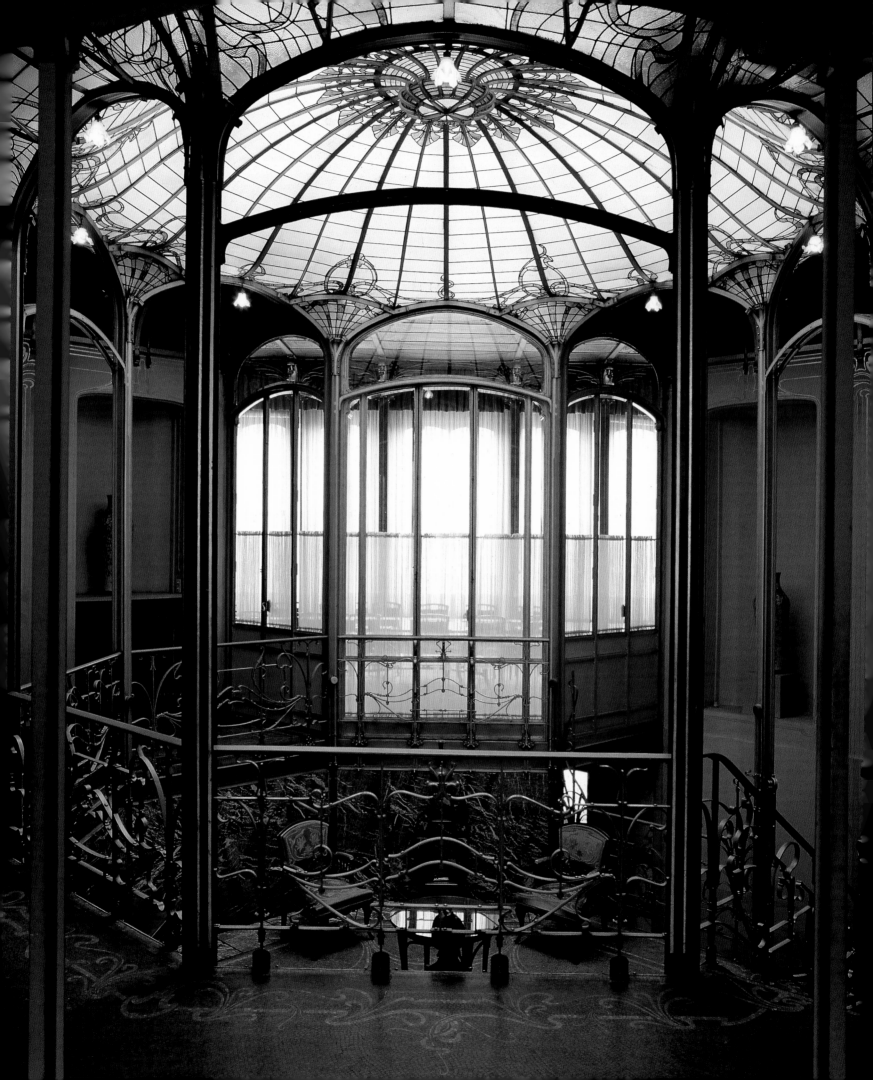

approved by Parliament in 1900. The growing popularization of Horta's style through the large department stores probably explains why his private clients became disenchanted. To them, Art Nouveau had been a way of expressing their rejection of tradition and conservatism. Robbed of its originality and now available to the man in the street, it had lost its symbolic appeal.

Horta's Art Nouveau clearly found its sources in Classicism, the Gothic Revival, neo-Rococo and Japonism – all popular at the time. However, it was without a doubt original and 'Brussels' in nature. When it came to designing private properties, Horta had to take into account that the division of land into long narrow strips meant that the interior of the houses would be poorly lit. In a traditional bourgeois house the three reception rooms on the first floor led off each other, with a corridor alongside that housed the entrance to the staircase. The kitchens were situated in a half-basement into which light came from the road through an enlarged basement window. This layout was problematic when it came to designing the facade.

In the Tassel House, Horta put in a central entrance at street-level with a cloakroom on the left and a waiting room on the right. He built the cellar-kitchen at the back under the dining room and linked the two levels with a concealed service staircase. As the houses he built were for people who liked to entertain, he was particularly concerned that the main entrance should be as welcoming as possible. He combined the practical (removing coats, washing hands and waiting to be shown through) with the symbolic – in spite of there being no immediate access to the heart of the house, it was open and offered a wealth of vistas. The intimate life of the inhabitants was spontaneously revealed to the invited guest. Horta believed that a house should not only reflect the lifestyle of the occupants, but that it should also paint a portrait of it.[14]

He disliked enclosed spaces and solid doors that hindered not only the free circulation of people, but also of air and light. A staircase should be neither a place of icy pomp and ceremony, nor a gloomy passageway. Lit by a window, it became a place in which to stroll through the colourful and harmonious landscape of the house. In the Tassel House, Horta introduced two wells of light, one in the conservatory, the other over the stairs, requiring him to cover the building with two sloping roofs (plate 1.10). Perfect spatial unity was achieved in the Van Eetvelde House, where the glass-roofed octagonal hall meant a circuitous route had to be taken to reach the first-floor drawing room from the ground-floor cloakroom (plate 18.4).

Like the artists of his time, Horta sought vibrant light

18.4 Victor Horta, Van Eetvelde House, the octagonal hall. Brussels, 1895-97. Photo: C.H. Bastin & J. Evrard, Brussels.

and coloured shadow. He invented a new spatial structure to allow as much light as possible to enter. In the Tassel, Frison and Van Eetvelde Houses, he incorporated a conservatory into the heart of each residence. During the nineteenth century these were frequently built onto facades. However, Horta's conservatories were not for the cultivation of rare plants, but to bring a magical light into the interior. It was the kind of light Huysmans described in *A Rebours*, where des Esseintes dripped coloured oils into an aquarium fitted between a real window and a false one, so that he could: 'treat himself, whenever he wished, to the green or brackish, opaline or silvery shades of a real river, depending on the colour of the sky, the strength of the sun, how likely it was to rain, in other words, on the season and the sky'.[15] Horta treated his clients to similar aesthetic delights.

Although Horta's houses might well have stirred the emotions, they were certainly not sanctuaries for decadent Aesthetes in search of sensual stimulation. They were designed for a middle class whose newly acquired wealth had grown out of a spirit of enterprise and a penchant for the new. As Horta himself was keen to stress in his *Mémoires*, when referring to the construction of the Solvay House: 'I was received into that particular milieu, because the audacity of picking me – a sure sign of energy and independence – demonstrated, albeit in a different way, of the energy required by the Solvay brothers to invent their soda.'[16] This vitality was evident in Horta's ornamental vocabulary – in a note written by the architect, he describes the enchanting moment when 'even I am amazed to see plans, elevations and details spurt spontaneously from the ends of my pencils'.[17] Through his search for a truly personal voice, aspired to by artists and sculptors since the Romantic period – although this did not become a preoccupation for architects until the *fin de siècle* – Horta firmly belonged to the end of the nineteenth century. It was in 1893 that Horta found his inner freedom, during the period between the conception of the Autrique House and that of the Tassel House. To this day we do not know what triggered this.

Horta was not oblivious to the expressive power of the lines and colours he saw in the paintings of the time. Symbolism was clearly important. In 1893 Octave Maus brought Paul Verlaine on a lecture tour to Belgium and Thorn-Prikker exhibited '*Fiancée*', which, according to Madeleine Octave Maus, 'claims to depict the subject through lines arranged in such a way as to recreate for the spectator the state of mind from which the work was born'.[18] Paintings were produced for the Tassel House in

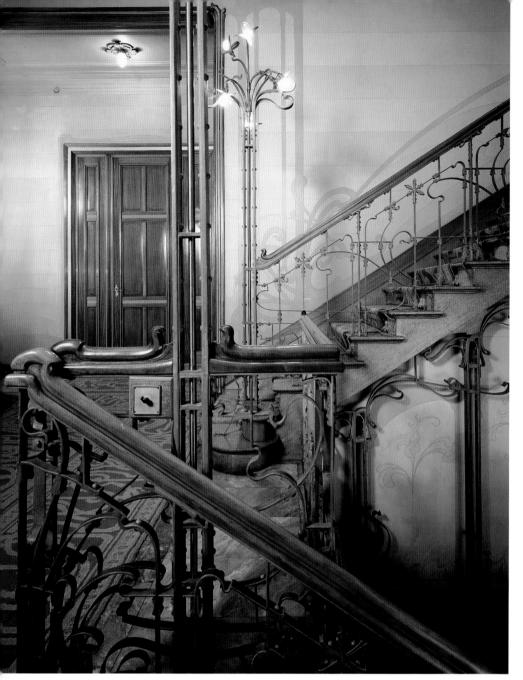

18.5 Victor Horta, Solvay House, stairwell level with first-floor landing. Brussels, 1894. Y. Oostens-Wittamer Hôtel Solvay. Photo: Oswald Pauwels © VAL 33.

18.6 Victor Horta, Horta House, dining room. Brussels, 1898-1900. Photo: C.H. Bastin & J. Evrard, Brussels.

1895. In 1894, Maurice Denis exhibited the *Procession under the Trees* at the Salon of the *Libre esthétique*.

Horta had a preference for warm colours, such as rose reds, honey yellows, golden yellows, ochres and oranges that blended well with the pale and red tones of exotic woods. He used green to contrast with these burnished colours of the setting sun. In the Solvay House,[19] he used a richly coloured green marble for the stairs which echoed the first-floor painted murals (plate 18.5), in gradations of green which gradually gave way to orangey-yellow tones on the floor above, and the grey-greens of the wrought ironwork. In the Van Eetvelde House, on the other hand, the flamboyant colours were confined to the dining room while the drawing room was predominantly green and gold. Matching the green of the onyx panelling the carefully chosen Liberty fabric – Lindsay P. Butterworth's 'Daffodils' – was a harmonious blend of

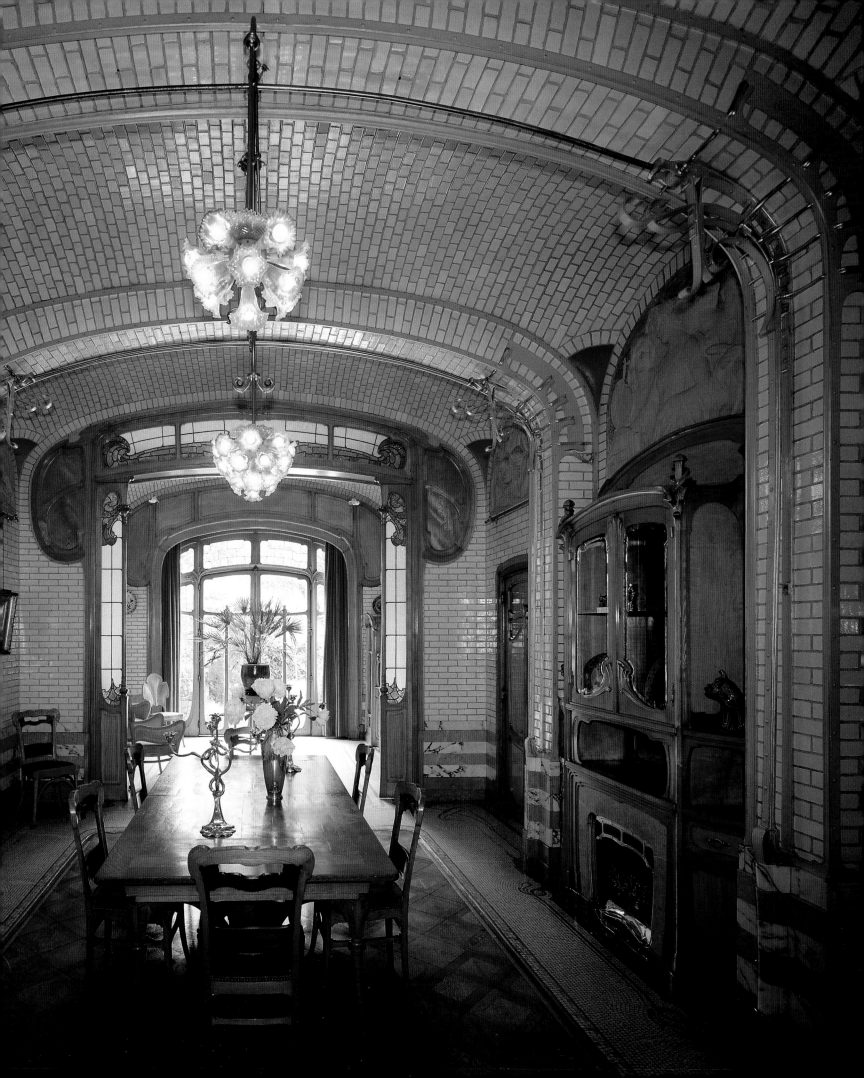

18.7 Victor Horta, Horta House, stairwell. Brussels, 1898-1900. Photo: C.H. Bastin & J. Evrard, Brussels.

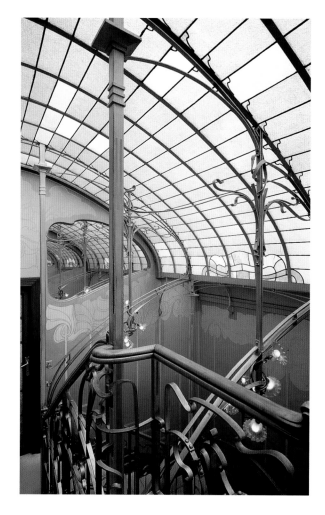

18.8 Victor Horta, Solvay House. Avenue Louise, Brussels, 1894.

nature of Horta's furniture. The century 'succeeded in surrounding woman in an atmosphere of depravity, fashioning furniture according to the shape of her charms, imitating her paroxysms of delight and the curls of her spasms, with the undulations and twistings of wood and copper'.[21]

Horta transformed the capitals of columns into bouquets of lines, echoed in the top corners of pieces of furniture, suggesting a springing to life of the closed forms of Classical architecture and the scarcely more open forms of Gothic architecture. In common with the sculptors of the period, he had a feeling for the three-dimensional and an ability to bring to life lines in space. The fluid dancing lines and shadows of the wrought ironwork interacted with those of the murals without being either identical or completely different. With their rhythms, their turbulence, the interplay of reflections and flashes of fleeting light, Horta's interiors were reminiscent of Verlaine's poetry. Horta used variations in natural light to avoid the tedium of solid surfaces. In his house in the rue Américaine, he set an unusually shaped window in a gabled wall so that the late afternoon sun shone through it above the main staircase (plate 18.7). The dining room walls were covered with white glazed bricks whose cool bare surface came alive in the interplay of light and shade from the garden.

The magic appeal of Horta's interiors was intensified by his unique use of electric lighting. What des Esseintes wanted were 'colours whose eloquence would be reinforced by the artificial light of the lamps'.[22] The Solvay House, the only house that remains more or less completely intact to this day, allows us to see the subtle effects of his artificial lighting (plates 18.1 and 18.5). Horta usually attached the light fittings to supporting structures. Some looked like hanging bells (an impression reinforced by the glass corollas), others like sinuous sprays of flowers, or, in the case of the centre lights, like a shower of stars. Yet this luminous extravaganza, intensified by the interplay of mirrors and bevelled windowpanes, always had a precise aim: to light a dining room or billiard table, or to bring to life the gilded ceiling motifs or the colours of a stained-glass window. The tracked opalescent glass, manufactured by the same process used by Tiffany, changed colour, depending on the source of light. During the day it filtered the light from the sky; in the evening and at night, lit from below, it took on different colours, so that the windows never looked like black holes. Horta replaced the candelabra on the mantelpiece with small lamps reflected in mirrors. The subtlety of the lighting and the elegance of its lines did not

green and yellow. The architect immortalized nature in an intensely stylized form in his materials: paintings, glass and wrought ironwork. The root motif, so clearly visible in the mural of the stairwell in the Tassel House, also appears at the base of his furniture. When designing his larger pieces, Horta avoided feet whenever possible. The piece of furniture was 'rooted into' the architecture by a continuous plinth. In his *Mémoires*, Horta explained that when he designed furniture he was guided by the same principles as those laid down for the building of houses.[20] His best work in this area was the built-in furniture (the sideboards for the Van Eetvelde and Solvay dining rooms as well as his own house); the chairs and tables frequently appeared unnecessarily complex (plate 18.6), as if the revealing of their structural skeleton necessarily went hand in hand with a degree of over-emphasis. The obvious Rococo influence was evidence that Horta had rejected the refined simplicity of the Arts and Crafts movement that had inspired Hankar and van de Velde. The following extract from *A Rebours*, referring to the eighteenth century, offers a perfect definition of the

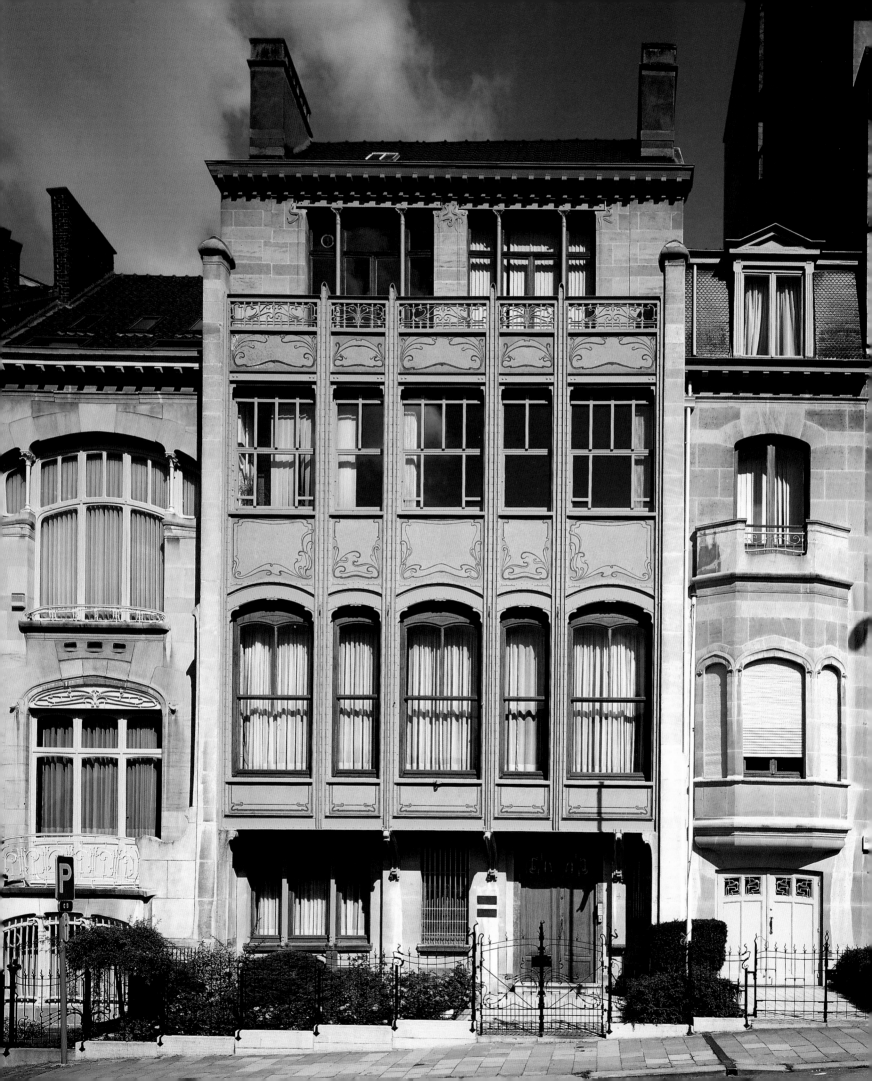

18.9 Victor Horta, Van Eetvelde House, facade. Brussels, 1895. Photo: C.H. Bastin & J. Evrard, Brussels.

18.10 Victor Horta, Deprez-Van de Velde House, detail of stonework. Brussels, 1895. Photo: C.H. Bastin & J. Evrard, Brussels.

exclude an element of tactile sensuality. Everywhere, Horta contrasted hot with cold (wood and metal, wood and marble) and rough with smooth (stone and marble). Making use of a wide range of materials, he gave them organic unity either by bringing them to life with a single flourish, or by highlighting the articulation or the fitting. He avoided pretentiousness by using industrial materials.

Allowing the ironwork to remain visible, he was the first to use industrial building techniques in middle-class residences. The use of such materials allowed a large number of windows in his facades and the elimination of a number of the interior load-bearing walls (plate 18.9). Structure and décor were inextricably linked. Thus, Horta applied the principles expounded by Viollet-le-Duc in *Entretiens sur l'architecture* (1863 and 1872) as he used contemporary materials and adapted both design and ornament when necessary so as to emphasize, rather than conceal, the structure. In the Solvay House he integrated French architectural style when he created an iron and glass vaulted roof in the shape of a double fan in order to illuminate the main staircase, and used contemporary materials to create an English perpendicular Gothic structure.[23]

Horta saw himself as the heir of those he referred to as the 'modern Gothics'. In 1894 he succeeded Ernest Jean Hendrickx, who had worked with Viollet-le-Duc in Paris in 1866–70, as Professor at the Free University of Brussels. He used industrially manufactured laminated iron and then had a craftsman turn it into wrought iron in his forge. The ends of the iron strips and linking pieces were shaped by hand to form a 'C'. Horta exploited the structural potential of metal, but called upon the expertise of the traditional craftsman when it came to integrating it into interior decoration. Dazzled by the controversial modernity of the material, the public was unaware that a highly qualified workforce had been involved. However, this made the manufacture of the metallic components extremely expensive. When Horta covered the walls of his dining room in the rue Américaine with glazed bricks, he used readily available materials. However, he stated in his *Mémoires* that it would have been 'better to have constructed the whole of his ground floor in marble',[24]

because such great care was needed when it came to fitting the bricks that it proved to be ruinous.

Horta was probably also inspired by the architecture of the Flemish neo-Renaissance. Many considered it to be the style that would lead to the affirmation of a Belgian national identity, so crucial to a newly formed State. In 1889 he did in fact spend several months in the workshop of the leading proponent of this style, Henri Heyaert, where he also befriended Paul Hankar.[25] What stayed with him was a sense of movement and a taste for the inherent colour in his material. However, it was above all his Classical training at the Académie des Beaux-Arts in Gent and then in Brussels (1881–84) that fuelled his dream of 'fine architecture', in which stone was the primary element. In his first major private commission, the Autrique House, Horta kept his fee to a minimum so that his clients would be able to afford white stone.[26] White stone was seldom used in buildings by the lower-middle class as it was so expensive. Brick facades were the norm in Brussels. Horta preferred stone facades, because stone could be subtly curved and sculpted so as to accentuate the main features of the design (plate 18.10). By using stone, Horta was seeking to bring to the middle-class house the lessons learned from his mentor Balat, 'who taught him the nature of real Classicism, thus enabling him to transfer its spirit … to other styles and draw new benefits from it'.[27] Horta did not regard Art Nouveau as being a break from the past. Instead his Classicism was a re-statement of underlying and intangible principles.

His desire to create monumental works (incompatible with private housing, which he increasingly came to believe was too susceptible to the vagaries of fashion) grew ever more urgent. In a similar spirit he more or less abandoned furniture design after 1905, with one notable exception – the internal refurbishment of the Wolfers shops in 1909–11. His plans for the Musée de Tournai in 1907–08 revealed a distinct return to more orthodox Classical sources.[28] The dome that was to cover the sculpture hall was an attempt to rethink Balat's design for the large conservatory at Laeken. Horta preserved the vertical continuity of the supports, which his master had interrupted, by placing a stone circle on the Doric columns supporting the glass and steel structure. The final proof of his move into the Classical style proper was the reintegration of the stone column as a basic architectural element, replacing the girder, angle-iron or cast-iron post.

In a note, Horta compared himself to a blazing meteor whose fires quickly vanished into space.[29] His Art Nouveau phase had lasted little more than 10 years …

Gillian Naylor

Munich: Secession and Jugendstil

Art flourished, art swayed the destinies of the town, art stretched above it her rose-bound sceptre and smiled. On every hand obsequious interest was displayed in her prosperity, on every hand she was served with industry and devotion. There was a downright cult of line, decoration, form, significance, beauty. Munich was radiant. (Thomas Mann, *Gladius Dei*, 1902)

19.1 Franz von Stuck, *Künstleraltar* in the studio of the Villa Stuck, 1906. Graphiksammlung im Münchner Stadtmuseum.

In Thomas Mann's 'radiant Munich', art was a major industry, the focus of social, intellectual and political life. The Wittelsbach dynasty, who had established their court there in the thirteenth century, were patrons, connoisseurs and collectors, and since the beginning of the nineteenth century their collections had been available to all. The Glyptothek, designed by Leo von Klenze in 1830, displayed Ludwig I's acquisitions of Greek and Roman antiquities; this was the first public museum in Germany, a symbol of Munich's Enlightenment. The Alte Pinakothek, also designed by von Klenze, contained the Wittelsbach's magnificent collections of 'Old Masters'. It opened to the public in 1836, and the Neue Pinakothek, completed in 1853, displayed Ludwig's collection of contemporary art.

At the beginning of the nineteenth century, therefore, Munich was consolidating its reputation as an art town. Known as 'Athens on the Isar', it celebrated international achievements in the art on display there. Its architecture mirrored the town's Enlightenment, and its prestigious Academy of Fine Arts, which had been established in 1808, was to attract students from the Nordic countries, Russia and Poland, as well as from the United States.[1] Unlike Vienna and Berlin, Munich was not a *Grossstadt*. Its population had risen from 36,000 to 95,000 between 1800 and 1840 and continued to rise throughout the century, so that by 1900 there were over half a million inhabitants (compared with Vienna's two million). Salt, beer, cloth and wine, and its position on a major trade route, had contributed to the town's prosperity, and its location also promoted its steady growth in the nineteenth century.

However, Munich's modernization was cultural rather than industrial. Ludwig I's Enlightenment projects had celebrated science as well as art, and in 1839 two members of the Bavarian Academy succeeded, appropriately enough, in 'painting' a picture with light, so the first photographs produced in Germany were of Munich, and the optical

industry was subsequently founded there.[2] Ludwig's successor, Maximilian II, set up Germany's first Institute of Hygiene in 1865 (although the town did not have a water supply until 1883), and the First International Electricity Exhibition was held in the Glaspalast in 1882. Munich's response to London's Crystal Palace, the Glaspalast was built as an exhibition hall in 1854 and its first exhibition – the *Allgemeine Ausstellung Deutscher Industrie und Gewerbeerzeugnisse des Zollvereins* (General Exhibition of German Industry and Trades of the Zollverein) – displayed industrial products from throughout Germany. The Glaspalast also provided space for exhibitions of work by both German and foreign artists, and in 1869 it housed the first exhibition of the newly formed *Münchner Künstlergenossenschaft* (Munich Artists' Association). There were over 3,000 exhibits (including works by Courbet and the French Barbizon painters), and 100,000 tickets were sold. (Munich then had a population of 160,000.)[3] The activities of the Artists' Association consolidated Munich's reputation as an art town. As well as exhibitions, it organized lotteries, dinners, dances, and, above all, parades. As one observer commented: 'a single successful fête organized by the artists, an effective parade, did more to popularize Munich art than half a dozen auspicious exhibitions.'[4]

The liberal policies of the Artists' Association in its early years promoted populism as well as the avant-garde, and they also encouraged sales. Munich's artistic community benefited from the activities of the Artists' Association – socially, intellectually and financially – at least until the 1880s. By this time, many of the artists found they could no longer compete in such a vigorous and eclectic marketplace. There were the inevitable disputes within the Association: debates about how many artists to include in the displays, who and what to exhibit, and whether national or international interests should be promoted. In response to the growing acrimony, a group of younger artists declared

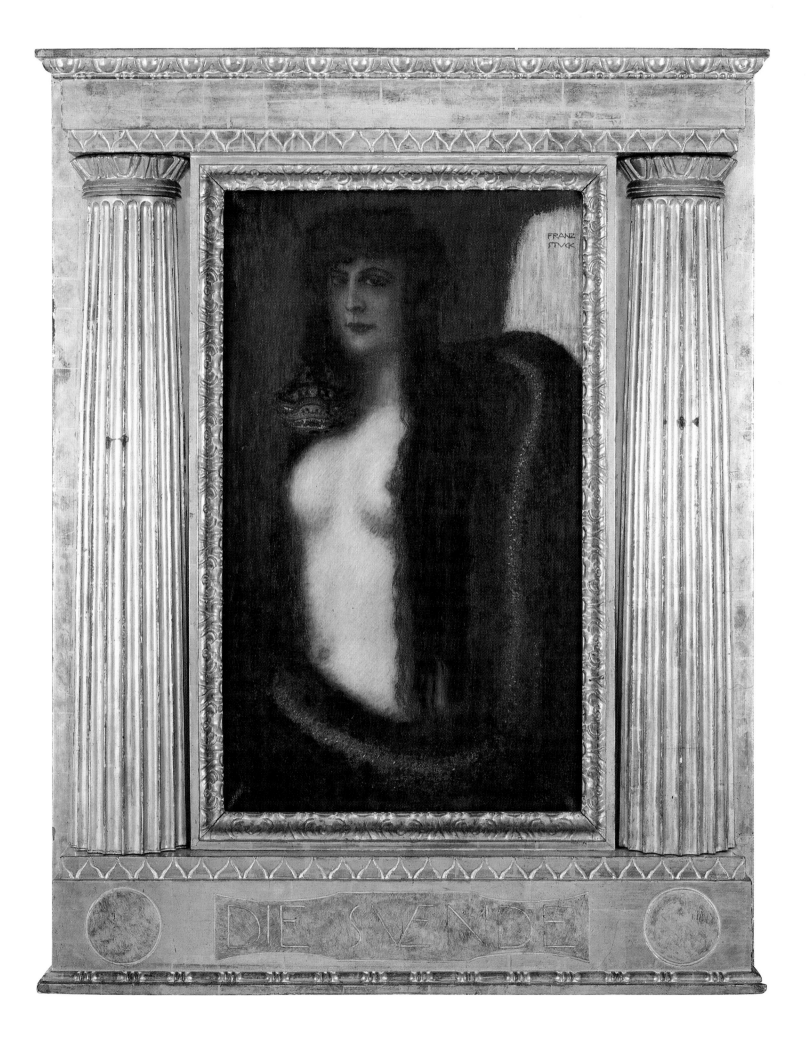

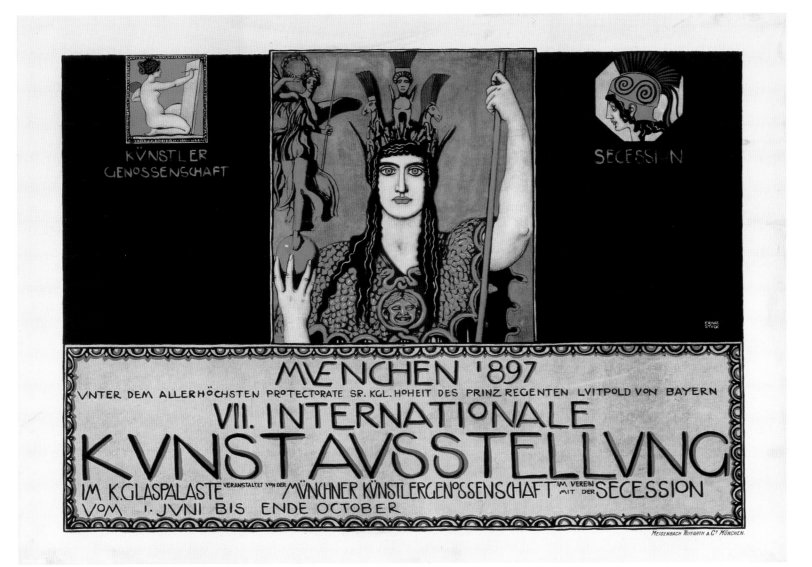

19.2 Franz von Stuck, *The Sin*.
Oil on canvas. German, *c*.1906.
Museum Villa Stuck, Munich.
Photo: Schenkung Ziersch.

19.3 Franz von Stuck,
VII Internationale Kunstausstellung.
Lithograph. German, 1897.
Museum Villa Stuck, Munich.
Photo: Wolfgang Pulfer.

their secession from the Association in 1892, and set up a rival organization, the *Verein Bildender Künstler Münchens* (the Munich Society of Visual Artists). In 1893 the new society had its own Secession Building, on a prime site on the Prinzregentenstrasse.

Unlike the Vienna Secessionists (see chapter twenty), the Munich dissenters could not complain of provincialism. The Artists' Association had promoted a European avant-garde, but it had also promoted traditionalism in its gargantuan exhibitions, and this apparent disregard for distinction – this failure to promote an élite – had led to what the Secessionists described as the 'demise of the Munich art market'. The Secessionists proposed more selective exhibitions of both avant-garde and traditional art, claiming to aspire to 'a new goal in small numbers'.[5]

As a portent of the future, the first Munich Secessionist exhibition in 1893 included paintings by Franz von Stuck

and Otto Eckmann, both representative of the new generation. Stuck (he was awarded his 'von' in 1906), was a self-made man, and an archetypal Munich artist. A miller's son, he was a millionaire by the time he was 50, and he built himself a magnificent house (the Villa Stuck) on the Prinzregentenstrasse in 1898. This is an imposing neo-Classical *Gesamtkunstwerk* – Stuck designed the furniture, furnishings, friezes and the electric light-fittings. The Villa's collection now includes the poster he designed for the first Secession exhibition. An elaborate *Künstleraltar* (artist's altar) in Stuck's studio (plate 19.1) displays his painting, *The Sin* (plate 19.2), which was also in the first exhibition, as its centrepiece. The poster (plate 19.3) shows a helmeted Pallas Athene. She is a Classical goddess, abstracted, two-dimensional and stylized, and she proclaims Stuck's preoccupation with the Classical past. *The Sin*, however, presents a subversion of this past. Sin is female, bare-breasted and

19.5 Otto Eckmann, *Irises*.
Colour woodcut published in *Pan*.
German, 1895.
V&A: NAL.

19.4 Thomas Theodor Heine,
Devil. Bronze. German, 1902.
Private Collection.
Photo: Mario Gastinger, Munich.
© DACS, 2000.

provocatively seductive, and the snake around her shoulders symbolizes betrayal and the forbidden fruits of knowledge. She is the archetypal *femme fatale*, and her threatening femininity signals her modernity.

Modernity, in the first Secession exhibition (as in those in the Glaspalast), was represented by both Naturalist and Symbolist painters. The Naturalists presented scenes from everyday life, many depicting the lives of peasants in the countryside or in their homesteads; this preoccupation with folk traditions and the simple life was to be reflected in the work of many of Munich's designers. The Symbolists, on the other hand, offered a more subversive world of introspection, desire and uncertainty, suggesting both universality and individuality through the manipulation of myth and the subconscious. Fernand Khnopff's *I Lock My Door Upon Myself* and Gerhard Munthe's *The Suitors* were included in the exhibition. Munthe's painting, with its stress on two-dimensionality and its obsessive repeating patterns, was later used as a cartoon for tapestry, indicating one obvious connection between the fine and the applied arts. These Symbolist, proto-Surrealist visions also lent themselves to caricature, especially in the pages of *Simplicissimus*, the satirical magazine which had been founded in Munich in 1895 by Alfred Langen. Thomas Theodor Heine's illustrations for *Simplicissimus*, for example, satirize the genre, and his grotesque bronze *Devil* (1902) challenges ideals of order and stability (plate 19.4; plate 9.15).

The other key exhibitor at the first Secessionist exhibition, Otto Eckmann, sold all his paintings in 1894 in order to concentrate on design. He had studied applied arts in Hamburg and Nuremberg before moving to Munich, and Justus Brinkmann – then Director of Hamburg's *Museum für Kunst und Gewerbe* (Museum for Arts and Crafts) – had introduced him to Japanese prints.[6] This was obviously a decisive experience for Eckmann, and in 1895 he began producing Japanese-inspired woodcut prints for *Pan* and for the Munich-based magazine *Die Jugend* (plate 19.5), which was launched in 1896. *Die*

Jugend was to give its name to the German equivalent of Art Nouveau: Jugendstil (plate 19.6). Like Art Nouveau, Jugendstil defies precise definition. It embraced von Stuck's Symbolism (he designed the *vignette* for *Pan*), together with a preoccupation with nature and natural form.

As well as working for *Die Jugend*, Eckmann designed wall-hangings, textiles, ceramics, metalware, light-fittings and furniture (plate 19.7). His *Five Swans* tapestry (1896–97) became an icon of Jugendstil. It was described as 'the freshest product of the new movement'[7] and more than 100 examples were woven (plate 11.12). It was illustrated in all the major 'art' magazines and was widely exhibited. Its fusion of the abstract and the naturalistic, its manipulation of space, its symmetries and its use of line defined its modernity. According to one critic, who acknowledged the Japanese influence, Eckmann had suppressed 'the material process' in order to concentrate 'entirely on the decorative'.[8] The 'decorative', for Eckmann (who was to become an instructor in ornamental

painting in the Berlin *Kunstgewerbeschule* in 1897), was derived from nature. His designs for metalwork, like his work for *Pan* and *Die Jugend*, celebrated natural form, evoking the rhythms and the tensions of flowers and leaves, buds and stems. His light-fittings and candlesticks demonstrated his interpretation of the *Neue Formen* (New Forms)[9] that were to replace historicism and transform both art and design.

The Secessionist designers' contribution to this Munich-based renaissance was demonstrated in the *VII Internationale Kunstaustellung* (Seventh International Art Exhibition) which was held in the Glaspalast in 1897. Two rooms in this vast exhibition (both the Artists' Association and the Secession group were exhibiting there) were devoted to the applied arts. Glass by Gallé and Tiffany was on show, but pride of place went to the work of Munich designers, including Otto Eckmann, Richard Riemerschmid, Hermann Obrist, August Endell and Bernhard Pankok. The aim of the exhibition was to present 'the best that *modern* applied art has accomplished'. The designs displayed had to 'fulfil the

19.6 Fritz Erler, cover of
Die Jugend. Colour lithograph.
German, 1901.
V&A: E.3178-1921.

19.7 Otto Eckmann, armchair.
Carved beech, leather. German,
1900. Made for Siegfried Bing.
V&A: 2009-1900.

requirements of our modern life'; they were to be original (neither imitative nor historicist), and they had to be 'abreast of the latest developments in technology'. In addition, the organizers would exclude 'such objects of modern applied art as appear to overstep the limits of artistic decorum or appear as exaggerated and misguided through a disregard for materials or through a striving for originality'.[10]

Early in 1898, the organizers of the Applied Art Section, including Riemerschmid and Obrist, announced the formation of the *Vereinigte Werkstätten für Kunst im Handwerk* (United Workshops for Art in Handicraft). The workshops were to consolidate the aims of the exhibition, and to promote both the production and the sale of modern design. From the outset, therefore, the *Vereinigte Werkstätten* stressed practicality rather than ideology. Despite the word *Handwerk* in the title, the English ideal of the hand-made was not emphasized, and the need for a division of labour was acknowledged. (It was taken for granted that 'craftsmen' would execute the artists' designs.) The use of machinery (or 'the latest technology') was recommended, and the aim was to 'offer the buyer products of the new arts and crafts … at a reasonable price'. The *Vereinigte Werkstätten*, therefore, were very different from their British and Austrian equivalents. Unlike the *Wiener Werkstätte* (see chapter twenty), they could not necessarily rely on wealthy patrons, and they were not concerned with the redemption of middle-class taste. Their founding aims were essentially practical – they were, after all, providing the 'artist' with an alternative form of income, as well as establishing Munich's role in the European renaissance of craftsmanship. Following the 1897 exhibition, Munich was to become a centre for the promotion of the new applied art. Posters and prints by Beardsley, Mucha and Steinlen, as well as illustrations for *Die Jugend* were exhibited in 1898, and in 1899 Charles Rennie Mackintosh and the Macdonalds, Charpentier, Lalique, Fabergé and Henry van de Velde, as well as work by the designers of the *Vereinigte Werkstätten*, were included in the Glaspalast exhibition.

These and subsequent displays at the turn of the century (including exhibitions in Dresden, Darmstadt, Krefeld, Paris and Berlin) demonstrated the Munich designers' responses to Art Nouveau, and their room in the 1897 exhibition had indicated the potential, as well as the complexity, of their approach. These designers (including Obrist, Endell, Riemerschmid and Pankok) were all confronting a personal interpretation of form, and although the architect Theodor Fischer had created an ensemble of their work, each designer had a personal conception of 'applied art'.

Hermann Obrist,[11] who was born in Switzerland, had arrived in Munich in 1894. He had studied medicine and botany in Heidelberg and Berlin, and he had also visited England and Scotland in 1887 (his mother was of Scottish descent). He then trained briefly as a designer (he studied ceramics at the *Kunstgewerbeschule* in Karlsruhe and in Thuringia), and as an artist at the Académie Julian in Paris, before moving to Florence in 1892 where he set up an embroidery workshop with Berthe Ruchet. In 1896 he exhibited 35 embroideries (designed by him and executed by Ruchet) in a gallery in Munich. This exhibition then travelled to Berlin and to London, where it was included in the Arts and Crafts Exhibition Society's programme, and it established Obrist as a pioneer of the 'New Art'. In November 1896 Mary Logan wrote in *The Studio*: 'There are few people to whom the embroideries of Herr Hermann Obrist will not come as a surprise … . His embroideries are copies of nothing, not even nature … he makes of embroidery a great decorative art, perhaps one of the greatest.'[12]

Obrist's embroideries evoke rather than imitate nature, and his 'whiplash' embroidery of 1895 (plate 1.12) is also an icon of Art Nouveau. Unlike the hermetic, Japanese-inspired patterns of Klimt and his colleagues in the *Wiener Werkstätte*, Obrist's designs float in space. They are tense, vibrant and flame-like, and Berthe Ruchet's remarkable skills emphasize the subtlety as well as the abstraction of Obrist's line. Georg Fuchs, writing in *Pan*, described the embroideries as 'organic' rather than 'naturalistic'. (Fuchs associated Naturalism with the work of the Japanese.)[13] Although Obrist, like so many of his contemporaries, was obviously impressed by Japanese work, one major source of his inspiration was the work of Ernst Haeckel, who had been publishing his studies of natural form since the 1860s.[14] Obrist may well have been introduced to Haeckel's work through his own botanical studies in Heidelberg, and several of his sketches and drawings are directly related to Haeckel's illustrations (plate 3.1). The marine forms of underwater flora and fauna which were included in Haeckel's *Kunstformen der Natur* (*Art Forms of Nature*)[15] relate to the abstract, quasi-Surreal qualities in Obrist's designs, where the forms seem suspended in non-gravitational space and subject to indefinable forces. Yet, as Fuchs pointed out, they remain 'organic' – based on scientific observation of natural form.

Similar qualities characterize the work of August Endell, Obrist's colleague and disciple. Endell was studying philosophy, psychology and aesthetics in Munich when he met Obrist, and decided to dedicate his life to art. In 1897 he

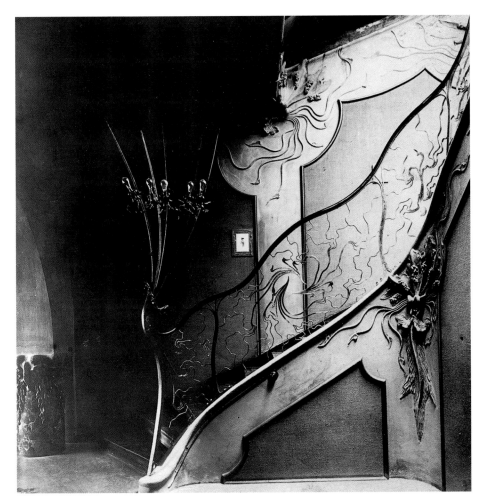

19.8 August Endell, Hof-Atelier
Elvira (Elvira Studio), stairwell.
Munich, *c.*1897.

Photo: Bildarchiv Foto, Marburg.

woodwork, metalwork, textiles and ceramics, and painting,
sculpture and drawing were also taught there. There was,
in fact, no demarcation between fine and applied art, and
no pressure for specialization – the students were encour-
aged to work in a range of media, and they all took an *Ele-
mentarunterricht* (elementary course) during which they were
allowed to '*jubelnd ausschwärmen*' (joyously swarm) with the
minimum of direction. There are obvious analogies with
the Weimar Bauhaus here, especially when Johannes Itten
was influencing its initial programme, and it is significant
that both Obrist and Endell, as well as Walter Gropius,
were considered for the Directorship of the Bauhaus.

Obrist and Endell represented one potent strand in the
Jugendstil ideal. They were both mystics and philosophers,
and for them art, like nature, was a universal life force.
They believed that design, or the revitalized Arts and
Crafts, should reflect the structures and the forces of
nature, and present a new dynamic order. 'In the chaos of
[Obrist's] form lies, in embryonic form, a higher architec-
tonic order' wrote Karl Scheffler in 1910.[19] The *Debschitz
Schule* survived until the First World War, although Endell
had moved to Berlin in 1901, and Obrist (who suffered
from deafness) had retired in 1904. The philosophies of
the *Schule*, however, were reflected in the work of its stu-
dents, and together with the designers associated with the
Vereinigte Werkstätten, they continued to demonstrate the
unique qualities of Munich Jugendstil.

By the turn of the century, the participation of the *Vere-
inigte Werkstätten* in various exhibitions had established both
Munich's and its designers' reputation, especially in Paris
and Berlin. Bernhard Pankok, for example, was awarded a
grand prix for a room he designed for the 1900 *Exposition
Universelle* in Paris. Pankok had trained first as a restorer
and decorator, and then as a painter before he arrived in
Munich in 1892. He designed *vignettes* for *Pan* and *Die
Jugend*, and then began designing furniture for the *Vereinigte
Werkstätten*. The display cabinet (1899, plate 3.19) which he
designed for Obrist's house in Schwabing is characteristic
of Pankok's work at this period. J.A. Lux, in 1908,
described it as '*spukhaft*' (ghostly), like something out of a
dream or a fairytale,[20] and its skeletal frame, like iinsects'
legs, demonstrates the organic and 'expressive forces' that
Obrist admired. Pankok, like Obrist and Endell, did not
stay in Munich for long. In 1901 he was appointed a Pro-
fessor in the School of Applied Art in Stuttgart. The *Vere-
inigte Werkstätten*, however, continued to maintain their
pioneering reputation, although concepts of 'innovation'
were to change radically in the years leading up to the
First World War.

designed the Hof-Atelier Elvira (Elvira Studio) for Anita
Augspurg and Sophia Goudstikker, radical feminists and
photographers who had decided to open their own photog-
raphy studio.[16] Ironically, only photographic records of this
building now survive (the Nazis removed its facade, which
they considered degenerate, in 1937, and the building was
destroyed in the Second World War). The facade (plate 1.5)
was defined by abstract swirling motifs; like Obrist's
embroideries, Endell's plaster relief floats in space, and it
also evokes a submarine landscape. The interior of the
studio, with its exuberant flowing metalwork (plate 19.8),
recalls the work of Horta, and both Obrist and Endell
designed furniture with similar metalwork decoration.

Obrist found 'organized images' in natural forms, 'full of
structures, full of expressive forces, full of linear, plastic,
constructive movements of unprecedented abundance, and
astonishing variety'.[17] Both he and Endell demonstrated
their theories in books and articles as well as lectures, and
in 1902 Obrist opened a school in Munich with Wilhelm
von Debschitz in order to promote his philosophies of
form. The *Debschitz Schule*[18] offered workshop training in

The long career of Richard Riemerschmid, who was born in Munich in 1868, mirrors the transformations in priorities for design, and the reinterpretation in Munich of those ideals of 'modernity' that were stressed in the *Werkstätten*'s founding statement. Riemerschmid had trained as a painter, and he had exhibited lyrical landscapes with the Secession in the early 1890s and produced illustrations for *Die Jugend*. The 1897 Glaspalast exhibition included a mural by Riemerschmid, a large cabinet, a stained-glass window depicting tennis players, and *Wolkengespenster* (*Cloud*

19.9 Richard Riemerschmid, *Garden of Eden*. Oil on canvas, with gessoed and painted wood. German, 1900. Collection Barlow Widmann, Munich. Photo: Mario Gastinger. © DACS, 2000.

Ghosts), a painting evoking *Walpurgisnacht* (in German folklore, the night of a witches' sabbath), with a radiant full moon, swirling clouds and demonic figures.

This versatility of both style and medium typifies Riemerschmid's achievement. In 1897, when he was first experimenting with 'applied' art, he was obviously aware of international developments. He subscribed to *The Studio*, and the stained glass, with its contemporary subject-matter, recalls the work of Tiffany. His painting, however, was mainstream Munich Symbolism, and moved across a dark Gothic range from demons and distraught maidens to sun-

filled yet hauntingly uninhabited landscapes (plate 19.9). His early furniture similarly plays on Gothic precedents.

Riemerschmid had designed his first furniture in 1895. Unable to find suitable furniture following his marriage, he had followed Arts and Crafts precedents and designed his own. Like the Glaspalast piece, these early designs draw on historical, as well as Arts and Crafts sources, although the decoration (brasswork and carving) is obviously inspired by contemporary Art Nouveau. Leopold Gmelin, reviewing the Glaspalast exhibition, praised Riemerschmid's cabinet for its 'simplicity of construction' and its 'modest materials'. He wrote that 'its structure is rendered wholly transparent'.[21] This stress on simplicity, and on formal or structural qualities, anticipates Modernism's preoccupation with designs that were 'drawn in space'.

Riemerschmid's best-known design – the music-room chair (plate 10.15), which was first exhibited in Dresden in 1899 – demonstrates this spatial awareness, and this fusion of form and structure. Made in the *Vereinigte Werkstätten*, the chair established Riemerschmid's reputation as a furniture designer, and it also led to further commissions at the turn of the century. One of the most important of these was for Carl Thieme, the Director of an insurance company, and from 1899 to *c*.1906 Riemerschmid was designing furniture and furnishings for the Haus Thieme (Thieme House) in Munich. Each room demonstrated a consistency of design. For example, the side-table and tea-table, like the music-room chair, emphasize structure to achieve forms that are both organic and functional, while the reception-room chairs (plate 19.10) are more formal. The golden motifs on the tall backs and the mother-of-pearl inlays are repeated on the armchairs; cabinets designed for the room also have mother-of-pearl inlays (plate 19.11).

Most of Riemerschmid's designs for private commissions were made in the *Vereinigte Werkstätten*, by master craftsmen such as Wenzell Till and Johann Zugschwert. Riemerschmid also designed carpets (including some for the Haus Thieme, plate 19.12), light-fittings and cutlery (plate 19.13), all of which were made by the *Werkstätten*. His success as a designer, and his ability to work in a range of media, also led to commissions from prestigious manufacturers such as Meissen. In 1903 the Meissen porcelain factory asked him to design a service 'in the same spirit as the best furniture and interior furnishings',[22] and he produced a simple range in blue and white, which related to the firm's eighteenth-century designs. These references to the past also characterize Riemerschmid's stoneware (most of it made for Reinhold Merkelbach of Grenzhausen). In this case, however, it is a folk past (a national past) that Riemer-

schmid is evoking, a past that could be celebrated through the production of 'everyday' goods – simple household wares that were available to all.

The ideals of William Morris and the pioneers of the English Arts and Crafts movement, as well as the intentions of the *Werkstätten* when they were first founded, were once again prioritized in these developments. It is significant that by 1901 Riemerschmid was also producing designs for the Dresden Workshops,[23] which had

been founded in 1898 by his brother-in-law, Karl Schmidt. The Dresden enterprise was as successful as its equivalent in Munich, but it had a more clearly defined social ideal, which was reflected in its priorities for production. Schmidt, who had been trained as a carpenter, was determined to design for everyman, rather than for an élite. He had visited England, and he applied the lessons of Morris and his followers to his own enterprise in Dresden-Hellerau, where he built a garden city

19.10 Richard Riemerschmid, side chair for reception room in the Haus Thieme (Thieme House). Maple and mother of pearl and upholstery. German, 1903. Stadtmuseum, Munich. Photo: Wolfgang Pulfer.

19.11 Richard Riemerschmid, cupboard for the reception room in the Haus Thieme (Thieme House). Stained maple and mother of pearl. German, 1903. Stadtmuseum, Munich. Photo: Wolfgang Pulfer.

19.12 Richard Riemerschmid, hand-knotted carpet for the Haus Thieme (Thieme House). Wool. German, 1903. Collection Barlow Widmann, Munich. Photo: Mario Gastinger. © DACS, 2000.

19.13 Richard Riemerschmid, cutlery. Silver. German, 1899–1900. Stadtmuseum, Munich. Photo: Wolfgang Pulfer.

19.14 Bruno Paul, *Kunst im Handwerk* exhibition poster. Colour lithograph. German, 1901. Stadtmuseum, Munich. Photo: Wolfgang Pulfer.

(designed by Riemerschmid) for his workers, with a training school and a theatre.

Schmidt broke with Arts and Crafts precedent, however, by introducing ranges of what he described as *Maschinenmöbel* (machine furniture) or *Typenmöbel* (type furniture), made from standardized components, combining machine and hand techniques. Riemerschmid designed his first *Maschinenmöbel* range for the Dresden Workshops in 1905, and these developments were welcomed by critics who challenged the excesses of Jugendstil. This furniture, designed 'in the spirit of the machine', was 'practical, simple, honourable and inexpensive', and it also signalled the renaissance of a national or German folk art that was appropriate to twentieth-century needs and ideals. Hermann Muthesius wrote: 'Here is middle-class art of general validity, here is folk art. … It is worthy of this name because it is modest and German.'[24] Riemerschmid's *Maschinenmöbel* and the Dresden Workshops' emphasis on the production of simple and inexpensive household goods – Riemerschmid also designed fabrics for them – confirmed the priorities of a new generation of design idealists in Germany. These products

were intended to be both economically viable and desirable, and at the same time they celebrated their German identity – restoring the spirit of *Volkskunst* (people's art) that would demonstrate Germany's unique contribution to twentieth-century design.

Several members of the Munich organization, including Bruno Paul (plate 19.14) and Peter Behrens, made this transition from Jugendstil to functionalism at the turn of the century, and it is no coincidence that the influential *Deutscher Werkbund* (German Work Association), which aimed to promote 'the best in art, industry and trade', was founded in Munich in 1907. The 'Munich style' was internationally acclaimed, but in France the achievements of these Munich designers were seen as an 'artistic and commercial Sedan'. It was the Germans, they maintained, and not the French, who had 'reformed the aesthetics of the home to make the modern house a combined work of art, a practical construction of simple and dignified beauty'.[25] The *Gesamtkunstwerk* could now be achieved through machine production; it was available to all and it was German, and it was in Munich that Art Nouveau was transformed into art for everyday life.

DER·ZEIT·IHRE·KVNST·
DER·KVNST·IHRE·FREIHEIT·

VER·SACRVM·

Gillian Naylor

Secession in Vienna

If, these days, you pass by the river Wien in the early morning… you can see,

behind the Academy, a crowd of people standing around a new building.

They are office people, workmen, women who should be on their way to work,

but instead stop in amazement, unable to tear themselves away. They stare, they interrogate

each other, they discuss this 'thing'. They think it strange, they have never seen anything

of the kind, they don't like it, it repels them. (Hermann Bahr, 1900)[1]

20.1 Josef Maria Olbrich,
Secession Building, Vienna,
1897–98.
Photo: C.H. Bastin & J. Evrard,
Brussels.

The 'thing' which fascinated and repelled the Viennese workers was the Secession Building (plate 20.1), designed by Josef Maria Olbrich in 1897. It was white and alien (they called it the 'Assyrian convenience'); it was crowned by a gilded cupola and it celebrated Art. The words '*Der Zeit ihre Kunst, Der Kunst ihre Freiheit*' ('To the Age its Art, To the Art its Freedom') were emblazoned over its doorway, and Art, in this context, embraced – or confronted – painting, sculpture, architecture and applied art.

Vienna, with its prestigious museums and art galleries, its palaces, its churches, its Opera House and its concert halls, was known as the City of Art. Its reconstruction from the 1860s involved a re-presentation of the city. The civic buildings on the *Ringstrasse* were designed to demonstrate historical or historicized hierarchies of order; the concentric layout of the broad ring-roads confirmed that order, and at the same time, it proclaimed the city's modernity. The old town formed the core of the ring – a reminder of the past – the buildings on its new periphery transformed the past into an ideal of the present. They were contemporary embodiments of Monarchy and Empire, Church and State, culture and learning. Designed to awe, they represented the need to maintain tradition; they were stations of control that were placed within the city like the Stations of the Cross.

As symbols of an imperial culture, these monuments were there to be admired and contemplated. The layout of the *Ringstrasse* both promoted and controlled circulation: this was a modern city, a nineteenth-century construction, designed for access as well as display. It was the capital of an Empire, the focus of commerce as well as government. Between 1850 and 1910 Vienna's population rose from half a million to two million inhabitants. Railways linked the city to European capitals. Electric street-lighting was installed in 1893, and electric trams were introduced in 1894, the same year that the architect Otto Wagner won

the competition to design and construct the Vienna City Railway. This new transport system (the *Stadtbahn*) was to provide access to the Inner City as well as the new suburbs. It involved engineering (the construction of tunnels and cuttings) and architecture (the design of new bridges, stations, seating, lighting, ticket offices and all the paraphernalia of modern urban transport). The project demonstrated concepts of urbanism that were alien to the *Ringstrasse* ideal, confronting what its architect was to describe as 'the colossal technical and scientific achievements as well as… the fundamentally practical character of modern mankind'.[2]

In 1894, the year that he embarked on the *Stadtbahn* project, Otto Wagner was appointed Professor of Architecture at the Academy of Fine Arts in Vienna. 'The sole departure for our artistic work must be modern life', he told his students in his inaugural lecture,[3] and this affirmation of modernity confirmed the convictions of several of his students and colleagues there. Olbrich, the architect of the Secession Building, was working in Wagner's office; Josef Hoffmann, who had been a student at the Academy, was also working for Wagner (from 1898–99). Koloman Moser studied at the Academy and at Vienna's *Kunstgewerbeschule* (School of Arts and Crafts), and he was to become a co-founder with Hoffmann of the *Wiener Werkstätte* (Vienna Workshops) in 1903.

In the 1890s, Olbrich, Hoffmann and Moser, representatives of a younger generation of artists and designers, were also campaigning for modernity. They were members of the *Künstlerhaus* – an exclusive organization which controlled who and what should represent the arts in Vienna – and they were challenging its authority. The old guard of the *Künstlerhaus* celebrated the status quo: all 'foreign' art was suspect, especially when it subverted tradition, and Austrian artists who campaigned on behalf of the new were denied support and exhibition space. Inspired by the model of the

Munich avant-garde, Hoffmann and his colleagues declared themselves Secessionists. The *Vereinigung Bildender Künstler Österreichs – Wiener Secession* (Association of Austrian Artists – Vienna Secession) was founded in April 1897 under the chairmanship of Gustav Klimt. *Ver Sacrum* (Sacred Spring), the journal of the Secession, was launched in January 1898, and the group's first exhibition opened in rented premises in March. A month later the foundation stone for the new Secession Building was laid (plate 20.1). Its early exhibitions introduced European art to Vienna – an eclectic selection focusing on the introspective Symbolism of painters such as Khnopff, Klinger, Segantini and Toorop. Viennese *fin-de-siècle* anxieties were represented by the work of Gustav Klimt. Klimt's early work for *Ringstrasse* commissions conform to historicist ideals, for example his paintings for the staircases in the Burgtheater (1886–88) and the Kunsthistorisches Museum (1891). When he allied himself to the Secessionists within the *Künstlerhaus*, however, Klimt both challenged and transformed conventional iconographies.

Klimt's *Pallas Athene* (plate 2.1), exhibited in the Secession Building when it opened in 1898, is no longer a Hellenic symbol of wisdom and the civic ideal. She is a pagan goddess, a Brunhilde with golden helmet and breastplate, carrying the orb of truth. Klimt's figure of 'Truth' is female, blind and naked, and her flaming hair commemorates the Jugendstil sisterhood. This *Pallas Athene*, however, celebrates a female ascendancy – the power as well as the threat of femininity – which Klimt presents as both real and abstract, anticipating his later portraits and allegories, for example the Beethoven frieze and the murals for the Palais Stoclet. Klimt's manipulation of the real and the abstract is characteristic of the Austrian (or Viennese) response to Art Nouveau. There are few references here to nature, or to metaphors of growth and decay, and his sources are ahistorical. His figures are stylized and iconic – they are modern interpretations of ancient archetypes. There are allusions to the neuroses and obsessions of Freudian analysis (Freud's *Interpretation of Dreams* was published in 1899), and Klimt's interpretations also suggest indulgence. His subjects, male and female, are shrouded in a blaze of colour in a mosaic or collage of geometric patterns and this interpretation of the decorative relates Klimt's paintings to architectural space.

The Eighth Secession Exhibition, which opened in November 1900, included contributions from Meier-Graefe's La Maison Moderne in Paris, C.R. Ashbee's Guild of Handicraft, and the Glasgow Four (Charles Rennie Mackintosh, Margaret Macdonald, and Frances and James Herbert McNair, who were given a room of their own to furnish). Work by Moser and Hoffmann, who were both teaching at Vienna's *Kunstgewerbeschule* at that time, was also displayed. Hoffmann had been appointed Professor at the *Kunstgewerbeschule* in 1899, the year that he left Otto Wagner's office. The School was founded in 1868 on the South Kensington model, and was linked with the Museum of Art and Industry (which had been set up in 1863). When Hoffmann joined it, both the School and the Museum were being radically reorganized (or 'Secessioned') by Arthur von Scala, then Director of the Museum. Otto Wagner was appointed to the curatorial board of the Museum; Felician von Myrbach, a Secessionist, took charge of the School; and Moser and Hoffmann were appointed to its staff. The new programme for the School was reflected both in the work of its students, and in Hoffmann's commitment to domestic architecture and design. He was involved in the *Wiener Kunst im Hause* (Viennese Art in the Home), an organization set up in 1901 'in order… to translate developments, ideas and experiments into combined work in a common cause'.[4] The Art in the Home exhibitions included work by his former students – many of whom went on to work for the *Wiener Werkstätte*.

C.R. Ashbee's Guild of Handicraft was one obvious model for the *Werkstätte*. Established in 1888 and located in the East End of London, the Guild was originally both a school and a workshop. In keeping with English Arts and Crafts idealism, however, its aims were essentially philanthropic, and based on the Ruskinian belief in social and moral redemption through design. Following the move to Chipping Campden, Gloucestershire, in 1901, the Guild's activities came to be associated with ruralism and the 'Simple Life' (see chapters eight and fourteen).[5] Hoffmann's intentions, however, were very different. He was concerned with raising the standards of Viennese craftsmanship, relating this craftsmanship to the modern interior, and promoting an urban ideal of decorative art. The exhibits selected for the early Secession displays set the standard; they represented a European avant-garde and an aesthetic rather than a social response to the challenges of modernity and the designers associated with the Secession developed a style that became quintessentially Viennese.

Recollecting the Eighth Secession Exhibition in 1900, Moser wrote:

> The exhibition was of prime importance in so far as artistic craftsmanship in Vienna was concerned… One saw for the first time modern interiors arranged in accordance with a new Viennese taste… And moreover, our works were neither Belgian, nor English, nor Japanese, but Viennese, as the majority of critics indeed acknowledged.[6]

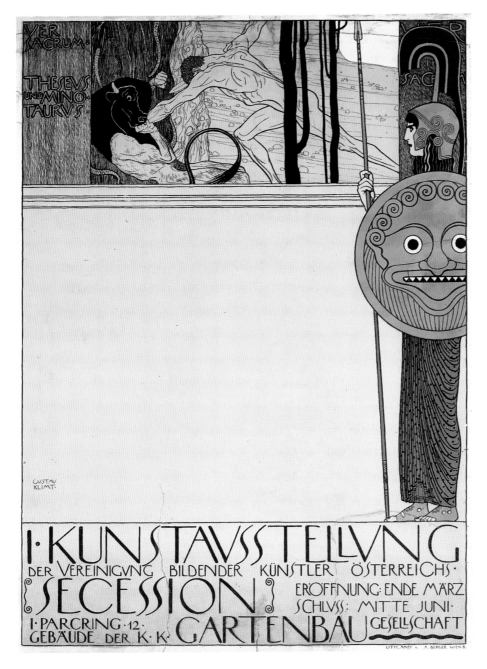

20.2 Gustav Klimt, *I Kunstausstellung Secession* (censored version). Colour lithograph. Austrian, 1898. MAK: Österreichisches Museum für angewandte Kunst.

Positive critical response to this 'new Viennese taste' was crucial. The Secession gained the support of influential Viennese writers, such as art critic Ludwig Hevesi who had coined its slogan (*Der Zeit ihre Kunst, Der Kunst ihre Freiheit*), and who published a history of the Secession (*Acht Jahre Secession*) in 1906.[7] The group's first 'history', however, was published in 1900 by Hermann Bahr, who also contributed to *Ver Sacrum* and who was an indefatigable campaigner in the early years. The support of the Viennese intelligentsia was reinforced by wider critical acclaim. Julius Meier-Graefe gave his encouragement, and Josef August Lux, Otto Wagner's biographer and also a pioneer historian of

the Modern movement,[8] was another influential supporter. He contributed to *Deutsche Kunst und Dekoration*, which had been founded in 1897 in Darmstadt by Alexander Koch. This was the first of the new art magazines to report on the work of the *Wiener Werkstätte*, publishing 12 issues on its achievements between 1904 and 1911. *The Studio*, the pioneer of these publications, printed a special issue on *The Art Revival in Austria* in 1906.

Hoffmann's contribution to the promotion of a style that was considered specifically Viennese was of considerable importance, and it reflects a range of responses to developments within Art Nouveau. Like so many of his contemporaries in Austria and throughout Europe, Hoffmann was impressed by English Arts and Crafts achievements. However, even before he became fully aware of the work of these designers and architects, he had discovered the vernacular, admiring 'the simple peasant buildings' he had seen in Italy and Slovenia in 1895 (he was awarded the *Prix de Rome* while studying at the Academy). These buildings were, he said 'without pomp and without stylistic architecture'.[9] Hoffmann's early work as a designer, therefore, demonstrates his preoccupation with the vernacular. In 1898 he designed a range of furniture for the painter Ernst Stöhr's studio house in Slovenia. Most of the chairs, cabinets and cupboards are in pine or other soft woods, and they were originally stained green; they were described as *Brettelstil* (plank style) and their simplicity evokes a folk tradition. This is a knowingly invented tradition, however. Hoffmann insets some of the designs with carved panels, using the abstracted plant forms of Art Nouveau.

Outlining his ideals for furniture design in an article he published in 1901, Hoffmann's concerns are signalled in the title *Einfache Möbel* (Simple Furniture). Like his English Arts and Crafts predecessors, he believed that truth to materials should be demonstrated in both making and use. 'Every piece of furniture' he wrote 'must make a principle apparent, so that we can distinguish clearly between a board, a pillar and a case piece.' The designer should 'respect the straight fibres of the wood', and not make 'curves on top of curves', and, 'the designing of things whose only value lies in artistic handicraft should be absolutely avoided'.[10] Therefore, Hoffmann rejected the formal and structural flamboyancies associated with some developments within Art Nouveau. Demonstrations of 'artistic handicraft' as an end in itself were meaningless, and the 'art' of design was revealed in a consistency, or unity, of intent.

The massive bureau which Hoffmann designed for Moser's studio in 1898 (plate 20.3) is an early attempt to

20.3 Josef Hoffmann, bureau for
Koloman Moser. Alder, originally
stained green, polished copper.
Austrian, c.1898.
MAK: Österreichisches Museum
für angewandte Kunst.

20.4 Josef Hoffmann, three-panel
screen. Ebonized wood frame,
gilt incised leather panels.
Austrian, 1899–1900.
Brighton Art Gallery and
Museums: The Royal Pavilion.

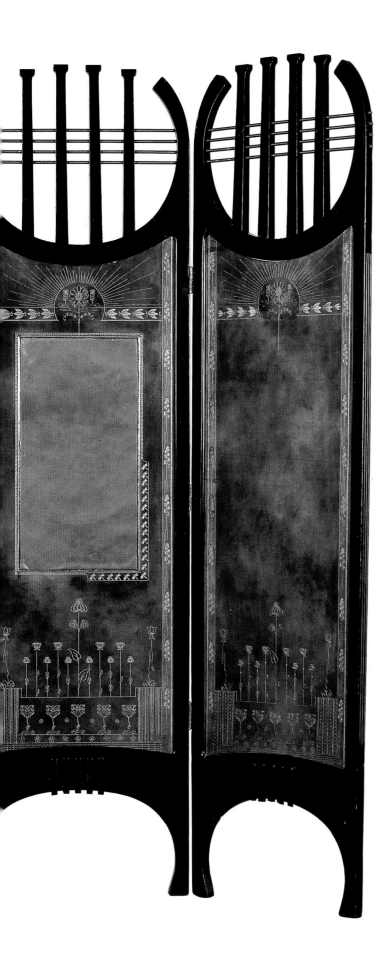

fuse form and decoration. Originally stained green, the bureau consists of two separate 'case units', and the design, with its symmetries and voids, resembles a fragment of Secessionist architecture. The elaborate brass hinges relate to the Art Nouveau of mainland Europe (and Olbrich's pattern-making). In this piece, and in the screen of 1899–1900 (plate 20.4), Hoffmann seems to be working towards a new language of form, one that will combine tradition and innovation. Most of the furniture Hoffmann subsequently designed was related to his architectural commissions. The bent beechwood dining chair (plate 20.5), with its circular motifs, was designed in 1904–05 for the dining room in the Purkersdorf Sanatorium, which was a fashionable retreat for wealthy Viennese. The Purkersdorf chairs, however – like so many of Hoffmann's designs for furniture – derive from a Viennese tradition of making. They were manufactured by J. & J. Kohn, who had also produced Hoffmann's adjustable armchair in 1901 (plate 10.7) and the chairs for the bar of the Cabaret Fledermaus (1907). Jacob and Josef Kohn specialized in the production of bentwood furniture, and their work is associated with the early nineteenth-

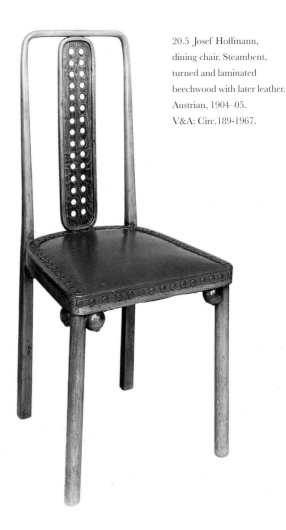

20.5 Josef Hoffmann, dining chair. Steambent, turned and laminated beechwood with later leather. Austrian, 1904–05. V&A: Circ.189-1967.

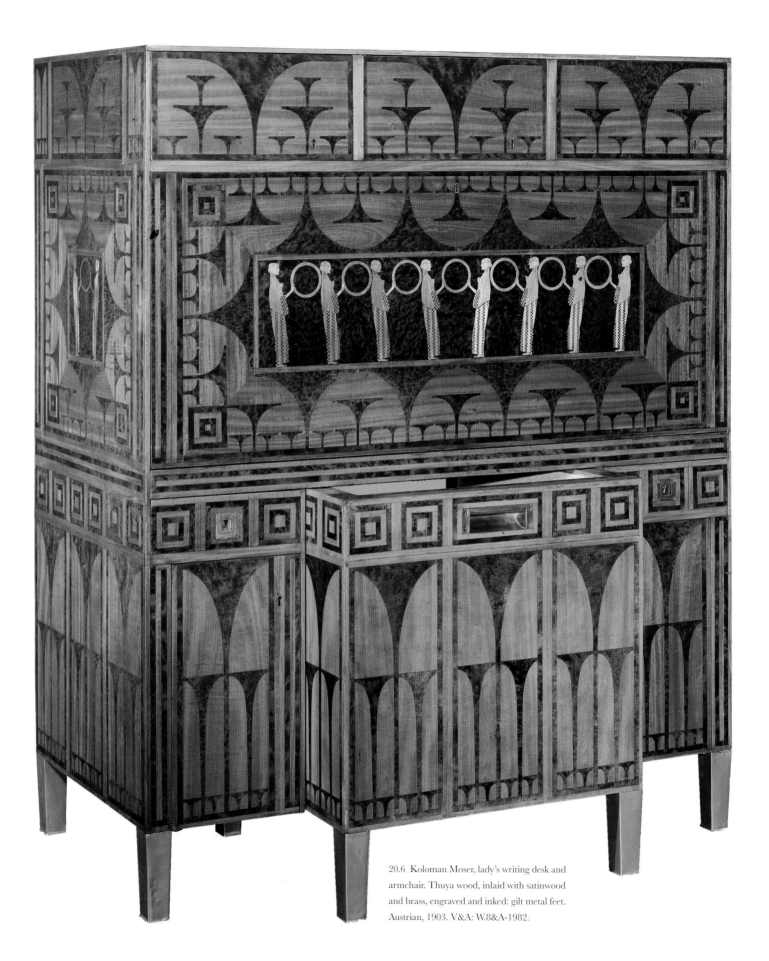

20.6 Koloman Moser, lady's writing desk and
armchair. Thuya wood, inlaid with satinwood
and brass, engraved and inked: gilt metal feet.
Austrian, 1903. V&A: W.8&A-1982.

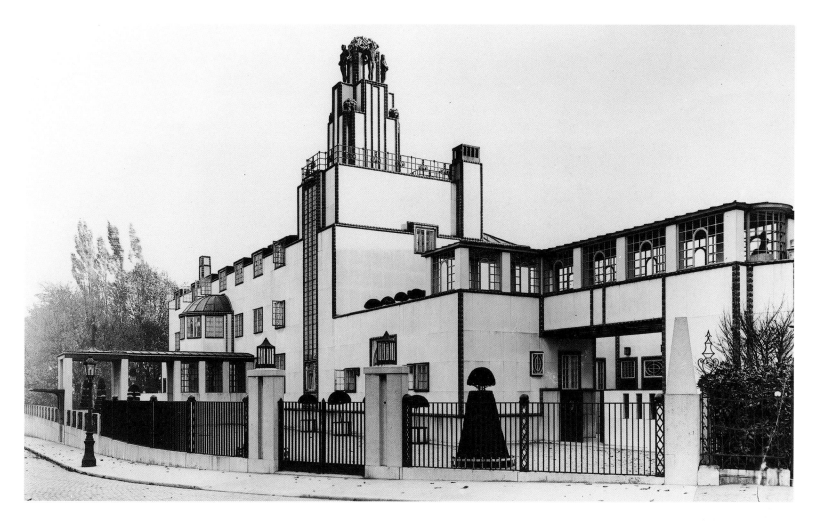

20.7 Josef Hoffmann,
Palais Stoclet. Brussels, 1905—11.
Photo: Bildarchiv Foto, Marburg.

20.8 Josef Hoffmann,
Palais Stoclet, detail of tower.
Brussels, 1905—11.
Photo: C.H. Bastin & J. Evrard,
Brussels.

century Biedermeier tradition and its manufacture of
unpretentious furniture for the middle classes. According to
Hoffmann, the 'Biedermeier time' was 'the last period, as
we saw it, to offer a valid expression of art'.[11] However, Bie-
dermeier 'art' was essentially urban; it was modest, under-
stated and neo-Classical. The *Wiener Werkstätte* aimed to
recreate the Biedermeier achievement, and to revalidate
and revitalize middle-class taste. A *Werkstätte* working pro-
gramme, published in 1905 and signed by Hoffmann and
Moser, stated that: 'our middle class is as yet very far from
having fulfilled its cultural task. Its turn has come to do full
and wholesale justice to its own evolution.'[12]

Werkstätte production, therefore, was defined against his-
toricism and the imitation of the past, against shoddy
mass-production and against the *tours de force* associated
with French and Belgian Art Nouveau. The aim, as with
English Arts and Crafts designers, was to 'produce good,
simple domestic requisites'. However, unlike the Arts and
Crafts protagonists, the *Werkstätte* founders acknowledged
that their work would be expensive, claiming that its
exclusivity signalled its social or redemptive role. They

20.9 Josef Hoffmann,
Wärndorfer cutlery. Silver and
steel. Austrian, 1904–08.
MAK: Österreichisches Museum
für angewandte Kunst.

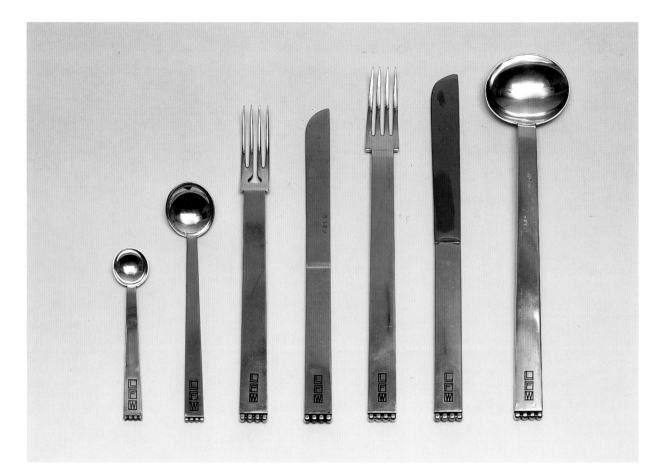

20.10 Josef Hoffmann,
'grid' basket. Electro-plated silver
and glass. Austrian, 1905.
V&A: C.30&A-1978.

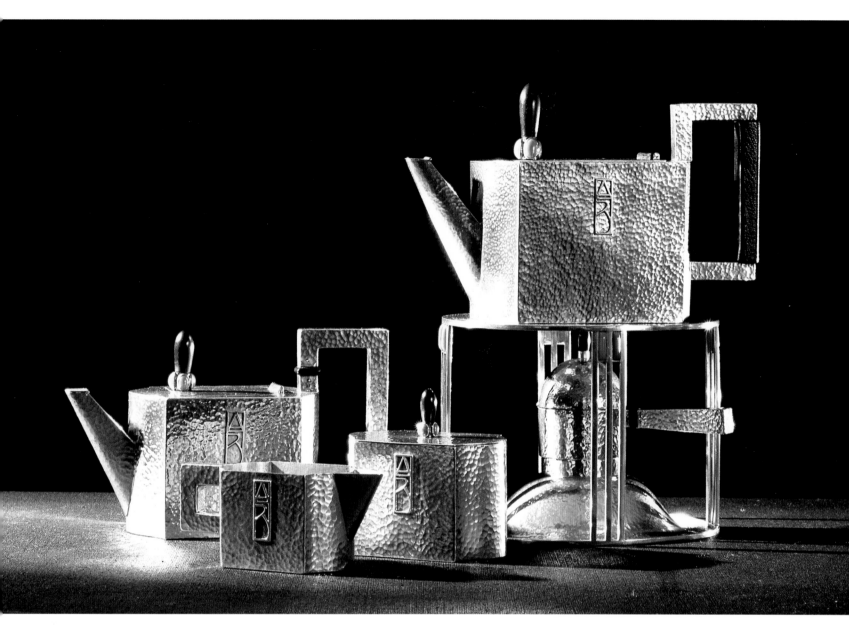

20.11 Josef Hoffmann,
tea-service. Silver, coral,
wood and leather. Austrian, 1903.
MAK: Österreichisches Museum
für angewandte Kunst.

were celebrating art and creativity; they were aiming at the highest, rather than the lowest common denominator; and they were redeeming middle-class taste. Like their mentor, Otto Wagner, they celebrated the city 'where modern luxury can be found', and they were competing with Paris, London, Berlin and Munich to establish Vienna as the focus of a sophisticated cosmopolitan modernity.

Hoffmann's and Moser's initial success was due to the patronage of wealthy clients (plate 20.6). Fritz Wärndorfer, a young Anglophile banker (whose family was involved in the textile industry), financed the *Werkstätte* in the early stages, enabling the partners to set up a small workshop and employ craftsmen. Hoffmann's and the *Werkstätte*'s most prestigious commission, however, came from Adolphe

Stoclet, the Belgian millionaire, who had spent some time in Vienna. He asked Hoffmann to design the Palais Stoclet (1905–11) in Brussels (plates 20.7 and 20.8). This commission, which came with no financial restraints, enabled Hoffmann to produce his ideal of a modern *Gesamtkunstwerk*. Every detail, including the carpets, wallpapers, glass, silverware, lighting, furniture and the fittings, was designed by Hoffmann and his colleagues, and made in Vienna

Hoffmann's purism is demonstrated by his designs for metalwork and glass, as well as furniture, during the early years of the *Werkstätte*. His silverware, for example, the cutlery he designed for the Wärndorfers (plate 20.9), his 'grid' baskets (plate 20.10) and vases, his tea-services (plate 20.11), and his table centrepieces are defined by their

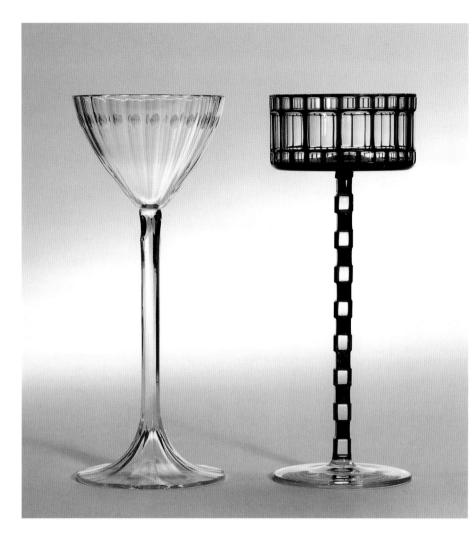

20.12 Otto Prutscher,
two wine glasses. Glass, cased,
wheel cut, Austrian, 1907.
V&A: Circ.391-1976; C.4-1979.

Söhne produced the glass, and the ceramics were made by the Viennese porcelain manufacturers J. Böck. This enlightened collaboration promoted designers such as Jutta Sika and Otto Prutscher (plate 20.12), and it also pioneered a creative avant-garde that both challenged and consolidated the achievements of Art Nouveau. *Wiener Werkstätte* glass proclaims the nature of the material, and relates form to decoration. However, form and decoration are pure and simple; the patterns are linear, and mainly in black and white. As the glass was designed for use rather than contemplation, sets were produced with co-ordinating geometries – geometries which related to designs for *Werkstätte* cutlery and silverware – so that a table setting could also aspire to the status of a *Gesamtkunstwerk*.[14] The same simplicity had been demonstrated in the ceramics exhibited by the *Werkstätte* in the early years when Böck was first involved with the *Kunstgewerbeschule*. In 1906, however, Michael Powolny and Bertold Löffler, both associated with the School and the *Werkstätte*, set up the *Wiener Keramik*, which collaborated with the *Werkstätte*. According to Hoffmann, this workshop 'soon attracted many artists. They delved enthusiastically into the mysteries of this ancient and wonderful craft, and learned how to use the appropriate glazes. In addition to ceramic figures, tea and coffee services, fruit baskets, dishes, boxes and vases in innumerable versions were also designed and manufactured'.[15] These ceramics defy stylistic definition, for while the tea and coffee services might relate to the *Werkstätte* 'laid table' aesthetic, the figures are individualistic and exuberant, signalling the pluralism of the *Werkstätte* approach, and the creativity and fantasy of designers such as Dagobert Pèche and Carl Otto Czeschka.

The patternmaking at the *Werkstätte* – in carpets, wallpapers and textiles – also demonstrated the Viennese response to Art Nouveau; Moser's contribution is important here. He had trained as a painter, and then established himself as a graphic designer and illustrator, producing posters for the Secession exhibitions, and illustrations for *Ver Sacrum*. He also designed textiles for the Viennese firm Johann Backhausen & Söhne, which was closely involved with *Werkstätte* production. (The *Werkstätte* produced their own hand-printed and painted materials from 1905, while Backhausen continued to make its machine-printed and woven textiles and carpets.) With Moser, natural forms are no longer naturalistic; the motifs are abstracted, reversed and interlocked in small-scale repeats (plate 20.13) which anticipate the hermetic fantasies of M.C. Escher. Hoffmann's early fabric designs, on the other hand, relate to his architectural commissions, and most of these are geo-

formal purity as well as by their workmanship. This is luxury for a discerning avant-garde, for an *haute bourgeoisie* that rejected the conventions of bourgeois taste. Many of these designs were made by silversmiths who were employed by the *Werkstätte* when they were established in 1903 and glass designed by Hoffmann and Moser (plate 13.7) was made for the *Werkstätte* by the glassmakers Bakalowits & Lobmeyr. When some of this work was exhibited by the *Werkstätte* in 1906, Hevesi wrote: 'Hoffmann's cutlery is as carefully designed as the precision instruments of the scientist, and a flower piece by him is so finely conceived, according to its form and purpose, that the same amount of mental energy would suffice to design a monument.'[13]

Early *Werkstätte* design was also an extension of Hoffmann's and Moser's teaching programmes in the *Kunstgewerbeschule*, and they employed several of their students or former students. Moser, who had established himself as a Secessionist illustrator before he joined the *Werkstätte*, taught glass and ceramics at the School. E. Bakalowits &

metric. In *Streber* (plate 20.14), a woven silk fabric produced by Backhausen in 1904, triangular motifs are supported by a web of fine lines, and *Notschrei*, designed for the Purkersdorf Sanatorium, is equally linear.

Before 1914 the *Werkstätte* were celebrated throughout Europe – in exhibitions, commissions and publications. The designers of the *Werkstätte* were producing glass, ceramics, cutlery, textiles and jewellery, and in 1910 a fashion department was launched under the direction of E.J. Wimmer-Wisgrill, signalling the *Werkstätte*'s determination to rival Paris and Parisian achievements. In 1914, however, the organization went into liquidation. Fritz Wärndorfer could no longer fund it (his family provided him with a one-way ticket to the United States), and the industrialist Otto Primavesi and his wife Mäda became major shareholders in a reconstructed company.

The *Wiener Werkstätte* ideal of craftsmanship responded to a *fin-de-siècle* dream of redemption through art, and like its counterparts in Europe and the United States, the Viennese movement was sustained by the patronage of an affluent élite. In Vienna it was also maintained by the pleasure of possession – an illusion of conspicuous consumption that ignored the realities of a failing Empire and a fickle market. This Viennese hedonism was also challenged by the alternative Modernism of the *Deutsche Werkstätten* and the *Deutscher Werkbund*, as well as by critics such as Adolf Loos, who condemned ornament as crime.[16] These new ideologies were to celebrate craft through industrial production; the decorative came to be associated with trivia, and the market was to be moulded to conform to a new spirit of purist production.

Needless to say, the old spirit of consumption survived and the *Werkstätte* continued to operate (they were finally closed down in 1932). In the inter-war period, the designers celebrated individuality and creativity; they were non-conformist, they defied austerity and they celebrated joy in making and pleasure in use. William Morris may not have recognized them as his progeny, and the new Modernists dismissed them as decadent. But, the *Werkstätte* were dedicated to dreams that money can buy – a pleasure in materials and materialism that creates the modern sense of style.

20.13 Koloman Moser, design
from *Die Quelle*. Austrian, 1901.
V&A: E.74-1978.

20.14 Josef Hoffmann,
Streber, textile. Austrian, 1904.
MAK: Österreichisches Museum
für angewandte Kunst.

Juliet Kinchin

Glasgow:
The Dark Daughter of the North

21.1 The Glasgow Four with friends at Dunure, c.1895. (Top): Frances Macdonald; (centre, left to right): Margaret Macdonald, Katherine Cameron, Janet Aitken, Agnes Raeburn, Jessie Keppie, John Keppie; (foreground, left to right): Herbert McNair, Charles Rennie Mackintosh. Photo: Glasgow School of Art.

Within Britain, Glasgow was the centre most closely aligned with stylistic developments in mainland Europe. As Walter Crane observed, 'the strange decorative disease known as *l'Art Nouveau* has more to do with Glasgow than the Morris school'.[1] Unlike manifestations of the New Art in many other centres, however, there was no obvious theoretical, political or organizational focus. Charles Rennie Mackintosh, by far the most prominent single figure associated with the style, was not important as a teacher or publicist, and shunned professional affiliations other than with his wife, the artist Margaret Macdonald. What the diverse individual talents involved in the Glasgow phenomenon *did* share, however, was a perceived connection with the city, a relationship which is implicit in the labels 'Glasgow Style' or 'Glasgow School'. Scottish polymath and social theorist Patrick Geddes constantly stressed the need for design to evoke 'the social personality' of a civic community, its regional character and unique 'life force'.[2] In this respect, Glasgow's New Art can be related to the distinctive institutional, commercial and industrial formations of the city, its geographic location and racial profile, and the specific character of the bourgeoisie.

Glasgow's 1901 International Exhibition demonstrated the assurance and practical dynamism of a municipal vision which united industry, art and science. At this point, the city's continued economic and cultural progress seemed unstoppable; approximately 40 per cent of Scotland's entire population was concentrated in the Clyde Valley. For Geddes, Glasgow's humming growth, powered by the most advanced engineering and industrial skills of the day, typified 'a great new age of cities', and the refusal of culture to be confined to capitals.[3] To counter the popular perception of Scotland as some sort of untamed Celtic fringe, he was at pains to point out that 'no population in the world is now so predominantly urban'.[4] The backbone

of Glasgow's economy – ships, locomotives, heavy engineering and textile production – had spawned numerous smaller ancillary industries. The kitting-out of countless ships and trains, for example, had ensured the development of a highly skilled and specialized furnishing industry. Most Glasgow Style designers had little or no involvement with the city's major industries, but their practice was locked into the related-skills base, and because of the commercial and industrial profile of the city the local people were aware of the importance of design and craft. The challenge for a young designer was, as Mackintosh put it, to clothe 'in grace and beauty the new forms and conditions that modern developments of life – social, commercial and religious – insist upon'.[5]

The stylistic assurance of Mackintosh and his contemporaries was in tune with the city's buoyant economy and its climate of thrusting individualism and internationalism (plate 21.1). For most Glasgow designers it was a routine matter to consider study or work abroad to be a holiday. On a student scholarship Mackintosh, the son of a policeman, could afford an Italian trip in 1891. Later, he and Margaret Macdonald oversaw exhibitions of their work in Vienna (1900) and Turin (1902, plate 21.2), and finally settled in the south of France. In the well-established tradition of 'the Enterprising Scot', many others sought work abroad, whether driven by ambition, evangelism or economic necessity. For example, E.A. Taylor and Jessie King had a studio in Paris where Taylor was *The Studio* correspondent for a number of years.

As Glasgow's international exhibitions so powerfully demonstrated, pride in the city's unrivalled feats of engineering was common to all classes. It was the skill and precision of the engineer that was fundamental to the perception of craft in Glasgow, in contrast to the Morrisian ideal which focused on vernacular and manual traditions. To most Glaswegians, for example, the Forth Bridge (com-

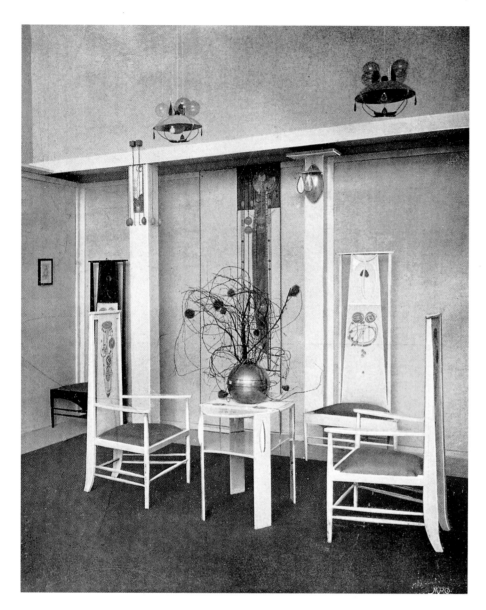

built their ideology into the city's infrastructure through a vigorous programme of improvements which tackled the water supply, sanitation, housing, health, education and arts provision. For cities on the scale and complexity of Glasgow, Geddes coined the term 'conurbation' to convey the idea of a city which embraced a region. This brought together the previously polarized and distinct concepts of town and country. A similar principle of synthesis informed the Glasgow Style, which expressed a psychological identification with the city while drawing on a wide range of imagery derived from nature. Emotional and recreational connections with the Scottish landscape formed a significant element of urban thinking. At the School of Art students were encouraged to draw plant life from the School's conservatory and to sketch outdoors. The distinctive colours associated with Glasgow's Art Nouveau were distilled from the magnificent scenery around the city – the heathery purples, misty greys, muted pinks and greens – but were used to express mystical harmonies, rather than the countryside as a place where a rural population lived and worked (plate 21.3).

21.2 Charles Rennie Mackintosh and Margaret Macdonald, Rose Boudoir at Turin 1902.

21.3 Jessie Newbery, collar and belt. Embroidered in silk on linen appliqué. Scottish, c.1900. V&A: Circ.189-1953; Circ.190-1953.

pleted in 1889) was a marvel and a thing of beauty; to William Morris it was 'the supremest specimen of all ugliness'.[6] Glasgow's industrial wealth was founded on the manipulation of metal rather than wood, and the fabric of the city was characterized by stone, not timber and brick. Indeed, it is a heightened perception of the qualities associated with metal – a material which could be bent, punctured, welded and moulded with great precision – that pervades the Glasgow Style.

The Glasgow Style appealed to, and was generated by, the middle classes, whose identity and character were fundamentally bound up with the concept of the City State. Citizens were proud of Glasgow's distinct economic and cultural apparatus which functioned independently from national and upper-class power structures. The industrial and mercantile élite who exerted political control literally

The provision of public parks (more than in any other British city) encouraged nature to penetrate right into the city, providing a necessary 'lung' and recreational space for its inhabitants. In addition, from 1856 a municipal water supply, so vital to health and amenity, was piped in directly from Loch Katrine in the Trossachs.

Having consolidated their wealth over one or two generations, the city's élite had sufficient leisure and education to indulge in extensive patronage of the arts. The growth in the number of public and commercial exhibition venues, such as the Glasgow Institute of Fine Arts (established 1861) and the City Art Gallery and Museum (opened in 1901), meant that, for the first time, artistic talent could be supported and retained in the west of Scotland. Like any other international commodity, fine and decorative arts were retailed in Glasgow with entrepreneurial flair. A

small, but sophisticated, network of dealers and decorators had been fostering an appreciation of European and Oriental artworks, as well as supporting local artists. Vincent van Gogh's portrait of the dealer Alexander Reid, his only British sitter, provides an eloquent testament to the strength of Glaswegian connections with contemporary artists abroad. In the 1880s and early 1890s an identifiable 'Glasgow School' of painters had risen to international prominence. Although their reputation was made largely by exhibitions in London and Germany, the support of local dealers and patrons was vital to their survival. Reid went so far as to finance two local artists, George Henry and Edward Atkinson Hornel (plate 21.4), to go to Japan in 1893–94, and in 1895 he exhibited controversial poster designs by the Misses Macdonald alongside work by Toulouse-Lautrec, Grasset and Beardsley.

Many of the 'artistic' types emerging from the Art School in the 1890s were able to sustain a reasonable livelihood working in independent design and craft studios, such as that set up by Margaret Macdonald and her sister Frances, or in small firms of artist-decorators. The commission of a tearoom interior for Miss Cranston was enough for George Walton to leave his job in a bank and set up his own decorating business in 1888 (plate 21.5). By 1900 the Glasgow Style had become an attractive business proposition for some of the large department stores such as

21.4 George Henry and E.A. Hornel, *The Druids - Bringing in the Mistletoe.*
Oil on canvas. Scottish, 1890.
© Glasgow Museums: Art Gallery & Museum, Kelvingrove.

21.5 George Walton, stencilled
linen frieze. Scottish, *c.*1903.
V&A: T.65-1946.

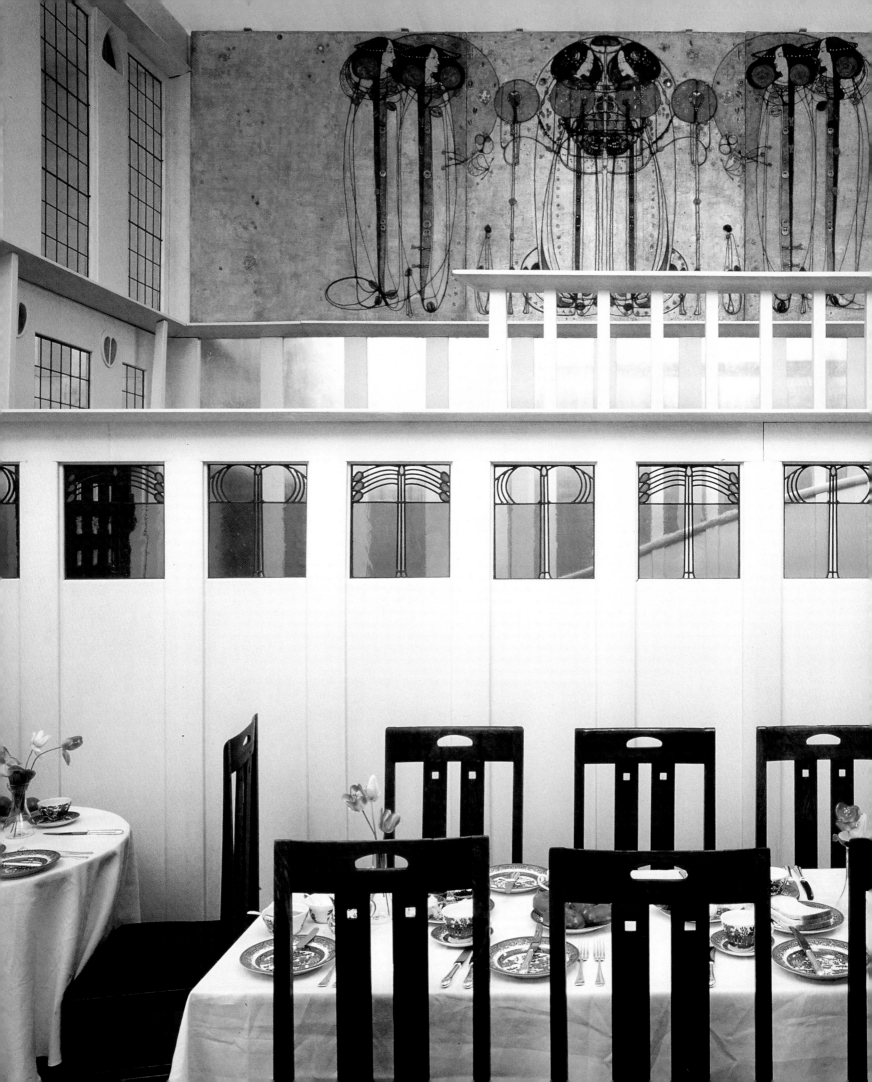

21.6 Ladies' Luncheon Room
(reconstructed), from Miss
Cranston's Ingram Street
Tearooms.
© Glasgow Museums: Art Gallery
& Museum, Kelvingrove.

Wylie & Lochhead and Pettigrew & Stevens, although it was more of a flirtation for publicity purposes than a wholesale conversion of their house style.

Unlike the middle ranks of society in Edinburgh – which were dominated by the professional classes – the Glasgow bourgeoisie were a precarious and volatile group lacking the old indicators of land and family. In the absence of shared backgrounds or values, therefore, *visual* indicators of status and difference assumed particular importance. This emphasis on individualism, and on material culture as a physical expression of economic achievement, had been firmly rooted in Glasgow's culture since the Enlightenment and competitive furnishing was seen as characteristic of Glaswegian taste. As noted in 1859: 'The sense of vision would seem to be consulted in the decoration of the homes of people at the expense of all other senses, and in this there is growing rivalship … in a thriving population where the genius of trade and manufacture was continually creating material wealth.'[7] Forty years later, the English architect Edwin Lutyens picked up on the same qualities of overstatement and theatricality in his description of a visit in 1897 to the newly opened Buchanan Street Tearooms designed by Walton and Mackintosh; the interiors were 'all very elaborately simple on very new school High Art Lines. The result is gorgeous! and a wee bit vulgar! … It is all quite good, all just a little outré, a thing we must avoid and shall too'.[8] Although appreciative, Lutyens clearly felt more at ease with the qualities of restraint, gentility and unassuming 'good taste' which were widely perceived as characteristic of English design.

Glasgow's 'artistic' tearooms, a peculiarly localized phenomenon, were closely identified with the tenor of life in the city. These spaces were renowned for being 'homely', and it is significant that so many were established and run by women, thereby bringing women out of the confines of domesticity. Miss Cranston's chain in particular was one of the sights of the city, giving thousands of people access to a vision of urban chic, fantasy and modernity (plate 21.6). She was Mackintosh's most generous and consistent patron, employing him between 1897 and 1914 to design interiors of both her home, Hous'hill (1906), and her famed series of tearooms (plates 21.7 and 21.8). The other individual to play a crucial role in the dissemination of the Glasgow Style was the publisher Walter Blackie. The Hill House (1902), his Helensburgh home designed by Mackintosh, was reviewed internationally (plate 21.9), but it was the hundreds of thousands of distinctive book covers produced under the auspices of his art manager Talwin Morris which established a more popular currency for the style (plate 21.10).

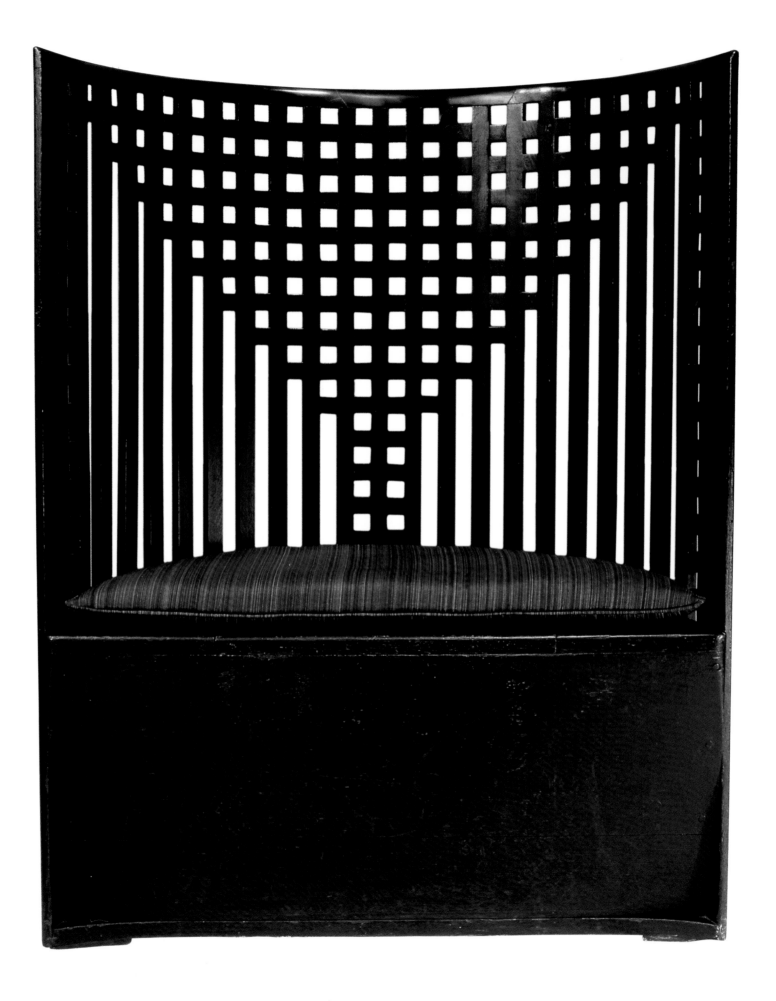

Civic and artistic agendas merged over the question of design education, which was seen as beneficial both to local prosperity and the city's image. Glasgow had a distinguished and diversified tradition in design education, dating back to the establishment in 1755 of the Foulis Academy within the city's Medieval university. By 1900 the main educational providers were the Glasgow School of Art and the Glasgow and West of Scotland Technical College (GWSTC). Although it would be a mistake to characterize these educational institutions as dominated by Art Nouveau, it is clear that they provided a breeding ground and focal point for the new style, ensuring its spread into many areas of commercial production and into school education. In particular, the emphasis on individualistic training in the

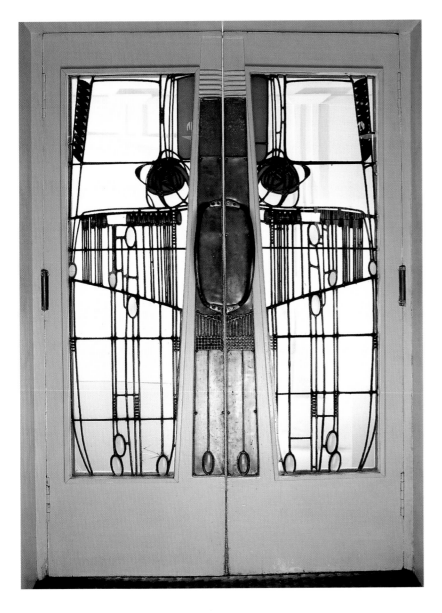

21.7 Charles Rennie Mackintosh, doors for the Salon du Luxe, Willow Tearooms, Glasgow. Pine, painted white, with leaded glass panels and metal handles. Scottish, 1903.
Photo: The Glasgow Picture Library, Glasgow. Morgan Grenfell Asset Management Ltd.

21.10 Talwin Morris, *The Book of the Home No. 3* (Glasgow, 1900). V&A: 47.W.388.

21.9 Charles Rennie Mackintosh, The Hill House: Perspective from the Southwest. Ink on paper. Scottish, 1903.
Photo: Glasgow School of Art.

21.8 Charles Rennie Mackintosh, chair. Ebonized oak, re-upholstered with horsehair. Scottish, 1904.
Photo: Glasgow School of Art.

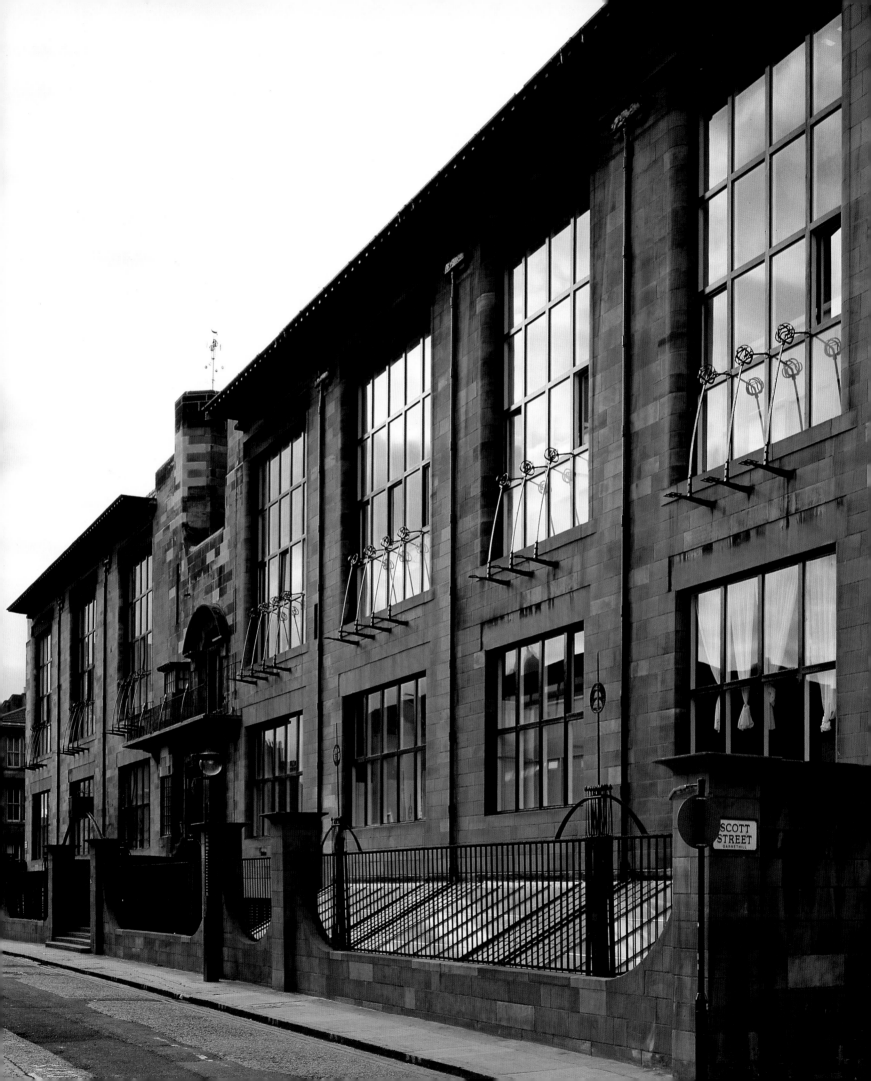

dynamic regime of Francis Newbery at the Art School created a space in which experimentation could flourish. He played a key role in recognizing and developing individual's talents, many of them women, and was of course instrumental in pressing for the remarkable new building designed by his protégé, Mackintosh (first stage opened 1899; completed 1907–09). This major public commission institutionalized the local reputation of the style (plate 21.11). There were professional practitioners on the teaching staff, and the introduction of evening and Saturday morning classes enabled teachers, apprentices and gifted amateurs to attend part-time. The more technical orientation of the GWSTC complemented the 'artistic' ethos of the Art School, and the two collaborated on the teaching of common areas such as technical drawing, architecture and furniture design, encouraging the development of a shared sensibility. Newbery's educational philosophy downplayed the distinction between art and design. E.A. Taylor, who had connections with both institutions, was an example of someone who made the transition from working as a draughtsman in a Clyde shipyard to designing 'artistic' furniture, stained glass and interiors. This was possible because the many types of design activity in the city shared an emphasis on drawing skills and the conceptual development of three-dimensional forms on paper.

The radical new form of language evolved in the 1890s by 'the Four' – Mackintosh, Margaret Macdonald, Frances Macdonald and her husband Herbert MacNair – was initially two-dimensional (plate 21.12). The highly stylized blend of plant and figurative forms adapted to ornamental purposes took the process of conventionalization, exemplified by the Design Reformers at the South Kensington Museum, to new extremes. Their highly charged Symbolism also demonstrated an openness to foreign developments, which can be attributed in part to the School of Art's policy (unusual in Britain) of employing foreign teaching staff, such as the Belgian Symbolist Jean Delville. What gave this repertoire its distinctiveness, however, was

the extent to which the Four (and other Glasgow designers) introduced a severe rectilinear geometry to their designs, which both controlled and was in contrast to the asymmetry and attenuation of the forms.

A new practical emphasis came with the introduction of

21.11 Charles Rennie Mackintosh, Glasgow School of Art. Glasgow, 1896-99. Photo: Mark Fiennes, Suffolk.

21.12 Charles Rennie Mackintosh, *The Scottish Musical Review*. Colour lithograph. Scottish, 1896. Glasgow Museums: Art Gallery & Museum, Kelvingrove.

21.13 Charles Rennie Mackintosh, casket. Silver, lapis lazuli and chalcedony. Scottish, 1909. V&A: M.20&A-1975.

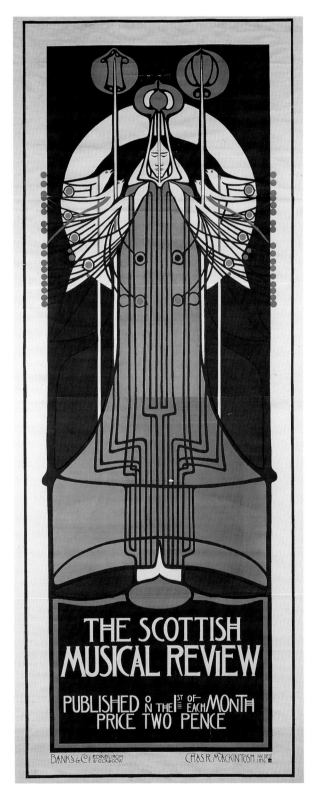

the Technical Studios to the Art School in 1893, which was aimed at developing a whole range of crafts, such as metalwork (plate 21.13), bookbinding, embroidery and stained glass. In contrast to the London Central School, where pupils engaged with materials from the outset, the Glasgow studios were only open to advanced students. Apart from strengthening existing craft industries, such as stained glass, this development created new demands for certain one-off domestic goods. The majority of students going through the Technical Studios were women, many of whom (such as Jessie King and the Macdonald sisters) went on to achieve new-found professional and economic independence.

Newbery was forceful in promoting his students' work. The Art Club, which he instituted in 1889, provided a framework for the exchange of ideas and an important testing ground for experimental and collaborative work in its annual exhibitions. He ensured that the School was prominently represented in exhibitions abroad, above all at the exhibition in Turin in 1902, where he masterminded the Scottish Section (plate 21.2) This was to prove the most comprehensive and coherent expression of the Glasgow Style, featuring not only acclaimed room settings by the Four and Mackintosh's design of the overall installation, but also work in a similar idiom by over 50 others.

In an urban and industrial world, crises of faith, identity, career and sexuality were commonplace. The criticisms of instability frequently applied to the Glasgow Style (such as references by the author A.F. Jennings to 'extravagance bordering on insanity' or 'lunatical topsy turvydom') reflected other areas of bourgeois experience.[9] As a result of the integrated nature of the economy, any snags in the wider trade cycle had an immediate knock-on effect, creating a boom-bust economy and industrial tensions. This introduced a note of anxiety to the general middle-class optimism, added to which was increasing disquiet at the appalling social consequences of Glasgow's unbridled growth. At the bottom of the social scale, wages were low compared to the national average, and seasonally erratic. Shocking social dislocation, and the signs of simultaneous growth and decay were impossible to avoid. The spectre of the lower classes – the apparent source of homicidal violence, disease and moral depravity – loomed large in middle-class consciousness (plate 21.14). Recurrent, life-threatening epidemics occurred, and the essential fragility of the municipal vision was underlined in 1901 when outbreaks of smallpox, and even the bubonic plague, threatened to undermine the massive public-relations exercise of the city's great International Exhibition. A siege mentality was intensified by the cramped and high-density pattern of building in Glasgow as compared to many other cities, which meant that different social classes were forced to live cheek-by-jowl.

Although hinting at the disruptive forces of fragmentation and alienation, the Glasgow Style also, arguably, provided a means of reimposing meaning and coherence on the fluid conditions of city life, helping to bolster it and to mask its unpalatable aspects. Its emphasis on the visual synthesis of opposing tendencies, and on the creation of pared-down self-contained environments, sent out strong messages of individuality and control. Mackintosh himself spoke of the need to express 'the etherial, indefinable side of art'.[10] George Logan, an active member of the Salvation Army, also described his work in spiritual terms, incorporating angels and fairies in his designs at every available opportunity, while his friend Jessie King, a minister's daughter, believed she was in touch with 'the Little People'. In common with other European centres in the late nineteenth century, Glasgow had an active Spiritualist Church, and had five branches of the Theosophical Society in the 1890s. Figures such as Annie Besant visited the Glasgow theosophists on several occasions. Particularly influential on the many artists and designers interested in this 'new religion' were Maurice Maeterlinck and Jean Delville. One senses a world of association beyond the ornament and forms of the Glasgow Style, ranging from faint subconscious allusion to full-blown Symbolism. The drooping plant forms and emaciated figures are half dead; the willowy, waistless female figures downplay the maternal role of women; the soaring attenuated verticals, the muted secondary colours and airy tones all reinforce the other-worldly aspects of the style. Physical comfort comes low on the list of priorities.

On one level, the dramatic white interiors created by Mackintosh and Macdonald can be read as a manifestation of an intensified middle-class obsession with health and self-preservation in Glasgow, as well as threatened boundaries being re-drawn. Preserving such whiteness in a notoriously smoggy city was an uphill struggle. Nevertheless, the constant physical battle against dirt not only helped keep disease at bay, but also provided an analogy for spiritual and sensual values.[11] The recourse to nature was equally fraught with ambivalence. Although the English Arts and Crafts movement celebrated the concept of craft communities in idyllic villages or small towns such as Gloucestershire's Chipping Campden, rural life in the west of Scotland was a rather different matter. This was an era of agricultural depression, continued clearances, land reform agitation and mass emigrations. Apart from the frequently inhospitable climate, the whole pattern of agriculture and crofting was unlike that of England. Vast tracts in

the west of Scotland in the late nineteenth century were characterized by a combination of large estates with sheep and deer, and sparsely scattered crofting communities. Many of those evicted Highlanders not packed onto ships bound for Canada, the United States or Australia, converged on Glasgow. The 'Crofting Wars', bitter confrontations between the dispossessed and landowners which came to a head in the 1880s and prompted military intervention, were given prominent news coverage in Scotland.

21.14 Close No. 118, High Street, Glasgow. Albumen print. Scottish, 1868-71.

Photo: T. & R. Annan, Glasgow.

The bitterness and trauma of this episode in Scottish history, and the general severity of the nineteenth-century agricultural depression, were not easily forgotten. The evocation of vernacular cottage interiors was also inappropriate to the Scottish pattern of tenement living.[12]

Protestantism, with all its complex Scottish ramifications, was another integral part of Glasgow's culture and history. Although Glasgow also had a large Catholic community, this was largely comprised of recent immigrant Irish or Highland workers who lacked the wealth and political clout necessary to impinge on the world of Art Nouveau. The association of Celtic culture with Ireland and hence Catholicism could explain why evidence of the Celtic revival, with its range of suitably sinuous forms, was not more pronounced in Glasgow designs, but remained centred on Edinburgh where it was not so socially problematic.

Geddes presented companionable love and co-operation as the highest expressions of the evolutionary process.[13] The principle of 'equal but different', of gendered opposites integrated to form a unity of impression, was also central to theosophical thought, and was reflected in the collaboration of the Newberys and the Four. In the interiors of their home in Southpark Avenue, the Mackintoshes created a circuitous journey of the imagination, aestheticizing the daily round of activities within the home. There is the sense of a steady casting off of the debris of the material world, starting with the symbolic divesting of outer garments in the hallway and culminating in the unclothed intimacy and spirituality of the white bedroom above. Ultimately even this extreme expression of interiority can be seen as a response to the city, a withdrawal fostered by the intensity of social change and the pressures of urban life.

Inevitably, in the context of the home, such an approach was easier to accommodate in bits and pieces than as a *Gesamtkunstwerk*. Even house-owners with relatively conservative tastes conceded the inclusion of the odd table-runner or planter in the Art Nouveau style, and many of the small craft studios which had proliferated since the 1890s prospered well into the inter-war period. Building developers were prepared to incorporate a dash of modern stained glass or tiling, or an 'artistic' or 'quaint' fire-surround here and there, but such piecemeal popularization inevitably diluted the coherence and startling intensity of the style. Steadily, the key figures who had driven the more experimental phase dispersed. The McNairs moved to Liverpool; Jessie King and E.A. Taylor moved to Manchester and then to Paris; Walton set up in London, and Talwin Morris died prematurely in 1911; and the Mackintoshes left Glasgow in 1912 for London and then moved to the south of France in 1923. As growing antagonisms and tensions surfaced, so Glasgow appeared increasingly divided by class, religion and politics. In the period of retrenchment following the First World War (owing to the loss of export markets to competitors such as Germany and the United States, and the delay in adopting new materials and technologies), the progressive image and self-conscious exaggerations of Art Nouveau no longer captured the dominant ethos of the city.

Lauren S. Weingarden

Louis Sullivan and
the Spirit of Nature

To appreciate the place of Louis H. Sullivan within the international Art Nouveau movement, it is important to bear in mind the idea of a connection between nature and modernity. Indeed, Sullivan's designs for the skyscraper, as well as his innovative mode of ornament, represent an American response to the nineteenth-century problem of creating a new architectural style to express contemporary social, economic and technological conditions. Furthermore, like many other practitioners of Art Nouveau, Sullivan turned to nature rather than historicist styles as the primary source of artistic renewal. However, this general *fin-de-siècle* concern with stylistic innovation was especially pressing within Sullivan's immediate circle of Chicago School architects.[1]

Following the Chicago Fire of 1871, real-estate speculators, builders and structural engineers flocked to the city to rebuild this mercantile hub of mid-western America. The first two of these contributed money and manpower, while the third brought the latest building technologies from the eastern States and from abroad. In this setting the engineers became modern-day heroes. Faced with the economic, social and geographic exigencies of Chicago, they enhanced existing building technologies with new ones so as to establish a rational system of skyscraper construction. In particular, these innovators developed the self-supporting, metallic building frame and a unified method of fireproofing, which, together with the passenger elevator, made it possible to build the new type of commercial building as tall as the client required.[2] The resulting vertical building mass was especially suited to post-fire real-estate practices and Chicago's grid-iron plan. Designed to accommodate high-density rental units on small lots, the skyscraper's multi-storeyed cage-like assemblage seemed to grow naturally from the urban terrain.

While skyscraper technology evolved during the 1880s, reaching its apogee by the early 1890s, Chicago School architects struggled to adorn this engineering feat with an appropriate 'style'. From the outset, many of these designers rejected the historical styles that New York and other east-coast architects used for the skyscraper and its prototypes. Instead, they sought a new style for a novel building type and mode of construction. Turning for solutions to the pre-eminent nineteenth-century theorists Eugène Viollet-le-Duc and John Ruskin, Chicago architects adapted two 'organic' schemas from their treatises. According to Viollet-le-Duc's Rationalist thought, the flora and fauna of the natural world provided a model for exhibiting the direct correlation between form and function, a correlation especially apt for expressing the modern reality of metallic cage construction.[3] Although this solution was seminal to the functionalist aim of the Modern movement in design, for many designers during the 1880s and 1890s its stark appearance exposed a brute reality that resisted stylistic expression. Alternatively, however, they adopted Ruskin's idea of architectural 'Naturalism', which sanctioned traditional building materials and surface ornamentation independent of internal construction. Thus, in an effort to suppress technological fact, the architect masked the fireproofed frame, using stone, brick or terracotta to preserve the proportions, textures and mass of traditional building designs.

What makes Sullivan unique among the Chicago School architects is his artistic skill in combining the visions of Viollet-le-Duc and Ruskin in his ornamented skyscrapers, dating from 1890 to 1904. He formulated a three-part composition of base, shaft and attic storey which emphasized the skyscraper's vertical dimensions. He placed low-relief panels of ornament between unbroken vertical piers and around the entire attic storey and cantilevered cornice. For twentieth-century viewers, these designs signified Sullivan's contributions to the later, modernist functionalist aesthetic. This view of architectural history was initiated

by Sullivan's contemporaries who used his triadic composition as a standard for evaluating all skyscraper designs, and championed him for heralding a new American style. However judicious their observations, the critics focused on the logical – rational – components of Sullivan's designs to the detriment of his ornament (see chapter thirty).[4]

To understand Sullivan's work within the international Art Nouveau movement, it is worth reconsidering Sullivan's own reasons for naturalizing the urban skyscraper. Above and beyond expressing structural reality, Sullivan sought to represent what he called the 'Infinite Creative Spirit', a generative cosmic force that joins humankind to nature, by means of an organic system of ornament and a symbolic language of architecture. More to the point, from the moment Sullivan began to realize an original mode of ornament – prior to realizing his definitive skyscraper design – he established his own criteria as to what constitutes a new American style. Seeking to create 'the True, the Poetic Architecture', he considered his ornament the crux of his stylistic innovations as well as his poetic expression.[5]

Like most of Chicago's post-fire builders, Sullivan does not count among its native sons. Born and raised in Boston and its environs, he arrived in Chicago in November 1873 to join his parents who had moved there in 1868.[6] Earlier in 1873, after completing one year of architectural studies at the Massachusetts Institute of Technology, Sullivan had left Boston for New York City to find work as an apprentice draftsman. He first went to the office of Richard Morris Hunt, the United States' first and foremost *beaux-arts* designer, from where he was directed to the Philadelphia office of Furness & Hewitt. Sullivan's employment with this firm had lasted only three months; his position had been terminated when the firm faced a financial setback. However, upon arriving in Chicago, he immediately found work in the office of William Le Baron Jenney, 'father' of Chicago skyscraper construction.[7] Seven months later, in

July 1874, Sullivan was bound for Paris to study architecture at the École des Beaux-Arts. Completing only one year of the programme, including a summer sojourn touring Europe, Sullivan returned to Chicago, where he soon set up his own business as a freelance designer. By the time Sullivan joined Dankmar Adler & Company in 1882, which became the partnership of Adler & Sullivan in 1883, he had established himself as an expert designer of 'frescoed' decoration and architectural ornament.[8]

The full potential of Sullivan's collaboration with Dankmar Adler, which lasted until 1896, was realized in their first major commission for a monumental commercial structure, the Auditorium Building, built between 1887 and 1889 (plate 22.1). For this work, Sullivan used an original mode of ornament for the interior decorative schemes. In particular, he created relief and stencilled fresco patterns consisting of interweaving realistic plant forms and abstract geometric substructures. Although the Auditorium Building remains a transitional design within Sullivan's development of the tall commercial building, the interior schemes show his change from being an interpreter of revival styles to a stylistic innovator.

Initially, Sullivan's practice of ornamental design was influenced by Frank Furness, the Philadelphia architect under whom he first apprenticed. At that time, Furness had perfected a personal interpretation of the Gothic Revival, wherein curvilinear patterns unified stock Medieval motifs and botanical images derived from the local landscape.[9] Between 1874 and 1880 Sullivan further developed the curvilinear aspects of this mode. In doing so, he was motivated by the meaning of the Gothic as well as its form. As his readings from architectural treatises and his own writings reveal, Sullivan selected this and other non-Classical, historical styles for their original conception in nature as opposed to using ready-made Classical precedents.[10] Subsequently, his studies and drawings for ornament dating from 1881–83 are marked by an even greater emphasis on spiralling and scrolling lines that dominate conventionalized plant forms. Given these transformations, in 1884 Sullivan created an original, yet mostly abstract, ornamental motif. In the '1884 Motif' (named for its appearance only in that year), scrolling tendril-like and undulating 'whiplash' forms radiate from, and encircle, a bossy-surfaced central orb (plate 22.2). Such an arrangement suggests amoebic and primordial life forms, if not an abstract symbol of their living energy. Whatever its meaning, the 1884 Motif represents Sullivan's decisive break with overt historical precedents.

Why did Sullivan develop this curvilinear abstraction

22.2 Adler & Sullivan, glazed terracotta relief panel from the Scoville Building. Chicago, 1884–85: '1884 Motif'. The St Louis Art Museum: gift of the General Services Administration.

22.3 John Ruskin, *Part of Cathedral of St Lo, Normandy*. From *The Seven Lamps of Architecture* (1849). V&A: 33.B.24.

linear distortion of Gothic ornament as a visual expression of the Medieval carver's intense feelings for the spiritual in nature. He thus interpreted the architect-artisan's works as poetic translations of God's works, providing a symbolic means of organic expression that he urged modern architects to renew. Ruskin first set out these concepts in *The Seven Lamps of Architecture* (1849). Here he codified ornamental techniques, natural materials, and abstract mass compositions into an architectural language for representing the indigenous landscape and its vital, spiritual essence (plate 22.3). Indeed, Ruskin beseeched his reader to emulate the Gothic architect-artisan, who, as expresser of these intangible realities, became the forebear of the nineteenth-century Romantic landscape poet (whom Ruskin also venerated).[12]

That Sullivan viewed Medieval architecture under Ruskin's lamps is revealed, in part, by the graphic means he developed for transcribing the native American landscape into his 'true, poetic architecture'. Furthermore, Sullivan developed his innovative system of ornament in accordance with Ruskin's general definition of architecture as 'that art which, taking up and admitting, as conditions of its working, the necessities and common uses of the building, impresses on its form certain characters venerable or beautiful, but otherwise unnecessary'. This definition also states what architecture conceals, 'the technical and constitutive elements [of] Building', or simply 'construction'.[13] Ruskin treated ornament derived from nature as the qualifying sign of architecture's status as a true art form. Thus, in *Seven Lamps*, he examined both close-up and more generalized views of 'the image architecture bears of natural creation'. At close range, Ruskin focused on actual botanical specimens and their counterparts in architecture. From a distance, he presented a more abstract view of nature, claiming that 'all perfectly beautiful forms must be composed of curves'. Ruskin elaborated on these ideas in the first volume of his second treatise, *The Stones of Venice* (1851), under the title 'The Material of Ornament'. Here he identified the expressive meaning of the curved line, stating: 'The essential character of Beauty depends on the expression of vital energy in organic things [found in] lines of changeful curve, ... expressive of action, of force of some kind.' However, for Ruskin, the curving, undulating and spiralling line not only recorded the patterns of growth and the incessant flux of nature, it was also a symbol of what he called the 'vital truth' of nature representing 'God's law'.[14]

While Sullivan seems to have developed the abstract 1884 Motif in accordance with Ruskin's symbolic inter-

beyond the conventionalized Gothic Revival prototypes? Visually, this device lent greater fluidity and movement to his ornament, providing an imagery more suggestive of the organic properties of actual plant forms. Indeed, as an avid student of the natural sciences, especially botany and nineteenth-century evolutionary theories, Sullivan sought the aid of modern scientific discourse to communicate the 'truth' of his artistic expression and to validate the natural origins of a new style.[11] However, this scientific orientation was complemented by, and subordinated to, an aesthetic discourse derived from John Ruskin's ideas about Gothic 'Naturalism' and its symbolic language of ornament. A brief review of Ruskin's tenets provides an understanding of why Sullivan exaggerated abstract curvilinear patterns and how this abstraction functioned as a means of expressing his metaphysical beliefs and humankind's spiritual kinship with nature.[12]

For Ruskin, the technique for conventionalizing botanical motifs was not just a matter of translating natural forms into architectural design. Rather, he viewed the

22.4 Louis Sullivan,
Ornamental Study, 13th April 1885.
Pencil on paper. American, 1885.
Avery Architectural Library,
Columbia University.

organic into the geometric, and, second, as organic inter-twinements that encroach the tectonic frame.[15] Likewise, in his ornamental studies dating from 1885, Sullivan sought to record his process of first extracting abstract patterns from nature and then transforming the natural specimen into an ornamental form (plate 22.4). In doing so, he frequently placed thumbnail sketches of plants and/or geometric notations above, below or to the side of the finished study. In these combinations, spiralling and undulating plant forms overlap and trespass geometric sub-structures and enframements. Furthermore, his recurring depictions of spiky-edged, yet sinuous, leafage recall Ruskin's drawings of thistle and acanthus leaves and their conversion to stone-carved Gothic ornament.

Sullivan remained engaged with Ruskin's Naturalist ideas throughout his career. Indeed, writing his illustrated treatise on ornament in 1922–23, he rehearsed Ruskin's morphological demonstrations, and, in the process of designing ornament and its symbolic functions, provided an explanation that fused science and metaphysics. Entitled *A System of Ornament According to a Philosophy of Man's Powers*, this treatise confirms that Sullivan intended his 'organic system of ornament' to provide both an artis-tic means of naturalizing skyscraper technology and a symbolic means of representing the 'Infinite Creative Spirit'.[16] Here and in earlier writings Sullivan demon-strated how the dynamic interaction of 'objective'-geometric and 'subjective'-botanical elements served to signify this omnipresent spirit. An analysis of Sullivan's writings in relation to these artistic theories reveals that his methods for naturalizing the skyscraper came from his earlier attainment of a new, albeit symbolic, mode of ornament.

When considering Sullivan's focus on nature, the year 1885 marks a turning point in more ways than one. He not only began using more realistic plant motifs in his designs for ornament, but he also published his first professional paper on the issue of stylistic renewal in the United States. In *Characteristics and Tendencies of an American Architecture Today* he sought to initiate 'the formation of a national style', not only derived from nature, but mediated by the artist-archi-tect's emotional response to nature's forms and vital rhythms. Here he explained that although the modern architect may be troubled by practical conditions in expressing 'an insuppressible yearning toward ideals', the artist-architect must constantly nurture such ideals, where nature 'yield[s] refreshing odors and the joy of color to the plodding wayfarer'. As he sees it, historical revivalism is only a transitional phase, during which the 'innate poetic

pretations of Gothic ornament, in 1885 he added more realistic representations of botanical elements to these curvilinear patterns. Turning away from abstraction, he sought to emulate the Gothic artist's poetic perception of the rural landscape. Thus, the more realistic plant imagery alludes to both the indigenous plant life of the United States and the primary source of Sullivan's artistic inspira-tion – Ruskin. Concurrent with this shift from abstraction to realism, Sullivan began to use a mode of illustration that further connects his procedures with Ruskin's, and, in turn, with the Gothic craftsman's. In his treatises Ruskin depicted the natural and the carved, 'conventionalized', botanical motif in two ways: first, as progressions of the

feelings' (inherent in the adapted styles) must be 'protected and nurtured' so that 'nature [will] yield up her poetic secrets' and thereby bring a 'national style' to fruition.[17]

By 1888, when he wrote *Style*, Sullivan had broken with revival styles and was confident that he had achieved a naturalistic means of expression. Armed with both evolutionary theories and Ruskin's translations of nature into symbolic expressions, he asserts: 'Style is ever thus the response of the organism to the surroundings.' Therefore, he instructs the reader to disassociate style as a *word* – signifying historical motifs – from the *thing*. Here style signifies the organic integrity of 'common and simple things' in nature – 'the grass, the rocks, the trees and running waters … right under our feet'. However, he replaces this Rationalist notion of organic expression with a Symbolist one, making the word 'style' synonymous with the word 'soul'. As he explains, each of these words functions as a 'symbol or arbitrary sign which stands for the inscrutable impelling force that determines an organism and its life; … that mysterious essence which we call our identity'.[18] In view of Sullivan's achievement in the Auditorium Building, we can assume that he now equated his innovative mode of ornament with his Romantic idea of stylistic renewal.

Indeed, Sullivan made this analogy in his 1892 essay 'Ornament in Architecture', in which he explicitly defined ornament as a 'Romantic' means of poetic expression. Responding to the rhetorical question 'Why do we need ornament?', he proposed that the architect observe a moratorium on ornament in order to rediscover the 'pure and simple', 'elemental' forms of architecture and their primal meanings, these being the objective, logical expressions of 'man's relation to nature and to his fellow man'. For Sullivan, however, designing reductivist geometric mass-compositions was merely the first phase in making rational construction artistic. Therefore, he provides another response to the original question. Intoning Ruskin's definition of architecture, he declares that 'ornament is mentally a luxury, not necessary'. Yet it was just this 'luxury' with which he was most concerned. Thus, he argues that ornament satisfies 'a craving to express … Romanticism', so that 'an organic system of ornament' conveys the 'high and sustained emotional tension' under which it is produced. Given this Romanticism, Sullivan conceives architectural ornament as 'a garment of poetic imagery', providing the subjective-emotional counterpart to the objective-geometric language of mass-composition and tectonic elements.[19]

Sullivan explained such a subjective/objective analogy between ornament and construction in *The Tall Office Build-ing Artistically Considered* (1896). Writing at the height of his career as a skyscraper designer, he first reviews the socio-economic conditions from which his three-part mass-composition was borne. Examining the logical relationship between the steel cage construction and the building's practical functions, he explains that the two-storey base designates retail or banking facilities, the vertical shaft designates the repetition of cell-like office spaces, and the attic storey designates that 'the circulatory system [emanating from the machinery contained at the basement level] completes itself, and makes its grand turn, ascending and descending'. Following this straightforward explanation, Sullivan takes a critical turn, resolving to reverse those brute socio-economic forces expressed in the one-sided 'pessimistic' (i.e. Rationalist) solutions to the tall office building. Therefore, in the last section of the essay, he pursues a 'fuller justification and higher sanctification' for the skyscraper, claiming: 'The true architect must realize … that the problem of the tall office building is one of the most stupendous, one of the most magnificent opportunities that the Lord of Nature in His beneficence has ever offered to the proud spirit of man.' Asking what is the chief characteristic of the tall office building, Sullivan states that because 'its loftiness is to the artist-nature its thrilling aspect, [loftiness] must be in turn be the dominant chord in [the artist-architect's] expression'.[20]

Sullivan and others carried the Chicago Style across the North American Continent. His declaration that 'loftiness' or verticality is the essence of the skyscraper and the source of its 'emotional appeal' was based on the artistic solution to the tall office building he had first formulated in the Wainwright Building (1890–91 in St Louis, Missouri, plate 22.5). In this design, as in his subsequent skyscrapers, Sullivan suppressed structural realism in order to emphasize verticality. To this end, he repeated structural and non-structural piers at equally spaced intervals. He also accented their attenuated proportions with unadorned surfaces and unbroken contours which altogether contrast with the recessed panels of relief ornament placed between the piers to designate floor levels. Capturing sunlight and shadow, the reliefs seem to dissolve the surfaces they adorn, showing nature's transience. This dematerialized effect, in turn, reinforces the verticality and solidity of the intervening piers. Indeed, viewing these uprights from their two-storey base, the viewer's gaze is directed through their soaring lines to the attic storey, the breadth of which is entirely adorned with relief ornament. According to Sullivan, this scintillating surface, together with the ornamented cornice that hovers above,

22.5 Adler & Sullivan,
Wainwright Building detail.
St Louis, Missouri, 1890-91.
Photo: The Art Institute of
Chicago. Richard Nickel.

22.6 Adler & Sullivan, Guaranty
Building. Buffalo, 1894-96.
Photo: David Phillips, Chicago.

22.7 Adler & Sullivan,
detail of elevation of Guaranty
Building. Buffalo, 1894-96.
Photo: David Phillips, Chicago.

22.8 Adler & Sullivan,
Transportation Building,
Columbian Worlds Fair.
Chicago, 1893.
Photo: Art Institute of Chicago.

signifies an ethereal, organic conclusion to the skyscaper's mechanical beginnings.

In the Guaranty Building (1894–96 in Buffalo, New York), Sullivan extended to his complete architectural compositions the dialectical synthesis upon which his organic system of ornament is based (plates 22.6 and 22.7). By cladding the entire geometric framework of the skyscraper in a 'garment' of low-relief terracotta ornament, he fully realized what he called 'our image of poetic art: utilitarian in foundation, harmonious in superstructure'.[21] Here, subtly varied ornamental patterns record the tensions and junctures of the underlying support-and-span steel cage construction. At the same time, these reliefs enhance the

gracefully ascending and descending tectonic lines, connoting nature's cyclical rhythms. As he explained in his architectural treatise, *Kindergarten Chats* (1901–02), under the chapter 'The Elements of Architecture: Objective and Subjective – Pier and Lintel', he conceived the vertical pier and horizontal lintel as two 'physical facts [or] symbols' and recovered their primordial meaning to be 'growth and decay, the elemental rhythms of birth and death'.[22] Thus, by viewing the entire building as an architectural means of poetic expression, the formal blending of reductivist structural frame and scintillating surface textures evoke the evanescent rhythms of nature emitted by the landscape. Of all Sullivan's skyscrapers, the Guaranty Building is most

visually akin to the French Art Nouveau style. Given his theoretical and his practical efforts to create a new style derived from nature, this kinship is to be expected. Yet, as suggested above, Sullivan's development of an organic means of expression was parallel with, but independent from, his French counterparts' endeavours. This provision notwithstanding, Sullivan's rapport with the French Art Nouveau was officially endorsed when in 1893 a French critic praised Sullivan's Transportation Building designed for Chicago's Columbian Worlds Fair (plate 22.8).[23]

Sullivan's polychromed, wholly ornamented Transportation Building provided a unique alternative to the core of the Worlds Fair, the Court of Honour, which was rendered in white plaster, a classical *beaux-arts* design arranged symmetrically around a rectangular waterway. Sullivan's build-

22.9 Louis Sullivan,
Getty tomb door. American, 1890.
Electro-type reproduction, 1894.
Musée d'Orsay, Paris.
Photo: Laurent Sully-Jaulmes.

ing was in a more informal setting. Sullivan combined 30 hues, dominated by red with varying tones of blue, yellow, and green, into the delicately interweaving patterns of his frescoed ornament. Viewed from a distance, the building emitted a radiant crimson effect. This optical illusion was reinforced by the Golden Doorway at the building's centre. Comprising a series of concentric half-circles within a monumental square frame, each of these surfaces was faced with gilded variations of Sullivan's low-relief ornament.[24]

It was precisely this chromatic and stylistic difference that merited the critical praise of André Bouilhet, the official representative of the Union Centrale des Arts Décoratifs. Singling out Sullivan's Transportation Building among all the architectural designs at the Fair, Bouilhet claimed, '*c'est une oeuvre bien personnelle* (it's a very personal work), owing to its complete absence of European stylistic precedents. In the same review, Bouilhet also extolled Sullivan's ornamentation in the Auditorium Building, for both its originality as well as its natural origins.[25] Even more surprising than his appreciation of Sullivan's originality, however, is Bouilhet's attention to Sullivan's Symbolist theories. Recognizing both his practical and artistic skills, Bouilhet stated: 'Monsieur Sullivan is an artist, a poet, a dreamer combined with a man of practicality.' However, when the critic reviewed Sullivan's artistic theories, he stressed the architect's mystical idea of art as a union between the soul of the artist and that of nature, the essence of which the artist translates into its material manifestation, the work of art.[26] Bouilhet's sanction of Sullivan's theories is especially noteworthy given the American critics' dismissal of, or disregard for, the architect's poetic pursuit. However, Bouilhet's endorsement can be explained by the fact that Sullivan's theories are closely related to contemporary French Symbolist theories. Indeed, many progressive artists and designers in Symbolist and Art Nouveau circles embraced aesthetic doctrines regarding the translation of the spirit of nature into the abstract and suggestive language of art (see chapters three and four). As with Sullivan, it was on the basis of these beliefs that the Symbolist artists emulated nineteenth-century idealist poets. Sullivan encouraged contact with Bouilhet, presenting him with '*une petite brochure*' entitled *An Essay on Inspiration* (1893). A more didactic variation of Sullivan's earlier, albeit highly esoteric, essay, *Inspiration* (1886), the later version constitutes a manifesto on the spiritual source of artistic inspiration and the process through which the artist translates the vital essence of things into the finished work of art.

Both the essay and the Transportation Building meant

22.10 Louis Sullivan, detail of main entrance, Schlesinger Meyer department store (now Carson-Pirie-Scott), 1899-1904. Photo: Hedrich-Blessing.

22.11 George Grant Elmslie, teller wicket (bank window). Bronze-plated cast iron. American, 1908. Made for Sullivan's National Farmers' Bank, Owatonna, Minnesota (1906-08). Elmslie was Sullivan's chief draftsman. Courtesy of Norwest Bank, Owatonna.

that the Union Centrale des Arts Décoratifs took notice of Sullivan, and this led to an extended liaison. After Bouilhet's meeting with Sullivan during the summer of 1893, the Union Centrale requested samples of his ornamentation for exhibition purposes. Sullivan responded by presenting as gifts casts of the doors from the Getty (plate 22.9) and the Wainwright tombs and ornamentation from the Transportation Building. These objects were accessioned by the Union Centrale in July and October 1893 for the future collection of the Musée des Arts Décoratifs (established in 1901). The Union Centrale, in turn, awarded Sullivan three medals (in gold, silver and bronze) both as an acknowledgement of his gift and 'as a tribute to the beauty and artistic merit of the art models'. A further honour was bestowed upon Sullivan when, in March 1895, the Union displayed these models in a special area of their galleries, named 'The Louis H. Sullivan Section'.[27]

Although Sullivan was gaining international recognition abroad, he encountered professional demise at home. Indeed, his mid-western clients had succumbed to the fashionable, high style of the White City's classical *beaux-arts* designs. Furthermore, in 1895 an economic depression forced the dissolution of the Adler & Sullivan partnership. On his own and lacking major commissions, Sullivan spent his remaining years writing as an architectural-social critic. A lifelong follower of American transcendentalist philosophy, he now despised the nation's materialism (which he identified with *beaux-arts* styles) and its attendant culture of technology. Sullivan's last skyscraper design, created for the Schlesinger Meyer department store (1899–1904; now Carson-Pirie-Scott Store) represents his antidote for this social deterioration (plate 22.10). In contrast to the Guaranty Building, where ornament works hand-in-hand with tectonic representation, in the Schlesinger Meyer design Sullivan clearly separated the one from the other. Here the two-storey base is sheathed entirely by low-relief ornament, while the tile-clad superstructure gives way to the reality of its skeletal cage construction. Sullivan composed this opposition for both practical and aesthetic reasons. The street-level enclosure of cast-iron ornament functions as display window frames, deliberately designed to attract a predominately female clientele (see chapter four).[28] The matter-of-fact design of the superstructure represents more open utilitarian spaces and displays which required more direct sunlight. For this reason, he adapted the wide tripartite 'Chicago window' to a minimalist articulation of the skeletal frame.

At the same time, however, this division between ornamented base and tectonic superstructure also reveals Sullivan's more urgent task as poet-architect. Concentrating his most 'emotional', artistic expression at the pedestrian level, Sullivan sought to provide the city-dweller with a return to nature, this being the nation's enduring source of spiritual and cultural renewal. That Sullivan sustained this ideal is well-illustrated by his building for the National Farmers' Bank in Owatonna, Minnesota (plate 22.11). Even when, later in his career, his commissions for ornamented skyscrapers waned, he sought to defer the cultural advancement of materialist values in rural America with the smaller-scale bank buildings he designed between 1906 and 1920. Then, as now, town residents affectionately referred to these polychromed and ornamented masterpieces as 'jewel-boxes'.

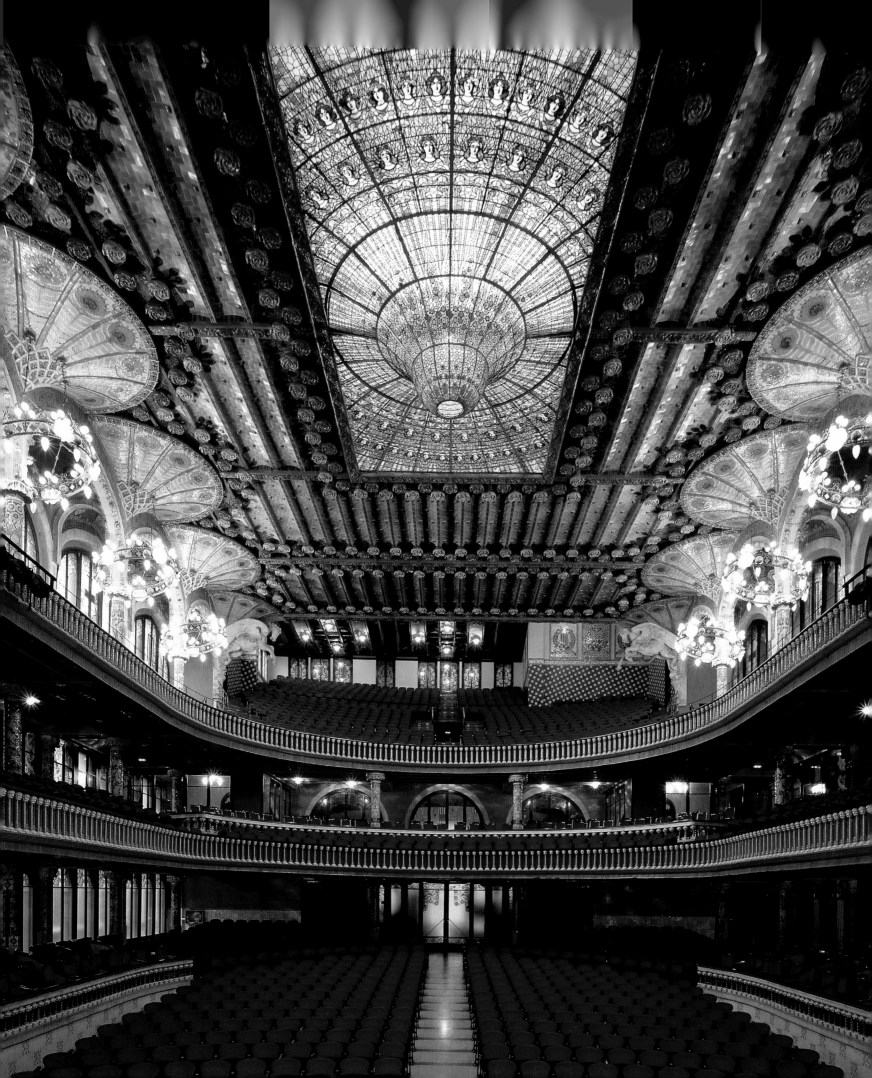

Ignasí de Solá-Morales

Barcelona:
Spirituality and Modernity

23.1 Lluís Domènech i Montaner, auditorium of Palau de la Música Catalana. Barcelona, 1905-08. Photo: Hisao Suzuki.

I n 1900 Barcelona was a city of half-a-million inhabitants. Part of it stood on the site of the former Medieval walled city which survived into the middle of the nineteenth century. Another district consisted of new buildings occupying less than a third of the area envisaged by Cerdà in his 1859 *Eixample* (enlargement) plan.[1] Finally, the city limits were extended to take in almost the entire plain of Barcelona, with the incorporation of the neighbouring communities of Les Corts, Sant Martí, Sant Gervasi and Gràcia in 1897, and Sarrià and Horta a few years later. As the business community accumulated capital throughout the nineteenth century, showing considerable skill in protecting its markets in Spain and in the colonies of Cuba and the Philippines, this fast-growing city became Spain's leading industrial centre.

In the face of the colonial crisis of 1898, the capitalists of Barcelona closed ranks. By repatriating capital, intensifying protectionism in the domestic market, and reorganizing Catalan politics, the city emerged triumphant from the so-called 'disaster' in the colonies. Whereas in the rest of Spain these events led to a period of economic stagnation and inspired the pessimistic ideology preached by the 'Generation of '98', Barcelona produced its own idiosyncratic version of what became known as 'regenerationism', wishing to draw a line under the 1875 restoration of the monarchy in the firm belief that the only way to respond to the crisis was through innovation and social reform. The city was convinced that, to carry out such a programme of modernization, it was imperative to have positive capitalist leadership from the worlds of industry and finance.

It is important to recall the political scene at the turn of the century. The 1901 Barcelona City Council elections brought victory for a group of young Catalan nationalists – industrialists and members of the liberal professions. Among the leading lights of this new, victorious party – the *Lliga Regionalista de Cataluña* – were Francesc Cambó, Verdaguer i

Callis, Enric Prat de la Riba, and Josep Puig i Cadafalch. From the outset, they regarded Barcelona as the great capital and the driving force behind their plans for economic and social regeneration. Unlike present-day Catalan nationalism, the *Lliga* was essentially a metropolitan movement. Policy documents issued by the *Lliga* contained constant appeals to transform Barcelona into 'a great metropolitan capital', 'the new Paris of the South' and 'the instrument of a people in the process of rebirth'. Municipal control was the basis of *Lliga* policy, and as soon as members took their places at Barcelona City Hall, they immediately set about defining new areas of responsibility and extending local authority powers. Firm support in policy co-ordination and development came from the *Mancomunitat de Catalunya*, an administrative union of the Catalan provinces.

The municipal programmes incorporated strategies for education, health, communications, and cultural and social reform. This marked an extraordinary expansion of the traditional field of city council responsibility, and a vast improvement over the squalid and woefully ineffectual efforts of Spain's central administration. With the arrival of the new century came the notion that the citizens of Barcelona should be able to rely on City Hall to provide the most modern public services. Nowhere else in Spain was this situation repeated. A similar change in attitude was evident in the field of culture. The post-Romantic artists and intellectuals of the 1880s and 1890s shared an ideal of transformation centred on the individual and the deliberate questioning and criticism of social convention. The traditional cultural conservatism of the men of the Catalan *Renaixença* and the radicalism of cultural magazines such as *L'Avenç* represented minority aspirations to establish an alternative point of view. Romantic Nazarenes, Ruskinians, Pre-Raphaelites, traditionalists, Medievalists, dedicated choral society members, 'excursionists' and archaeologists were all part of the *fin-de-siècle* cultural scene.

What is conveniently termed *modernista* architecture is a combination of quite different ideological and figurative tendencies. The *modernistas* included nearly three generations of architects of various political persuasions, whose artistic vision was often so dissimilar that it is hard to regard them as a homogeneous group. Although it is difficult to determine precisely what *modernista* means, it is well enough established to be accepted as a definition of a specific type of architecture. It shunned pure eclecticism and academic planning methods, and, enlisting the aid of a whole range of artists and artisans, created an architecture of undeniably distinctive local character.

Modernista was initially a theological and literary concept before it was applied to architecture. Architects practising between 1888 and 1908 are unlikely to have consciously regarded themselves as *modernistas*. It is only with hindsight that we can draw the necessary parallels with literary movements and contemporary thought and extend the term to embrace architecture. In any case, the architecture of the period is characterized by a climate of expressive symbolism, faith in technology and modern scientific inventions, adoration of the art of Richard Wagner and *fin-de-siècle* decadence, together with ardent Catalan nationalism. All of these contributed to some extent to the blossoming of artistic creativity, and have their equivalents in other centres where modernity in art and design was an issue.

During the last three decades of the nineteenth century, two different cultural attitudes prevailed among the progressive Catalan middle classes and influenced architectural style. First, some architects were inspired by firm faith in the social and material progress resulting from the development of capitalism. At the same time, they were fully aware of the relationship between what they were achieving in Catalonia and what was going on simultaneously in other major European cities. As the pace of construction accelerated in the great city of Barcelona, those architects politically committed to the new wave of Catalan nationalism, such as Lluis Domènech i Montaner, Antoni Gallissà, Josep Vilaseca, Pere Falqués, the Bonaventura brothers, Joaquim Bassegoda, Josep Domènech i Estap, Camil Oliveras, Josep Puig i Cadafalch, Joaquim Raspall, Salvador Valeri and Jeroni Granell, developed a global style that both experimented with new building technology and revelled in exuberant decoration. Their aim was to create a total fusion of different art forms to produce architecture for the new social institutions and the new ruling classes. Second, there was another group of architects of a quite different social and ideological hue. They were men who

sympathized with the Church's reaction to modern society and the changing conventions of urban life and proposed more Utopian and more radical models. Theirs was a revolutionary architecture designed to atone for what they saw as the grave sins of Western civilization. It took its inspiration from the Church, and all its advocates were moulded by both theological and Aesthetic ideas which provided a means of trying to understand modern life in the city.

The leading defender of this ideology was Antoní Gaudí, the most gifted architect of the period and creator of works of great power, unequalled in their dramatic impact. This remarkable and eccentric personality was surrounded by a host of followers, enthralled by the compelling discourse of the master from Raus. Among the most outstanding members of Gaudí's circle were Francesc Berenguer, Josep María Jujol, Joan Rubió, Bernardí Martorell, Jeroni Martorel, Cesar Martinell, Lluís Moncunill and Manuel Sayrach.

Lluís Domènech i Montaner was the prime example of the first type of Catalan *modernista* architect (plate 23.1). He graduated from the School of Architecture in Madrid in 1873, as Barcelona did not have a school of its own at the time. He soon distinguished himself as a respected member of his profession. His prowess as a scholar and historian and his prominence as a committed Catalanist politician only served to enhance his reputation. Domènech i Montaner's architecture shows the greatest affinity with that of other contemporary European architects. Like Otto Wagner in Vienna, H. Petrus Berlage in Amsterdam, Victor Horta in Brussels and Louis Sullivan in Chicago, Domènech sought to create a synthesis between the use of modern technology and the revival of traditional local crafts, by making sophisticated and spectacular use of the decorative arts. He constantly skirted around historical styles, but never produced historicist architecture. The most impressive aspects of Domènech are the soundness of his compositional ideas and the clarity and order of his projects, which respect the rationality inherited from the best academic traditions without falling into the trap of rigidity and affectation, as academic architecture had done (plate 23.2). The combination of this virtue, coupled with his obvious technical daring, can be seen in his self-confident use of large metallic structures, as in the Palau de la Música (1905–08) and the Café-Restaurant for the International Exhibition of 1888. We also see it in the freedom with which he adopts traditional solutions, such as vaults partitioned by structural brick walls or structures based on arches built of a combination of stone and ceramics.

Along with Domènech i Montaner's technical skills, we

23.2 Lluis Domènech i Montaner, Palau de la Música Catalana. Barcelona, 1905-08. Photo: Hisao Suzuki.

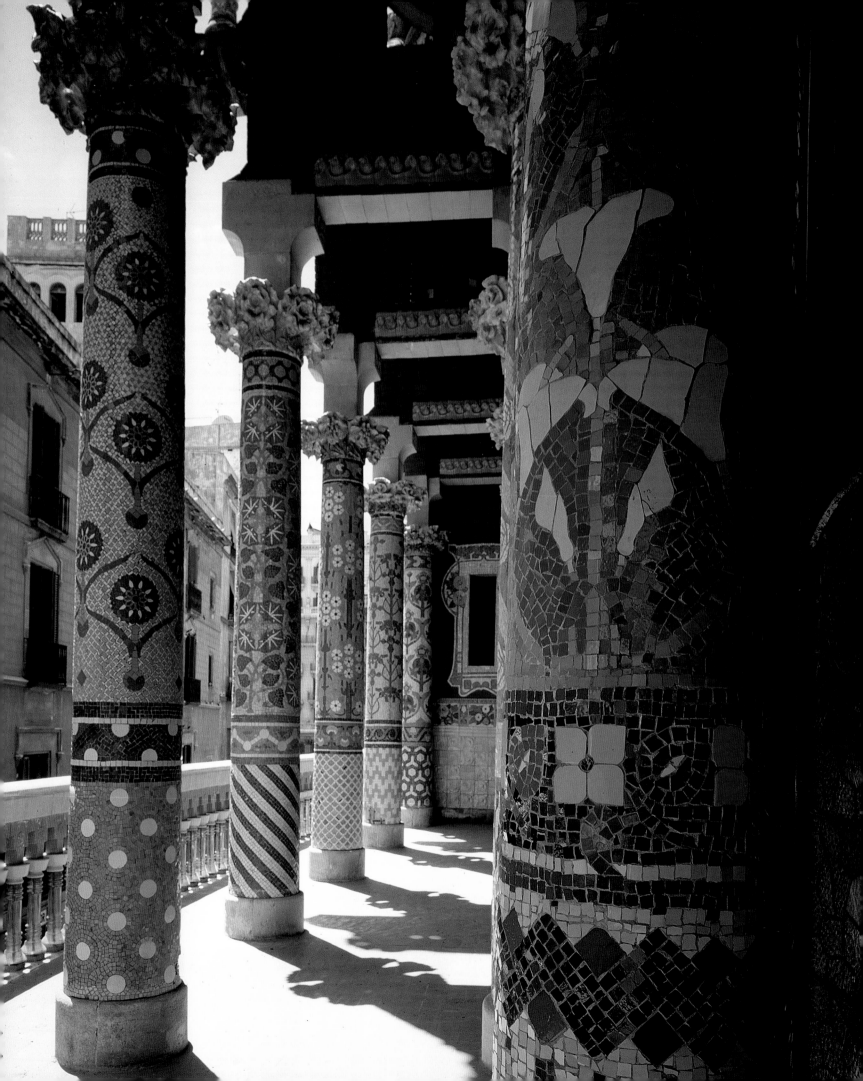

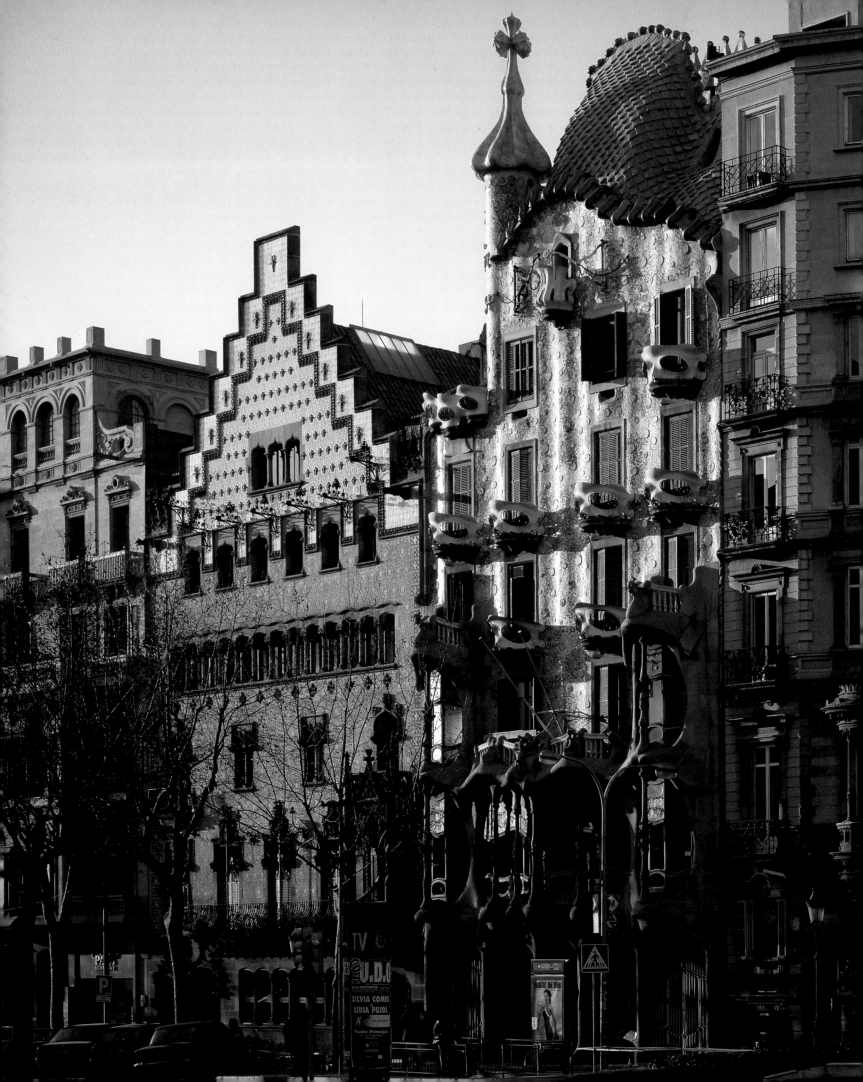

should also note his enormous historical knowledge. As Professor of Composition at Barcelona's newly founded School of Architecture, he was an inspirational teacher. He was an inexhaustible fount of ideas, with his idiosyncratic synthesis of historical knowledge, analysis of the great theories of architecture and technical and decorative procedures employed by architects through the ages. As well as the 1888 Café-Restaurant and the Palau de la Música (his most accomplished, innovative and thrilling achievement), the Santa Creu Hospital (1902–10), the Pere Mata Psychiatric Institute at Reus (1897–1919), Casa Tomás (1895–98), Casa Lleó Morera (1905), Casa Fuster (1908–10), and similar buildings in Barcelona and other Catalan cities, are all evidence of the energy and imagination with which Domènech linked and worked seemingly unconnected architectural styles, techniques and decorative elements. His closest devotee and collaborator was Antoní María Gallissà, whose premature death cut short a brilliant career. Gallissà's buildings in Barcelona and other cities are usually of smaller dimensions and his work often included the adaptation of existing buildings or small improvement projects.

After the 1888 Exhibition, Domènech i Montaner and Gallissà established a training centre for craftsmen and other specialists in the decorative arts. The centre was set up in Domènech's unfinished Café-Restaurant building, popularly known as the 'castle of the three dragons' because of its resemblance to the stereotypical castles featured in stage designs of the period. Gallissà organized an experimental workshop with a team of specialists representing the most flourishing traditional crafts, including Arnau for sculpture and decorative reliefs and Tiestos for iron forging. Casany, brought in from the renowned ceramics centre of Manises to take part in the experiment, came armed with all his expertise in form, colour and texture. Also joining the assembled company were glaziers, locksmiths, flooring and paving experts, and furniture-makers, who between them were capable of producing the masterly floral and other dazzling designs which were an essential feature of this architectural style. Among the significant names of the period were Escofet, Granell, Vidal, Homar, Serra and Masrriera.

The new generation of architects who graduated in the final years of the nineteenth century not only brought to fruition the dynamic process of creating a modern and cosmopolitan Catalonia. They also brought with them different aesthetic perceptions. The architect who best represents this evolution is probably Josep Puig i Cadafalch, who graduated in 1891 and was a prominent public figure during the period of the establishment of Catalan institutions between 1905 and 1923. Like Domènech i Montaner, with whom he studied, Puig i Cadafalch combined architecture and politics – he became a leading figure in the *Lliga Regionalista*. He was also an architectural historian, whose research into Romanesque art was published worldwide.

Influenced in his youth by the two contemporary giants, Gaudí and Domènech i Montaner, Puig i Cadafalch strove towards greater balance, elegance and cosmopolitanism in his own work. His youthful output at the beginning of the twentieth century consisted mainly of large multi-occupancy housing developments and single-family houses. Like the architecture of Charles Rennie Mackintosh and the Secessionists, his work was inspired by local traditions, in this case the provincial Baroque of Catalonia, as well as northern European Baroque and Medieval civic architecture. The result, which included more and more elements of the civic architecture of the early Spanish Renaissance, displays the stylish harmony of form, material and colour. Little remained of the architect's original eclecticism, as a taste for taut, monochrome surfaces and restrained ornamentation came to dominate the fluid, dynamic spaces of his buildings. Casa Trinxet (1904), Casa Macaya (1901), Casa Quadras (1904), Casa Ametller (1898–1900) (plate 23.3), Casa Puig (1903), Casa Company (1911), Casa Llorach (1904) and Casa Mintadas (1901) are among the many fine examples of this first flowering of private architecture.

G audí and his followers detested the word '*modernismo*'. They wanted absolutely nothing to do with the set of values it represented. They had no desire to be identified with the *modernista* heresy, denounced by the Church authorities as the kind of progressive stance which could never be reconciled with official Catholic doctrine. The Church's condemnation of *modernista* thinkers and theologians gained widespread support among those, who, like the clergy, had difficulties in assimilating the ideas of modern civilization.

For Gaudí, too, the word '*modernismo*' evoked the anarchistic views of Barcelona's *fin-de-siècle* artists and literati, the philosophical nihilism influenced by Ibsen, Tolstoy and Nietzsche, visions of debauchery and the glorification of the carefree, unconventional bohemian lifestyle. To combat this state of affairs, Gaudí and his friends formed *El Cercle de Sant Lluc* (Circle of Saint Luke). The purpose of the Circle was to set an example of moral rectitude and clean

23.3 Josep Puig i Cadafalch, Casa Ametller, 1898-1900, and Antoní Gaudí, Casa Batlló, Barcelona, 1904-06. Photo: Hisao Suzuki.

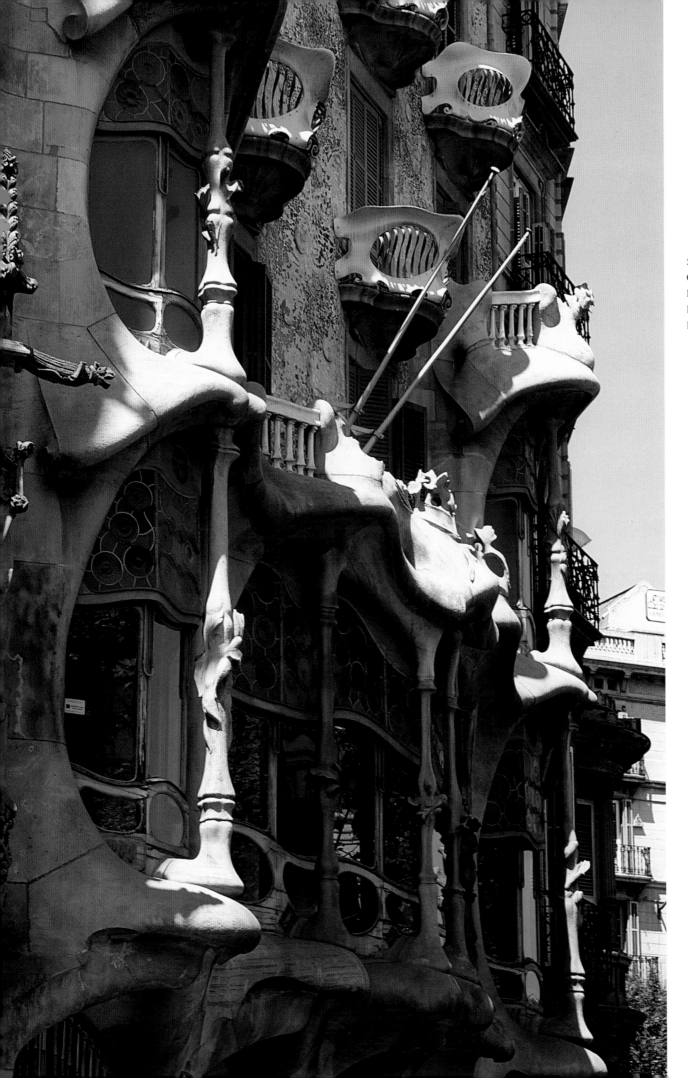

23.4 Antoni Gaudí,
Casa Batlló, detail of facade.
Barcelona, 1904-06.
Photo: C.H. Bastin & J. Evrard,
Brussels.

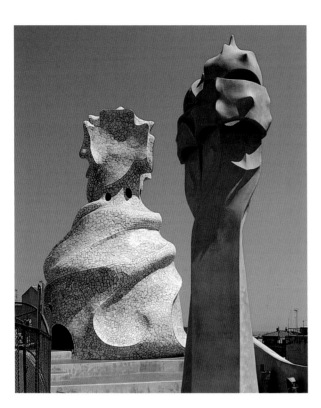

23.5 Antoní Gaudí, Casa Milà, roof line. Barcelona, 1906-10. Photo: C.H. Bastin & J. Evrard, Brussels.

23.6 Antoní Gaudí, Casa Milà, detail of facade showing wrought-iron balconies. Barcelona, 1906-10. Photo: C.H. Bastin & J. Evrard, Brussels.

living as an alternative to the agnosticism and what they saw as the amoral behaviour of Barcelona's *modernistas*.

Gaudí's architecture was also a reaction to *fin-de-siècle* style which he found unreasonably eclectic, optimistic and confident. His architecture for the new century was born out of a desire to go back to basics, and his projects owed little to prevailing trends. Essentially, he sought to uncover the logical basis of architecture. Influenced by the Rationalism of Viollet-le-Duc and the morality of Ruskin, Gaudí wanted to create architecture based on the criteria of function, and structure. He explored Western architectural traditions and, accepting the Gothic as the most advanced and autonomous style, he took this line of reasoning to its extreme by experimenting (in theory and practice), especially in the field of religious architecture. Having, as a young man, experimented with the stylistic repertoire from Gothic and Moorish, to Baroque and Classical, the mature Gaudí formulated a highly personal architectural vocabulary, which transcended the styles of the past and created a new interpretation of the primary elements of architecture. A radical form of decoration – harsh, expressionistic and

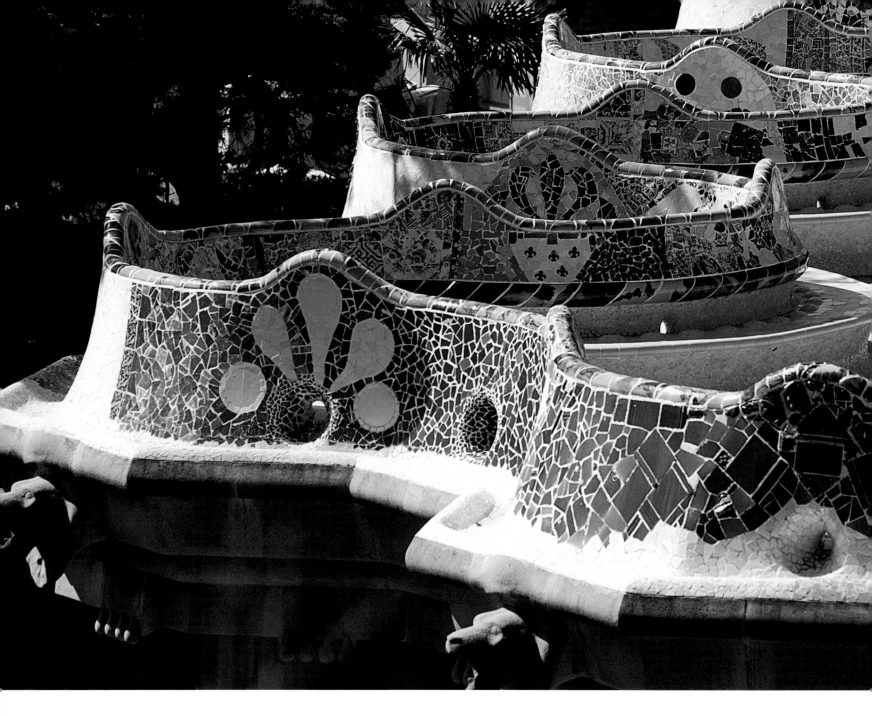

23.7 Antoni Gaudi, Park Güell, wall. Barcelona, 1900-14. Photo: C.H. Bastin & J. Evrard, Brussels.

archaic, but reflecting a bizarre recreation of the natural world – can be seen in his post-1900 works in Barcelona, such as the Park Güell (1900–14), the Sagrada Familia (1884 to the present), the unfinished church in the Colonia Güell (1898–1925), the Casa Batlló (1904–06; plate 23.4) and the Casa Milà (1906–10; plates 23.5 and 23.6). Every piece of ornamentation on each one of his buildings bears Gaudí's unmistakable trademark.

As regards houses, Cerdà's *Eixample* project for Barcelona (beginning in 1860) had set the standard for the construction of apartment blocks. The buildings, constructed on a square grid formation of load-bearing walls, enjoyed open aspects on two sides, one looking out onto the street, the other onto airy patio gardens.

Basing his experiments on this model, Gaudí explored a series of solutions which moved further and further away from the conventional interior and exterior layout. Not only did he create a completely new concept of decoration, but also a real revision of the kind of apartment-block architecture prevailing in Barcelona and other major European cities. The internal and external organization of Casas Milà, Batlló and Calvet are examples of the reasoning in which Gaudí engaged with inexhaustible passion. The fluid lines, the spatial freedom and the elasticity of facades and internal walls are all the result of this same preoccupation with re-evaluating the building's conventional form and suggesting the most spectacular alternatives in terms of construction, style and decoration. The same radical revision also applied to single buildings, whether they were detached family houses or small buildings designed for other purposes.

Irrespective of their different functions, locations and

styles, detached houses, such as Bellesguard (1900–02) and Capricho de Comillas (1883–85), the Palacio Güell (1885–89; plates 23.7 and 23.8), Casa Vicens (1883–85) and the Güell stables (1887), all share a distinctively quirky compositional style. The crucial characteristic of most of these buildings is the technique of 'collage', namely the use of different and discordant materials creating the effect of an impossible jigsaw puzzle. The design of these buildings, and

which to provide an answer to the perennial problems of architecture of whatever period. The project for the Tangier Missionaries, the church at the Colonia, Güell and, above all, the interminable and still unfinished Templo Expiatorio de la Sagrada Familia are clear examples of how to tackle the problem. The key to this latter work of colossal boldness (plates 23.9 and 23.10), which synthesizes Gaudí's radical approach and extreme aspira-

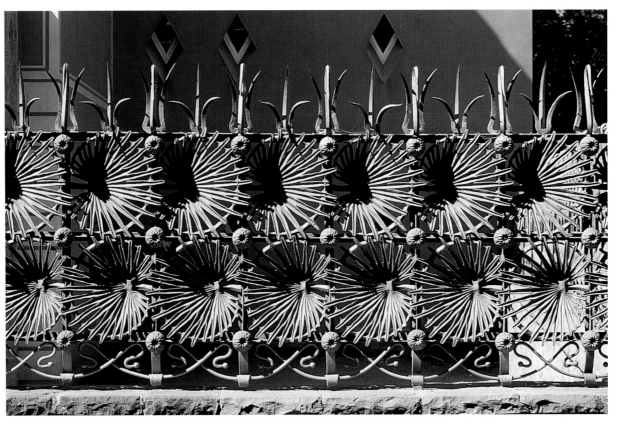

23.8 Antoní Gaudí,
Park Güell, gate, wrought iron.
Barcelona, 1900-14.
Photo: C.H. Bastin & J. Evrard,
Brussels.

the wild, assortment of 'pieces' of which they are constructed, tends to produce a sensation of chaos, of a kaleidoscopic world with no beginning and no end. They also bear witness to the uncompromising conviction of a man who sees this association of disparate fragments as the best response to the moribund methods of academic composition.

However, the best expression of Gaudí's passion for experimentation is, without doubt, his religious architecture. Gaudí considered the place of worship as an architectural paradigm, the ultimate challenge demanding the architect's maximum concentration and the utmost clarity of thought. Such examples display Gaudí's fundamentalism and reflect the intransigent Catholic attitudes to which he subscribed. In common with contemporary thinking in Britain, Germany and France, Gaudí viewed Christian religious architecture as the touchstone from

tions, lies in the very fact that it is still incomplete, showing just how excessive the project was.

Gaudí did not work alone on any of his projects, least of all the Sagrada Familia. Although he rejected any suggestion of a Gaudí 'school', he was a great educator who gathered around him a large group of collaborators, architects, artists and artisans. Their contribution was crucial to the final result of his projects.

Perhaps his most notable assistants were Francesc Berenguer, Joan Rubió and Josep María Jujol. Berenguer, who had no formal qualifications, worked for almost all his life alongside Gaudí. He was the master's trusted confidant, both professionally and in his private life. Berenguer also completed projects of his own, some of them with Gaudí or other colleagues, in the Gràcia district of Barcelona where he was born. He also contributed to the

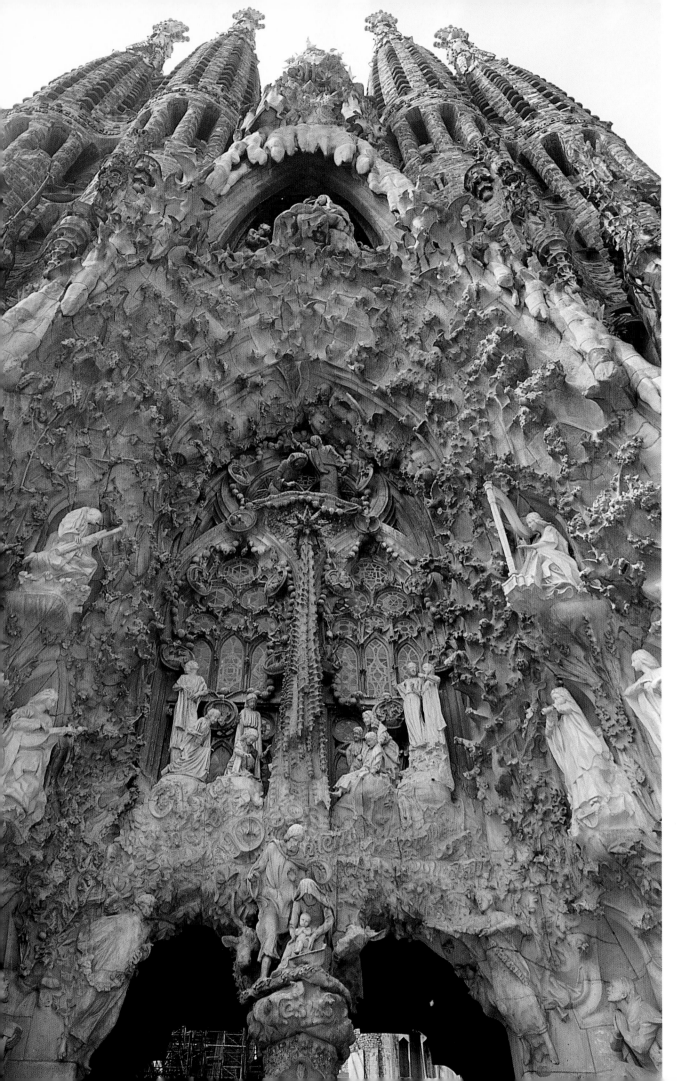

23.9 Antoni Gaudí,
Sagrada Familia, detail of façade.
Barcelona, 1883-1926.
Photo: C.H. Bastin & J. Evrard,
Brussels.

23.10 Antoni Gaudí,
Sagrada Familia.
Barcelona, 1883-1926.
Photo: C.H. Bastin & J. Evrard,
Brussels.

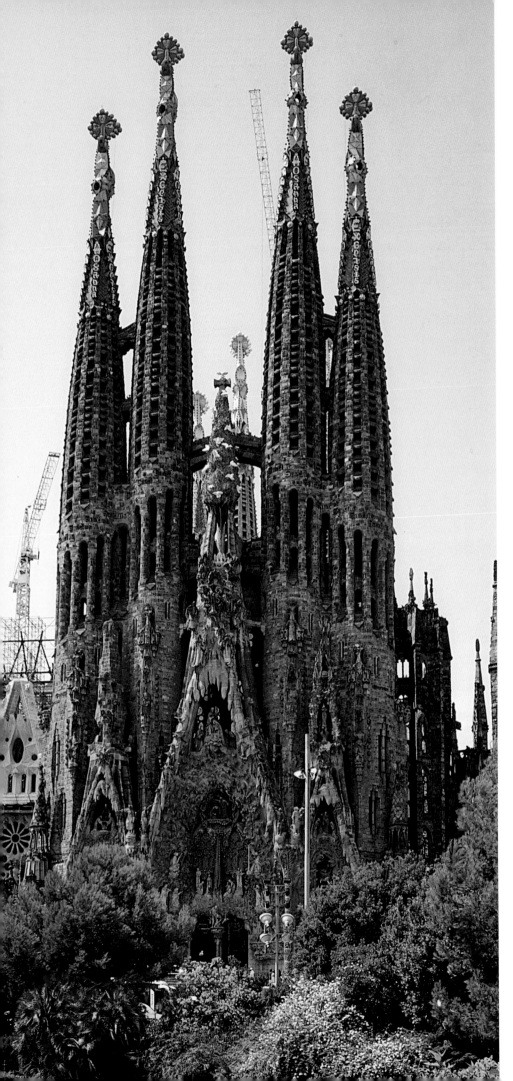

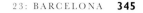

Güell wine cellars at Garraf (1888–90), the school and schoolmaster's house in the Colonia Güell (1914) and the Sanctuary of Sant Josep de la Muntanya (1910).

Joan Rubió i Bellver worked alongside Gaudí, both as a young man and later as a freelance. He played an important role in other Gaudían projects, such as the second phase of the Sagrada Familia (1891–1900), the Park Güell (1900–14) and internal improvements to the Cathedral of Mallorca (1904–14). At the same time, Rubió built to his own design a large number of detached family houses, mainly on the outskirts of Barcelona, in which Gaudí's influence can be seen in Rubió's adoption of specific structural solutions, as well as the application of Gaudí-like techniques, such as collage, displacement and juxtaposition. Casas Golferichs (1901), Canals (1900), Alemany (1901), 'El Frare Blanc' (the so-called 'White Friar', built for the Roviralta family in 1903–13), Dolcet (1900), Rialp (1908), Ripol-Noble (1910) and Trinxet (1923–25) are just a few illustrations of Rubió's special talent.

The most gifted architect in Gaudí's circle was without doubt, however, Josep María Jujol. Not only did he make outstanding contributions to some of Gaudí's works, but his own later projects can also be considered as some of the most interesting to emerge in Europe during the period. Jujol had an enormous talent for devising shapes. He evolved a spontaneous design style in which the accumulation of very different elements produced a viscous mosaic of a whole series of seemingly unrelated ideas. His decorations are composed of colours, shapes, rhythms, numbers, letters and symbols, made up of all sorts of bits, pieces and *objets trouvés* to dazzling and sometimes disturbing effect.

The balconies of the Casa Milà, the mosaic facade of the Casa Batlló, the dome vaults of the Hall of Columns in the Park Güell, and the bench surrounding the park's esplanade, bear the unmistakable hallmark of the Jujol-Gaudí partnership. Independently, too, Jujol showed strokes of genius in his designs for some minor, low-budget commissions, including improvements to existing buildings. La Torre del Ous (1913–16), the Masia Negre (1914) at Sant Joan Despí, the churches at Vistabella (1918–23) and Montferri (1926–29), and improvements to the Pallaresos building (1920), are clearly a unique example of an ethereal, allusive, all-encompassing architectural style in which a number of expressionist motifs and surrealist concepts are impressively presented and developed '*avant la lettre*'. Jujol's intention was to demonstrate how variations in construction and ornamentation can run parallel. His work is an intimate but glorious experiment in modern architecture, and an illustration of the disturbing nature of Gaudí's spacial concepts.

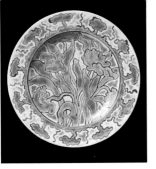

David Crowley

Budapest:
International Metropolis
and National Capital

24.1 Ödön Lechner, interior
of The Museum of Applied Arts.
Budapest, 1896.
Photo: Gábor Barka.

Although *fin-de-siècle* Budapest has been eclipsed by the mass of studies of *fin-de-siècle* Vienna, a convincing claim could be made for the Hungarian capital as *the* modern city in the Austro-Hungarian Dual Monarchy. Budapest grew at an astonishing rate after the 1860s to become one of the great metropolises of Europe. In the last three decades of the nineteenth century, its population grew faster than any other city in mainland Europe: from 300,000 to over one million residents. Its extraordinary growth resulted from many factors, but – symbolically and practically – it was Budapest's new place as the hub of a dense rail network which transformed it into a thriving crossroads at the heart of Europe. The city became a sprawling, urban processor in which raw materials were worked into commodities, peasants were transformed into proletarians and new forms of cultural expression were tested.

The city's rapid free-fall into the modern age was not without tensions, however. The industrial and commercial metropolis drew people from the rural areas, gathering Magyars, Jews and other ethnic groups to a city in which conservative social bonds did not hold. As agriculture declined under competition brought by the spread of the railways, the bourgeoisie relinquished their small, increasingly inefficient landholdings for positions in the rapidly expanding bureaucracy or the professions. Moreover, Budapest's growing middle classes constituted a new social force which came to challenge the hegemony of the aristocracy, for many years secure in its self-appointed role as defender of Hungarian interests. The fact that the largest and most advanced part of Hungarian industry was located in the capital accentuated differences between the city and the country (in 1910 over one-third of Hungary's major factories and one-fifth of its craft workshops were located there). The growing confidence of Budapest's bourgeoisie in the vitality of Hungarian industry, trade and

culture gave added impetus to the calls for full Hungarian sovereignty which reached a crescendo around 1900. Although the *Ausgleich* (Compromise) negotiated with Austria in 1867, which created the Dual Monarchy, had secured a privileged degree of autonomy for the Magyars from other peoples living under Franz-Joseph's rule, voices continued to call for full independence. Moreover, the rising influence of middle-class nationalism in the last years of the century exerted a powerful influence over patterns of culture. By the end of the century, national issues affected all forms of cultural expression in Hungary. Budapest, over all other locations in Hungary, provided the creative environment in which new forms of culture and expressions of Hungarian identity were tested, discussed and, ultimately, modernized.

From the 1880s a number of architects and artists – including Ödön Lechner, the 'father' of modern Hungarian architecture – sought, in his words, to 'shape a new age in art, to give birth to a new style'.[1] This aim can, in the first instance, be understood as part of a European-wide rejection of historicism in architecture and the applied arts in a modern age. In this spirit, Lechner and other Hungarian architects and artists were receptive to the emergence of Art Nouveau in Europe. However, Art Nouveau was usually seen – by both its critics and advocates – as an alien international phenomenon, which needed to be accommodated with internal Hungarian conditions.

Lechner was the key figure in the development of both modern architecture and an emphatically Hungarian language of design. Looking back over his career of more than four decades, he claimed in 1911 that: 'I have always pursued the distant ideal of creating a Hungarian national style.'[2] Although the style he developed was not without contradictions or vociferous critics, his influence over a generation of young architects who started practice around 1900 was very strong. Throughout his career he displayed

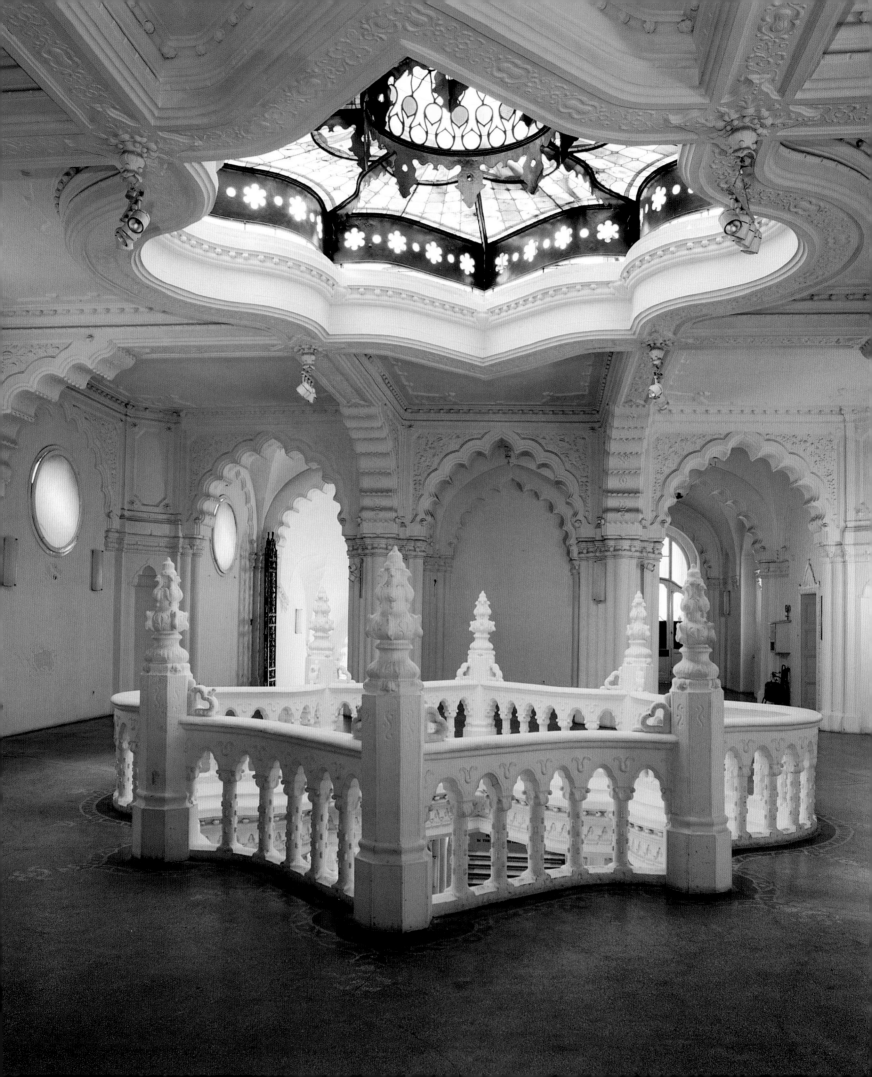

24.2 Ödön Lechner, interior
of The Museum of Applied Arts.
Budapest, 1896.
Photo: Gábor Barka.

24.3 József Huszka, Plate
XXXIX from *Magyar Ornamentika*
(Budapest, 1898).
V&A: G.58.G.18.

a practical interest in new building materials and techniques as well as historical languages of form. His early commissions, such as the Town Hall in Szeged (1881–83), drew heavily on the French Renaissance revival style. In fact, Lechner acknowledged that at that time he had wished to 'harmonize' the 'primitive crudeness of Magyar folk art and the refinement of French culture'. His thinking was not simply a form of undisciplined eclecticism. He imagined that it would be possible to conceive of a properly Hungarian style by fusing suitable languages of form. He claimed that the archetypal model of this kind of synthesis was to be found in the way imperial British architecture had accommodated Indian architectural forms.

During two visits to Britain and in research on contemporary buildings in India, such as Calcutta Railway Station, Lechner believed that he had encountered a vein of architecture which invoked ancient and even ancestral decorative forms without lapsing into historicism. Behind Lechner's conception (as with Wagner in Vienna) lay Gottfried Semper's influential theory of *Bekleidung* (dressing/cladding), namely the idea that a distinction could be made between the functional/structural core of a building and its cover.[3] Once freed from its load-bearing function by modern construction techniques, the surface of a building was suitable for expressive and decorative attention. In this way, Lechner dressed his major building projects in the capital with ornamental schemes designed to establish continuity with the Hungarian past, while utilizing modern engineering.

Lechner's reputation was made by the buildings he designed from the early 1890s. They were a coherent attempt to create a national style and are usually credited as being the first examples of Art Nouveau architecture in Hungary. The Museum of Applied Arts, for example, designed as part of the national centennial celebrations in 1896, is regarded as the keystone in the development of an emphatically national style and a pioneering building in the history of modern architecture in Hungary (plates 24.1 and 24.2). Using building materials such as brick faced with glazed tiles and wrought ironwork, in the belief that they were characteristically Hungarian, Lechner designed an edifice that owed relatively little to historical precedent. The unconventional, exotic appearance of the building was achieved by, for example, capping its dome with a *baldachin*-shaped lantern and by 'capping' the four wings with haunched, vaulted domes. The roof was given a powerful decorative effect by richly coloured pyrogranite tiles and Orientalist figures made by the Zsolnay factory, and majolica bricks covered the street-facing facade and wings.

Lechner stressed both the practical function of architectural ceramics in the 'dusty, smoky air of the modern city' as well as the national roots of this use of tiles. The arabesques of the entrance and the spatial rhythm of the facade reinforced its Orientalist character. Lechner's design was a far cry from the Classical ideal of the museum and aroused much controversy.

In Lechner's design for the Museum of Applied Arts, modern structural devices such as steel beams, decoratively pierced, and consoles which span the central hall were also symbols. The canopy effect created by the span was intended to evoke the ancestral tent of the semi-nomadic Magyar tribes. Other quotations include arches opening the galleries and overlooking the main exhibition hall, derived from Mogul architectural details (which Lechner probably saw during a visit to the South Kensington Museum in 1889). At that time, little was actually known about the origins of the Magyar peoples. Late nineteenth-century Hungary clung tenaciously to the idea that it retained, in some deeply ingrained way, traces of its roots in the East.[4] However, Lechner was better informed about the roots of Hungarian culture than many of his

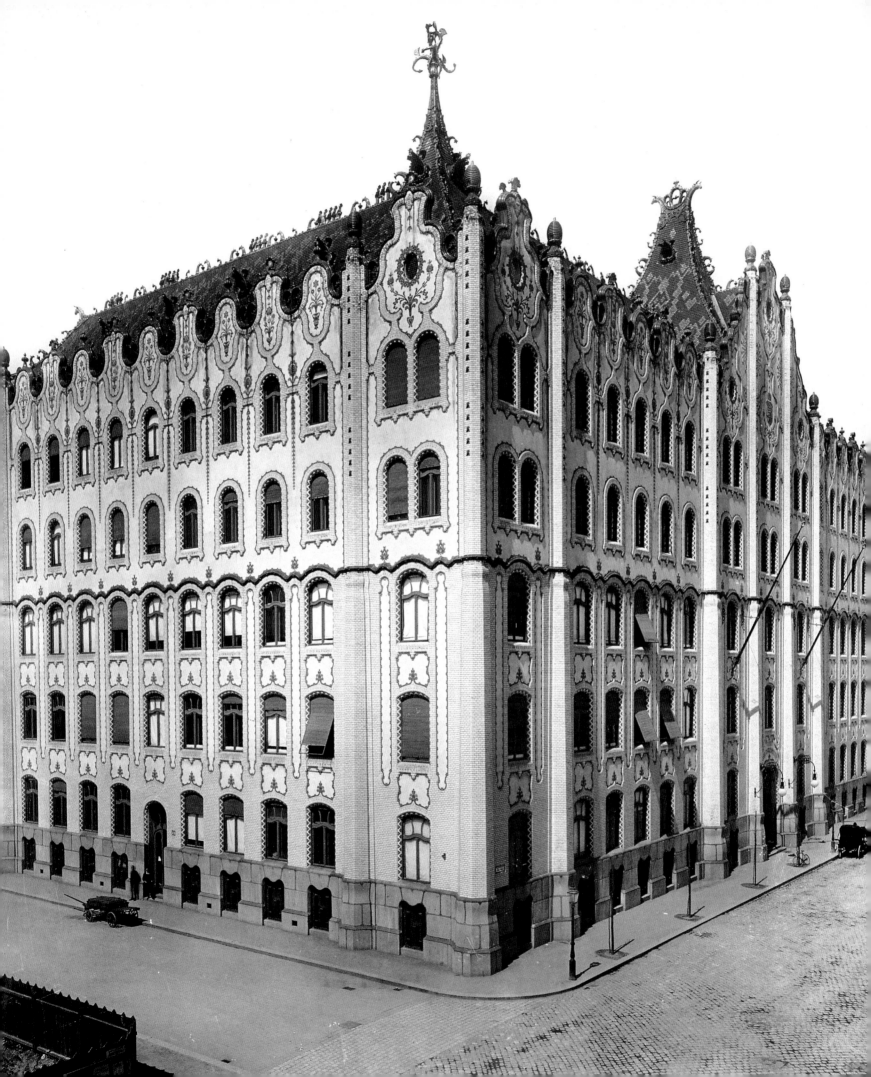

24.4 Ödön Lechner,
Postal Savings Bank.
Budapest, 1899-1901.
Courtesy of Gábor Barka.

contemporaries. He was well acquainted with the work of József Huszka, a pioneer of ethnography in Hungary (plate 24.3). Huszka's activities as a collector and author of books published from 1885 on peasant art, clothes and tools offered compelling evidence of connections between Hungarian, Persian and Indian art.[5] He compared vernacular traditions of embroidery with the gold work found in Avarian burial sites and with Sassanian palmettes. Huszka's studies were used by Lechner as a key source of reference. Consequently, his use of Eastern ornament was often combined with figures derived from the vernacular. In fact, his reputation as a pioneering Art Nouveau architect lies as much in his use of these stylized motifs as his dramatic roof-lines and parapets (plate 24.4). Lechner, and the

circle of architects associated with him, favoured commonplace natural motifs (such as the flora and fauna of the Hungarian peasant countryside, including tulips and bees) over exotic and literary forms, such as the orchids and Medusas found in many Art Nouveau buildings and interiors in Western Europe. Indeed, the tulip was widely adopted as a symbol of Hungarian identity, an identity claiming roots in the countryside. A prominent craft association organized around the turn of the century to promote rural industry, for example, was called *Tulipán*. In 1906, when a nationalist campaign against the economic 'rule' of Austria prompted the so-called 'tulip movement', Hungarians wore red cloth tulips to demonstrate their commitment to a boycott of Austrian goods.

In the eyes of his supporters, Lechner had developed a model of design which suggested a method and new sources for a Hungarian language of form. As a modernist, he objected to the singling out of any one 'national style'. The importance of Art Nouveau or the 'secession' to him was that it hastened change:

> That which is Classical and historical today, that they
> respect so much, was at one time modern and grew
> out of some kind of secession, whether dissident or
> revolutionary. … It is continuous artistic rebirth,
> redevelopment and reshaping – for this is secession –
> that we have to thank for the old styles and indeed the
> new ones too.[6]

Nevertheless, the particular Hungarian recipe which Lechner had promoted was adopted by many architects and designers in the early years of the new century. In 1901 the Victoria and Albert Museum acquired a number of pieces

24.5 Ödön Faragó, cabinet, table, armchair and chair. Poplar, wrought iron, ash stained green, silk upholstery (later leather). Hungarian, 1900. V&A: 143-1901; 147-1901; 145-1901; 144-1901.

of furniture designed by Ödön Faragó and shown at the Paris *Exposition Universelle* of the previous year (plate 24.5). These designs exploited the mix of the vernacular and the urbane that typifies this strain of Hungarian Art Nouveau. A graduate of the Vienna *Kunstgewerbeschule* (see chapter twenty), Faragó had designed furniture in a range of traditional styles for leading manufacturers in Budapest in the 1890s. However, by 1900, the Lechnerian model for modern design had become fashionable. Faragó was commissioned to furnish a room in the summer house in the grounds of the Royal Castle, Buda, for Elisabeth von Wittelsbach, Empress of Austria and Queen of Hungary, a remarkably popular figure in Budapest. Unlike the grand 'Austrian' Baroque interiors of the castle complex (remodelling as part of the expansion of the royal residence began in 1896 and was completed in 1905), the walls of this fantastical space were decorated with peasant motifs arranged to suggest a sheltering bower (a common motif in the decorative arts in Europe at that time). Similarly, Faragó's armchair for the summer house, an unmistakably modern design made by Lörincz Lengyel in Szeged, combines a carved and stained ash frame with an embroidered seat based on *Kodmön* jackets worn in Békés County. The patron of this scheme died in 1898, unleashing a great wave of Hungarian mourning. Queen Elisabeth had been adopted by Hungarian nationalists as a kind of emblem of the nation, bound in an unhappy marriage with Austria. In return, Franz-Joseph's consort had displayed unexpected public affection for Hungarian culture. Her summer-house interior seems to have mirrored the Dual Monarchy's uneasy compromise between Hungarian identity and Austrian rule.

The Zsolnay ceramics manufactury in Pécs was another significant source of Art Nouveau design. Already well established (employing, at that time, 900 workers), the factory achieved great international acclaim between 1898 and 1908 (plate 24.6). Its second owner, Vilmos Zsolnay, had high ambitions for his company when he bought it from his bankrupt brother in 1865.[7] Seeking to compete with high-quality Austrian and Czech ceramic wares, he courted foreign highly skilled craftsmen to oversee his company's production; scientists to invent new glaze recipes and manufacturing processes; and artist-designers to improve the aesthetic quality of the firm's wares. The premium placed on invention and design was maintained in the 1890s when Zsolnay and Vincze Wartha (a chemist) invented *Eozin*, a metal, iridescent glaze. In addition, the elegant Art Nouveau designs produced by artists such as Sándor Apáti Abt and Lajos Mack were well suited to the brilliant lustre of this ceramic process. The 'fantasy' of *Eozin*, which seemed to flood colour across the surface of any ceramic form, was matched in their designs for floral

24.6 Zsolnay factory, vase. Porcelain-faience covered in Eozin glaze. Hungarian, 1899. The Museum of Applied Arts, Budapest.

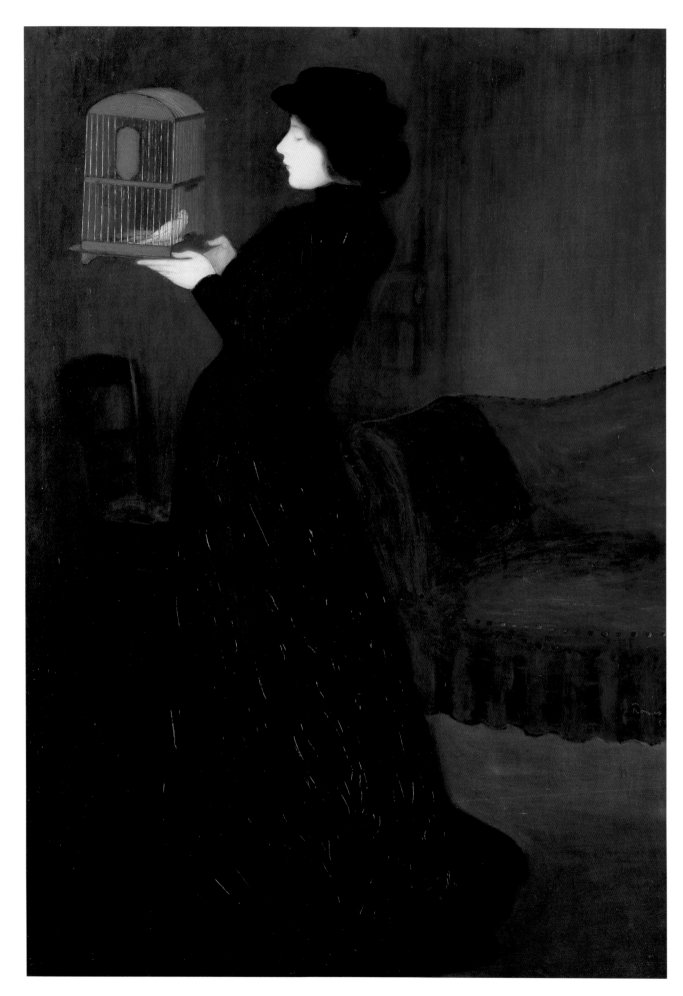

24.7 József Rippl-
Rónai, *Woman with a Bird
Cage*.
Oil on canvas.
Hungarian, 1892.
The National Gallery
of Art, Budapest.

for its collections);[9] from the growing use of its motifs in magazines and other graphic forms; and from the adoption of the Art Nouveau idiom by many of Budapest's established craftsmen. These craftsmen included Tamás Kántor, a cabinetmaker who made a number of Faragó's designs, and Miksa Róth, a glassmaker who worked with the painter József Rippl-Rónai.

Rippl-Rónai was probably the most outstanding artist to work with the Zsolnay company during the period. However, his work in the decorative arts constitutes an important contrast to the ethos established by Lechner. This is not surprising given Rippl-Rónai's curriculum vitae. Living in France from 1887, after training as a painter at the Munich Academy, he painted with the Pont-Aven School, was a member of the Nabis, and exhibited decorative works at Bing's L'Art Nouveau in 1897 (plate 24.7). In fact, Bing published a small folio of his lithographs illustrating a collection of poems by the Belgian Symbolist Georges Rodenbach, entitled *Les Vierges* (The Virgins) in 1895 (plate 24.8). In these languid illustrations of women reading and walking in gardens, Rippl-Rónai concentrates on rhythmic, fluid lines and flat fields of bright colour. In these images – which owe much to Paul Gauguin and Maurice Denis – the Hungarian artist synthesizes their separate elements into a balanced, flowing whole to such an extent that the suggestion of narrative or even subject seems to recede. In 1896 he began the design and supervision of the manufacture of furnishings for a palace dining room for Count Tivadar Andrássy, a Liberal MP in the Hungarian Parliament. This project was one of the great Art Nouveau schemes in Hungary, and, in marked contrast to schemes by Lechner and his colleagues, displayed a powerfully international character.

Unlike many Hungarian artists of the period, Rippl-Rónai's work, whether produced abroad or at home, shunned the self-conscious national character sought by his compatriots. Nevertheless, like other Hungarian artists and architects who had worked and studied in Western Europe, Rippl-Rónai was a catalyst in the germination of new ideas in his native country. His art developed a strongly decorative and sensual character in the 1890s. It is not surprising that he became an enthusiast for the decorative arts (under the influence of the Nabis, and his friend Aristide Maillol) and was much taken with the idea of the *Gesamtkunstwerk*. The clearest evidence of this is found in his designs for the dining room for Count Andrássy's Buda palace (destroyed in the Second World War). Working in the belief that a spiritual and stylistic harmony could be brought to all aspects of domestic life, he produced designs

24.8 József Rippl-Rónai, plate from Georges Rodenbach's *Les Vierges* (published by Siegfried Bing, 1895). V&A: 95.JJ.52.

vases and fluid, graceful statuettes. Zsolnay's wares in this period were invariably great successes at the many International Exhibitions. At the *Esposizione Internationale* in Milan in 1906 the Zsolnay ceramic fountain, the centrepiece of the Hungarian Hall designed by Géza Maróti, was no exception. Art Nouveau design had become a popular style exploited in vogue interiors and products and in official displays abroad. The reasons for the acceptance of Art Nouveau design from 1900 stem, according to Ildikó Nagy,[8] from the popular interest in International Exhibitions such as the one held in Paris in 1900 (from which the Hungarian Museum of Applied Arts bought many exhibits

for furniture, lighting, tapestries, glasses, vases, stained-glass windows and a 30-metre-long embroidered frieze, many of which were recorded in the pages of *Magyar Iparművészet*, the leading Hungarian applied arts magazine of the period.[10] As Andrássy was a discerning and critical patron, rejecting a number of Rippl-Rónai's proposals, it is difficult today to identify the precise disposition of this interior. Its 'reconstruction' is an imaginative act, relying on contemporary opinion, some sketches and photographs, and the few pieces of glass, textiles and ceramics held by the Museum of Applied Arts in Budapest and in private collections.[11]

Rippl-Rónai's scheme was undoubtedly shaped by a Japoniste aesthetic. The oxidized bronze panels as trees in silhouette on the cupboard made by Endre Thék owed much to the flat, calligraphic representation of nature in the Japanese tradition; and the simple fireplace, composed of flat ceramic tiles on which the vividly coloured glazes seemed to have been allowed to flow and fuse at random, within a mahogany frame, suggests a bamboo screen. Unlike Lechner, there is no evidence to suggest that Rippl-Rónai's Orientalism was part of a nationalist agenda. On the contrary, it is evidence of internationalism; that is the spread of a fashionable idiom from France to Budapest. Furthermore, various parts of Andrássy's dining room were made in workshops across Europe. Each part was unique, drawing inspiration from nature – searching out the essential, phenomenal forms of nature rather than representing them in a conventional manner. Echoing the dreamy women in *Les Vierges*, the centrepiece of the Andrássy scheme was a large embroidery made in Neuilly depicting a 'Woman in Red' (plate 24.9). This Synthetist image showed a woman, who is sometimes interpreted as Andrássy's wife, absorbed – literally and emotionally – in nature. Many of the objects were unusual – some had an abstract, idiosyncratic character breaching the norms of conventional taste of the day. The strange and irregular shapes of the delicate blown glass made in the Zitmann workshop in Wiesbaden, were, for example, regarded as faulty and clumsy by contemporary observers. However, they must be regarded today as exceptional examples of Art Nouveau in Europe.

24.9 József Rippl-Rónai,
Woman in Red. Embroidered
wall hanging. Hungarian, 1898.
The Museum of Applied Arts,
Budapest.

Despite contemporary criticism levelled at Rippl-Rónai for his idiosyncratic expression and decadence, and at Lechner for his Romanticism, by the early 1900s Art Nouveau – in its various guises – had had a great impact on Hungarian taste. It was even employed to represent the nation abroad. In officially sanctioned displays at exhibitions such as the Paris *Exposition Universelle* (for which the Agence du Musée Commercial Royal Hongrois orchestrated a display of modern decorative art), and the *Esposizione d'Arte Decorativa Moderna* in Milan in 1906 (for

which a superb national pavilion was designed by Maróti), Hungarian Art Nouveau was used to signal both modernity and national vitality to an international audience.

From about 1902 new attitudes to national culture emerged which affected all areas of art and design and seemed, in retrospect, to demand that Hungarian culture turn inwards and reject the modern 'European' processes of urbanization and industrialization which patriotic supporters such as Lechner had advocated strongly. The most evident manifestation of this shift was a new and more pro-

24.10 Kóroly Kós, three-panel screen. Hungarian, *c.*1908. The Museum of Applied Arts, Budapest.

24.11 Aladár Körösfő i-Kriesch, *Women of Kalotaszeg*. Woven tapestry. Hungarian, 1908. Gödöllő Városi Museum.

found interest in Hungarian peasant culture, and, in particular, in Transylvanian life. This interest was not new. Lechner had already looked to the vernacular as a source for national motifs which could be applied as ornament on his buildings: 'We must learn this Hungarian folk style, like any language … . We must find out its rules, become immersed in its particular spirit, so that later on, as transmitters of culture, *we can introduce the spirit of these forms into the larger-scale, more advanced, even monumental architectural projects of our time.*'[12] The importance of peasant art was, for Lechner, a matter of 'style' and of 'forms' which could be applied to the modern building types of the age. It was a particular use of history which allowed him to create buildings which were simultaneously modern and national.

In contrast, new groups emerged after 1900 which had different attitudes towards the peasant culture. Lechner's approach came to be viewed by figures such as Károly Kós, the key figure behind a group of architects trained at the Budapest Technical University known as *Fiatalok* (the

Young), as 'a well-intentioned mistake' (plate 24.10). *Fiatalok* shared a strong interest in collecting examples of peasant art and sketching peasant homes, Medieval fortified churches, turreted towers and 'Székely gates' – studded and carved wooden archways with pitched roofs. Their researches, although spread across Hungary, focused on Transylvania, then a province in the south-east of the kingdom inhabited by the Székely (ethnic Hungarians). This region held particular significance both in Hungarian history, and in the eyes of these young architects infused with an Arts and Crafts ideology. National Romantic myths had cast the 'people of Attila', as the Székely were dubbed at the time, as a living 'treasury' of Magyar life. The people of the region had maintained some degree of independence during Turkish rule over Hungary in the sixteenth and seventeenth centuries. Living in the most underdeveloped area of the kingdom, they were, it seemed, untouched by the processes of modernization which had transformed much of the country. Consequently the architectural forms that were found in Transylvania – rustic stonework foundations, plain white-washed walls and wooden architectural structures such as porticoes – were claimed as an authentic, national language of building forms. Where Kós and his colleagues differed from Lechner lay in the significance attached to how Transylvanian architecture was attuned to its surroundings. It seemed part of nature. Although they designed buildings in Budapest, the *Fiatalok*'s fascination with distant rural life was the sign of a growing disaffection with the social effects of technical and material progress so evident in the capital.

Fascination with peasant life was shared by a group of artists who escaped Budapest to form an artist's colony. The Gödöllő Workshops were established in 1902 by the painter Aladár Körösfő i-Kriesch, who sought to revive the art of weaving in Hungary.[13] He was given support from the State in the form of a donation of looms from a bankrupt weaver's workshop. Körösfő i-Kriesch was initially joined in this project by Leo Belmonte, a Swedish-French painter who had learnt the *haut-lisse* (high warp) weaving technique at the Manufacture des Gobelins in Paris. Later, in 1907, he was joined by Sándor Nagy, a painter and graphic designer who had studied at the Académie Julian in Paris in the 1890s. The Workshops extended their interests in the 1900s to include leatherwork, stained glass and furniture, as well as the paintings and graphic works produced by individual members. These artist-designers formed, with their families, a 'colony' near the village of Gödöllő outside Budapest. Women from the village (as well as the artists' wives) were employed and trained as weavers. One handwoven tapestry

24.12 János Vaszary, *The Fair*. Wool tapestry. Hungarian, 1905. The Museum of Applied Arts, Budapest.

24.13 Árpád Dékáni, lace edging made by the Halas Lace Workshop. Hungarian, 1903. The Museum of Applied Arts, Budapest.

designed by Körösfő i-Kriesch in 1908 depicted three women from Kalotaszeg in their Sunday clothes – richly embroidered skirts which offered the opportunity to celebrate the decorative traditions of the Transylvanian peasantry, as well as the greater theme of community (plate 24.11). In fact, perhaps the most significant aspect of the Gödöllő Workshops was the sense of community which underpinned the venture. This is clear in the decision to establish a community of makers outside the city, common in Arts and Crafts Design Reform movements of the day (as were the group's vegetarianism and interest in eurythmics). An associate, Ede Wigand Thoroczkai, also designed community buildings for small villages such as the combined school-church in Gálfalva (1909).[14] In this he shared a common interest in the lives and homes of the peasantry and working classes with *Fiatalok*.

In the early years of the new century the Hungarian fascination with the lives and culture of the peasantry was more than just a turn of fashion, although, as János Gerle has claimed, it later 'degenerated' into one.[15] Many acknowledged that the appeal of peasant art and culture was, in the first instance, a response to the pressures of modernity (plate 24.12). 'Folk art is conspicuously decorative,' claimed Körösfő i-Kriesch, 'for its maker has enough time to give it its due structural form and put its decoration on it, not being deprived of the use of his imagination by

everyday worries and the pressure of modern circumstances.'[16] Such pronouncements, when studied alone, inevitably seem naïve and conservative, given the political and economic condition of Hungary and Budapest. Yet when the attitudes of these modern artists and designers are charted against the political and social tensions of the day, other reasons for the interest in the peasant culture can be identified. It was part of a search for a new – a modern – Hungary and a new 'Hungarianness' (plate 24.13). Figures such as Lechner broke the grip of international academic traditions of design which had dominated architecture and the applied arts. Lechner may have celebrated the restlessness and innovation of Art Nouveau, but paradoxically, in its 'Hungarian' guise, it was (with rare exceptions such as Rippl-Rónai's works for Andrássy) riddled with nostalgia. However, the sources which Lechner 'discovered', and to which the Gödöllő artists turned, suggest a new social vision.

The powerful appeal of Art Nouveau in general was the challenge that it issued to the conservative, hierarchical vision of culture associated with the 'national leadership' of the aristocracy and with mainstream European historicism. In its Magyarized guise, the rise of Art Nouveau suggests a crisis in authority of traditional forms of culture, and the self-conscious discovery of new, and, in some ways, 'popular' sources for Hungarian design.

Milena Lamarová

The New Art in Prague

25.1 Oswald Polivká,
entrance to the Novák Building.
Nové Město, Prague, 1901–04.
Photo: Paul Greenhalgh.

It was the last two decades of the nineteenth century that made Prague, with its rich history, beauty and innumerable architectural and artistic monuments, into a modern city. As with many other cities subjected to the forces of modernization, the processes of change were dynamic and contradictory, comprising elements of both fantasy and rationality, sentiment and objectivity, magnanimity and provincial narrow-mindedness, uncertainty and optimism.

A new visual language came to cover the city, in the form of posters. Photography also appeared, although not merely as a snapshot, souvenir picture or document, but through the work of photographers such as František Drtikol, as a new artistic medium aiming to find its place among the fine arts.

As an aspiring modern metropolis, Prague responded to the international popularity of large International Exhibitions by staging three of its own in 1891, 1895 and 1898. To an extent, all three presented technological progress as a mythological event and juxtaposed this with idyllic visions of Czech rural life. These were celebrations of the age of technical prowess, clothed in folk costume.

The first Exhibition, the Jubilee Exhibition of the Lands of the Czech Kingdom, provided the template. In addition to a hall with new patents and inventions, visitors were able to undertake sightseeing trips by balloon and afterwards take refreshments at the 'American Bar'. The Eiffel Tower provided the inspiration for the building of a number of steel engineering structures. The Central Palace, as the main pavilion was called, was designed by Bedřich Münzberger and František Prášil (an expert in bridge construction). This consisted of a steel arch construction of huge dimensions (12,867 m²), covered with glass – a testimony to the technological progress of the period and still in use at the Prague exhibition grounds today. In the middle of all this was a Czech rural cottage. The Ethno-graphic Exhibition of 1895 went much further and focused directly on the ideal image of Czech rural life (plate 25.2). In 1898, the theme of architecture and engineering brought technological progress once more to the fore.

Thus, during the two decades in which Art Nouveau developed, the effort to define the national genius and roots of Czech art within a European context remained a constant issue. The overall content and focus of Art Nouveau as a new lifestyle inspired by the exoticism of distant lands and cultures, as well as new philosophical and scientific findings, all proved attractive. The Czechs had tended to seek out an appropriate art by looking to their own traditions, and especially folk culture, but were now invited to join in European activity and identify Czech nature and culture within a broader, and at the same time more autonomous, framework. The city developed ways of disseminating the new ideas in art and design. Apart from rapidly developing journalism and high-quality art journals (with articles sent by correspondents from other countries, discussions and theoretical essays), there was a broad basis for the applied arts in schools and industrial enterprises. Technical schools were founded from the mid-nineteenth century, chiefly in the disciplines of glass, ceramics and metal.

The rhythm of the city during the two last decades of the century changed markedly because of extensive redevelopment. The overall demolition and redevelopment project was entrusted in 1896 to the English engineer William Henry Lindley. New opportunities for building provided scope for a modern art. This spirit of modernization led to the creation of numerous buildings which had elements of Art Nouveau in their exterior decoration and decorative details (plate 25.1). Most of these were influenced by the Baroque spirit of the city. Examples include the work of Friedrich Ohmann, a Professor at the Prague School of Applied Arts, who, between 1893 and 1898,

25.2 Vojtech Hynais,
Czecho/Slav Ethnographic
Exhibition, Prague.
Colour lithograph. Czech, 1895.
V&A: E.2423-1938.

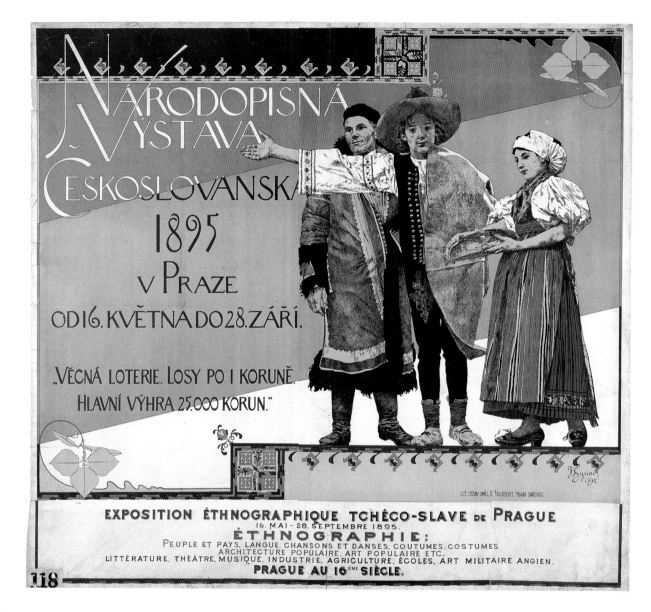

25.3 Friedrich Ohmann, Hotel
Central. Prague, 1899-1901.
Photo: Jan Malý.

designed a Music Theatre in Prague-Karlín, an insurance company building on Wenceslas Square, Štorch House on the Old Town Square and a building (since destroyed) that housed a bank and the popular Corso Coffee House. He exercised great sensitivity in the selection and combination of decorative details (plate 25.3). With its two tall towers, the Central Railway Station in Prague (plate 25.4), designed by Josef Fanta and completed in 1909, became a beacon for the modern city, a structure that signalled stateliness, dignity and harmonious accord with an age of fast machines. The new style was successfully applied in the work of Alois Dryák, thanks to his sense of decoration and experience in using Arts and Crafts ideas in architecture. The same was true for Bedřich Bendelmayer. An example of their playful and yet disciplined decorating is the Hotel Europa on Wenceslas Square (plate 25.5).

Dušan Jurkovič was one of the most original of the new architects. Like many others, having been influenced by the new English domestic architecture, he applied this knowledge to his layout and composition, as well as employing vernacular materials and folk motifs. He designed a distinctive family house in Prague-Bubeneč and others in Brno (1908). He used folklorist elements, particularly ornaments carved in wood, at the Pustevny guest house in Radhošt (1897–99) and at Luhačovice Spa (1901–08). Jurkovič's furniture was also based on rural furnishings, but in addition to ornamental qualities he endowed it with features of functional efficiency and comfort.

Symbolism as a distinct part of the Art Nouveau style had a strong background in Czech art. Czech Symbolism had two main threads. First, it took the form of neo-Romanticism developed by Hanuš Schwaiger and Maxmil-

25.4 Josef Fanta,
Central Railway Station,
Prague 1909.
Photo: Jan Malý.

25.5 Bedřich Bendelmayer
and Alois Dryák, Hotel Europa,
Prague, 1903-05.
Photo: Jan Malý.

25.6 František Bílek, *Tilling the soil
is Punishment for Our Sins*. Plaster.
Czech, 1892.
Hlavnítho masta Prahy Gallery,
Prague. Photo: Jan Malý.

ián Pirner and the seminal work of the sculptor, graphic artist and architect František Bílek. Of these, Bílek is by far the most important. A Symbolist, a mystic and a friend of the poets Otakar Březina and Julius Zeyer,[1] Bílek was an outstanding figure of Czech Art Nouveau, inspired in his Utopian ideas and cosmic visions by William Blake, among others. His art consisted largely of monumental ceramic vases with figurative decoration, which followed on from his Symbolist sculpture. The character of Czech Symbolism generally, and with Bílek in particular, was very dramatic and often bound up in themes of the social and national ill-fate of the Czech people (plate 25.6). The second thread saw the continuation of Pre-Raphaelite

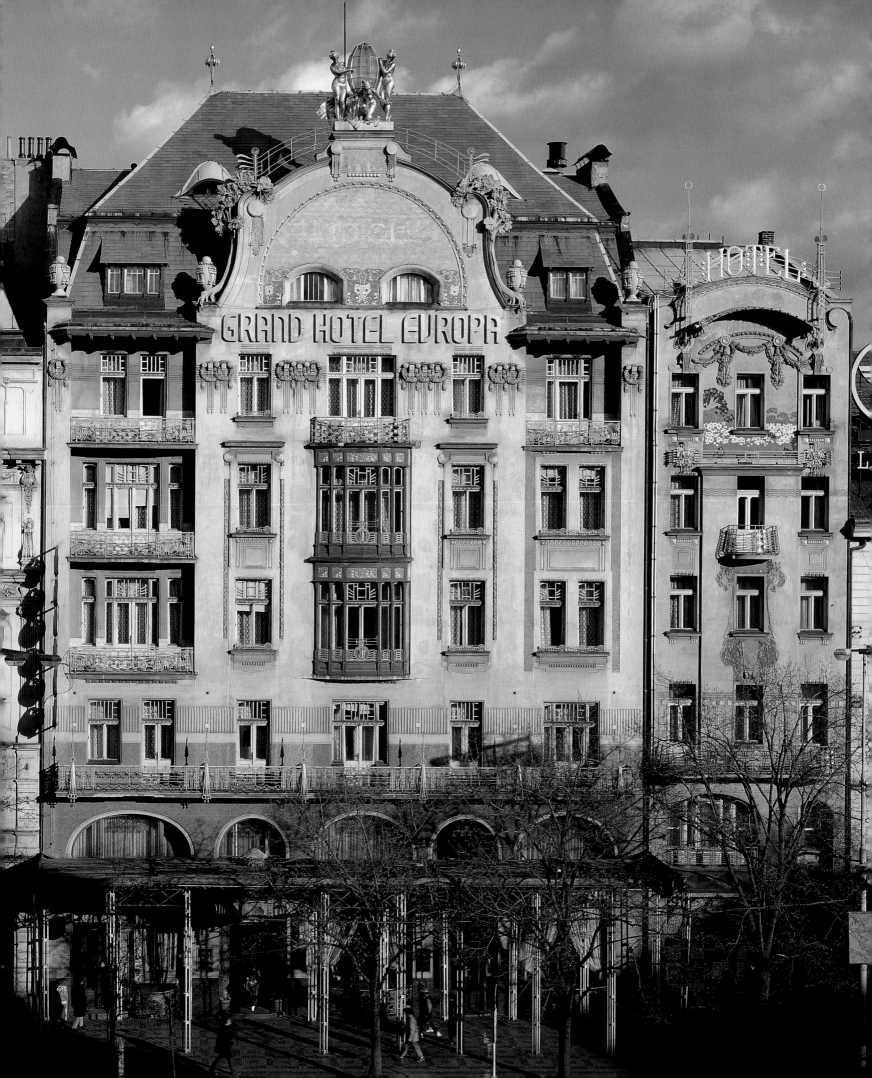

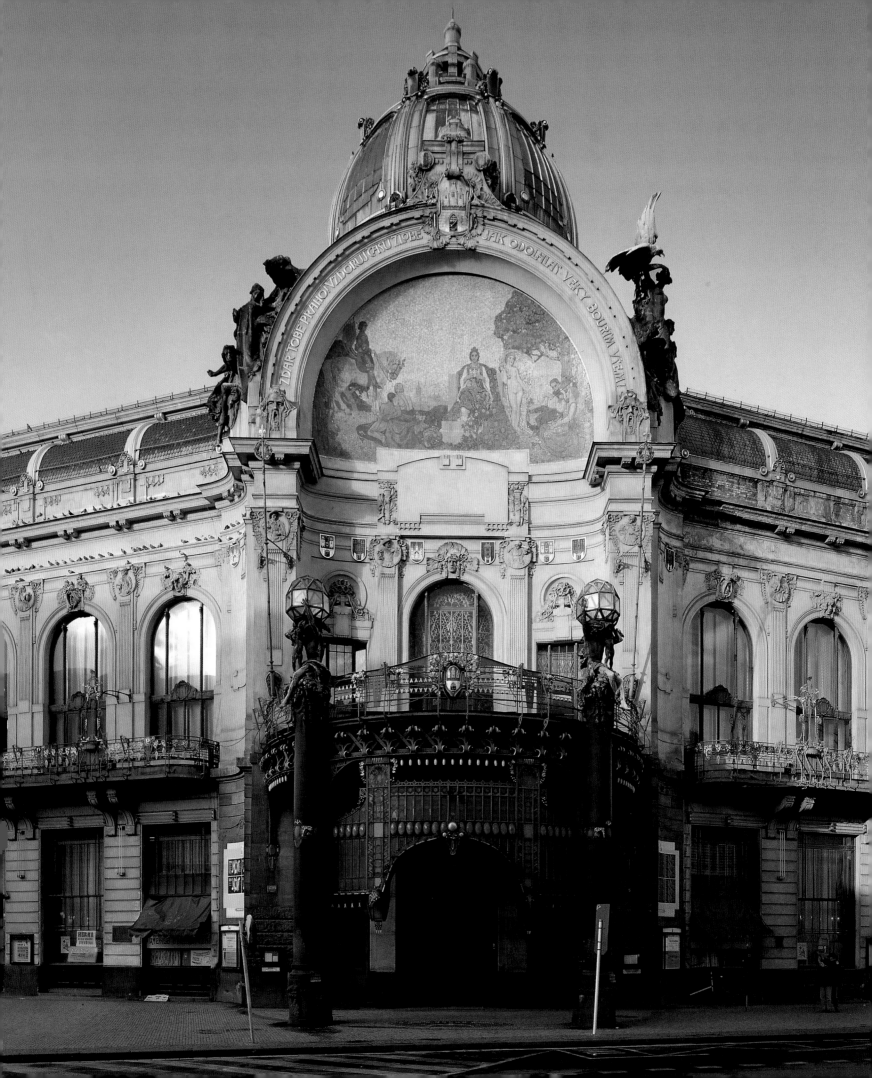

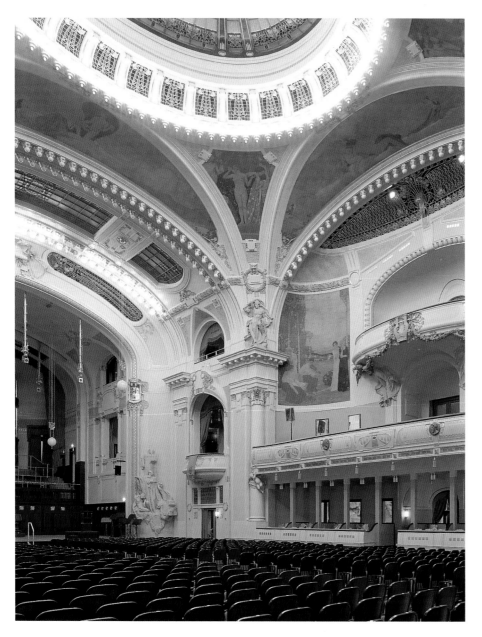

25.8 Osvald Polívka and Antonín Balšánek, the Municipal House showing Smetana Concert Hall. Prague, 1903–11.
Photo: Fotoarchiv Obecní dům.

25.7 Osvald Polívka and Antonín Balšánek, the Municipal House. Prague, 1903–11.
Photo: Jan Malý.

counterbalance to the former German Casino located nearby. Its architects, Osvald Polívka and Antonín Balšánek, were selected after two competitions were unsuccessful in identifying a design. The shape of the site was irregular, which necessitated careful planning and construction. The central, plastically developed part is dominated by a tall cupola, from which two-storey wings extend on both sides. The centre of the building is the Smetana Hall (plate 25.8), a large concert venue. It is surrounded by a number of other spaces with representative, exhibition, social, restaurant and business functions. The Municipal House contained many compromises, but as far as the craft of building was concerned, all the arts and crafts that existed at the time were represented, together with the most sophisticated technology of the day. The decoration of the Municipal House was a monumental project in which an entire generation of leading Czech artists took part. It was marked by its patriotic eclecticism, which was rendered with visual imagination of the highest quality. Richly decorated, its allegorical scenes and symbols of the Czech lands show the efforts taken to represent the Czech identity at an international level.[2]

By the first decade of the new century, Art Nouveau had become a characteristic feature of new Prague architecture. Flourishing building activity, the construction of tall apartment houses and centres for various Czech middle-class institutions, inspired an originality of decorative and symbolic motifs. They were mostly reminiscent of the ideals or virtues of liberalism, but also the conformity of success and diligence in life, rendered in all kinds of allegories. Houses in Pařížská Street and those on the Vltava embankment are an example of the abundance of decorative quality. Stucco was used generously, mascarons were a frequent motif, and metal banisters, grilles and balconies provided ample opportunities for the application of Art Nouveau lines. Etched or sandblasted glass as well as coloured stained-glass windows became an indispensable element of the decorative repertoire. It was an expression of a kind of Naturalism accentuated by rhythmical Art Nouveau ornamentation. It could be said that Prague absorbed the Naturalism and plasticity of Art Nouveau into the topography of its hilly terrain.

Czech arts and crafts practitioners extracted their own vision from the vast current of European Art Nouveau, which together with literature and philosophy created a whole new phase of cultural development. It was something more than just a new formal style. The New Art, as interpreted by young Czech artists, critics and theorists, was intended to have moral and ethical value. For

Anglophilia in the work of Jan Preisler and Max Švabinský. Eventually, Symbolism and the spiritual exploration of the meaning and movement of the organic world provided the starting point for the transition to abstract painting by two Czech painters and graphic artists, František Kupka and Vojtěch Preissig. Very much in the spirit of other early abstract artists such as Piet Mondrian in Holland or Wassily Kandinsky in Russia, Kupka and Preissig combined an intense spiritualism (Kupka became involved in theosophy) with mathematical precision.

The Municipal House (built in 1903–11) became one of the most popular Art Nouveau buildings (plate 25.7). It was conceived as a representative building of the Czech City Corporation and was intended to provide an emphatic

ideological and political reasons, an effort existed in the Czech lands to break free from the Viennese ornamental style and define an independent standard of their own. This standard was termed *Moderna*.[3] The notion of *Moderna* was designed to express the more general values of Art Nouveau. These were aptly characterized by the prominent theorist and critic František Xaver Šalda in several of his essays. His *New Beauty: Its Genesis and Character* was one of the most fundamental programme statements of the Czech movement, promoting 'Style as a highest cultural value, as a unity of art and life which is an expression of necessity, not "speculation or cheap applause"'.[4] His essay on applied art and the revival of its relationship to fine art, in terms of a new unity between them, was even more significant and clear-sighted. Šalda wrote:

> From derived shapes accumulated through fantasy or
> convention we return to basic, simple and purposeful
> shapes … from false decorations to the structure and the
> frame, from the secondary to the principal and primary … .
> All arts are slowly liberating themselves from the solitude
> of their material seclusion and feel with increasing
> intensity that their foundations and roots are ornamental
> and symbolic, that their purpose is to work on the
> decoration of life, to work on the whole … the value of art
> and life is becoming the subject of our hopes.[5]

Following this spirit, most young artists, who were brought together in the Mánes Association (founded in 1887), understood *Moderna* as a revision and assessment of the function of art in society and life. This also concerned artistic approaches, thinking and intentions. The desire to connect art and life was manifested at that time by the incorporation of artists into practical workshop production. For example, the Ginzkey textile factory in Vratislavice near Liberec executed carpets after designs by artists such as Alphonse Mucha and Josef Maria Olbrich. A factory producing ceramic tiles and facing bricks worked closely with the School of Applied Arts, which was very active in this field and encouraged its students to work towards the practical application of decorative techniques. These trends included the founding of the Artěl co-operative in 1908 on a similar basis to the *Wiener Werkstätte*, albeit on a more modest scale (see chapter twenty). Artěl's programme statement declared: 'Our association has been founded in opposition to the factory stencil and surrogate; we want to revive the meaning of visual work and taste in everyday life.' From the beginning, Artěl fulfilled a progressive role of interpreting art in manufacturing. Its range of activity included glass, ceramics, toys, furniture, jewellery, textiles, wallpaper and even patterns for house painters.

Czech glassworks did not have difficulty adapting to the new style. The foundry techniques of the Loetz glassworks in Klášterský Mlýn enabled the application of patterns which appeared at the Louis Comfort Tiffany Exhibition at the Liberec Museum in 1897 (plate 13.6). The Harrachov glassworks in Nový Svět was an important centre, producing a wide range of various kinds of glass and combinations of glass and metal. Commissions were ordered from this glassworks by the Prague School of Applied Arts. Josef Rindskopf & Sons Glassworks stood out for its production of opaque glass of the lithyalin type, often with rich colour structures. The utilization of the glassmaking tradition, with its skill in old techniques, led to artistic activity, which, although it did not measure up to the innovative production of Gallé or Tiffany, undoubtedly contributed to the character of European glassmaking. In terms of industrial production, the Art Nouveau style was successfully employed by the Amphora ceramic factory in Trnovany near Teplice, which met with great acclaim at International Exhibitions. The Pfeiffer & Löwenstein porcelain works in Ostrov near Slavkov produced characteristic dining services which were considered the best in all of Austria-Hungary. The Karl Knoll Company and the Karlovy Vary Company also produced successful wares.

The symbolically motivated style of French floralism dominated between 1897 and 1902. It was strongly reflected both in serial factory production and within the sphere of the Prague School of Applied Arts, which was founded in 1885 as the second one of its kind after the Vienna School. Celda Klouček and his Department specialized in decorative details and the decoration of metal and ceramics. Emanuel Novák was the Director of the jewellery department, while Franta Anýž worked with metal, and his metal foundry executed the most demanding commissions. Anna Boudová-Suchardová was a leading personality in the field of applied art. As a painter and ceramic artist, she applied her plastic sensibility above all in monumental vases with asymmetrical floral decoration. The Prague School of Applied Arts participated in the Paris *Exposition Universelle* in 1900 and the St Louis Worlds Fair in 1904, and was awarded medals at both.

During the initial phase of Art Nouveau influences, the art of Alphonse Mucha played a role, but it had a relatively limited impact in Czechoslovakia due to the artist's prolonged stays in France and the United States, where he achieved great success. To a certain extent Mucha became detached from the intrinsic Czech character. His brilliant posters, sophisticated jewellery for Sarah Bernhardt and

25.9 Jan Kotěra, railway carriage for the Ringhoffer Company. 1899.

opinions. Kotěra was a spontaneous draughtsman and ornamentalist, a designer of interior decoration and a creator of stunningly refined spaces. British architects were among his most powerful influences: he admired the work of M.H. Baillie Scott, C.H. Townsend, C.F.A. Voysey and Charles Rennie Mackintosh. He also came to take great interest in the work of Victor Horta, Hector Guimard, and the decorative artists Émile Gallé and René Lalique.

In the autumn of 1898, Jan Kotěra was appointed Professor at the School of Applied Arts, replacing Friedrich Ohmann. Twelve years later, he became Professor at the Academy of Fine Art. His pedagogical influence was enormous. His charisma, critical mind and creative thinking won him great credit, but also a number of enemies. The article 'New Art', which Kotěra published in 1900, was a kind of summary of the Wagnerian lesson and thought on architecture which he had adopted. He wrote:

> Architectural creation has two functions: first, the
> constructive creation of space, and second, decoration.
> It follows that the part they have in common, i.e. the
> creation of space and construction, must constitute the
> reason for a new movement, not the shape and form of
> decoration: the former is the intrinsic truth, the latter is
> an expression of truth … . A new form cannot stem from
> aesthetic speculation; it can only emerge out of a new
> purpose and construction.[7]

This standpoint paved the way for the entire subsequent development of Czech modern architecture. It represented a fundamental contribution to the definition of the Czech *Moderna* in all its aspects.

Kotěra's interest encompassed all disciplines related to architecture and interior decoration. He was a designer *par excellence*. In addition to furniture, he designed textile accessories, metalwork grilles, tombstones, railings, lighting fixtures, stucco, ceramic tiles, wallpaper and linoleum. In 1899 he also designed a saloon tram for Prague, a saloon railway carriage for the Ringhoffer Company (plate 25.9), and a number of successful exhibition installations.

In about 1906–08, alongside trends in other European centres, the flamboyance of the floral Art Nouveau began to give way to a simpler, more geometric approach. It was a period of synthesis, when the processes of conventionalization developed within Art Nouveau began to add sensuality to practicality. Kotěra's efforts to achieve clear construction of objects and their purpose led to a process of simplification of form and ornament, which was characterized at the same time by a sophistication of proportion and careful attention to detail. The Viennese and Belgians seemed to move in a similar direction. Kotěra's

design for the shop of Georges Fouquet in Paris gave his work an exotic cosmopolitanism that was quite alien to the nature of Czech expression (plates 9.15, 15.13 and 16.9). Nevertheless, he took part in the decoration of the Municipal House, and following his return to Czechoslovakia he focused on completing the monumental Slavonic Epopee, which occupied him virtually until the time of his death.[6]

The orientation of Czech Art Nouveau after 1900 was influenced most by the personality and work of Jan Kotěra. A gradual departure from French patterns was inevitable and from 1905, as in several other centres, geometrization began to emerge as the basis for stylistic abstraction. The young Jan Kotěra studied at a special school of the Academy in Vienna under Professor Otto Wagner from 1894-97. His fellow students included Josef Maria Olbrich, Josef Hoffmann and Josip Plečnik. Journeys to other countries and the study of books provided this gentle, genuine spirit with a firm structure of personal

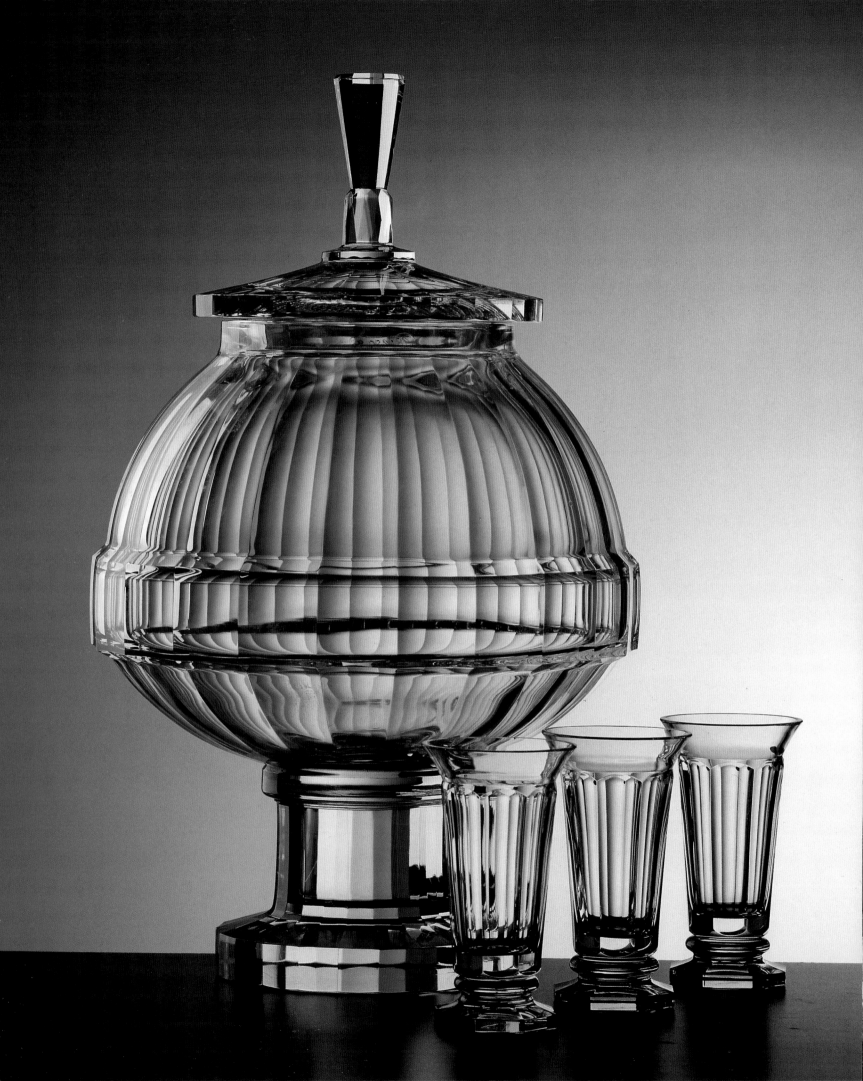

tectonics were based on the simplest spatial and plastic articulation which proved visually the most impressive. He emphasized large plain areas, which he occasionally interrupted and animated by small details. He demonstrated his sense of grand form as early as 1904, when he designed a crystal-glass punch set for the St Louis Worlds Fair of 1904. The set was executed by the Harrachov glassworks in Nový Svět (plate 25.10).The monumental cupola-like shape and the fine engraved ornament of the bowl represented an object of great expressive value. The exhibition of the Prague School of Applied Arts at St Louis in 1904, which was designed by Kotěra, abandoned for the first time the concept of an exhibition pavilion filled with artefacts. Instead, Kotěra created an integrated space in which architectural and ornamental elements were geometrical, airy and linear and could themselves become artefacts.

In his furniture design, Kotěra's development went through several phases (plate 25.11). He was inspired by folk art with its functional qualities and genuine practical purpose. Regardless of the sophistication and elegance of his mature forms, the vernacular remained an undercurrent in his work. This took the form of proportion and form, rather than vernacular symbols. The armchair he designed for the National Theatre in 1902, for example, has a richly elaborated silhouette of bends and waves, but on closer examination it actually represents a highly logical

tectonic structure (plate 25.12). In 1903 Kotěra created a wickerwork armchair with a vertically structured back. His furniture then began to acquire an increasingly geometrical character. He repeatedly returned to the heavy type of armchair with a low, semicircular back, such as the one featured at the exhibition installation of the Mánes Association in 1905, at the National House in Prostějov, where the armchairs resembled enclosed cubes. Finally in 1908 he designed the armchairs resting on three flat legs with a large arched back supported by lathed columns for the drawing room of his own villa.

Kotěra's first building in Prague was Peterka House on Wenceslas Square (1899–1900; plate 25.13). He provided it with harmonic articulation, subtle decoration and a grandly conceived entrance with large areas of glazing. The upper floors of the facade owe a great deal to Victor Horta's Tassel House. His sense of tectonic structure manifested itself in an original manner in two later buildings, the Municipal Museum in Hradec Králové (1906–12) and the Pavilion of Technical Education at the Jubilee Exhibition of the Chamber of Trade and Commerce in Prague (1907–08, plate 25.14), in which he collaborated with his pupils, Pavel Janák and Josef Gočár. Both of these public buildings are examples of the dynamic distribution of mass with balanced tectonics and a logical decorative system which is mostly geometric, but which also respects

the plastic character and layout of the building. The overall appearance of both buildings is strangely unlike other public architecture existing at that time; buildings designed to serve cultural purposes were no exception.

The construction of Kotěra's own villa (1908–09) in Prague-Vinohrady confirmed the path he had taken. The large areas of the walls are composed in an asymmetrical order. Despite almost lacking decoration, they feature varied surface textures. The proportion and arrangement of the windows are also given an elaborate asymmetry. At the same time, the Laitcher House was built in Prague-Vinohrady, and its design reveals partial Dutch influences that were not uncommon at the time. Some of the architects who systematically followed the path of *Moderna* were inspired by 'brick' architecture. A pupil of Kotěra's, Otakar Novotný, designed a house for the publisher Štenč

25.12 Jan Kotěra, armchair for National Theatre. Wood. Czech, 1902. UPM Prague. Photo: Miloslav Šebek.

in Salvátorská Street, Prague (1909), in which red bricks are combined with white-glazed bricks on the ornaments as well as with copper sheeting. Laichter's house is totally geometrical and is accentuated by its material, namely brick arranged into geometric ornament in the most visible places. The furnishings correspond with the building's style. Finally, the *Mozarteum*, Urbánek's house in Jungmannova Street, Prague (1912–13), displays Kotěra's maturity and confidence.

Kotěra's pupils, Pavel Janák and Josef Gočár, headed the Cubist movement from 1911. Pavel Janák was the leading theoretician, and in his articles for *Umělecký měsíčník* he elaborated the new principles of architectural work influenced by Wilhelm Worringer, Theodore Lipps and Adolf Hildebrandt. Hildebrandt's work *The Issue of Form in Visual Art* of 1893 was published in Czech in 1913. The work of this generation oriented itself towards Cubism very swiftly and dynamically. Kotěra himself did not completely ignore Cubism. In 1913 he participated in the competition to design the Jan Žižka memorial on Vìtkov hill in Prague-Žižkov (in collaboration with the sculptor Jan Štursa). His design involved the radical articulation of mass with sharp angles and a large spatial arrangement. It seems that Kotěra, who approached Cubism with reservations, wanted to try out the new style.

Essentially, Kotěra's personality and his whole fundamental approach was bound to cultivated restraint of expression and function, as well as spontaneous aesthetic feeling which he expressed in decorative details, and the design of interior accessories. His charisma, talent and intuition predetermined his career as a teacher, organizer and innovator. For a long time he was the head of the Mánes Association, and in 1913 he founded the Union of Czech Artwork, an institution similar to the German *Werkbund* (chapter nineteen).

Thus, the tensions of rapid social, industrial and economic modernization that visited the whole of Europe can be seen in *fin-de-siècle* Prague. The old and the new, the vernacular and the cosmopolitan, the mystical and the rational, the geometric and the organic, met to form the new urban vision. Perhaps more quickly than in most centres, however, the arrival of Rationalism, Cubism and Abstraction in the arts brought the reign of Art Nouveau to an end.

25.13 Jan Kotěra, Peterka House.
Prague, 1899-1900.
Photo: Jan Malý.

25.14 Jan Kotěra, Pavilion
of Technical Education
at the Chamber of Trade and
Commerce Jubilee Exhibition
1907-08, Prague.
Photo: Jan Malý.

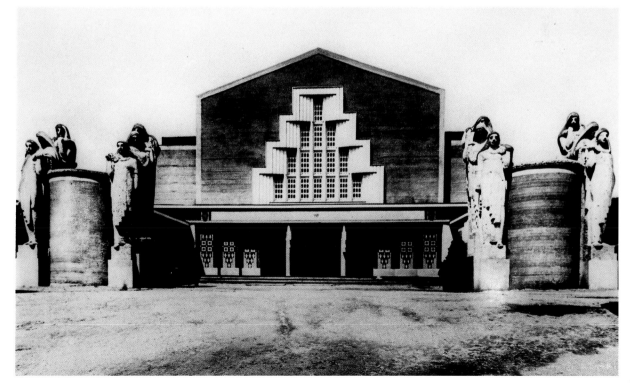

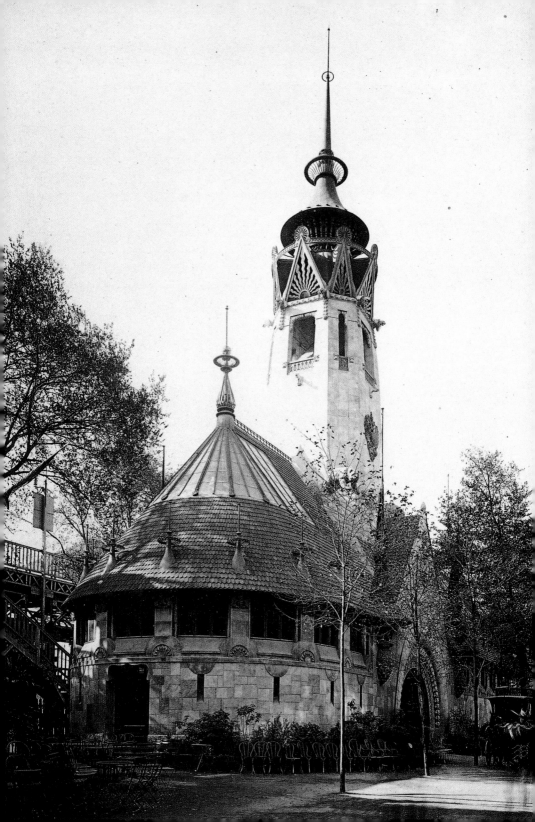

Jennifer Opie

Helsinki:
Saarinen and Finnish Jugend

26.1 Gesellius, Lindgren & Saarinen, Finnish Pavilion designed 1898-1900 for *Exposition Universelle*. Paris, 1900. Museum of Finnish Architecture, Helsinki.

The architectural language that Gottlieb Eliel Saarinen and his fellow students invented in the 1890s was premised on the idea of the new. It was practised by young architects – the new generation in rebellion against the German-Swedish Classicism of their seniors and tutors. It was anti-Classical and incorporated rustification, archaism, Naturalism, Symbolism and story-telling in its details. It was simultaneously ethnic and cosmopolitan, a mix of vernacularism with stylistic borrowings from England, Germany and the United States, and 'new' materials. It was Romantic and nationalistic, and, in Finland's 'Golden Age', it was Finland's Art Nouveau.

Of all the Nordic countries at the end of the nineteenth century, Finland had an especially rich diversity of distinctive architecture, art and design. Internationally, the best-known architectural practice was Gesellius, Lindgren & Saarinen (G. L. & S., set up in 1896), mostly by virtue of Saarinen's subsequent reputation in the United States and elsewhere. However, others were crucial to the history: Lars Sonck, Sigurd Frosterus, Onni Tarjanne, for example, and Wivi Lönn, the most successful of a remarkable group of women architects. Helsinki and cities such as Tampere and Joenssu boasted a rich choice of buildings. Outside the cities, 'wilderness studios', often designed by the artists themselves, were pioneering architectural types in the 1890s, and country houses for the wealthy and artistically inclined provided architects with opportunities to exercise inventiveness and a contemporary style.

In 1948, looking back on his student years of 1894–97, Saarinen wrote: 'it finally became evident that Classical form after all is not the form to be used for contemporary purpose, but that our time must develop an architectural form of its own. So was the reasoning in forward-looking circles and, for sure, forward-looking circles are the only criterion'.[1] The Finnish Pavilion, designed by G. L. & S. for the *Exposition Universelle* of 1900 in Paris, was a summation

of the new style (plate 26.1). In the important journal *L'Art et décoration* it was accorded an extensively illustrated article over the first 11 pages. The young architect Saarinen was credited with the designs, aided by Herman Gesellius and Armas Lindgren. Gustave Soulier wrote enthusiastically and with great sympathy:

> Character imposes itself so powerfully on the complete architectural and decorative ensemble which is the Finnish Pavilion, this odd union of roughness and tenderness from a people who have retained something primitive with the utmost sincerity thanks to the rigorous climate, the struggles which they must endure and also the persistence of their national legends.[2]

For seven centuries Finland was the eastern half of Sweden. In 1809 Russia invaded and conquered the province, which, with the Ahvenanmaa (Åland) Islands, became a Grand Duchy under Tsar Alexander I. The political centre was moved east to Helsinki. Although industrial and commercial interests expanded from the 1870s, particularly in the export of wood and paper products to the vast Russian markets and in the building of railways, Finland remained largely agrarian and the rural population poorly educated. Swedish-speaking Finns – who felt no less Finnish than the Finnish-speakers – preserved their local domination of cultural and economic activities. Finland under the Tsars was a favoured province, but towards the end of the century Finnish society became increasingly unsettled. Relations between Finland and Russia deteriorated as Russia was drawn into the nationalist Pan-Slavic movement, a reaction against Westernization. Although ties with Russia remained very strong – about 15,000 Finns lived in St Petersburg, and, in the 1880s and 1890s, there were many shared artistic events, some organized by Sergei Diaghilev – by imposing increasingly aggressive 'Russification' on Finland, Russia provoked a nationalism there which was taken up especially by

artists, writers and architects, on both sides of the Finnish-Swedish language divide. A newly emerging national awareness took hold and this significantly motivated Finnish culture.

Research into the Finnish language began as early as the end of the eighteenth century, and the first glimmerings of a national consciousness appeared among the educated classes. During the 1860s Aleksis Kivi wrote in Finnish what are now regarded as the first, great works in the language, and from the 1830s to the 1890s literary, craft, art

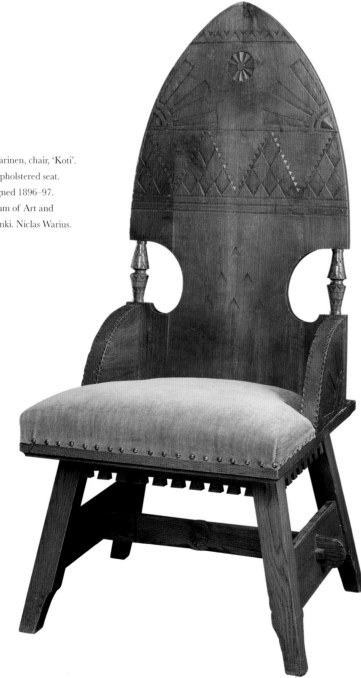

26.2 Eliel Saarinen, chair, 'Koti'. Oak and re-upholstered seat. Finnish, designed 1896–97. Photo: Museum of Art and Design, Helsinki. Niclas Warius.

and technical schools and societies were established. A great writer, artist or musician could give a country real status and individuality, and for Finland Kasimir Leino wrote in 1898: 'if such a genius were to appear who, by immersing himself in that ancient Finnish spirit which produced those porches and gables, could create a building, then would we have a Messiah among architects. And that is exactly what we need to stand alongside Aleksis Kivi, Gallén and Sibelius.'[3]

The key to the development of a specifically Finnish architecture, art and design was the Karelian province. This area, which now extends over the border into Finnish-speaking Russian Karelia, was (and still is) of great importance for Finns. This importance was established in 1849 with the full publication by Elias Lönnrot, under the collective title *The Kalevala*, of the oral and sung tradition of folk stories or poems about epic heroes from Karelia. These heroes were identified as the hardy forest Karelian peoples, unspoilt by an imposed civilizing – and they were fast disappearing. The gathering of their folklore by Lönnrot was seen as a last-minute rescue of the ancient Finnish inheritance, and this was to provide inspiration in the creation of a new and distinctively Finnish style. By the 1890s the Karelians had acquired a mythic status in the imagination of the artists of the time. Painters first went there in the late 1880s, followed shortly after by student architects. Karelian log-built houses appeared a humble but genuine answer to the far grander Swedish 'Old Norse' and Norwegian 'Dragon style' wood-architecture of Dalecarlia and Gudbrandsdalen.[4] Russian log-building too was to be observed but avoided in the search for the essential Finland. In 1889, the painter Axel Gallén (later Akseli Gallen-Kallela) drew the first sketches for Kalela, his house at Ruovesi, basing the design and construction partly on Karelian farmhouses and partly on the farm buildings of central Finland. In 1893, the sculptor Emil Wikström completed his log-built wilderness studio at Visavuori. Two years later architect Lars Sonck built his own granite and wood house, Lasses Villa, at Finström on the Ahvenanmaa Islands, again incorporating many Karelian features.

For 30 years there had been debate over the use of granite as a building material arising, initially, from the writings of Gottfried Semper, A.W.N. Pugin and John Ruskin, all urging 'truth' and 'honesty' in the use of materials. Granite had long been exported from Finland to Germany and Russia and the Finns themselves began to take advantage of this local material, thereby patriotically supporting Finnish industry. It was also identified with the resilient, flinty character which the Finns were promoting as their

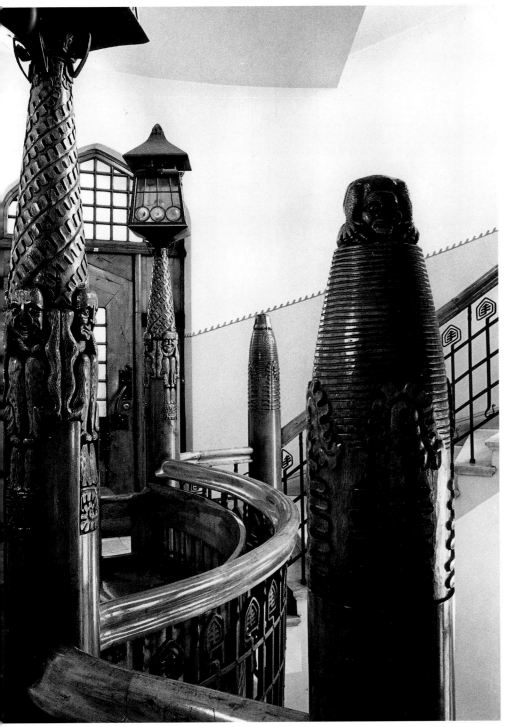

26.3 Gesellius, Lindgren & Saarinen, Pohjola Building stairwell. Helsinki, 1899. Museum of Finnish Architecture, Helsinki.

also a primary source, offering as it did the opportunity to present the stone as natural, truthful, and honest.

The influence of castles, with their massive towers such as that at Savonlinna, and of Medieval churches is clearly discernible, especially in the domestic architecture of G. L. & S. Particularly ambitious in his use of 'rubble' and the American/Scottish 'squared rubble' was Lars Sonck, whose crowning work (designed in 1901) is St John's Church in Tampere, now the cathedral. Here the proportions are heroically Medieval: the lowering entrance is flanked by squat gates and towers of massive proportions. In the 1890s, as Saarinen and his near-contemporaries began their studies, the call for a modern, national architecture began in earnest. It was met with a style which was a combination of wood and granite, treading a narrow path between all of these influences. This was accepted as the Finnish 'national style', when at the end of the century national pride on the international stage demanded it.

When G. L. & S. was set up in 1896 all three architects were still at the Polytechnic Institute, and the political background to their student life, of language struggles between Swedish and Finnish and the increasingly suppressive policy of 'Russification', were formative influences. In the late 1890s their first competition entries coincided with Helsinki's commercial expansion. While still students they entered a winning design, 'Koti' (1896–97), for furnishings for a gentleman's rooms in Finnish style organized by the Friends of Finnish Handicrafts (plate 26.2). In early 1897 they won first prize in a competition for a building with an apartment for the businessman Julius Tallberg. This relatively discreet, gently curvaceous building was followed in 1899 by designs for the Pohjola Insurance Company, a building completed in 1901. This was the partners' most extraordinary exercise in what became known as national Romantic architecture. Taking the Karelian theme of the 'North' ('Pohjola' in *The Kalevala*), the exterior of the building is of squared 'rubble' granite and soapstone with a low, arched entrance guarded by sinister, dwarfish figures, a theme carried into the building and up the elegant main staircase. Above the entrance, crouching bears (the company's symbol) with a connecting frieze of fir-tree branches complete the choice of national symbols. The oak doors are massive and heavily embellished with wrought iron and embossed copperwork. The contemporary description of this extraordinary work was 'Finnish Naturalism';[5] the term 'National Romanticism' had yet to be coined. Not surprisingly, it was an enormous attraction during its building; crowds watched and discussed every detail as it grew before their eyes (plate 26.3).

national temperament. It was argued that new methods of construction should be as much the key to a new style as the materials and motifs, so architects looked abroad for ways of working the intractable granite, first to Aberdeen in Scotland and then to North America. As has been well-documented, the work of Henry Hobson Richardson was disseminated in Finland by Swedish architects and via journals. Medieval rough (undressed) granite architecture was

26.4 Gesellius, Lindgren & Saarinen, Olofsborg apartment building elevation, ink and watercolour. Finnish, 1900. Museum of Finnish Architecture, Helsinki.

In 1900 the practice designed an apartment and commercial building for the company Fast.AB Olofsborg, in the developing area of Katajanokka in Helsinki (plate 26.4). The influence of Medieval architecture is pronounced; historian Hausen suggests that the building took its name from Olanvinlinna Castle. Yet, although there are suspended projecting windows and a rounded tower, giving a definite hint of archaism about the building, its smooth plasticity and asymmetry give it a distinctive quality which is unmatched by any of its neighbours. In many ways, this building is the consummate synthesis of historicism and the New Art.

A new competition was announced in 1898, this time for a pavilion to represent Finland in the *Exposition Universelle* to be held in Paris in 1900. Marking as it would the start of a new century, the exhibition assumed especial importance for every nation, but for Finland it had even more significance, coming at a time when nationalism, possibly even independence, was the issue of the moment. Remarkably, although a province, Finland managed to negotiate a pavilion of its own, independent of Russia. In the summer of 1898 the G. L. & S. practice was awarded first prize in the competition for its entry 'Isidor'. It is now thought to have been largely the work of Saarinen. The design took in so wide a variety of influences and motifs – not least the semi-circular American-style door[6] – that to a non-Finn it looks totally exotic and therefore authentic. (The door was based

on American models developed by H.H. Richardson and Louis Sullivan; see chapter twenty-two.) Little enough of accuracy was known of the country outside Finland, although contemporary French reviews pointed out that they were already familiar with the work of Finnish painters and sculptors in the Paris arts circles of the 1880s and 1890s, and, therefore, were well-acquainted with the national character.[7] For the Finns themselves, there were enough elements to satisfy nationalistic cravings: granite with wood details; an abundance of carved squirrels, bears, pine cones and even frogs; a generally archaic style and format evocative of Medieval churches and with a distinctly Nordic, more particularly, a Karelian, look to the geometrically patterned tower gables. Moreover, with its overwhelming emphasis on granite rather than wood, it didn't look Russian. The Pavilion was, for the moment, the definitive statement on the Finnish national style in stone.

Inside the Pavilion there were scattered displays of furniture such as the 'Betula' suite by Saarinen himself. Paintings and sculptures, and some didactic displays to do with Finnish culture from fishing to furniture design and government systems, were displayed in cases designed by the Swedish-Italian Count Louis Sparre. There was a newsstand designed by Lars Sonck, and in the centre, an elaborate, pinnacled stand for a display by the Finnish Geological Commission of stone resources and a geological curiosity, the Bjurböle meteor that had landed recently.

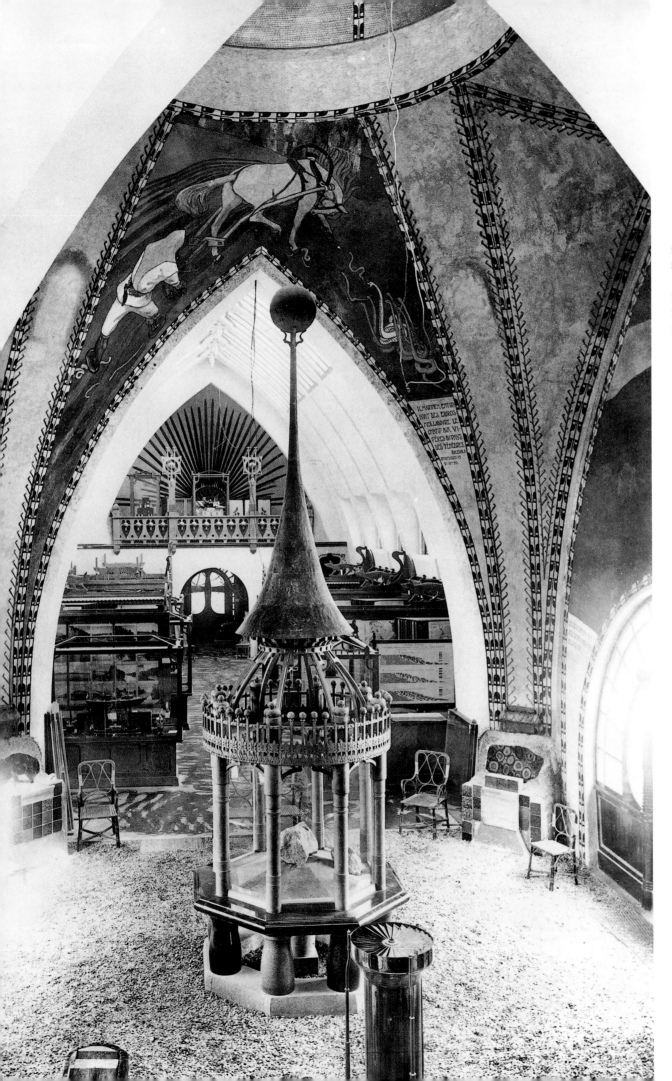

26.5 Gesellius, Lindgren &
Saarinen, Finnish Pavilion interior,
1898-1900, *Exposition Universelle*.
Paris, 1900.
Museum of Finnish Architecture,
Helsinki.

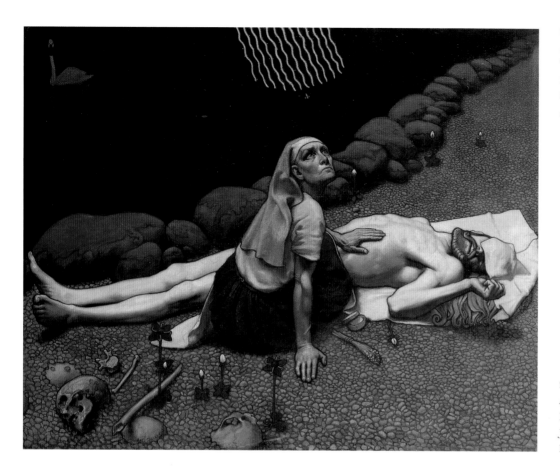

26.6 Akseli Gallen-Kallela, *Lemminkäinen's Mother*. Tempera on canvas. Finnish, 1897. Helsinki Ateneum, Antell Collection. Photo: The Central Art Archives/ Jouko Könönen.

26.7 Akseli Gallen-Kallela, *Autumn Five Crosses*. Oil on canvas. Finnish, 1902. Study for the Jusélius Mausoleum frescoes. Private Collection.

26.8 Akseli Gallen-Kallela,
ryijy rug, *The Flame*. Woven wool.
Finnish, designed 1899
(made by the Friends of Finnish
Handicrafts 1984).
Photo: Museum of Art and
Design, Helskinki / Jean Barbier.

The ceilings were decorated with spectacular frescoes by Akseli Gallen-Kallela with scenes from the Kalevala (plate 26.5). Gallen-Kallela was Finland's national artist. A larger-than-life character, he was the central figure in Karelianism in the 1890s; whereas other artists and architects made brief forays into Karelia, Gallen-Kallela adopted it as his own. A Swedish-Finn, born Axel Waldemar Gallén in comfortable circumstances, he formally changed his name to the Finnish version in 1907. As a 19-year-old, he was a precocious, Realist painter studying in Paris during the 1880s, one of an international circle which included Finns, Swedes and Norwegians. By all accounts (not least his own), he was a striking and energetic man, of heroic stature and with grand and ambitious expectations. By 1900 he had painted some of his greatest works based on *The Kalevala*, in a fully developed mature style which was the result of his experience of Parisian and Berlin Symbolism in the mid-1890s (plate 26.6). In these, a powerful vision was expressed in a technique of strong lines and colours and flattened, stylized images, and was hailed as an entirely new painting style (plate 26.7).

At the eastern, apsical end of the Pavilion was a domestic interior by the Iris company. The Iris project was begun by Count Louis Sparre. Enthused by Gallen-Kallela, Sparre travelled with him to Karelia in 1889. By the end of the 1890s, Gallen-Kallela was either proficient in, or knowledgeable about, textile design, patterning, weaving, woodcuts and carving, etching, poster design, stained glass and all forms of painting. He had also designed his own house. In 1896 Sparre travelled to Europe and England, visiting the Liberty shop in Regent Street, London, and staying with Charles Holme, proprietor of *The Studio* and owner-occupier of William Morris' Red House.[8] On his return to Finland in the following year, Sparre set up the Iris project in the ancient eastern town of Porvoo. A factory was to make a range of domestic goods to a contemporary standard of design, which, nevertheless, was to be drawn from traditional techniques and design sources, and was to meet simple, domestic principles.

The invitation to Gallen-Kallela (as a Finn, rather than to Sparre who was Swedish) to present applied arts in the Pavilion was made under the heading 'Finnish cottage industry', as the Russians intended that the province's industrial arts (and the main displays of fine arts) should come within their section. In what was known as the Iris Room, Gallen-Kallela created a complete domestic interior – a total work of art (a *Gesamtkunstwerk*). He designed the furniture, the tiled stove, the wall hangings and the rug now famous as *The Flame* (plate 26.8), which intro-

26.9 Willy Finch, bowl and mug.
Earthenware. Finnish, 1897-1900.
V&A: Circ.758-9–1966.

26.10 Gesellius, Lindgren &
Saarinen, National Museum.
Helsinki, 1901.
Musuem of Finnish Architecture,
Helsinki.

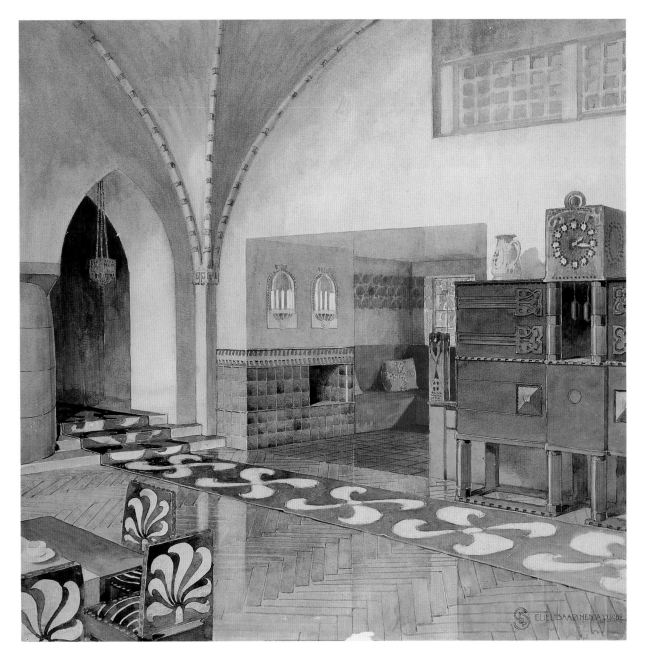

26.11 Eliel Saarinen,
Great Hall, Suur-Merijoki.
Ink and watercolour. Finnish,
1903. House designed by
Gesellius, Lindgren & Saarinen
in 1900.
Museum of Finnish Archiecture,
Helsinki.

duced the ancient weaving technique known as *ryijy* to an international audience. Iris ceramics, by Willy Finch, were displayed in the cabinet and on the mantelpiece (plate 26.9). The whole interior was a triumph as a collaborative exercise and it was acclaimed by the press for its simplicity and beauty.

The sensational success of the Pavilion as an expression of national identity was extremely important for G. L. & S. The practice was established as a leader of the new generation and well-placed to win the next – and in many ways far more important – national competition launched in 1901, that for the proposed National Museum. A very different project, as a building devoted to the preservation

and display of the national culture embodied in the archaeological, historical and ethnographic collections, the National Museum had a symbolism far beyond its immediate and practical role. From the beginning, there was no doubt that the building was to be of the country's bedrock. By 1899, granite and soapstone, with all their variations of texture and colour, provided the national vocabulary. It was also certain that the National Museum's architectural style should in some way represent Finnish history specifically. Discussion on the most suitable plan began during the mid-1890s, particularly on the new idea that the museum building should itself be a reflection of the collections within it. In the G. L. & S. design – as built –

Medieval art was contained in a Medieval church and military equipment in a castle tower. The entire building (plate 26.10), within its walls a small town of different buildings, is pinned together by the unifying, tall tower which dominates from the street and by the restraint in ornamentation, in dramatic contrast to the Pohjola building of only two years earlier and then still under construction. The textures of the squared rubble granite and the soapstone provided the principle ornament.

Domestic housing, designed by Saarinen from 1897, offered entirely different opportunities. Suur-Merijoki Farm was planned from 1900 and built on the Merijoki estate in Karelia, now on the Russian side of the border. The most vivid views of the Farm, which was largely destroyed during the Second World War, are watercolours, mostly by Saarinen himself. These show luscious interiors richly decorated with individual and built-in furniture, lamps, wall-paintings, decorative tiles, stained glass, muslin and tapestry hangings and *ryijy* rugs (plates 26.11 and 26.12). The house itself was a mix of undressed stone and white-painted facades. It was contained within a low wall, with round towers, low arches and the G. L. & S. trademark of a massive front door with copper embellishments by Eric O.W Ehrström. It was the 'complete work of art', the ideal of the late 1890s, with the exterior, interiors and furnishings fully designed down to the last detail and all carefully planned to suit the client's personality and interests.

By 1901, the partners had decided that the time had come to build a house for themselves. They chose a dramatic site, high on a bluff overlooking Lake Vitträsk, isolated but not far from the new south coast railway which provided a connection to Helsinki. Hvitträsk is the consummate synthesis of the practice's experience and its particular visual identity at this date. G. L. & S. had already moved from entirely wood-and-granite construction and often favoured rendered and painted walls, in the manner of the British architects C.F.A. Voysey and M.H. Baillie Scott. At Hvitträsk they combined all three materials and the site in an organic whole. Using the dramatic approach to the site and the steep drop to the lake behind, the building grows organically from the rocky bluff (plate 26.13), essential for the fully Romantic dwelling. Wooden verandahs supported on short wooden columns, a steepled wooden tower, a squat, round gateway tower with rough granite base and rendered walls relieved by apparently 'scattered', carefully exposed and naturally irregular granite stones, and massive doors with wrought-iron hinges and handles all contributed to an air of Medievalism (plate 26.14). However, the main purpose of the wooden tower over the north wing (burnt

26.12 Eliel Saarinen, Library, Suur-Merijoki, 1903.
Ink and watercolour. Finnish, 1903. House designed by Gesellius, Lindgren & Saarinen in 1900.
Museum of Finnish Archiecture, Helsinki.

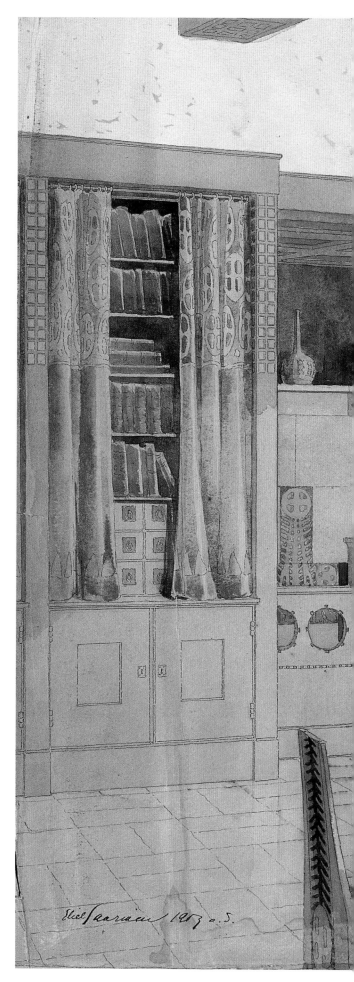

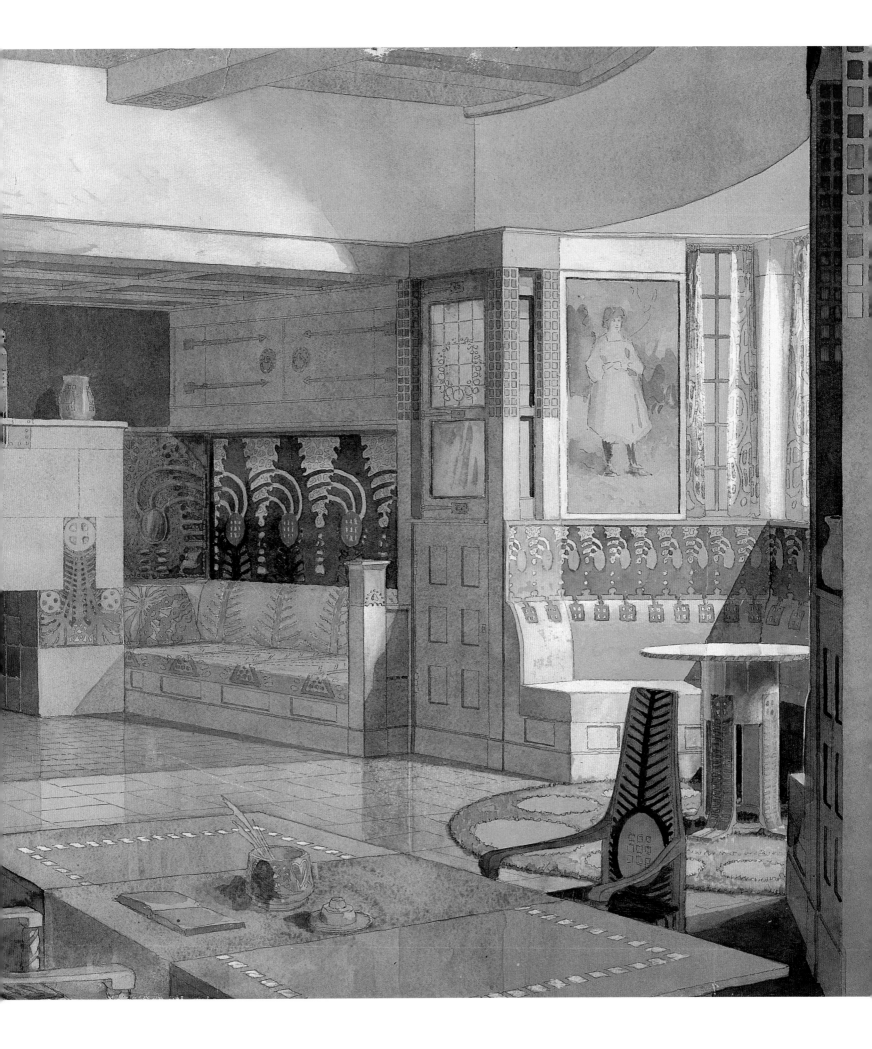

26.13 Gesellius, Lindgren &
Saarinen, Hvitträsk, north and
south gables. Ink and watercolour.
Finnish, 1902. House designed
by G. L. & S. in 1901.
Museum of Finnish Archiecture,
Helsinki.

26.14 Gesellius, Lindgren &
Saarinen, Hvitträsk, view of
wooden tower above Lindgren's
north wing. Photograph taken
1906-07.
Museum of Finnish Archiecture,
Helsinki.

down in 1922) was to unify the complex; the inner gardens surrounding the wings (one for each partner) were terraced with flower gardens in the early years, the roofs are red-tiled and, within the courtyard, the overwhelming sense is more of peaceful balance than of fortification.

Inside, the only complete space to be seen now is that of Saarinen's south wing. Here Saarinen designed the most rhythmic of internal spaces. Natural light shed through arched windows into a darkened hall with monumental round log-columns, seating areas, and widely differing ceiling heights, are all used on the ground floor to intense effect. Upstairs the bedrooms, children's room and flower room are painted white, and are light and airy (much as those at Suur-Merijoki were), and with an acknowledged debt to Mackintosh and Voysey. Over time, Saarinen designed 9 or 10 furniture suites for the house (plate 26.15). The Friends of Finnish Handicrafts wove some *ryijy* rugs, but most were made by Loja Saarinen.

Hvitträsk was occupied by the entire practice (which had broken up by 1905) only briefly, but Saarinen and his family visited every year until just before his death. The house's particular character comes as much from the fact that it changed organically over this period as from the original concept. 'The house as a work of art' was a contemporary ideal, the potential of which, arguably, was explored more fully at Hvitträsk than at any other of the practice's projects. The striking setting helped in an all-embracing concept in which the very trees and rocks play as important a part in the whole as the building itself, and the smallest detail of the furnishings within are as important as the activities of the human occupiers. The generous

studio space, the areas given over to cultivated gardens, and the opportunities for decoration of all sorts, are all indicative of the busy, artistic lives led by the Saarinens in particular and their many assistants. Artist friends were frequent visitors. Music was important – Jean Sibelius was regularly entertained and Gustav Mahler arrived with Gallen-Kallela. The art critics Julius Meier-Graefe and Ugo Ojetti visited; even Maxim Gorky stayed, escaping from the Russian secret police in 1904–05.[9]

While the National Museum's plans were being finalized, the national Romantic style continued into the new century at the hands of other architects, such as Karl Lindahl and Valter Thomé for the Helsinki Polytechnical Students' Union in 1901 and for the publishers Otava in 1905–06; Usko Nyström at the Grand Hotel Cascade at Imatra in 1902; and Lars Sonck for the Helsinki Telephone Company in 1904. Yet the undiluted Finnish National Romantic style was short-lived. The coming together of motifs and materials had barely been identified or agreed as the long-awaited 'new style' in 1901,[10] before a counter-movement began to form. In 1904, Saarinen's first designs for the railway station in Helsinki included such Finnish symbols as bears, towers and stonework. However, Sigurd Frosterus (a former pupil of Henry van de Velde, rapidly acquiring a reputation as an arch-Realist) and Gustaf Strengell argued that the style was neither modern nor forward-looking, and that it was irrelevant to the function of a railway station. This, plus Saarinen's own increasing Rationalism, brought about a radical change in the final design. The railway station as built celebrates a driving, industrial modernity – a dramatic change from the National Museum which commission it closely followed. The national style (and with it Romanticism) had been dealt a death blow.

After the break-up of G. L. & S., although the three architects re-grouped on occasions, their paths rapidly diverged. But, during the period of their collaboration, the combined strengths of all three made the practice enormously successful. The coming together of consummate skill in the ground-planning and the external

26.15 Eliel Saarinen, armchair. Wood. Finnish, 1902-03. From Hvitträsk dining room. Hvitträsk Foundation loan.

articulation of their buildings was often the key to their success in competitions. The sumptuous colour, the wealth of detail and the orchestration of rich and harmonious spaces within the buildings were a hallmark of G. L. & S. design throughout the three men's collaboration. The timing of their graduation, at a point when both clients and architects were looking for a new mode, meant that there were revolutionary opportunities. The mastery of the vocabulary of stone, wood and local decorative traditions by G. L. & S., and its skill in using the landscape to create an organic whole, established it as the leader of the modern style. Never active politically themselves, the partners' interests nevertheless matched the political mood, and their buildings acquired a significance, which, for the few years around 1900, was also associated with modernity. That the search for a 'national style' would not or could not necessarily result in a 'new style' was the coming debate, and one which was sparked by Helsinki's railway station.[11]

The means by which Finnish architecture and interior design made a lasting impression on the twentieth century was through individual commissions, in which the self-conscious, national statement played no part. Humanistic, comfortable proportions combined with a sympathetic response to the surrounding landscape were the outstanding legacy. In this Saarinen was undoubtedly the leading influence. By 1904 lowering doorways and defensive windows had given way to clean lines and deliberately balanced proportions, even a return to a sort of Classicism, with surrounding landscapes which were carefully acknowledged or generously included. The whole undoubtedly reflected the architect's awareness of European, British and American domestic architecture, but it was the supremely balanced synthesis of these many qualities which Saarinen classically perfected at Cranbrook in the United States in the early 1930s.

Despite Saarinen's later fame, despite the partners' travels, researches and contacts throughout Europe and England, and those of their Finnish contemporaries, despite the acknowledged parallels with architects and designers in Sweden and Norway, Austria, Germany, Britain and the United States, Finnish national Romantic architecture and design has been lost to view more effectively than almost any other aspect of the New Art. There have been a number of important exhibitions and publications which have striven to put *fin-de-siècle* Finland back onto the design map. Yet, even now, it often appears as an afterthought, following on a long way after mainland Europe – France, Belgium and Holland, and even Britain, Germany and Austria – with which it is directly associated.

Wendy Salmond

Moscow Modern

Moscow is not a city that readily springs to mind as a rich source of Art Nouveau. The unsuspecting visitor can quite easily overlook the wealth and variety of *stil modern* buildings in this Medieval city, so discreetly are they tucked away amid its winding streets. The idea of such a patently foreign import in the heart of Old Russia sits oddly with popular notions of Russian culture. Indeed, the very phrase 'Moscow Modern' seems an oxymoron, for nothing could appear more contrary to a city whose image is symbolized by the golden domes and bell-towers that dominate the skyline.

In 1900, three years after its 750th anniversary, Moscow still held a vital place in the national imagination as the centre of traditional Russian values. Piously apostrophized as 'Holy Moscow' and 'Moscow of the Golden Domes', it was the very antithesis of St Petersburg, the new capital which Peter the Great had founded in 1703 on the Gulf of Finland. Moscow's identity was linked above all with the Kremlin, a complex of splendid Medieval cathedrals whose triangular outer walls marked the heart of the city's rather chaotic plan. 'Moscow is the Kremlin, and to *feel* the Kremlin is to *know* Moscow' was how one visitor put it.[1] No multi-storey apartment houses yet marred its silhouette, and only the white-walled bulk and huge golden dome of the new Cathedral of Christ the Redeemer (consecrated in 1882) challenged its supremacy. The very coherence of the city's skyline created an impression of 'Oriental splendour', dazzling the eye 'as by a brilliant stage scene, more enchantment than reality' (plate 27.1).[2]

Yet behind this exotic facade, with its Byzantine origins and its aura of a Thousand and One Nights, lay a very different Moscow, or rather a host of Moscows, each representing a layer of the city's rich society and culture. Just a few minutes walk from the Kremlin were the fashionable districts around the Arbat, Prechistenka, Povarka and Ostozhenka Streets, where entire blocks were lined with buildings in the Empire style, built to exacting aesthetic codes after the devastating Moscow fire of 1812. Across the Moscow River to the south, in Zamoskvoreche, were the quiet streets and walled properties of the merchant community, immortalized in the dramas of Aleksandr Ostrovsky as a bastion of patriarchal resistance to change. Going north-east one came to Kalanchevskaia Square, where three of Moscow's six railway lines converged, while nearby were the notorious doss-houses of Khitrov Market, home to the city's 'down and out'. Further north, beyond the Garden Ring (the old fortification line that had once marked the outer reaches of the city) was an unregulated suburban sprawl of shanty towns and factory communities that housed the legions of peasants who arrived from the provinces in search of new lives.[3] In short, by 1900 Moscow was a city full of mixed cultural messages.

For the entire eighteenth century and half of the nineteenth century, Moscow had been a sleepy backwater, the stronghold of a hereditary nobility in retreat from bureaucratic St Petersburg. But when the Great Reforms of 1861 abolished the institution of serfdom in Russia, they also paved the way for rapid modernization and social change. Former serfs took advantage of their freedom to amass fortunes in trade and industry, while the nobility saw their own wealth, derived from country estates once supplied with free serf labour, decline. Thanks to the entrepreneurship of these peasants-turned-merchants, Moscow became the centre of an enormous textile industry and the hub of the empire's railroad system. The population soared, so that by the beginning of the twentieth century the city had one million inhabitants, making Moscow the tenth most populous of the world's cities. Out of those ten cities, it was the fastest growing.[4] There were, however, plentiful signs that the modernization of Moscow was far from complete. The 1902 census reckoned that 86.9 per cent of the city's inhabitants were peasants.[5] Two-thirds of these

27.2 William Walcot, with substantial modifications by Ilev Kekushev and others, Hotel Metropol. Moscow, 1899–1905.
Photo: William C. Brumfield.

newcomers lived in the settlements beyond the Garden Ring, plagued by all the miseries of rapid urban growth – poor sanitation, inadequate water supplies and minimal transportation. The clear division of the city has been described as a 'big village and modern metropolis'.[6] To a critical observer unseduced by its fairytale facade, capitalist Moscow could well have deserved this description, dating from 1935: 'a city lacking the technical accomplishments of Western capitals, while combining all the shortcomings of the big city, foreign as well as Russian'.[7]

Moscow's *stil modern* architecture cannot, perhaps, capture the full complexity of the city's confrontation with the modern age, but it does highlight the areas of greatest friction between past and present. Take, for example, the Hotel Metropol (1899–1905), one of the city's first modern buildings (plate 27.2). Occupying an entire city block just a few minutes walk from Red Square and the Kremlin, its grandiose size and luxurious amenities implicitly pitted a new secular and capitalist Moscow against the 'Autocracy,

Nationality, Orthodoxy' of the old city. Decorated on the outside with panoramic majolica *panneaux* on Egyptian and French Medieval themes, and fitted out inside in the latest Art Nouveau fashion, the Metropol unabashedly welcomed Western European influence. If under Alexander III (1882–94) a spate of building in the so-called 'Old Russian' style had seemed to return Moscow to its 'true path', now in the reign of his son Nicholas II (reigned 1894–1918), the old capital once again looked West with a mixture of misgiving and optimism, envy and admiration.

Of the many architects and designers who helped to sow the seeds of Art Nouveau in Moscow, it is Fyodor Shekhtel who has become most closely identified with Moscow Modern. This is not, however, because he created a recognizable 'signature style', as Gaudí did in Barcelona or Horta in Brussels. Instead, as if recognizing the impossibility of reducing the Muscovite experience of modernity to one all-encompassing truth, Shekhtel approached the design of mansions and banks, railway stations, apartment houses

and churches with all the attention to appropriate dress and mood of a theatre designer. (Theatre design had, in fact, been his first profession.) As one of the favourite architects of Moscow's new merchant élite, Shekhtel designed for a class and a city undergoing a painful metamorphosis. In drawing a clear distinction between the public and the private spaces of modern life, between the desire to be cosmopolitan and the need to demonstrate a clear national identity, and between mundane reality and fantasy, Shekhtel helped to define the fundamental dilemma facing *fin-de-siècle*

27.3 Elena Polenova, plate from *Mir Isskustva* (St Petersburg, 1900).

Moscow and Muscovites, namely how to be modern without a loss of national identity.

In the first few years of the twentieth century Art Nouveau was imported to Moscow with epidemic speed. The 'whiplash curve' and the woman's head with flowing tresses embellished many a Moscow apartment house and mansion. Russian manufacturers did a brisk trade in Art Nouveau porcelain, fabrics, wallpaper, stained glass and furniture, while shop signs, advertisements, and print media of every kind exposed the emerging middle class to Art Nouveau, Jugendstil and Vienna Secession style (see chapters nineteen and twenty). Even icons, Easter eggs, and the gold brocade of priests' vestments were not immune to this latest infusion of Western taste. Very quickly, however, 'pure' modern became equated with the least desirable aspects of modern urban life, and with the spectre of a homogenizing European culture that threatened to swallow up Russian identity. It also came to be identified with the search by the wealthy merchant class for a distinctive style of its own, and was thus a symbol of the *parvenu*, hiding his peasant origins beneath the veneer of Western ways. Those looking for an antidote to the 'cheap commercial style' of international Art Nouveau found it in the neo-Russian style, a fusion of vernacular forms and *fin-de-siècle* sensibility that was uniquely associated with Moscow.

The neo-Russian style was the creation of the Mamontov circle, a group of artists who found a sympathetic patron in the railway magnate Savva Mamontov, and who were frequent guests at Abramtsevo, his Moscow-province estate. Longing for beauty, poetry and fantasy amid the banality of modern Russian life, artists such as Viktor Vasnetsov, Mikhail Vrubel and Elena Polenova (plate 27.3) found a rich vein of inspiration in peasant culture. Collecting choice pieces of woodcarving, lace and embroidery, they wove folk ornament and fairytales into their paintings, and tried their hand at architecture, building and decorating a small church on the Abramtsevo estate inspired by the simple white-walled churches of Novgorod. When Mamontov founded his own private opera company in Moscow in 1885, the group became set and costume designers, finding fresh scope for their imagination in the Russian operas of Nikolai Rimsky-Korsakov. The fairytale characters from Rimsky-Korsakov's *The Snow Maiden* and *Sadko* inspired Vrubel to create a series of majolica figurines at the Abramtsevo Ceramics Factory (founded in 1890), and Abramtsevo became the crucible for a revival of Old Russian majolica ware and decorative architectural tiles. (The lavish use of Abramt-

27.4 Fyodor Shekhtel,
Iaroslavl Railway Station.
Moscow, 1902–04.
Photo: William C. Brumfield.

sevo tiles is still one of the distinguishing features of Moscow modern architecture.)

In the hands of Elena Polenova the resurrection of folk art had more far-reaching effects. As Director of a carpentry workshop for peasant boys on the Abramtsevo estate, Polenova designed furniture that borrowed ornamental motifs and shapes from objects she saw still being used in peasant life. What began as a philanthropic experiment – to stop peasant boys from drifting off to the city in search of better pay and bright lights – became for Polenova a serious search for national- and self-expression. Throughout the 1890s she composed an entire grammar of ornament, derived from familiar Russian wildflowers and wildlife, but stylized after the manner of English illustrator Walter Crane, and inspired (so her friends reported) by dreams and music. Polenova used her modernized Russian ornament in the illustration of folktales, in 'symbolic paintings', and in designs for the Solomenko embroidery workshops of Savva Mamontov's niece Maria F. Iakunchikova. The example she set – of a professional artist designing for *kustari* (peasant artisans) – was copied in dozens of provincial workshops run by landowners or local government agencies. The phenomenon of peasant men and women crafting furniture and embroideries adorned with 'folk'

ornament in the style of Polenova is one of the most poignant signs of Russia's confrontation with modernity at the turn of the century.[8]

The neo-Russian style enjoyed its greatest success at the 1900 Paris *Exposition Universelle*, where the Russian Village designed by Konstantin Korovin and Aleksandr Golovin was hailed as a genuine synthesis of the vernacular and the modern. (The Russian government had learned from bitter experience that Western Europe expected Russia to be unambiguously Russian when it joined other aspiring nations at the Worlds Fairs of the late nineteenth century.) Yet even in Moscow, the heartland of Old Russia, a style capable of modernizing vernacular forms had an important role to play in keeping alive certain cultural myths. Shekhtel's transformation of the Iaroslavl Railway Station (1902–04; plate 27.4) was a case in point. Located on Kalanchevskaia Square, where thousands poured in and out of Moscow each day, the station was literally a gateway between city and countryside. More specifically, its refurbished facade and interior functioned as a spectacular advertisement for the expansion of the Moscow-Iaroslavl Railroad northwards to Arkhangelsk. The imposing *kokoshnik* roof of the main entrance conjured up a larger-than-life vision of remote northern churches, the ceramic tile inlays

27.5 Design for a study in the neo-Russian style. Russian, *c.*1902. Private Collection, France.

in the facade (produced at the Abramtsevo Ceramics Factory) painted scenes of storybook peasant villages, and the schematic fir trees cut in low relief into the white walls of the entrance evoked unspoiled virgin forests. Located in one of the most disreputable parts of the city, the building created a visible disjunction with its site, so that the traveller experienced a 'division into two worlds'; in the words of Shekhtel's biographer, Evgenia Kirichenko: 'Below is the rational present of urban Moscow, above it the ideal world of the sublime – the beautiful and harsh North.'⁹

More than anything else, it was this clash between reality and fantasy that was the neo-Russian style's intrinsic flaw. Although it fully satisfied Western Europe's Romantic identification of Russia with peasants, the remote countryside and a picturesquely Medieval way of life, for most urban Russians struggling to put their past behind them, actually living in such an environment was little more than play-acting. All the wrong-headedness of such a solution was summed up by its critics in the derogatory word '*berendeevka*', which conjured up the fantasy kingdom of Tsar Berendei in *The Snow Maiden*, a place one might escape to at the theatre, but which was quite unsuitable for modern living. Few Muscovites were bold enough to face the realities of daily life in such fancy dress, and the number of

interiors entirely decked out in a riot of carved, painted and embroidered ornament seems to have been very small (plate 27.5). In its extreme ornamental form, the neo-Russian style was an embarrassment. Its lack of restraint was a grotesque caricature of the stereotypically expansive, Oriental Russian character. Those qualities popularly associated with Russian culture – barbaric colour, riotous ornament, child-like primitivism and crude craftsmanship – increasingly struck observers as utterly incompatible with the modern need for harmony, beauty and comfort. In the hands of its most extreme practitioners, Sergei Maliutin and Aleksandr Golovin, the neo-Russian style exuded an exaggerated primitive vigour that irritated the nerves rather than soothing them.

That Shekhtel never designed a private residence or apartment house in the neo-Russian style indicates how well he (and presumably his clients) understood its limitations – unlike Maliutin, whose Pertsova House (1/1 Kursovoi Lane, built in 1905–06) is one of Moscow's most eccentric modern buildings. In 1904 Shekhtel won the commission to design an apartment house for the Stroganov School of Technical Drawing (24 Miasnitskaia Street). The Stroganov was Moscow's premiere design school. Its mission was to provide Russian indus-

27.6 Fyodor Shekhtel, Riabushinsky mansion. Moscow, 1900-02. Photo: William C. Brumfield.

27.7 Fyodor Shekhtel, view of the main stairway from the dining room, Riabushinsky mansion. Moscow, 1900-02. Photo: William C. Brumfield.

try with designers adept at a modernized national design language that would make Russian goods competitive on the international market. Yet Shekhtel, who himself taught composition at the school, was careful not to confuse its public profile with the demands of private life. For the majolica decoration of the otherwise plain and rectilinear facade he chose not the firebirds or giant wild strawberries made popular by the Mamontov group, but a web of graceful floral garlands rendered in a Beardsleyan dotted line. Fluent as he was in the theatrical idiom of vernacular forms, Shekhtel clearly understood that this *berendeevka* could scarcely satisfy the complex needs of the modern Russian. As the critic Mikhail Syrkin put it, in 1900:

> Surely Russian folkways lack the expressive power that would allow the new man, for whom nothing human is foreign, to encapsulate his whole soul in them? Can we really take up residence in a peasant hut, when we want to drag the peasant out of it and settle him in a more cultivated abode? Why is there this demand to install the factory owner in the chambers of a Moscow *boyar*? Are these really the same kind of people? Isn't it better to use our own strengths to create a new environment, a new residence based on the habits, ideas and needs of modern man, and in the process to keep abreast of similar successes among other nations?[10]

Like other boom cities at the turn of the century, Moscow confronted its citizens with unaccustomed pressures that intensified their need for the spiritual and physical comfort of the private domain. Educated Russians in touch with events further West felt themselves victims of a universal *malaise*, and could empathize fully with the Utopian intentions of the Darmstadt colony. As a reviewer wrote in the St Petersburg *World of Art* magazine: 'We can only rejoice that a start has finally been made to the artistic transformation of the ugly reality that surrounds us, and from which the sensitive modern man suffers so cruelly.'[11] Yet there was also a pervasive sense of how much uglier that reality was for the sensitive Russian. The philistinism of Russian society, its careless vandalism of historic monu-

ments and its fawning dependence on foreign fashions, together with Moscow's unregulated growth, threatened to turn it into just another big European city. All this conspired to make any attempt to aestheticize modern life seem especially difficult. 'It's all very well for Darmstadt and Turin to breed "artists' colonies", to build villas, pavilions and theatres', Sergei Diaghilev pointed out. 'They also have interested Mycaenases and entire parks at their disposal, and an unlimited store of trained craftsmen, and most important, blue sky, high spirits, a cheery heart – all of which of course produces splendid results.'[12]

Moscow's Mycaenases came almost exclusively from among the educated merchant class, whose wealthiest families had usurped the nobility's role as the city's leading philanthropists, collectors and art patrons. In their choice of residence, the younger generation of Shchukins, Morozovs and Riabushinskys showed an eclecticism that might have signalled a tenuous sense of class identity, or, conversely, a desire to impress upon the world their individualism, so different from their fathers' stereotypically merchant lifestyle. Moving out of their traditional enclaves in Zamoskvoreche, these merchant sons settled in the fashionable districts of central Moscow. In some cases they simply took over the 'gentry nests' which the nobility had vacated when their fortunes declined. In others they settled on a variety of modern interpretations, hence its nickname 'the millionaire style'.

For a merchant who wanted his residence to communicate more nuanced messages about his ideals and his status, Shekhtel was the ideal choice. In the mansion he designed for the banker Stepan Riabushinsky in 1900–02 (6 Malaia Nikitskaia; plate 27.6) Shekhtel attained a rare balance between the competing claims of modernity and tradition. Made of Ferro-concrete, painted pink and faced with glazed tiles, the Riabushinsky mansion was the last word in modernity and convenience. Encircling the exterior walls was a mosaic frieze of exotic orchids against a brilliant blue sky, the very antithesis of the harebells, lilies-of-the-valley and sunflowers that were a staple of the neo-Russian style's ornamental vocabulary. Inside, a breathtaking staircase cascaded in a wave from the second floor (plate 27.7), while marine forms floated on the moulded ceilings and Art Nouveau serpentines undulated from the parquet floor to the stained-glass windows.

Yet the mansion was not a simple pastiche of international Art Nouveau, nor was its owner the kind of Moscow merchant who wished to conceal his origins beneath such a disguise. Although in public life Riabushinsky was a banker, his real passion was Russian icons and ecclesiastical

27.8 Ivan Fomin, dining room of grey maple shown at the 1902 Exhibition of Architecture and Industrial Art in the New Style. From *Mir Isskustva* (St Petersburg, 1903).

embroideries, and the house was to be a showcase for his extraordinary collection. Moreover, like many prominent merchant families, the Riabushinskys were Old Believers, members of a much-persecuted sect that had broken with the official Orthodox Church in the 1660s over fundamental questions of ritual and dogma. As Old Believers were forbidden by law to worship publicly in their own churches, the house included a private chapel, reached by way of a back staircase with its own separate entrance. In ways far more subtle than the ornamental vernacular made popular by the Mamontov artists, Shekhtel designed an environment as complex as its owner's identity. The masses and porches of the exterior were reminiscent of Old Russian churches, while the interior staircase, despite its internationalism, could also be read as a metaphor for the merchant hero of the Russian fairytale, *Sadko*, who descends into the underwater kingdom to choose a bride.[13] As one writer has aptly described it, the Riabushinsky mansion was 'nine centuries of Old Orthodox piety encased in a modernist jewel box'.[14] Here the Old Belief and the new style merged in a paradoxical but entirely organic fusion of meanings; a hybrid that would later be utilized by Ilya Bondarenko in the churches he designed for Old Believer communities after 1905, when freedom of worship was restored in Russia.

Only one designer, Shekhtel's own pupil Ivan Fomin, managed to refine the formula for a Russified modern still further. In the winter of 1902–03 Moscow's New Architectural Society held an Exhibition of Architecture and Industrial Art in the New Style. Begun as an exercise in promoting the new Vienna and Glasgow styles (Josef Maria Olbrich and Charles Rennie Mackintosh were guest exhibitors) the exhibition became instead a referendum on the possibility of a new direction in the Russian style. Although the study designed by William Walcot (one of the Hotel Metropol architects) was dismissed as 'a product of that Decadent style that has already outlived its time', Fomin preserved 'just the spirit of past epochs and create[d] things fully answering the demands of contemporary art' (plate 27.8). Fomin's determination not simply to imitate the styles of his foreign guests earned Olbrich's approval, but for Russians the old question remained: did they want to live in such rooms? Even Fomin's supporters recognized in these interiors 'the pessimism that reigns in our era, both in literature and in life'. His stark blue-grey dining room, with its fountain, Medieval chandeliers and massive fireplace, tended to depress rather than cheer its occupants. Two hours spent in the subterranean gloom of his black and white *gornitsa* (the 'parlour' of a peasant hut) could drive a man to suicide. The signs of national identity

that still remained (a polar bear motif here, a crude geometric shape there) were ultimately swallowed up in the Chekhovian mood of modern urban man – melancholy, introspective and pessimistic.

Ultimately it was perhaps only in the theatre that Moscow's modernity could be fully reconciled with its past – not the theatre of diverting entertainment, however, but the new psychological drama of the Moscow Art Theatre, which debuted in 1898. The repertoire of the Moscow Art Theatre was a microcosm of the city's own layered history. It encompassed pre-Petrine history (Aleksei Tolstoy's *Tsar Fyodor Ioannovich*, 1898) and the squalor of the modern city (Gorky's *The Lower Depths*, 1902), fairytale fantasy (Ostrovsky's *The Snow Maiden*, 1900) and the darkest corners of peasant life (Leo Tolstoy's *The Power of Darkness*, 1902). Above all, it was the familiar banality of contemporary middle-class life in Russia, captured in Anton Chekov's *The Seagull* (1898) or *The Cherry Orchard* (1904), that struck a chord in the audience. The Moscow Art Theatre became a place where one went to experience the psychological truth about the past and present. It is where Muscovites went to see themselves.

It is not coincidental that the remodelling of new premises for the Moscow Art Theatre in 1902 was one of Shekhtel's last great modern achievements (plate 27.9). Here he showed himself to be not just a competent professional satisfying his client's fantasies, but a soulmate in complete sympathy with the aspirations of the theatre and its merchant Mycaenas, Savva Morozov. In Shekhtel's hands the theatre itself became a kind of interior world, providing the comfort and quiet that the modern man sought, but rarely found, in his own life.

> Everything bears the imprint of thought and taste. Everything is severe and stylish, with not a single strident tone or colour. You immediately feel that you are crossing the threshold of a real temple of art. ... Not a single bright or gilded spot is allowed, so as not to unnecessarily fatigue the audience's eyes, the effect of bright colours being confined exclusively to the stage set.[15]

Rather than being a theatrical event in itself, the foyer and stage of the Moscow Art Theatre became a backdrop against which the complexities of modern Muscovite experience were played out. By 1905, the year of the first Russian Revolution, Moscow Modern as an innovative style and the city's response to the call of Art Nouveau had passed. The stage was now set for the advent of neo-Classicism and functionalism, styles which, although far less ambiguous, could never compete with Moscow Modern in the complexity and fluidity of their meanings.

27.9 Fyodor Shekhtel, view of proscenium, Moscow Art Theatre. Russian, 1902.
Photo: William C. Brumfield.

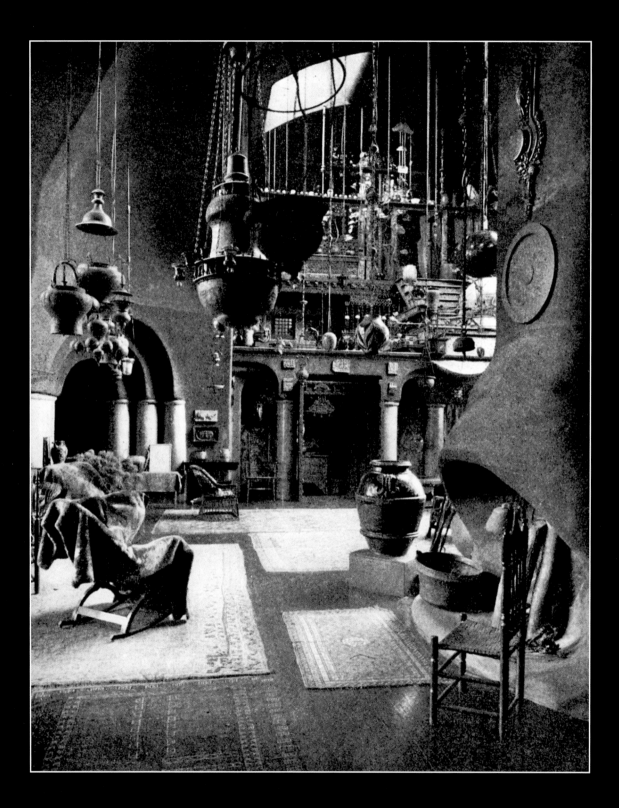

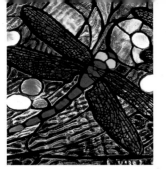

Alice Cooney Frelinghuysen

Louis Comfort Tiffany and New York

The architectural critic Alfred D.F. Hamlin, writing for the influential American publication *The Craftsman* in 1905, proclaimed that Louis Comfort Tiffany was one of the first true prophets of Art Nouveau.[1] Tiffany was the United States' most innovative and prodigious artist working during the late nineteenth and early twentieth centuries. Although he began as a painter, Tiffany found his *métier* in the world of design and the decorative arts. The embodiment of the artistic spirit of the Gilded Age, the theatrical and enormously imaginative Tiffany included among his patrons some of the leading figures of the day. An omnivorous observer, this progressive American artist embraced the prevailing proliferation of new media and styles with a zeal unmatched by his peers. In the various partnerships and companies he formed, beginning as early as the late 1870s, he made significant experiments with new forms of glassmaking, and the revolutionary glass that he developed was celebrated for its astonishing variety of colours, shapes, and iridescence.

Tiffany's creations exemplified the diverse themes associated with the 'New Art'. Steeped in the artistic urban milieu of New York City, he established his design workshops to direct the production of myriad art objects with the goal of incorporating them into a complete integrated aesthetic whole. Furthermore, Tiffany's continual striving to rethink each medium available to the decorative artist led to untried methods and innovative techniques, especially in glass, resulting in art objects that looked completely new to the progressive patrons of his day. Consistent with many other artists working within the Art Nouveau style, Tiffany drew from exotic sources – Chinese, Japanese, Islamic, Celtic and Native American – infusing them with his own original artistic sensibility to create richly textured works of art. Equally important was his intense scrutiny of plants and insects, which he reinterpreted in lush, colourful and often sensual celebrations of the natural world. In so doing, his work attained a prestigious place not only within the cultured élite of New York, but also worldwide.

Tiffany established and pursued his artistic career of nearly five decades in New York, where he was born and raised. By the 1870s, when he was embarking on his artistic career, New York had asserted itself as the cultural capital of the United States in much the same way that the city had become the nation's financial and commercial centre. This coincided with a period of renewed interest in the arts in all media, inspired by the British Aesthetic movement's dissemination to the United States. The founding of the city's many prominent cultural institutions was emblematic of this heightened commitment to art – the National Academy of Design erected a new building in 1863; the Cooper Union for the Advancement of Science and Art was founded in 1859; the American Society of Painters in Watercolours in 1866; The Metropolitan Museum of Art in 1870; the Art Students' League in 1875; the Society of American Artists in 1877; the Society of Decorative Art in 1878; and The Metropolitan Museum of Art School in 1880.[2] Many of these educational enterprises offered design and craft training, fostering career opportunities, for women in particular.

New York City not only provided a pool of creative talent to occupy positions in Tiffany's ateliers, but it also attracted affluent potential patrons. The wealth generated by that great metropolis in the wake of post-Civil War prosperity was expressed in the many grand houses, clubs and churches that were being built and decorated during the 1880s and 1890s by notable civic and economic leaders, such as the financier Pierpont Morgan, the railroad tycoon Cornelius Vanderbilt II, the President of The Metropolitan Museum of Art John Taylor Johnston, and the sugar magnate Henry Osborne Havemeyer. These same families pursued the collection of art objects of all

kinds with a zeal equal to their pursuit of wealth. These collections were procured from the emerging breed of art and antiques dealers who were instrumental in guiding their patrons' acquisitive energies, and were displayed in their elaborate houses, decorated by some of the most notable taste-makers of the day, including Herter Brothers and Tiffany. New York City was the nation's centre not only for the display of art but also for published discussions of it, which ranged from art criticism to household decorating advice. The proliferation of art and decorative art publications, many of which were plentifully illustrated, was instrumental in transmitting the aesthetic ideas that were germinating in New York to cities and towns across the country.

New York was also home to the successful silver and jewellery firm founded by his father, Charles Lewis Tiffany, where Louis was steeped in the finest quality craftsmanship and design, as well as marketing genius. Edward C. Moore, Art Director at Tiffany & Co., was perhaps the most influential individual during the formative years of Tiffany's decorative career. Moore was one of the first designers to embrace fully Japanese and Islamic art, developing a number of so-called Saracenic designs as well as a line of mixed metal silver in the Japanesque style, which received international acclaim. He had an exhaustive reference library, which included Owen Jones' *Grammar of Ornament* (1856), and he was also inspired by his extensive collections of ancient, Medieval, Oriental and Islamic decorative art objects. Moore's love of exotic sources, expressed in his collecting interests and in his silver designs, undoubtedly had a profound influence on the young Tiffany.

Tiffany's love of the exotic was further nurtured by his many travels, beginning shortly after the completion of his schooling in 1865 when he travelled abroad several times throughout Europe and North Africa, absorbing the scenery, architecture and art. These journeys opened his eyes to the prevailing art movements in England and mainland Europe, and they gave him significant exposure to the exotic cultures of the Arab world. Following his third trip abroad in 1870, Tiffany returned to the artistically rich environment that New York could provide.

Having produced his first design work in 1878, when he decorated his own home, Tiffany entered into his first commercial ventures as a designer. By 1880 he had formed partnerships with furniture and woodwork specialist Lockwood de Forest, and textile designer and embroidery specialist Candace Wheeler. Such collaboration among artists was a complete departure from the practices of the day. Associated Artists, as his partnership with Wheeler was called,

which may have been loosely modelled on William Morris' precedent in London, was unusual in bringing together varied artistic talents to integrate all of the arts into a comprehensive whole. The design teams produced wall decorations, flooring, lighting fixtures, windows, furniture and upholstery, and oversaw the procurement for clients of requisite imported furnishings such as carved woodwork and Oriental rugs. During the four years of their partnerships, Tiffany and his associates enjoyed the benefits of a remarkable client list, due in no small measure to Tiffany's stature in New York society. He received commissions to decorate the homes of wealthy merchants of the day: the house of the notable literary figure Mark Twain in Hartford, Connecticut; the prestigious Veterans' Room of the Seventh Regiment Armoury in New York; and the Red and Blue Rooms of the White House under President Chester Arthur. Along with the second home that he designed for his own family within a larger free-standing house commissioned from McKim, Mead & White by his father at Madison Avenue and Seventy-second Street (1885), with its evocative, theatrical top-floor studio room (plate 28.1), these interiors reveal Tiffany's aim and ability to orchestrate all of the arts into a single, expressive artistic environment.

During the 1880s, Tiffany continued to focus his individual artistic talents on interior decoration, with special emphasis on the production of the richly coloured leaded-glass windows whose experimental techniques and new subject-matter garnered much acclaim. The years surrounding 1890 marked the most imaginative and energetic period of his career. The decade commenced with his collaboration with American painter Samuel Colman on the interiors for the Fifth Avenue house of his most important patrons, Louisine and Henry Osborne Havemeyer. Completed in 1892, Siegfried Bing evocatively described the entrance hall after his visit to the United States in 1894, saying the walls 'gleamed a rich variety of subtle, sober, chalky whites surmounted by polychromed friezes, diapered with the thousand details of woven cashmere'.[3] The rooms of the house combined historically unrelated objects, including paintings, prints, metalwork, glass and ceramics, in subtle aesthetic relationships. The library, for example, drew on early historical sources, looking to Celtic and Viking designs, and the Music Room drew its thematic inspiration from Japanese art (plate 28.2). Tiffany participated in the major International Exhibitions of the period and in the inaugural exhibition of Siegfried Bing's L'Art Nouveau gallery in 1895 as well as in subsequent years, giving him a constant European presence. His work was published in the major international art periodicals that

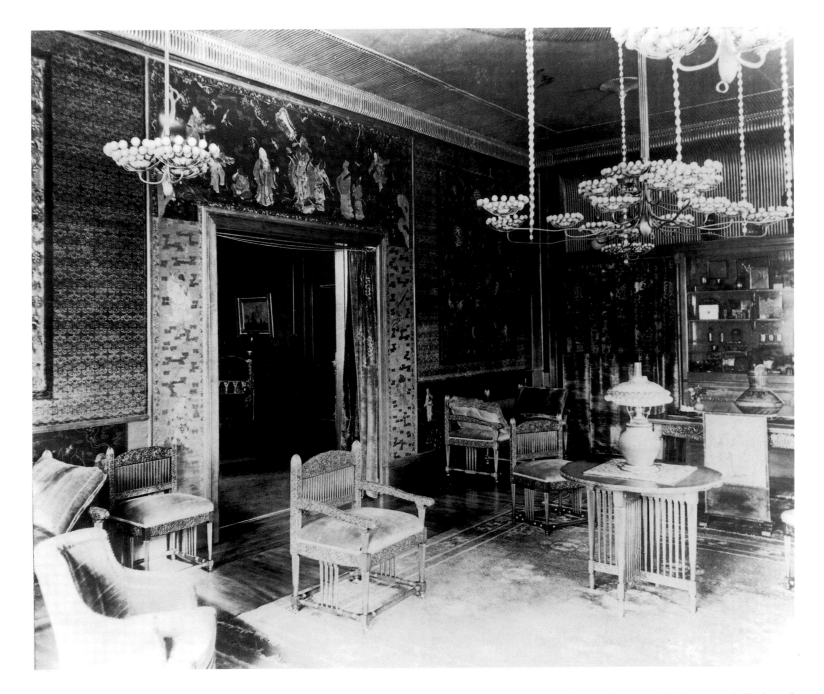

28.2 The Music Room
at H.O. Havemeyer House,
One East Sixty-sixth Street,
New York, 1892.
The Metropolitan Museum
of Art, New York.

covered the New Art, of which he was a part by virtue of the enthusiasm with which the European artistic community embraced his work.

The flourishing of the Art Nouveau style coincided directly with the mature period of Tiffany's career and his work is more inextricably linked to it than any other American designer. His work during this period aligns closely with some of the major stylistic themes associated with Art Nouveau, and he was personally aware of the style through the work he viewed on his frequent European travels, his participation at the International Exhibitions of the day, his involvement with Bing's Parisian

gallery, and his voracious appetite for art periodicals and books. The American public, however, were distinctly ambivalent towards Art Nouveau, with its connotations of permissiveness, degeneracy, and, perhaps, social revolution. This may account for the absence of any published statement on Art Nouveau by the company, or indeed, by Tiffany himself. His own attitudes may have been tempered by his concern for his reputation in the United States and the fear of jeopardizing the marketability of his work if it were too closely associated with a style, about which the public was, at best, unsure.

Throughout the art world, and at Tiffany's firm in par-

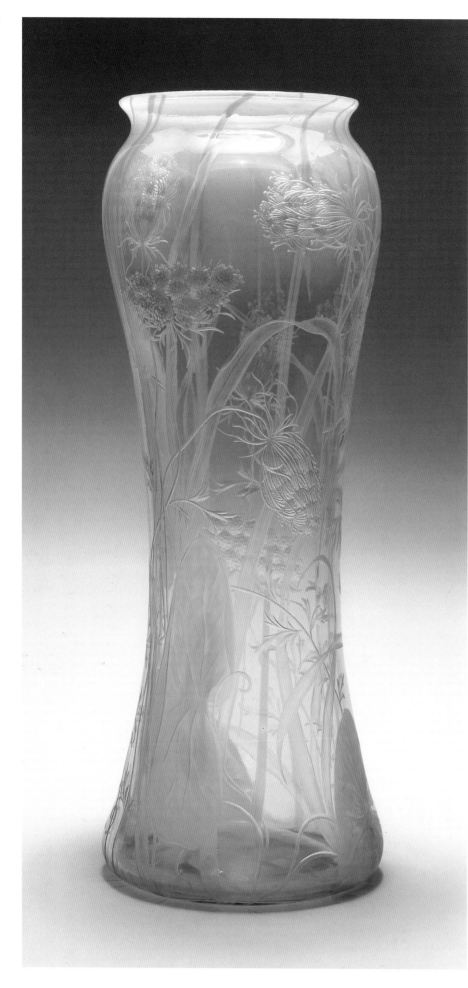

ticular, the period saw tremendous experimentation in a wide variety of media. Tiffany made this possible in 1893 by constructing new workshops and furnaces in a large building in Corona, Queens, just outside the city centre, while his expanding showrooms remained in Manhattan. The first of the experimental media, blown glass, utilized the scientific properties that Tiffany had introduced in the novel glass he used in the windows he had been making for over a decade. His work in blown glass may have commenced under his supervision as early as the mid-1880s for use in such lighting fixtures as the exotic Moorish-inspired hanging shades reminiscent of mosque lamps that were suspended from the darkened ceiling of his theatrical top-floor studio. To supervise the furnaces, he hired Arthur Nash, a skilled worker formerly of Thomas Webb's establishment in Stourbridge, England. Nash brought a high degree of glassmaking proficiency to the new enterprise. The Webb firm, well-known to Tiffany through the display of its wares in his father's china and glassware department, was particularly noted for its coloured art glass as well as its cut cameo glass. Technically proficient, the designs were nonetheless rather conservative, relying strictly on historical forms and motifs. In this new environment, working with Nash and his glass chemist, Dr Parker McIlhenny, Tiffany yet again challenged the traditional boundaries of the medium to create something entirely new for the American public. It derived, no doubt, from the interest in novel colours, forms and textures that began in the 1880s with various American firms, which produced 'art glass' vessels that recalled historical forms and often replicated other materials.

His first public offering of blown-glass vessels may have been at the Columbian Exposition of 1893 in Chicago. Tiffany's extensive participation in the International Exhibitions of the day gave him unprecedented international exposure and recognition. The exhibit in 1893 was a watershed for his career. The Tiffany display, placed prominently beside the impressive showing of Tiffany & Co., incorporated a wide variety of decorations, including a complete chapel replete with mosaic reredos, steps, altar and baptismal font, a variety of different types of leaded-glass windows, jewelled altar ornaments and an enormous

28.3 L.C. Tiffany, Tiffany Glass and Decorating Company, vase. Carved, cut and engraved *favrile* glass. American, *c*.1895-98. The Metropolitan Museum of Art, New York. William Cullen Bryant Fellows Gifts, 1997.

gasolier. He called the blown glass he displayed '*fabrile*', recalling the Old English term for craftsmanship, and later the more elegant *favrile*.

One of Tiffany's most significant craftsmen was Fredolin Kreischmann, an Austrian by birth and training who worked as a glass engraver in Stourbridge from 1886 until 1892, just prior to his arrival at the Tiffany ateliers. Although his English wares were derivative, Kreischmann flourished under Tiffany's artistic direction and he began decorating vases in a new style that relates closely to the sinuous curves and fluidity associated with the formal aspects of Art Nouveau. One such vase, a departure from the many coloured glasses that are typically associated with Tiffany's work, is almost entirely colourless with a flush of milky blue-white opalescence at the uppermost rim (plate 28.3). The transparency of the glass itself contributes to the airy quality that was enhanced by the cut and engraved decoration of lily pads and Queen Anne's lace. The vase relates loosely to the work of Émile Gallé, considered one of the greatest glassmakers associated with Art Nouveau. Tiffany would have been aware of Gallé's work as early as the late 1870s, when it was first being sold through his father's emporium. Although Tiffany never directly acknowledged the influence of Gallé on his work, he visited Nancy and his appreciation for it can be seen in the comment, 'Émile Gallé exhibited in Paris some very original and artistic glass,' which was in a selected chronology of glassmaking that the company published in 1896.[4]

In creating his glasswares, Tiffany looked to historical and exotic sources in much the same way that he did in his interior decoration. He formed numerous collections which included large holdings of varied art objects, from Roman glass, Chinese and Japanese ceramics and metalwork, and Islamic ceramics and carpets to Native American works of art. Even within the first several years of his efforts in blown glass, for example, he began replicating the pitted iridescent surfaces found on ancient glasses that had been buried for centuries. More typically, the form of the *favrile* vessels bore direct historical references to Classical Grecian shapes or to Islamic forms, seen especially in his replications of Persian rose-water sprinklers (plate 7.2).

Nature was Tiffany's constant muse, as can be seen in much of the art that he produced. Like Gallé, he assiduously studied the horticultural and gardening texts in his extensive library.[5] He lavished much attention on his own natural environment, creating myriad gardens with sweeps of blossoming plants, shrubs and trees at Laurelton Hall, the Long Island country estate he created between 1902

28.4 L.C. Tiffany, Tiffany Glass and Decorating Company, vase. Blown *favrile* glass. American, *c.*1895-1900. Collection Eric Streiner, New York.

and 1905. He demonstrated an affinity for plant life native to North America, and, in particular, to his immediate surroundings rather than to rare botanical specimens from around the world, which became the preoccupation of many during this period. The wild flowers (Queen Anne's lace, wisteria and magnolias) and aquatic plants (waterlilies and even seaweed) lent themselves to a more freeform, fluid interpretation when expressed in his singular glass. Nature was central to Tiffany. Some of his vase forms emulated plant forms in their entirety. One such example emerges from its plump bulb-like base, extending up to unfold in an opened ruffled leafage (plate 28.4). Even the colouration, of a sleek silvery white shading to green, replicates the leek or onion plant in an extraordinary likeness. Still others suggest colourful blossoms suspended on

28.5 L.C. Tiffany, Tiffany Glass and Decorating
Company, vase. Blown *favrile* glass. American,
1893–96. The Metropolitan Museum of Art,
New York. Gift of H.O. Havermeyer, 1896.

28.6 L.C. Tiffany, Tiffany Glass and Decorating
Company, vase. Blown *favrile* glass. American,
1893-96. The Metropolitan Museum of Art, New
York. Gift of H.O. Havermeyer, 1896.

28.7 L.C. Tiffany, Tiffany Glass and
Decorating Company, *Four Seasons* window.
Leaded *favrile* glass. American, 1897.
Jason McCoy Inc., New York.

slender stems (plate 28.5), and relate to the work of the German glassmaker Karl Koepping, whose work was also showcased at the 1900 *Exposition Universelle* (plate 13.8).

The early years of Tiffany's experimental work in blown glass saw the development of lustre and iridescent surfaces, sometimes expressed as ribbons of abstract reflective metallic designs or as generalized leaf and stem shapes fluidly disposed over the surface of a vase. The decoration is at one with the form, utilizing the glassmaking process to full effect, whereby the leafy ornament expands and elongates as the object does.[6] The iridescence that he achieved was particularly well-suited to the evocation of peacock feathers on glass, whereby each individual thread of the feather was articulated in glass, the whole glowing with rainbow colour evocative of the oily sheen of the plumage itself (plate 28.6). In the centuries-old European tradition of setting precious porcelain objects in gold or silver, Bing asked the Belgian-trained artist Édouard Colonna to design mounts for a number of Tiffany's *favrile* glass vases. The sensuous designs and the shimmering surfaces of the glass played off the silver mounts, which in a few instances incorporated enamel decoration. One such example features a brilliant-red vase with lustrous feathered designs set with delicate handles in sinuous curves highlighted with tiny enamel jewels. The handles themselves enclose the rainbow-hued eyes of the peacock feather in *plique-à-jour* enamel.[7] This vase and several others with Colonna mounts in the Art Nouveau style were included in Bing's exhibition in Paris of 1899.

In a conscious effort to be seen as an artist of the world rather than as an American or even a New Yorker, Tiffany avidly sought worldwide recognition. Beginning with the Columbian Exposition of 1893 in Chicago, he focused his considerable energy on the major displays of his work at the International Exhibitions. He exhibited abroad as early as 1895 at Bing's gallery, in 1899 in London at the Grafton Gallery, at the Paris Salon and La Société des Artists Français in 1899 and 1900, at the Paris *Exposition Universelle* in 1900, and Turin's *Prima Esposizione d'Arte Decorativa Moderna* in 1902, where Tiffany Studios opened the American Section. However, he placed the highest premium on the Paris *Exposition Universelle* in 1900, which presented him with an opportunity to produce works in a freer vein. A pair of tall *torchères* with large clustered shades marked the entrance to the Paris display, which included about 100 pieces of blown *favrile* glass, a fantastic punch bowl, numerous windows (like the one shown in plate 28.7), and an unusual leaded-glass screen (plate 28.14). The colours of the punch bowl were described as 'indescribably harmonious, and yet brilliant, running from as deep blue, green,

28.8 L.C. Tiffany, Tiffany Glass and Decorating Company, punch bowl with three ladles. *Favrile* glass, gilded silver. American, 1900. ©Virginia Museum of Fine Arts: gift of the Sydney and Frances Lewis Art Nouveau Fund. Photo: Katherine Wetzel.

28.9 L.C. Tiffany, Tiffany Studios, enamel tray. Enamel on copper. American, *c.*1900. Erving and Joyce Wolf Collection.

purple – yes, even black as the sea – to the delicate, airy tones of the sunshine on the mist of form, in silver and gold' (plate 28.8).[8]

Tiffany had begun experimentation in enamelling by 1898, finding affinity in a medium so closely related to glass. Nature provided the direct source material for much of the enamel work produced at his studios. A large tray takes the shape of a two-dimensional gourd, complete with broken-off stem (plate 28.9). Furthermore, the tray, in a complete denial of the piece's functionality, displays the leaves, blossoms and fruit of a gourd in relief on a mottled green translucent enamel ground. The enamel colourings of the natural forms are rendered in the infinite hues found in nature itself. The direct inspiration for the piece, although ultimately Japanese, was more probably the work of Edward C. Moore in the gourd-shaped hammered trays produced by Tiffany & Co. in silver, with relief decoration in polychrome metals of such Japanesque motifs as the iris or the dragonfly, motifs that Louis admired and utilized in many of his own firm's designs.[9]

The organic qualities of Tiffany's enamels were often translated into ceramics. Indeed, many of the ceramic forms that Tiffany first exhibited publicly at the 1904 Louisiana Purchase Exhibition in St Louis were moulded directly after similar shapes created in enamel on copper. In the enamel vases, and subsequently in many pottery ones, the plant form actually creates the vessel (plate 28.10). He drew on the examples he had seen at the 1900 *Exposition Universelle* in Paris (in particular, the work of the Danish potters for Bing and Grøndahl). The freedom allowed by Art Nouveau enabled Tiffany to defy the functionality of the piece as a vessel to retain water and to hold flowers, in favour of having the plant form be the vase itself.

Nature also served as the stimulus for many of Tiffany's lighting designs, the earliest example of which may have been his Queen Anne's lace chandelier for the Havemeyer House. His blown hanging shades revealed internal leafy designs, and the leaded-glass shades that Tiffany's ateliers began to produce by the late 1890s translated some of his favourite motifs of the natural world into glass. An early dragonfly shade, a design exhibited in Paris at the *Exposition Universelle* of 1900, transcends the more typical slavish renderings of nature in leaded glass. Its expressiveness

derives from the sense of movement conveyed by the upward spiral of the dragonfly's body. The gossamer insects appear to float on scrolled wave-like forms. Two small cartoons of the shade suggest different colour schemes, each in variations of blues and greens, the design's rhythmic quality accentuated by the sprinkling of sparkling glass jewels punctuating the shade (plate 28.11).[10] Like many of the motifs utilized in his lampshades, Tiffany variously interpreted the dragonfly in jewellery and mosaic designs as well.

Insects and field and wild flowers were the inspiration for the earliest jewellery that Tiffany designed and had made in his workshops. Tied inextricably to nature, the hair ornaments or necklaces embodied such motifs as Queen Anne's lace, clover, sage, berries, grapes, forget-me-nots, dandelion seedballs and dragonflies. One of his first jewellery designs was a necklace composed of grapevines that he introduced to the public in an unfinished state at the St Louis Worlds Fair of 1904 (plate 28.12). Combining his luminescent enamelwork leaves with grapes of fiery opals, he rendered the natural plant in a combination of eye-catching light and colour with a modest simplicity of design. After he moved his jewellery studio to Tiffany & Co.'s headquarters in 1907, his necklaces and brooches, although often incorporating naturalistic themes and details, took on more stylized designs (plate 28.13).

One of Tiffany's most complex and dramatic figurative compositions for stained glass was the two-panelled window designed and executed in 1897 for the Long Island (New York) home of the oil magnate Walter Jennings (plate 28.7). The panels feature four women clad in loose-fitting Grecian robes, each figure an allegory to one of the sea-

28.10 L.C. Tiffany, Tiffany Studios, vase. Glazed ceramic. American, *c.*1904-10. The Metropolitan Museum of Art, New York.

28.11 L.C. Tiffany, Tiffany Studios, dragonfly shade. Leaded glass. American, *c.*1899-1905.
© 2000, Sotheby's Inc.

28.12 L.C. Tiffany, Tiffany Studios, grapevine necklace. Opals, gold and enamel. American, 1904.
The Metropolitan Museum of Art, New York.

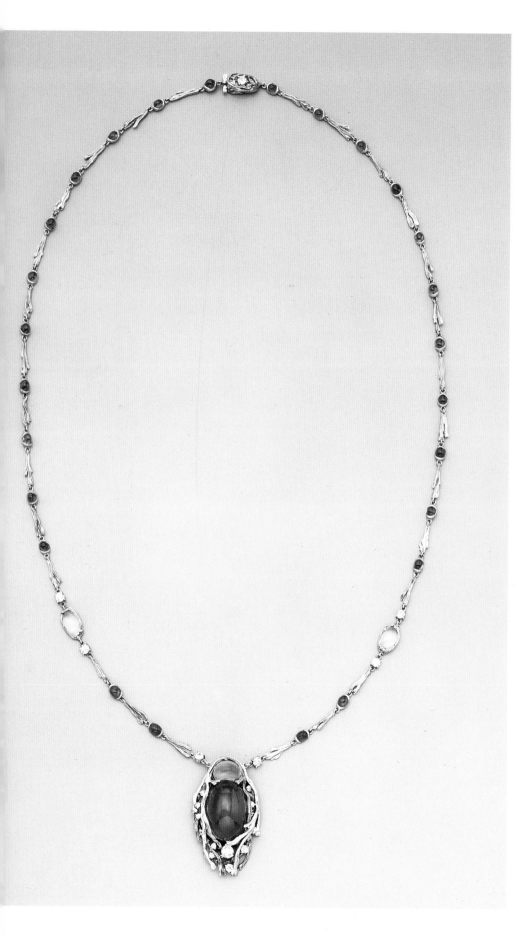

sons – Spring and Summer in the top panel and Autumn and Winter in the bottom panel. The languidly posed women gesture in ways suggestive of the season they represent – Autumn raises her arms to collect coloured leaves, while Winter holds her hands close to a blazing fire for warmth. Yet the figures are ultimately minor players in this scene, as Tiffany is far more interested in suggesting the seasons through nature itself. In the vignette representing Winter, for example, Tiffany has embedded bits of threads of glass in the sheet glass while still in its molten state to effectively simulate the look and texture of pine needles in much the same way that Gallé decorated vases of about the same date. The four elements are also represented – air as the sky, earth as providing the growing and variously blossoming or shedding trees, water in the fountain that divides spring and summer, and fire as the vertical element between Autumn and Winter.

Perhaps a final example will sum up the work of the single most important *fin-de-siècle* designer in the United States. An unusual folding screen, composed of leaded-glass panels depicting autumnal fruits, vegetables and flowers densely displayed in asymmetrical designs on a rigid trellis, conflates Tiffany's fascination with Japanese art and his reliance on nature for inspiration (plate 28.14). Called a dining-room screen when it was described in the period literature, it brings full circle some of Tiffany's earliest designs in leaded glass, such as the window he made in 1879 for the dining room of the pharmaceuticals magnate George Kemp, which incorporated luscious depictions of squash and eggplants. In that quintessential Tiffany-designed New York interior, the window displayed a theme appropriate to the use of the room and played an integral part in the scheme conceived as a homogeneous whole. The folding screen, too, was conceived to work within an interior space, as further indicated by the lower half of the panels, composed of marbleized glass in shades of greys and browns, to blend with a wood-panelled dado. This re-interpreted design was considered by many to be the masterpiece of his impressive display at the *Exposition Universelle* in Paris of 1900, and remains today one of the most eloquent expressions of the Art Nouveau style.

28.13 Tiffany Studios, 'Seaweed' necklace. Star sapphire, sapphires, diamonds, moonstones, platinum, gold. American, *c.*1915–1925. © Tiffany & Co. Archives 2000.

28.14 L.C. Tiffany, Tiffany Glass and Decorating Company, three-panel folding screen. Leaded *favrile* glass in bronze frame. American, *c.*1900. Lillian Nassau Ltd, New York.

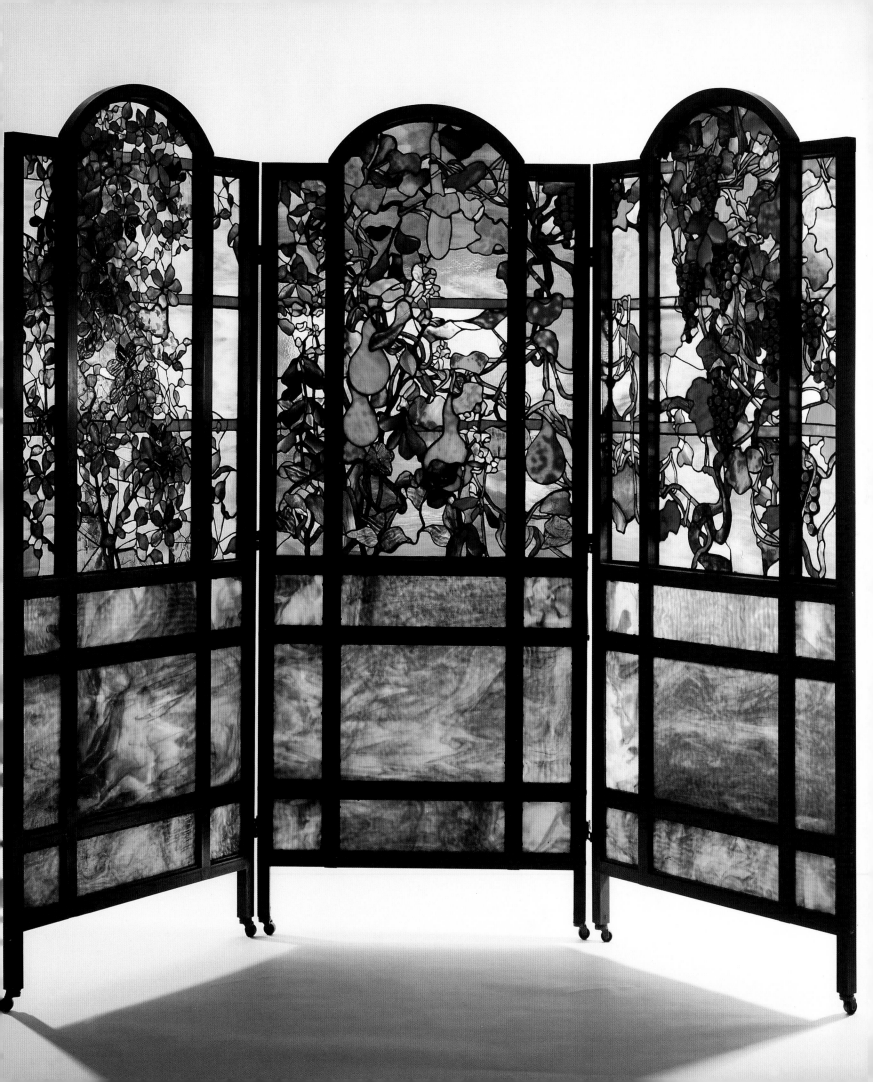

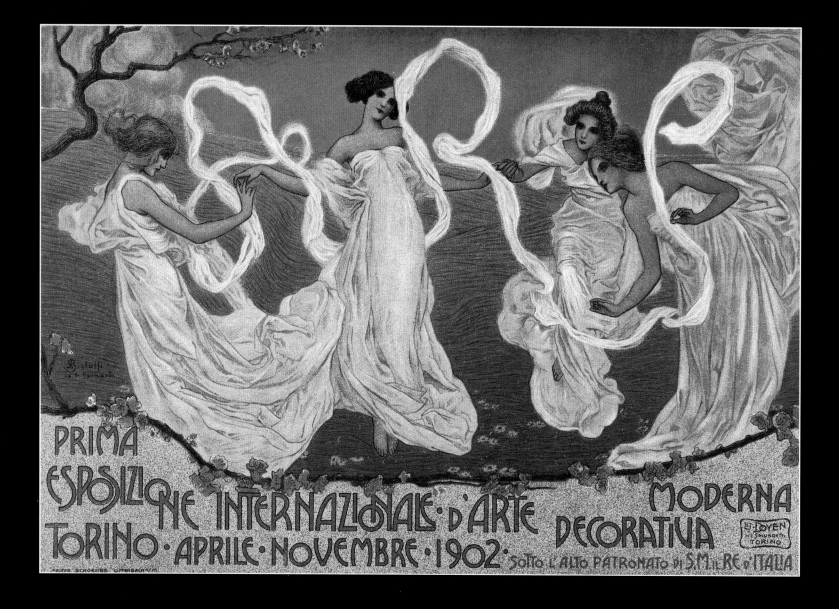

Wendy Kaplan

Turin:
Stile Floreale, a 'Liberty' for Italy?

Newly united as a country, Italy at the turn of the century had to establish not only a national identity, but also one that would be suited for the modern age. Its *Risorgimento* in the 1860s had brought together diverse regions with long-standing political, economic and social divisions. The south was largely impoverished, overwhelmingly rural and, with few roads and railway lines, geographically isolated from the more industrialized, urbanized north. (Naples and Palermo were to some extent an exception, with their developing factories and steamship connections.) Citizens of the major northern cities of Milan, Genoa and Turin felt a closer cultural connection to Vienna, London and Paris than to Rome or Naples, and looked to the Germanic countries, Britain, and, above all, France as models for industrialization, a capitalist economy and aesthetic taste.

The quest for a new style came from the conviction that every age should have a characteristic artistic expression, and that the unprecedented changes engendered by innovations in transportation, communication and consumption required new artistic forms. Italy was particularly self-conscious about this quest, since its northern cities were in the throes of their first, and belated, industrial revolution – one based on electricity and the internal combustion engine. By 1900, Turin was a leader in the country's economic growth. It was the city where the Agnellis produced their cars (Fiat) and the Pirellis made tyres. It had for centuries been an important regional capital: the centre of Piedmont and the domain of the powerful House of Savoy. And, as the focal point of the struggle for Italian unification, Turin became the first national capital in 1861; the King of Piedmont, Victor Emmanuel II, became the first king of modern Italy. Although the capital was soon moved to Florence and then to Rome, Turin remained a centre for progressive political movements. Having hosted the First Italian Exposition of Architecture in 1890, and an

exhibition of Italian decorative arts in 1898, it seemed the logical location for the most ambitious display of international modern decorative arts that had ever been attempted – the 1902 *Prima Esposizione d'Arte Decorativa Moderna*. The fact that Turin was not at the time perceived as an historical centre for art was in its favour, since the organizers reasoned that the *Esposizione* would be less bound by the shackles of the past.

Reading period accounts of the Turin *Esposizione*, one is struck by how little discrepancy there is between the way late twentieth-century historians perceived the Italian aims for the Turin *Esposizione* and how such goals were presented by critics and the Exposition's organizers in 1902. The prominent critic Alfredo Melani (who was also an architect and a furniture designer) summarized these aspirations for an American audience in *The Architectural Record*. First, he lamented Italy's 'marked tendency towards the old Classicism, towards that style which is absolutely out of harmony with the aim of modern art'.[1] Italy was seen as failing to produce an art for its own time, because of this dependence on styles that had flourished centuries ago, when its cities had been world centres for culture and commerce. This, of course, violated the basic mandate of Art Nouveau. As Hector Guimard had stated, all art 'in order to be true must be the product of the soil where it exists and of the period which needs it'. All countries must 'evolve for themselves a national art'.[2] Melani's articles provide only one example among dozens that demonstrate that the Italians were fully, and often painfully, aware of the need to compete in world markets. Convinced that exposure to the modern design of other European countries would serve as an impetus for Italy's own development, the *Esposizione*'s organizers and participants saw it as the ideal transmitter, since all the countries that were protagonists in the establishment of Art Nouveau would be represented. Devoted only to decorative art, it would provide an invaluable spur

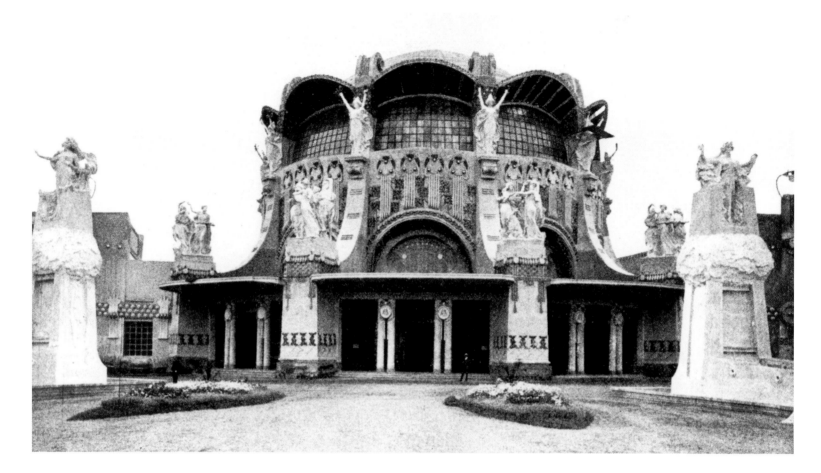

29.2 Raimondo d'Aronco,
Pavilion of interiors at Turin
Exposition, 1902.
The Wolfsonian-Florida
International University,
Miami Beach, Florida:
Mitchell Wolfson Jr. Collection.

for Italy's nascent art industries. In exchange, during its seven-month run Italy would 'give the world a spectacle fit to win a pardon for its former apathy' to modern art.[3]

This chapter analyses the Italian contribution to Art Nouveau in the context of the country's own displays at Turin, focusing on the *Esposizione*'s architecture and the efforts of three of the city's furniture-makers. The *Esposizione*'s organizing committee consisted of the city's leading architects, critics and decorators, including the prominent sculptor Leonardo Bistolfii, who designed the *Esposizione*'s official poster (plate 29.1). The art critic Enrico Thovez was elected as secretary, and together with Bistolfi and three other committee members he founded *L'Arte Decorativa Moderna*, a Torinese journal that laboured mightily to advance the cause of Italian modernity. (As was true throughout Europe and the United States, art journals and exhibitions were the prime agents for disseminating the new style.) Contributing to many other journals as well, Thovez discussed in Britain's *The Studio* the manifesto of the *Esposizione* committee, which declared: 'Nothing would be accepted but original work showing a decided effort at renovation of form … every reproduction of historic styles would be rigorously excluded.'[4] The judges appointed were

critics and designers from the European countries represented at the *Esposizione*, including Alfredo Melani and the English Design Reformer Walter Crane, with the latter selected as honorary president. Although the judges were an international group, the exhibitors competed for gold or silver medals or for a certificate of honour among their own countrymen, not against firms from other countries.

The construction of the *Esposizione* architecture provides an example for understanding the problems inherent in Italy's efforts to establish a place for itself as a 'modern' country. The design competition was won by Raimondo d'Aronco, a gifted architect who worked outside Italy for much of his career, including, for the nine years previous to the Turin *Esposizione*, as court architect to the Sultan at Constantinople. D'Aronco was responsible for the design of the main building as well as the majority of the other pavilions, but was not present most of the time actually to supervize the construction. That task fell to Annibale Rigotti, who had been awarded second prize in the design competition and had also worked for d'Aronco in Constantinople. (After the *Esposizione*, Rigotti continued his career as a respected practitioner of the new art.)

While d'Aronco's buildings were praised by inter-

national and local critics for their adherence to the tenets of Art Nouveau, they were often criticized for merely echoing the architectural vocabulary of the Viennese Secession. Gustave Soulier was one of the sternest critics: 'We have to say that he achieved the opposite of what he should have striven for. ... D'Aronco's architecture originated in Vienna and reached him via Darmstadt and is therefore a fusion of the styles of Wagner and Olbrich, just to cite two names.'[5] D'Aronco's entrance pavilions (plate 29.2) received the greatest censure on the grounds of imitation – many critics pointed out how closely they resembled the entrance pavilions Olbrich had designed the previous year for the exhibition of the Darmstadt artist's colony. Like Olbrich's work, d'Aronco's buildings were characterized by an organic geometry of flowing lines (many simulating waves), circular and checkerboard patterns, floral motifs in bright colours and a monumentality achieved by massive tapering pylons (plates 29.3 and 29.4).

By awarding the buildings to the Italian architect who had the most experience of architectural trends outside the country, the *Esposizione* committee opened itself to the criticism that his work would not provide the unique *national* statement demanded by the New Art. Foreign critics were not alone in this opinion. Melani, for example, believed that if d'Aronco could only have 'forgotten his infatuation for the Secession, his work would have been a more pronounced success'.[6] Others, however, defended him, asserting that he had made a creative and original statement, and that he was making a new synthesis from the same Oriental and Middle Eastern sources as the Viennese did. They declared, in fact, that Italians had an even greater right to such borrowing because of their geographic proximity to these regions, especially d'Aronco, who had lived for many years in Constantinople. His supporters declared that he had fulfilled the mission of clothing the *Esposizione* buildings in modern garb, demonstrating that Italy could be an equal player in codifying the new style.

Clearly the Italians were in a difficult position. They wanted to create opportunities for greater exposure to modern art that would inspire them to manufacture competitive products in its name. They were criticized, however,

29.3 Raimondo d'Aronco,
entrance to Pavilion of interiors
at Turin Exposition, 1902.
The Wolfsonian-Florida
International University,
Miami Beach, Florida:
Mitchell Wolfson Jr. Collection.

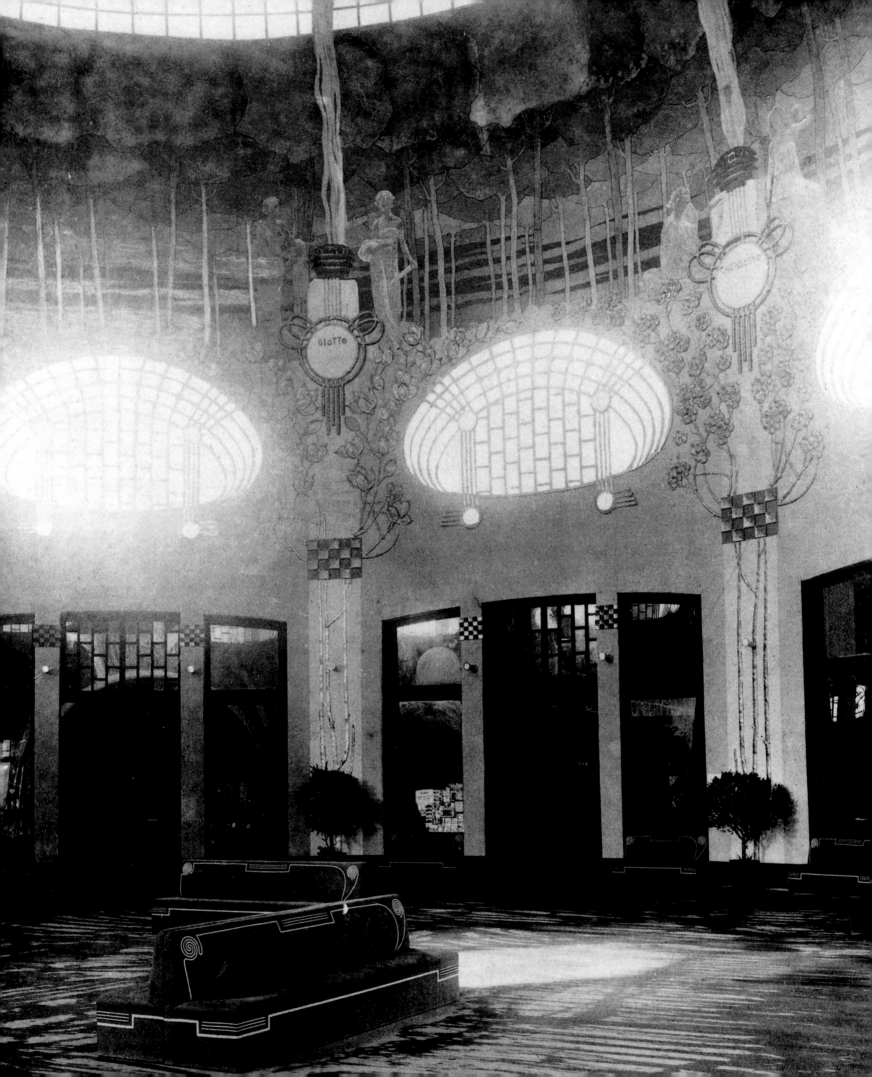

when they adhered too closely to their own sixteenth- and seventeenth-century precedents and also when they seemed overly inspired by modern art in other European countries. Furthermore, they had the additional difficulty of forging a national identity in a country where people still thought of themselves first as citizens of a particular region or city. No consensus existed about the way forwards, although all agreed on the ultimate destination. Italy's late entry into the arena highlights the difficulty of fulfilling *both* Art Nouveau injunctions – to be new as well as national – to express what was by 1902 an internationally recognized vocabulary of modern design, while formulating a unique national identity. Despite valiant efforts, the Italian contribution at Turin was fated to displease many critics, as the country lacked the basic infrastructure for large-scale production as well as an orientation towards the new. Furthermore, the very ideals of Art Nouveau contained inherent contradictions that could not be reconciled.

Even the name for the new style was contested. As Melani declared: '*Arte nuova, stile nuovo, stile moderno, stile Liberty, stile floreale*, in how many different ways is this new aesthetic movement indicated!'[7] '*Stile Liberty*' and '*stile floreale*' were the terms most often used – Liberty after the London company whose fabrics were imported for 'modern' Italian interiors, and *floreale* after the nature-based ornamentation that characterized the style. The first name shows how greatly Italians were influenced by British Design Reform and by a company that disseminated the movement's principles by commercializing and diluting its ideals. The second demonstrates how the appearance of modern art was determined most by the dictate that nature should serve as design inspiration. That this would be applied more often to innovations in decoration rather than to form was lamented at the time. The Italian proclivity for traditional forms is seen in the use of another of the names for Art Nouveau, *dolce stil nuovo* (sweet new style). This thirteenth-century term, associated with Dante's circle in Florence, suggested continuity with Italy's Pre-Raphaelite past as well as a connection to British Design Reformers.[8]

This variety of terms highlights the basic criticism of Italian Art Nouveau. As U. Fleres stated: 'Called floral or even Liberty, the new style, or, in imitation of the old-fashioned literary formula, this "sweet new style" is not worthy of praise or blame, precisely because it is just a style.'[9] Both native and foreign critics were disappointed that at Turin, Italians had still not evolved a distinct national school. Other persistent attacks concerned excessive ornamentation, lack of unity, and, as discussed above, plagiarism of Belgian, French, Austrian and British design. Even the

harshest critic, however, agreed with the assessment that Italian craftsmanship was beyond reproach; it was considered the only aspect of the long adherence to past traditions worth retaining. Pleas were issued for Italians to take their superb technical skills and apply them to the creation of a style for the new age.

Given these challenges and limitations, what could and did Italy accomplish? The manifesto for the *Esposizione* had established three categories; the modern house, the modern room, and the house and street. Each was to be judged according to whether it fulfilled the aspirations of Art Nouveau – to establish a more democratic art, to create an art based on nature and purged of quotations from the past, and to realize a *Gesamtkunstwerk* (a total work of art where the building, its furnishings and its setting form a whole).

Examining the work of three Torinese furniture-makers who won awards at the *Esposizione* elucidates Italy's efforts to follow the *Esposizione*'s criteria. The companies of Vittorio Valabrega, Giacomo Cometti and Agostino Lauro represent the different modes of production by which Italy sought to provide its emerging class of industrialists and professionals with a new art, visually distinct from that of their forefathers. These three were among the firms singled out for high praise, as the critics did concur that there were at least *some* original and worthy voices to be heard among the 260 Italian exhibitors. For example, despite his general accusation that Italians had produced 'gaudily exaggerated and overdecorated' work, the influential German writer George Fuchs admired the contributions of Valabrega and Lauro.[10]

It was Valabrega who led the way towards the goal of greater accessibility by producing objects in multiples and using machines. By the time of the 1902 Turin *Esposizione*, Valabrega had been manufacturing furniture for decades. Like that of most firms in the 1880s and 1990s, its furniture was made in a wide variety of historical styles intended to provide consumers with the choice of any period they liked. At the 1898 Turin *Esposizione* of Italian decorative art, Valabrega had offered the innovation of a Salon in *stile floreale*, in addition to bedrooms in Renaissance revival and Louis XV styles. At the *Exposition Universelle* in Paris in 1900, the company's furniture won a gold medal for its *stile floreale* display.

At the Turin *Esposizione* in 1902 Valabrega showed an entire apartment, including a bedroom, study, living room and entrance way. No longer one style among many, *stile floreale* was presented as the realization of modern art. According to the journal *Il Giovane Artista Moderno*, Valabrega was

29.4 Raimondo d'Aronco, interior of Pavilion of interiors at Turin Exposition, 1902.

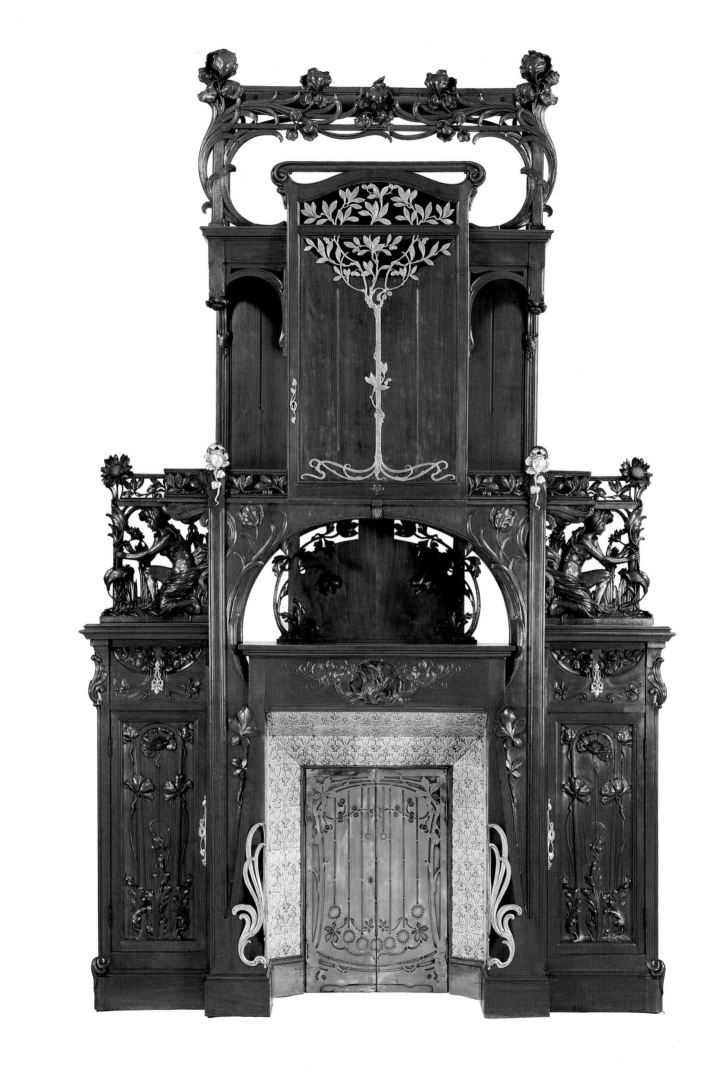

assisted in his efforts by a Professor Beroggio, who painted the ceiling and walls, and by other companies which supplied stained glass, lighting and leather decoration.[11] Valabrega's efforts to work collaboratively with other firms in the creation of a totally unified environment were rewarded with a silver medal. The jurors also noted, 'the Valabrega company will be able unlike any other to produce commercial furniture of a well-disposed modern aspect'.[12] Valabrega, with its modern factory employing more than 50 upholsterers, woodworkers, sculptors and varnishers, was one of the few Italian firms that could reach a larger market.

While Valabrega sought to receive recognition for its success at reaching the middle classes, the firm was more interested in showing off its most ambitious, elaborate designs. Displayed in both Paris and Turin, a *caminiera* (chimneypiece) deservedly received the most press attention as a *tour de force* of Art Nouveau (plate 29.5). Its carved floral decoration is both expertly executed and well integrated into the structure of the piece. The upward motion of the leaves and flowers complements the soaring verticality; the tile and metalwork provide an appealing contrast of colour and texture. Although period photographs show the piece with a metal backplate emblazoned with the words 'Valabrega Turin' instead of the floral pattern seen here, this chimneypiece is almost certainly the one shown at the expositions. Two others may have been made subsequently, but they would not have been identical, as this one is for display only. (The tiles as positioned could not have withstood much heat and are attached with animal glue rather than with masonry.)

The Vittorio Valabrega company represents one way that the Italians could compete in an international market place – with well-designed and well-manufactured furniture for a fairly broad clientele. Giacomo Cometti's firm represents another approach, one that had its roots in the English Arts and Crafts movement.

This is the model of the artist-turned-craftsman, who is convinced that furnishings are not only as aesthetically valid as paintings or sculpture, but also that these objects also provide a more complete artistic experience.

Cometti trained as a sculptor with

29.5 Vittorio Valabrega Company, chimneypiece. Walnut, glazed ceramic, brass, glass. Italian, 1900. The Wolfsonian-Florida International University, Miami Beach, Florida: Mitchell Wolfson Jr. Collection.

29.6 Giacomo Cometti, chair. Carved oak. Italian, 1902. The Wolfsonian-Florida International University, Miami Beach, Florida: Mitchell Wolfson Jr. Collection.

Leonardo Bistolfi, and in this capacity showed at the 1898 Turin *Esposizione*. That year, however, he also designed his first interior. In 1900 he received an honourable mention in Paris for a complete room, with his mentor Bistolfi contributing painted panels. In Turin 1902, he was awarded a diploma of honour for two interiors, which included a chair and a sideboard (plates 29.6 and 29.7). After praising the logic of the construction and the way the furniture's sculpted ornament seems to grow from the inherent qualities of the wood, the citation states: 'above all there persists the example he gives as an artist, as an active guide of workers and as a worker himself … . He refuses all facile, vulgar forms that are lucrative and only produced to please the uncultivated masses.'[13] He was one of the few designers to receive accolades for simplicity: his work was considered to be a true expression of modern ideals about the integration of form and ornament. The furniture is subtle and almost severe, with carved ornament and attenuated metalwork in low relief. Equally concerned with the interplay of void and mass, Cometti never allowed the structure of the piece to be overwhelmed with decoration.

Cometti's workshop was small – four cabinetmakers and a finisher – so his output was limited. What he contributed to the development of Italian Art Nouveau is the fulfilment of the ideal of the artistic workshop (it was also a school of the applied arts, providing the kind of training which all the critics agreed Italy desperately needed) and of collaboration with architects in the goal of *Gesamtkunstwerk*. For example, the year after Turin, he provided the interiors for a villa by Annibale Rigotti.

With its emphasis on integrated room settings, the Italian Section succeeded in one of the major goals for the New Art. Of the three categories established in the *Esposizione* manifesto, the call for the modern room was most often achieved. Given time, money and space constraints, the categories of 'house' and especially of 'house and street' were more difficult to realize. However, the furniture manufacturer Agostino Lauro made an ambitious attempt with his construction of a *palazzina* (villa). The owner of a large furniture-manufacturing company, Lauro had already, in the years before the 1902 *Esposizione*, supplied the interiors for villas and public buildings in and around Turin. The *Esposizione* committee must have selected Lauro on the strength of his success at large, integrated commissions and for his entrepreneurial skills. He must also have possessed considerable political savvy, as the *palazzina* (plate 29.8) was the only building for the display of Italian design not by d'Aronco.

For the construction of the *palazzina*, Lauro should be

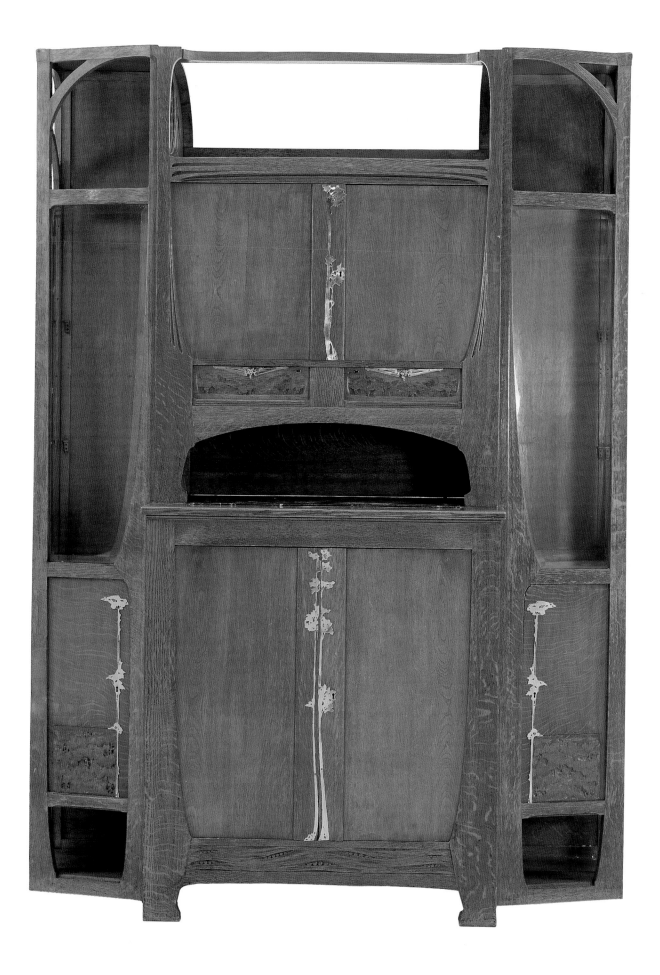

29.7 Giacomo Cometti, sideboard. Carved oak, brass mounts and marble. Italian, 1902. The Wolfsonian-Florida International University, Miami Beach, Florida: Mitchell Wolfson Jr. Collection.

considered more as impresario than designer. As the critic A. Frizzi explained, it was: 'Conceived by one of Torino's best known decorators … Agostino Lauro managed to assemble the talents of a quantity of firms and industrialists in a collective show.'[14] The Italians wanted to demonstrate that they could create a unified modern art statement, a completely integrated interior and exterior.

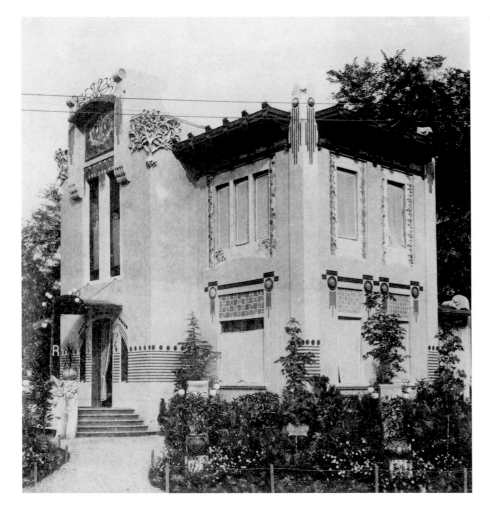

29.8 Agostino Lauro, Lauro *palazzina*, sideview. Italian, 1902. The Wolfsonian-Florida International University, Miami Beach, Florida: Mitchell Wolfson Jr. Collection.

Lauro brought together the skills of many different Torinese craftsmen to provide glass and mirrors, upholstery, stucco and ironwork, 'Venetian' floors and painted decoration, and to design a garden. His own company provided the furniture, with another from Turin supplying furniture for the garden. He also turned to a few firms outside the city, such as Casa Cantagalli (a well-known ceramics company from Florence) to make tiles and mosaics. Although the Torinese engineer Giuseppe Velati-Bellini was the architect, Lauro was considered the mastermind, and the *palazzina* was always associated with his name.

Like d'Aronco's work, Velati-Bellini's building was much influenced by Austrian design. Its form was defined by

squares and rectangles, the roof was flat (except for the central cornice), and a series of horizontal lines and circles gave definition to the ground floor. However, the *palazzina* showed the Italian proclivity towards brightly coloured floral decoration. Around the upstairs windows Frizzi describes: 'flowers in their natural colours climbing around reeds of cane. There are also gourds, grapes, wisteria, balsam, poppies, roses, chrysanthemums, water lilies.' Edible vegetation was celebrated as well: 'Brightly coloured groups of fruit such as lemons, grapes, figs as well as pine cones sparkle on the frieze of the mouldings.'[15]

Many admired the *palazzina* and viewed its presence as proof-positive that Italy had made its own harmonious modern statement. As was the case with progressive design in other European countries, this integration was achieved by the use of built-ins for seating and storage, by the leitmotif of the 'whiplash curve' unifying the windows, fabrics and furniture, and by the close co-ordination of all the contributing craftspeople. The criticism of the *palazzina*, however, echoed the general assessment of the Italian contribution to the *Esposizione*. The building was deemed overdone, too dependent on Austrian and German precedent, and not really integrated either with the environment (it was considered ill-suited to the climate) or as a work of art.

Although Lauro was awarded a gold medal, the jury could hardly have been more grudging in its praise. The official report warned the reader not to get 'the misleading impression that we admired the *palazzina* Lauro with an easy conscience'. The jury was careful to isolate what it admired. Lauro was praised for 'the first attempt made in Italy, in a public show, on a subject of such vital importance to modern art', for his efforts to bring together so many disparate craftspeople, artists and industrial designers, and for the success of certain parts of the interior, such as the fabrics and the design of the furniture in the dining room, salon and bedroom. However, the usual litany of complaint followed: 'no external discipline of architecture, no logical distribution of rooms, visual luxury rather than refined richness.'[16] Evidently, the gold medal was given for effort rather than for execution.

The validity of the criticism is difficult to assess, since only partial views of the rooms exist in photographs and none of the interiors are known to have survived. Lauro's great strengths as a furniture designer can be better evaluated by examining the double parlour he installed *c*.1900 in a villa in Sordevolo, outside Turin (plate 29.9). It was commissioned by Federico Vercelloni, a leading textile manufacture, who matched the profile of the clientele for the *stile floreale* – the newly wealthy, urban, industrial class. The

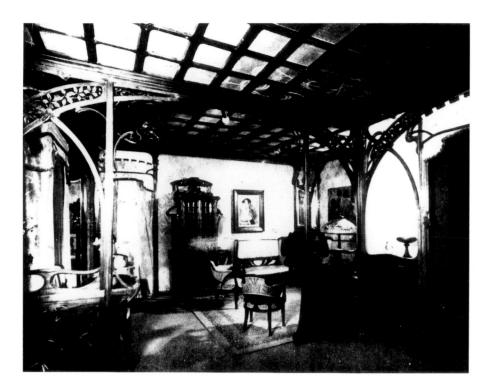

rooms, which are now in the collection of The Wolfsonian-Florida International University in Miami Beach, are a triumph of *Gesamtkunstwerk*: the furniture, window treatment and walls all share the motifs of swirling vines and tendrils. As historian Gabriel Weisberg observed, indoors and out were also integrated:

> In several places, the wooden supports in the room's corners and in the divider between the two sections of the parlour formed stylized supports that held up an illusionary 'outdoor' wooden trellis that covered the ceiling. The room interior further assumed the appearance of an outdoor arbor when the linen fabric that covered this trellis was painted with flower and vine designs.[17]

Modern in style, the rooms, with their electrified iron lamps, were also modern in technology.

Some of the furniture, such as the sofa (plate 29.10), the vitrine and the armchairs were also displayed in the Lauro Pavilion. Since one of the preliminary drawings for the rooms at Sordevolo is dated April 1900, Lauro must have

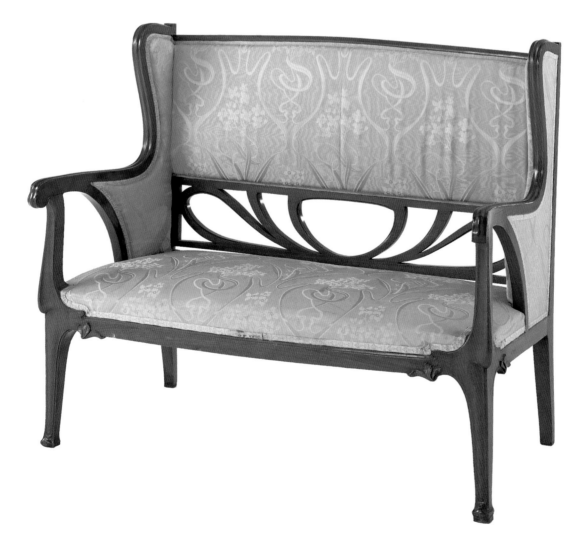

29.9 Agostino Lauro, double parlour, Sordevolo. Italian, *c*.1900. The Wolfsonian-Florida International University, Miami Beach, Florida: Mitchell Wolfson Jr. Collection.

29.10 Agostino Lauro, sofa. Carved mahogany with green silk upholstery. Italian, *c*.1900-01. The Wolfsonian-Florida International University, Miami Beach, Florida: Mitchell Wolfson Jr. Collection.

29.11 Alberto Issel, desk. Oak, metal, leather, fabric and paint. Italian, 1902. The Wolfsonian-Florida International University, Miami Beach, Florida: Mitchell Wolfson Jr. Collection.

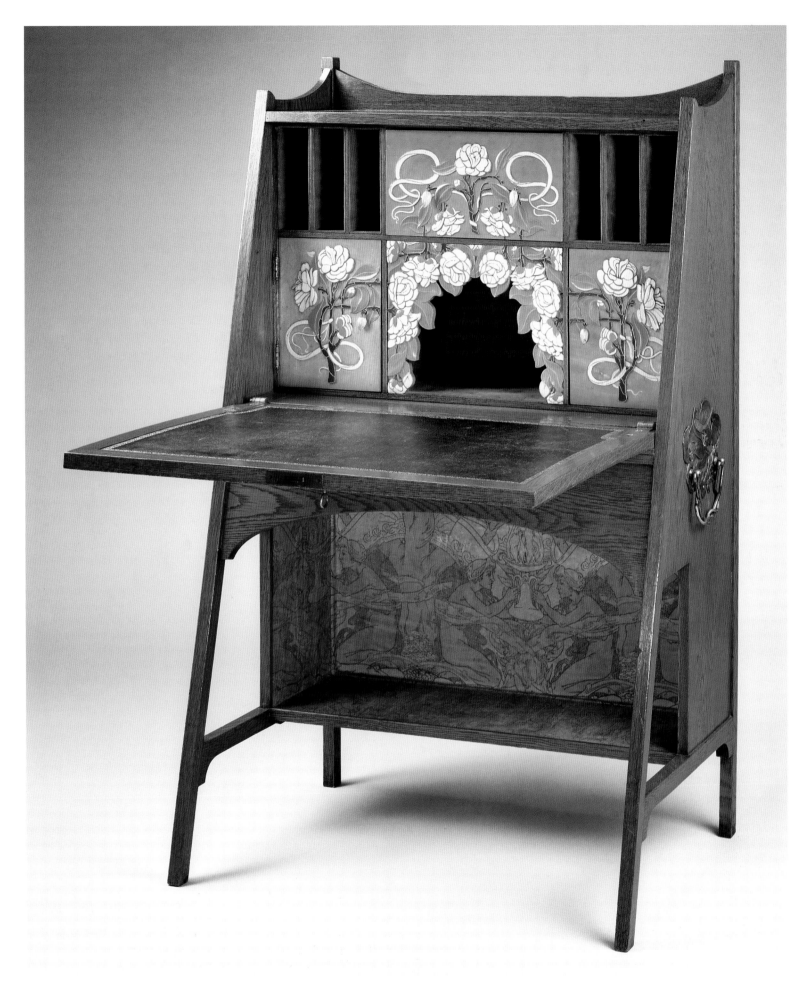

been pleased enough with the designs to use them again at Turin, where they would have been available for sale or for order. It also suggests that these pieces may already have been part of his upscale factory line, and a client would not necessarily have had to commission an entire suite or a complete interior.

Despite all the criticisms, Italy demonstrated considerable success at meeting the agenda of the *Esposizione* committee. Of course, much Italian design did not fulfil this brief. Much was still historicist, inaccessible to all but the wealthy, and *not* harmoniously executed. Italy was not alone in these failings; they were shared by many other countries at the *Esposizione*. But given the impediments to Italy's development as a modern nation, it is remarkable how much was achieved. Valabrega's furniture factory, Cometti's artistic workshop and Lauro's interior decoration business demonstrate that Italy could in fact produce work of sophistication and quality equal to the best in Europe.

The Torinese companies were not the only Italian furniture makers who were praised at Turin. For large-scale production, critics admired Alberto Issel of Genoa (plate 29.11), who, like Cometti, began his career as an artist but abandoned painting for the applied arts. The work of Carlo Zen's factory in Milan was also lauded, but perhaps the greatest admiration for factory production was bestowed upon the designs that the Sicilian architect Ernesto Basile produced for the Ducrot factory in Palermo (plate 29.12). The Milanese Carlo Bugatti's work was considered the most original. He was admired as an autodidact whose Moorish and Oriental-looking creations were solely the product of his vivid imagination (plate 29.13).

Even the most enthusiastic critics were not very clear about what made Italian Art Nouveau characteristically Italian. Such a categorization would have been impossible as there was no established national style. Still defining itself, the country was struggling with the basic issues of modernity. Was its identity to be national or international? Could a future of industrialization and urbanization incorporate centuries-old traditions? Unlike most protagonists of the movement in other countries – architects who left their distinctive mark on public buildings – the leading figures in Italy were craftsmen or artists-turned-craftsmen. These designers did not have the same public forum, and, in addition, had stronger regional identities than national ones. Therefore, the best Italian work was highly personal, executed with superlative skill.

The Turin *Esposizione* itself represents the final flowering of Art Nouveau, and the Italian contribution came late to the style. However, the real achievement of *stile floreale* should not be overlooked. It was a significant part of Italy's growing assertiveness as an independent nation. The critic G. Macchi was correct when he extended the botanical metaphor to observe: 'Turin, too, offers flowers to admire that are no less beautiful and perfumed, although not the first or the freshest.'[18]

29.12 Ernesto Basile, chair.
Stained wood with caned seat.
Italian, 1902.
V&A: W.12-1985.

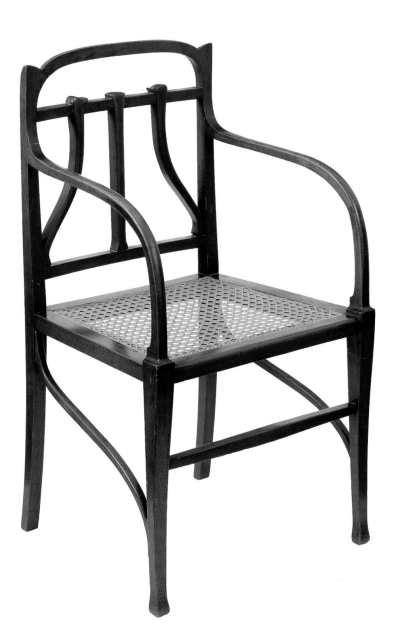

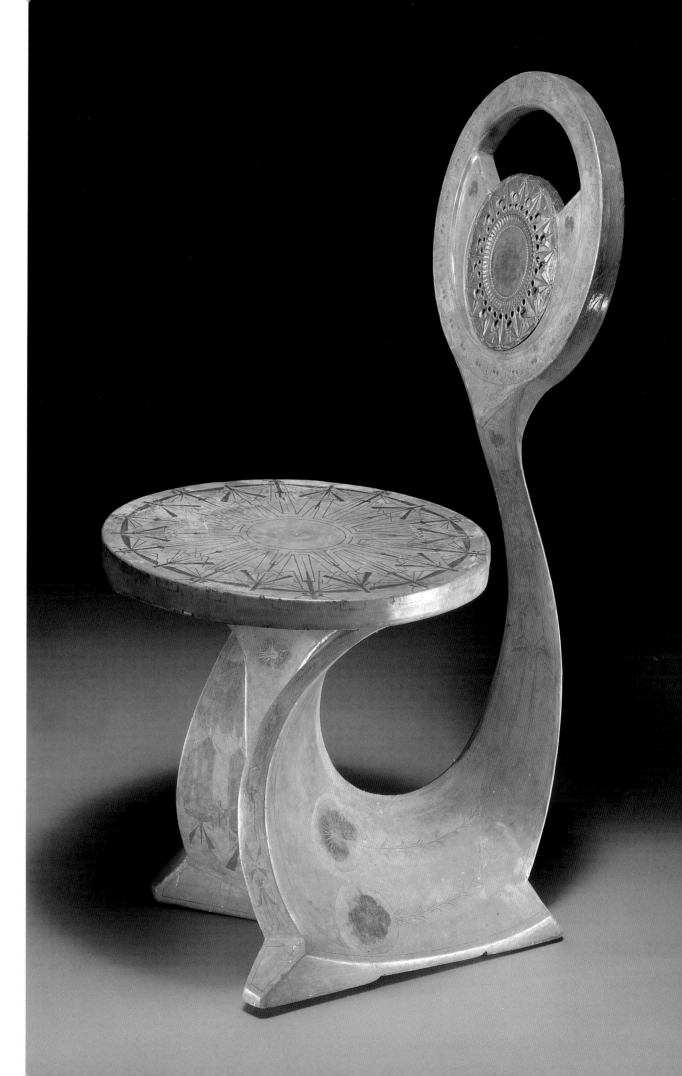

29.13 Carlo Bugatti, chair.
Parchment over wood, copper,
paint. Italian, 1902.
©Virginia Museum of Fine Arts:
gift of the Sydney and Frances
Lewis Art Nouveau Fund.
Photo: Katherine Wetzel.

PART V

Conclusion

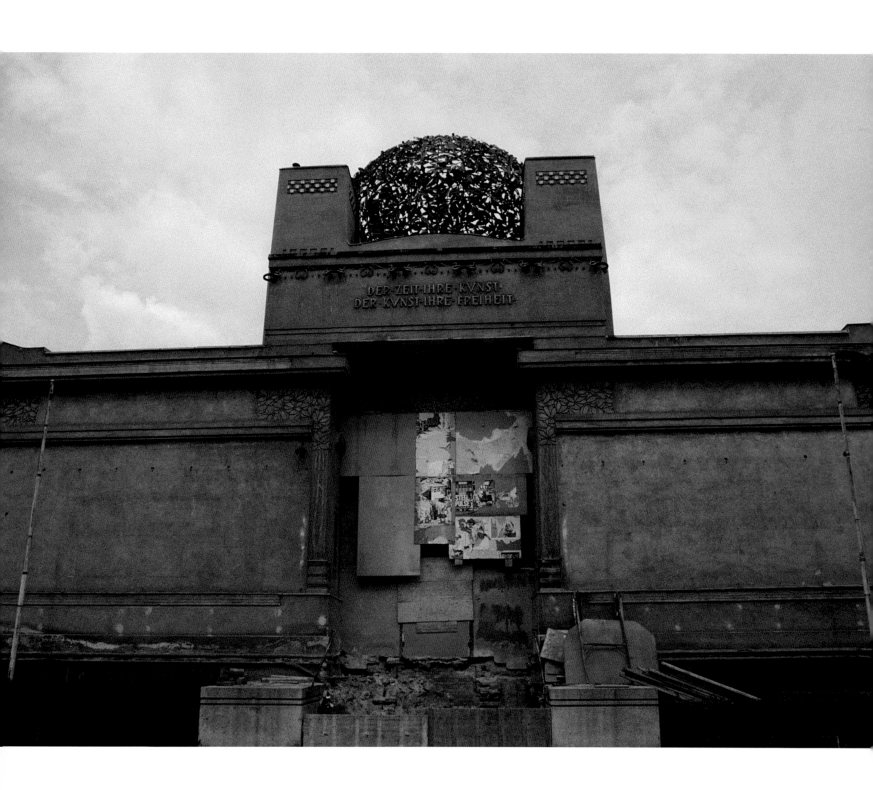

Paul Greenhalgh

A Strange Death...

Decorative Art can no longer exist any more than the 'styles' themselves ...
Culture has taken a step forward and the hierarchical system of decoration has collapsed.

(Le Corbusier, *L'Art décoratif d'aujourd'hui*, 1925)

30.1 Josef Maria Olbrich,
the Vienna Secession Building
in 1985.
Photograph Paul Greenhalgh.
© DACS, 2000.

Art Nouveau was the first self-conscious attempt to create a modernist style premised on decoration. It was also the last. The demise of a style is usually less well studied than its rise, but endings are quite often as revealing as beginnings.

As the pages of this volume record, the style had various local endings even before 1905, as individuals moved on from it, companies ceased making it and governments deserted it. On an individual level, some designers tested the boundaries of the style by openly questioning the repertoire of forms it took on in other national schools. Josef Hoffmann, Richard Riemerschmid, Gustave Ser-rurier-Bovy and Eliel Saarinen, for example, simplified their designs and pushed away from florid manifestations of the style in the popular realm. While their shift was widely perceived by the critical fraternity at the time as a development within the parameters of the style itself, it revealed that Art Nouveau was not a stable phenomenon, but was constantly in intellectual and aesthetic flux.

Some manufacturers and retailers that had dealt in the style dropped it. Most famously perhaps, Arthur Liberty, who had always been unsure about the ideological agendas associated with the style and with its more flamboyant excesses, declared it, in an atmosphere of increasing English xenophobia, to be a foreign aberration. Elsewhere, the enthusiasm of some governments flagged in the face of general international tension. In some Nordic and Eastern European countries, for example, the ethnic components of the style were encouraged to come aggressively to the fore, resulting in what became known as National Romanticism. The direct and indirect organs of State dedicated to economic affairs in some countries became concerned about the commercial performance of the style and began to make noise on the subject of saleability. But these partial desertions and waverings were not the norm. The style was still omnipresent and being consumed in the department

stores, trade fairs, journals and expositions of Europe at the end of the first decade of the new century. From then, however, the decline was so marked that it barely made it to the First World War as a recognizable lobby in the public domain.

In 1935 historian George Dangerfield published his seminal work *The Strange Death of Liberal England*. The historiographic thesis of this volume was that the Liberal Party in England, and by implication the wider creed of political Liberalism, had been killed. Moreover, Dangerfield contested, this potent socio-political force that had, in so many ways, shaped most industrialized nations, had suffered no ordinary death. Liberalism in the nineteenth century was formed by a broad church of moralists and socio-economic visionaries whose values, as the twentieth century began to unfold, appeared increasingly incompatible. Appearance became reality after 1910 as Liberalism was torn in two by the aggressively opposed forces of the left and right, who occupied its ground so completely that what had been an established, supposedly permanent institution and ideology, was wiped out as a serious political force inside a generation. The 'strange' aspect of the death concerned the extent to which Liberalism had undermined itself from within. Many Liberals moved out of the creed, either to the left or the right, to attach themselves to the political group that now appeared to represent their view more fully.

The analogy with Art Nouveau is striking. The style had been attacked from its inception by the forces of aesthetic and social conservatism, and it had survived these without undue damage. Intellectually and ideologically, the forces that largely destroyed Art Nouveau were in fact invented from within the parameters of the style itself. Internal polarizations became a prelude to exodus, so that by the end of the first decade of the new century the style

30.2 Victor Horta,
Belgian Pavilion, *Exposition
Universelle*. Paris, 1925.

had effectively torn itself apart, the two halves drifting to the left and right.

Given its composition, perhaps such an end was inevitable. The modernity of Art Nouveau was a result of tensions between options forced upon designer and consumer by the situation each found themselves in: tensions between the individual and society, the past and the future, morality and amorality, technology and the body, the rational and the mystical, the natural and the artificial. These can be observed within the individual schools, the *oeuvres* of designers and even within single objects. In this sense, Art Nouveau was a dynamic but unstable compound, a set of combinations and antagonisms, collectively struggling to express the idea of the new in varied situations across Europe and the United States at a time when it was not at all clear how the new was to be expressed. Individuals within the Art Nouveau camp often appear to be unnatural bedfellows.

But the style was essentially – fundamentally – reconciliatory. It was to do with the possibilities of eclecticism; as part of the agenda the contrary was made compatible and the incongruous consistent. While it is clear that the designers understood themselves to be living in an environment that had been modernized, that had been made dynamic through the collision of vying worldviews, they did not, on the whole, feel that their task was a reductive one that might entail the elimination or simplification of cultural options. Art Nouveau absorbed the sources and ideas available to it; it was to do with the assimilation, not elimination, of stimuli. Decoration was the vehicle deliberately selected by key individuals within the style because it had the potential to be all-embracing and cumulative, and thus offered the best option for intervention in a changing world.

Such a complex formulation had to unravel. When it did, for those who accomplished the unravelling, the nature

30.3 Henry van de Velde, Belgian Pavilion, *Exposition Universelle*, Paris 1937.

of modernity remained the central issue. Two broad but distinct groupings separated out. The first wished to continue the radical agenda by formulating a modernist design that continued to pursue social and material progress, and that remained morally committed to the transformation of society. Idealist and mainly of the political left, this element would culminate in the development of the Modern movement in design. The second element rejected this moral idealism and sought to replace Art Nouveau with a style that attempted to represent modern life, rather than to change it. This approach used the eclecticism developed within Art Nouveau to create an exotic, hedonist style for the new age. A heady celebration of luxury and the ethos of consumerism, it was based firmly on high-level craft practice and the continuing of an eclectic, decorative approach. Retrospectively, the approach came to be collectively identified under the name Art Deco.

The careers of Victor Horta and Henry van de Velde

provide a microcosm of this rift. As chapters two and eighteen reveal, the Classical heritage that Horta had brilliantly manipulated as an element within his Art Nouveau work came steadily to dominate his vision. The combination he pioneered as he left his Art Nouveau phase behind, of Classical language and Rationalist geometry, anticipated what became a standard public architecture across Europe in the interwar years. His design for the Belgian Pavilion for the Paris *Exposition Universelle des Arts Décoratifs et Industriel* of 1925 reveals a conservative agenda, an architecture dedicated to the virtues of stability, using the Classical heritage to describe the nature of authority (plate 30.2). Van de Velde went in the opposite direction. For him, modernism remained an unfinished project; he rigorously eliminated the last vestiges of historicism from his style and followed the agenda he had set out in *Deblaiement d'art.* His Rationalism, powerfully driven by a virtually religious commitment to social transformation, made him a leading light in the

Modern movement in design. His pavilion for the Belgian government for the Paris Exposition of 1937 is a sophisticated exercise in the High International Style (plate 30.3).[1]

Horta's progress was consistent with a broad pattern within the Art Nouveau camp. Across Europe and North America, historical styles that had been a component within Art Nouveau were now used to facilitate a return to historical order. A number of German designers, for exam-

30.4 Paul Follot, dining room, Salon d'Automne, 1912.

ple, pushed the Biedermeier style powerfully into the foreground. A body of this work – christened '*Munichois*' by the French – was shown in Paris at the *Salon d'Automme* of 1910. Between 1910 and 1912 at this Salon, and also at the Salons of the *Société des Artistes Décorateurs* and that of the *Indépendantes*, a number of French designers who had been closely associated with Art Nouveau exhibited variations on Empire and Louis styles. Paul Follot (plate 30.4), Maurice Dufrène, René Lalique, Tony Selmersheim and Léon Jallot, for example, all made this move. At the same time, a new generation of *artistes décorateurs*, including Louis Süe, André Mare, André Groult and, most importantly, Jacques-Émile Ruhlmann, developed an eclectic look that simultaneously attempted to create a contemporary style while celebrating the French heritage. This had much in common with Art Nouveau practice, except that there was an underlying agenda with Art Nouveau to create a modern style that implied more than simply the aesthetic

and commercial dimensions. In Art Deco, this was clearly absent. Collectively, Deco designs were for the high-luxury market, not prototypes for a new way of living.[2] The Decoists and their apologists were to become, after the First World War when their star was in the ascendant, overtly hostile to Art Nouveau. The French critic and supporter of Art Deco, Émile Bayard, was typical in believing that, unlike truly significant styles, Art Nouveau had arrived 'too suddenly and chaotically', and without the maturing influence of tradition. 'Style', he believed,

> as one means when speaking of Louis XIV or Louis XV,
> or Empire, doesn't come from an idea or stroke of genius.
> It forms with a slow grace from successive qualities that
> arrive at the same ideal, often coming along very different
> routes. There never was a style that was solely to do with
> personal effort and creative originality.[3]

During the 1920s the idea of 'evolution through tradition' came powerfully to the fore among the leading *artistes-décorateurs*.

The way the various groups that constituted the Modern movement in design approached the world owed much to Art Nouveau. The Purists (centred on the journal *L'Esprit nouveau*) in France, the De Stijl movement in Holland, Constructivism and Suprematism in Russia, and the Bauhaus in Germany, in their morality, politics, view of technology, aesthetic outlook and in their idea of how the various arts

related to one another, owed much to various of their Art Nouveau forebears. Indeed, many of them had been in the Art Nouveau camp. The proclamations of Charpentier, Endell, Jourdain, Sullivan, van de Velde and a hundred others rang down through the decades. As significantly, the young Modernists also emulated the organizational acumen and the whole approach to publicity of the Art Nouveau movements: the self-conscious manifestos and publications, the relationship to patronage, retail outlets and exhibitions all emulated the previous generation.

However, despite the fact that a good number of Art Nouveau designers became Modernists, and the intellectual, aesthetic and political agendas overlapped heavily with Art Nouveau, there was widespread animosity towards it within Modernist ranks; so much so, that by 1930 it was held to be synonymous with all that was bad in design. Theoretical positions had come into play that necessitated its rejection. The most important of these were a commitment to anti-decoration, function and abstraction. In achieving the first of these, none was more significant than the radical Austrian architect Adolf Loos, whose writings powerfully set the agenda for the next phase of Modernist activity in design. Aggressive, dry and witty, his article *Ornament and Crime* of 1908 attacked the idea that objects of daily use should be ornamented. The author took his reasoning from anthropology and evolutionist (social Darwinist) biology:

> The child is amoral. To us, the Papuan is also amoral.
> The Papuan kills his enemies and devours them.
> He is no criminal. If, however, the modern man slaughters
> and devours somebody, he is a criminal or a degenerate …
> the man of our time who daubs the walls with erotic
> symbols to satisfy an inner urge is a criminal or a
> degenerate … . One can measure the culture of a country
> by the degree to which its lavatory walls are daubed … .
> With children it is a natural phenomenon … . But what is
> natural to the Papuan and the child is a symptom of
> degeneration in modern man. I have made the following
> observation and have announced it to the world:
> The evolution of culture is synonymous with the removal
> of ornament from objects of daily use.[4]

He then went on to attack the concept of modern ornament itself, directing his venom at Art Nouveau practitioners: 'Where are Otto Eckmann's products today? Where will Olbrich's work be, ten years from now?'[5]

Design reformers throughout the nineteenth century had taken a stance against over-decoration and promoted the importance of function as an element within the design process. Louis Sullivan, for example, had famously railed against the over-ornate historicism he saw all around him in contemporary architecture:

> Is not a noble and simple dignity sufficient? Why should we
> ask more? … I should say that it would be greatly to our
> aesthetic good if we should refrain entirely from the use of
> ornament for a period of years, in order that our thought
> might concentrate acutely upon the production of
> buildings well-formed and comely in the nude.[6]

But Sullivan and other design reformers of his generation differed from Loos. The Sullivan passage is deceptive, in that within the context of his thought, and indeed the whole article the quotation is taken from, it is clear that he understood decoration to have a vital and primary role in architecture. In his world, simplicity, complexity and decoration were relative terms that changed from context to context and commission to commission. He railed against unnecessary decoration from the standpoint that decoration was necessary. By contrast, Loos was one of the first thinkers to see simplicity in design as being to do not only with beauty and economy but also as an ideological issue. For him simplicity, or purity, was not a relative but an absolute value, a condition associated with higher civilization which humankind was evolving towards.

Appropriating anthropological terminology, Loos and many who came after him inverted the widely held view among anthropologists themselves that decorative art became omnipresent and complex when societies rose and gained in sophistication, to arrive at the opposite view. He believed that decoration was reduced and ultimately eliminated as societies evolved onto higher levels. Citing what had become the archetypes of 'under-evolution' within Modern movement circles – criminals (and by implication the masses), 'savages' and children – Modernist thinker Herbert Read was typical in asserting, in 1934, that:

> There exists in Man a certain feeling of *horror vacui*, an
> incapacity to tolerate empty space. The feeling is strongest
> in certain savage races, and in decadent periods of
> civilization. It may be an irradicable a feeling; it is
> probably the same instinct that causes certain people to
> scribble on lavatory walls … . A plain empty surface seems
> to be an irresistible attraction to the most controlled of
> men; it is the delight of all uncontrolled children.

By then, the *fin de siècle* had come to represent one such 'decadent period of civilization'. The most important of the Modernist thinkers, Le Corbusier (born Charles Eduard Jenneret), reprinted *Ornament and Crime* in his journal *L'Esprit nouveau* in 1920 and developed the evolutionist – progressive – idea of visual culture to its definitive pitch.

30.5 Le Corbusier, Pavillon
de l'Esprit nouveau, *Exposition
Universelle*, Paris 1925.
© FLC / DACS, London 2000.

As generations of Darwinists before him had done, the young Le Corbusier fused biological evolution with the idea of progress in politics and economy to create an essentialist model of society that had at its core the inevitable ascent of culture. His Platonism effectively turned architecture and design into material quests for perfect Form. For him, visual culture had to evolve to the point at which the absolutely functional would meet the absolutely pure. This was absolute beauty. Decoration was a relative component that positioned architecture and design in a location. Unlike pure science or pure art, it could not be reduced to fundamental forms; it was not part of the idea of progress and therefore it was synonymous with under-evolved culture. His villas and urban schemes of the 1920s, exemplified perhaps in his Pavillon de l'Esprit nouveau for the Paris *Exposition Universelle* of 1925, were material manifestos for a way of designing that by-passed the decorative arts (plate 30.5).

Ironically, nature itself was undermined as a source for the visual arts by the new evolutionist logic. The Platonism of Le Corbusier and the Purists, and the mysticism of De Stijl and the Suprematists, invariably suggested that human evolution was a movement away from the physical rudeness of the material, natural world, towards a higher, metaphysical, non-corporeal state. Evolutionism became a quasi-religious support to the new design. Throughout the twentieth century, future – higher – civilizations have invariably been associated with the non-physical processes of the mind. The evolution of nature implied no nature,

and so the natural, sexual and bestial elements in Art Nouveau could only be viewed with distaste. Thus, Art Nouveau practitioners, who developed a decorative language based on a vision of nature as an evolutionary force were now themselves victims of what the pioneers of the Modern movement were pronouncing as the next phase of development.

Nevertheless, the next phase had to be based on something. The use of unorthodox histories and symbolism had formed the character of Art Nouveau, but nature had been the crucial alternative to normative historicism; it was what most overtly allowed the style claims to modernity. It had come to mean a great deal at the *fin de siècle*: it tied physicality to cognition; subjective to objective expression; and sexuality to spiritualism. Art Nouveau was never likely to be replaced until a significant alternative to nature was found. Around the end of the first decade of the new century this was accomplished when abstraction became intellectually robust enough to occupy its ground.

While its advent is normally associated with developments in painting, abstraction gained its cultural weight partly through developments in the decorative arts. The process of conventionalization described in chapter three was a philosophical as well as a practical development. Conventionalization implied artifice, which, when pushed to its logical conclusion, implied abstraction. In the closing decades of the old century, the cultural meaning of abstraction achieved in this way increasingly became a subject of interest as part of the larger debate on the meaning of art. Philosopher-historian Alois Riegl, in his *Stilfragen* of 1893, was among the first to position the idea of abstraction at the core of practice in the arts from the beginning of civilization. Riegl rejected Gottfried Semper's notion that the history of style was determined by materials and technologies, and posited the idea, based on empirical studies of prehistoric, ancient and 'primitive' ornament, that underlying art was an instinctive 'will to form', based on abstract geometric patterns.

Wilhelm Worringer, in his seminal work *Abstraction and Empathy* (1908, published in the same year as Loos' *Ornament and Crime*), absorbed Riegl and developed a powerful role for abstraction in the history of creativity. Worringer positioned abstraction alongside empathy, a concept most fully developed by the eminent psychologist and aesthetician Theodore Lipps. Lipps believed empathy to be a vital component in the communication process that constituted the work of art. For him, the essence of art was not located in the physical fabric of the art object itself, but

was to be found in the empathetic relationship forged between viewer and object. Empathy was relativist, and involved not only the properties of the work of art but the individual response of the viewer, in what Worringer described as 'a decisive step from aesthetic objectivism to aesthetic subjectivism'.[8] He positioned abstraction and empathy as the two opposed poles motivating art through all time and civilizations. For him, empathy described the subjective need of the self to possess and identify itself with the world; most forms of representational, and, more significantly, Naturalist art, are motivated by it. By contrast, the earliest civilizations produced geometric abstract ornament, driven by the unconscious 'will to form'. Abstraction is associated with mathematics by Worringer, in that it is simultaneously rational and mystical; it is motivated by the need of the self to provide itself with structure and meaning in order that it differentiate itself from nature and collectivize itself with humanity: 'it is our intention, having associated the concept of Naturalism with the process of empathy, to associate the concept of style with the other pole of human experience, namely with the urge to abstraction.'[9]

In a similar spirit, tracts in favour of universalist models emerged in the wake of Worringer, from thinkers as diverse as Wassily Kandinsky, František Kupka and Clive Bell. Thus, geometric abstraction could now be seen as a key to the development of a final, absolute style, that could range across international boundaries and penetrate deep into the human pysche. It could be cited as a presence in the work of all peoples, from the musings of Plato to the drawings of aboriginal peoples. Via mathematics and physics, it could be associated with the rhythms in music, which was considered another universalist form. In short, it could do what nature did and more. Thus, the universalist ideas that first emerged within the ranks of Symbolist and Art Nouveau thinkers were now to be expressed in an idiom that was used to reject Art Nouveau itself.

The element of function in design implied another area in which Art Nouveau came under increasingly negative scrutiny. In this context, function did not only imply usage, it had an aesthetic dimension and an emphatically symbolic role. Function did not simply imply the way an object worked, it stood for the concept of work itself. The new generation of Utopian socialists celebrated work, meritocracy and anti-privilege through objects and buildings that looked as if they worked, that had the ambience of tools and shelters. The ideology of work counted against designs premised on hedonism. Loos had written

in praise of English plumbers far more pointedly than he had of English decorators.

Art Nouveau grew in a world of ever-expanding consumption. It thrived on the new machinery of commerce, department stores, shopping centres, advertising, marketing and selling. Indeed, regardless of his or her view of the world, the central role of the designer was to increase the value of artefacts through the application of art. On the political left, however, consumption was increasingly seen in a negative light, and especially consumption that could be deemed superfluous or unnecessary. By 1910 there was already a developed heritage of anti-consumption theory. Marx and Ruskin had long before independently identified it as part of the structure of alienation. In 1896, American economist Thorstein Veblen went further, in his *Theory of the Leisure Class* (1899). In this text he coined the famous phrase 'conspicuous consumption', a phenomenon he believed to be part of the psychological weaponry of high capital, an unpleasant, uncreative aspect of the cycle of commodities, motivated by jealousy and rivalry. Following this logic, the Modern movement in design was to be powerfully centred on production and aggressively suspicious of consumption. Decoration generally, and Art Nouveau specifically, came to stand for the conspicuous consumption of the middle classes, with their privatized, internalized and unhealthy desires.

However, Art Nouveau fared better in another area of Modernist culture: Surrealism. The Surrealist project held more in common with Art Nouveau than simply a shared debt to Symbolism. Art Nouveau designers developed approaches to nature that would ultimately impact on the aesthetic strategies of the Surrealists. Salvador Dalí admired Guimard's Metro station designs, seeing in them a thinly disguised sexual tension, but the influence goes far deeper than this famous championing. The term 'Surrealism' was reputedly coined by Guillaume Apollinaire before the First World War; he described how he had considered the label 'Surnaturalism', but noted that this was a term already in use in academic circles. Surnaturalism, incorporating automatism, probably describes best the approaches to nature used by first-generation Surrealists Hans (Jean) Arp and Joán Miró, and the organic, biomorphic abstraction that later became a core Surrealist practice. This approach to the natural world was pioneered by Guimard, Mackintosh, Gaudí and other architect-designers of the *fin-de-siècle* generation. The cell-like structures that suggest human, plant and mineral form could be observed on the streets of European cities even as the young Surrealists formed their

30.6 Hans Arp, *Forms*.
Etching. French, 1934.
V&A: Circ.287-1964.

sensibilities. The two generations were separated by the advent of Freud and by the coming to full fruition of non-objective abstraction in painting and sculpture, which allowed the Surrealists to take the Art Nouveau Naturalist strategy of metamorphosis to its highest pitch. Perhaps this is witnessed nowhere better than in Arp's art (plate 30.6) and poetry:

> the stones are filled with bowels. bravo. bravo.
>
> the stones are filled with air.
>
> the stones are branches of waters.
>
> on the stone that replaces the mouth a leaf-fishbone grows. bravo
>
> a voice of stone is having a *tête-à-tête* toe to toe with a gaze of stone.[10]

Thus, as a result of the dismissal of decoration and nature as forces in the advanced visual arts, Art Nouveau came to be associated not with regeneration and positivist ideals of progress, but with the terminal negation of stasis and degeneration. Max Nordau's notorious work, *Degeneration* (1895), appeared to sum up the style and the age to the full satisfaction of the succeeding generation. The ideological space Art Nouveau had occupied had been closed, and, despite the progeny of its various parts, as a radical, collective, modern, *decorative* style, it had no off-spring.

Further into the twentieth century, however, the misfortune of Art Nouveau's 'strange death' did come to be acknowledged. After the Second World War, occasional books and exhibitions recognized the style and began to rescue its heritage. Then, during the 1960s, despite the continuing demolition of architectural works all over Europe, the first sustained turn-around in the fortunes of the style occurred. Key monographs and exhibitions began to make sense of the heritage. More important in retrospect, a generation of brilliant dealers and collectors began to identify, gather and trade in the style. The work of these pioneers is reflected in the contents of this volume and the exhibition that accompanied it. The dramatic liberalization of culture during the 1960s undoubtedly affected, and was affected by, this collation and re-presentation of the *fin de siècle*.

A second, powerful stage of recovery can be witnessed during the 1980s, this being inspired by two major shifts within visual culture. First, changes in the legislation and technologies of buildings conservation meant that the architectural heritage of the nineteenth century was prevented from further decline. Buildings in Brussels, Chicago, Glasgow, Paris, Vienna and other key centres were saved and restored. Having come close to obliteration, many of the urban spaces of Art Nouveau will now survive well into the new millennium. Second, the crisis within Modernist ranks led to the rise of what has generically (and eccentrically) become known as 'post-Modernism', and to a reassessment of the role of ornament in the visual arts. For designers at work at our own *fin de siècle*, there appears to be the potential for the creation of a narrative-driven, complex design idiom that might map onto our own plural and ornate lifestyles. Vitally it has also allowed us to look at Art Nouveau again without the ideological baggage of the preceding decades.

In the early years of a new millennium, the Art Nouveau generation might seem very distant. George Dangerfield believed his own interwar generation had the same sense of distance. He observed that his contemporaries viewed the pre-war world as somehow belonging to another time and place. He shrewdly recognized, however, that the people of this apparently disappeared universe had largely invented the later world: 'The War hastened everything – in politics, in economics, in behaviour – but it started nothing.'[11] Perhaps this would be fairest to say of the men and women who created Art Nouveau: that, in the larger sense, they finished almost nothing. But for those of us alive in the complex vortex of a world entering a new era, we say that they started almost everything.

Notes

CHAPTER ONE

1. Geffroy in Watelet (1974), p.57.
2. Retté, Adolphe, *La Plume*, 1 March 1898, p.129.
3. It 'was a movement, not a style' (Duncan, 1994); 'a fad, but also a style', Beyer in Brunhammer (1976); and a 'negation of the concept of style' (Nicoletti, 1973).
4. Bouillon (1985), p.226.
5. Rheims (1966), p.7.
6. As note 5 above, p.12.
7. Schmutzler (1962).
8. Silverman (1989), p.1.
9. Borsi, Franco and Godoli, Ezio, *Paris 1900* (St Albans, Granada, 1978), p.11, emphasis added.
10. Beyer (1976), p.13.
11. Lenning (1951), p.3.
12. Culot, Maurice, in Russell (1979).
13. Greenhalgh (1993).
14. Duncan (1994), p.7.
15. Masini (1976; 1984), p.10.
16. Silverman (1989), p.1.
17. Mourey (1902), p.121.
18. Meier-Graefe (1908), p.1.
19. Trebilcock (1981), p.1
20. Pollard, Sidney, 'The Industrial Revolution: An Overview' in Mikulás and Porter *The Industrial Revolution in Context* (Cambridge, Cambridge University Press, 1996), p.379.
21. Mourey (1902), p.121.
22. Bing (1902; reprinted 1970).
23. Melani in Holt (1988), p.153.
24. Endell in Benton, Benton and Sharp (1975), p.21.
25. Mackintosh, C.R., in *Seemliness* (1902); reprinted in Robertson, P. (ed.), *Charles Rennie Mackintosh, the Architectural Papers* (Glasgow, White Cockade, 1900).
26. 'Modern Manufacture and Design' in *Sesame and Lilies, The Two Paths and the King of the Golden River* (1859).
27. Ashbee, C.R., 'Decorative Art from a Workshop Point of View', paper to the Edinburgh Congress for Art (London, 1889).
28. Aurier in Chipp (1968), p.89.
29. Meier-Graefe (1908), p.1.
30. *Ibid*.
31. 'Allgeine Bemerkungen zu einer synthese der Kunst', *Pan*, August 1899, pp.261–70.
32. Gallé (September 1897), pp.229–50.
33. Anon., advertisement for Galeries des Artistes Moderne, *La Plume*, 15 January 1898, p.63.
34. Elder-Duncan in Greenhalgh (1993), p.134.
35. See chapters four, six, eight and seventeen.
36. Bing, Siegfried, 'L'Art Nouveau', *The Architectural Record*, vol.XII, no.3, 1902, pp.279–85.
37. Figures supplied in Findling (1990).

CHAPTER TWO

1. Quoted from *The Architectural Record*, vol.XII, no.3, 1902, pp.279-85; reprinted in Koch (1970), p.217.
2. *The Sources of Art Nouveau* (1956; reprinted 1976), p.138.
3. See chapters six and seven.
4. Nietzsche (1889), translated by Hollingdale (1956; reprinted 1968), p.30.
5. Huysmans, J.-K. (1884), translated as *Against Nature* (London, Penguin Books, 1959), p.40.
6. Murray, Gilbert, *The Swinburne Letters IV* (London, 1897), p.44, quoted in Jenkyns (1980), p.294.

7. Montgomery Hyde, H., *The Trials of Oscar Wilde* (London, Hodge, 1948), p.236.
8. Beyer in Brunhammer (1976), p.12.
9. See chapter twenty.
10. See Greenhalgh (1988), pp.112–20 and pp.143–45; 'Problems in French Furniture' in Greenhalgh (1990); and Troy (1991).
11. Silverman (1989), p.23.
12. Ironside, Robin, in *The Brothers Goncourt, French Eighteenth Century Painters* (this translation London, Phaidon, 1948), p.10.
13. Anon. (March, 1903), p.4.
14. de Félice, Roger, *French Furniture under Louis XV* (London, Heinemann, 1927), p.5.
15. Huysmans, as note 5 above, p.123.
16. Germann, Georg, *The Gothic Revival in Europe and Britain: Sources, Influences, Ideas* (London, Lund-Humphries, 1972), p.9.
17. Viollet-le-Duc, E.E. (1863–72, Paris), vol.II.
18. 'The Deteriorative Power of Conventional Art', lecture delivered at the South Kensington Museum 1858, reprinted in *Sesame and Lilies, The Two Paths and the King of the Golden River* (1859).
19. Sweeney, J.J., 'Antoni Gaudí', *The Magazine of Art*, New York, May 1953, pp.195–205; and Tschudi-Madsen (1967), p.63.
20. Brunhammer (Paris, Grand Palais, 1980), p.377.
21. Gordon Bowe (1993), p.127.
22. Meier-Graefe (1908); translated from German edition (1904), p.315.
23. Lukacs (1993), p.176.
24. Rousseau, J.J., *A Discourse on the Moral Effects of the Arts and Sciences* (1750); this publication translated by G.D.H. Cole (1993), p.6.
25. Olender (1992), p.4.
26. Brock, William, *Science for All: Studies in the History of Victorian Science and Education* (Aldershot, Variorum, 1996), p.IX: 366.
27. Quoted in Amishai-Maisels (1985), p.15.
28. Denis, Maurice, *Definition of NeoTraditionalism* (1890), translated in Chipp (1968), p.99.
29. Ruskin, John, *Time and Tide* (London, 1867), p.87.
30. Transactions of the National Association for the Advancement of Art and its Application to Industry, Edinburgh Meeting (1890), p.192.
31. Crane (1892), p.15.
32. Hildebrand (1892), p.2.
33. Anon., (March, 1903), p.4.

CHAPTER THREE

1. See also *Les Liliacées* (Paris, 1802) and Rousseau, J.J., *La Botanique de J.J. Rousseau* (Paris, 1805).
2. Wornum (1855), pp. 8–9.
3. Carter, James, *Two Lectures on Taste* (London, 1834), p.7.
4. As note 2 above.
5. Midgley and Lilley (1902), p.13.
6. Semper, Gottfried, 'The Attributes of Formal Beauty', in Hermann, Wolfgang (ed.), *Gottfried Semper: In Search of Architecture* (Cambridge, Massachusetts, The MIT Press, 1989), p.219.
7. Thiébault-Sisson, *Art et décoration*, vol.1, January–June 1897, p.17.
8. Whistler, J.M., 'Ten O'Clock Lecture', quoted in Small, Ian (1975), p.25.
9. Gauguin, Paul, 'Abstraction' in Chipp (1968), p.60.
10. Quoted in Lambourne (1997), p.176.
11. Huysmans, translated by Robert Baldick (1959), p.36.
12. See chapter eight.
13. Wilde, Oscar, 'Phrases and Philosophies for the Use of the Young' from *Art and Decoration* (1920), p.1.
14. Grasset, Eugène, 'Introduction' in Verneuil (1898), p.11.

15. May, Walther, *Goethe, Humboldt, Darwin, Haeckel* (Berlin, Steglitz, 1906).
16. Quoted from p.32.
17. Young (1985), p.16.
18. Anon., 'L'Art domestique de M. Vallgren', *Art et décoration*, vol.2, July–December 1897, p.50.
19. Sullivan, Louis, 'Emotional Architecture as Compared with Intellectual: A Study in Subjective and Objective' in *Kindergarten Chats and Other Writings* (reprint 1979), p.191.
20. Nietzsche (1889); this translation Hollingdale (1968), p.73.
21. 'Entwicklungslehre und Aesthetik', *Pan*, vol.V, no.4, 1900, p.239.
22. Mourey, Gabriel, 'An Interview on "L'Art Nouveau" with Alexandre Charpentier', *The Architectural Record*, vol.XII, no.2, June 1902, p.123.
23. Burdett (1925), p.36.
24. Desmond and Moore (1991), p.421.
25. Bowler (1983), p.199.
26. Van de Velde, Henry, *Les Formules de la beauté architectonique moderne* (Weimar, 1916), p.81. Quoted by Culot, Maurice, in Brunhammer (1976), p.332.
27. Guimard, Hector, 'An Architect's Opinion of Art Nouveau', *The Architectural Record*, no.2, June 1902, p.127.
28. See Krause, Erica, 'L'Influence de Ernst Haeckel sur l'Art Nouveau' in *L'Âme au corps: arts et sciences 1793–1993* (Paris, Gallimard, 1993), p.342.

CHAPTER FOUR

1. Uzanne, Octave, 'On the Drawings of M. Georges de Feure', *The Studio*, vol.XII, 1897, p.96.
2. Rheims (1965; 1966), p.129.
3. See Campbell, B.F., *Ancient Wisdom Revived: A History of the Theosophical Movement* (Berkeley and Los Angeles, University of California Press, 1980), p.11.
4. *La Plume*, 15 May 1899.
5. Quoted in Chipp (1968).
6. Péladan (1892), p.viii.
7. As note 6 above, p.xi.
8. Baldick, Robert (ed. and trans), *Pages from the Goncourt Journal* (Oxford, Oxford University Press, 1988), p.68.
9. James, Henry, *New York Tribune*, autumn 1874. Quoted in Christiansen (1994), p.395.
10. Jozé, Victor, 'Le Féminisme et le bons sens', *La Plume*, no.154, 15–30 September 1895, pp.391–92. Quoted in Silverman (1989), p.72.
11. Carabin, Rupert, 'Le Bois', *L'Art et l'Industrie*, March 1910. Quoted in Pepall (1995), p.415.
12. As note 1 above.
13. Dijkstra, Bram, *Idols of Perversity: Fantasies of feminine evil in fin-de-siècle culture* (Oxford, Oxford University Press, 1986), p.viii.
14. Hindle, Maurice, 'Introduction' in Stoker (1897; 1993), p.x.
15. Showalter (1990), p.188.
16. Vallance, Aymer, *The Magazine of Art*, 1903, p.169. Quoted in Greenhalgh in Kaplan (1995).
17. Pite, Beresford, Voysey, C.F.A. and Blomfield, Reginald, 'L'Art Nouveau: What it is and What is Thought of it?', *The Magazine of Art*, 1904.
18. Wilde (1894), act one.
19. Huysmans (1884; 1959).
20. Uzanne, Octave, 'Eugène Grasset and Decorative Art in France', *The Studio*, vol.IV, 1895-96, p.43.
21. See Silverman (1989).
22. Apter, Emily, 'Cabinet Secrets: Fetishism, Prostitution and the Fin-de-siècle Interior', *Assemblage: A Critical Journal of Architecture and Design*.

23. Symons, Arthur, 'Aubrey Beardsley: An Appreciation', in Reade (1966), p.x.
24. Cogeval, Guy, *Lost Paradise: Symbolist Europe* (Montreal, Museum of Fine Arts, 1995), p.33.
25. With thanks to Jeanne-David Jumeau Laford; see 'Jacquemin' in *Peintres de l'âme* (Musée d'Ixelles, forthcoming).
26. Dellamora, Richard, 'Homosexual Scandal and Compulsory Heterosexuality in the 1890s', in Pykett (1992), p.81.

CHAPTER FIVE

1. Péladan's 19-volume series, *La Décadence Latine (Éthopée)* (1884–1906) mirrored Zola's 20-volume *Rougon-Macquart* series.
2. de Goncourt, Edmond, *Préfaces et manifestes littéraires* (Paris, Charpentier, 1888).
3. In *The Philosophy of Furniture* (1840, translated by Baudelaire 1852) and his short story, *Landor's Cottage* in *The Flag of Union*, 9 June 1849, translated by Baudelaire in 1865.
4. de Goncourt, Edmond, *Chérie* (1884), preface.
5. Published 1859.
6. Letter to Paul Demeny, 15 May 1871.
7. Valéry's emphasis.
8. See Ghil, René and Mallarmé Stéphene, *Traité du Verbe* (1886).
9. See variations on the Wagnerian 'pantheon' in: Laforgue's *Moralités légendaires* (1887), Cox's 1880 translation of Mallarmé's *Les Dieux Antiques*; Édouard Schuré's *Les Grands Initiés* (1889) and James Frazer's *Golden Bough* (1890–1915).
10. See Péladan, in the opening quote to this chapter, and the Goncourt brothers' *Journal*, with its passionate plea for the élitist, solitary, celibate artist who lives solely for what he creates.
11. See Baudelaire's attack against narrative structure in his preface to *Petits Poèmes en Prose* (1869) and Mallarmé's preface to *Un Coup de dés* (1897).
12. Bourget, Paul, 'Théorie de la Décadence' in *Essais de psychologie contemporaine* (1883).
13. Retté (1897).
14. Adam (after 1910).
15. Zola's *Nana* and *Roman Expérimental* were published in 1880, and his volume of short stories, *Soirées de Médan*, was particularly visible.
16. Saint Georges de Bouhélier, *Manifeste du Naturisme* (1897); M. Le Blond, *Essai sur le Naturisme* (1896); Camille Lemmonier's final work; and Maurice Maeterlinck, *La Vie des Abeilles* (1901).
17. Méliès, George, *Le voyage dans la lune* (1902); Capellani's *Germinal* (1913); Feuillade's *Les Vampires* (1915-16).
18. 'Tableau de Groupe' by Laurencin, Marie (which brings together Apollinaire and Picasso) and the Ballet Russes (in Paris from 1909) are two of the major pre-1914 artistic events associated with modernity.
19. Marinetti, 'Manifeste Futuriste', *Le Figaro*, 1909.

CHAPTER SIX

1. Wilde, Oscar, 'The Decay of Lying', *De Profundis and other Writings* (London, Penguin, 1986), p.82. (First published in *The Nineteenth Century*, January 1899, London.)
2. Bird, Isabella, *Unbeaten Tracks in Japan* (London, 1880), quoted in Littlewood (1996), p.65.
3. See Silverman (1989), pp.17–39.
4. Weisberg (1986), p.18.
5. Bing, Siegfried, *Le Japon artistique*, vol.1, no.1, May 1886, pp.3–4.
6. Gonse, Louis, 'Korin', *Le Japon artistique*, vol.4, no.23, March 1890, p.287.
7. See Guth (1993), pp.161–91.

8. See Conant (1984).
9. Baur, Hermann, review of the Japanese Exhibition of the Secession, 1900, quoted in Berger (1992), p.346.
10. Van de Velde, Henry, 'Die Linie', quoted in Berger (1992), p.275.
11. Gauguin, Paul, letter to Émile Bernard, December 1888, quoted in Guerin (1978), pp.25–26.
12. Such screens, although still quite rare in the West, do appear in some of the catalogues of French collections and a number of screens, including three by Kōrin, were shown in the Paris *Exposition Universelle* of 1900.
13. As note 5 above, p.6.
14. Vever (1908), pp.758–59.
15. Bing, Siegfried, introduction to *Salon annuel des peintures japonais* (Paris, 1884), quoted in Silverman (1989), p.130.
16. *Catalogue of Chinese Objects in the South Kensington Museum* (London, 1872), p.57.
17. Gonse, Louis, 'The Japanese as Decorators', *Le Japon artistique*, vol.1, no.2, June 1888, p.10.
18. Lowell (1893), pp.25, 110.
19. Aurier, Albert, 'Revanche', *Le Moderniste*, July 1889. Quoted in Evett (1982), p.99.
20. See Littlewood (1996).
21. See Impey and Fairley (1995).
22. Quoted in Ajioka Chiaki, 'Early Mingei and the Development of Japanese Crafts, 1920s–1940s', unpublished PhD thesis, Australian National University, 1995, p.128.
23. Commission Impériale du Japon (1900).
24. Arthur Lasenby Liberty (the British Juror for pottery and porcelain in 1900), *Report of His Majesty's Commissioners for the Paris International Exhibition 1900* (London, 1901), vol.II, p.174.
25. See Finn (1995), p.214.

CHAPTER SEVEN

1. The ornament known as 'arabesque' is a mode of curvilinear decoration comprising flowing, intertwined patterns most commonly based on floral, leaf or geometric forms. Originally formulated in the Islamic world, it is a highly flexible style which lends itself equally to the composition of single motifs or to space-filling background patterns. Its adaptability led to widespread use in Europe from an early date, and it was particularly important in the development of Renaissance 'strapwork' forms.
2. Unpublished account of the life of Bugatti, written by a relative, Mlle L'Ebe Bugatti, dated May 1972.
3. See *Journal of Decorative Art*, October 1888, pp.158–59.
4. Tschudi-Madsen (1956), p.205.
5. See Eidelberg, M., *Édouard Colonna* (Ohio, Dayton Art Institute, 1983).
6. See *Raimondo d'Aronco: disegni d'architettura* (Rome, Galleria Nazionale d'Arte Moderna, 1980).
7. Pevsner and Richards (1973), p.4.
8. See Zerbst, Rainer, *Antoní Gaudí* (Cologne, Taschen, 1993), p. 21.
9. This term is coined by Howard (1996), p.109.
10. The Zsolnay firm was certainly aware of the existence of either these artefacts, their Tiffany copies or both, as they produced vessels in lustreware which almost exactly resembled the 'swan-necked' form.
11. See, for example, the collection of short stories by women writers of the *fin de siècle*, Showalter (1993). In several of these stories the 'new women' characters identify themselves with their vision of the Oriental woman, seeing her as a symbol of freedom of movement, expression and sexuality.
12. Berma, Harold, *The Abage Encyclopaedia of Bronzes, Sculptors and Founders 1800–1930* (Chicago, Abage, 1976), vol.2, p.448.
13. For example, the very detailed study of Bernhardt by Pronier (1936) makes no mention of it.
14. Wilde, *The Sphinx* (1894), p.2.
15. As note 14 above, p.15.
16. Huysmans, translated by Robert Baldick (1959), p.66.
17. Quoted in Ellmann (1984), p.344.
18. Anon., in Champier, Victor *et al.*, *Chefs d'Oeuvre of the Exposition Universelle of 1900*, vol.10 (Philadelphia, 1900), p.39.
19. For descriptions of the effect of electricity, see Jullian, Philippe (1974), pp.82 *et seq.*

CHAPTER EIGHT

1. Gautier, T., 'English Art from a French Point of View', *Temple Bar Magazine*, June–September 1862, p.321. Translation of an unidentified article on the British sections of the 1862 International Exhibition in London.
2. As note 1 above, p.320.
3. As note 1 above, p.321.
4. Dierkens-Aubry, Françoise, *Art Nouveau in Belgium: Architecture and Interior Design* (Brussels, Duculot, 1991), p.10.
5. Document 18439, South Kensington File: Donaldson, George.
6. Meier-Graefe (1908), p.46.
7. Bing, Siegfried, 'L'Art Nouveau', *The Craftsman*, vol.5, no.1, October 1903, p.7.
8. Dresser (1873), p.2.
9. Kane, Sir Robert, 'The Great Industrial Exhibition of 1853', *Journal of Industrial Progress*, January 1854 (Dublin, 1854), p.3
10. See Baker (1999).
11. Ruskin, John, *Letter V, Time and Tide: Notes on the Construction of Sheepfolds*, lecture to the Cambridge School of Art (London, Everyman, undated), p.20.
12. As note 11.
13. As note 11, p.87.
14. Ruskin (1851), quoted in Alasdair Clayre (ed.), *Nature and Industrialization* (Milton Keynes, Open University Press, 1977), p.255.
15. William Morris, *The Lesser Arts*, quoted in Greenhalgh (1993), pp.45–46.
16. Mackmurdo, Arthur, Heygate, *Address to the Birmingham Conference of the National Association for the Advancement of Art and its Application to Industry* (London, 1888), p.161.
17. Crane, Walter, *Presidential Address to the Liverpool Conference of the National Association for the Advancement of Art and its Application to Industry* (London, 1888), p.216.
18. Crane (1892), p.109; see also Greenhalgh, Paul, 'The History of Craft' in Dormer (1997), pp.20–52.
19. See Crawford (1985); Crawford (1984), pp.2–27; and Swanton, E.W., *A Country Museum* (Haslemere, Haslemere Educational Museum, 1947).
20. See Wilson, Susan, MA thesis, Royal College of Art, London, 1996.
21. Hamilton (1882), p.vii.
22. Pater (1873), p.238.
23. Wilde (1891), p.253.
24. Wilde, Oscar, 'L'Envoi' in *Art et décoration* (London, 1920), pp.122–23.
25. Wilde (1890), preface.
26. Quoted in Anderson and Koval (1994), p.215.
27. Quoted in Merrill (1959), pp.295–96.
28. Morris, William, *Transactions of the National Association for the Advancement of Art and its Application to Industry, Edinburgh Meeting 1890* (London, 1890), p.199.
29. Watson, Anne, 'Not just a Sideboard: E.W. Godwin's Celebrated Design of 1867', *Studies in the Decorative Arts*, vol.IV, no.2, 1997, pp.63–84.
30. As note 29 above.
31. See Greenhalgh, Paul, 'The English Compromise: Modernism and National Consciousness 1890–1930', in Kaplan (1995).
32. Harris (1967), p.x.
33. Rambosson, Yvanhoé, 'Aubrey Beardsley', *La Plume*, 1 April 1898, p.218.
34. Montgomery Hyde (1948), pp.122–23.

CHAPTER NINE

1. Baudelaire, Charles, 'The Painter of Modern Life', in Charvet, P.E. (trans), *Selected Writings on Art and Literature* (London, Penguin, 1972), p.403.
2. Talmeyr, Maurice, 'L'Âge de l'affiche', *Revue des deux mondes*, no.137, September 1896, pp.201–06. Quoted in Varnedoe and Gopnik, *High and Low Art* (New York MOMA, 1991), p.236.
3. Huysmans, J.-K., 'The Poster and Art Collector', *Certains*, vol.VI, no.XXX1, February 1901, p.51.
4. Needham, Raymond, 'Japanese Art and Poster Design', *The Poster*, 1901, pp.102–03.
5. Hiatt, Charles, 'Toulouse-Lautrec and his Posters', *The Poster*, May 1899, pp.183–85.
6. Anon., *The Poster*, October 1900, p.65.
7. Khnopff, Fernand, 'Some English Art Works at the Libre Esthétique at Brussels', *The Studio*, vol.III, 1894, p.32.
8. 'The Lay Figure Speaks', *The Studio*, vol.II, 1894, p.114.
9. *Art Journal Review*, quoted in Calloway (1998), p.82.
10. Meier-Graefe, Julius, 'Continental Bookbindings', *The Studio*, vol.IX, 1896–97, p.38.
11. As note 10 above, p.40.
12. Denis, Maurice, from the 'Influence of Paul Gauguin' (1903). Quoted in Chipp (1968), p.104.
13. Anon., *The Poster*, New York, March 1896, p.38.
14. Quoted in Heyman, Therese, *Posters American Style* (Washington, Smithsonian Institution, 1998), p.17.
15. Nazzi, Louis, quoted in Abdy (1969), p.69.

CHAPTER TEN

1. Duncan (1982), p.10.
2. See Jacques, G.M., 'L'Intérieur rénové', *L'Art décoratif*, 24 September 1900, pp.217–28.
3. See Sedeyn (1921), p.24.
4. For reference to one of the most significant of these interiors, see Possémé, Evelyne, 'Le salon du bois du pavillon de l'Union Centrale des Arts Décoratifs à l'Exposition Universelle de 1900', *La Revue de l'art* 3, no.117, 1997, pp.64–70.
5. Soulier, Gustave, 'L'Art dans l'habitation', *Art et décoration*, January–July 1900, pp.105–17. Soulier used the phrase 'impression of harmony' to describe this integrated ensemble.
6. See Weisberg (1986). See also Weisberg, Gabriel P., 'Bing's Craftsman Workshops: A Location and Importance Revealed', *Source*, 3, autumn 1983, pp.42–48.
7. Preliminary drawings by Bing's designers are conserved in the Musée des Arts Décoratifs in Paris. Some examples are reproduced in Weisberg, as note 6 above.
8. Weisberg, Gabriel P., 'Siegfried Bing and Industry: The Hidden Side of Art Nouveau', *Apollo*, no.78, November 1988, pp.326–29.
9. As note 8 above.
10. Weisberg, as note 6 above.
11. See Bouvier (1991).
12. For references to the interior of Marjorelle's factory, see *Revue Industrielle de L'Est* (1906).
13. Mercy, George, 'Enquêtes industrielles de L'Événement, L'Art industriel en Lorraine', *L'Événement*, 4 September 1900, p.2.
14. Bouvier, as note 11 above, pp.58–93. The irony of any competition between Bing and Majorelle is that Bing's shop, and possibly his workshop, were acquired by Majorelle when Bing sold them in 1904.
15. For a discussion of critical reaction to these pieces in 1900, see Weisberg, as note 6 above.
16. Soulier, Gustave, 'Quelques meubles d'Eugène Gaillard', *Art et décoration*, 1902, pp.21–27. Gaillard's own training helped him to understand engineering principles quite well.
17. Soulier, Gustave, 'Croquis d'intérieurs', *L'Art décoratif*, no.41, February 1902, pp.190–96.
18. On Art Nouveau as a prelude to modernism, see Troy (1991).
19. Couyba, Charles M., 'L'Art Décoratif en France', *La Nouvelle Revue*, 4, July–August 1908, pp.106–12.

CHAPTER ELEVEN

1. Logan, Mary, 'Hermann Obrist's Embroidered Decoration', *The Studio*, vol.IX, 1897, p.102.
2. Kelvin, Norman, letter from William Morris to Thomas Wardle, 19 April, letter 324, *The Collected Letters of William Morris* (Princeton, Princeton University Press, 1984), vol.1.
3. *The Studio*, vol.1, 1893, p.231.
4. *The Studio*, vol.VII, 1896, p.215.
5. Museum numbers 472–1896 to 477–1896.
6. Parry (1988), p.76.
7. Records of manufacturers are kept in the Musée de l'Impression sur Etoffe, Mulhouse, France.
8. Bedford, June and Davies, Ivor, 'Remembering Charles Rennie Mackintosh, A Recorded Interview with Mary Sturrock', *Connoisseur*, vol.183, no.738, August 1973, p.282.
9. Arthur, Liz, 'A Quiet Heroine, Jessie Newbery', *Quilters Review*, winter 1992, p.7.
10. Quoted in Weiss, 'Hermann Obrist' in Hiesinger (1988), p.79.
11. Information from Mark Turner, consultant at the Silver Studio, Middlesex University.
12. T.128-186–1957.
13. The silk screen panels are in the Badisches Landesmuseum, Karlsruhe, Germany (nos 73/167, 73/168; and 74/47, 74/49). The two printed square, velveteen panels are owned by the V&A (T.316-1965, T.317-1965). These were originally imported by Messrs Hines, Stroud & Co. of London. The original design for T.316-1965 is in the collection of the Wurttembergisches Landesmuseum, Stuttgart, Germany (no.1972-42).
14. Uzanne, Octave, 'Eugène Grasset and Decorative Art in France', *The Studio*, vol.IV, 1894, pp.37–47.
15. *The Queen*, 20 September 1902.
16. *The Studio*, vol.XVI, 1899, p.136 and p.138.
17. Gronwoldt (1980), cat.177-88.

CHAPTER TWELVE

1. 'Grand Feu Ceramics', *Keramik Studio*, vol.V, 1903, p.6.
2. Carriès' recipes were published in *Art et décoration*, October 1910, pp.97–108.
3. As note 1 above, pp.8–9.
4. Quoted in Bodelsen (1964), p.18, from *Le Soir, journal d'information*, 23 April 1995.
5. Paul Gauguin in *Le Moderniste*, 13 June 1889.
6. Bodelsen, as note 4 above, p.191.
7. Doat (1905) and in *Keramik Studio* in instalments.
8. *Society of Arts Journal*, 24 June 1892.
9. Bodelsen (1975), p.65.

CHAPTER THIRTEEN

The author gratefully acknowledges the assistance of Jean-Luc Olivié, Musée des Arts Décoratifs, Paris.

1. Olivié (1995), p.246. Quoted from Émile Gallé, 'Le Vase Prouvé' in *Écrit pour l'art* (Paris, Librarie Renouard, 1908).
2. Henrivaux (1902), p.6.
3. As note 2 above, pp.70–77.
4. As note 2 above, p.23.
5. This criticism was refuted by Count Robert de Montesquiou as being 'insensitive to the dignity of this glass, next-of-kin to precious and semi-precious stones'; see Garner (1976; 1990), p.134.
6. Bloch-Dermant, J., *L'Art du Verre en France 1860–1914* (Lausanne, Edita, 1974), p.148.
7. Mentasti, Rosa Barovier, *Venetian Glass 1890–1990* (Verona, Arsenate Editrice, 1992), pp.34–36.
8. *Pan*, vol.II, no.2, opposite 252, 1896–97.
9. *The Studio*, vol.X, 1897, p.200.
10. Hilschenz (1973), pp 96–101. See also Schou-Christensen, J., 'Glaskunst omkring ar 1900', *Et Jubilaeumskriff* (Det danske Kunstindustrimuseum, 1969), pp.160–82.
11. Rudoe, J., 'James Powell & Sons and the Continental Avant-garde before 1914' in Jackson, Lesley (ed.), *Whitefriars Glass: The Art of James Powell and Sons* (Shepton Beauchamp, Richard Dennis, 1996), pp.54–65.

CHAPTER FOURTEEN

1. *Journal de L'architecture*, no.4, April 1848, p.3. Quoted by M. Culot in Russell (1979).
2. Guerin (1978), p.28.
3. Loyer in Russell (1979), p.114.
4. 'The Art Movement – *Castel Béranger* – The New Art in Architectural Decoration', *Magazine of Art*, vol.XXV, 1901, pp.85–87.
5. George Bans (1900).
6. *La Construction Moderne*, Paris, 16 February 1913.
7. J. Kinchin, 'Mackintosh and the City' in Kaplan (1996).
8. Louis H. Sullivan (1896).

CHAPTER FIFTEEN

1. Gallé, Émile, 'Les Salons de 1897: Objets d'art', *Gazette des beaux-arts*, vol.XVIII, September 1897. Translation by Dusinberre (1991), p.232.
2. Bénédite, Léonce, 'Le Bijou à l'Exposition Universelle', *Art et décoration*, vol.VIII, 1900. Dusinberre as note 1 above, p.239.
3. Vever (1908), pp.690–91. These quotations in English are taken from the forthcoming translation of Vever by Katherine Purcell and Geoffrey Munn (London, Thames & Hudson, 2000).
4. As note 3 above, p.710.
5. As note 3 above, p.728.
6. As note 3 above, p.740.
7. *The Lady's Realm*, September 1901, p.x.
8. Vever, Henri, 'Les Bijoux aux Salons de 1898', *Art et décoration*, vol.III, 1898. Translation by Dusinberre as note 1 above, p.233.
9. 'Jewellery at the Paris Exhibition', *The Jeweller and Metalworker*, 1 June 1900, p.712.
10. I am indebted to Clive Wainright for drawing this previously overlooked exhibition to my attention.
11. 'Bric-a-brac at the New Gallery', *Art Journal*, 1898, pp.379–80.
12. *The Lady's Realm*, May 1901, p.40.
13. As note 8 above.
14. Ruskin, John, *The Seven Lamps of Architecture* (London, 1849), chapter 4.
15. Michelet, Jules, 'On the Renovation of

Our Arts by the Study of the Insect', *The Insect* (London, 1875), pp.206–07.
16. *The Studio*, vol.XXXV, 1905, pp.129–32.
17. Possémé, Evelyne, 'Landscape in the Work of René Lalique', *The Jewels of Lalique* (Paris and New York, 1998), p.149. The drawing is in the collection of the Musée Lalique, Paris.
18. As note 9 above, p.714.
19. As note 15 above, p.201.
20. As note 15 above, p.204.
21. As note 9 above.
22. Illustrated in Vever, as note 3 above, p. 681.
23. The author's thanks go to Martin Brendall of the Natural History Museum, London, for identifying this beetle.
24. *The Craftsman*, April 1903.
25. Vever, as note 3 above, p.626.
26. Vever, as note 3 above, pp.624–26.
27. *The Lady's Realm*, vol.XV, 1903–04, p.33.
28. Vever, as note 3 above, pp.732–33.
29. *The Studio*, vol.XXXV, 1905, p.128.

CHAPTER SIXTEEN

The author would like to thank Philip Ward-Jackson, Philippe Garner, Diana Keith Neal and Ulrika Goetz for help in preparing this chapter.

1. *The Magazine of Art*, vol.2, 1904, p.211.
2. As note 1 above, p.211.
3. As note 1 above, p.212.
4. As note 1 above, p.326.
5. As note 1 above, p.213.
6. As note 1 above, p.326.
7. As note 1 above, p.209.
8. As note 1 above, p.264.
9. As note 1 above, p.213.
10. See Beattie (1983), p.143 and p.218.
11. Duncan (1987), p 5.
12. *Revue des arts décoratifs*, vol.1, 1880.
13. *Revue des arts décoratifs*, vol.11, 1890.
14. Galerie Patrice Bellanger, Paris, *Jean-Joseph Carriès 1855–1894* (Paris, 1997).
15. *Revue des arts décoratifs*, vol.15, 1895, pp.393–94.
16. *Gazette des beaux-arts*, vol.8, 1892, pp.38–39.
17. *Revue des arts décoratifs*, vol.12, 1892, pp.5–16.
18. The one exception is Silverman (1989).
19. As note 18 above, p.244.
20. As note 18 above, pp.243–69.
21. *Revue des arts décoratifs*, vol.12, 1891, p.395.
22. As note 18 above, p.209.
23. *Revue des arts décoratifs*, vol.15, 1895, pp.194–96.
24. *Gazette des beaux-arts*, vol.8, 1892, p.37.
25. *The Magazine of Art*, vol.23, 1899, p.307.
26. *Revue des arts décoratifs*, vol.16, 1896, pp.2226–27.
27. Weisberg (1986).
28. As note 27 above.
29. Blühm (1996).
30. As note 29 above, pp.73–82.
31. *Gazette des beaux-arts*, vol.23, 1900, p.505.
32. *The Magazine of Art*, vol.2, 1904, p.263.

CHAPTER SEVENTEEN

1. For the Eiffel Tower's importance as both a symbol of progress and a construction made with modern materials, see Levin (1990).
2. Improving conditions in society extended to eliminating disease. Cholera was still considered a deadly plague in Paris in 1892. It was extensively discussed in newspaper articles of the time, as were the government's actions to combat the disease. See issues of the newspaper *Le Temps* throughout 1892 for references.
3. On the Third Republic and the visual arts, see Vaisse (1995). Although this book is useful for its references to painting, it is less substantial in its discussion of the decorative arts, a field in which public and private initiatives were often interrelated.

4. Figures crucial to changes being made in the visual arts included two advocates of modernity: Henri Roujon (Director des Beaux-Arts) and Georges Leygues (Minister of Public Instruction and the Beaux-Arts from 1898 to 1902). Neither man has been studied.
5. Naylor (1978), pp.9–22.
6. Thiébaut, Philippe, 'L'Art Nouveau' in Thiébaut (1992), p.59. Thiébaut argues that Guimard was too occupied with the Paris Metro to participate fully at the *Exposition Universelle*. He notes that Guimard did exhibit in classe 66 under fixed decoration for public buildings and under classe 90 for 'papiers peints', amongst other works.
7. On the importance of the Metro designs, see Frontisi, Claude, 'Hector Guimard et son Temps' in Naylor (1978), pp.21–43.
8. See Thiébaut, Philippe, 'Le Style Guimard' in Naylor (1978), pp.63–73.
9. See Thiébaut, Philippe, 'Guimard et les industries d'art' in Naylor (1978), pp.359–62.
10. 'Chronique de l'Exposition, L'Art Nouveau I', *Le National*, 18 August 1900, p.1 (unsigned but most likely by Morel-Lacordaire).
11. Morel-Lacordaire, J.-H., 'Chronique de l'Exposition, L'Art Nouveau II', *Le National*, 19 August 1900, p.1. The fact that this article was published in a Sunday edition and on the front page of the newspaper – emphasizes the importance that the journal was giving to this aspect of the Exposition.
12. As note 11 above.
13. Morel-Lacordaire, J.-H., 'Chronique de l'Exposition, L'Art Nouveau III', *Le National*, 21 August 1900, p.1.
14. Morel-Lacordaire, J.-H., 'Chronique de l'Exposition, L'Art Nouveau IV', *Le National*, 22 August 1900, p.1.
15. Morel-Lacordaire, J.-H., 'Chronique de l'Exposition, L'Art Libre ou L'Art Nouveau', *Le National*, 25 August 1900, p.1. This is the first time this writer unites these two terms.
16. As note 15 above. Morel-Lacordaire's use of the phrase established its importance for the twentieth century.
17. Early speculation on the need for State support of the decorative arts is found in Larroumet (1895).
18. See *Chambre de Députés, Session de 1901, Rapport … portant sur la fixation du Budget Général de l'Exercise 1902 (Ministère de l'Instruction Publique et des Beaux-Arts), Service des Beaux-Arts, par M. Couyba, Député*, Paris, 1901.
19. As note 18 above, pp.309–10.
20. On the value of the Union Centrale pavilion in 1900, see Possémé (1997), pp.64–70.
21. See Guerrand, Roger-Henri, 'Hector Guimard et ses amis', in Musée d'Orsay, Paris, *Guimard: Colloque International* (Paris, 1994), pp.60ff.
22. 'Première Exposition de l'Habitation, July–November 1903', *Exposition Internationale de l'Habitation des Industries du Bâtiment et des Travaux Publics … au Grand Palais des Champs Elysées* (Paris, 1903), pp. 4–5. The fact that much of the furniture was in bad condition added to the sense of hopelessness.
23. As note 22 above, pp.48–49.
24. On Sauvage, see Loyer and Guéné (1987).
25. The disappearance of both Meier-Graefe's 'La Maison Moderne' and Bing's shop 'L'Art Nouveau', as well as the termination of Bing's workshops (all around 1903), can be linked to this change in the Art Nouveau creative climate and the movement towards greater utility at the expense of luxury. For a discussion of Bing's demise, see Weisberg (1986), pp.260–65. Bing did participate in the Exposition de l'Habitation under 'Décoration d'intérieurs'; see 'Première Exposition', p.147.
26. See *Bulletin mensuel de la Société du Nouveau Paris*, no.3, December 1903.

27. Massu, Claude, 'L'Art Nouveau, art du nouveau monde. Guimard et les États-Unis au début du XXe siècle', in Musée d'Orsay, Paris, *Guimard: Colloque International* (Paris, 1994), p.91.
28. Loyer, François, 'L'Art Nouveau après l'Art Nouveau', in Musée d'Orsay, Paris, *Guimard: Colloque International* (Paris, 1994), pp.103–12.
29. See Escholier (undated), pp.157–58. Escholier did not always support Guimard's creations, yet he recognized the designer's uniqueness and value to the entire period.
30. On the maintenance of Art Nouveau in the 1920s, see Loyer (1987), p.424 and p.436. On the issues of early modernism in France, see Troy (1991).

CHAPTER EIGHTEEN

1. Demey (1990).
2. Ranieri (undated).
3. Aubry, Françoise, 'L'Exposition de Tervuren en 1897: scénographie Art Nouveau et arts primitifs' in *Paris-Bruxelles, Bruxelles-Paris*, (Paris, Grand Palais and Gent, Musée des Beaux-Arts, 1997), pp.397–402.
4. Horta (ed. Duliere, 1985).
5. Vandenbreeden, Jos, 'Le Palais des Beaux-Arts – vers une architecture urbanistique', in Palais des Beaux-Arts, Brussels, *Horta – Naissance et dépassement de l'Art Nouveau* (Ghent and New York, Flammarion and Ludion Press, 1996), pp.155–67. See Aubry and Vandenbreeden (1996) for English edition.
6. Speech made before the Senate by the future King Léopold II, as note 2 above, p.32.
7. Montens, V., 'Les clients de Victor Horta' in *Horta – Naissance et dépassement de l'Art Nouveau* (Gent, Flammarion/Ludion, Europalia Horta, 1996), pp.117–36.
8. Freemason and Member of Parliament, representing the Belgian Workers' Party.
9. Freemason and member of the Belgian Workers' Party from 1894; senator and Member of Parliament.
10. Vinck was a freemason, and member of the Belgian Workers' Party from 1893, and a senator.
11. Delhaye and Dierkens-Aubrey (1987).
12. As note 4 above, p.43.
13. As note 4 above, p.48.
14. As note 4 above, p.47.
15. Huysmans (1977), p.100 (folio).
16. As note 4 above, p.65.
17. As note 4 above, p.282.
18. Maus (1926), p.148.
19. Oostens-Wittamer (1980).
20. As note 4 above, p.47.
21. As note 15 above, p.93.
22. As note 15 above, p.91.
23. Atlas published by A. Morel & Co. (1864), plate XXVI.
24. As note 4 above, p.72.
25. Horta worked in Heyaert's workshop from 1 March to 30 June 1888.
26. As note 4 above, p.31.
27. As note 4 above, p.12.
28. Le Vailly de Tilleghem, S., 'Horta et Le Musée des Beaux-Arts de Tournai' in *Architectures rêvées* (Tournai, Casterman, 1996), pp.24–58.
29. As note 4 above, p.282.

CHAPTER NINETEEN

1. See Makela (1990), p.5; and *passim* for details of the policies and the politics of the Genossenschaft and the secession.
2. Nohbauer (1994), p.61.
3. As note 1 above, p.6.
4. Wolf, Georg Jacob, *Münchner Künstlergenossenschaft und Secession* (Munich, Drei Eulen-Verlag, undated). Quoted in Makela, as note 1 above, p.8.

5. Memorandum of the Verein Bildender Künstler Münchens; quoted in Makela, as note 1 above, p.145. (Makela includes the founding statements of the Verein as appendices to her book.)
6. See Spielmann, Heinz, 'The Jugendstil Collection at the Museum für Kunst und Gewerbe, Hamburg', *The Journal of the Decorative Arts Society, 1890–1940*, no.6, 1982, pp.37–48.
7. Quoted in Hiesinger (1988), p.54.
8. As note 7 above, p.54.
9. Eckmann (1897).
10. Programme of the Committee of the Section for Decorative Arts of the 7th International Exhibition in the Königliche Glaspalast, Munich, 24 February 1897. Quoted in Hiesinger as note 7, above, p.169. Hiesinger includes translations of the Vereinigte Werkstätte's founding documents, pp.169–70.
11. See *inter alia* Ottomeyer (1997); Reto, Niggl, *Hermann Obrist: Spitzenwirbelspirale* (Staat Museen Kassel, 1997), pp.23–53; Wichmann (1984); *Design Issues*, vol.3, no.1, spring 1986; Ziegert, Beate, *The Debschitzschule, Munich, 1902–1914*, pp.28–41; and Obrist (1903).
12. Logan, M., 'Hermann Obrist's Embroidered Decorations', *The Studio*, vol.9, no.44, November 1896, pp.98–105.
13. Fuchs, G., 'Hermann Obrist', *Pan*, vol.1, no.5, 1896–97, pp.318–25.
14. Haeckel, E., *Natürliche Schöpfungsgeschichte* (Berlin, 1868) and subsequent editions.
15. Haeckel (1899–1903). Haeckel's work was published in instalments. See Kockerbeck, C., *Ernst Haeckel's 'Kunstformen der Natur' und ihr Einfluss auf die deutsche bildende Kunst der Jahrhundertende* (Frankfurt, 1986).
16. See Herz, R. and Bruns, B. (eds), *Hof. Atelier Elvira, 1887–1928* (Munich, Münchner Stadtmuseum, 1986). Exhibition catalogue of the Photography Museum.
17. Obrist, Hermann, 'Die Lehr – und Versuch – Ateliers für Angewandte Kunst', *Dekorative Kunst*, vol.12, 1904, pp.228–27. Quoted in Hiesinger, as note 7 above, p.80.
18. For information on the Debschitz-Schule, see Wingler (1977), pp.68–92; Ziegert, B., *Design Issues* (1986), pp.20–21; and Naylor (1985).
19. Scheffler, K., *Kunst und Künstler*, vol.10, 1910, p.556. Quoted in Hiesinger as note 7 above, p.84.
20. Lux (1908), p.157.
21. Gmelin, L., 'Die Kleinkunst auf der Kunstausstellung zu München 1897', *Kunst und Handwerk*, vol.47, 1897–98, p.19. Quoted in Hiesinger, as note 7 above, p.108.
22. Quoted in Hiesinger, as note 7 above, p.133. See also Rudoe, Judy, *Aspects of Design Reform in the German Ceramic Industry around 1900* (Decorative Arts Society, 1850 to present, 1990), pp.24–33.
23. The Dresdener Werkstätte für Handwerkskunst 1898 became the Deutsche Werkstätten in 1907.
24. See Naumann, F., 'Die Kunst im Zeitalter der Maschine', *Kunstwart*, no.17, 1904; and Muthesius, H., 'Die Kunst Richard Riemerschmids', *Die Kunst*, vol.4, 1904, pp.249–83.
25. Quoted from Brunhammer and Tise (1990), p.23.

CHAPTER TWENTY

1. Bahr (1900; quoted in Vergo, 1975), p.34.
2. Wagner, Otto, *Die Groszstadt* (Vienna, 1911), p.39. Quoted in Schorske (1961), p.74.
3. Otto Wagner's inaugural lecture 'Moderne Architektur' was first published as a textbook for his students in 1895. It was re-written and re-printed several times. The quotations are

from the 1902 edition (Wagner, 1988 – English edition). (The sentence is published in capitals in the original text.)
4. Quoted from Schweiger (1984), p.22
5. See MacCarthy (1981).
6. Schweiger (1984), p.19.
7. Hevesi, L., *Acht Jahre Sezession (March 1899–June 1905)* (Vienna, Verlagsbuchhandlung Carl Konegen, 1906).
8. Lux (1914); Lux (1905).
9. Hoffmann, J., 'My Work', lecture given in 1911. Quoted in Sekler (1985), p.291.
10. Hoffmann (1901). Translated and reprinted in Sekler (1985) pp.483–84.
11. Quoted from Schweiger (1984), p.30.
12. Reprinted in Schweiger, as note 11 above, pp.42–43.
13. Hevesi (1909), pp.228–29. Quoted in Vergo (1975), p.142.
14. *Wiener Werkstätte* exhibitions celebrated *Der Gedeckte Tisch* (The Laid Table): in 1906, for example, it presented an exhibition on the theme in its showrooms in Vienna with sixty different table settings.
15. Hoffmann, J., *My Life*. Quoted in Schweiger, as note 11, p.205.
16. Loos (1908). Quoted in *Programmes and Manifestos on 20th-Century Architecture* (London, Lund Humphries, 1964), pp.19–24.

CHAPTER TWENTY-ONE

1. Crane, W., *William Morris to Whistler* (London, G.Bell & Sons, 1911), p.232.
2. Geddes (1910), chapters XVII–XVIII *passim*.
3. As note 2 above, p.277.
4. As note 2 above.
5. Mackintosh, Charles Rennie, 'Seemliness (1902)' in Robertson (1990), p.222.
6. Quoted from Mackay, Thomas, *The Life of Sir John Fowler, Engineer, Bart, KCMG, etc.* (London, 1900), chapter XI 'The Forth Bridge'.
7. *Illustrated Railway Guide, Edinburgh – Glasgow* (Glasgow, 1859), p.328.
8. *The Letters of Edwin Lutyens to his Wife Lady Emily* (London, Collins, 1985), p.50.
9. A.F. Jennings, *Our Homes and How to Beautify Them* (undated), p.61.
10. As note 5 above, p.223.
11. This theme is taken up by Brett (1992), chapter 4.
12. Muthesius, Herman, *The English House* (London, 1904; reprinted London, BSP Professional Books, 1987), pp.8–9; 144.
13. Geddes, P., *The Evolution of Sex* (1889).

CHAPTER TWENTY-TWO

1. 'Chicago School' designates the architects who standardized commercial design in the mid-west during the last quarter of the nineteenth century. See Allen Brooks, H., '"Chicago School": Metamorphosis of a Term,' *Journal of the Society of Architectural Historians*, vol.25, May 1966, pp.115–18.
2. For the international development of the self-supporting iron frame, see Lawson, Gerald R., 'The Iron Skeleton Frame: Interactions between Europe and the United States' in Zukowsky (1987), pp.39–56; and Condit (1964).
3. The first English translations of Viollet-le-Duc's two-volume treatise *Entretiens sur l'architecture* (1863–1872) were a one-volume US edition, Henry Van Brunt's *Discourses on Architecture* (1875), and a two-volume British edition, *Benjamin Bucknall's Lectures on Architecture* (1877–81).
4. See Morrison, Hugh, *Louis Sullivan: Prophet of Modern Architecture* (New York, 1935). For Sullivan's general affinity with Art Nouveau, see Grady, James, 'Nature and the Art

Nouveau', *Art Bulletin*, vol.37, September 1955, pp.187–92.
5. Sullivan, L. 'Emotional Architecture as Compared with Intellectual: A Study in Objective and Subjective', in Athey, Isabella, *Kindergarten Chats Revised 1918 and Other Writings* (New York, 1947), p.194.
6. The biographical data is from Twombly (1986).
7. Jenney's First Leiter Building (1879 in Chicago) and his Home Insurance Building (1886 in Chicago) are traditionally considered the first examples of the Chicago School skyscraper.
8. Sullivan and his contemporaries applied the term 'fresco' to a method of stencilling patterns with a stiff, short-bristled brush; see Vinci, John, *The Trading Room: Louis Sullivan and the Chicago Stock Exchange Room* (Chicago, Art Institute of Chicago, 1977), pp.33–36.
9. See O'Gorman, James, *The Architecture of Frank Furness* (Philadelphia, 1973).
10. For Sullivan's development as a designer of ornament, see Sprague, Paul E., *Drawings of Louis Henry Sullivan: A Catalogue of the Frank Lloyd Wright Collection at the Avery Architectural Library* (Princeton, Princeton University Press, 1979); and Van Zanten, David, 'Sullivan to 1890' in de Witt, Wim (ed.), *Louis Sullivan: The Function of Ornament* (New York, W.W. Norton, 1986).
11. These sources include works by Charles Darwin, Ernst Haeckel and Herbert Spencer.
12. For Sullivan's interpretation of Ruskin, see Weingarden, Lauren S., 'Louis H. Sullivan's Ornament and the Poetics of Architecture', in Zukowsky (1987); and 'Naturalized Nationalism: a Ruskinian Discourse on the Search for an American Style of Architecture', *Winterthur Portfolio*, vol.24, spring 1989, pp.43–68.
13. Ruskin, John, *The Seven Lamps of Architecture* (New York, George Allen Publishers, 1849; reprinted George Allen Publishers, 1979), pp.15–17.
14. Ruskin, John, *The Stones of Venice*, here cited from Cook and Wedderburn (1903–12): 'The Material of Ornament', vol.I, pp.268 and 270–71; 'The Nature of Gothic', vol.II. See also as note 13 above, p.100 and p.104. Ruskin's illustration of 'Abstract Lines' appears in *The Stones of Venice*, vol.I, pl.7.
15. See also Ruskin's illustration of 'The Acanthus of Torcello' in *The Stones of Venice*, as note 14 above, vol.II, pl.2.
16. Sullivan (1924; facsimile entitled *Louis H. Sullivan: A System of Architectural Ornament*, essay by Lauren S. Weingarden, New York, 1990).
17. Sullivan, L., 'Characteristics and Tendencies of American Architecture', in Athey, Isabella, *Kindergarten Chats Revised 1918 and Other Writings* (New York, 1947), pp.177–80.
18. Sullivan, L., 'Style', in Twombly, Robert, *Louis Sullivan: The Public Papers* (Chicago, 1988), pp.45–52.
19. Sullivan, L., 'Ornament in Architecture', in Athey, Isabella, *Kindergarten Chats Revised 1918 and Other Writings* (New York, 1947), p.187.
20. Sullivan, L., 'The Tall Office Building Artistically Considered', in Athey, Isabella, *Kindergarten Chats Revised 1918 and Other Writings* (New York, 1947), p.202 and p.206.
21. Sullivan, L. *Kindergarten Chats* (1918), p.161.
22. Sullivan, L. *Kindergarten Chats* (1901–02); Bragdon, Claude (ed.), *Kindergarten Chats* (Lawrence, Kansas, 1934), p.167.
23. See Weingarden, Lauren S., 'Louis H. Sullivan: Investigation of a Second French Connection', *Journal of the Society of Architectural Historians*, vol.39, December 1980, pp.297–303.
24. See Weingarden, Lauren S., 'The Colours of Nature: Louis Sullivan's Architectural

Polychromy and Nineteenth-Century Colour Theory', *Winterthur Portfolio*, vol.20, no.4, winter 1985, pp.243–60.
25. Bouilhet, André, 'L'Exposition de Chicago', *Revue des arts décoratifs*, vol.14, 1893–94, p.69 and p.72.
26. As note 25 above, pp.68–69.
27. 'France Honours Louis H. Sullivan', *Inland Architect and News Record*, vol.25, March 1895, pp.20–21. For documentation of the Union's acquisitions, see Weingarden, as note 23 above.
28. See Siry, Joseph, *Carson-Pirie-Scott: Louis Sullivan and the Chicago Department Store* (Chicago, University of Chicago Press, 1988).

CHAPTER TWENTY-THREE

1. The Catalan form of 'Ensanche'.

CHAPTER TWENTY-FOUR

1. Lechner, Ö., 'Önéletrajzi vázlat' in A. *Ház* (1911), pp.344–46.
2. As note 1 above.
3. See Moravánszky, A., 'The Aesthetics of the Mask: The Critical Reception of Wagner's Moderne Architektur and Architectural Theory in Central Europe', in Mallgrave, H.F. (1993), pp.199-243.
4. Apponyi quoted in Miklos (1934), p.15.
5. J. Huszka's important works are *Magyar díszítő styl* (Budapest, 1885) and *Magyar Ornamentika* (Budapest, Pátria, 1898).
6. As note 1 above.
7. For a history of the Zsolnay company, see Hárs (1988); and Csenkey (1992).
8. Nagy, I., 'The Character of Hungarian Art Nouveau as Presented in Hungarian Research', *Acta Historia Arta*, vol.28, 1982, p.404.
9. See Batári, F., 'Art Nouveau 1900: Presentation des objets d'art acquis à l'Exposition Universelle de Paris', *Ars Decorativa*, 1977, pp.175–80.
10. Lázár, Béla, 'Rippl-Rónai, József', *Magyar Iparmüvészet*, vol.XV, 1912, pp.81–100.
11. Andrássy sold his Budapest residence in 1909 and removed to his family estate at Tiszadob. It is likely that the dining room was reassembled there in 1911 or 1912.
12. Lechner, Ö., 'Magyar formanyelv nem volt, hanem lesz' in *Müvészet* (1906), p.6.
13. See Gellér, K. and Keserü, K., *A Gödöllö Müvésztelep* (Budapest, Cégér, 1987); Keserü (1988), pp.1–23; and 'The Gödöllö Artists Colony and KÉVE' in Szabadi (1989), pp.81–94.
14. See Levetus, A.S., 'Edmund Wiegand' in *Der Architekt* (1911–13), pp.17–25.
15. 'Thoughts on the Turn of the Century Architecture' in Gerle (1990), p.12.
16. Körösfö i-Kriesch, A., 'A népmüvészetröl', *Magyar Iparmüvészet*, 1913, p.352.

CHAPTER TWENTY-FIVE

1. Otokar Březina and Julius Zeyer were important figures of the Czech Decadent movement which was concentrated mainly around the magazine *Modern Revue* (founded in 1894).
2. Mention should be made of several of the most important painters and sculptors who participated in the decoration of the Municipal House: Mikoláš Aleš (1852–1913), Bohumil Kafka (1878–1942), Josef Mařatka (1874–1937), Alphonse Mucha (1860–1939), Jan Preisler (1872–1918), Ladislav Šaloun (1870–1946), Max Švabinský (1873–1962), Josef Wenig (1885–1939) and František Ženísek (1849–1916).
3. The Czech word 'Moderna' is untranslatable. Basically, it means the break

from superficial decorativism to ethical concepts and responsibility to purpose.

4. Šalda František Xaver, 'Nová krása: jeji geneze a charakter', *Volné směry*, vol.VII, Prague, 1903, p.169 and p.181.
5. Šalda František Xaver, 'Smysl dnesní, t. zv. Renaissance uměleckého prumyslu', *Volné směry*, vol.VII, Prague, 1903, pp.137–38.
6. The Alphonse Mucha Museum opened in Prague in February 1998.
7. *Volné směry*, 1900, p.189.

CHAPTER TWENTY-SIX

Very grateful thanks to Sickan Park (Finnish Embassy) for raising sponsorship; Marianne Aav (Museum of Art & Design, Helsinki); Timo Keinänen (Museum of Finnish Architecture, Helsinki); Pekka Korvenmaa (University of Art & Design, Helsinki); Marketta Tamminen (Porvoo Museum); Soili Sinisalo (Ateneum, Helsinki)

1. Quoted in Hausen (1990), p.12.
2. *Art et décoration*, vol.VIII, 1900, p.2.
3. As note 1 above, p.9.
4. As note 1 above, p.13.
5. Ringbom (1987), p.171.
6. As note 5 above, p.153.
7. *Art et décoration*, vol.VIII, 1900, p.1.
8. Munck and Tamminen (1990), p.61.
9. As note 1 above, p.54.
10. As note 5 above, p.27.
11. As note 5 above, p.51.

CHAPTER TWENTY-SEVEN

1. Bishop Bury (1915), p.2.
2. Beavington Atkinson, J., *An Art Tour to Russia* (London and New York, Waterstone and Hippocrene Books, 1986), p.224.
3. For an understanding of social changes in *fin-de-siècle* Moscow, the author is indebted to Thurston (1987) and Bradley (1985).
4. Bradley, as note 3 above, p.4.
5. Bradley, as note 3 above, p.34.
6. Bradley, as note 3 above, p.59.
7. Goldenberg, P., *Planirovka zhilogo kvartala Moskvy 17, 18 i 19 vv* (Moscow-Leningrad, 1935), p.117.
8. On this Arts and Crafts revival, see Salmond (1996).
9. Kirichenko, Evgenia, *Moskva. Pamiatniki arkhitektury 1930-1910-kh godov* (Moscow, Iskusstvo, 1977), pp.100–01.
10. Syrkin, Mikhail, *Plasticheskie iskusstva* (St Petersburg, 1900), p.18.
11. N.V., 'Darmshtadtskaia koloniia khudozhnikov', *Mir iskusstva*, no.2, 1901, p.126.
12. Diagilev, Sergei, 'Mir iskusstva', *Khronika*, 1903, p.8.
13. Clowes, Edith W., 'Merchants on Stage and in Life' in West and Petrov (1992), p.157.
14. West, James L., 'Riabushinsky's Utopian Capitalism' in West and Petrov (1992), p.16.
15. Quoted in Dumova (1992), pp.149–50.

CHAPTER TWENTY-EIGHT

1. Hamlin, Alfred D.F., 'Style in Architecture,' *The Craftsman*, vol.8, 1905.
2. Stein, Roger B., 'Artefact as Ideology: The Aesthetic Movement in its American Cultural Context' in Burke (1986), pp.36–38.
3. Bing (Robert Koch edition, 1970), p.130.
4. See Tiffany & Co. (1896), p.22.
5. *Extensive Collection of the Louis Comfort Tiffany Foundation (contents of Laurelton Hall)*, sale catalogue (New York, Parke-Bernet Galleries, Inc., 24–28 September 1946), lots 584–713.
6. See Bradshaw, W.R., 'Favrile Glass', *House Beautiful*, vol.7, no.5, April 1900, pp.275–79.
7. 'Exhibition Notes', *The China Decorator*, April 1900.

8. See Tiffany & Co. archival photograph in Burke (1986), p.268.
9. Frelinghuysen (1998), p.70, fig. 88.
10. The drawings for the dragonfly shade are in New York's Metropolitan Museum.

CHAPTER TWENTY-NINE

1. Melani, Alfredo, 'L'Art Nouveau at Turin. An Account of the Exposition', *The Architectural Record*, vol.12, November 1902, pp.585–99.
2. Guimard, Hector, 'An Architect's Opinion of L'Art Nouveau', *The Architectural Record*, vol.12, November 1902, p.131.
3. As note 1 above.
4. Thovez, Enrico, 'The First International Exhibition of Modern Decorative Art at Turin', *The Studio*, vol.26, June 1902, p.46.
5. Soulier, Gustave, 'L'Exposition Internationale d'Art Décoratif Moderne à Turin', *L'Art décoratif*, June 1902, p.129, in Fratini (1903; reprint, 1970), pp.66–67. Fratini's book is an anthology of critical responses to the Turin *Esposizione* written by Italian commentators, as well as French, German and British commentators.
6. As note 1 above, p.589.
7. Quoted in Etlin (1991), p.41.
8. See Rossana Bossaglia in Weisberg (1988), p.5; and in Bossaglia, Godoli and Rosci (1994), p.411. Several Italian scholars, including Bossaglia, prefer the term 'Stile Liberty' and consider '*Stile Floreale*' to be too restrictive, representing only one aspect of the movement.
9. U. Fleres, 'Lo stile nuovo', *Rivista d'Italia*, vol.2, December 1902, p.1055, in Fratini (1903, reprint 1970), p.112.
10. Fuchs (1902), pp.217–42.
11. *Il Giovane Artista Moderno*, vol.1, anno I, 1902, p.12.
12. *Relazione della Giuria Internazionale della Prima Esposizione d'Arte Decorativa Moderna* (Turin, 1902). Translation in Valabrega object file, The Wolfsonian-Florida International University.
13. As note 12 above, p.149.
14. Frizzi, A., 'L'Ingegneria Civile e le Arti Industriali' in Fratini, as note 9 above, pp.353–55. Translated text, p.1.
15. As note 14 above, p.2 of translation.
16. *Relazione della Giuria Internazionale della Prima Esposizione d'Arte Decorativa Moderna* (Turin, 1902), vol.1, p.164.
17. Weisberg, as note 8, above, p.54.
18. Macchi, G., 'L'Esposizione d'arte decorativa moderna di Torino', *Il Tempo*, Milan, 7 July 1902, in Fratini, as note 9 above, p.84.

CHAPTER THIRTY

1. See Wilms, Mimi, 'The Struggle of Belgian Modernism Between the Wars' in Greenhalgh, Paul (1990), pp.145–62.
2. Greenhalgh, Paul, 'The Struggles in French Furniture' in Greenhalgh, as note 1 above, pp.51–81.
3. Sedeyn (1921).
4. Arts Council, *The Architecture of Adolf Loos* (London, Arts Council, 1985), p.100.
5. As note 4 above, p.102.
6. 'Ornament in Architecture', *Engineering Magazine* (1892) in Greenhalgh (1993), p.10.
7. *Art and Industry* (London, 1934), quoted in Greenhalgh, as note 6 above, p.19.
8. Worringer (1908; this edition 1951), p.4.
9. As note 8 above, p.34.
10. From 'The Air is a Root' (1933) in Jean Arp, *Collected Writings* (London, Calder & Boyars, 1974), p.71.
11. George Dangerfield (London, 1935), p.7.

Bibliography

BIBLIOGRAPHIC STUDIES AND ANTHOLOGIES OF PRIMARY SOURCES

Banham, Joanna, *Encyclopedia of Interior Design* (London and Chicago, Fitzroy Dearborn, 1997), 2 vols.

Benton, Benton and Sharp, *Form and Function* (Milton Keynes, Open University Press, 1975).

Chipp, H.B. (ed.), *Theories of Modern Art* (Berkeley, Los Angeles and London, University of California Press, 1968).

Conrads, Ulrich, *Programmes and Manifestos on Twentieth Century Architecture* (London, Lund Humphries, 1964).

Dorra, Henri, *Symbolist Art Theories: A Critical Anthology* (Berkeley and Los Angeles, University of California Press, 1994).

Fanelli, G. and Godoli, E., *Dizionario degli Illustratori Simbolisti e Art Nouveau* (Florence, Cantini, 1986).

Findling, John, *Historical Dictionary of Worlds Fairs and Expositions, 1851–1988* (New York, Greenwood, 1990).

Fleming, John and Honour, Hugh, *The Penguin Dictionary of Decorative Arts* (London, Penguin Books, 1977).

Grady, James, 'A Bibliography of the Art Nouveau', *Journal of the Society of Architectural Historians*, vol. XIV, no.2, 1955, Crawfordsville, Ind., pp.18–27.

Greenhalgh, Paul (ed.), *Quotations and Sources on Design and the Decorative Arts (1800–1990)* (Manchester, Manchester University Press, 1993).

Harrison C., Wood P. and Gaiger, J., *Art in Theory: 1815–1900* (Oxford, Blackwell, 1998).

Holt, Elizabeth Gilmore, *A Documentary History of Art: Volume 3 From the Classicists to the Impressionists* (New York, Anchor, 1966).

Holt, Elizabeth, Gilmore, *The Expanding World of Art 1874–1902, Volume I: Expositions and State Fine Arts Exhibitions* (New Haven and London, Yale University Press, 1988).

Julier, Guy, *Encyclopedia of Twentieth Century Design and Designers* (London, Thames & Hudson, 1993).

Kempton, Richard, *Art Nouveau: An Annotated Bibliography* (Los Angeles, Hennessey & Ingalls, 1977).

Reff, Theodore (ed.), *Fine Art Sections of Paris Expositions Universelles 1855, 1867, 1878, 1889, 1900* (New York, Garland, 1981).

Small, Ian, *The Aesthetes* (London, Routledge & Kegan Paul, 1975).

Weisberg, Gabriel, P. and Menon, Elizabeth, *Art Nouveau: A Research Guide for Design Reform in France, Belgium, England, and the United States* (New York, Garland, 1998).

GENERAL WORKS ON ART NOUVEAU

Amaya, Mario, *Art Nouveau* (London, Studio Vista, 1966).

Arwas, Victor, *Glass, Art Nouveau to Art Deco* (London, Academy Editions, 1977).

Barillo, Renato, *Art Nouveau* (London, Hamlyn, 1966; New York, Tudor, 1969).

Battersby, Martin, *Art Nouveau* (London, Hamlyn, 1969).

Beattie, Susan, *The New Sculpture* (New Haven and London, Yale University Press University Press, 1983).

Becker, Vivienne, *Art Nouveau Jewellery* (New York, Dutton, 1985; London, Thames & Hudson, 1998).

Benton, T. and Millikin, S., *Art Nouveau* (Milton Keynes, Open University Press, 1975).

Bouillon, Jean-Paul, *Art Nouveau 1870–1914* (Geneva, Skira, 1985).

Buffet-Challie, Laurence, *Le Modern style* (Paris, Baschet, 1975), translated by Geoffrey Williams as *The Art Nouveau Style* (London, Academy Editions, 1982).

Brunhammer, Yvonne *et al.* (eds), *Art Nouveau Belgium, France* (Houston, Institute for the Arts, Rice University, 1976).

Bury, Shirley, *Jewellery 1789–1910 – The International Era* (Woodbridge, Antique Collectors' Club, 1991).

Champigneulles, Bernard, *L'Art Nouveau* (Paris, Somogy, 1972).

Clausen, Meredith, 'Architecture and the Poster: Toward a Redefinition of the Art Nouveau', *Gazette des beaux-arts*,106, September 1985, pp.81–94.

Cremonan, Italo, *Il Tempo dell'Art Nouveau, Modern Style, Sezession, Jugendstil, Arts and Crafts, Floreale, Liberty* (Firenze, Vallecchi, 1964).

Duncan, Alastair, *Art Nouveau Furniture* (New York, Clarkson N. Potter Inc., 1982).

Duncan, Alastair, *Art Nouveau Sculpture* (London, Academy Editions, 1987).

Duncan, Alastair, *Art Nouveau* (London, Thames & Hudson, 1994).

Fahr-Becker, Gabriele, *Art Nouveau* (Cologne, Taschen, 1997).

Gordon Bowe, N. (ed.), *Art and the National Dream: The Search for Vernacular Expression in Turn of the Century Design* (Dublin, Irish Academic Press, 1993).

Grady, James, 'Nature and the Art Nouveau', *The Art Bulletin*, Princeton, New Jersey, vol.XXXVII, no.3, 1955, pp.187-94.

Greenhalgh, Paul (ed.), *Modernism in Design* (London, Reaktion Books, 1990).

Guerrand, Roger-Henri, *L'Art Nouveau en Europe* (Paris, Plon, 1965).

Hardy, William, *A Guide to Art Nouveau Style* (London, Apple Press, 1988).

Haslam, Malcolm, *In the Nouveau Style* (Boston, Little Brown, 1989).

Hope, Henry 'The Sources of Art Nouveau' (December 1942, unpublished PhD dissertation, Harvard University).

Howard, Jeremy, *Art Nouveau: International and National Styles in Europe* (Manchester, Manchester University Press, 1996).

Hutter, Heribert, *Art Nouveau* (Vienna, Rosenbaum, 1965).

Jullian, Philippe, *The Triumph of Art Nouveau: The Paris Exhibition of 1900* (London, Phaidon Press, 1974).

Latham, I. (ed.), 'New Free Style', *Architectural Design 1/2*, 1980.

Lenning, Henry, *The Art Nouveau* (The Hague, Martinus Nijhoff, 1951).

Masini, Lara-Vinca, *Art Nouveau* (1976), translated from the Italian by Linda Fairbairn (Italy, Aldo Martello Giunti, 1976; London, Thames & Hudson, 1984).

Meier-Graefe, Julius, *Modern Art: Being a Contribution to a New System of Aesthetics* (1904, Stuttgart, 3 vols; English edition: London, Heinemann, 1908, 2 vols.)

Mortier, Roland and Sulzberger, Suzanne, *L'Art Nouveau: littérature et beaux-arts à la fin du XIXème siècle* (Brussels, Editions de l'Université de Bruxelles, 1981).

Museum of Applied Arts, Budapest, *Style 1900; A Great Experiment of Modernism in the Applied Arts* (Budapest, 1996).

Pevsner, Nikolaus and Richards, J.M. (eds), *The Anti-Rationalists* (London, The Architectural Press, 1973).

Rheims, Maurice, *L'Objet 1900* (Paris, Arts et Métiers Graphiques, 1964).

Rheims, Maurice, *L'Art 1900, ou le style Jules Verne* (Paris, Arts et Métiers Graphiques, 1965), translated as *The Age of Art Nouveau* (London, Thames & Hudson, 1966).

Russell, Frank (ed.), *Art Nouveau Architecture* (London, Academy Editions, 1979).

Silverman, Debora, *Art Nouveau in Fin-de-Siècle France, Politics, Psychology and Style* (Berkeley and Los Angeles, University of California Press, 1989).

Schmutzler, Robert, *Art Nouveau – Jugendstil* (Stuttgart, Hatje, 1962), translated as *Art Nouveau* (London, Thames & Hudson, 1964).

Selz, Peter and Constantine, Mildred (eds), *Art Nouveau: Art and Design at the turn of the century* (New York, MOMA, 1959).

Sembach, K.J., *Art Nouveau* (Cologne, Taschen, 1991).

Snowman, A. Kenneth (ed.), *The Master Jewellers* (London, Thames & Hudson, 1990).

Troy, Nancy, *Modernism and the Decorative Arts: From Art Nouveau to Le Corbusier* (New Haven and London, Yale University Press, 1991).

Tschudi-Madsen, Stephan, *The Sources of Art Nouveau* (Oslo: H. Aschehoug & Co., 1956).

Tschudi-Madsen, Stephan, *Art Nouveau* (London, Thames & Hudson, 1967).

SELECTED CONTEMPORARY DEFINITIONS OF AND STATEMENTS ON ART NOUVEAU

'L'Art Nouveau', *The Art Journal*, 1900, London.

Bajot, Édouard, *L'Art Nouveau: Décoration et ameublement* (Paris, 1898).

Bing, Samuel, 'L'Art Nouveau', *The Architectural Record*, vol. XII, 1902, New York, pp.279-85.

Bing, Siegfried, 'L'Art Nouveau', *The Craftsman*, October 1903.

Champier, Victor, 'Les Expositions de l'Art Nouveau', *Revue des arts décoratifs*, no.16, 1896, pp.1-16.

Couyba, Charles, 'L'Art Décoratif en France', *La Nouvelle Revue*, vol.4, July/August 1908.

Day, Lewis F., 'L'Art Nouveau', *The Art Journal*, 1900, pp.293–97.

Elder-Duncan, J.H., *The House Beautiful and Useful* (London and New York, Cassell, 1907).

Grasset, Eugène, 'L'Art Nouveau' Special Issue, *La Plume*, May 1894, Paris.

Guimard, Hector, 'An Architect's opinion of l'Art Nouveau', *The Architectural Record*, vol.XII, June 1902, pp.126–137.

Hamlin, A.D.F, 'L'Art Nouveau: Its Significance and Value', *The Craftsman*, December 1902, London.

Lahor, Jean (pseudonym of Henri Cazalis), *L'Art Nouveau, son histoire; l'Art Nouveau étranger à l'exposition; l'Art Nouveau au point de vue social* (Paris, Lemerre, 1901).

Marx, Roger, 'L'Art Nouveau', *Le Rapide*, 13 February 1893.

Mourey Gabriel, 'L'Art Nouveau with Alexandre Charpentier', *The Architectural Record*, vol XII, no.2, June 1902, p.121.

Schoper, Jean, 'L'Art Nouveau', *The Craftsman*, June 1903.

CONTEXTUAL MATERIALS: CONTEMPORARY TREATISES ON DECORATIVE ART AND DESIGN

Bell, Clive, *Art* (London, Chatto & Windus, 1914).

Blery, Eugène, *Guide industriel dessiné d'après nature* (Paris, 1878).

Braquemond, J.M., *Du dessin et de la couleur* (Paris, 1885).

Brenci Esercizi, G., *Graduati di Disegno Proprietà Artistica* (Florence, c.1895).

Cherbuliez, V., *L'Art et la nature* (Paris, 1892).

Crane, Walter, *Line and Form* (London, Bell, 1900).

Day, Lewis F., *Nature in Ornament* (London, B.T. Batsford, 1892).

Dresser, Christopher, *The Art of Decorative Design* (London, Day & Son, 1862).

de Goncourt, Edmond, *La Maison d'un artiste* (Paris, Charpentier, 1881).

Grasset, Eugène, *La Plante et ses applications ornamentales* (Paris, Libraire Centrale des Beaux-Arts, 1899).

Hulme, F. Edward et al., *Art Studies from Nature as Applied to Design* (London, Virtue, 1872).

Hulme, F. Edward, *The Birth and Development of Ornament* (London, 1894).

Jackson, Holbrook, *The Eighteen Nineties: A Review of Art and Ideas at the Close of the Nineteenth Century* (New York, Knopf, 1913).

Johnson, Philip and Hitchcock, H.R., *The International Style: Architecture Since 1922* (New York, W.W. Norton, 1932).

Jones, Owen, *The Grammar of Ornament* (London, Day & Son, 1856).

Keller, A., *La Décor par la plante. L'Ornement et la végétation: théorie décorative et applications industrielles* (Paris, 1902).

Krumbholz, K., *Das Vegetable Ornament* (1879).

Le Corbusier (Charles Éduard Jenneret), *L'Art décoratifs aujourd'hui* (Paris, Cres & Cie, 1925; various reprints).

Loos, Adolf, *Ornament and Crime* (1908; reprinted by Arts Council of Britain, 1985).

Luthmer, F., *Blühenformen als Motive für Flachornament* (Berlin, 1893).

Meurer, M., *Pflanzenformen* (Berlin, 1895).

Midgely, W. and Lilley, A.E.V., *Plant Form and Design* (London, Clay & Son, 1902, sixth edition).

Riegel, Alois, *Stilfragen* (Berlin, 1893).

Seder, A., *Die Pflanze in Kunst und Gewerbe* (Munich, 1886).

Semper, Gottfried, *Der Stil in den Technischen und Architektonischen Kunsten* (Frankfurt, 1860).

Trenter, A., *Pflanzen Studien* (1899).

Verneuil, M.P. *Étude de la plante, son application aux industries d'art* (Paris, 1901).

Ward, J.W., *Treatise on Decorative Art and Architectural Ornament* (London, Chapman & Hall, 1897).

Wilde, Oscar, *Art and Decoration* (London, Methuen, 1920).

Wornum, Ralph Nicholson, *Analysis of Ornament* (London, Chapman & Hall, 1855).

Worringer, Wilhelm, *Abstraction and Empathy* (Germany, 1908; London, Routledge & Kegan Paul, 1951).

Viollet-le-Duc, Eugène, *Entretiens sur l'Architecture* (Paris, 1863–1872; translated London, 1877).

CONTEMPORARY SOURCES: LITERARY, CULTURAL, ECONOMIC, SCIENTIFIC AND SOCIAL

Charcot, J. M., *Les Difformes et les malades dans l'art* (Paris, Lecrosnier & Babé, 1889).

Cooke, E.T. and Wedderburn, Alexander, *The Complete Works of John Ruskin* (London, George Allen, 1903–12), 39 vols.

Darwin, Charles, *On the Origin of Species* (London, 1859; many reprints).

Darwin, Charles, *The Descent of Man* (London, 1871), 2 vols.

Flaubert, Gustave, *Oeuvres complètes* (Paris, Club de l'Honnête Homme, 1973).

Ghil, René, *Les Dates et les oeuvres: Symbolisme et poésie scientifique* (Paris, Cres & Cie, 1923).

de Goncourt, Edmond and Jules, *Journal des Goncourt, mémoires de la vie littéraire* (Paris, Charpentier, 1887; reprinted Paris, Robert Laffont, 1989), 3 vols.

Hartley, Antony (ed.), *Mallarmé's Complete Poems* (London, Penguin Books, 1965).

Hichens, Robert, *The Green Carnation* (New York, 1894).

Huysmans, J.-K., *A Rebours* (Paris, 1884); translated by Robert Baldick as *Against Nature* (London, Penguin Books, 1959).

de Montesquiou, Robert, *Les Roseaux Pensants* (Paris, 1897).

Moréas, Jean, 'Un Manifeste Littéraire, le Symbolisme', *Le Figaro*, 18 September 1886

(reprinted in Henri Dorra, 1994 – see page 1 of this volume's bibliography).

Morice, Charles, *La Littérature de tout à l'heure* (Paris, 1889).

Morris, William, *News from Nowhere* (London, Kelmscott Press, 1891).

Nietzsche, Friedrich, *Twilight of the Idols* (1889; English edition translated by R.J. Hollingdale, London, Penguin Books, 1956; reprinted London, Penguin Books, 1968).

Nietzsche, Friedrich, *Thus Spoke Zarathrustra* (London, Dent & Son, 1958).

Nordau, Max, *Degeneration* (New York, 1895).

Pater, Walter, *The Renaissance* (London, Macmillan, 1873).

Péladan, Joséphin, *Typhonia* (Paris, Dentu, 1892).

Péladan, Joséphin, *L'Art idéaliste et mystique* (Paris, 1894).

Ruskin, John, *Complete works.* 34 volumes (London, George Allen, 1903).

Retté, Adolphe, *Aspects* (Paris, Bibliothèque Artistique et Littéraire, 1897).

Rimbaud, Arthur, *Une saison d'enfer; Illuminations; Oeuvres diverse* (1873; this edition Paris, Presse Pocket, 1982).

Rousseau, J.J., *A Discourse on the Moral Effects of the Arts and Sciences* (Paris, 1750); translated by G.D.H. Cole as *The Social Contract and the Discourses* (London, Everyman, 1993).

Stoker, Bram, *Dracula: A Tale* (London, 1897; London, Penguin Books, 1993).

Symons, Arthur, *The Symbolist Movement in Literature* (London, 1897).

Veblen, Thorstein, Bund, *The Theory of the Leisure Class* (1899; reprint New York, Dover, 1994).

Verlaine, Paul, *Les Poètes maudits* (Paris, 1888).

Verlaine, Paul, *Hommes et femmes (Femmes*, 1890; *Hommes*, 1904; translated by Alistair Elliot, London, Anvil Press Poetry, 1979) .

Verneuil, M.P., *L'Animal dans la décoration* (Paris, Librairie Centrale des Beaux-Arts, 1898).

Wilde, Oscar, *The Picture of Dorian Gray* (London, 1890).

Wilde, Oscar, *Salome, a Tragedy in One Act*, illustrated by Aubrey Beardsley (London: Elkin Mathews & John Lane, 1894).

Wilde, Oscar, *The Sphinx* (London: Elkin Mathews & John Lane, 1894).

Zola, Émile, *L'Assommoir* (Paris, 1876; reprint London, Penguin Books, 1970).

SECONDARY SOURCES: LITERARY, ARTISTIC AND SOCIAL

Abraham, P. and Desné, R., *Histoire littéraire de la France. Vol.10: 1873–1913* (Paris, Editions Sociales, 1978).

Banham, Reyner, *Theory and Design in the First Machine Age* (London, The Architectural Press, 1960).

Berman, Marshall, *All that is Solid Melts into Air* (London, Verso, 1983).

Berry, James Duncan, 'The Legacy of Gottfried Semper: Studies in Spathistorismus', PhD, Brown University, 1989).

Bertrand, J.P., *Le Roman célibataire, d'A Rebours à paludes* (Paris, Corti, 1996).

Blühm, Andreas et al., *The Colour of Sculpture 1840–1910* (Amsterdam, Van Vogh Museum, 1996).

Birnie Danzker, Jo-Anne, *Loïe Fuller: Getanzler Jugendstil* (Munich, Museum Villa Stuck, Prestel, 1995).

Bowler, Peter, *Evolution: The History of an Idea* (Berkeley and Los Angeles, University of California Press, 1983).

Briggs, Asa and Snowman, Daniel, *Fin de Siècle: How Centuries End, 1400-2000* (New Haven and London, Yale University Press, 1996).

Campbell, Bruce, F., *Ancient Wisdom Revived: A History of the Theosophical Movement* (Berkeley

and Los Angeles, University of California Press, 1980).

Cassou, Jean, Languy, Émile and Pevsner, Nikolaus, *Les Sources du 20ème Siècle* (Paris, Éditions des Deux Mondes, 1961).

Christiansen, Rupert, *Tales of the New Babylon* (London, 1994).

Clair, Jean et al., *L'Âme au corps: arts et sciences 1793–1993* (Paris, Gallimard, 1993).

Cranston, Sylvia, *The Extraordinary Life and Influence of Madame Blavatsky* (London, Tarcher, 1993).

Cumming, Elizabeth and Kaplan, Wendy, *The Arts and Crafts Movement* (London, Thames & Hudson, 1991).

Desmond A. and Moore, C., *Darwin* (London, Michael Joseph, 1991).

Djikstra, Bram, *Idols of Perversity: Fantasies of Feminine Evil in the Fin de Siècle* (Oxford, Oxford University Press, 1986).

Donahue, N.H. (ed.), *Invisible Cathedrals: The Expressionist Art History of Wilhelm Worringer* (Pennsylvania, Pennsylvania University Press, 1995).

Dowling, Linda, *Language and Decadence in the Victorian Fin de Siècle* (Princeton, Princeton University Press, 1986).

Dupays, Paul, *Vie prestigieuse des expositions historique* (Paris, Didier, 1939).

Giedion, Siegfried, *Mechanization Takes Command* (Oxford, Oxford University Press, 1948).

Goldwater, Robert, *Symbolism* (New York, Harper & Row, 1989).

Greenhalgh, Paul, *Ephemeral Vistas: Expositions Universelles, Great Exhibitions and Worlds Fairs 1851–1939* (Manchester, Manchester University Press, 1988).

Hamon, Philippe, *Expositions: Literature and architecture in nineteenth-century France* (Berkeley and Oxford, University of California Press, 1992).

Herrmann, Wolfgang, *Gottfried Semper: In Search of Architecture* (Cambridge, Massachusetts, The MIT Press, 1989).

Herbert, E.W., *The Artist and Social Reform: France, Belgium, 1885–1898* (New Haven, Yale University Press, 1961).

Heskett, John, *Industrial Design* (London, Thames & Hudson, 1980).

Hitchcock, H.R., *Architecture: Nineteenth and Twentieth Centuries* (London, Pelican, 1958).

Hobsbawm, Eric, *The Age of Empire, 1870–1914* (London, Pelican, 1968).

Hunt, Lynn, *Eroticism and the Body Politic* (Baltimore, The John Hopkins University Press, 1991).

Hunt, Lynn, *The Invention of Pornography* (New York, Zone, 1993).

Isay, Raymond, *Panorama des Expositions Universelles* (Paris, Gallimard, 1937).

Kaplan, Wendy (ed.), *Designing Modernity: The Arts of Reform and Persuasion, 1885–1945* (London, Thames & Hudson, 1995).

Kern, Stephen, *The Culture of Love* (Cambridge, Massachusetts, Harvard University Press, 1992).

Kracauer, Siegfried, *The Mass Ornament* (Suhricamp Verlag, 1963; Cambridge, Massachusetts, Harvard University Press, 1995).

Kumar, Krishan, *Utopia and Anti-Utopia in Modern Times* (Oxford, Blackwell, 1987).

MacKenzie, John, *Orientalism, History, Theory and the Arts* (Manchester, Manchester University Press, 1995).

Mikulas and Porter (eds), *The Industrial Revolution in Context* (Cambridge, Cambridge University Press, 1996).

Olender, Maurice, *The Languages of Paradise: Race, Religion and Philology in the Nineteenth Century*, translated by Arthur Goldhammer (Cambridge, Massachusetts, Harvard University Press, 1992).

de Palacio, Jean, *Pierrot fin de siècle, ou les métamorphoses d'un masque* (Paris, Seguier, 1990).

de Palacio, Jean, *Formes et figures de la décadence* (Paris, Seguier, 1994).

Pepall, Rosalind, *Lost Paradise. Symbolist Europe* (Montreal, Museum of Fine Arts, 1995).

Pevsner, Nikolaus, *Pioneers of Modern Design from William Morris to Walter Gropius* (London, Penguin Books, 1936; London, Penguin Books, 1960).

Pingeot, A. and Hoozee, R., *Paris-Bruxelles, Bruxelles-Paris: Réalisme, Impressionisme, Symbolisme, Art Nouveau* (Antwerp, Fond. Mercator, 1997).

Pooley, C.P. (ed.), *Housing Strategies in Europe 1880–1930* (Leicester, Leicester University Press, 1992).

Pronier, Ernest, *Une vie au théâtre: Sarah Bernhardt* (Geneva, Éditions Alex Jullien, 1936).

Pykett, Lyn, *Reading Fin-de-Siècle Fictions* (London, Longman, 1992).

Rewald, John, *Post-Impressionism; From Van Gogh to Gauguin* (New York, MOMA, 1962).

Richards, R.J., *Darwin and the Emergence of Evolutionary Theories of Mind and Behaviour* (Chicago, University of Chicago Press, 1987).

Showalter, Elaine, *Sexual Anarchy: Gender and Culture in the Fin de Siècle* (London, Virago, 1990).

Showalter, Elaine (ed.), *Daughters of Decadence* (London, Virago, 1993).

Stone, Norman, *Europe Transformed: 1878–1919* (London, Fontana, 1983).

Sweetman, John, *The Oriental Obsession* (Cambridge, Cambridge University Press, 1987).

Timmers, Margaret (ed.), *The Power of the Poster* (London, V&A Publications, 1998).

Trebilcock, Clive, *The Industrialiazation of the Continental Powers, 1780–1914* (London, Longman, 1981).

Union centrale des Arts Décoratifs, Paris, *Le Livre des Expositions Universelles, 1851–1989* (Paris, 1983).

Young, R.M., *Darwin's Metaphor: Nature's Place in Victorian Culture* (Cambridge, Cambridge University Press, 1985).

Texts by Nation

Austria

JOURNALS

Der Architekt (1895–1914, Vienna)
Das Interieur (1900–15, Vienna)
Kunst und Kunsthandwerk (1898–1924, Vienna)
Ver Sacrum (1898–1903, Vienna)
Wiener Bauindustrie Zeitung (1883–1904, Vienna)

PRIMARY MATERIALS

Bahr, Hermann, *Secession* (Vienna, Wiener Verlag, 1900).

Hevesi, Ludwig, 'Die Wiener Secession und ihr "Ver Sacrum"', *Kunstgewerbeblatt*, 10 May 1899, Leipzig, pp.141–53.

Hevesi, Lajos, *Acht Jahre Sezession* (March 1899–June 1905), (Verlagsbuchhandlung Carl Konegen, Vienna, 1906; reprinted Briecha, O., Ritter Verlag, Klagenfurt, 1984).

Hevesi, Lajos, *Altkunst-Neukunst: Wien 1894–1908* (Verlagsbuchhandlung Carl Konegen, Vienna, 1909).

Hoffmann, Josef, *Einfache Möbel*, *Das Interieur* (Vienna, 1901), vol.2, pp.193–208.

Holme, Charles, (ed.) 'The Art Revival in Austria', *The Studio*, London, 1906.

Kossatz, H.H., 'The Vienna Secession and its early relations with Great Britain', *Studio International*, vol.181, no.929, London, pp.9–20.

Loos, Adolf, 'Ornament and Crime, 1908', in *Programmes and Manifestos on 20th-Century Architecture* (London, Lund Humphries, 1964), pp.19–24.

Lux, J.A., 'XIV. Kunstausstellung der Vereinigung Bildender Künstler Österreichischen Secession', *Deutsche Kunst und Dekoration*, vol.10, no.1, Darmstadt 1902, p.457 ff.

Lux, J.A., *Otto Wagner* (Munich, 1914).

SECONDARY SOURCES

Arts Council of Great Britain, *The Architecture of Adolf Loos* (London, Arts Council of Great Britain, 1985).

Behal, Vera, *Möbel der Jugendstil, Sammlung des Österreichisches Museums für Angewandte Kunst* (Munich, Prestel Verlag, 1981).

Billcliffe, R. and Vergo, P., 'Charles Rennie Mackintosh and the Austrian Art Revival', *The Burlington Magazine 119*, November 1977, London, pp.739–44.

Clair, Jean, Vienne, *1880–1938: L'Apocalypse joyeuse, catalogue d'exposition* (Paris, Centre Georges Pompidou, 1986).

Eisler, Max, 'Joseph Hoffmann, 1870–1920', *Wendingen 3* (Special Issue) August–September 1920, Amsterdam, p.4 ff.

Eisler Max, *Gustav Klimt* (Vienna, Staatsdruckerei, 1920).

Fanelli, Giovanni and Godoli, Ezio, *La linea viennese: grafica art nouveau* (Florence, Cantini, 1989).

Fischer Fine Art, London, *Vienna Turn of the Century Art and Design* (London, 1979).

Fischer Fine Art, London, *Vienna: A Birthplace of 20th century Design. Part I: Purism and Functionalism, Konstruktiver Jugendstil* (London, 1981).

Franzke, Irmela, *Jugendstil, Glas, Graphik, Keramik, Metall, Möbel, Skulpturen und Textilien von 1880 bis 1915* (Karlsruhe, Badisches Landesmuseum, 1987).

Historisches Museum der Stadt Wien, Vienna, *Traum und Wirklichkeit: Wien, 1870–1930.* . (Vienna, 1985).

Lux, J.A., *Die Moderne Wohnung und Ihre Ausstattung* (Vienna and Leipzig, Wiener Verlag, 1905).

Neuwirth, Waltraud, *Das Glas des Jugendstils: Sammlung des Österreichichen Museums für Angewandte Kunst, Wien* (Munich, Prestel Verlag, 1973).

Neuwirth, Waltraud, *Österreichische Keramik des Jugendstils: Sammlung des Österreichischen Museums für Angewandte Kunst, Wien* (Munich, Prestel Verlag, 1974).

Neuwirth, Waltraud, *Wiener Werkstätte: Avantgarde, Art Deco, Industrial Design* (Vienna, Neuwirth, 1984).

Novotny, Fritz, and Dobal, Johannes, *Gustav Klimt: with a catalogue raisonné of his paintings* (New York and Washington, Frederick A. Praeger, 1968).

Pabst, Michael, *Wiener Grafik um 1900* (Munich, 1900).

Powell, Nicolas, *The Sacred Spring. The Arts in Vienna 1898–1918* (London, Studio Vista, 1974).

Schmuttermeier, Elisabeth (ed.), *Wiener Werkstätte Atelier Viennois 1903–1932* (Brussels, 1987).

Schorske, Carl, *Fin-de-Siècle Vienna: Politics and Culture* (London, Weidenfeld & Nicolson, 1961).

Schweiger, Werner, *Wiener Werkstätte, Design in Vienna, 1903–1932* (London, Thames & Hudson, 1984).

Sekler, Eduard, *Josef Hoffmann, The Architectural Work* (Princeton, Princeton University Press, 1985).

Varnedoe, Kirk, *Vienna 1900: Art, Architecture and Design* (New York, The Museum of Modern Art, 1986).

Vergo, Peter, *Art in Vienna 1898–1918: Klimt, Kokoschka and their Contemporaries* (London, Phaidon Press, 1975, 1993, 1994).

Völker, Angela, *Wiener Mode und Modefotografie: Die Modeabteilung der Wiener Werkstätte 1911–1932* (Vienna, Österreichisches Museum für Angewandte Kunst, 1984).

Völker, Angela, *Textiles of the Wiener Werkstätte, 1910–1932* (New York, Rizzoli, 1994).

Wagner, Otto, *Modern Architecture*, introduction and translation by Harry Francis (Malibu, Getty Center Publications, 1988).

Waissenberger, *Wien 1870–1930* (Salzburg and Vienna, Residenz Verlag, 1984).

Weiser, Armand, *Joseph Hoffmann* (Geneva, 1930).

Wieland Schmied, *Nach Klimt, Schriften zur Kunst* (Salzburg, Galerie Welz, 1979).

Whitford, Frank, *Gustav Klimt* (London, Thames & Hudson, 1990).

Belgium

JOURNALS

L'Art Belge (1902, Brussels)
L'Art et la vie (1881–1914, Brussels)
L'Art moderne (1881–1914, Brussels)
L'Émulation (1874, Brussels)
La Basoche, revue littéraire et artistique (1884–86, Brussels)
La Wallonie (1886–92, Brussels)

PRIMARY MATERIALS

Centre National pour l'étude du XIXème siècle, Brussels, *Catalogue des dix Expositions annuelles Les Vingts Bruxelles* (Brussels, 1981).

Conrardy Charles and Thibaut, Raymond, 'Paul Hankar, 1859–1901', in *La Cité*, June and July 1923.

Destrée, Jules, *Révolution verbale et révolution pratique* (Brussels, Henri Lamertin, 1913).

Dumont-Wilden, L., *Fernand Khnopff* (Brussels, G. van Oest & Cie, 1907).

Geffroy, Gustave, *Catalogue de l'exposition de l'art appliqué Liège* (Liège, 1905).

Khnopff, Fernand, 'Belgian book-plates', *The Studio*, Special Issue, winter 1898–99.

Maus, Madeleine (ed.), *Trente années de lutte pour l'art, 1884–1914* (Brussels, Librairie l'Oiseau Bleu, 1926).

Maus, Octave, 'Habitations Modernes', *L'Art moderne*, 22 July 1900.

Maus, Octave, *L'Art et la vie en Belgique 1830–1905* (Brussels, 1929).

Maus, Octave and Soulier, 'Gustave, L'art décoratif en Belgique, MM. Paul Hankar et Adolphe Crespin', *Art et décoration*, September 1897, pp.86–96.

Sedeyn, E., Victor Horta, *L'Art décoratif*, March 1902, pp.230–42.

Serrurier-Bovy, Gustave, *Album d'interieur*, Liège (undated, Belgium).

Soulier, Gustave, 'Serrurier-Bovy', *Art et décoration*, no.4, 1898, pp.78–85.

Thiebault-Sisson, 'L'Art décoratif en Belgique. Un novateur: Victor Horta', *Art et décoration*, 1897, pp.11–18.

Verheren, Émile, *Quelques notes sur l'oeuvre de Fernand Khnopff, 1881–1887* (Brussels, Veuve Monnom, 1887).

Van de Velde, Henry, *Déblaiement d'Art* (Brussels: first published in pamphlet form, 1894; reprinted and expanded 1895; this edition Archive Architecture Moderne, undated).

Van de Velde, Henry, *Geschichte meines Lebens* (Munich, 1962).

Wouters, de Bouchout and Chevalier de, *L'Art Nouveau et l'enseignement* (Malines, 1903).

SECONDARY SOURCES

Aubry, Françoise, *Victor Horta à Bruxelles* (Brussels, Racine, 1996).

Aubry, Françoise and Vandenbreeden, Jos, *Victor Horta: Art Nouveau to Modernism* (Brussels and New York, Palais des Beaux-Arts and Harry N. Abrams, 1996).

Borsi, Franco, 'Guimard et Horta' in *Guimard: colloque international Musée d'Orsay, 1992* (Paris, Musée d'Orsay, 1994), pp.329–52.

Borsi, Franco and Wieser, Hans, *Bruxelles, Capitale de l'Art Nouveau* (Brussels, Atelier Vokaer, 1971).

Borsi, Franco and Portoghesi, P., *Victor Horta* (Brussels, Atelier Vokaer, 1970 and 1990).

Bruggemans, J. and Vandenbreeden, Jos, *Victor Horta, Architect* (Brussels, 1970).

Cohen, M., *Victor Horta* (Bologna, 1994).

Culot, Maurice and Terlinden, F., *Antoine Pompe et l'effort moderne en Belgique 1890–1940* (Brussels, Musée d'Ixelles, 1969).

Delchavelier, Charles, 'Gustave Serrurier-Bovy', *Clarté*, no.5, 1930, Brussels.

Delevoy, R., De Cros, C. and Ollinger-Zinque, G., *Fernand Khnopff, catalogue de l'oeuvre* (Brussels, Cosmos Monographie/Leber Hossmann, revised and expanded edition, 1987).

Delevoy, Robert, *Victor Horta* (Brussels, Monographies de l'Art Belge, 1958).

Delhaye, J. and Dierkens-Aubry, Françoise, *La Maison du Peuple de Victor Horta* (Brussels, Atelier Vakaer, 1987).

Demey, Thierry, Bruxelles, *Chroniques d'une capitale en chantier* (Brussels, Paul Lergrain/Éditions CFC, 1990).

Dernie, D. and Carew-Cox, A., *Victor Horta* (London, Academy Editions, 1995).

Dierkens-Aubry, Françoise and Vandenbreeden, Jos, *Art Nouveau in Belgium: Architecture and Interior Design* (Belgium, Duculot, 1991).

Draguet, Michel, *Splendeur de l'idéal: Idéalisme et Symbolisme en Belgique, Rops, Khnopff, Delville et leur temps* (Brussels, SDZ, Musée de l'Art Wallon, undated).

Eidelberg, M. and Henrion-Giele, S., 'Horta and Bing, An Unwritten Episode of l'Art Nouveau', *The Burlington Magazine*, November 1977, pp.747–56.

Elaut and Possemiers, *Op Wandez door de Belle*

Epoque: Antwerpen, Berchem, Cogels Osylei (Brussels, de Standaard, 1988).

Guiot, Marc (ed.), *Architectes Schaerbeekois: Maîtres de l'Art Nouveau* (Brussels, CRHU, Schaerbeek, undated).

Hammacher, A.M., *Le Monde de Henri Van de Velde* (Antwerp, 1967).

Hanser, D.A., 'The early works of Victor Horta: the origins of Art Nouveau Architecture', PhD thesis, University of Illinois at Urbana-Champaign, 1994.

Helbig, J., 'Notes sur l'évolution de la céramique en Belgique. 1850–1950', *Revue Belge d'archeologie et d'histoire de l'art*, vol. XIX, 1950, Brussels, pp.212–18.

Henrion-Giele, S., 'La Maison de Victor Horta dans le contexte de son époque', *Cahiers Henry Van de Velde*, no.12, 1973, pp.3–14.

Horta, Victor, *Mémoires*, edited by Duliere, C. (Brussels, 1985).

Kroller-Muller Museum, *Henri Van de Velde* (Otterloo, Kroller-Muller Museum, 1964).

Kunstgewerbemuseum, Zurich, *Henry Van de Velde 1863–1957* (Zurich, 1958).

Lemaire, C., 'Architecture en rupture de tradition', *Bulletin de la Fédération des Industries Belges*, September 1970, pp.277–96.

Loyer, Françoise, *Paul Hankar* (Brussels, Archives d'Architecture Moderne, 1986).

Loze, P. and F., *Belgique Art Nouveau. De Victor Horta et Antoine Pompe* (Ghent, Snoeck-Ducaju, 1991).

Loze, Pierre, *Guide de Bruxelles XIXe et Art Nouveau* (Brussels, Atelier Vokaer, undated).

Martiny, V.G., *La Société Centrale d'Architecture de Belgique depuis sa fondation, 1872–1974* (Brussels, SCAB, 1974).

de Maeyer, C., *Paul Hankar* (Brussels, Éditions Meddens, 1963).

Musées Royaux d'Art et d'Histoire, Brussels, *Philippe et Marcel Wolfers. De l'Art Nouveau à l'Art Deco* (Brussels, 1992).

Musées Royaux des Beaux-Arts de Bruxelles, Brussels, *Bruxelles, Les Vingts et la Libre Esthétique. Cent ans après* (Brussels, 1993).

Nishizawa, F., 'Victor Horta', *Architecture and Urbanism*, vol. I, no. 4, April 1971, pp.85–97.

Oostens-Wittamer, Yolande, *La Belle Époque: Belgian posters, watercolours and drawings* (Washington, IEF, 1970).

Oostens-Wittamer, Yolande, *Horta, L'Hôtel Solvay* (Louvain-la-Neuve, Collège Érasme, 1980), 2 vols.

Palais des Beaux Arts, Brussels, *Art Nouveau Belgique* (Brussels, 1980).

Philippe, Joseph, *Le Val-Saint-Lambert: ses cristalleries et l'art du verre en Belgique* (Liège, Eugène Wahle, 1974).

Portoghesi, P. and Wieser, H., *Bruxelles, Capitale de l'Art Nouveau* (Brussels, Atelier Vokaer, 1971 and 1992).

Puttemans, P. and Herve, L., *Architecture moderne en Belgique* (Brussels, Atelier Vokaer, 1974).

Ranieris, L., *Léopold II urbaniste* (Brussels, Hayez, undated).

Robert-Jones, Philippe, *Fernand Khnopff et ses rapports avec la Sécession Viennoise* (Brussels, Musées Royaux des Beaux-Arts de Bruxelles and CNEDS, Leberhossmann, 1987).

Robert-Jones, Philippe (ed.), *Bruxelles fin-de-siècle* (Paris, Flammarion, 1994).

Schneede, Marina, 'Henri Van de Velde', in *An Zeih Ungs Krafts* (Munich, Munich Stadtmuseum, 1987).

Sembach, Klaus-Jurgen, *Henry Van de Velde* (London, Thames & Hudson, 1989).

Sembach, Klaus-Jurgen and Schulte, Birgit, *Henry Van de Velde* (Hagen, Karl Ernst Osthaus Museum, 1992).

Watelet, Jacques-Grégoire, *Gustave Serrurier-Bovy, architecte et décorateur 1858-1910* (Brussels, Palais des Académies, 1974).

Watelet, Jacques-Grégoire, *Serrurier-Bovy* (London, Lund Humphries, 1987).

Britain

JOURNALS

The Architectural Review (1896, London)
The Artist (1880–1902, London)
The Art Journal (1839–1912, London)
Arts and Crafts (1904–06, London)
The Dial (1889–97, London)
The Dome (1897–1900, London)
The Hobby Horse (1883–93, London)
Journal of Industrial Progress (1853, Dublin)
The Magazine of Art (1878–1904, London)
The Modern Style (1902, London)
The Pageant (1896–97, London)
The Poster (1898–1900, London)
The Poster and Art Collector (1898–1901, London)
The Studio (1893, London)
The Savoy (1896, London)
The Yellow Book (1894–97, London)

PRIMARY MATERIALS

Chesneau, Ernest, *The English School of Painting* (London, Cassell, 1885).

Crane, Walter, *The Claims of Decorative Art* (London, Lawrence & Bullen, 1892).

The Crystal Palace Exhibition Illustrated Catalogue (London, 1851; reprinted New York, Dover, 1970).

Destrée, Olivier, *Les Préraphaélites: notes sur l'art décoratif et la peinture en Angleterre* (Brussels, 1894).

Dresser, Christopher, *The Principles of Decorative Design* (London, Cassell, 1873).

Gallatin, A.E., *Aubrey Beardsley's Drawings: A Catalogue and a List of Criticism* (New York, A.S. Wiener, 1903; reissued and expanded 1945).

Geddes, P., *Cities in Evolution* (London, 1910).

Godwin, Edward, W., *Art Furniture* (London, B.T. Batsford, 1877).

Hamilton, Walter, *The Aesthetic Movement in England* (London, Reeves & Turner, 1882).

Helix, 'The Industrial Exhibition of 1851', *Westminster and Quarterly Review*, April 1850.

Hulme, F. Edward, *Art Instruction in England* (London, Longmans, Green & Co., 1882).

Marillier, H.C., *The Early Works of Beardsley* (London, The Bodley Head, 1899).

Martin, David, *Glasgow School of Painters* (London, 1897).

Montgomery Hyde, H. (ed.), *The Trials of Oscar Wilde* (London, William Hodge, 1948).

Mourey, Gabriel, *Passé le Detroit: La Vie et l'Art à Londres* (Paris, Ollendorf, 1895).

Mourey, Gabriel, *D.G. Rossetti et les Préraphaélites Anglais* (Paris, H. Laurens, 1910).

National Association for the Advancement of Art and its Application to Industry, London, *Transactions* (London, 1888, 1889 and 1890). Published lectures by Ashbee, Crane, Day, Cobden-Sanderson, Mackmurdo, Morris.

The Official Descriptive and Illustrated Catalogue of the Exhibition of the Industry of all Nations (London, 1851), 4 vols.

Redgrave, Richard, *Manual of Design* (London, Chapman & Hall, 1876).

Spielmann, Sir Isidore, *Paris International Exhibition 1900: The Royal Pavilion* (London, Royal Commission, 1900).

Spielmann, M.H., *John Ruskin* (London, Cassell, 1900).

Spielmann, M.H. and Layard, G.S., *The Life and Work of Kate Greenaway* (London, 1905).

Sizeranne, Robert de la, *La Peinture Anglaise contemporaine* (Paris, Hachette, 1895).

Symons, Arthur, *Aubrey Beardsley* (London, 1898).

Symons, Arthur, *Studies in Seven Arts* (London, 1906).

Vallance, Aymer, *Aubrey Beardsley: Fifty Drawings* (London, Leonard Smithers, 1897).

Wilde, Oscar, *Essays and Lecturers* (London, Methuen, 1908).

Wilde, Oscar, 'The Truth of Masks' in *Intentions* (London, 1891).

Wilde, Oscar, *Art and Decoration* (London, Methuen, 1920).

'The Work of Christopher Dresser', *The Studio*, vol. XV, 1898, pp.104–14.

Yapp, G.W., *Art Education at Home and Abroad* (London, Chapman & Hall, 1852).

SECONDARY SOURCES

Anderson and Koval, *James McNeill Whistler: Beyond the Myth* (New York, Carroll & Graf, 1994), p.215.

Aslin, Elizabeth, *The Aesthetic Movement* (London, Paul Elek, 1975).

Baker, Malcolm, (ed.), *A Grand Design: The Making of the Collections of the Victoria and Albert Museum* (New York and London, Harry N. Abrams and V&A Publications, 1997; reissued V&A Publications, 1999).

Brett, David, *C.R. Mackintosh: The Poetics of Workmanship* (London, Reaktion Books, 1992).

British Art and Design 1900–1960 (London, V&A Publications, 1983).

Burdett, Osbert, *The Beardsley Period* (London, The Bodley Head, 1925).

Burkhauser, Jude (ed.), *Glasgow girls: Women in Art & Design, 1880–1920* (Edinburgh, Canongate, 1990).

Calloway, Stephen, *Aubrey Beardsley* (London, V&A Publications, 1998).

Carter, E., 'Arthur Mackmurdo', *Journal of the Royal Institute of British Architects*, vol.II, April 1942, London.

Crawford, Alan, *By Hammer and Hand: The Arts and Crafts Movement in Birmingham* (Birmingham, Birmingham Museum and Art Gallery, 1984).

Crawford, Alan, *C.R. Ashbee: Architect, Designer and Romantic Socialist* (New Haven and London, Yale University Press, 1985).

Crawford, Alan, *Charles Rennie Mackintosh* (London, 1995).

Cummming, Elizabeth, and Kaplan, Wendy, *The Arts and Crafts Movement* (London, Thames & Hudson, 1991).

Davey, Peter, *Arts and Crafts Architecture: The Search for Earthly Paradise* (London, The Architectural Press, 1980).

Denis, Raphael, 'The South Kensington System' (PhD, University of London, Courtauld Institute, 1996).

Dormant, Richard, *Alfred Gilbert* (New Haven and London, Yale University Press, 1985).

Dormer, Peter (ed.), *The Culture of Craft* (Manchester, Manchester University Press, 1997).

Dowling, Linda, *Language and Decadence in the Victorian Fin de Siècle* (Princeton, Princeton University Press, 1986).

Eadie, William, *Movements of Modernity: The Case of Glasgow and Art Nouveau* (London and New York, Routledge, 1990).

Ellmann, Richard, *Oscar Wilde* (London, Penguin Books, 1987).

Farr, Dennis, *English Art 1870-1940* (Oxford, Clarendon, 1978).

Gaunt, William and Clayton-Stamm, M., *William De Morgan* (London, 1971).

Gere, Charlotte and Whiteway, Michael, *Nineteenth Century Design from Pugin to Mackintosh* (London and New York, Weidenfeld & Nicolson and Harry N. Abrams, 1993).

Gloag, John, *Victorian Taste* (London, A&C Black, 1961).

Greenwood, Martin, *The Designs of William De Morgan* (Ilmister, Richard Dennis, 1989).

Halen, Vidar, *Christopher Dresser* (London, Phaidon Press, 1999).

Harris, Bruce (ed.), *The Collected Works of Aubrey Beardsley* (New York, Bounty, 1967).

Helland, Janice, *The Studios of Frances and Margaret Macdonald* (Manchester, Manchester University Press, 1996).

Howarth, Thomas, *Charles Rennie Mackintosh and the Modern Movement* (London, Routledge & Kegan Paul, 1952).

Jenkyns, Richard, *The Victorians and Ancient Greece* (London, Blackwell, 1980).

Jenkyns, Richard, *Dignity and Decadence: Victorian Art and the Classical Inheritance* (London, HarperCollins, 1991).

Jennings, Humphrey, *Pandaemonium: The Coming of the Machine as Seen by Contemporary Observers* (London, André Deutsch, 1985).

Kaplan, Wendy (ed.), *Charles Rennie Mackintosh* (Glasgow Museums, Abbeville Press, 1996)

Kinchin, Perilla and Kinchin, Juliet, *Glasgow's Great Exhibitions: 1888, 1901, 1901, 1938, 1988* (Wendlebury, White Cockade, 1988).

Lambourne, Lionel, *The Aesthetic Movement* (London, Phaidon Press, 1997).

Long, Helen, *The Edwardian House* (Manchester, Manchester University Press, 1993).

MacCarthy, Fiona, *The Simple Life* (London, Lund Humphries, 1981).

MacCarthy, Fiona, *British Design Since 1880* (London, Lund Humphries, 1982).

MacCarthy, Fiona, *William Morris* (London, Faber & Faber, 1996).

Macaulay, Robertson, P. (ed.), *Charles Rennie Mackintosh, the Architectural Papers* (Glasgow, The Hunterian Art Gallery, 1990).

Macfall, Haldane, *Aubrey Beardsley, The Man and the Works* (London, 1928).

MacKenzie, John, *Propaganda and Empire: The Manipulation of British Public Opinion 1880–1960* (Manchester, Manchester University Press, 1984).

Merrill, Linda, *A Pot of Paint: Aesthetics on Trial in Whistler v. Ruskin* (Washington, Smithsonian Institute Press, 1959), p.295-96.

Naylor, Gillian, *The Arts and Crafts Movement: a study of its sources, ideals, influence on design theory* (London, Studio Vista, 1971).

Nuttgens, P. (ed.), *Mackintosh and his Contemporaries* (London, John Murray, 1988).

Parry, Linda, *Textiles of the Arts and Crafts Movement* (London, Thames & Hudson, 1988).

Parry, Linda (ed.), *William Morris* (London, Philip Wilson and V&A Publications, 1996).

Reade, Brian, *Aubrey Beardsley*. Introduction by John Rothenstein. (London, Studio Vista, 1966).

Robertson, Pamela (ed.), *Charles Rennie Mackintosh: The Architectural Papers* (Glasgow, The Hunterian Art Gallery, 1990).

Schmutzler, Robert, 'The English Origins of Art Nouveau', *The Architectural Review*, vol.CXVII, no.698, February 1955, pp.108–17.

Service, Alaistair, *Edwardian Architecture and its Origins* (London, The Architectural Press, 1975).

Sparrow, Walter Shaw, 'William de Morgan and His Pottery', *The International Studio*, no.8, 1899, pp. 222–31.

Thompson, Edward Percy, *William Morris: Romantic to Revolutionary* (London, Merlin, 1955).

Tilbrook, A.J., *The Designs of Archibald Knox for Liberty* (London, Richard Dennis, 1995).

Tillyard, Stella, *The Impact of Modernism: The Visual Arts in Edwardian England* (London, Routledge, Kegan & Paul, 1988).

Upstone and Wilton (eds), *The Age of Rossetti, Burne-Jones and Watts: Symbolism in Britain 1860-1910* (London, Tate Gallery, 1997).

Watkinson, Ray, *William Morris as Designer* (London, Trefoil, 1990).

Central and Eastern Europe

PRIMARY MATERIALS

Bishop Bury, *Russian Life Today* (London and Milwaukee, 1915).
Kotěra, Jan, 'O novum umĕni', *Volné smĕry*, vol.IV, 1900, Prague, p.189.
Kotěra, Jan, *Meine une meiner Schüler Arbeiten, 1898–1901* (Vienna, 1902).
Kotěra, Jan, 'Interier c.k. Umĕleckoprumyslové skoly prazský pro Svátovou vystavu v St Louis 1904', *Volné smĕry*, vol. VIII, 1904, Prague, p.119.
Pazaurek, Gustav, *Moderne Gläser* (Leipzig, 1901).
Šalda František Xaver, 'Smysl dnesni t.zv, renaissance umĕleckoprumyslu' *Volné smĕry*, vol.VII, 1903, Prague, pp.137-38.

SECONDARY SOURCES

Adlerova, Alena, *Česká secese. Užité umĕni* (Umĕleckoprumyslové Museum, Prague, 1981)
Arwas, Victor, *Alphonse Mucha: Master of Art Nouveau* (New York, Saint Martin's Press, 1986).
Bakonyi, T. and Kubiszy M., *Ödön Lechner* (Budapest, 1981).
Bansky Kiss, E. *et al.*, *Zsolnay: Ungarische Jugendstilkeramik* (Vienna, 1986).
Borisova, Elena A. and Sternin Grigory, *Russian Art Nouveau* (New York, Rizzoli, 1988).
Bowlt, J., *The Silver Age: Russian Art of the Early Twentieth Century and the World of Art Group* (Newtonville, Oriental Research Partners, 1979).
Bradley, Joseph, *Muzhik and Moscovite Urbanization in Late Imperial Russia* (Berkeley and Los Angeles, University of California Press, 1985).
Brumfield, William Craft, *The Origins of Modernism in Russian Architecture* (Berkeley and Los Angeles, University of California Press, 1991).
Cooke, Catherine, 'Shekhtel in Kelvingrove and Mackintosh on the Petrovka. Two Russo-Scottish Exhibitions at the Turn of the Century', *Scottish Slavonic Review*, no.10, spring 1988, pp.177–205.
Crowley, David, *National Style and Nation-state: Design in Poland from the Vernacular Revival to the International Style* (Manchester, Manchester University Press, 1992).
Csenkey, Éva, *Zsolnay Szecessziós Kérámiak* (Budapest, 1992).
Dumova, Nataliia, *Moskovskie metsenaty* (Moscow, Molodaia gvardiia, 1992).
Ellridge, Arthur, *Mucha: le triomphe du modern style* (Paris, Terrail, 1992).
Éri, G. and Jobbágyi, Z. (eds), *A Golden Age: Art And Society in Hungary 1896–1914* (Budapest and London, Corvina and Barbican Art Gallery, 1990).
Gerle, Janos *et al.*, *A Szâzadforduló Magyar Épitészete, Szépirodalmi Könyvkiado* (Budapest, Bonex, 1990).
Hanak, Peter, *The Garden and the Workshop: Essays on the cultural history of Vienna and Budapest* (Princeton, Princeton University Press, 1998).
Hárs, E., *Zsolnay Kerámia* (Budapest, Felelös Kiadó, 1992).
Howard, Jeremy, *The Union of Youth* (Manchester, Manchester University Press, 1992).
Hungarian Museum of Architecture, Budapest, *Ödön Lechner, 1845–1914* (Budapest, 1988).
Krastins, J., *Jugendstil in der Rigaer Baukunst* (Michelstadt, 1992).
Kennedy, Janet, *The Mir Iskusstva Group and Russian Art* (New York, Garland, 1977).

Keserü, Katalin, 'The Workshops of Gödöllö: transformations of a Morrisian Theme', *Journal of Design History*, vol.1, no.1, 1988, pp.1–23.
Kirichenko, Evgenia, *Russian Design and the Fine Arts 1750–1931* (New York, Harry N. Abrams, 1991).
Kohomoto, S. *et al.*, *Panorama: Architecture and Applied Arts in Hungary 1896–1916* (Kyoto, 1995).
Kusák, Dalibor, *Mucha* (Prague, BB/art, 1992).
Lukacs, John, *Budapest 1900. A Historical Portrait of a City and its Culture* (London, Weidenfeld & Nicolson, 1993).
Mallgrave, H.F. (ed.), *Otto Wagner: Reflections on the Raiment of Modernity* (Paris, Getty Center Programme Publications, 1993).
Mansbach, S. (ed.), *Standing in the Tempest: Painters of the Hungarian Avant Garde 1908–1930* (Santa Barbara, 1991).
Miklos, E., *Picturesque Hungary* (Budapest, Cserépfalvi, 1934).
Moravánszky, Ákos, *Competing Visions: Aesthetic Invention and Social Imagination in Central European Architecture, 1867–1918* (Cambridge, Massachusetts, The MIT Press, 1998).
Mucha, Jiri, *Alphonse Mucha, His Life and Art* (London, Academy Editions, 1989).
Musée du Petit Palais, Paris, *L'Art 1900 en Hongrie* (Paris, 1976–77).
Novotný, Otakar, *Jan Kotĕra a jeho doba* (Prague, 1958).
Raeburn, Michael, *The Twilight of the Tsars* (London, Hayward Gallery, 1991).
Rennert, Jack and Weil, Alain, *Alphonse Mucha: The Complete Posters and Panels* (Boston, G.K. Hall, 'A. Hjert & Hjert Book' series, 1984).
Ricke, H. (ed.), *Lötz Böhmisches Glas 1880–1940* (Munich, Werkmonografie, 1989).
Salmond, Wendy R., *Arts and Crafts in Late Imperial Russia: Reviving the Kustar Art Industries, 1870–1917* (New York and Cambridge, Cambridge University Press, 1996).
Sármány-Parsons, Ilona, 'The Influence of the British Arts and Crafts Movement in Budapest and Vienna', in *Acta Historia Artium*, no.33, 1987–88, pp.181–98.
Svozil, Bohumil, *Česká basnicka moderna* (Prague, 1987).
Szabadi, Judit, *Art Nouveau in Hungary* (Budapest, Corvina, 1989).
Thurston, Robert W., *Liberal City, Conservative State: Moscow and Russia's Urban Crisis, 1906–14* (Oxford, Oxford University Press, 1987).
Varga, Vera, *Róth Miksa Müvészete* (Budapest, Helikon, 1993).
Vlček, Tomáš, *Praha 1900* (Prague, Panorama, 1986).
Vitochová, M. *et al.*, *Prague Art Nouveau* (Prague, 1993).
Vokacová, V. *et al.*, *Prager Jugendstil* (Heidelberg, 1992).
West, James L. and Iurii A. Petrov (eds), *Merchant Moscow. Images of Russia's Vanished Bourgeoisie* (Princeton, Princeton University Press, 1992).
Wittlich. P., *Česká Secese* (Prague, Odeon, 1982).
Wittlich, P., *Prague: Fin de siècle* (Paris, Flammarion, 1992).

France

JOURNALS

L'Ameublement (1870–1902, Paris)
L'Art appliqué (French edition of *Modern Stil*, 1903–05, Paris)
L'Art décoratif (1898–1914, Paris)
Art et décoration (1897–1938, Paris)
L'Art et les artistes (1905–19, Paris)
L'Art et l'idée (1892, Paris)
Le Bijou (1874–1914, Paris)

L'Estampe et l'affiche (1897–99, Paris)
Gazette des beaux-arts (1859–1947, Paris)
L'Imagier (1894–96, Paris)
Nancy–Artiste (1882, Nancy)
L'Oeuvre d'art (1893–99, Paris)
La Plume (1899–1913, Paris)
La Revue blanche (1891–1903, Paris)
Revue de l'Art (1897–1937, Paris)
La Revue de l'art ancien et moderne (1897–1937, Paris)
Revue des art décoratifs (1880–1902, Paris)
La Revue encyclopédique (1895–1905, Paris)

PRIMARY MATERIALS

Adam, Paul, *La morale de Paris* (Paris, l'Édition moderne, Librairie Ambert (after 1900).
Alexandre, Arsène and Jean Carriès, *Histoire d'une oeuvre et d'une vie* (Paris, 1895).
Babelon, Ernst et al, *L'Art à l'Exposition Universelle* (Paris, Librairie de l'Art Ancien et Moderne, Rouam & Cie, 1900).
Champier, Victor, *Les expositions d'art à l'Exposition Universelle de 1889* (Paris, 1890).
Cherbuliez, Victor, *L'Art et la nature* (Paris, 1892).
Croal, D. Thomson, 'The Paris Exhibition 1900', *The Art Journal Special*, 1901, London.
Denis, Maurice, *Théories 1890–1910* (Paris, 1920).
Doat, Taxile, *Grand feu céramique* (Paris and Syracuse, 1905).
Escholier, Raymond, *Le Nouveau Paris, la vie artistique de la cité moderne* (Paris, undated).
Exposition de l'École de Nancy, catalogue officiel illustré (Paris, Pavillon de Marsan, 1903).
de Fourcaud, Louis, *Émile Gallé* (Paris, Librairie de l'Art Ancien et Moderne, 1903).
Frantz, Henry, 'Émile Gallé and the Decorative Artists of Nancy', *The Studio*, vol.XXVIII, 1903, London.
Gaillard, Eugène, *A propos du Mobilier* (Paris, 1908).
Gallé, Émile, *Écrits pour l'art, 1884–89* (Paris, 1908).
Gallé, Émile, 'Les Salons de 1897', *Gazette des beaux-arts*, vol.18, September 1897, pp.229–50.
Gallé, Émile, *Exposition de l'École de Nancy à Paris, 1ère série* (Paris, Le Mobilier, 1901).
Geffroy, Gustave, *Les Industries artistiques françaises et étrangères à l'Exposition Universelle de 1900* (Paris, 1901).
Gillet, Louis, 'Émile Gallé: Le Poème du verre', *La Revue hebdomadaire*, vol.XIX, 1910, Paris.
Grasset, Eugène, 'Eugène Grasset', *La Plume*, no.12, 15 May 1894, pp.114.
de Goncourt, Edmond and Jules, *French Eighteenth-Century Painters* (1948; London, Phaidon Press, 1981).
Henrivaux, J., *La Verrerie à l'Exposition Universelle de 1900* (Paris, E.Bernard & Cie, 1902).
Hovelaque, Émile, 'The Life and Work of Jean Carriés', *The Architectural Review*, vols III and IX, 1897–99, London.
Koechlin, Raymond, *Le Pavillon de l'Union Centrale des Arts Décoratifs à l'Exposition de 1900* (Paris, 1900).
Larroumet, Gustave, *L'Art et l'État en France* (Paris, 1895).
Maindron, Ernest, *Les Affiches illustrées 1886–1895* (Paris, Librairie Artistique, 1896).
Marx, Roger, 'L'Estampe originale', *Le Voltaire*, 4-5 April 1893.
Marx, Roger, 'Les Maîtres décorateurs français, René Lalique', *Art et décoration*, vol.6, 1899.
Marx, Roger, *La Décoration et les industries d'art à l'Exposition Universelle de 1900* (Paris, Delagrave, 1901).
Marx, Roger, *L'Art social* (Paris, Charpentier, 1913).
Mauclair, Camille, 'La Réforme de l'art

décoratif en France', *La Nouvelle Revue*, no.98, January–February 1896, pp.724–46.
Mourey, Gabriel, *Les Arts de la vie et le règne de la laideur* (Paris, Ollendorff, 1899).
Mourey, Gabriel, 'L'Art décoratif à l'Exposition Universelle', *La Revue encyclopédique*, no.10, 1900, pp.801–10.
Musées Nationaux de France, *Encyclopédie de la fleur, les fleurs et les fruits photographiques et groupes d'après nature* (Paris, c.1896).
Nocq, Henri, 'Tendances nouvelles. Enquête sur l'évolution des industries d'art', in *Journal des Artistes*, September 1894, Paris.
Ramiro, Erastène, *Catalogue descriptif et analytique de l'oeuvre gravé de Félicien Rops* (Paris, Conquêt, 1887).
Ramiro, Erastène, *Supplément au catalogue de l'oeuvre gravé de Félicien Rops* (Paris, Floury, 1895).
Renan, Ary and Gustave Moreau, *Gazette des beaux-arts*, 1900, Paris.
Sedeyn, Émile, *Le Mobilier* (Paris, F.Rieder & Cie, 1921).
Signac, Paul, 'Hector Guimard: L'art dans l'habitation moderne, le Castel Béranger', *La Revue blanche*, 15 February 1899, pp.317–19.
Soulier, Gustave, 'Quelques meubles d'Eugène Gaillard', *Art et décoration*, vol.111, 1902.
Soulier, Gustave, 'Croquis d'intérieurs', *L'Art décoratif*, no.41, February, 1902.
Uzanne, Octave, 'Les Décorateurs originaux de ce temps, un maître potier Auguste Delaherche', *L'Art et l'idée*, no.1, January–June 1892, pp.81–90.
Uzanne, Octave, 'Auguste Delaherche', *L'Art moderne*, no.12, 1892, pp.85–86.
Varenne, Gaston, 'La Pensée et l'art d'Émile Gallé', *Mercure de France*, Paris, 1910.

SECONDARY SOURCES

Abdy, Jane, *The French Poster* (London, Studio Vista, 1969).
Alexandre, Arsène, *Paul Gauguin, sa vie et le sens de son oeuvre* (Paris, Bernheim-Jeune, 1930).
Alexandria, Virginia, *Art Nouveau Jewellery by René Lalique* (The International Exhibitions Foundation, 1985).
Amishai-Maisels, Ziva, *Gauguin's Religious Themes* (New York, Garland, 1985).
Arwas, Victor, *Berthon and Grasset* (London, Academy Editions, 1978).
Bacri, Clothilde *et al.*, *Daum, Masters of French Decorative Glass* (London, Thames & Hudson, 1993).
Barten, Sigrid *et al.*, *René Lalique, Jewellery, Glass* (Paris, Musée des Arts Décoratifs, 1991).
Becker, Vivienne, *The Jewellery of Lalique* (London, Goldsmiths' Company, 1987).
Bellanger, Patrice (ed), *Jean-Joseph Carriès, 1855–1894* (Paris, 1997).
Bernier, G., 'Ses Amis et ses artistes', *La Revue blanche* (Paris, Hazan, 1991).
Bodelsen, Merete, 'Gauguin Ceramics in Danish Collections', in *Det danske Kunstindustrimuseum Virksomhed* (Copenhagen, Munksgaard, 1960), pp.91–124.
Bodelsen, Merete, *Gauguin's Ceramics. A Study in the Development of his Art* (London, Faber & Faber, 1964).
Bodelsen, Merete, 'Sèvres-Copenhagen, Crystal Glazes and Stoneware at the Turn of the Century', in *Royal Copenhagen Porcelain 1775–1795* (Copenhagen, Royal Copenhagen Porcelain Factory, 1975), pp.59- –88.
Borsi, Franco, *Paris 1900* (Brussels, Vokaar, 1976).
Borsi, Franco and Godoli, Ezio, *Paris: Art Nouveau, architecture et décoration* (Paris, 1978, 1989).
Bouvier, Roselyne, *Majorelle, une aventure moderne* (Paris, La Bibliothèque des Arts et Éditions Serpenoise, 1991).

Boyer, Patricia Ecker (ed.), *The Nabis and the Parisian Avant-Garde* (New Brunswick and London, Rutgers University Press, 1988).

Broderie et tissus (Nancy, Musée de l'École, 1980).

Brunhammer, Yvonne, *Viollet-le-Duc* (Paris, Grand Palais, 1980).

Brunhammer, Yvonne and Tise, Suzanne, *The Decorative Arts in France. La Société des Artistes Décorateurs, 1900–42* (New York, Rizzoli, and Paris, Flammarion, 1992).

Brunhammer, Yvonne, *The Jewels of Lalique* (Paris and New York, Flammarion, 1998).

Charpentier, Françoise-Thérèse, *Émile Gallé, industriel et poète 1846–1904* (Nancy, Universite de Nancy II, 1978).

Charpentier, Françoise-Thérèse, *La Céramique de Gallé* (Nancy, Musée de l'École de Nancy, 1984).

Charpentier, Françoise-Thérèse and Debize, Christian, *Art Nouveau, l'École de Nancy* (Paris, Serpenoise, 1987).

Charpentier, Françoise-Thérèse and Thiébaut, Philippe, *Gallé* (Paris, Musée du Luxembourg, 1985).

D'Albis, Jean, *Céramique impressionniste, l'atelier Haviland de Paris-Auteuil, 1873–1882* (Paris, 1975).

D'Albis, Jean, *Ernest Chaplet, un céramiste Art Nouveau* (Paris, Presses de la Conaissance, 1976).

Decaudin, Michel, *La Crise des valeurs Symbolistes. Vingt ans de poésie française* (Paris, Privat, 1960).

Devigne, Roger, 'La lettre et le décor du livre pendant la période 1880–1905', *Arts et métiers graphiques*, LIV, 1936, Paris.

Duncan, Alaistair, *Louis Majorelle: Master of Art Nouveau Design* (New York, Thames & Hudson, 1989).

Duncan, Alaistair, *The Paris Salons 1895–1914. Jewellery, The Designers* (Woodbridge, Antique Collectors' Club, 1994), 2 vols.

Dusinberre, Deke, *René Lalique: Jewellery, Glass* (Paris, Musée des Arts Décoratifs, 1991).

Ellridge, Arthur, *Mucha: The Triumph of Art Nouveau* (Paris, Terrail, 1992).

Eisenmann, Stephen, *Gauguin's Skirt* (1997).

Exsteens, Maurice, *L'oeuvre gravé et lithographie de Félicien Rops* (Paris, Éditions Pellet, 1928).

Ferré, Felipe, Rheims Maurice and Vigne Georges, *Hector Guimard architecte* (Paris, Bibliothèque des Arts, 1988).

Fondation Paul Ricard, *Paris, l'art et la vie en France: la Belle Époque* (Paris, Bendor, 1971).

Galerie du Luxembourg, Paris, *L'Oeuvre de Rupert Carabin, 1862–1932* (Paris, 1974).

Garner, Philippe, *Émile Gallé* (London, Academy Editions, 1976, 1990).

Garvey, Eleanor, 'Art Nouveau and the French Book of the Eighteen Nineties', *Harvard Library Bulletin*, vol. XII, no.3, 1958, Cambridge, Massachussetts, p.379.

de Gary, Marie-Noelle, *Fouquet 1860–1960, Schmuck-Künstler in Paris* (Zurich, Museum Bellerive, 1984).

Grady, James, 'Hector Guimard: An overlooked Master of Art Nouveau', *Apollo*, April 1969, pp.284–95.

Greenhalgh, Paul (ed.), *Modernism in Design* (London, Reaktion Books, 1993).

Guerin, Daniel, *Paul Gauguin: Writings of a Savage* (New York, Viking, 1978; reprinted 1996).

Herbert, R.L., 'Seurat and Jules Chéret', *Art Bulletin*, vol.40, no.2, June 1958, pp.156–8.

Humbert, Agnes, *Les Nabis et leur époque, 1888–1900* (Geneva, P.Cailler, 1954).

Isay, Raymond, *Panorama des Expositions Universelles* (Paris, Gallimard, 1937).

Koch, Michael *et al.*, *The Belle Époque of French Jewellery, 1850–1910* (London, Thomas Heneage & Co., 1990).

Joyant, Maurice, *Henri de Toulouse-Lautrec*,

1864–1901 (Paris, Helleu et Sergent, 1922, vols. I-II).

Levin, Miriam, R., *When the Eiffel Tower Was New: French Visions of Progress at the Centennial of the Revolution* (Massachussetts, Mount Holyoke College Art Museum, 1990).

Lehni, N. and Martin, E., *F.R. Carabin, 1862–1932* (Strasbourg, Musée de Strasbourg, 1993).

Loevgren, Sven, *The Genesis of Modernism: Seurat, Gauguin, Van Gogh and French Symbolism in the 1880s* (Stockholm, 1959; New York, Hacker Books, 1983).

Loyer, François, *Paris, XIXe siècle: L'immeuble et la rue* (Paris, Hazan, 1987).

Loyer, François and Guéné, Hélène, *Henri Sauvage: les immeubles à gradins* (Liège, Mardaga, 1987).

Mandell, R.D., *Paris 1900: The Great Worlds Fair* (Toronto, University of Toronto Press, 1967).

Marcilhac, Félix, *René Lalique 1860–1945, Maître-Verrier. Analyse de l'oeuvre et catalogue raisonné* (Paris, Éditions de l'amateur, 1989).

Marx, Roger, *Les Maîtres de l'affiche 1896–1900*, with an introduction by A. Weill (Paris, Editions du Chêne, 1978).

Millar, Michael, *The Bon Marché: Bourgeoise Culture and the Department Store 1869–1920* (Princeton, Princeton University Press, 1981).

Millman, Ian, *Georges de Feure, maître du Symbolisme et de l'Art Nouveau* (Courbevoie, ACR Éditions, 1992).

Mortimer, Tony, *Lalique: Jewellery and Glassware* (London, Pyramid, 1989).

Naylor, Gillian *et al.*, *Hector Guimard* (London, 1978).

Olivié, Jean-Luc, 'The discovery of an unknown collection of Émile Gallé's glass', in *Royal Glass* (Copenhagen, Christianborg Palace, 1995), pp.232–59.

Orsay, Musée d', *Colloque international* (Paris, Musée d'Orsay, 1994).

Pickvance, Richard, *Gauguin and the School of Pont Aven* (Indianapolis Museum of Art, 1994).

Possémé, Evelyne, 'Le Salon du bois du Pavillon de l'Union Centrale des Arts Décoratifs l'Exposition Universelle de 1900', *La Revue de l'art ancien et moderne*, vol.3, no.117, 1997.

Richardson, J., *Seurat. Paintings and Drawings* (London, Artemis, 1978).

Rudorff, Raymond, *Belle Époque: Paris in the Nineties* (London, Hamish Hamilton, 1972).

Silverman, Debora, 'The Brothers de Goncourts, Maison d'un Artiste, French Art Nouveau Between History and the Psyche, 1869–1889', *Arts Magazine*, no.59, May 1985, pp.119–29.

Stadtmuseum, Munich, *Nancy 1900, Jugendstil in Lothringen* (Munich, 1980).

Thiébaut, Philippe and Nonne, Monique, *Gallé* (Paris, Éditions de la Réunion des Musées Nationaux, 1985).

Thiébaut, Philippe, *Guimard* (Paris, Éditions de la Réunion des Musées Nationaux, 1992).

Thomas, Valerie, *L'École de Nancy, 1889–1909* (Paris, Éditions de la Réunion des Musées Nationaux, 1999).

Vaisse, Pierre, *La Troisième République et les peintres* (Paris, Flammarion, 1995).

Vigne, Georges, *Hector Guimard et l'Art Nouveau* (Paris, 1990).

Weber, Eugène, *Peasants into Frenchmen: The Modernisation of Rural France, 1870–1914* (London, Chatto & Windus, 1977).

Weisberg, Gabriel, 'Bing's Craftsman Workshops: A Location and Importance Revealed', *Source 3*, autumn 1983.

Weisberg, Gabriel, *Art Nouveau Bing, Paris Style 1900* (New York and Washington, Harry N. Abrams and SITES, 1986).

Weisberg, Gabriel, 'Siegfried Bing and Industry: The Hidden Side of Art Nouveau', *Apollo*, vol.78, November 1988.

Williams, Rosalind, *Dream Worlds: Mass Consumption in 19th-century France* (Chicago, University of Chicago Press, 1982).

Zeldin, Theodore, *France, 1848–1945* (2 vols: Oxford, Oxford University Press, 1973 and 1977; 5 vols: Oxford, Oxford University Press, 1979).

Germany

JOURNALS

Die Architektur des XX. Jahrhunderts (1901–14, Berlin)

Avalun (1901, Munich)

Dekorative Kunst (1897–1929, Munich)

Dekorative Vorbilder (1889–1915, Stuttgart)

Deutsche Kunst und Dekoration (1897–1932, Darmstadt)

Die Kunst (1899–1940)

Das Kunstgewerbe (1890–95, Dresden)

Die Kunst unserer Zeit (1889–1912, Munich)

Die Jugend (1896–1920, Munich, vols 1–25)

Der Moderne Stil (1899–1905, Stuttgart)

Pan (1895, Berlin)

Simplicissimus (c.1896, Munich)

PRIMARY MATERIALS

Bode, Wilhelm, 'Hermann Obrist', *Pan*, Special Edition, 1896, Berlin.

Bornstein, P., *Am Ende des Jahrhunderts* (Berlin, 1901).

Eckmann, Otto, *Neue Formen: Dekorative Entwürfe für die Praxis* (Berlin, 1897).

Endell, August, 'Formenschönheit und Dekorative Kunst', *Dekorative Kunst*, vol.2, 1898, pp.119–25.

Endell, August, 'Architektonische Erstlinge', *Die Kunst*, vol.2, 1900, pp.297–317.

Fendler, F., 'Um Wiener-Sezession', *Berliner Architektur-Welt*, Special Issue, 1901, Berlin.

Fuchs, G., 'Hermann Obrist', *Pan*, no.1, vol.5, 1896–97, pp.318–25.

Haeckel, Ernst, *Kunstformen der Natur* (Leipzig and Vienna, 1899-1903; many editions).

Joseph, David, *Geschichte der Baukunst des XIX. Jahrhunderts* (Leipzig, 1910).

Koch, Alexander, *Darmstadt, eine Stätte moderner Kunsbestrebungen*, (Darmstadt, 1905).

Krumbholz, K., *Das Vegetable Ornament* (1879).

Logan, M., 'Hermann Obrist's Embroidered Decorations', *The Studio*, vol.9, no.44, November 1896, pp.98-105.

Luthmer, F., *Blütenfornformen als Motive für Flächenornament* (Frankfurt, 1893).

Lux, Joseph August, *Das Neue Kunstgewerbe in Deutschland* (Leipzig, 1908).

Lux, Joseph August, *Joseph Maria Olbrich* (Berlin, Wasmuth, 1919).

Meurer, M., *Pflanzenformen* (Berlin, 1895).

Muthesius, Herman, 'Kunstgewerbe, Jugendstil und bürgerliche Kunst', *Die Rheinlande*, vol.VII, 1903-04, p.53.

Obrist, Hermann, *Neue Möglichkeiten in der Bildenden Kunst, 1896–1900* (Leipzig, 1903).

Obrist, Hermann, 'Die Lehr – und Versuch – Ateliers für Angewandte Kunst', *Dekorative Kunst*, vol.12, 1904.

Pazaurek, G., *Moderne Gläser* (Leipzig, 1901).

Schultze, Otto, 'Jugendstil-Sünden', *Kunst und Handwerk*, 1901–02, Munich.

Schultze-Naumburg, P., 'Der Sezessionsstil', *Der Kunstwart*, vol.XV, part 1, 1901–02, Munich, p.326.

Wechsler, Alfred, *Modernes Kunstgewerbe* (Strasbourg, Heitz, 1901).

SECONDARY SOURCES

Bauer, Richard, *Prinzregentenzeit: München und die Münchner in Fotografien* (Munich, Verlag C.H. Beck, 1988).

Danzker, J. Birnie, *Die Villa Stuck in München* (Munich, Bayerische Vereinsbank, 1992).

Danzker, J. Birnie, *Franz von Stuck, Die Sammlung des Museums Von Stuck* (Munich, Museum Villa Von Stuck, 1997).

Dingelstedt, Kurt, *Jugendstil in der angewandten Kunst: ein Brevier* (Braunschweig, Klinkhardt & Biermann, 1959).

Eschmann, Karl, *Jugendstil: Ursprünge, Parallelen, Folgen, Göttingen* (Muster-Schmidt, 1991).

Evans, R.J., *Society and Politics in Wilhemine Germany* (London, Harper & Row, 1978).

Grönwoldt, Ruth, *Art Nouveau: Textil-Dekor um 1900* (Stuttgart, Württembergisches Landesmuseum, 1980).

Günther, Sonja, *Interieurs um 1900: Bernhard Pankok, Bruno Paul und Richard Riemerschmid als Mitarbeiter der Vereinigten Werkstätten für Kunst im Handwerk* (Munich, 1971).

Günther, Sonja, *Bruno Paul 1874–1968* (Berlin, Gebr. Mann, 1992).

Hermand, Jost (ed.), *Jugendstil: Einforschungsbericht 1918–1964* (Stuttgart, 1965).

Hiesinger, Kathryn Bloom (ed), *Art Nouveau in Munich* (Philadelphia and Munich, Philadelphia Museum of Art and Prestel-Verlag, 1988).

Hilschenz, H., *Das Glas des Jugendstils, Katalog der Sammlung Hentrich im Kunstmuseum Düsseldorf* (Munich, 1973).

Himmelheber, Georg, *Die Kunst des deutschen Möbels. Vol.3: Klassizismus, Historismus, Jugendstil* (Munich, Prestel-Verlag, 1983).

Lenman, Robin, 'Politics and Culture: the State and the Avant-Garde in Munich 1886–1914', pp.90–111 in Evans, R.J. (ed.), *Society and Politics in Wilhemine Germany* (London, Harper & Row, 1978).

Makela, Maria, *The Munich Secession: Art and Artists in Turn-of-the-Century Munich* (Princeton, Princeton University Press, 1990).

Museum of Arts and Crafts, Frankfurt, *Jugendstil* (Frankfurt, 1955).

Naylor, G., *The Bauhaus Re-assessed* (London, The Herbert Press, 1985).

Nerdinger, Winfried, *Richard Riemerschmid vom Jugendstil zum Werkbund* (Munich, Prestel-Verlag, 1982).

Nöhbauer, Hans F., *Munich: City of the Arts* (Munich, Hirmer Verlag, 1994).

Ottomeyer, Hans, *Jugendstil Möbel* (Munich, Prestel-Verlag, 1988). Catalogue of the furniture in the Munich Stadtmuseum.

Ottomeyer, Hans (ed.), with Margot Brandlhuber, *Wege in die Moderne: Jugendstil in München, 1896–1914* (Munich and Berlin, Klinkhardt & Biermann Verlagsbuchhandlung, GmbH, 1997).

Paret, P., *The Berlin Secession: Modernism and its Enemies in Imperial Germany* (Cambridge, Massachusetts, Belknap Press, 1980).

Seling, Helmut (ed.), *Jugendstil. Der Weg ins 20. Jahrhundert* (Heidelberg, 1959).

Textile Museum, Krefeld, *Stoffe um 1900* (Krefeld, 1977).

Wichmann, Hans, *Deutsche Werkstätten und WK-Verband, 1898–1990* (Munich, Prestel Verlag, 1992).

Wichmann, Hans, *Von Morris bis Memphis: Textilien der Neuen Sammlung Ende 19. Bis Ende 20. Jahrhundert* (Munich and Basel, Birkhäuser Verlag, 1990). Based on the collections in the Staatliches Museum für angewandte Kunst.

Wichmann, S., *Jugendstil Art Nouveau: Floral and Functional Forms* (Boston, Little Brown, 1984).

Wingler, H.M. (ed.), *Kunstschulreform, 1900–33* (Berlin, Studio Reihe, 1977).

Japan and Japonism

JOURNALS

Bing, Samuel (sic), *Le Japon artistique* (English: London, Sampson, Low, Marston, Searle & Rivington Ltd, 1886), 6 vols.

PRIMARY MATERIALS

Alcock, Rutherford, *Art and Industries in Japan* (London, Virtue & Co, 1878).

Anderson, William, *The Pictorial Arts of Japan* (London, Sampson, Low, Marston, Searle & Rivington, 1886).

Brinckmann, Justus, *Kunst und Handwerk in Japan* (Berlin, R. Wagner, 1889).

Commission Impériale du Japon à l'Exposition Universelle de Paris 1900, *Histoire de l'art Japonais* (Paris, Maurice de Brunoff, 1900).

Dresser, Christopher, *Japan: Its Architecture, Art and Art Manufactures* (London, Longmans, Green & Co., 1882).

de Goncourt, Edmond, *Outamaro, le Peintre des Maisons Vertes* (Paris, Bibliothéque Charpentier, 1891).

de Goncourt, Edmond, *Hokousai* (Paris, Bibliothéque Charpentier, 1896).

Gonse, Louis, *L'Art Japonais* (Paris, A. Quantin, 1883).

Hearn, Lafcadio, *Glimpses of Unfamiliar Japan* (Boston and New York, Houghton, Mifflin & Co., 1894).

Huisch, Marcus, *Japan and its Art* (London, The Fine Art Society Ltd., 1889).

Jarves, James Jackson, *A Glimpse at the Art of Japan* (New York, Hurd & Houghton, 1876).

Liberty, Arthur Lasenby, 'A lecture on the "Art productions of Japan" delivered by Mr Lasenby Liberty, June 1, in the building of the Bijitsu Kiokai, at Sakuragaoka, Uyeno, Tokio', *Journal of the Society of Arts*, vol.XXXVII, 12 July 1889, pp.694–97.

Liberty, Arthur Lasenby, 'The Industrial Art and Manufactures of Japan', *Journal of the Society of Arts*, vol.XXXVIII, 6 June 1890, pp.673–84.

Lowell, Percival, *The Soul of the Far East* (Boston and New York, Houghton, Mifflin & Co., 1893).

Menpes, Mortimer, *Japan: A Record in Colour* (London, A&C Black, 1901).

Migeon, Gaston, *Chefs-d'Oeuvre d'art Japonais* (Paris, D.A. Longuet, 1905).

Morse, Edward, *Japanese Homes and their Surroundings* (Boston, Ticknor & Co., 1886).

Objets d'art du Japon et de la Chine, peintures, livres: textes réunis par T. Hayashi. Sale catalogue. (Paris, 1902).

Revon, Michel, *Étude sur Hokusai* (Paris, Lecéne, Oudin & Cie, 1896).

Vever, Henri, *La Bijouterie Française au XIXème siècle* (Paris, H. Floury, 1908).

de Wyzewa, Teodor, *Les Peintres de Jadis et d'aujourd'hui* (Paris, Perrin & Cie, 1903).

SECONDARY SOURCES

Berger, Klaus, *Japonisme in Western Painting from Whistler to Matisse* (Cambridge, New York, Port Chester, Melbourne and Sydney, Cambridge University Press, 1992).

Conant, Ellen P., 'Émile Guimet's Mission to Japan, a cultural context for Japonisme', in Conroy, Davis and Pattersons (1984 – see below).

Conroy, Davis and Pattersons (eds), *Japan in Transition: Thought and Action in the Meiji Era, 1862–1912* (Rutherford, New Jersey, Fairleigh Dickinson University Press, 1984).

Evett, Elisa, *The Critical Reception of Japanese Art in Late Nineteenth-Century Europe* (Ann Arbour, Michigan, UMI Research Press, 1982).

Finn, Dallas, *Meiji Revisited: The Sites of Victorian Japan* (New York and Tokyo, Weatherhill, 1995).

Galeries Nationales du Grand Palais, Paris, *Le Japonisme* (Paris, Éditions de la Réunion des Musées Nationaux, 1988).

Guth, Christine, *Art, Tea, and Industry: Masuda Takashi and the Mitsui Circle* (Princeton, Princeton University Press, 1993).

Harris, Neil, 'All the World a Melting Pot? Japan at American Fairs, 1876–1904' in Akira Iriye (ed.), *Mutual Images: Essays in American–Japanese Relations* (Cambridge, Massachusetts and London, Harvard University Press, 1975).

Harris, Victor, *Japanese Imperial Craftmen: Meiji Art from the Khalili Collection* (London, British Museum Press, 1994).

Hillier, Jack, *Japanese Prints and Drawings from the Vever Collection* (New York and London, Sotheby Parke Bernet, 1976).

Hosley, William, *The Japan Idea: Art and Life in Victorian America* (Hartford, Connecticut, Wadsworth Atheneum, 1990).

Impey, Oliver and Fairley, Malcom (eds), *Meiji no Takara: Treasures of Imperial Japan* (London, Kibo Foundation, 1995), 5 vols.

Lancaster, Clay, 'Oriental Contribution to Art Nouveau', *The Art Bulletin*, vol.XXXIV, 1952, New York, pp.297–310.

Littlewood, Ian, *The Idea of Japan: Western Images, Western Myths* (London, Secker & Warburg, 1996).

Meech, Julia and Weisberg, Gabriel, *Japonisme comes to America: The Japanese impact on the graphic arts, 1870–1925* (New York and Tokyo, Nelson Atkins Museum of Art, Kansas; The Jane Voorhees Zimmerli Art Museum, New Brunswick; The Setagaya Museum; 1990–91).

Shively, Donald (ed.), *Tradition and Modernization in Japanese Culture* (Princeton, Princeton University Press, 1976).

Takaoka City Museum of Art, Takaoka, *French Painting and Ukiyo-e: The Eye of Tadamasa Hayashi, a Bridge Between Eastern and Western Cultures* (Takaoka, 1996).

Watanabe, Toshio, *High Victorian Japonisme* (New York, Peter Lang, 1991).

Watanabe, Toshio, *Ruskin in Japan: Nature for Art, Art for Life* (Cambridge, Massachusetts, The MIT Press, 1995).

Watanabe, Toshio and Sato, Tomoka, *Japan and Britain: An Aesthetic Dialogue 1850–1930* (London, Lund Humphries, 1991).

Weisberg, Gabriel P., *Japonisme: Japanese Influence on French art, 1854–1910* (Cleveland, Cleveland Museum of Art, 1975).

Wichmann Siegfried, *Japonisme, the Japanese Influence on Western Art since 1858* (London, Thames & Hudson, 1981).

Yamada, Chisaburo (ed.), *Japonisme in Art: An International Symposium* (Tokyo, Committee for the Year 2001 and Kodansha International, 1980).

Yamane, Naito and Clark, Tim, *Rimpa Art from the Idemitsu Collection* (Tokyo and London, British Museum Press, 1998).

The Nordic Nations

PRIMARY MATERIALS

Ahrenburg, J., 'Der Neue Stil in Finland', *Moderne Bauformen*, vol.11, 1904.

Blomstedt, Yrjö and Sucksdorff, Victor, *Karjalaisa Rakennuksia ja Koriste-muotoja* (Helsinki, 1901).

Halén, Widar, *Dragons from the North* (Oslo, Museum of Applied Arts, 1992).

Hildebrand, Hans, *The Industrial Arts of Scandinavia in the Pagan Time* (London, Chapman & Hall, 1892).

Key, Ellen, *Skönhet för alla* (Stockholm, Bonniers, 1899).

Leach, Henry Goddard, 'Sweden. A Nation of Craftsmen', *The Craftsman*, December 1912, pp.295–305.

Lönnrot, Elias, *The Kalevala or Poems of the Kaleva District* (trans. Francis Peabody Magouin, Cambridge, Massachusetts, Harvard University Press, 1963).

National Gallery, Oslo, *Tradisjon og Fornyelse* (Oslo, 1994).

Opstad, Jan-Lauritz, *Norsk Art Nouveau* (Oslo, C. Huitfeldt Forlag, 1979).

Opstad, Jan-Lauritz, *Nordenfjeldske, Kunstindustrimuseum vaerskole og atelier for Kunstvaevning 1898-1909* (Trondheim, Nordenfjeldske Kunstindustrimuseum, 1983).

Worsaae, J.J.A., *Industrial Arts of Denmark* (London, Chapman & Hall, 1882).

SECONDARY SOURCES

Amberg, Anna-Lisa, *Saarisen's Interior Design* (Helsinki, Museum of Applied Art, 1984)

Ateneum, Helsinki, *Lars Sonck 1870–1956, architect* (Helsinki, 1981).

Ateneum, Helsinki, *Alfred William Finch 1854–1930* (Helsinki, 1991).

Ateneum, Helsinki, *Akseli Gallen-Kallela* (Helsinki, 1996).

Boulton-Smith, John, *The Golden Age of Finnish Art* (Helsinki, Otava, 1985).

Christ-Janer, A., *Eliel Saarinen* (Chicago, Chicago University Press, 1948).

Danish Museum of Decorative Art, Copenhagen, *Thorvald Bindesbøll: En dansk pioner* (Copenhagen, 1996).

Danish Museum of Decorative Art, Copenhagen, *Dansk Keramik 1850–1997* (Copenhagen, 1997).

Eriksson, Eva, 'Den Moderna Stadens födelse. Svensk arkitektur 1890–1920', *Birth of the Modern Town: Swedish Architecture 1890–1920* (Stockholm, 1990).

Grytten, Harald, *Jugendbyen Ålesund: The City of Art Nouveau* (Oslo, Arfo, 1997).

Hård af Segerstad, U., *Modern Finnish Design* (London, 1969).

Hård af Segerstad, U., *Carl Larsson's Home* (Stockholm, Granath & Hård, 1975).

Hausen, Marika *et al.*, *Eliel Saarinen, Projects, 1896-1923* (Helsinki, Museum of Finnish Architecture, 1990).

Hausen, Marika with Amberg, Anna-Lisa and Tytti Valtoo, *Hvitträsk – The Home as a Work of Art* (Helsinki, Otava, 1990).

Hidemark, Elisabet Stavenow, *Svensk Jugend* (Stockholm, Nordiska Museet, 1963; reprinted Stockholm, Rekolid, 1991).

Korvenmaa, Pekka, *Innovation versus Tradition. The Architect Lars Sonck, Works and Projects 1900–1910* (Helsinki, Suomen Muinaismuistoyhdistyksen aikakauskirja, 1991).

Kruskopf, E., *100 years of Finnish industrial design: Finnish Society of Crafts and Design 1875–1975* (Helsinki, Otava, 1991).

MacKeith, Peter B. and Kerstin, Smeds, *The Finland Pavilions. Finland at the Universal Expositions 1900–1992* (Helsinki, Kustannus Oy City, 1993).

Martin, Timo and Sivén, Douglas, *Akseli Gallen-Kallela, National Artist of Finland* (Gallen-Kallela Museum, 1996).

McFadden, David R., *Scandinavian Modern Design 1880–1980* (New York, Harry N. Abrams, 1983).

Moorhouse, Jonathan, Carapetian Michael and Ahtola-Moorhouse, Leena, *Helsinki Jugendstil Architecture 1895–1915* (Helsinki, Otava, 1987.)

Munck, Marita and Tamminen, Marketta, *Furniture by Louis Sparre* (Porvoo, Porvoo Museum, 1990).

Musée d'Art Moderne, Paris, *Lumière du Monde, Lumière du Ciel* (Paris, 1998).

Museum of Finnish Architecture, Helsinki, *Saarinen in Finland* (Helsinki, 1984).

Okkonen, Onni, *A.Gallen-Kallela, Elämä ja taide* (Porvoo, Wysoy, 1949).

Palais des Beaux-Arts, Brussels, *Finlande 1900, Peinture, Architecture, Arts Décoratifs* (Brussels, 1974).

Richards, Sir J.M., *A Guide to Finnish Architecture* (London, 1966).

Richards, Sir J.M., *800 years of Finnish Architecture* (London, 1978).

Ringbom, Sixten, *Stone – Style and Truth: The Vogue for Natural Stone in Architecture 1880–1910* (Helsinki, Suomen Muinaismuistoyhdistyksen Aikakauskirja, 1987).

Royal Copenhagen, *Royal Copenhagen at Sophienholm* (Sophienholm, 1996).

Saarinen, Eliel, *Search For Form: A Fundamental Approach to Art* (New York, Reinhold, 1948).

Smeds, Kerstin, *Helsingfors-Paris Finland på världsutställningen 1851–1900* (Vammala, Svenska Litterarsällskapet i Finland, 1996).

Suhonen, Pekka, *Designed by Akseli Gallen-Kallela, Craftsman and Participator* (Espoo, Gallen-Kallela Museum, 1989).

Supinen, M., *A.B. Iris Suuri Yritys* (Sulkava, Kustannusosakeyhtiö Taide, 1993).

Thue, Anniken, *Frida Hansen og de andre* (Oslo, Museum of Applied Arts, 1991).

Wittkop, Gregory and Balmori, Diana, *Saarinen House and Garden: A Total Work of Art* (New York, Bloomfield Hills, 1995).

Southern Europe

JOURNALS

Annuale dei Lavori Publici (1862, Rome)

L'Arte (1898–1901, Rome)

Arte Italiana Decorativa e Industriale (1890–1914, Rome and Venice)

L'Edilizia Moderna (1892, Milan)

Emporium (1895, Bergamo)

PRIMARY MATERIALS

L'Archittera alla Prima Esposizione Internazionale d'Arte Decorativa Moderna, Torino (Turin, Crudo & Lattuada, 1902).

Catalogo della Prima Esposizione Internazionale d'Arte Decorativa Moderna, Torino (Turin, 1902).

Crane, Walter, 'Modern Decorative Art at Turin, General Impressions', *The Magazine of Art*, 1902, pp.488–93.

Fierens-Gevaert, H., 'L'Exposition de Turin', *La Revue de l'art ancien et moderne*, July–December, 1902.

Fratini, Francesca R. (ed.), *Esposizione Torino 1902, Polemiche in Italia sull'Arte Nuova* (Turin, 1903; reprint, Martano, 1970).

Fuchs, G., Koch, A. and Newbery, F., *L'Exposition Internationale des Arts Décoratifs Modernes à Turin 1902* (Darmstadt, Koch, 1902).

'The International Exhibition of Decorative Art at Turin: The Italian Section', *International Studio*, July–October 1902.

Marx, Roger, 'L'Exposition Internationale d'Art Décoratif Moderne à Turin', *Gazette des beaux-arts*, vol.28, December 1902, pp.506–10.

Melani, Alfredo, 'L'Art Nouveau at Turin. An Account of the Exposition', *The Architectural Record*, vol.12, November 1902, pp.585–99; vol.12, December 1902, pp.735–50.

Pica, Vittorio, *L'Arte Decorative all'Esposizione di Torino del 1902* (Bergamo, Istituto Italiano d'Arti Grafiche, 1903).

Puig i Cadalfach, Josep, *L'Arquitectura Romànica a Catalunya* (Barcelona, Institute d'Estudis Catalans, 1909).

SECONDARY SOURCES

Barilli, Renato, *Il Liberty* (Milan, 1966; English edition: London, Hamlyn, 1969).

Bassegoda Nonell, Juan, *El gran Gaudí* (Barcelona, Salvat, 1985).

Bohigas, Oriol, *Resena y catalogo de arquitectura modernista* (Barcelona, Editorial Lumen, 1973, 1983), 2 vols.

Borras, M.L. and Pratz, Joan, *Domènech i Montaner: arquitecto del modernismo* (Barcelona, Editions Poligrafa, 1971).

Bossaglia, R., Godoli, E., and Rosci, M., *Torino 1902: Le Arti Decorative Internaziole del Nuevo Secolo* (Milan, Fabbri Editori, 1994).

Bossaglia, Rossana, *Il Liberty in Italia* (Milan, Alberto Mondadori Editore, 1968; 1998).

Brosio, Valentino, *Lo Stile Liberty in Italia* (Milan, A. Vallardi, 1967).

Casanelles, Eusebi, *Antonio Gaudí: A Reappraisal* (London, Studio Vista, 1967).

Cirici, Alexandre, *El arte modernista catalan* (Barcelona, Ayma Editor, 1951).

Cremona, Italo, *Il tempo dell'art nouveau* (Florence, Valecchi, 1964).

Collins, George, *Antonio Gaudí* (New York, George Braziller Inc., 1960).

Collins, George and Forinas, Maurice F., *A bibliography of Antoní Gaudí and Catalan Movement 1870–1930* (Charlottesville, University of Virginia, The American Association of Architectural Bibliographers, 1973).

Dalisi, Riccardo, *Gaudí: mobili e oggetti* (Milan, Electa, 1979)

Etlin, Richard A., *Modernism in Italian Architecture, 1890–1940* (Cambridge, Massachusetts, The MIT Press, 1991).

De Guttry and Malno, *Il Mobile Liberty Italiano* (Roma-Bari, Editori Laterza, 1983; revised 1994).

Fanelli, Giovanni and Bonito Fanelli, Rosalia, *Il Tessuto Moderno: Disegno, moda, architettura 1890–1940* (Florence, Vallecchi, 1976).

Flores, Carlos, *Gaudí, Jujol y el modernismo Catalán* (Madrid, Aguilar, 1982).

Fratini, Francesca. R., *Torino 1902, Polemiche in Italia sull'Arte Nuova* (Turin, Martano, 1970).

Freixa, Mireia, *El modernismo en España* (Madrid, Cátedra, 1986).

Freixa, Mireia, *Las Vanguardias del Siglo XIX* (Barcelona, Gili, 1982).

Galerie CGER, Brussels, *Antoni Gaudí (1852–1926). .* (Barcelona, Fundacio Caixa de Pensions, 1985).

Godoli, E. and Rosci, M. (eds), *Torino, 1902. Le Arti Decorative Internazionali del Nuovo Secolo* (Milan, Fabbri Editori, 1994).

Kaplan, Temma, *Red City, Blue Period: Social movements in Picasso's Barcelona* (Berkeley and Los Angeles, University of California Press, 1992).

Lacuesta, R. and Gonzalez, A., *Arquitectura modernista en Cataluña. Guía Arquitectura* (Barcelona, Editorial Gustavo Gili, 1990).

Ligtelijn, V. and Saarister, R., *Josep M. Jujol* (Rotterdam, 010 Publishers, 1996).

Meeks, Carroll L.V., 'The Real "Liberty" of Italy: the Stile Floreale', *Art Bulletin*, June 1961, pp.113–30.

Permanyer, L, and Underhill, S., *Gaudí of Barcelona* (New York, Rizzoli, 1997).

Solá-Morales Rubio, Ignasi de, *Gaudí* (Barcelona, Ediciones Poligrafa, 1984).

Solá-Morales Rubio, Ignasi de, *Fin de Siècle Architecture in Barcelona* (Barcelona, Gili, 1992).

Solá-Morales Rubio, Ignasi de, *Jujol* (Barcelona, Ediciones Poligrafa, 1990).

Sterner, Gabrielle, *Antoní Gaudí: Architecture in Barcelona* (New York, Woodbury, 1985).

Weisberg, Gabriel P., *Stile Floreale; the cult of nature in Italian design* (Miami, Florida, The Wolfsonian Foundation, 1988).

Woodward, Christopher, *Barcelona: The Buildings of Europe* (Manchester, Manchester University Press, 1992).

United States of America

JOURNALS

American Architect (1909–21, New York)
American Architect and Building News (1876–1908, Boston)
The Architectural Record (1891– present, New York)
The Craftsman (1901–16, New York)
The International Studio (1897–1931, New York)
The Poster (1896, New York)

PRIMARY MATERIALS

Adams, J.C., 'What a Great City Might Be – A Lesson from the White City', *New England Magazine*, XIV, March 1896, pp.3–13.

Bancroft, H.H., *The Book of the Fair* (Chicago, 1895).

Batchelder, Ernest A., *The Principles of Design* (Chicago, Inland Printer, 1911).

Bing, Siegfried, *Artistic America, Tiffany Glass and Art Nouveau*. Introduction by Robert Koch. (Cambridge, Massachusetts and London, Harvard University Press, 1970).

Croly, Herbert, 'The New World and the New Art', *The Architectural Record*, vol.XII, no.2, June 1902, pp.135–53.

Hamlin, A.D.F., *A History of Ornament* (New York, 1916), 2 vols.

Hopkinson Smith, F., *American Illustrators* (New York, 1892).

Jenney, William Le Baron, 'The Chicago Construction, or Tall Buildings on a Compressible Soil', *Inland Architect and News Record*, vol.XVIII, November 1891, p.41.

de Kay, Charles, *The Art Work of Louis C. Tiffany* (New York, Doubleday, 1914; reprint New York, Apollo, 1987).

Rohlfs, Charles, 'The Grain of Wood', *House Beautiful*, vol.IX, February 1901.

Sargent, Irene, 'The Wavy Line', *The Craftsman*, vol.II, 1902, New York, pp.131–42.

Schuyler, Montgomery, 'State Buildings at the Worlds Fair', *The Architectural Record*, vol.III, July–September 1893, pp.55–71.

St Louis, *Lousiana Purchase Exposition General Report* (Washington, Committee for Industrial Expositions, 1906).

Sullivan, Louis, 'An Unaffected School of Modern Architecture: Will it Come?', *The Artist*, vol.24, January 1899, pp.33-34.

Sullivan, Louis, ' Is our Art a Betrayal Rather than an Expression of American Life?', *The Craftsman*, vol.XV, no.4, pp.402–04.

Sullivan, Louis, *A System of Architectural Ornament According with a Philosophy of Man's Powers* (New York, American Institue of Architects, 1924).

Sullivan, Louis, *Kindergarten Chats and Other Writings* (New York, Scarab Fraternity Press, 1934; reprint New York, Dover, 1979).

Tiffany & Co., *Tiffany Favrile Glass* (New York, Tiffany Studios, 1896).

Tiffany, Louis, C., 'Color and Its Kinship to Sound', *The Art World*, vol.II, no.2, May 1917, pp.142–44.

Waern, Cecilia, 'The Industrial Arts of America: the Tiffany Glass and Decorating Company', *The Studio*, vol.11, no.2, September 1897, pp.156–65, and vol.14, no.63, June 1898, pp.16–21.

Wilde, Oscar, *Decorative Art in America* (New York, Brentano, 1906).

Wright, Frank Lloyd, *Frank Lloyd Wright Collected Writings*, edited by Bruce Brooks, introduction by Kenneth, Frampton (New York, Rizzoli, 1992).

SECONDARY SOURCES

Applebaum, Stanley, *The Chicago Worlds Fair of 1893* (New York, 1980).

Badger, Reid, *The Great American Fair: The Worlds Columbian Exposition and American Culture* (Chicago, Nelson Hall, 1979).

Burke, Doreen Bolger, Freedman, Jonathan and Frelinghuysen, Alice Cooney, *In Pursuit of Beauty: Americans and the Aesthetic Movement* (New York, The Metropolitan Museum of Art, 1986).

Clark, Garth, *American Ceramics, 1876 to the Present* (London, Booth-Clibborn Editions, 1987).

Clark, Garth, *The Mad Potter of Bilioxi: The Art and Life of George E. Ohr* (New York, Abbeville, 1989).

Clark, Garth and M. Hughto, *A Century of Ceramics in the United States, 1878–1978* (New York, Dutton, 1979).

Clark, R.J., *The Shaping of Art and Architecture in 19th-Century America* (New York, MOMA, 1972).

Condit, Carl, *The Chicago School of Architecture: A History of Commercial and Public Building in the Chicago Area, 1875–1925* (Chicago, University of Chicago Press, 1964).

Corn, Joseph and Horrigan, Brian, *Yesterday's Tomorrows: Past Visions of the American Future* (New York, 1984).

Couldray, Vivienne, *The Art of Louis Comfort Tiffany* (London, Quarto, 1989).

Craig, Lois, *The Federal Presence: Architecture, Politics and Symbols in United States Government Building* (Cambridge, Massachusetts, The MIT Press, 1978).

Darling, Sharon S., *Chicago Ceramics and Glass (1871–1933)* (Chicago, Chicago History Society, 1979).

Duncan, Alaistair, Eidelberg, Martin and Harris, Neil, *Masterworks of Louis Comfort Tiffany* (London, Thames & Hudson, 1989).

Everson Museum of Art, *American Ceramics: The Collection of Everson Museum of Art* (New York, Rizzoli, 1989).

Eidelberg, Martin, 'The Ceramic Art of William H. Grueby', *The American Connoisseur*, 1972–73.

Eidelberg. Martin and Mayer, R.R., *Opulence in an Age of Industry: Turn of the Century Decorative Arts in the Sigmund Freeman Collection* (New Brunswick, University of New Jersey Press, 1993).

Evans, Paul, *Art Pottery of the United States* (New York, Scribner, 1974).

Findling, John, *Chicago's Great World Fairs* (Manchester, Manchester University Press, 1994).

Frelinghuysen, Alice Cooney, *Louis Comfort Tiffany at the Metropolitan Museum of Art* (New York, the Metropolitan Museum of Art, 1998).

Harris, Neil *et al.*, *Grand Illusions: Chicago's Worlds Fair of 1893* (Chicago, Chicago Historical Society, 1993).

Haskell, Barbara, *The American Century: Art and Culture 1900–1950* (New York, Whitney Museum of Art, 1999).

Johnson, Diane Chalmers, *American Art Nouveau* (New York, Harry N. Abrams, 1979).

Kaplan, Wendy, *The Art That is Life: The Arts and Crafts Movement in America, 1875–1920* (Boston, Museum of Fine Arts, 1987).

Koch, Robert, *Louis C. Tiffany: Rebel in Glass* (New York, 1964).

Koch, Robert, *Louis Tiffany's Art Glass* (New York, Crown, 1977).

Mayer-Thurman, Christa, *Raiment for the Lord's Service: a thousand years of western vestments* (Chicago, Art Institute of Chicago, 1975).

McGraw Bogue, D., *The Van Briggle Story* (Colorado Springs, 1968).

McKean, Hugh F., *The 'Lost' Treasures of Louis Comfort Tiffany* (New York, Doubleday, 1980).

Mumford, Lewis, *The Roots of Contemporary American Architecture* (New York, Reinhold, 1952).

Mumford, Lewis, *The Brown Decades: A Study of the Arts in America 1865–1895* (New York, Dover Publications, 1971).

Museum of Modern Art (MOMA), New York, *Early Modern Architecture in Chicago, 1870–1910* (New York, 1940).

Peck, H., *The Book of Rookwood Pottery* (New York, Crown Publishers, 1968).

Potter, Norman and Jackson, Douglas, *Tiffany* (London, Pyramid, 1988).

Proddow, Penny and Healy, Debra, *American Jewelry: Glamour and Tradition* (New York, Rizzoli, 1987).

Revi, Albert, *American Art Nouveau Glass* (New York, 1968).

Rydell, Robert, *All the World's a Fair: Visions of Empire at America's International Expositions, 1876–1916* (Chicago, 1984).

Rydell, Robert, *The Books of the Fairs* (Chicago, American Libary Association, 1992).

John and Mabel Ringling Museum, *Louis Comfort Tiffany and His Times* (Sarasota, 1975).

Storrer, William A., *The Architecture of Frank Lloyd Wright: A Complete Package* (Cambridge, Massachusetts, The MIT Press, 1982).

Sullivan, Louis, *Louis H. Sullivan Architectural Ornament Collection, Southern Illinois University* (Edwardsville, Southern Illinois University, 1981).

Tessa, Paul, *The Art of Louis Comfort Tiffany* (Baldock, The Apple Press, 1987).

Twombly, Robert, *Louis Sullivan: His Life and Work* (Chicago, University of Chicago Press, 1986).

Weingarden, L.S., 'Louis H. Sullivan: Investigation of a Second French Connection', *Journal of the Society of Architectural Historians*, vol.39, December 1980, pp.297–303.

Weingarden, L.S., *Louis H. Sullivan: The Banks* (Cambridge, Massachusetts, The MIT Press, 1987).

Wright, Frank Lloyd, *An Autobiography* (London, Quartet, 1977).

Zapata, Janat, *The Jewellery and Enamels of Louis Comfort Tiffany* (London, Thames & Hudson, 1993).

Zukowsky, John (ed.), *Chicago Architecture, 1872–1922: Birth of a Metropolis* (Munich, Prestel Verlag, 1987).

Where the objects are illustrated earlier
in this volume, plate numbers are cited.

Illustrated Object List
Art Nouveau 1890–1914 Exhibition,
National Gallery of Art, Washington

Hector Guimard, *Entrance to the Métropolitain*, c.1898 (detail). Cat no.202.
National Gallery of Art, Washington: Gift of Robert P. and Arlene R. Kogod.

I INTRODUCTION
The Worlds Fair
Paris, 1900

* indicates a variant of a work exhibited at the 1900 Worlds Fair; + indicates a work probably exhibited at the Fair.

I Henrik Bull (Norwegian, 1864–1953) and David Andersen (Norwegian, 1843–1901), *Dragonship jardinière*, 1899–1900, silver. 23.1 × 90 × 33.7 cms; 9$^{1}/_{8}$ × 35$^{7}/_{16}$ × 13$^{1}/_{4}$ ins. The Oslo Museum of Applied Arts. Pl. 1.6.

2 Pierre-Adrien Dalpayrat (French, 1844–1910), *Vase, c.*1900, stoneware with gilt bronze mounts on mahogany stand. 99.1 cms; 39 ins. Collection of Joseph Holtzman, New York. +

3 Ödön Farago (Hungarian, active 1896–1935), *Cabinet*, 1900, poplar and wrought iron. 198.5 × 118 × 51 cms; 78$^{1}/_{8}$ × 46$^{7}/_{16}$ × 20$^{1}/_{16}$ ins. V&A, London. Pl. 24.5, center left.

4 Georges De Feure (French, 1868–1943), *La Verrerie* (Glass-making) from the pavilion L'Art Nouveau Bing, 1899–1900, oil on canvas. 280 × 103 cms; 110$^{1}/_{4}$ × 40$^{9}/_{16}$ ins. Private collection.

5 Georges De Feure (French, 1868–1943), *Chair from sitting room of the pavilion L'Art Nouveau Bing*, 1900, gilded beechwood and embroidery. 99.5 × 42.5 × 39 cms; 39$^{3}/_{16}$ × 16$^{3}/_{4}$ × 15$^{3}/_{8}$ ins. Danish Museum of Decorative Art, Copenhagen. Pl. 2.7.

6 Georges De Feure (French, 1868–1943), *Settee from sitting room of the pavilion L'Art Nouveau Bing*, 1900, gilded beechwood and embroidery. 90.6 × 121.4 × 52 cms; 35$^{11}/_{16}$ × 47$^{13}/_{16}$ × 20$^{1}/_{2}$ ins. Danish Museum of Decorative Art, Copenhagen. Pl. 2.7.

7 Georges De Feure (French, 1868–1943), *Table from sitting room of the pavilion L'Art Nouveau Bing*, 1900, gilded beechwood and green leather. 75.5 × 71.5 × 50 cms; 29$^{3}/_{4}$ × 28$^{1}/_{8}$ × 19$^{11}/_{16}$ ins. Danish Museum of Decorative Art, Copenhagen. Pl. 2.7.

8 Georges De Feure (French, 1868–1943), *Carpet from sitting room of the pavilion L'Art Nouveau Bing*, 1900, silk. 196 × 120 cms; 77$^{3}/_{16}$ × 47$^{1}/_{4}$ ins. Danish Museum of Decorative Art, Copenhagen.

9 Georges De Feure (French, 1868–1943), *Wallcovering from sitting room of the pavilion L'Art Nouveau Bing*, 1900, silk satin. 175.7 × 185.7 cms; 69$^{3}/_{16}$ × 73$^{1}/_{8}$ ins. Danish Museum of Decorative Art, Copenhagen. Pl. 2.7.

10 Eugène Gaillard (French, 1862–1933), *Textile*, 1900, printed cotton velveteen. 198 × 85 cms; 77$^{15}/_{16}$ × 33$^{7}/_{16}$ ins. Musée de la Mode et du Textile, Paris. Pl. 7.5.

II Eugène Gaillard (French, 1862–1933), *Cabinet from dining room of the pavilion L'Art Nouveau Bing*, 1900, walnut and gilded bronze. 263.5 × 223 × 51 cms; 103$^{3}/_{4}$ × 87$^{13}/_{16}$ × 20$^{1}/_{16}$ ins. Danish Museum of Decorative Art, Copenhagen. Pl. 10.6.

12 Émile Gallé (French, 1846–1904), *Firescreen*, 1900, ash with applied floral decoration and marquetry in various woods, back veneered with maple. 107.5 × 56 × 35 cms; 42$^{5}/_{16}$ × 22$^{1}/_{16}$ × 13$^{3}/_{4}$ ins. V&A, London. Pl. 10.11.

13 Émile Gallé (French, 1846–1904), *Vase, c.*1900, glass, metal, and pearls. 47.4 cms; 18$^{11}/_{16}$ ins. Musée des Beaux-Arts, Reims.

14 William Christmas Codman (American, 1839–1921) and Gorham Manufacturing Corporation (American, firm active 1815 onwards), *Claret jug, c.*1900, silver and crystal. 35.2 × 17.8 × 14.9cms; 13$^{7}/_{8}$ × 7 × 5$^{7}/_{8}$ ins. High Museum of Art, Atlanta: Virginia Carroll Crawford Collection.

15 Egide Rombaux (Belgian, 1865–1942) and Franz Hoosemans (Belgian, b.1857), *Candelabrum*, 1899, ivory and silver. 45.2 cms; 17$^{13}/_{16}$ ins. Kunstindustrimuseet, Oslo. Pl. 16.8. *

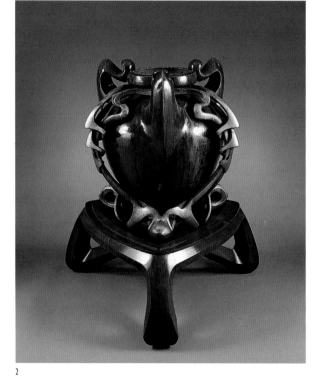

2 4 14

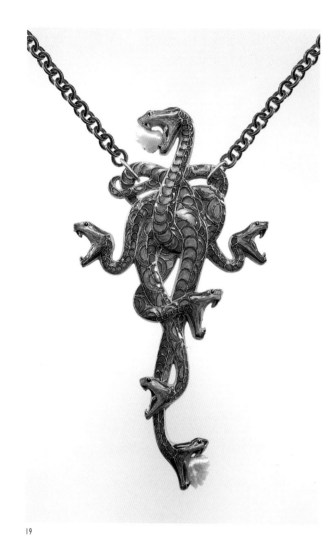

19

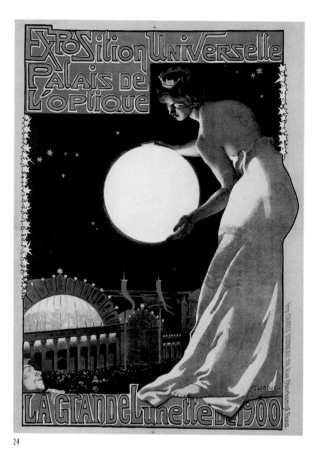

24

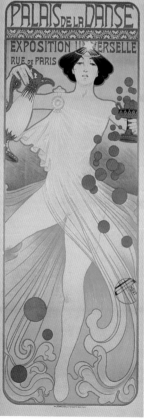

29

19 René Lalique (French, 1860–1945), *Coiled snake pendant*, 1898–99, gold, pearls, and enamel. 11 × 5.9 cms; 4⁵/₁₆ × 2⁵/₁₆ ins. The State Hermitage Museum, St Petersburg.

20 René Lalique (French, 1860–1945), *Winged female figure*, c.1899–1900, bronze. 99 × 101.5 × 35 cms; 39 × 39¹⁵/₁₆ × 13³/₄. Private collection, New York. Pl. 15.11.

21 René Lalique (French, 1860–1945), *Winged female figure*, c.1899–1900, bronze. 99 × 101.5 × 35 cms; 39 × 39¹⁵/₁₆ × 13³/₄ ins. Private collection, New York.

22 René Lalique (French, 1860–1945), *Winged female figure*, c.1899–1900, bronze, 99 × 101.5 × 35 cms; 39 × 39¹⁵/₁₆ × 13³/₄ ins. Private collection.

23 Agathon Léonard (French, 1841–1903) and Sèvres National Porcelain Manufactory (French, firm active c.1760 onwards), *Jeu de l'écharpe (Scarf Dance) Table setting*, 1900–03, porcelain. 56 cms; 22¹/₁₆ ins. V&A, London. Pl. 12.7. *

16 Hutton & Sons (English, firm active 1800–1923), *Cup and cover*, 1900, silver. 32.5 × 14.9 × 8.3 cms; 12¹³/₁₆ × 5⁷/₈ × 3¹/₄ ins. V&A, London. Pl. 8.17.

17 René Lalique (French, 1860–1945), *Iris bracelet*, 1897, gold, enamel, and opals. 4.9 × 17.2 cms; 1¹⁵/₁₆ × 6³/₄ ins. Private collection, New York. Pl. 15.3.

18 René Lalique (French, 1860–1945), *Dragonfly woman corsage ornament*, c.1897–98, gold, enamel, chrysoprase, moonstones, and diamonds, 23 × 26.5 cms; 9¹/₁₆ × 10⁷/₁₆ ins. Calouste Gulbenkian Foundation, Lisbon. Pl. 4.12.

24 Georges Leroux (French, 1877–1957), *Exposition Universelle, Palais de l'Optique* (Worlds Fair, Palace of Optics), 1900, color lithograph. 94 × 128.9 cms; 37 × 50³/₄ ins. Laura Gold, Park South Gallery at Carnegie Hall, New York.

25 Louis Majorelle (French, 1859–1926), *Armchair*, c.1900, mahogany; reupholstered. 122 × 60 × 55.8 cms; 48¹/₁₆ × 23⁵/₈ × 21¹⁵/₁₆ ins. V&A, London.

26 Alphonse Marie Mucha (Czech, 1860–1939), *Bust of a young woman, from the Houbigant display at the Fair*, 1900, electroplated and parcel-gilt bronze. 29 × 22 × 10 cms; 11⁷/₁₆ × 8¹¹/₁₆ × 3¹⁵/₁₆ ins. Mucha Trust. Pl. 16.9.

27 Alphonse Marie Mucha (Czech, 1860–1939), *Oesterreich auf der Weltaustellung Paris 1900 (Austria at the Paris Worlds Fair 1900)*, 1900, color lithograph. 101.9 × 71.4 cms; 40¹/₈ × 28¹/₈ ins. The Mitchell Wolfson Jr. Collection, The Wolfsonian-Florida International University, Miami Beach.

28 Manuel Orazi (Italian, 1860–1934), *Loïe Fuller*, 1900, color lithograph. 136.2 × 23.8 cms; 53⁵/₈ × 9³/₈ ins. Collection Victor Arwas.

29 Manuel Orazi (Italian, 1860–1934), *Palais de la Dance*, 1900, color lithograph. 54.6 × 153.4 cms; 21¹/₂ × 60³/₈ ins. Joel and Debra Ruby, Houston.

30

31

31 Kataro Shirayamadani (b. Japan, 1865–1948) and Rookwood Pottery Company (American, firm active 1880–1967), *Vase*, 1898, earthenware. 24.1 × 16.8 cms; 9¹/₂ × 6⁵/₈ ins. Cincinnati Art Museum: Gift of the Rookwood Pottery Company.

30 Maria Longworth Nichols Storer (American, 1849–1932) and Rookwood Pottery Company (American, firm active 1880–1967), *Seahorse vase with octopus mount*, 1897, earthenware with metal mounts, tiger's eyes, moonstones, and pearls. 39.7cms; 15⁵/₈ ins. Charles Hosmer Morse Museum of American Art, Winter Park. +

32 Louis Comfort Tiffany (American, 1848–1933), *Three-panel screen*, c.1900, leaded favrile glass in bronze frame. 178.7 × 225.6 cms; 70³/₈ × 88¹³/₁₆ ins. Lillian Nassau Ltd., New York. Pl. 28.14.

33 Vittorio Valabrega (Italian, 1861–1952), *Chimneypiece*, 1900, walnut, ceramic, brass, and glass. 304 × 190.5 × 38 cms; 119¹¹/₁₆ × 75 × 14¹⁵/₁₆ ins. The Mitchell Wolfson Jr. Collection, The Wolfsonian–Florida International University, Miami Beach. Pl. 29.5.

34 Vilmos Zsolnay (Hungarian, 1828–1900), *Vase*, 1899, earthenware with iridescent metallic luster Eosin glaze. 39.4 × 27.9 cms; 15¹/₂ × 11 ins. The Minneapolis Institute of Arts: Gift of the Norwest Corporation, Minneapolis.

II SOURCES OF THE NEW STYLE
Celtic and Viking Revivals

35 Edmond Johnson (Irish, 1840s–1900), *Copy of the Tara brooch*, 1891–92, after 8th-century original. 20 cms; 7⁷/₈ ins. The David and Alfred Smart Museum of Art, The University of Chicago: University Transfer, Gift of the Field Museum of Natural History.

36 Edmond Johnson (Irish, 1840s–1900), *Copy of the Ardagh chalice*, c.1892, after 8th-century original, silver, glass, and enamel. 15.9 × 19.1 cms; 6¹/₄ × 7¹/₂ ins. The David and Alfred Smart Museum of Art, The University of Chicago: Gift of Mr and Mrs Edward A. Maser.

35

34

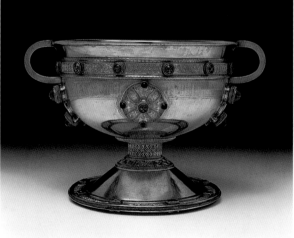

36

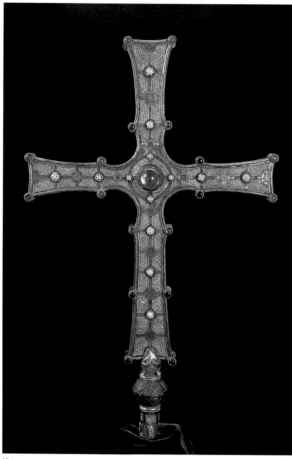

37

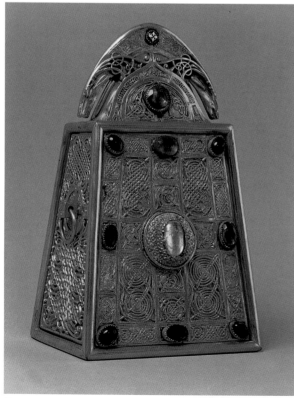

38

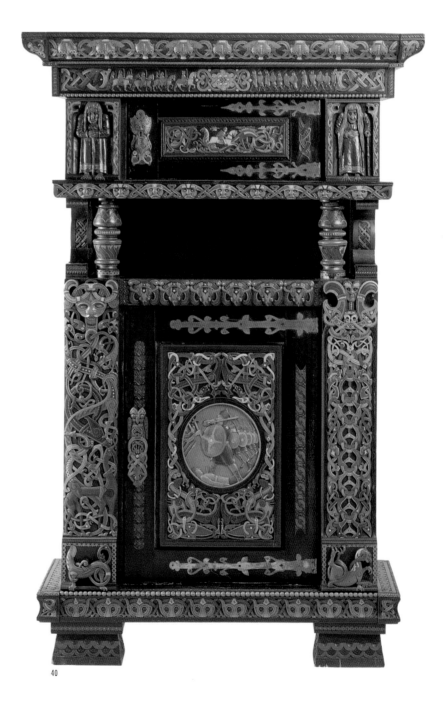

40

37 Edmond Johnson (Irish, 1840s–1900), *Copy of the Cross of Cong*, c.1892, after c.1123 original by Maeljesu MacBratdan O'Echan. 75.6 × 47.6 × 6.4 cms; 29³/₄ × 18³/₄ × 2¹/₂ ins. The David and Alfred Smart Museum of Art, The University of Chicago: University Transfer, Gift of the Field Museum of Natural History.

38 Edmond Johnson (Irish, 1840s–1900), *Copy of the Shrine of St Patrick's Bell*, c.1892, after c.1100 original by Cudulig Ua Inmainen, gilt over metal, silver, and glass. 27.9 cms; 11 ins. The David and Alfred Smart Museum of Art, The University of Chicago: University Transfer, Gift of the Field Museum of Natural History.

39 Owen Jones (English, 1809–74) with Francis Bedford (English, 1816–94), *The Grammar of Ornament* (London, 1856). 55.7 × 36.9 cms; 21¹⁵/₁₆ × 14¹/₂ ins. National Gallery of Art, Washington: Mark J. Millard Architectural Collection. Pl. 8.1.

40 Lars Kinsarvik (Norwegian, 1846–1925), *Cabinet*, 1898–1900, carved and painted fir. 188.9 × 124.1 cms; 74³/₈ × 48⁷/₈ ins. Kunstindustrimuseet, Oslo.

45

47

49

Rococo

49 Charles Cressent (French, cabinet maker, 1685–1768) *Wall clock*, 1735–40, with movement by Robert Robin (French, clock maker, 1742–99), gilt bronze. 132.1 × 59.7 × 30.5 cms; 52 × 23 1/2 × 12 ins. Dalva Brothers, Inc.

50 *Pair of wall lights* (French, c.1740–45), gilt bronze. 57.8 cms; 22 3/4 ins. National Gallery of Art, Washington: Gift of George D. Widener and Eleanor Widener Dixon.

51 Antoní Gaudí (Spanish, 1852–1926), *Wall clock from the Casa Milà, Barcelona*, 1905–10, gilded wood. 130 × 50 × 20 cms; 51 3/16 × 19 11/16 × 7 7/8 ins. The Saint Louis Art Museum: Funds given by the Richard Brumbaugh Trust in memory of Richard Irving Brumbaugh and in honor of the donors to the 1996 Annual Appeal and Museum Purchase, by exchange.

52 Johann Joachim Kaendler (German, c.1706–75), *Candelabrum: Swan among rushes*, c.1750, porcelain. 69.2 × 59 × 40 cms; 27 1/4 × 23 1/4 × 15 1/4 ins. National Gallery of Art, Washington: Gift of George D. Widener.

53 Jean-Mathieu Chevallier (French, 1696–1768), *Chest of drawers*, mid-18th century, veneered on oak stained black, with tulipwood, kingwood, sycamore, purplewood, boxwood, and other woods, gilt bronze mounts, and marble top. 85 × 139.2 × 64.6 cms; 33 1/2 × 57 3/4 × 25 3/8 ins. National Gallery of Art, Washington: Widener Collection.

54

41 Lars Kinsarvik (Norwegian, 1846–1925), *Armchair*, 1900, carved and painted pine. 94 × 55.9 × 47 cms; 37 × 22 × 18 1/2 ins. V&A, London. Pl. 2.19.

42 Archibald Knox (English, 1864–1933), *Cigarette box*, 1903–04, silver, wood, and opals. 11.2 × 21.5 × 13 cms; 4 7/16 × 8 7/16 × 5 1/8 ins. V&A, London. Pl. 2.16.

43 Gerhard Munthe (Norwegian, 1849–1929), *Table*, 1896, carved and painted wood. 74.5 cms; 29 5/16 ins. The Norwegian Folk Museum, Oslo. Pl. 2.17.

44 Gerhard Munthe (Norwegian, 1849–1929), *Armchair*, 1896, carved and painted wood. 112 × 61 × 58 cms; 44 1/8 × 24 × 22 13/16 ins. The Norwegian Folk Museum, Oslo. Pl. 2.18.

45 Louis Sullivan (American, 1856–1924), *Staircase baluster from the Guaranty Building, Buffalo, New York*, 1894–95, metal. Seymour H. Persky.

46 Louis Sullivan (American, 1856–1924), *Staircase baluster from the Guaranty Building, Buffalo, New York*, 1894–95, metal. Seymour H. Persky.

47 Louis Sullivan (American, 1856–1924) and George Grant Elmslie (American, 1871–1952), *Elevator medallion from the Schlesinger and Mayer Store, Chicago*, 1848–99, copper-plated cast iron. 59 cms; 29 1/4 ins. Seymour Persky.

48 *Facsimile of page from The Book of Kells*, from *Vetusta Monumenta*, vol.6, Society of Antiquaries (London, 1897), after c.800 original. 55.6 × 39 cms; 21 7/8 × 15 3/8 ins. V&A, London.

54 *Panel or cover* (probably French, 1700–10), silk damask with supplementary pattern wefts of silk and metallic yarns. 244 × 113 cms; 96¹/₁₆ × 44¹/₂ ins. Museum of Fine Arts, Boston: Textile Income Purchase Fund.

Japan and China

55 Mochizuki Hanzan (Japanese, late 18th century), *Inrō (small container)*, 1775–1800, wood with lacquer and glazed pottery. 5.8 × 7.9 × 3.3 cms; 2⁵/₁₆ × 3¹/₈ × 1⁵/₁₆ ins. V&A, London. Pl. 6.11.

56 Suzuki Harunobu (Japanese, 1724–70), *A Courtesan and Attendant on a Moonlit Veranda*, from the series *Genre Poets of the Four Seasons* (c.1765–70), woodblock print. 26 × 19 cms; 10¹/₄ × 7¹/₂ ins. V&A, London. Pl. 6.4.

57 Utagawa Hiroshige (Japanese, 1797–1858), *Awa province, Naruto Rapids*, from the series *Views of Famous Places in the Sixty-Odd Provinces* (1855), woodblock print. 38 × 25.5 cms; 14¹⁵/₁₆ × 10¹/₁₆ ins. V&A, London. Pl. 6.3.

58 Katsushika Hokusai (Japanese, 1760–1849), *Kirifuri Fall in Kurokami Mountain, Shimotsuke Province*, from the series *Going the Round of the Waterfalls of the Country* (c.1827), woodblock print. 38 × 25.5 cms; 14¹⁵/₁₆ × 10¹/₁₆ ins. V&A, London. Pl. 6.2.

59 Utagawa Kunisada (Japanese, 1786–1864), *Komurasaki from Kadatama-ya*, from the series *Women of the Yoshiwara* (c.1830–34), woodblock print. 50 × 20 cms; 19¹¹/₁₆ × 7⁷/₈ ins. V&A, London.

60 Utagawa Kunisada (Japanese, 1786–1864), *Scene from Genji Monogatari* (1847–52), woodblock print. 38 × 25.5 cms; 14¹⁵/₁₆ × 10¹/₁₆ ins. V&A, London. Pl. 6.8.

61 René Lalique (French, 1860–1945), *Buckle with irises*, c.1897, silver and parcel gilt. 19.1 × 6.7 cms; 7¹/₂ × 2⁵/₈ ins. V&A, London. Pl. 6.10.

62 Camille Martin (French, 1861–98) and René Wiener (French, 1856–1939), *Portfolio for L'Estampe Originale*, 1893–94, tooled mosaic leather. 62 × 45.5 cms; 24⁷/₁₆ × 17¹⁵/₁₆ ins. Musée de l'Ecole de Nancy. Pl. 9.10.

63 *Large cabinet* (Chinese, 16th–17th century), redwood and brass. 187.6 × 91.8 × 50.2 cms; 73⁷/₈ × 36¹/₈ × 19³/₄ ins. The Minneapolis Institute of Arts: Gift of Ruth and Bruce Dayton.

64 *Box of five trays with decoration of crabs and waves* (Chinese, 16th century), gold *makie* on black lacquer. 31.8 × 15.2 × 17.2 cms; 12¹/₂ × 6 × 6³/₄ ins. Florence and Herbert Irving.

65 *Tsuba (sword guard)* (Japanese, 1700–1800), iron with gold and silver inlay. 0.4 × 8.2 cms; ³/₁₆ × 3¹/₄ ins. V&A, London. Pl. 6.10.

66 *Vase* (Chinese, c.1700–1800), jade. 11 × 10.5 × 5.5 cms; 4⁵/₁₆ × 4¹/₈ × 2³/₁₆ ins. V&A, London.

67 *Scroll box* (Japanese, c.1750–1850), wood with black and gold lacquer. 5.3 × 6.9 × 149.7 cms; 2¹/₁₆ × 2¹¹/₁₆ × 19⁹/₁₆ ins. V&A, London. Pl. 6.6.

68 *Vase* (Chinese, 1760–1840), jade. 17 × 32 × 9 cms; 6¹¹/₁₆ × 12⁵/₈ × 3⁹/₁₆ ins. V&A, London. Pl. 6.12.

63

69 *Chair* (Chinese, c.1800), purple sandalwood. 94 × 58.1 × 47 cms; 37 × 22⁷/₈ × 18¹/₂ ins. The Nelson-Atkins Museum of Art, Kansas City: Purchase, Nelson Trust.

70 *Inrō (small container)* (Japanese, 1800–50), black lacquer, gold foil, and shell. 9.5 × 4.5 × 3 cms; 3³/₄ × 1³/₄ × 1³/₁₆ ins. V&A, London.

71 *Vase* (Chinese, c.1800–75), bronze. 40.6 × 12 cms; 16 × 4³/₄ ins. V&A, London. Pl. 6.1.

72 *Kesa (Buddhist priest's mantle)* (Japanese, 1800–80), woven silk. 112.5 × 205 cms; 44⁵/₁₆ × 80¹¹/₁₆ ins. V&A, London. Pl. 6.7.

73 *Kimono* (Japanese, 1860–90), resist-dyed and embroidered silk. Bought from Liberty & Co. 161 × 127 cms; 63³/₈ × 50 ins. V&A, London.

74 *Yoshitomi* (Japanese, early 19th century), *Inrō (small container)*, c.1830–80, ivory with lacquer, shell, and hardstones. 8.2 × 5 × 1.2 cms; 3¹/₄ × 1¹⁵/₁₆ × ¹/₂ ins. V&A, London.

75 Tsukioka Yoshitoshi (Japanese, 1839–92), *The Ghost of Genji's Lover*, from the series *One Hundred Views of the Moon* (1886), woodblock print. 38 × 25.5 cms; 14¹⁵/₁₆ × 10¹/₁₆ ins. V&A, London. Pl. 6.9.

76 Shibata Zeshin (Japanese, 1807–91), *Inrō (small container)*, 1865, wood with lacquer. 10 × 7.3 × 1.8 cms; 3¹⁵/₁₆ × 2⁷/₈ × ¹¹/₁₆ ins. V&A, London.

64

The Islamic World

77 Carlo Bugatti (Italian, 1856–1940), *Hanging cabinet*, c.1900, wood with mirror glass and inlaid ivory and metals. 116.8 × 69.9 × 20.3 cms; 46 × 27¹/₂ × 8 ins. Sam and Connie Perkins, Olathe, Kansas.

78 *Textile* (Persian, 16th century), woven silk. 45 × 46 cms; 17¹¹/₁₆ × 18¹/₈ ins. V&A, London.

79 *Textile* (Persian, early 19th century), woven silk. 75 × 78.5 cms; 29¹/₂ × 30 ins. V&A, London. Pl. 7.1.

80 Louis Comfort Tiffany (American, 1848–1933), *Flask*, 1896, favrile glass. 40.6 cms; 16 ins. V&A, London. Pl. 7.2 center.

81 *Tiles from a cornice in the mosque at Meshed* (Persian, c.1200–15), fritware with luster-painted overglaze decoration. 47 × 133 × 6 cms; 18¹/₂ × 52³/₈ × 2³/₈ ins. V&A, London.

82 *Mosque lamp* (Egyptian, c.1350), glass painted in enamels. 35.5 × 30.4 cms; 14 × 11¹⁵/₁₆ ins. V&A, London. Pl. 7.3.

83 *Panel from a pulpit door* (Egyptian, 15th century), wood beading inlaid with ivory and ebony. 202.5 × 44 × 4.5 cms; 79³/₄ × 17⁵/₁₆ × 1³/₄ ins. V&A, London.

84 *Vase* (Syrian, 16th century), earthenware. 40.8 × 19.7 cms; 16¹/₁₆ × 7³/₄ ins. V&A, London.

85 *Table* (Turkish, 16th century), wood with ivory, ebony, and mother-of-pearl marquetry and fritware with underglaze painting. 47.9 cms; 18⁷/₈ ins. V&A, London.

77

86 *Tile panel* (Turkish, c.1570), fritware with polychrome underglaze painting. 78.5 × 152 × 55 cms; 30⁷/₈ × 59¹³/₁₆ × 2³/₁₆ ins. V&A, London.

87 *Flask* (Persian, c.1885), glass. 35 × 11.56 cms; 14 × 7³/₈ ins. V&A, London. Pl. 7.2.

88 *Flask* (Persian, c.1885), glass. 36.6 × 10.4 cms; 14⁷/₁₆ × 7³/₈ ins. V&A, London. Pl. 7.2.

89 *Flask* (Persian, c.1885), glass. 33.6 × 10.2 cms; 14 × 4³/₁₆ ins. V&A, London.

90 *Flask* (Persian, c.1885), glass. 31.2 × 10.7 cms; 12⁵/₁₆ × 4³/₁₆ ins. V&A, London.

The Arts & Crafts and Aesthetic Movements in England

91 Charles Robert Ashbee (English, 1863–1942), *Bowl and cover*, 1900–01, silver and enamel set with a cabochon. 10.9 × 26.5 × 12.4 cms; 4⁵/₁₆ × 10⁷/₁₆ × 4⁷/₈ ins. V&A, London. Pl. 8.11.

95 Sir Edward Coley Burne-Jones (English, 1833–98), *The Viking Ship*, 1883–84, leaded glass. 81.3 × 80 cms; 32 × 31¹/₂ ins. Delaware Art Museum: F. V. du Pont Acquisition Fund.

95

92 Charles Robert Ashbee (English, 1863–1942), *Decanter*, 1904–05, silver, glass, and chrysoprase. 23.5 × 13 cms; 9¹/₄ × 5¹/₈ ins; diameter: 13 cms; 5¹/₈ ins. V&A, London. Pl. 14.4.

93 Aubrey Beardsley (English, 1872–98), *Siegfried Act II*, 1892–93, pen, ink, and wash. 41.4 × 30.1 cms; 16⁵/₁₆ × 11⁷/₈ ins. V&A, London.

94 Aubrey Beardsley (English, 1872–98), *'J'ai baisé ta bouche Iokanaan'*, design for *The Climax* (from Oscar Wilde's *Salome*, 1893), print. 22.8 × 12.7 cms; 9 × 5 ins. V&A, London. Pl. 1.9.

96 Walter Crane (English, 1845–1915), *Design for swan wallpaper*, 1875, gouache and watercolor. 53 × 53 cms; 20⁷/₈ × 20⁷/₈ ins. V&A, London. Pl. 8.5.

97 William De Morgan (English, 1839–1917), *Vase*, 1888–1898, earthenware with luster glaze. 58 × 24.2 cms; 22¹³/₁₆ × 9¹/₂ ins. V&A, London. Pl. 8.5.

98 William De Morgan (English, 1839–1917), *Vase*, 1888–98, earthenware with luster glaze. 29.5 × 22.4 cms; 11⁵/₈ × 8¹³/₁₆ ins. V&A, London. Pl. 8.5.

99 William De Morgan (English, 1839–1917), *Vase*, 1889, earthenware with luster glaze. 30.1 × 19.6 cms; 11⁷/₈ × 7¹¹/₁₆ ins. V&A, London. Pl. 8.5.

100 Doulton & Co. (English, firm active 1901–56), *Vase for Liberty & Co.*, *c.*1905, stoneware. 32.4 × 7.6 × 7.6 cms; 12³/₄ × 3 × 3 ins; diameter: 7.6 cms; 3 ins. V&A, London.

101 Christopher Dresser (English, 1834–1904), *'Clutha' range vase, c.*1885, glass with aventurine. 49 cms; 19⁵/₁₆ ins. V&A, London. Pl. 8.16.

102 F. Steiner & Co. Ltd. (English, firm active 1840s–1955), *Textile*, 1906, printed cotton. 56 × 77 cms; 22 × 30⁵/₁₆ ins. V&A, London.

105 Edward William Godwin (English, 1833–86), *Sideboard*, 1876, ebonized mahogany with silver-plated handles and inset panels of embossed Japanese leather and paper, silver-plated fittings. 178 × 256 × 87 cms; 70¹/₁₆ × 100¹³/₁₆ × 34¹/₄ ins. V&A, London. Pl. 8.13.

106 Kate Harris (English, active 1899–1905) and Hutton & Sons (English, firm active 1800–1923), *Cup and cover*, 1901, silver inset with precious stones. The Minneapolis Institute of Arts: Gift of the Decorative Arts Council.

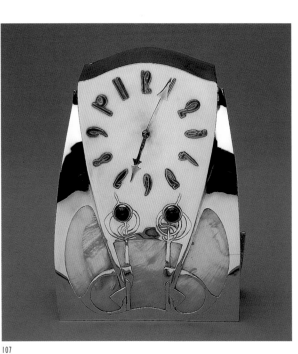
107

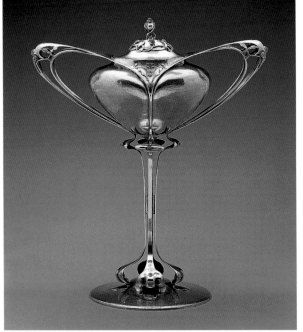
106

103 Alexander Fisher (English, 1864–1939), *Peacock sconce*, *c.*1899, steel, bronze, silver, brass, and enamel. 91.4 × 73.6 × 16.5 cms; 6 × 29 × 6¹/₂ ins. V&A, London. Pl. 8.18.

104 Sir Alfred Gilbert (English, 1854–1934), *The Virgin*, 1899, painted bronze. 49.5 cms; 19¹/₂ ins. From a parish church in Scotland.

107 Archibald Knox (English, 1864–1933) and Liberty & Co (English, firm active 1875 onwards), *Clock*, 1903, silver, mother-of-pearl, copper, and lapis lazuli. 24.5 × 20.3 × 8.9 cms; 9⁵/₈ × 8 × 3¹/₂ ins. Private collection.

108 Arthur Heygate Mackmurdo (English, 1851–1942), *Chair*, 1882, mahogany and leather. 97.1 × 49.5 × 47.5 cms; 38¹/₄ × 19¹/₂ × 18¹¹/₁₆ ins. V&A, London. Pl. 8.7.

109 Arthur Heygate Mackmurdo (English, 1851–1942), *Titlepage for Wren's City Churches*, 1883, woodcut. 29 × 22.8 cms; 11⁷/₁₆ × 24.4 ins. V&A, London. Pl. 8.8.

110 Arthur Heygate Mackmurdo (English, 1851–1942), *Cromer Bird textile*, *c.*1884, printed cotton. 91.4 × 81.3 cms; 36 × 32 ins. V&A, London.

111 William Morris (English, 1834–1896), *Curtain with peacock and dragon design*, 1878, woven wool. 411 × 360 cms; 161¹³/₁₆ × 141³/₄ ins. V&A, London. Pl. 8.4.

112 Harry Napper (English, 1860–1930), *Textile with convolvulus and seed pod*, 1898, block-printed cotton. 90 × 157 cms; 35⁷/₁₆ × 61¹³/₁₆ ins. V&A, London. Pl. 11.2.

113 Charles Ricketts (English, 1866–1933), *Cover for The Sphinx* (by Oscar Wilde, 1894), gold leaf on vellum. 22.1 × 18 × 1.5 cms; 8¹¹/₁₆ × 7¹/₁₆ x⁹/₁₆ ins. V&A, London. Pl. 9.8.

114 Dante Gabriel Rossetti (English, 1828–82), *Beata Beatrix*, 1877–82, oil on canvas. 84 × 64.8 cms; 33¹/₁₆ × 25¹/₂ ins. Birmingham City Museum and Art Gallery.

115 Charles Frances Annesley Voysey (English, 1857–1941), *Textile with landscape and animals*, 1897, woolen double cloth. 172 × 161 cms; 67¹¹/₁₆ × 63³/₈ ins. V&A, London. Pl. 8.9.

116 James McNeill Whistler (American, 1834–1903), *Variations in violet and green*, 1871, oil on canvas. 66 × 35.5 cms; 26 × 14 ins. Musée d'Orsay, Paris.

116

Symbolism

117 Sarah Bernhardt (American, 1844–1923), *Inkwell (self-portrait as a sphinx)*, 1880, bronze. 31.8 cms; 12¹⁄₂ ins. Museum of Fine Arts, Boston: Helen and Alice Colburn Fund.

118 Jean Carriès (French, 1855–94), *Mask*, 1890–92, salt-glazed stoneware. 25.6 × 25.4 × 15.8 cms; 10¹⁄₁₆ × 10 × 6¹⁄₄ ins. V&A, London. Pl. 16.2.

119 Maurice Denis (French, 1870–1943), *The Road to Mount Calvary*, 1889, oil on canvas. 41 × 32.5 cms; 16¹⁄₈ × 12¹³⁄₁₆ ins. Musée d'Orsay, Paris. Pl. 4.4.

120 Félix Fix-Masseau (French, b.1869), *The Secret*, 1894, ivory and painted mahogany. 76 × 17.5 × 18 cms; 29¹⁵⁄₁₆ × 6⁷⁄₈ × 7¹⁄₁₆ ins. Musée d'Orsay, Paris. Pl. 4.19.

121 Paul Gauguin (French, 1848–1903), *Self-portrait*, 1889, oil on wood. 79.2 × 51.3 cms; 31¹⁄₄ × 20¹⁄₄ ins. National Gallery of Art, Washington: Chester Dale Collection.

122 Paul Gauguin (French, 1848–1903), *Eve*, 1890, glazed ceramic. 60.6 × 27.9 × 27.3 cms; 23⁷⁄₈ × 11 × 10³⁄₄ ins. National Gallery of Art, Washington: Ailsa Mellon Bruce Fund.

123 Paul Gauguin (French, 1848–1903), *Parau na te Varua ino (Words of the Devil)*, 1892, oil on canvas. 91.7 × 68.5 cms; 36¹⁄₈ × 27 ins. National Gallery of Art, Washington: Gift of the W. Averell Harriman Foundation, in memory of Marie N. Harriman.

124 Paul Gauguin (French, 1848–1903) and Émile Bernard (French, 1868–1941), *Bretonnerie corner cabinet*, 1888, carved and painted wood. 274 × 107 × 74.5 cms; 104¹⁄₈ × 42¹⁄₂ × 29⁵⁄₁₆ ins. Private collection. Pl. 2.15.

125 Ferdinand Khnopff (Belgian, 1858–1921), *Avec Grégoire Le Roy. Mon coeur pleure d'autrefois (With Grégoire Le Roy. My heart weeps for the past)*, 1889, crayon on paper. 25.4 × 15.2 cms; 10 × 6 ins. The Hearn Family Trust.

126 Ferdinand Khnopff (Belgian, 1858–1921), *L'Aile bleue (The Blue Wing)*, 1894, oil on canvas. 88.5 × 28.5 cms; 34¹³⁄₁₆ × 11¹⁄₄ ins. Private collection.

127 Ferdinand Khnopff (Belgian, 1858–1921), *Head of Medusa*, 1900, polished bronze on a Siennese marble base. 71 cms; 27¹⁵⁄₁₆ ins. Private collection.

117

125

126

128 Ferdinand Khnopff (Belgian, 1858–1921), *Souvenir de Bruges. L'entrée du béguinage (Entrance to the convent of the Beguines)*, 1904, colored graphite, charcoal, and pastel. 27 × 43.5 cms; 10⁵/₈ × 17¹/₈ ins. The Hearn Family Trust.

129 Gustave Moreau (French, 1826–98), *L'Apparition*, 1876, oil on canvas. 142 × 103 cms; 55⁷/₈ × 40⁹/₁₆ ins. Musée Gustave Moreau, Paris. Pl. 7.9.

128

130 Edvard Munch (Norwegian, 1863–1944), *The Vampire*, 1893, oil on canvas. 91 × 109 cms; 35¹³/₁₆ × 42¹⁵/₁₆ ins. Munch Museum, Oslo. Pl. 4.16.

131 Edvard Munch (Norwegian, 1863–1944), *Madonna*, 1895, color lithograph and woodcut (1902 printing). 66.2 × 50.4 cms; 26¹/₁₆ × 19¹³/₁₆ ins. National Gallery of Art, Washington: The Sarah G. and Lionel C. Epstein Family Collection.

132 Victor Émile Prouvé (French, 1858–1943), *Bookbinding for Salammbô*, 1893, tooled mosaic leather and bronze. 42 × 33 cms; 16⁹/₁₆ × 13 ins. Musée de l'École de Nancy. Pl. 9.9.

133 Paul Ranson (French, 1862–1909), *Nabi Landscape*, 1890, oil on canvas. 89 × 115 cms; 35¹/₁₆ × 45¹/₄ ins. Private collection. Pl. 4.5.

134 Odilon Redon (French, 1840–1916), *Portrait of Gauguin*, 1903–05, oil on canvas. 66 × 54.5 cms; 26 × 21⁷/₁₆ ins. Musée d'Orsay, Paris. Pl. 4.7.

135 József Rippl-Rónai (Hungarian, 1861–1927), *Woman with Bird Cage*, 1892, oil on canvas. 185.5 × 130 cms; 73¹/₁₆ × 51³/₁₆ ins. Hungarian National Gallery, Budapest. Pl. 24.7.

136 Félicien Rops (Belgian, 1833–98), *Frontispiece to The Modesty of Sodoma* (by Gustave Guiches, Paris, 1888), etching. 27 × 20.5 cms; 10⁵/₈ × 8¹/₁₆ ins. V&A, London.

137 Paul Sérusier (French, 1863–1927), *The Talisman*, 1888, oil on wood. 27 × 22 cms; 10⁵/₈ × 8¹¹/₁₆ ins. Musée d'Orsay, Paris. Pl. 4.1.

138 Paul Signac (French, 1863–1935), *Portrait of Félix Fénéon (Opus 217, Against the Enamel of a Background Rhythmic with Beats and Angles, Tones, and Tints)*, 1890, oil on canvas. 73.7 × 92.7 cms; 29 × 36¹/₂ ins. Private collection. Pl. 4.9.

139 Jan Toorop (Dutch, 1858–1928), *Mirror, c.*1895, wood with gesso and metal foil. 70 × 50 cms; 27⁹/₁₆ × 19¹¹/₁₆ ins. Private collection.

The Cult of Nature

140 Thorvald Bindesbøll (Danish, 1846–1908), *Vase*, 1893, earthenware, incised and painted. 57.4 × 36.8 cms; 22⁵/₈ × 14¹/₂ ins. Danish Museum of Decorative Art, Copenhagen. Pl. 3.7.

141 Leopold Blaschka (German, 1822–95), *Sea Creatures*, glass. Cornell University, Department of Ecology and Evolutionary Biology.

142 Ernest Chaplet (French, 1835–1909), *Vase*, 1884–88, porcelain. 28 cms; 11 ins. Musée National de Céramique, Sèvres. Pl. 12.5.

143 Pierre-Adrien Dalpayrat (French, 1844–1910), *Gourd*, 1893–1900, stoneware. 36.8 × 16.5 cms; 14¹/₂ × 6¹/₂ ins. V&A, London. Pl. 12.3.

144 Daum Frères (French, firm active 1878 onwards), *Ashtray, c.*1909, glass paste. 5.5 × 17 cms; 2³/₁₆ × 6¹¹/₁₆ ins. Musée des Beaux-Arts de Nancy.

145 Daum Frères (French, firm active 1878 onwards) and Henri Bergé (dates unknown), *Dragonfly vase*, 1904, glass with applied decoration, acid-etched, and wheel-engraved. 36.5 × 14.5 cms; 14³/₈ × 5¹¹/₁₆ ins. Musée des Beaux-Arts de Nancy, Pl. 13.3.

146 Daum Frères (French, firm active 1878 onwards) and Louis Majorelle (French, 1859–1926), *Floral form lamp, c.*1903, wheel-carved glass and bronze. 71.8 × 26.7 cms; 28¹/₄ × 10¹/₂ ins. Private collection.

147 Auguste Delaherche (French, 1857–1940), *Vase*, 1890–92, stoneware. 66.5 cms; 26³/₁₆ ins. V&A, London. Pl. 12.3, center.

148 Taxile Doat (French, 1851–1938), *Vase with shell*, 1900, porcelain with crystalline cobalt glaze, stoneware stand. 20.8 cms; 8³/₁₆ ins. Danish Museum of Decorative Art, Copenhagen. Pl. 12.1.

152

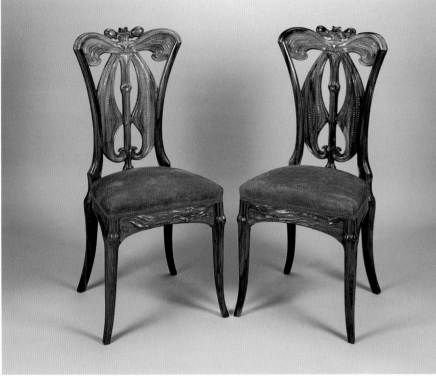

153

149 Fernand Dubois (Belgian, 1861–1939), *Inkwell with stylized orchid motif*, c.1900, bronze. 10 × 15 × 11 cms; 3¹⁵/₁₆ × 5⁷/₈ × 4⁵/₁₆ ins. Private collection.

150 Georges Fouquet (French, 1862–1957), *Orchid brooch*, 1900, gold, enamel, ruby, pearl, and plique-à-jour enamel. 10 × 10.5 cms; 3¹⁵/₁₆ × 4¹/₈ ins. University of East Anglia, Anderson Collection. Pl. 15.6.

151 Georges Fouquet (French, 1862–1957), *Hornet brooch*, 1901, gold and enamel. 18.8 × 12.4 cms; 7³/₈ × 4⁷/₈ ins. V&A, London. Pl. 15.12.

152 Émile Gallé (French, 1846–1904), *Dragonfly table*, c.1897–1900, wood and marquetry. 74.3 × 76.8 × 56.5 cms; 29¹/₄ × 30¹/₄ × 22¹/₄ ins. Private collection.

153 Émile Gallé (French, 1846–1904), *Pair of dragonfly chairs*, c.1904, wood. 98.4 × 44.5 × 40.6 cms; 38³/₄ × 17¹/₂ × 16 ins. Private collection.

154 Émile Gallé (French, 1846–1904), *Sketch for vase with insects*, c.1889, pencil, gouache, and watercolor. 32.5 × 32.3 cms; 12¹³/₁₆ × 12¹¹/₁₆ ins. Musée d'Orsay, Paris.

155 Émile Gallé (French, 1846–1904), *Sketch for orchid vase*, 1899–1900, pencil and watercolor. 30.7 × 24.1 cms; 12¹/₁₆ × 9¹/₂ ins. Musée d'Orsay, Paris.

156 Émile Gallé (French, 1846–1904), *Orchid vase*, 1900, mold-blown glass with layered, applied, and wheel-carved decoration. 23.5 × 14.5 × 10.5 cms; 9¹/₄ × 5¹¹/₁₆ × 4¹/₈ ins. Chateau-Musée, Boulogne-sur-Mer.

157 Émile Gallé (French, 1846–1904), *Bat vase*, c.1903–04, wheel-cut and acid-etched glass with applied cabochons over silver foil. 37.5 cms; 14³/₄ ins. V&A, London. Pl. 13.1.

158 Émile Gallé (French, 1846–1904), *Dragonfly cup*, c.1904, carved and applied glass. 14.5 cms; 5¹¹/₁₆ ins. Private collection.

159 C.V. Gibert (French, silversmith) and F. Nicoud (French, cutler), *Pieces from a dessert set*, c.1890, silver. Cooper-Hewitt National Design Museum, Smithsonian Institution, New York: Museum purchase from Smithsonian Institution Collection Acquisition Program, Decorative Arts Association Acquisitions, and Sarah Cooper-Hewitt Funds.

160 Eugène Samuel Grasset (French, 1841–1917), *'Snowdrops in Ornament'*, from *Plants & Their Applications to Ornament* (London, 1897; plate 32), 47.4 × 38 cms; 18¹¹/₁₆ × 14¹⁵/₁₆ ins. V&A, London. Pl. 3.4.

161 Ernst Heinrich Philipp August Haeckel (German, 1834–1919), *Kunstformen der Natur (Art Forms in Nature), Batrachia (Frogs)* (Leipzig and Vienna, 1899–1904; pl. 68). 36.5 × 29 cms; 14³/₈ × 11⁷/₁₆ ins. Smithsonian Institution Libraries, Washington.

162 Ernst Heinrich Philipp August Haeckel (German, 1834–1919), *Kunstformen der Natur (Art Forms in Nature), Actiniae (Anemones)* (Leipzig and Vienna, 1898; pl. 49). 36.5 × 29 cms; 14³/₈ × 11⁷/₁₆ ins. V&A, London. Pl. 3.1.

163 Georges Hoentschel (French, 1860?–1915), *Vase*, 1895, stoneware. 44.6 cms; 17⁹/₁₆ ins. V&A, London. Pl. 12.3.

164 Imperial Glassworks (Russian, firm active 1777–1917), *Vase*, 1904, glass, wheel-cut and cased. 25 cms; 9³/₁₆ ins. V&A, London. Pl. 13.5.

165 Prince Bogdar Karageorgevitch (Serbian, 1861–1908), *Coffee spoons, fruitknife, paperknives*, c.1900, silver. V&A, London. Pl. 14.14.

166 Karl Koepping (German, 1848–1914) and Fredrick Zitzmann (German, 1840–1906), *Goblet with purple foot*, c.1895–96, glass. 31.5 × 9 cms; 12³/₈ × 3⁹/₁₆ ins. Danish Museum of Decorative Art, Copenhagen. Pl. 13.8.

167 Karl Koepping (German, 1848–1914) and Fredrick Zitzmann (German, 1840–1906), *Goblet with amber bowl*, c.1895–96, glass. 30.5 × 11.9 cms; 12 × 4¹¹/₁₆ ins. Danish Museum of Decorative Art, Copenhagen. Pl. 13.8.

168 Karl Koepping (German, 1848–1914) and Fredrick Zitzmann (German, 1840–1906), *Goblet with lavender bowl*, c.1895–96, glass. 25.5 × 8 cms; 10¹/₁₆ × 3¹/₈ ins. Danish Museum of Decorative Art, Copenhagen. Pl. 13.8

169 René Lalique (French, 1860–1945), *Choker*, c.1899, chased gold, translucent enamel, glass, and pearls. 5.6 × 30.5 × 0.3 cms; 2³/₁₆ × 12 × ¹/₈ ins. Virginia Museum of Fine Arts, Richmond: Gift of Sydney and Frances Lewis.

170 René Lalique (French, 1860–1945), *Anemone pendant*, c.1900–02, gold, enamel, and ivory. 9.8 × 6.2 cms; 3⁷/₈ × 2⁷/₁₆ ins. Calouste Gulbenkian Foundation, Lisbon. Pl. 15.8.

171 René Lalique (French, 1860–1945), *Damselflies necklace*, c.1900–02, gold, enamel, aquamarines, and diamonds. 22 × 17 cms; 8¹¹/₁₆ × 6¹¹/₁₆ ins. Private collection, London. Pl. 15.9.

169

172 René Lalique (French, 1860–1945), *Blister beetle corsage ornament, c.*1903–04, gold, glass, enamel, silver, and tourmaline, 5.2 × 16 cms; 2¹/₁₆ × 6³/₁₆ ins. Calouste Gulbenkian Foundation, Lisbon. Pl. 15.10.

173 Max Ritter von Spaun and Johannes Loetz-Witwe Glassworks (Czech, firm active 1836–1939), *Vase*, 1900, iridized glass. 19 × 28.5 cms; 7¹/₂ × 11¹/₄ ins. V&A, London. Pl. 13.6.

174 Louis Majorelle (French, 1859–1926), *Gates*, 1906, wrought iron and bronze. 126.7 × 150.2 × 7 cms; 49⁷/₈ × 59¹/₈ × 2³/₄ ins. The Toledo Museum of Art: Mr and Mrs George M. Jones Jr Fund.

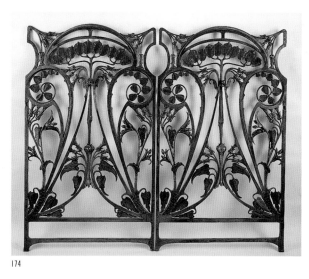

174

175 Louis Majorelle (French, 1859–1926) and Daum Frères (French, firm active 1878 onwards), *Le Figuier de Barbarie lamp*, 1903, patinated bronze and carved glass. 75 × 48 cms; 29¹/₂ × 18⁷/₈ ins. Musée de L'École de Nancy. Pl. 3.11.

176 Louis Majorelle (French, 1859–1926) and Daum Frères (French, firm active 1878 onwards), *Orchidée Desk, c.*1903, carved and inlaid mahogany, gilt-bronze, and glass. 92.7 × 175.3 × 90.2 cms; 36¹/₂ × 69 × 35¹/₂ ins. Anonymous.

177 Louis Majorelle (French, 1859–1926) and Daum Frères (French, firm active 1878 onwards), *Pair of magnolia lamps, c.*1903, gilt-bronze and carved glass. 79.7 × 37 cms; 31³/₈ × 14⁹/₁₆ ins. Private collection. Pl. 3.8.

178 Camille Martin (French, 1861–98), *La Mélancolie desk folder*, 1893, tooled mosaic leather. 51 × 33 cms; 20¹/₁₆ × 13 ins. Musée de L'École de Nancy.

179 Maw and Company (English, firm active 1850–1967), *Four tiles showing plant structure, c.*1860–80, earthenware. 23 × 23 cms; 9¹/₁₆ × 9¹/₁₆ ins. V&A, London.

180 Alphonse Marie Mucha (Czech, 1860–1939), *Les documents décoratifs*, Librairie Centrale des Beaux Arts (Paris, 1902; Pl 29). 47 × 36.4 × 5.5 cms; 18¹/₂ × 14⁵/₁₆ × 2³/₁₆ ins. V&A, London.

181 Thorolf Prytz (Norwegian, 1858–1938) and Jacob Tostrups (Norwegian, 1806–90), *Snowdrop cup, c.*1900, plique-à-jour enamel. 22.2 × 14.3 cms; 8³/₄ × 5⁵/₈ ins. The Oslo Museum of Applied Arts. Pl. 3.6.

182 Adelaide Alsop Robineau (American, 1865–1929), *Crab vase*, 1908, porcelain. 18.7 × 6.4 cms; 7³/₈ × 2¹/₂ ins. Everson Museum of Art, Syracuse, New York.

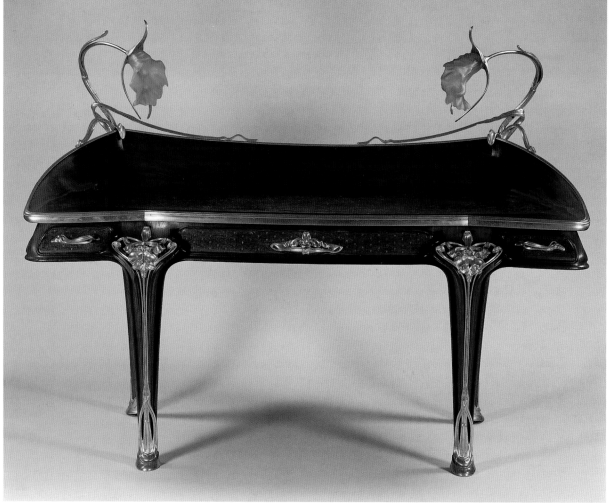

176

182

183

184

III CITIES

A Paris

186 Pierre Bonnard (French, 1867–1947), *La Revue blanche*, 1894, color lithograph. 77 × 59.5 cms; 30⁵/₁₆ × 23⁷/₁₆ ins. Royal Pavilion, Libraries and Museums Brighton and Hove. Pl. 5.2.

187 Rupert Carabin (French, 1862–1932), *Chair*, 1896, wood. 111 × 63 cms; 43¹¹/₁₆ × 24¹³/₁₆ ins. Private collection. Pl. 4.14.

188 Rupert Carabin (French, 1862–1932), *Chair*, 1895, walnut. 72 × 62 cms; 28¹¹/₁₆ × 23³/₄ ins. Private collection. Pl. 3.10.

189 Rupert Carabin (French, 1862–1932), *Table*, 1896, wood. 77 × 88 cms; 30⁵/₁₆ × 34⁵/₈ ins. Private collection. Pl. 10.3.

190 Jules Chéret (French, 1836–1932), *La Loïe Fuller*, 1893, color lithograph. 123.5 × 87 cms; 48⁵/₈ × 34¹/₄ ins. V&A, London. Pl. 9.2.

183 Tiffany Studios (American, firm active 1892–1932), *18-light lily table lamp*, c.1902, favrile glass and bronze. 50.8 × 49.5 cms; 20 × 19¹/₂ ins. Private collection.

184 Artus van Briggle (American, 1869–1904), *Lorelei vase*, c.1902, earthenware. 26.7 × 10.8 cms; 10¹/₂ × 4¹/₄ ins. Everson Museum of Art, Syracuse, New York: Gift of Ronald and Andrew Kuchta in memory of Clara May Kuchta.

185 Weduwe N.S.A. Brantjes & Co (Dutch), *Dish*, c.1900, earthenware. 44.7 cms; 17⁵/₈ ins. V&A, London. Pl. 12.12.

191 Édouard Colonna (American, 1862–1948), *Vitrine* (designed for Siegfried Bing), c.1900, oak with glass and metal. 132 × 91.5 × 89 cms; 51¹⁵/₁₆ × 36 × 35¹/₁₆ ins. V&A, London.

192 Édouard Colonna (American, 1862–1948) and Cornille Brothers (French, firm active 1875–1939), *Curtain*, c.1900, woven silk. 330 × 193 cms; 129¹⁵/₁₆ × 76 ins. V&A, London. Pl. 11.5.

193 Georges De Feure (French, 1868–1943), *Journal des vents*, 1898, color lithograph. 64 × 49.5 cms; 25³/₁₆ × 19¹/₂ ins. Private collection.

194 Georges De Feure (French, 1868–1943), *Furniture fittings*, c.1900, electroplated silver on

cast copper. 10.5 × 53 × 32 cms; 4¹/₈ × 20⁷/₈ × 12⁵/₈ ins. V&A, London. Pl. 14.12.

195 Paul Follot (French, 1877–1941), Tea set, c.1904, silverplate. Tray: 42.5 × 61.6 × 4.5 cms; 16³/₄ × 24¹/₄ × 1³/₄ ins. Private collection.

196 Georges Fouquet (French, 1862–1957), *Winged serpent corsage ornament*, 1902, gold, enamel,

193

diamonds, and pearls. 18.8 × 12.4 cms; 7³/₈ × 4⁷/₈ ins. Private collection, New York. Pl.15.5.

197 Eugène Samuel Grasset (French, 1841–1917), *La Vitrioleuse* (*The Poison Maker*), 1894, color lithograph. 39.7 × 27.5 cms; 15⁵/₈ × 10¹³/₁₆ ins. Collection Victor Arwas, London. Pl. 9.4.

198 Eugène Samuel Grasset (French, 1841–1917),

La Morphinomane (*The morphine addict*), 1897, color lithograph. 56.7 × 42 cms; 22⁵/₁₆ × 16⁹/₁₆ ins. V&A, London. Pl. 4.23.

199 Eugène Samuel Grasset (French, 1841–1917) and Maison Vever (French, firm active 1880–1942), *'Apparitions' brooch*, 1900, gold, enamel, ivory, and topaz. 6.2 × 3.9 × 1.3 cms; 2⁷/₁₆ × 1⁹/₁₆ x¹/₂ ins. Musée d'Orsay, Paris, Pl. 1.7.

200

200 Hector Guimard (French, 1867–1942) and Maison Mardelé (firm established 1820), *Wallpaper from the Castel Béranger*, 1896–98, printed paper. 102 × 50 cms; 40³/₁₆ × 19¹¹/₁₆ ins. Bibliothèque Forney, Ville de Paris.

201 Hector Guimard (French, 1867–1942), *Buffet*, c.1906, pearwood, marble, and glass. 270.5 × 228.6 × 48.9 cms; 106¹/₂ × 90 × 19¹/₄ ins. Private collection.

202 Hector Guimard (French, 1867–1942), *Entrance to the Métropolitain*, c.1898, cast iron and bronze. 421 × 370 × 584 cms; 165³/₄ × 145¹¹/₁₆ × 229¹⁵/₁₆ ins. National Gallery of Art, Washington: Gift of Robert P. and Arlene R. Kogod.

203 Hector Guimard (French, 1867–1942), *Window grille from Castel Henriette*, 1899, wrought iron. 225 × 153.2 × 7 cms; 88⁹/₁₆ × 60⁵/₁₆ × 2³/₄ ins. The Birkenhead Collection; on loan to the V&A, London. Pl. 17.10, Pl. 17.11.

204 Hector Guimard (French, 1867–1942), *Fireplace from Castel Val*, c.1903, Pearwood and bronze. 93.4 × 114.5 × 35.4 cms; 36³/₄ × 45¹/₁₆ × 13¹⁵/₁₆ ins. The Toledo Museum of Art: Purchased with funds from the Florence Scott Libbey Bequest in memory of her father, Maurice A. Scott.

205 Hector Guimard (French, 1867–1942), *Jardinière*, c.1905, cast iron. 142.2 × 53.2 cms; 56 × 21 ins. The Birkenhead Collection. Pl. 17.6.

206 Hector Guimard (French, 1867–1942), *Cross*, c.1910, cast iron with marble. 142.2 × 53.2 cms; 56 × 21 ins. The Birkenhead Collection.

207 Hector Guimard (French, 1867–1942) and Fonderies Saint-Dizier (French, firm active 1890 onwards), *Numbers 0–9*, 1900, cast iron. 14 × 10.5 cms; 5¹/₂ × 4¹/₈ ins. Private collection. Pl. 17.7.

208 Hector Guimard (French, 1867–1942) and Fonderies Saint-Dizier (French, firm active 1890 onwards), *Pair of balustrade ornaments*, 1909–11, cast iron. 85.1 × 58.4 × 2.5 cms; 33¹/₂ × 23 × 1 ins. The Menil Collection, Houston.

209 Hector Guimard (French, 1867–1942) and Fonderies Saint-Dizier (French, firm active 1890 onwards), *Balustrade*, 1913–26, cast iron. 35 × 93.5 cms; 13³/₄ × 36¹³/₁₆ ins. Musée d'Orsay, Paris.

210 René Lalique (French, 1860–1945), *Princess Lointaine pendant*, 1898–99, gold, enamel, diamonds, and amethyst. 11.7 × 5.7 cms; 4 3/ 4 ins × 2¹/₄ ins; chain: 62 cms; 22¹/₄ ins. Private collection, London. Pl. 15.1.

211 François-Raoul Larche (French, 1860–1912), *Loïe Fuller table lamp*, c.1900, gilt bronze. 45.7cms; 18 ins. Private collection.

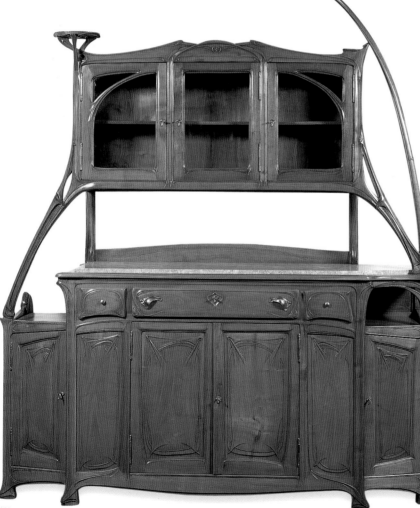

201

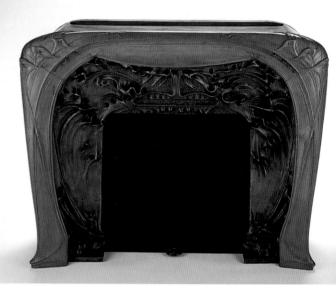

204

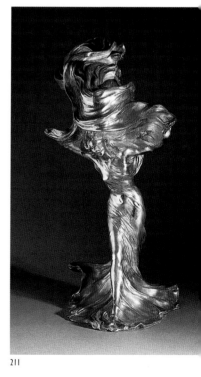

211

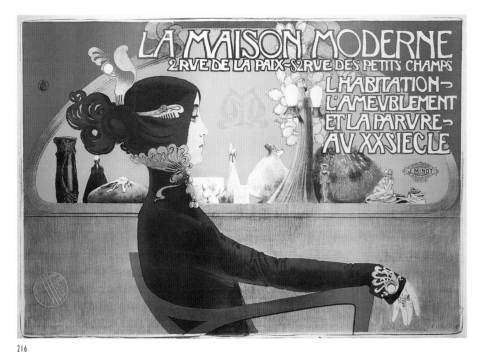

216

colored gemstones. 20 × 20 cms; 7⅞ × 7⅞ ins. Private collection. Pl. 15.13.

216 Manuel Orazi (Italian, 1860–1934), *La Maison Moderne*, 1900–07, color lithograph. 78.7 × 113 cms; 31 × 44½ ins. Collection of Jack Rennert, New York.

217 Paul Ranson (French, 1862–1909), *Textile*, 1898, printed cotton. 180 × 80 cms; 70⅞ × 31½ ins. Museum of Applied Arts, Budapest. Pl. 11.6.

218 Reissner, Stellmacher, & Kessler (Austrian, firm active *c.*1900), *Loïe Fuller*, *c.*1900, earthenware. 49.5 cms; 19½ ins. University of East Anglia: Anderson Collection.

222 Henri de Toulouse-Lautrec (French, 1864–1901), *Divan Japonais*, 1892, color lithograph. 61.9 × 60.9 cms; 24⅜ × 24 ins. V&A, London. Pl. 9.3.

223 Henri de Toulouse-Lautrec (French, 1864–1901), *Miss Loïe Fuller*, 1893, color lithograph. 38.4 × 28.1 cms; 15⅛ × 11¹¹⁄₁₆ ins. National Gallery of Art, Washington: Rosenwald Collection.

224 Henri de Toulouse-Lautrec (French, 1864–1901), *Jane Avril*, 1893, color lithograph. 126.1 × 91.8 cms; 49⅝ × 36⅛ ins. The Museum of Modern Art, New York: Gift of A. Conger Goodyear.

212 Alphonse Marie Mucha (Czech, 1860–1939), *La Dame aux Camélias*, 1896, color lithograph. 206 × 77 cms; 81⅛ × 30⁵⁄₁₆ ins. V&A, London.

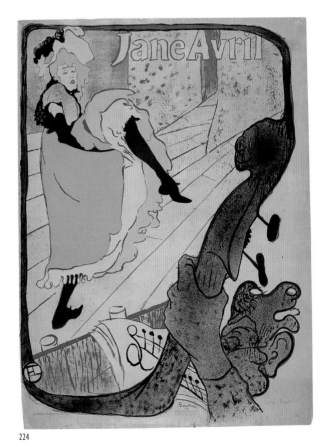

224

225

213 Alphonse Marie Mucha (Czech, 1860–1939), *Job*, 1897, color lithograph. 61.9 × 45cms; 24⅜ × 17¹¹⁄₁₆ ins. V&A, London. Pl. 9.5.

214 Alphonse Marie Mucha (Czech, 1860–1939), *Nature*, *c.*1900, gilt bronze, silver, and marble. 69.2 × 27.9 × 30.5 cms; 27¼ × 11 × 12 ins. Virginia Museum of Fine Arts, Richmond: The Sydney and Frances Lewis Art Nouveau Fund. Pl. 3.15.

215 Alphonse Marie Mucha (Czech, 1860–1939), *Bodice ornament*, *c.*1900, gold, ivory, enamel, opals, pearls, and

219 Carlos Schwabe (French, 1866–1926), *Rose+Croix Salon*, 1892, color lithograph. 191.3 × 81.2 cms; 75⁵⁄₁₆ × 31¹⁵⁄₁₆ ins. V&A, London. Pl. 4.6.

220 Pierre Selmersheim (French, b.1879), *Inkwell*, 1900, gilt bronze. 33 × 44 cms; 13 × 17⁵⁄₁₆ ins. Danish Museum of Decorative Arts, Copenhagen.

221 Théophile Alexandre Steinlen (French, 1859–1923), *Cabaret du chat noir*, 1896, color lithograph. 134.7 × 94.4 cms; 53¹⁄₁₆ × 37³⁄₁₆ ins. V&A, London. Pl. 9.21.

B. Brussels

225 Gisbert Combaz (Belgian, 1869–1941), *1er Congrès international des avocats (First International Congress of Lawyers)*, 1897, color lithograph. 157 × 76 cms; 61¹³⁄₁₆ × 29¹⁵⁄₁₆ ins. Collection Jack Rennert, New York.

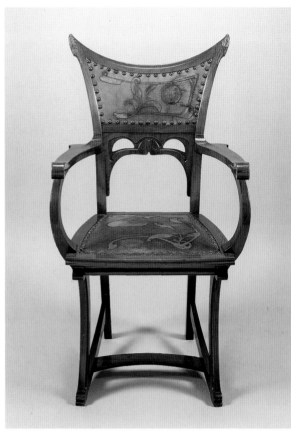

242

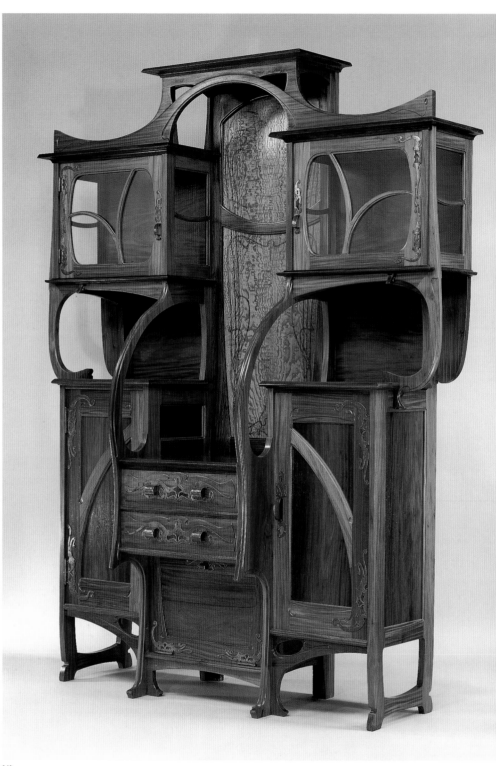

243

226 Adolphe Crespin (Belgian, 1859–1944), *Gebrande Koffies De Gulden Bie* (*Golden Bee Roasted Coffee*), 1893, color lithograph. 106 × 83.4 cms; 41³/₄ × 32¹³/₁₆ ins. V&A, London.

227 Fernand Dubois (Belgian, 1861–1939), *Candelabrum*, *c*.1899, electro-plated bronze. 53.5 × 20.5 × 16 cms; 21¹/₁₆ × 8¹/₁₆ × 6⁵/₁₆ ins. Musée Horta, Brussels. Pl. 14.6.

228 Victor Horta (Belgian, 1861–1947), *Chair*, mahogany, reupholstered with silk after a design by Eugène Grasset of 1898. 79.5 × 45.5 × 44 cms; 31⁵/₁₆ × 17¹⁵/₁₆ × 17⁵/₁₆ ins. Musée Horta, Brussels.

229 Victor Horta (Belgian, 1861–1947), *Two balcony panels from Deprez Van de Velde Hotel*, 1896, laminated wrought iron. 100 × 225 cms; 39³/₈ × 88⁹/₁₆ ins

and 65 × 232 cms; 25⁹/₁₆ × 91 ins. Musée Horta, Brussels.

230 Victor Horta (Belgian, 1861–1947), *Standing lamp*, *c*.1897, brass. 174 × 40 cms; 68¹/₂ × 15³/₄ ins. Musée Horta, Brussels.

231 Victor Horta (Belgian, 1861–1947), *Stained glass window*, *c*.1897, glass and oak. 89 × 13.5 × 2 cms; 35¹/₁₆ × 5⁵/₁₆ × ¹³/₁₆ ins. Private collection.

232 Victor Horta (Belgian, 1861–1947), *Table*, *c*.1900, ash and marble. 74.5 × 134 × 82 cms; 29⁵/₁₆ × 52³/₄ × 32⁵/₁₆ ins. Musée Horta, Brussels.

233 Victor Horta (Belgian, 1861–1947), *Armchair*, 1902, sycamore and velvet. 95 × 73 × 70.5 cms; 37³/₈ × 28³/₄ × 27³/₄ ins. Musée Horta, Brussels.

234 Ferdinand Khnopff (Belgian, 1858–1921), *Des Caresses*, 1896, oil on canvas. 50.5 × 151 cms; 19⁷/₈ × 59⁷/₁₆ ins. Musées Royaux des Beaux-Arts de Belgique, Brussels. Pl. 4.18.

235 Henri Meunier (Belgian, 1831–1905), *Rajah*, 1897, color lithograph. 64 × 80.5 cms; 25³/₁₆ × 31¹¹/₁₆ ins. V&A, London. Pl. 9.6.

236 Henri Ottevaere (Belgian, 1870–1944), *Bookbinding* for Edgar Allan Poe's *Histoires Extraordinaires* (*Fantastic Tales*), 1899, leather. 23.6 × 15.2 cms; 9⁵/₁₆ × 6 ins. Museum für Kunst und Gewerbe, Hamburg.

245

248

33a

246

237 Henri Ottevaere (Belgian, 1870–1944), *Bookbinding* for Edgar Allan Poe's *Nouvelles Histoires Extraordinaires* (*New Fantastic Tales*), 1899, leather. 23.6 × 15.2 cms; 9⁵⁄₁₆ × 6 ins. Museum für Kunst und Gewerbe, Hamburg.

238 T. Privat-Livemont (Belgian, 1861–1936), *Bec Auer*, 1896, color lithograph. 110.5 × 81.4 cms; 43¹⁄₂ × 32¹⁄₁₆ ins. V&A, London. Pl. 9.7.

239 T. Privat-Livemont (Belgian, 1861–1936), *Bitter Oriental*, 1897, color lithograph. 110.4 × 83.4 cms; 43⁷⁄₁₆ × 32¹³⁄₁₆ ins. V&A, London.

240 Théodore van Rysselberghe (Belgian, 1862–1926), *La Libre Esthétique*, 1897, color lithograph. 95 × 71 cms; 37³⁄₈ × 27¹⁵⁄₁₆ ins. V&A, London.

241 Gustave Serrurier-Bovy (Belgian, 1858–1910), *Pedestal*, 1897, congolese palissandre. 159.4 × 98.4 × 78.7 cms; 62³⁄₄ × 38³⁄₄ × 31 ins. The Minneapolis Institute of Arts: Gift of the Norwest Corporation, Minneapolis. Pl. 10.2.

242 Gustave Serrurier-Bovy (Belgian, 1858–1910), *Armchair*, c.1899, wood and original leather seat. 106.7 × 60.3 ×

53.3 cms; 42 × 23³⁄₄ × 21 ins. Private collection.

243 Gustave Serrurier-Bovy (Belgian, 1858–1910), *Cabinet-vitrine*, 1899, red narra and ash with copper and enamel mounts. 248.9 × 213.4 × 63.5 cms; 98 × 84 × 25 ins. The Metropolitan Museum of Art, New York: Gift of Mr and Mrs Lloyd Macklowe.

244 Gustave Serrurier-Bovy (Belgian, 1858–1910), *Clock*, 1900–10, oak, brass, iron, and other materials. 70 × 37.5 × 26.5 cms; 27⁹⁄₁₆ × 14³⁄₄ × 10⁷⁄₁₆ ins. Private collection.

245 Fernand Toussaint (Belgian, 1873–1955), *Le Sillon*, 1895, color lithograph. 89.5 × 110.5 cms; 35¹⁄₄ × 43¹⁄₂ ins. Mr and Mrs Jean-Louis Lamot.

246 Fernand Toussaint (Belgian, 1873–1955), *Café Jacqmotte*, 1896. 78.7 × 110.8 cms; 31 × 43⁵⁄₈ ins. Museum für Kunst und Gewerbe, Hamburg.

247 Henry van de Velde (Belgian, 1863–1957), *Bookbinding* for W.Y. Fletcher's *English Bookbinding in the British Museum* (1895), leather. 30 × 31 cms; 11¹³⁄₁₆ × 12³⁄₁₆ ins. Museum für Kunst und Gewerbe, Hamburg.

248 Henry van de Velde (Belgian, 1863–1957), *Tropon: L'Aliment le plus concentré* (*Tropon: The Most Nourishing Food*), 1898, color lithograph. 111.8 × 77.2 cms; 44 × 30³⁄₈ ins. The Museum of Modern Art, New York: Arthur Drexler Fund.

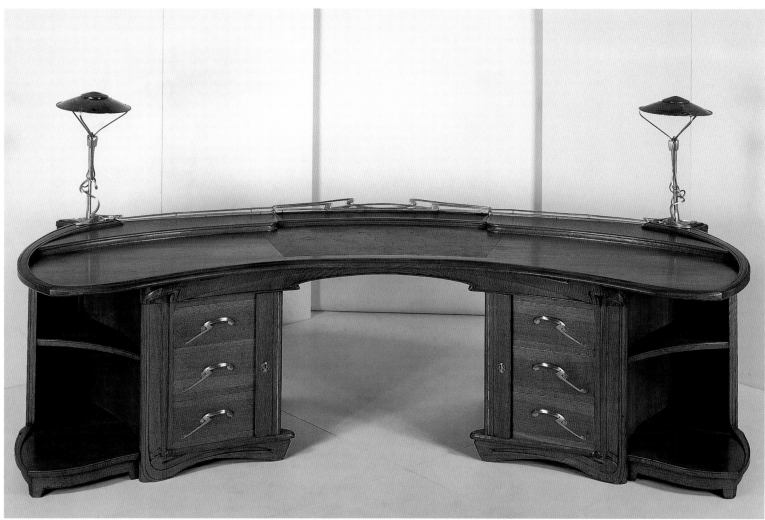

250

249 Henry van de Velde (Belgian, 1863–1957), *Candelabrum*, 1898–99, electroplated bronze. 58.5 × 50.8 cms; 23¹/₁₆ × 20 ins. Musées Royaux d'Art et d'Histoire, Brussels. Pl. 14.5.

250 Henry van de Velde (Belgian, 1863–1957), *Writing desk and chair* (desk shown), 1898–99, oak, bronze, copper, lamps of red copper. 128 × 267 × 122 cms; 50³/₈ × 105¹/₈ × 48¹/₁₆ ins. Musée d'Orsay, Paris.

251 Charles Van der Stappen (Belgian, 1843–1910), *Sphinx mystérieux*, 1897, ivory and silver gilt. 57 × 46 × 41.5 cms; 22⁷/₁₆ × 18¹/₈ × 16⁵/₁₆ ins. Musées Royaux d'Art et d'Histoire, Brussels. Pl. 16.7.

252 Philippe Wolfers (Belgian, 1858–1929), *Civilization and Barbary*, 1897, ivory, silver, and onyx. 46 × 55 cms; 18¹/₈ × 21⁵/₈ ins. Private collection. Pl. 3.9.

253 Philippe Wolfers (Belgian, 1858–1929), *Centerpiece*, 1900, silver. 26.7 × 31.8 cms; 10¹/₂ × 12¹/₂ ins. The Mitchell Wolfson Jr. Collection, The Wolfsonian-Florida International University, Miami Beach, Florida.

254 Philippe Wolfers (Belgian, 1858–1929), *Vase*, c.1900, chased and wheel-cut with silver-gilt mount. 40 × 20 cms; 15³/₄ × 7⁷/₈ ins. Private collection. Pl. 13.11.

255 Philippe Wolfers (Belgian, 1858–1929), *Orchid hair ornament*, 1902, gold, enamel, diamonds, gold, and rubies. 7.6 × 7.6 cms; 3 × 3 ins. V&A, London. Pl. 15.4.

253

C. Glasgow

256 Margaret Macdonald (Scottish, 1865–1933), *The White Rose and the Red Rose*, 1902, painted gesso on hessian, set with glass beads. 101 × 103.5 cms; 39³/₄ × 40³/₄ ins. Donald and Eleanor Taffner.

257 Margaret Macdonald (Scottish, 1865–1933) and Francis Macdonald (Scottish, 1874–1921), *The Glasgow Institute of the Fine Arts*, c.1895, colour lithograph. 238.1 × 100.3 cms; 93³/₄ × 39¹/₂ ins. Prints and Photographs Division, Library of Congress, Washington, D.C.

258 Charles Rennie Mackintosh (Scottish, 1868–1928), *Lady's Luncheon Room* from Miss Cranston's Ingram Street Tearooms, Glasgow, 1900, reconstructed 1992–95. Glasgow Museums: Art Gallery and Museum, Kelvingrove. Pl. 21.6.

259 Charles Rennie Mackintosh (Scottish, 1868–1928), *The Scottish Musical Review*, 1896, color lithograph. 245 × 99.4 cms; 97⁹/₁₆ × 39¹⁵/₁₆ ins. Glasgow Museums: Art Gallery and Museum, Kelvingrove. Pl. 21.7.

260 Charles Rennie Mackintosh (Scottish, 1868–1928), *High-back Chair*, 1897–1900, oak. 136.5 × 50.6 × 46 cms; 53³/₄ × 22¹/₁₆ × 18¹/₈ ins. V&A, London. Pl. 2.21.

261 Charles Rennie Mackintosh (Scottish, 1868–1928), *Order Desk Chair*, from Miss Cranston's Willow Tearooms, 1904, ebonized oak. 118.2 × 94 × 42 cms; 46⁹/₁₆ × 37 × 16⁹/₁₆ ins. Glasgow School of Art Collection. Pl. 21.8.

D. Vienna

262 Carl Otto Czeschka (Austrian, 1878–1960), *Vitrine*, c.1907–08, silver and beveled glass with moonstone, enamel, mother-of-pearl, ivory, baroque pearl, opal, and lapis lazuli decoration; base veneered in walnut and Makassar ebony. 162.6 × 61 × 31.8 cms; 64 × 24 × 12¹/₂ ins. Private collection.

263 Josef Hoffmann (Austrian, 1870–1956), *Chest for photographs*, c.1902, palisander and maple veneer, inlaid white metal, nickel-plated metal fitting. 55.9 × 52.9 × 37.2 cms; 22 × 20¹³/₁₆ × 14⁵/₈ ins. The Art Institute of Chicago: Restricted gift through The Antiquarian Society in honor of Lynn Springer Roberts.

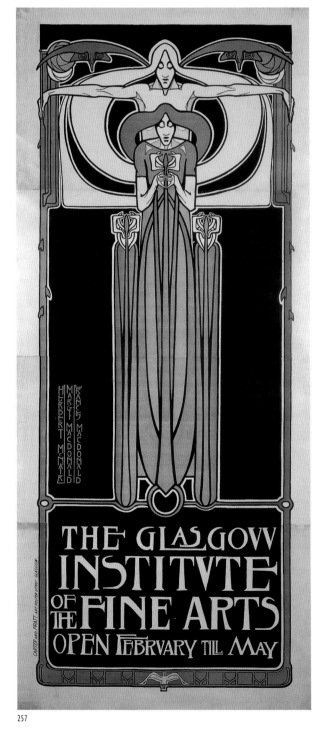

257

263

264 Josef Hoffmann (Austrian, 1870–1956), *Bureau for Koloman Moser*, c.1898, alder, originally stained green, polished. 213 × 130 × 66 cms; 83⅞ × 51³⁄₁₆ × 26 ins. MAK – The Austrian Museum of Applied Arts, Vienna. Pl. 20.3.

265 Josef Hoffmann (Austrian, 1870–1956), *Three-panel screen*, 1899–1900, ebonised wood frame, gilt incised leather panels. 156 × 123 cms; 61⁷⁄₁₆ × 48⁷⁄₁₆ ins. Royal Pavilion, Libraries and Museums, Brighton and Hove. Pl. 20.4.

266 Josef Hoffmann (Austrian, 1870–1956), *Wärndorfer cutlery*, 1904–08, silver and steel. MAK – The Austrian Museum of Applied Arts, Vienna. Pl. 20.9.

267 Josef Hoffmann (Austrian, 1870–1956), *'Grid' basket*, 1905, electroplated silver and red glass. 6.8 × 8 × 1.8 cms; 2¹¹⁄₁₆ × 3⅛ × ¹¹⁄₁₆ ins. V&A, London. Pl. 20.10.

268 Josef Hoffmann (Austrian, 1870–1956), *Skyscraper basket*, c.1905, silver. 24.1 × 3.8 cms; 9½ × 1½ ins. Private collection.

272 Josef Hoffmann (Austrian, 1870–1956) and Wiener Werkstätte (Austrian, firm active 1903–32), *Fruit basket*, 1904, silver. 27 × 23 × 23 cms; 10⅝ × 9¹⁄₁₆ × 9¹⁄₁₆ ins. V&A, London. Pl. 14.7.

273 Josef Hoffmann (Austrian, 1870–1956) and Wiener Werkstätte (Austrian, firm active 1903–32), *Centerpiece*, 1905, silver. 10.2 × 22.9 cms; 4 × 9 ins. Private collection.

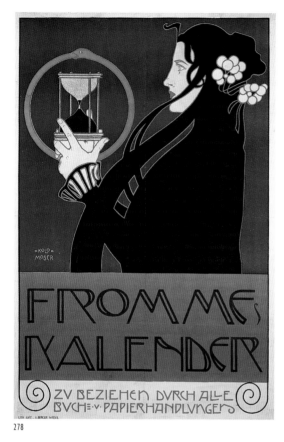

278

268

273

269 Josef Hoffmann (Austrian, 1870–1956), *Tablecloth*, c.1905, woven cloth. 136 × 137 cms; 53¹⁵⁄₁₆ × 53¹⁵⁄₁₆ ins. V&A, London. Pl. 11.13.

270 Josef Hoffmann (Austrian, 1870–1956), *Adjustable armchair*, c.1908, steam-bent beechwood and plywood. 110 × 62 × 83 cms; 43⁵⁄₁₆ × 24⁷⁄₁₆ × 32¹¹⁄₁₆ ins. V&A, London. Pl. 10.7.

271 Josef Hoffmann (Austrian, 1870–1956) and Wiener Werkstätte (Austrian, firm active 1903–32), *Tea service*, 1903, silver, coral, wood, and leather. Samovar and stand: 25.5 cms; 10¹⁄₁₆ ins. MAK – The Austrian Museum of Applied Arts, Vienna. Pl. 20.11.

274 Adolf Jettmar (Austrian, 1869–1939), *Secession. XXVII. Ausstellung (27th Secession Exhibition)*, 1903, color lithograph. 59.5 × 44.5 cms; 23⁷⁄₁₆ × 17½ ins. V&A, London.

275 Gustav Klimt (Austrian, 1862–1918), *I Kunstausstellung Secession (1st Secession Art Exhibition)*, 1898, color lithograph. 63.4 × 52.9 cms; 24¹⁵⁄₁₆ × 20¹³⁄₁₆ ins. MAK – The Austrian Museum of Applied Arts, Vienna. Pl. 20.2.

276 Gustav Klimt (Austrian, 1862–1918), *Pallas Athene*, 1898, oil on canvas. 75 × 75 cms; 29½ × 29½ ins. Museen der Stadt Wien, Vienna. Pl. 2.1.

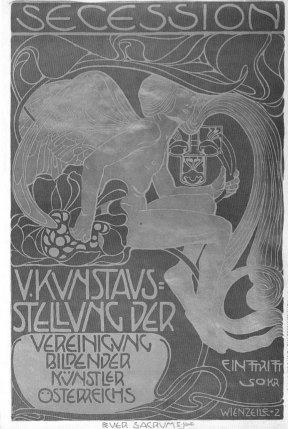

279

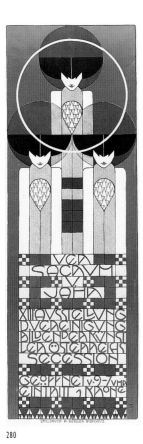

280

277 Gustav Klimt (Austrian, 1862–1918), *Baby (Cradle)*, 1917–18, oil on canvas. 110.9 × 110.4 cms; 43⁵/₈ × 43¹/₂ ins. National Gallery of Art, Washington: Gift of Otto and Franciska Kallir with the help of the Carol and Edwin Gaines Fullinwider Fund.

278 Koloman Moser (Austrian, 1868–1918), *Frommes Kalender (Religious calendar)*, 1898, color lithograph. 95.3 × 61.6 cms; 37¹/₂ × 24¹/₄ ins. The Museum of Modern Art, New York: Given anonymously.

279 Koloman Moser (Austrian, 1868–1918), *Secession. V. Kunstausstellung (5th Secession Art Exhibition)*, 1899, color lithograph. Museum für Kunst und Gewerbe, Hamburg.

280 Koloman Moser (Austrian, 1868–1918), *Vers Sacrum. V. Jahr. XIII Ausstellung (Vers Sacrum 5th Year, 13th Exhibition)* 1902, color lithograph. 177.2 × 59.7 cms; 69³/₄ × 23¹/₂ ins. Museum für Kunst und Gewerbe, Hamburg.

281 Koloman Moser (Austrian, 1868–1918), *Basket bud vase*, c.1904, silver. 20.3 × 7.6 cms; 8 × 3 ins. Private collection.

282 Koloman Moser (Austrian, 1868–1918) and Caspar Hrazdil (Austrian, dates unknown), *Lady's writing desk and armchair*, 1903, thuya wood, inlaid with satinwood and brass, engraved and inked, gilt-metal feet. 145.5 × 119.4 × 60 cms; 57⁵/₁₆ × 47 × 23⁵/₈ ins. V&A, London. Pl. 20.6.

283 Otto Prutscher (Austrian, 1880–1949), *Wine glass*, 1907, cased and wheel-cut glass. 16.2 × 8 cms; 6³/₈ × 3¹/₈ ins. V&A, London. Pl. 20.12, left.

284 Otto Prutscher (Austrian, 1880–1949), *Wine glass*, 1907, cased and wheel-cut glass. 21 × 8.6 cms; 8¹/₄ × 3³/₈ ins. V&A, London. Pl. 20.12, right.

285 Alfred Roller (Austrian, 1864–1935), *XIV Ausstellung Secession (14th Secession Exhibition)*, 1902, color lithograph. 90.2 × 35.6 cms; 35¹/₂ × 14 ins. Private collection.

286 Alfred Roller (Austrian, 1864–1935), *XVI Ausstellung (16th Exhibition)*, 1902, color lithograph. 189.2 × 63.9 cms; 74¹/₂ × 25³/₁₆ ins. V&A, London. Pl. 9.18.

281

285

E. Munich

287 Peter Behrens (German, 1868–1940), *The Kiss*, 1899, color woodcut. 57 × 44 cms; 22⁷/₁₆ × 17⁵/₁₆ ins. Private collection. Pl. 9.14.

288 Otto Eckmann (German, 1865–1902) and Scherrebek Weaving School (German, founded 1896), *Five Swans*, 1897, woven wool. 76 × 24.6 cms; 29¹⁵/₁₆ × 9¹¹/₁₆ ins. Danish Museum of Decorative Art, Copenhagen. Pl. 11.12.

289 Otto Eckmann (German, 1865–1902), *Armchair*, 1900, carved beech and leather. 95 × 71 × 56 cms; 37³/₈ × 27¹⁵/₁₆ × 22¹/₁₆ ins. V&A, London. Pl. 19.7.

290 August Endell (German, 1871–1925), *Clock*, c.1902–05, stained oak, aluminum leaf, clockwork. 203.2 × 94.6 × 48.9 cms; 80 × 37¹/₄ × 19¹/₄ ins. The Mitchell Wolfson Jr. Collection, The Wolfsonian-Florida International University, Miami Beach, Florida.

290

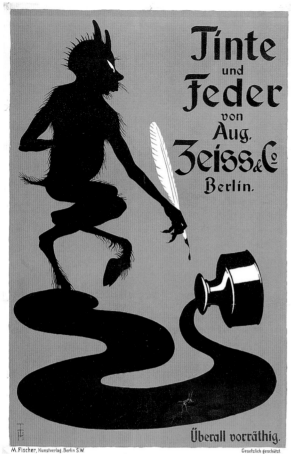

291

294

291 Thomas Theodor Heine (German, 1867–1948), *Tinte und Feder (Pen and Ink)*, 1896, color lithograph. Museum für Kunst und Gewerbe, Hamburg.

292 Thomas Theodor Heine (German, 1867–1948), *Simplicissimus*, c.1900, color lithograph. 35 × 34.9 cms; 13³/₄ × 13³/₄ ins. V&A, London. Pl. 9.15.

293 Thomas Theodor Heine (German, 1867–1948), *Devil*, c.1902, patinated bronze. 41 × 22.3 × 14.2 cms; 16¹/₈ × 8³/₄ × 5⁹/₁₆ ins. Private collection. Pl. 19.4.

294 Thomas Theodor Heine (German, 1867–1948), *Die 11 Scharfrichter (The Eleven Executioners)*, 1903, color lithograph. 110.5 × 66 cms; 43¹/₂ × 26 ins. Museum für Kunst und Gewerbe, Hamburg.

295 Bruno Paul (German, 1874–1968), *Kunst im Handwerk (Art in Handicraft)*, 1901, color lithograph. 88.5 × 59.5 cms; 34¹³/₁₆ × 23⁷/₁₆ ins. Stadtmuseum Munich. Pl. 19.14.

296 Bruno Paul (German, 1874–1968) and Vereinigte Werkstätten für Kunst im Handwerk (German, established 1897), *Candelabrum*, 1901, brass. 40.3 × 68 × 22 cms; 15⁷/₈ × 26³/₄ × 8¹¹/₁₆ ins. Stadtmuseum, Munich. Pl. 14.8.

297 Ernst Riegel (German, 1871–1939), *Goblet*, 1903, silver, silver-gilt, and uncut opals. 23.4 × 9.5 × 9.5 cms; 9³/₁₆ × 3³/₄ × 3³/₄ ins. Stadtmuseum, Munich. Pl. 14.10.

298 Richard Riemerschmid (German, 1868–1957), *Garden of Eden*, 1900, oil on canvas with gessoed and painted wood frame. 160 × 164 cms; 63 × 64⁹/₁₆ ins. Collection Barlow Widmann. Pl. 19.9.

299 Richard Riemerschmid (German, 1868–1957), *Carpet* for Thieme House, 1903, handknotted wool. 220 × 230 cms; 86⁵/₈ × 90⁹/₁₆ ins. Collection Barlow Widmann. Pl. 19.12.

300 Richard Riemerschmid (German, 1868–1957), *Cupboard* for Thieme House, 1903, stained maple and mother-of-pearl. 138 × 95 × 50 cms; 54⁵/₁₆ × 37³/₈ × 19¹¹/₁₆ ins. Stadtmuseum, Munich. Pl. 19.10.

301 Richard Riemerschmid (German, 1868–1957), *Side chair* for Thieme House, 1903, maple, mother-of-pearl, and upholstery. 112 × 46 × 59 cms; 44¹/₈ × 18¹/₈ × 23¹/₄ ins. Stadtmuseum, Munich. Pl. 19.10.

302 Richard Riemerschmid (German, 1868–1957) and Liberty & Co. (English, firm active 1875 onwards), *Chair*, 1898–99, walnut and leather. 78 × 58 × 48 cms; 30¹¹/₁₆ × 22¹³/₁₆ × 18⁷/₈ ins. V&A, London. Pl. 10.15.

308

307 Franz von Stuck (German, 1863–1928), *VII. Internationale Kunstausstellung (7th International Art Exhibition)*, 1897, color lithograph. 70 × 98 cms; 27⁹/₁₆ × 35⁷/₁₆ ins. Museum Villa Stuck, Munich. Pl. 19.3.

308 Franz von Stuck (German, 1863–1928), *Die Sünde (The Sin)*, *c.*1906, oil on canvas. 88.6 × 53.5 cms; 34⁷/₈ × 21¹/₁₆ ins. Frye Art Museum, Seattle.

309 Ludwig Vierthaler (German, 1875–1967), *Mirror*, *c.*1906, copper, enamel, glass, and wood. 88 × 41.9 × 7.6 cms; 34⁵/₈ × 16¹/₂ × 3 ins. The Mitchell Wolfson Jr. Collection, The Wolfsonian-Florida International, University, Miami Beach, Florida.

310 Josef Rudolf Witzel (German, 1867–1925), *Jugend (Youth)*, 1896, color lithograph. 70.2 × 114.9 cms; 27⁵/₈ × 45¹/₄ ins. The Museum of Modern Art, New York: Acquired by exchange.

F. Turin

311 Leonardo Bistolfi (Italian, 1859–1933), *Prima Esposizione internazionale d'arte decorativa moderna – Torino aprile–novembre (First international exhibition of modern decorative art. Turin – April–November)*, *c.*1902, color lithograph. 110 × 144.5 cms; 43⁵/₁₆ × 56⁷/₈ ins. Museo Civico L. Bailo, Treviso. Pl. 29.1.

312 Carlo Bugatti (Italian, 1856–1940), *Frame*, *c.*1895–1902, vellum, hammered copper, pewter, brass, walnut, beech, and ebonized beech. 104.9 × 91 × 4 cms; 41⁵/₁₆ × 35¹³/₁₆ × 1⁹/₁₆ ins. The Art Institute of Chicago: Gift of the Antiquarian Society Annual Tour 1974 and the Jessie Spalding Landon Fund.

303 Richard Riemerschmid (German, 1868–1957) and Vereinigte Werkstätten für Kunst im Handwerk (German, firm established 1897), *Candlestick*, 1898, brass. 20 × 27 × 7.8 cms; 7⁷/₈ × 10⁵/₈ × 3¹/₁₆ ins. Private collection. Pl. 14.9.

304 Richard Riemerschmid (German, 1868–1957) and Vereinigte Werkstätten für Kunst im Handwerk (German, firm established 1897), *Table*, 1898–1899, wood. 77 × 65 × 57 cms; 30⁵/₁₆ × 25⁹/₁₆ × 22⁷/₁₆ ins. V&A, London. Pl. 10.15.

305 Richard Riemerschmid (German, 1868–1957) and Vereinigte Werkstätten für Kunst im Handwerk (German, firm established 1897), *Cutlery*, 1899–1900, wood and silver. Knife length: 23.5 cms; 9¹/₄ ins. Stadtmuseum, Munich. Pl. 19.13.

306 Joseph Sattler (German, 1867–1931), *Pan*, 1895, color lithograph. 39.9 × 23.7 cms; 15¹¹/₁₆ × 9⁵/₁₆ ins. V&A, London. Pl. 1.15.

310

312

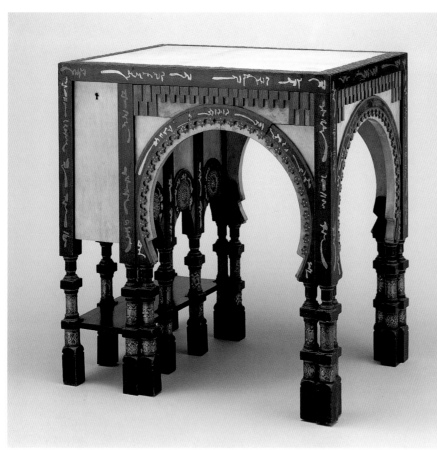

313

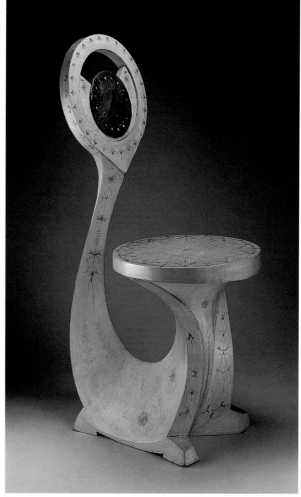

317 Adolfo Hohnstein (German, 1854–1928), *Fiammiferi senza Fosforo del Dottor Craveri (Dr Craveri's Safety Matches without Phosphorus)*, c.1900, color lithograph. 149 × 78 cms; 58¹¹/₁₆ × 30¹¹/₁₆ cms. Museo Municipale di Treviso.

318 Adolfo Hohnstein (German, 1854–1928), *Vino-Vermouth, F.co Cinzano e Cia (Vermouth Wine)* c.1910, ink on paper. 81.3 × 111.8 cms; 32 × 44 ins. Museo Municipale di Treviso.

319 Adolfo Hohnstein (German, 1854–1928), *Fratelli Rittatore*, c.1901, color lithograph. 62 × 50 cms; 24⁷/₁₆ × 19¹¹/₁₆ ins. Museo Civico L. Bailo, Treviso.

320 Alberto Issel (Italian, 1848–1926), *Desk*, 1902, oak, metal, leather, fabric, and paint. 132.5 × 82.3 × 49.3 cms; 52³/₁₆ × 32³/₈ × 19⁷/₁₆ ins. The Mitchell Wolfson Jr. Collection, The Wolfsonian–Florida International University, Miami Beach, Florida. Pl. 29.11.

321 Agostino Lauro (Italian, 1861–1924), *Double parlor* from a villa in Sordevolo, 1900–01. The Mitchell Wolfson Jr. Collection, The Wolfsonian–Florida International University, Miami Beach. Pl. 29.9, 29.10.

322 Leopoldo Metlicovitz (Italian, 1868–1944), *Cabrira*, c.1914, color lithograph. 201 × 145 cms; 79¹/₈ × 57¹/₁₆ ins. Museo Civico L. Bailo, Treviso.

313 Carlo Bugatti (Italian, 1856–1940), *Lady's desk*, c.1895–1902, vellum, copper, pewter, walnut, and ebonized beech. 74.6 × 71.1 × 54 cms; 29³/₈ × 28 × 21¹/₄ ins. The Art Institute of Chicago: Gift of the Antiquarian Society Annual Tour 1974 and the Jessie Spalding Landon Fund.

314 Carlo Bugatti (Italian, 1856–1940), *Cobra chair*, c.1902, vellum, wood, copper, pencil, and paint. 97.8 × 53.3 × 37.2 cms; 38¹/₂ × 21 × 14⁵/₈ ins. Carnegie Museum of Art, Pittsburgh: Berdan Memorial Trust Fund, Helen Johnston Acquisition Fund and Decorative Arts Purchase Fund.

315 Carlo Bugatti (Italian, 1856–1940), *Tea set*, c.1908–10, silver and ivory. Tray: 12.4 × 75.6 × 19.1 cms; 4⁷/₈ × 29³/₄ × 7¹/₂ ins. Private collection.

316 Marcello Dudovich (Italian, 1878–1962), *Società Torinese Automobili Elettrici (Turin Electric Car Company)*, c.1910, color lithograph. 140.3 × 205.7 cms; 55¹/₄ × 81 ins. Museo Civico L. Bailo, Treviso.

315

314

323

G. New York

323 John White Alexander (American, 1856–1915), *Isabella and the Pot of Basil*, 1897, oil on canvas. 191.9 × 89.5 cms; 75⁹/₁₆ × 35¹/₄ ins. Museum of Fine Arts, Boston: Gift of Ernest Wadsworth Longfellow.

324 William H. Bradley (American, 1868–1962), *Drawing for 'The Masqueraders' poster*, 1894, pen, ink and wash drawing. 40.6 × 71.1 cms; 16 × 28 ins. The Metropolitan Museum of Art, New York: Gift of Fern Bradley Dufner, The Will Bradley Collection, 1952.

325 William H. Bradley (American, 1868–1962), *Narcoticure*, 1895, color lithograph. 115 × 81.4 cms; 45¹/₄ × 32¹/₁₆ ins. Prints and Photographs Division, Library of Congress, Washington, D.C.

324

325

326

328

329

326 William H. Bradley (American, 1868–1962), *The Modern Poster*, 1895, letterpress. 49.2 × 29.5 cms; 19³/₈ × 11⁵/₈ ins. Virginia Museum of Fine Arts, Richmond: The Arthur and Margaret Glasgow Fund and The Sydney and Frances Lewis Endowment Fund.

327 William H. Bradley (American, 1868–1962), *Victor Bicycles*, 1896, color lithograph. 65.5 × 99.5 cms; 25¹³/₁₆ × 39³/₁₆ ins. V&A, London. Pl. 9.19.

328 Gorham Manufacturing Corporation (American, firm active 1815 onwards), *Ewer and platter*, silver. 54.6 × 43.5 cms; 21¹/₂ × 17¹/₈ ins. The Metropolitan Museum of Art, New York: Gift of Hugh Grant.

329 Gorham Manufacturing Corporation (American, firm active 1815 onwards), *Presentation Cup*, 1914, silver. 48.3 × 33 cms; 19 × 13 ins. The Newark Museum: Gift of James Hillas, 1967.

330 Marcus and Company (American, firm founded 1892), *Orchid pin*, 1900, gold, plique-à-jour enamel, pearls, and platinum. 11.4 × 6.5 cms; 4¹/₂ × 2¹/₂ ins. Private collection, New York. Pl. 15.2.

331

331 Edward Penfield (American, 1866–1925), *Poster Calendar*, 1897, color lithograph. 45.6 × 30.5 cms; 17^{15}/$_{16}$ × 12 ins. Prints and Photographs Division, Library of Congress, Washington, D.C.

332 Louis J. Rhead (American, 1857–1926), *Read the Sun*, 1895, color lithograph. 118.7 × 71.1 cms; 46³/₄ × 28 ins. Virginia Museum of Fine Arts, Richmond: The Arthur and Margaret Glasgow Fund and The Sydney and Frances Lewis Endowment Fund.

333 Louis J. Rhead (American, 1857–1926), *Le Journal de la Beauté*, 1897, color lithograph. 84.3 × 154.3 cms; 33³/₁₆ × 60³/₄ ins. The Metropolitan Museum of Art, New York: Leonard A. Lauder Collection of American Posters.

332

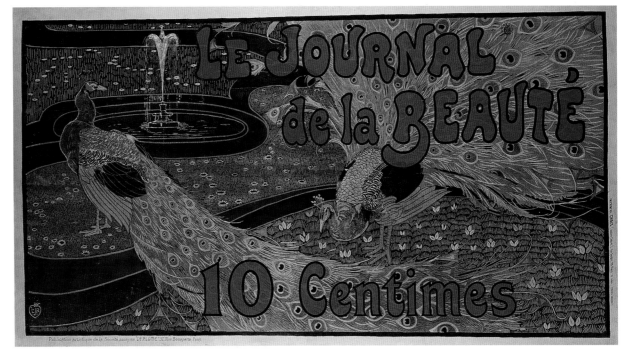

333

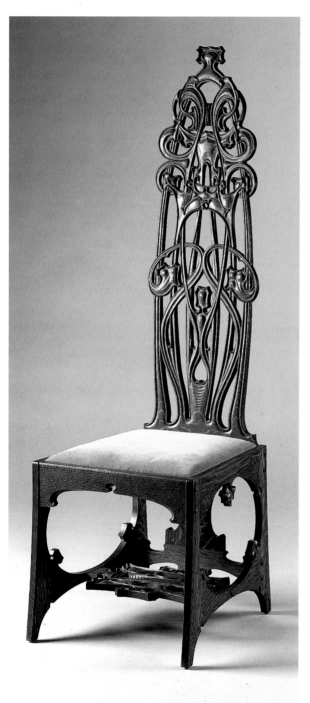

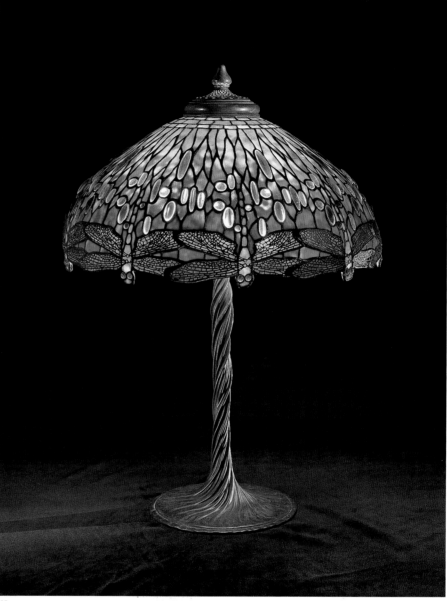

337

334 Charles Rohlfs (American, 1853–1936), *Tall-backed chair, c.*1898, oak. 137 × 44.5 × 41.3 cms; 53¹⁵/₁₆ × 17¹/₂ × 16¹/₄ ins. The Art Museum, Princeton University: Gift of Roland Rohlfs.

335 Charles Rohlfs (American, 1853–1936), *Hall chair, c.*1900, oak. 144.1 × 48.3 × 38.1 cms; 56³/₄ × 19 × 15 ins. Los Angeles County Museum of Art: Gift of Max Palevsky and Jodie Evans.

336 Charles Rohlfs (American, 1853–1936), *Clock,* 1901, oak with green glass and clockworks. 259.1 × 76.2 × 38.1 cms; 102 × 30 × 15 ins. Town of Clarence, NY.

337 Tiffany Studios (American, 1892–1932), *Dragonfly lamp, c.*1910, stained glass and bronze. 75.6 cms; 29³/₄ ins. Chrysler Museum of Art, Norfolk, Virginia: Gift of Walter P. Chrysler.

338 Tiffany Studios (American, firm active 1892–1932), *Box,* 1895–1905, cypriote glass and bronze. 12.1 × 25.1 × 17.2 cms; 4³/₄ × 9⁷/₈ × 6³/₄ ins. Private collection.

339 Tiffany Studios (American, firm active 1892–1932), *Gourd tray, c.*1900, enamel on copper. 64.8 × 35.5 cms; 25¹/₂ × 14 ins. Erving and Joyce Wolf Collection. Pl. 28.9.

334

338

340

340 Tiffany Studios (American, firm active 1892–1932), *Jack-in-the-pulpit vase*, c.1900–10, favrile glass. 50.8 × 27.3 cms; 20 × 10¾ ins. Private collection.

341 Tiffany Studios (American, firm active 1892–1932), *Wisteria table lamp*, c.1902, leaded glass and bronze. 64.8 × 46.3 cms; 25½ × 18¼ ins. Lillian Nassau Ltd., New York. Pl. 3.5.

342 Tiffany Studios (American, firm active 1892–1932), *Jack-in-the-pulpit vase*, c.1903, blown favrile glass. 38.8 × 18.4 cms; 15¼ × 7¼ ins. Collection of Eric Streiner, New York. Pl. 28.4.

343 Tiffany Studios (American, firm active 1892–1932), *Cobweb Lamp*, c.1904, favrile glass, bronze, and mosaic. 74.9 cms; 29½ ins. Virginia Museum of Fine Arts, Richmond: Gift of Sydney and Frances Lewis.

344 Tiffany Studios (American, firm active 1892–1932), *Fern vase*, 1904–10, earthenware (semi-porcelainous). 30.5 cms; 12 ins. Dr Martin Eidelberg, New York.

345 Louis Comfort Tiffany (American, 1848–1933), *Dandelion hair ornament*, 1904, platinum, enamel, black opals, pink opals, and demantoid garnets. 8.3 cms; 3¼ ins. Private collection.

343

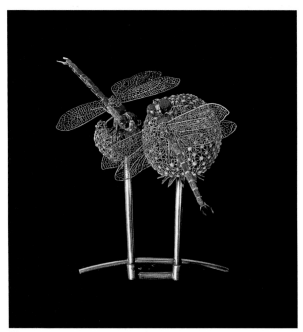

345

348

350

349

346 Louis Comfort Tiffany (American, 1848–1933), *Vase*, c.1904–14, semi-porcelainous clay. 27.6 cms; 10⅞ ins. Private collection.

347 Louis Comfort Tiffany (American, 1848–1933), *Fern vase*, c.1906–14, ceramic. 27.6 cms; 10⅞ ins. Cooper-Hewitt National Design Museum, Smithsonian Institution, New York: Gift of Marcia and William Goodman.

348 Louis Comfort Tiffany (American, 1848–1933) and Tiffany Furnaces (American, 1902–24), *Lava bowl*, 1908, favrile glass. 16.8 cms; 6⅝ ins. The Metropolitan Museum of Art, New York: Gift of Louis Comfort Tiffany Foundation.

349 Louis Comfort Tiffany (American, 1848–1933), Tiffany Glass and Decorating Company (American, 1892–1932), and Fredolin Kreischmann (Austrian, 1853–98), *Vase*, 1895–98, cased, cut, and engraved favrile glass, 31.1 cms; 12¼ ins. The Metropolitan Museum of Art, New York: Purchase, William Cullen Bryant Fellows Gifts.

350 Charles Herbert Woodbury (American, 1864–1940), *The July Century*, 1895, letterpress and lithograph. 48.3 × 30 cms; 19 × 11¹³/₁₆ ins. Prints and Photographs Division, Library of Congress, Washington, D.C.

352

353

354

356

H. Chicago

351 William H. Bradley (American, 1868–1962), *The Serpentine Dancer* (from *The Chap-Book* of 1 December, 1894), lithograph. 20 × 12.7 cms; 7⁷/₈ × 5 ins. Chicago Historical Society.

352 William H. Bradley (American, 1868–1962), *The Skirt Dancer* (from *The Chap-Book* of 1 December, 1894), 1894, lithograph. 20 × 12.7 cms; 7⁷/₈ × 5 ins. Houghton Library, Harvard University, Cambridge.

353 William H. Bradley (American, 1868–1962), *The Echo*, 1894, color lithograph. 54 × 36.8 cms; 21¼ × 14½ ins. Prints and Photographs Division, Library of Congress, Washington, D.C.

354 William H. Bradley (American, 1868–1962), *The Chap-Book, 'The Blue Lady'*, 1894, color lithograph. 46.5 × 31.6 cms; 18⁵/₁₆ × 12⁷/₁₆ ins. Chicago Historical Society.

355 William H. Bradley (American, 1868–1962), *The Masquerade* (for the *Chicago Sunday Tribune*), 1895, lithograph. 46.4 × 31.8 cms; 18¼ × 12½ ins. Chicago Historical Society.

356 William H. Bradley (American, 1868–1962), *Thanksgiving No., The Chap-Book*, 1895, color lithograph. 50.8 × 33.7 cms; 20 × 13¼ ins. Prints and Photographs Division, Library of Congress, Washington, D.C.

357 George Grant Elmslie (American, 1871–1952), *Teller wicket*, 1907–08, copper-plated cast iron, 104.1 × 58.4 cms; 41 × 23 ins. The Toledo Museum of Art: Purchase with funds from the Florence Scott Libbey Bequest in memory of her father, Maurice A. Scott.

358 George Grant Elmslie (American, 1871–1952), *Dining room chair*, 1910, oak. David and Patricia Gebhard collection.

359 George Grant Elmslie (American, 1871–1952), *Window from the J. C. Cross House*, Minneapolis, 1911, clear and stained leaded glass. 152.4 × 38.1 cms; 60 × 15 ins. The Metropolitan Museum of Art, New York: Gift of Roger G. Kennedy.

357

359

360

361

360 George Washington Maher (American, 1864–1926), *Thistle mosaic panel from the James A. Patten House*, Evanston, 1901, glass tile mosaic, gold, and silver leaf. 96.5 × 47 × 5.7 cms; 38 × 18¹/₂ × 2¹/₄ ins. Meredith Wise Mendes and Michael Levitin.

361 George Washington Maher (American, 1864–1926), *Thistle textile from the James A. Patten House*, Evanston, 1901, silk and cotton. 200.7 cms; 79 ins. The Saint Louis Art Museum.

362 George Washington Maher (American, 1864–1926), *Thistle lunette from the Patrick King House, Wausau, Wisconsin*, 1901, stained glass. 87.6 × 142.2 cms; 34¹/₂ × 56 ins. Chicago Historical Society.

363 George Washington Maher (American, 1864–1926), *Window from the Foler Stone House*, c.1903, stained glass. 60.6 × 14.6 cms; 23⁷/₈ × 5³/₄ ins. Chicago Historical Society

363

362

364

365

366

364 Frederick Winthrop
Ramsdell (American,
1865–1915), *American Crescent
Cycles*, 1899, color lithograph.
165.1 × 114.3 cms; 65 × 45 ins.
Steven Schmidt.

365 Louis Sullivan (American,
1856–1924), *Section of stencil frieze
from the Chicago Stock Exchange*,
1893–94, oil on canvas mounted
on paper, 144.8 × 121.9 cms;
57 × 48 ins. Seymour H. Persky.

366 Louis Sullivan (American,
1856–1924), *Elevator grille from
the Chicago Stock Exchange* (detail),
1893–94, painted cast and
wrought iron. 297.2 cms;
117 ins. Seymour H. Persky

367 Louis Sullivan (American, 1856–1924), *Wall sconce from the Henry B. Babson House, Riverside,* Illinois, 1907, brass and leaded glass. 31.4 × 13.7 × 24.8 cms; 12³⁄₈ × 5³⁄₈ × 9³⁄₄ ins. Los Angeles County Museum of Art: Gift of Max Palevsky and Jodie Evans.

368 Louis Sullivan (American, 1856–1924), *Multicolored block from the Henry B. Babson House, Riverside,* Illinois, *c.*1907, terracotta. 64.8 cms; 25¹⁄₂ ins. University Museum, Southern Illinois University.

369 William James Dodd (American, 1862–1930) and Gates Pottery Company (American, firm active 1885–1923), *Teco Vase,* 1904, earthenware. 25.4 cms; 10 ins. Chicago Historical Society.

370 Fritz Albert (American) and Gates Pottery Company (American, firm active 1885–1923), *Teco Vase* (1904–05), earthenware. 37.5 cms; 14³⁄₄ ins. Private collection.

371 Frank Lloyd Wright (American, 1869–1959) and Gates Pottery Company (American, firm active 1885–1923), *Teco Vase from Unity Temple, c.*1906, earthenware. 74.9 × 35.6 × 35.6 cms; 29¹⁄₂ × 14 × 14 ins. Unity Temple Unitarian Universalist Congregation of Oak Park.

372 Frank Lloyd Wright (American, 1869–1959) and James A. Miller (American, b.1850), *Weed holder, c.*1895, copper. 71.1 × 10.8 cms; 28 × 4¹⁄₄ ins. Seymour H. Persky.

373 Frank Lloyd Wright (American, 1869–1959), *Lamp, c.*1898–1999, copper. 71.1 × 30.2 cms; 28 × 11⁷⁄₈ ins. Seymour H. Persky.

374 Frank Lloyd Wright (American, 1869–1959), *Urn, c.*1900, copper. 47 × 47 cms; 18¹⁄₂ × 18¹⁄₂ ins. Seymour H. Persky.

367

370

374, 372, 373

375

Name Index

NOTE: Illustration plate numbers are in italic, and are listed after the page numbers. Page numbers in bold indicate chapters.

Abramtsevo Ceramics Factory 391, 392–3
Adam, Paul (1862–1920) 97
Adler, Dankmar (1844–1900), partnership with Sullivan 224, 324
Åhlström, Betzy 213
Aitken, Janet *21.1*
Albert, Prince-Consort (1819–61) 129
Allais, Alphonse (1854–1905), *Ubu roi* 98
Amphora ceramic factory 368
Andersen, David, silverware 217, 228
Anderson, William (1842–1900), *Pictorial Arts of Japan* 106
Andrassy, Count Tivadar (1860–1929) 354–5
André, Émile (1871–1933) 44, 172
Anyž, Franta (1876–1934) 368
Apáti Abt, Sándor (1870–1916) 199, 352–4
Apollinaire, Guillaume (1880–1918) 94, 99, 435, *5.8*
Appert Frères, crackled glass 210
Arnau, Eusebi 339
d'Aronco, Raimondo (1857–1932) 28, 119–20, 259, 415
 at the *Prima Esposizione d'Arte Decorativa Moderna* (Turin 1902) 32, 119–20, 414–15, *29.2*, *29.3*, *29.4*
Arp, Hans (Jean) (1886–1966) 435, 436, *30.6*
Artêl cooperative 368
Ashbee, Charles Robert (C.R.) (1863–1942) 19, 49, 81, 133, 137, 143, 145, 237, *8.11*, *14.4*
 decorative silverware 225–6, 229, *14.4*
 Secessionism and 229
Associated Artists 400
Aubert, Félix (1866–?) 184, 256
Aubry, Françoise, Victor Horta and Brussels **275–85**
Aucoc, Louis (1850–1932) 228, 237
Augspurg, Anita 293
Aurier, (George-)Albert (1865–92) 19, 75, 112
Autrique, Eugène (1860–?) 276

Backhausen, Johann & Söhne, textile production 308, 309, *20.14*
Bacon, John H.F. 251
Baffier, Jean (1857–1921) 253–4
Bahr, Hermann 301
Baillie-Scott, M.H. (Mackay Hugh) (1865–1945) 369, 384
Bakalowits & Lobmeyr, glassmakers 308
Bakalowits, E. & Söhne, glassware 215, 308
Balat, Alphonse Huber-François (1818–95) 221, 275
Balšánek, Antonín (1865–1921), the Municipal House (Prague) 367, *25.7*, *25.8*
Bans, George 223
Barlow, Hannah and Florence 196

Barovier, Giuseppe (1853–1942) 215
Barrias, Louis-Ernest (1841–1905), *Nature Unveiling Herself to Science* 256
Bartlett, Paul Wayland (1865–1925) 256, 259
Barye, Antoine-Louis (1796–1875) 259
 Surtout de Table 259
Basile, Ernesto (1857–1932) 40, 174, 424, *29.12*
Bassegoda, Joaquim 336
Baudelaire, Charles Pierre (1821–67) 94, 97, 138, 149
Bayard, Émile, art critic 432
Beardsley, Aubrey (1872–98) 26, 61, 89, 116, 145, 161, 292
 book illustration 116, 143, *5.5*
 and Japanese prints 89, 107, 123
 Lysistrata prints 89
 Morte D'Arthur illustrations 143
 Salome prints 24, 28, 88, 123, 143, 155, *1.9*
 The Studio (magazine) 24, 28, 143, 154, *1.14*
Beeger, silverware sales 228
Beggarstaff brothers 161
Behrens, Peter (1868–1940) 28, 158, 159, 230, 297
 ceramics designs 198, 201, *12.6*
 glasswork designs 216
 The Kiss, colour woodcut 159, *9.14*
Bell, (Arthur) Clive (1881–1964) 435
Bellery-Desfontaines, Henri (1867–1909) 157–8, 179
 L'Enigme 9.15
Belmonte, Leo (1870–1956) 357
Benard, André 223
Bendelmayer, Bedřich (1872–1932), Hotel Europa (Prague) 362, *25.5*
Berenguer, Francesc (1866–1914) 336, 343–5
Bergé, Henri (1870–1937) 212, 213
Berlage, H Petrus (1856–1934) 336
Bernard, Émile (1868–1941) 48, 81
 corner cabinet *2.15*
Bernhardt, Sarah (1845–1923) 85, 122, 151–3, 210, 248, 368
Bernheim, Hippolyte (1840–1919) 89
Beroggio, Professor, assistance to Valabrega 419
Berthon, Paul Émile (1872–1909) 151
Besant, Annie (1847–1933) 320
Besnard, Charlotte (b.1855) 256
Beyer, Victor, on A N and Classicism 38
Bierbaum, Otto (1865–1910), *Pan* (magazine) 158
Bigelow, Samuel (1850–1926) 106
Bigot, Alexandre (1862–1927) 198
Bílek, František (1872–1941) 28, 364
 Tilling the soil is Punishment for Our Sins 364, *25.6*
Bindesbøll, Thorvald (1846–1908) 61
 painted earthenware 205–7, *3.7*
 silver designs 228, 237
Binet, René (1866–1911), and the *Exposition Universelle* (Paris 1900) 125, *7.10*, *7.11*
Bing & Gro[/]ndahl, ceramics 201–2, 407

Bing, Marcel (1875–1920) 66, 170
Bing, Siegfried (Samuel) (1838–1905) 27, 28, 29, 111, 119, 128, 157, 400
 exhibition on modern book design (1896) 155
 exhibitions of Japanese prints 105
 Le Japon artistique (magazine) 29, 101–5, 109–10
 L'Art Nouveau gallery shop 26, 94, 105, 157, 170–1, 180, 184, 204, 217, 234, 256, 269, 400, 405, *1.11*, *10.9*, *11.6*, *17.8*, *17.9*
 Oriental Art Boutique 101, 171, *6.1*
 Pavillon Bing 32, 43, 166, 171, 184, 212, 269, *2.7*, *10.5*, *10.9*, *17.9*
 textiles 179, 184, *11.6*
Bird, Isabelle (1831–1904), views of Japan 101
Bistolfi, Leonardo (1859–1833) 419
 poster 414, *29.1*
Blake, William (1757–1827) 364
Blizard, F.S. 251
Blondat, Max (1872–1925) 260
Boberg, Ferdinand (1860–1946) & Anna (1864–1935), glasswork designers 213
Boch Frères, ceramics company 204
Bochons, Léon 179
Böck, J, porcelain manufacturers 308
Böcklin, Arnold (1827–1901) 158
Bodelsen, Merete, Gauguin study 197
Bodenhausen, Eberhard, Freiherr von 69
Böhm, Adolph (1861–1927) 160
Bonaventura brothers 336
Bonebakker, silverware sales 228
Bonnard, Pierre (1867–1947) 75, 96, 157, *5.2*
Boucher, François (1703–70), *Portrait of Madame de Pompadour 2.11*
Boucheron, Frederick (1830–1902) 110, 228, 238, 243
Boudová-Suchardová, Anna (1870–1940), applied arts 368
Bouilhet, André 331
Bourdelle, Émile-Antoine (1861–1929) 256
Bourges, Élémir (1852–1925) 94
Bourget, Paul (1852–1935) 94, 97
Bouval, Maurice (1863–1916), busts of *Pavot* and *Iris* 260
Bowler, Peter, on scientists and radicals 69
Bracquemond, Félix Auguste-Joseph (1833–1914) 101, 196, 228
 On Drawing and Colour 58
Bradley, Will (1868–1962) 28, 161–2
 The Chap Book designs 161
 Victor Bicycles 107, *9.19*
Brantjes, Weduwe N.S.A., ceramics manufactures 193, 202, *12.12*
Breton, André (1896–1966) 32
Březina, Otakar (1868–1929), poet 364
Brinckmann, Justus, *Kunst und Handwerk in Japan* 106
Brinkmann, Justus (1843–1915) 290
Brocard, Philippe-Joseph (d.1896) 210
Brock, William 48
Brouwer, Willem (1877–1933) 193
Brown, Ford Madox (1821–93) 81
Bruneau, Alfred (1857–1934) 94
Brunhammer, Yvonne 46
Buffa, Giovanni, *Medusa* 86, *4.20*
Bugatti, Carlo (1856–1940) 118–19, 424

furniture design 28, 107, 424, *7.4*, *29.13*
Bull, Henrik (1864–1953), dragon ship jardinière 50, 52, *1.6*
Burdett, Osbert 69
Burgun, Schverer & Cie glassworks 213
Burne-Jones, Edward Coley (1833–98) 77, 132, 138
 sideboard *8.6*
Burty, Philippe (1830–1890) 101, 111
Bussière, Ernest (1863–1913) 212
Butterworth, Lindsay P 280–2

Cachet, C A Lion *see* Lion Cachet
Caldecott, Randolph (1846–86) 196
Cambó i Batlle, Francesc d'Assis (1876–1947) 335
Cameron, Katherine (1874–1965?) *21.1*
Cantagalli
 lustre glazes 199
 tiles and mosaics for Lauro's *palazzina* 421
Carabin, Rupert (1862–1932)
 furniture designs 65, 84, 165, 252, 252–3, *3.10*, *4.14*, *10.3*, *16.1*
 statuette of Loïe Fuller 261
Cardeillac, silverware workshop 228
Carder, Frederick (1863–1963) 218–19
Carlyle, Thomas (1795–1881) 129
Carrier-Belleuse, Albert-Ernest (1824–87) 253
Carriès, Jean (Joseph-Marie) (1855–94)
 Princesse de Polignac doorway 253
 sculpted stoneware 194, 253, *12.2*, *16.2*
 Le Faune endormi (The Sleeping Faun) 194, *12.2*
Carrington, Charles, pornographer 89
Carson, Edward Henry, Baron (1854–1935) 38, 145
Casany, ceramicist 339
Castelot Jollivet, F, on magic and science 74
Céard, Henry, *Terrains à vendre au bord de la mer* 98
Cerdà, *Eixample* project in Barcelona 335, 342
Cézanne, Paul (1839–1906) 81
Chalon, Louis (1866–1916) 260
Champenois, printing firm 149–50
Chaplet, Ernest (1835–1909) 110
 barbotine painting technique 196, 204
 porcelain 197, *12.5*
 stoneware 194, 196–7
Charcot, Jean-Martin (1825–93) 73, 89
Charpentier, Alexandre (1856–1909) 18, 28, 69, 81, 254, 256, 259, 272, 292, 433
 Armoire à layette 256, *16.5*
Charpentier (publisher) 93
Chavannes *see* Puvis de Chavannes
Chéret, Gustave-Joseph (1838–94), sculpted artefacts 253–4
Chéret, Jules (1836–1932), posters 149–50, 161, *9.2*
Christian, Désiré (1846–1907) 213
Christophe, first French cartoon (1889) 96
Churberg, Fanny Maria (1845–92) 191
Les Cinq, artist's group 20, 254

furniture design 28, 107, 424, *7.4*, *29.13*
Claudel, Camille (1864–1943) 256
Claudel, Paul (1868–1950) 97
 Cinq grandes odes 98
Clausen, George (1852–1944) 251
Clément, Adolphe 200
Clifford, Helen, modern metal **221–35**
Co-operative Wholesale Society, biscuit tins *1.3*
Cobden-Sanderson, Thomas (1840–1922) 49, 133
Codman, William 234
Cole, Henry (1808–82) 129
Colenbrander, Theodor Christiaan Adriaen (1841–1930)
 carpet designs 188
 ceramics motifs 202
Collinson, James (1825–81) 130
Colman, Samuel, collaboration with Tiffany 400
Colonna, Édouard (1862–1948) 234
 furniture designs 170, 171
 interior from L'Art Nouveau Bing (1900) *17.9*
 mounts for Tiffany glassware 405
 textile designs 119, 183, 184, *11.5*
Colton, William Robert (1867–1920) 251
Cometti, Giacomo (1863–1938) 417, 419, 424, *29.6*, *29.7*
Coppée, Francis (1842–1908) 94
Corbusier *see* Le Corbusier
Cordier, Charles Henri-Joseph (1827–1905) 256
Corning Glassworks 219
Corona Glassworks (Long Island) 218
Courbet, Gustave (1819–77) 287
Couyba, Charles 177, 271
Crane, Walter (1845–1915) 49, 133, 139, 145, 154, 225, 227, 251, 311, 392, 414
 ceramic designs 193
 wallpapers 59, 137, *8.10*
 The Claims of Decorative Art - Dijsselhof's binding *9.11*
Crespin, Adolphe (1859–1944) 153
Cros, Henry (1840–1907) 209
Crowley, David, Budapest **347–59**
Czeschka, Carl Otto (1878–1960) 237, 308

Dalí, Salvador (1904–89) 435
Dalou, Aimé-Jules (1838–1902) 253
Dalpayrat, Pierre-Adrian (1844–1910) 110, 194, 197, 197–8, *12.3*
Dammouse, Albert-Louis (1846–1926) 196
Dampt, Jean(-Auguste) (1854–1945) 254–6
 The Fairy Mélusine and the Knight Raymondin 254, *16.4*
 Songe d'Or bed 256
Dangerfield, George, *The Strange Death of Liberal England* 429
Darwin, Charles Robert (1809–82) 22, 55, 65, 69
Daudet, Alphonse (1840–97) 98
Daum, Antonin (1864–1930) 44, 212, *13.3*, *13.4*
Daum, Auguste (1853–1909) 27, 28, 44, 212–13, *13.3*, *13.4*
Daum Frères 27, 65, 110, 212–13, 217, 234, *3.8*, *3.11*, *13.3*, *13.4*
Daum, Jean (1825–85) 212
Day, Fred Holland (1864–1933) 90
Day, Lewis F. (1845–1910) 145
De Feure *see* Feure
de Forest, Lockwood 400

De Morgan, William Frend
(1839–1917) 115, 116, 132
 lustre glazes 199, *8.5*
Debain, A, silversmith 227
Debschitz, Wilhelm von
(1871–1948), Obrist and 293
Debussy, (Achille-)Claude
(1862–1918) 96
Degas, Edgar (1834–1917) 38
Dékáni, Árpád (1861–1931) 359,
24.13
Delaherche, Auguste (1857–1940)
110, 194, 197, 204, *12.3*
Dellamora, Richard 90
Delville, Jean (1867–1953) 319, 320
Deneken, Friedrich 191
Denis, Maurice (1870–1943) 48, 75,
81, 157
 book illustrations 96, *5.3*
 print media 157
 Procession under the Trees 280
 The Road to Calvary 75–6, *4.4*
Desbois, Jules (1851–1935) 253–5
Deschamps, Léon Julien
(1860–c.1913), *La Plume* (magazine)
15, 29, 75, 82
Desrosiers, Charles 248, *15.12*
Deuss & Oetker (Krefeld)
 commercial weavers 191
Diaghilev, Sergei Pavlovich
(1872–1929) 375, 395
Dijsselhoff, Gerrit Willem
(1866–1924) 156
 Kunst en Samenleving bookbinding
 9.11
Doat, Taxile (1851–1939) 193, 194,
197, 205, *12.1*
Doesburg, Theo van (1883–1931) 81
Dollfus Mieg & Co, textile printing
180
Domènech i Montaner, Lluís
(1849–1923) 336–9
 Café-Restaurant (1888) 336, 339
 Palau de la Música Catalana
 336, 339, *23.1, 23.2*
Donaldson, George (1845–1925)127
Doulton & Co, ceramics 143, 193,
196, 198
Dresser, Christopher (1834–1904)
55, 58, 101, 115, 116, 128, 139,
142
 'Clutha' glass 216, *8.16*
 textile patterns 182
Drtikol, František (1878–1961) *25.1*
Dryák, Alois (1872–1932) 362
 Hotel Europa (Prague) *25.5*
Dubois, Fernand (1861–1939) 227,
254, *14.6*
Dufrène, Maurice (1876–1955)
41–3, 207, 272, 432, *12.17*
Dujardin, Édouard (1861–1949)
 La Revue indépendante 75
 Les Lauriers sont coupés 97
Durand-Ruel, art dealer 76
Duray, Lamaresquier and Paumier,
Paris Metro designs 223
Dutailly, ceramic glaze chemist 200
Dutert, Charles Louis-Ferdinand
(1845–1906), The Machine Hall
(Paris 1889) 221

Eckmann, Otto (1865–1902) 28,
159, 289, 290–1
 furniture *19.7*
 Japanese influence 110, 159,
 290, *19.5*
 metalwork designs 291
 tapestry designs 191, 290, *11.12*
 woodcut prints 290
 Five Swans tapestry 191, 290,
 11.12

Irises, colour woodcut 159, *19.5*
 Die Woche title page 160
Ehrström, Eric O W (1881–1934)
384
Eiffel, Gustave (1832–1923), Tower
(Paris 1889) 221, *14.1*
Elder Duncan, J H 20–1, 22–3
Ellis, (Henry) Havelock (1859–1939)
89
Elmslie, George Grant (1871–1952),
Sullivan's draughtsman *22.11*
Endell, August (1871–1925) 19, 28,
70, 291, 292–3, 433
 Hof-Atelier Elvira designs 107,
 293, *1.5, 19.8*
Engel-Gros, Frederic 180
Engelhardt, Valdemar (1860–1915)
200
Ensor, James (1860–1949) 81
Erler, Fritz (1868–1940) 159
 Die Jugend cover *19.6*
Escher, Maurits Cornelis (1902–72)
308
Escofet, in Barcelona 339

Fabergé, Peter Carl (1846–1920) 292
Falize, Lucien (1839–97) 228
Falqués, Pere 336
Fanta, Josef (1856–1954), Central
Railway Station (Prague) 362, *25.4*
Faragó, Ödön (1869–1935) 28, 352,
24.5
Fauré, Gabriel (1845–1924) 96
Félice, Roger de 45
Fénéon, Félix (1861–1944) 80, 81,
4.9
Fenollosa, Ernest (1853–1908) 106,
113
Feuillâtre, Eugène (1870–1916)
228–9, 237, 240
Feure, Georges De (1868–1943) 28,
96, 108, 157
 furniture designs 170, 173, *2.7*
 images of women 84–5, *4.15*
 Louis' style designs 43, 173, *2.7*
 metal furniture fittings 234–5,
 14.12
 stained glass 212
 textiles 179, 183, 184, *2.7*
 use of colour 108, *4.15*
 L'esprit du mal 4.15
Finch, Alfred William (Willy)
(1854–1930) 81, 130, 204, 383,
26.9
First Japan Trading and
Manufacturing Company 112
Fischer, Theodor (1857–1927) 292
Fisher, Alexander (1864–1936) 143,
225, *8.18*
Fix-Masseau, Félix (1869–1937) 256
 The Secret 86, *4.19*
Flammarion (publishers) 93
Flaubert, Gustave (1821–80) 93
 Salammbô 122
Fleres, U, on Italian A N 417
Follot, Paul (1877–1941) 41–3
 furniture (Salon d'Automne
 1912) 432, *30.4*
 ornamental silverware 235,
 14.13
Fomin, Ivan Aleksandrovich
(1872–1936) 396–7, *27.8*
Fort, Paul (1872–1960) 97
Fouquet, Georges (1862–1957) 237,
238, 240, 242, 243, 248, 259, *15.5,
15.6*
Fourcaud, Louis de (1851–1914)
253, 261
Foy, René 237, 240, 249
Fragonard, Jean Honoré
(1732–1806) 43

Frampton, George James
(1860–1928) 251, 261
France, Anatole (1844–1924) 154
Franz, Henri 223
Fratelli Toso, glassmakers 215
Freer, Charles (1856–1919) 106
Frelinghuysen, Alice Cooney, Tiffany
and New York **399–411**
Freud, Sigmund (1865–1939) 89,
300, 436
Frison, Maurice 276
Frosterus, Sigurd (1876–1956) 375,
387
Fuchs, George (1868–1949) 292
Fuller, Loïe (1862–1928) 85, 123,
200, 261, *12.7*
 Chéret's poster of 150, *9.2*
 Loïe Fuller Pavilion 32, 261,
 1.17, 16.12
 sculptures of 261, *16.11*
 use of electric light 240, 261
Furnémont, Léon 276
Furness & Hewitt, architects 324
Furness, Frank (1839–1912) 324

Gaillard, Eugène (1862–1933) 61,
234, 237, 272
 furniture designs 170–1, *10.6*
 model rooms 166, *10.5*
 printed cotton velveteen 119, *7.5*
 textile designs 183, *7.5*
Gaillard, Lucien (1861–?)
 employs Japanese craftsmen 112,
 242
 horn combs 242
Gallé, Charles (1818–1902) 210
Gallé, Émile (1846–1904) 20, 26, 27,
28, 31, 55, 89, 130, 209–10, 234,
237, 369, *1.4*
 furniture design 172, 173, 174,
 10.11
 glassware 44, 118, 209–13, 217,
 219, 291, 403, *1.4, 2.9, 3.12,
 13.1, 13.2*
 Japanese influences 107, 109,
 210
 nature and 210–12, *13.1, 13.2*
 political convictions 209
 Symbolism and biology 65,
 210–12, *3.12, 13.1, 13.2*
 Hand 210, *1.4*
Gallén, Aksel (1865–1931) *see*
Gallen-Kallela, Akseli
Gallen-Kallela, Akseli (1865–1931)
28, 38–3, 108, 191, 376, 381–3,
387
 Gesamtkunstwerk 381–3
 Symbolism 381, *26.6, 26.7*
 Autumn's Five Crosses 26.7
 Bil-Bol poster 159–60, *9.16*
 Finnish Pavilion decorations
 (Paris 1900) 381–3, *26.8*
 The Flame rug 381–3, *26.8*
 Lemminkäinen's Mother 26.6
Gallissà, Antoni María (1861–1903)
336, 339
Gardet, Georges 259
Garnier, Charles Jean-Louis
(1825–98), Paris Opera House 40
Gaudernack, Gustav (1865–1914)
217
Gaudí, Antoni (1852–1926) 28, 40,
46, 50, 130, 435, *2.3, 23.10*
 architectural decoration 341–2,
 343, *23.4, 23.5, 23.6, 23.9,
 23.10*
 architectural ironwork 224, 345,
 23.6, 23.8
 Casa Batlló 121, 224, 342, *23.3,
 23.4*
 Casa Calvet 342

Casa Milà 121, 224, 342, *23.5,
23.6*
 Catalan/Moresque style 120–1,
 23.3, 23.5, 23.7, 23.10
 circle of assistants 343–5
 Colonia Güell 342, 343, 345
 house designs 342–3, *23.3, 23.4,
 23.5, 23.6*
 influences 341–2
 Islamic influences 120–1, *23.3,
 23.5, 23.7*
 Naturalism 224, 342, *23.6, 23.8*
 Palacio Güell (Park Güell) 224,
 342, *23.7, 23.8*
 and the Roman Church 74, 336,
 339–41, 343, *23.10*
 Sagrada Familia 74, 342, *23.9,
 23.10*
 use of metamorphosis 66, *3.16,
 3.17*
Gauguin, Paul (1848–1903) 48, 81,
96, 108, 292
 corner cabinet *2.15*
 and the Nabis 75–6, 157
 Oriental art collection 101, 108
 stoneware 196–7, *12.4*
 Syntheticism and 59, 75
 Self Portrait 75, *4.3*
 The Vision after the Sermon 75, *4.2*
Gautier, Judith (1845–1917), *Poems de
la libellule* 244
Gautier, Théophile (1811–72) 127
 Mademoiselle de Maupin 138
 Tombeau 96
Geddes, Patrick (1854–1932) 311,
312, 321
Geffroy, Gustave (1855–1926) 252
 L'Apprentice 98
Gesellius, Hermann (1874–1916) 375
Gesellius, Lindgren & Saarinen
(G. L. & S.)
 competition entries 377, 378,
 26.2
 domestic architecture 377, 378,
 384–7, *26.4, 26.11, 26.12,
 26.13, 26.14*
 Finnish Pavilion (Paris 1900)
 375, 378, 383, *26.1, 26.6*
 Hvitträsk 384–7, *26.13, 26.14*
 National Museum (Helsinki)
 383–4, 387, *26.10*
 Pohjola Building 377, *26.3*
 see also Saarinen, Eliel Gottlieb
Ghil, René (1862–1925), *Légendes
d'âme et de sang* 94
Gide, André
 Les Caves du Vatican 97
 Les Nourritures terrestres 99
 Le Voyage d'Urien 96
Gilbert, Alfred (1854–1934) 139,
251, 251–2
 decorative metalwork 225, 252
 Epergne 40, 252, *2.4*
 Eros statue 252
Gilbert and Sullivan, *Patience* 138
Gillot, Charles (1853–1903) 151
Gilmour, Margaret (1860–1942) 227
Ginori, lustre glazes 199
Ginskey, Alfred 179
Ginzkey textile factory 368
Giraud, Albert 96
Girault, Charles-Louis (1851–1932)
275

Goethe, Johann Wolfgang von
(1749–1832) 62
Gogh, Vincent van (1853–90) 81,
93, 312
Golovin, Alexandr Yakovlevich
(1865–1930) 392, 393
Goncourt brothers 82, 93, 99
 on Naturalism and Symbolism
 94
 promotion of Rococo 41, 101,
 2.6
Goncourt, Edmond de (1822–96)
93, 98, 210, 253
 Japanese art collection 101
 Chérie 97
 La Faustin 94
 Germinie Lacerteux 94
 La Maison d'un artiste 94
 *Outamaro: Le peintre des maisons
 vertes* 89
Goncourt, Jules de (1830–70) *see*
Goncourt brothers
Gonse, Louis (1846–1921) 105–6
Gorham Silverware Company 232,
234, *14.11*
Gorky, Maxim (1868–1936) 387
Goscombe-John, William
(1860–1952) 251
Goudstikker, Sophia 293
Gradl, Hermann (1869–1934),
porcelain fish service 201, *12.9*
Granell, Jeroni 336, 339
Grasset, Eugène (1841–1917) 55, 62,
159
 jewellery designs 238, *1.7*
 posters 150–1, 161
 textile designs 184–6
 use of colour 108, *9.4*
 'Apparitions' (brooch) *1.7*
 Histoire des quatre fils Aymon book
 design 150–1
 La Morphinomane 88, *4.23*
 Salon des cents poster 151
 Snowdrops in Ornament 3.4
 La Vitrioleuse poster 151, *9.4*
Gravestein, Wegerif, batik
techniques 188, *11.9*
Greber family, stoneware 198
Greenaway, Kate (1846–1901) 139,
196
Greenhalgh, Paul
 Art Nouveau style **15–33**
 historical sources of A N **37–53**
 nature and A N **55–71**
 A Strange Death [of Art
 Nouveau] **429–36**
 'Le Style Anglais' **127–45**
 Symbolism - religious and
 profane **73–91**
Grimm, Brothers, source of fantasy
art 159
Gropius, Walter Adolf (1883–1969)
293
Groult, André (1884–1967) 432
Gruber, Jacques (1870–1936) 44,
213
Grueby Faience company 193, 204,
12.14
Grueby, William Henry (1867–1925)
204
Guimard, Hector (1867–1942) 28,
46, 70, **265–73**, 369, 413, 435
 architectural decoration 107,
 265, *17.3*
 Castel Béranger 165, 223, 265,
 267, 272, *17.2, 17.3*
 Castel Henriette 272, 273, *17.11*
 École du Sacré Coeur 46, 89,
 4.24
 furniture designs 165, 174, *10.13*
 'Metro' entrances 32, 46, 223,

265, 267–8, 272, 435, *17.4, 17.5*
numerals *17.7*
ornamental ironwork 221–3, *17.6, 17.7, 17.10*
sexual imagery 66, 89, *4.24*
stoneware designs 200, *12.8*
Guimet, Émile (1836–1918) 106
Gurschner, Gustav (1873–1971) 260, *16.10*

Haeckel, Ernst Heinrich (1834–1919) 62, 69, 70, 292
 presentation of organic life 55, 70, 212, 224, *3.1*
Halas Lace Workshop *24.13*
Hallet, Max 276
Hamilton, Walter, *The Aesthetic Movement in England* 137
Hamlin, Alfred D F, on L.C.Tiffany 399
Hammer, Marius 228
Hamon, Philippe, literature and French decadence **93–9**
Hanem, Kuchuk 122
Hankar, Paul (1859–1901) 119, 275, 285
 decorative metalwork 227
 house designs 38
 interiors 32, *1.16*
Hansen, Frida (1855–1931) 188–91, *11.11*
 The Milky Way tapestry 188
 The Pentecostal Choir tapestry 188
Harrachov glassworks 213, 368, 371, *25.10*
Hartgring, W P (1874–1940) 202
Harunobu, Suzuki (1724–70), *A Courtesan and Attendant on a Moonlit Veranda* 105, *6.4*
Haussman, Georges Eugène, Baron (1809–91) 149
Haviland, Charles and Théodore, ceramics maanufactures 196, 204
Hayashi, Tadamasa (1851–1906) 112–13
Hegermann-Lindencrone, Effie (1860–1945) 201
Heine, Thomas Theodor (1867–1948)
 Devil 290, *19.3*
 Simplicissimus illustrations 159, 290, *9.15*
Henrivaux, Jules, on Gallé 212
Henry, George (1858–1943)
 Japan visit 313
 The Druids - Bringing in the Mistletoe 21.4
Herder, Johann Gottfried (1744–1803) 48
Herter brothers, interior decorators (New York) 400
Hevesi, Ludwig, art critic 301, 308
Hexamer, Frédérich 196
Heyaert, Henri, Hort and 285
Hiatt, Charles 150
Hildebrand, Hans 52
Hildebrandt, Adolf von (1847–1921) 372
Hiromachi, Shugio (1853–1927) 112
Hiroshige, Utagawa (Ando) (1797–1858), *Awa Province, Naruto Rapids* 105, 107, 109, *6.3*
Hobé, Georges (1854–1936) 275
Hoentschel, Georges (1855–1915) 194, *12.3*
Hoetger, Bernhard (1874–1949), statuette of Loïe Fuller 261
Hoffmann, Josef (1870–1956) 28, 40, 109, 130, 140, 160, 173, 237, 429

decorative silverware 229, 307–8, *14.7, 20.9, 20.10, 20.11*
 at the *Exposition Universelle* (1900) *1.18*
 furniture design 170, 173, 301–7, *10.7, 20.3, 20.4, 20.5*
 Gesamkunstwerk 307–8
 glasswork designs 215, 216, 308, *13.7*
 Palais Stoclet 229–30, 307, *20.7, 20.8*
 Secessionism and 299, 300, 301–8
 textiles 179, 191, 308–9, *11.13, 20.14*
 Wiener Kunst im Hause 300
 Wiener Werkstätte 229, 299, 305–9
 Einfache Möbel (Simple Furniture) 301
Hokusai, Katsushika (1760–1849), *Kirifuri Fall in Kurokami Mountain* 105, 106, *6.2*
Holme, Charles (1848–1923), *The Studio* (magazine) 154, 381
Homar, in Barcelona 339
Hooker, J.D. (Joseph Dalton), botanical drawing 55, *3.2*
Hoosemans, Frans 84, 227, 256, 259, *4.13, 16.8*
Hornel, Edward Atkinson (1864–1933) 313
 The Druids - Bringing in the Mistletoe 21.4
Horta, Victor (1861–1947) 26, 28, 46, 59, 204, 227, 336, 369
 architectural decoration 107, 275–6, 282, *1.10, 14.2*
 architectural materials 223, 285, *14.2*
 architectural philosophy 279
 Aubecq House 276
 Belgian Pavilion (Paris 1925) 431, *30.2*
 Brussels rebuilding **275–85**
 furniture designs 282, 285
 Gare Centrale (Brussels) 275
 Grand Bazar Anspach department store 276
 Horta House 223, 282, *14.2, 18.6, 18.7*
 Hôtel Tassel (Tassel House) 24, 38, 276, 279–80, 282, 371, *1.10, 2.2*
 Innovation department store 223, 276
 interiors 279, 282
 ironwork 223, 285
 Maison du Peuple 46, 223, 276, *1.2*
 Max Hallet House 276
 Musée de Tournai 285
 Oriental art collection 101
 Palais des Beaux-Arts 275
 patronage 74, 275, 276
 Roger House 276
 Solvay House 275–6, 279, 280, 282, 285, *18.1, 18.5, 18.8*
 style influences 279, 282, 285
 textiles 179, 183–4
 use of electric lighting 282
 Van Eetvelde House 223, 275, 279, 280, 282, *18.2, 18.4*
 Waucquez department store 276, *18.3*
 Wolfers shops 276, 285
Houillon, Louis 240
Les Huit, artist's group 20, 254
Hukin & Heath, decorative metalwork 225
Humboldt, F H Alexander von (1769–1859) 48

Hunt & Roskell, goldsmiths 232
Hunt, Richard Morris (1827–95) 324
Hunt, William Holman (1827–1910) 130
Huret, Jules 93
Huszka, József (1854–1934) 121, 351
 Magyar Ornamentika 24.3
Hutton, William, & Sons
 decorative metalwork 225, 235
 silverware 143, *8.17*
Huxley, Thomas Henry (1825–95) 62
Huysmans, Joris-Karl (1848–1907) 75
 on Moreau's Salome 88, 123
 on replanning of Paris 149
 A Rebours 38, 45, 59, 82, 94, 123, 259, 279, 282
Hynais, Vojtěch (1854–1925), poster *25.2*

Iakuncikova, Maria F, Solomenko workshops 392
Ibels, Henri-Gabriel (1867–1936) 157
d'Illzach, Ringel 196
Iris ceramics company 27, 204
 in the Finnish Pavilion (Paris 1900) 381–3, *26.9*
Issel, Alberto (1848–1926) 424, *29.11*
Itten, Johannes (1888–1967) 293

Jackson, Anna, Japanese art and the West **101–13**
Jacobs, Henri (1864–1935) 223
Jacquemin, Jeanne (1863–1938) 90
 La Douloureuse et glorieuse couronne 4.26
Jallot, Léon 170, 432
James, Henry (1843–1916) 82
Jammes, Francis (1868–1938) 98
Janák, Pavel (1882–1956) 371, 372
Jarry, Alfred, *Ubu roi* (1873–1907) 98
Jeckyll, Thomas (1827–81) 139
Jenneret, Charles Edouard *see* Le Corbusier
Jenney, William Le Baron (1832–1907) 324
Jennings, A F 320
Jensen, Georg (1866–1935) 228, 237
Jones, Owen (1809–74), *The Grammar of Ornament* 129, 400, *8.1*
Jouffroy, François (1806–82) 254
Jourdain, Frantz (1847–1937?) 28, 46, 271, 272, 273, 433
Jouve, Paul 198
Jujol, Josep María (1879–1949) 336, 343, 345
Jurkovič, Dušan (1868–1947) 362

Kader, Alexander, Art Nouveau sculpture **251–61**
Kahn, Gustave (1859–1936) 75, 81, 97
Kandinsky, Wassily (1866–1944) 367, 435
Kane, Sir Robert (1809–1890) 128–9
Kántor, Tamás 354
Kaplan, Wendy, Turin: *Stile Floreale* **413–25**
Karageorgevitch, Prince Bojidar, silver cutlery *14.14*
Karlovy Vary Company, porcelain wares 368
Kekushev, Lev (1862–?1918), Hotel Metropol (Moscow) *27.2*
Keller, silverware workshop 228

Keller & Guérin ceramics 212
Kempen & Zoon, silver manufactory 228
Keppie, John (1863–1945) and Jessie (1868–1951) *21.1*
Keserü, Katalin 47
Khnopff, Fernand (1858–1921) 81, 90, 96, 154, 300
 Des Caresses 4.18
 I Lock My Door Upon Myself 290
 With Georges Rodenbach: A Dead City 5.4
Kinchin, Juliet, Art Nouveau in Glasgow 224, **311–21**
King, Jessie M. (1875–1949) 311, 320, 321
Kinsarvik, Lars (1846–1925) 50, 52, *2.19*
Kirichenko, Evgenia, on Iaroslavl Railway Station 393
Kiritsu Ko[-]sho[-] Kaisha, Japanese art exporters 112
Kirschner, Marie (1852–1931) 216
Kistemaeckers (publishers) 93, 96
Kivi, Alexis 376
Klenze, Leo von (1784–1864)
 The Alte Pinakothek 287
 The Glyptothek 287
 The Neue Pinakothek 287
Klimt, Gustav (1862–1918) 40, 159, 160, 215
 Oriental art collection 101, 105, 108
 Vienna Secession and 300
 Judith II (Salome) 88, *4.22*
 I Künstausstellung Secession 20.2
 Pallas Athene 300, *2.1*
Klinger, Max (1857–1920) 300
Klouček, Celda (1855–1935) 368
Knoll, Karl, Company, porcelain wares 368
Knowles, James Pitcairn (1864–?) 157
Knox, Archibald (1864–1933) 116, 143
 Cymric and Tudric ware 50, 226, 228, *2.16*
 decorative metalwork 225
 Silver Studio patterns 181
Koch, Alexander, art editor 301
Koch, of Berlin, jewellers 242
Koechlin-Baumgartner & Cie, textile printing 180
Koepping, Karl (1848–1914)
 glasswork designs 216–17, 405, *13.8*
 Pan (magazine) editor 216
Kohn, J & J *see* Kohn, Jacob and Kohn, Joseph
Kohn, Jacob (1791–1868) 179, 303–5
Kohn, Josef (1818–84) 179, 303–5
Kok, J Juriaan (1861–1919) 202, *12.11*
Kōrin, Ogata (1658–1716) 106, 111
Körösfő i-Kriesch, Aladár (1863–1920) 357–9
 Women of Kalotaszeg tapestry 357–9, *24.11*
Korovin, Konstantin Alekseyerich (1861–1939), Russian Village (Paris 1900) 392
Kós, Károly (1883–1977) 357, *24.10*
Kotěra, Jan (1871–1923) 28, 32, 369–73
 architecture 369, 371–2, *25.13, 25.14*
 furniture 371, *25.11, 25.12*
 glassware 371, *25.10*
 railway carriage designs 369, *25.9*

Kovalszky, Sarolta 191
Krafft-Ebing, Richard von, Baron (1840–1902) 89
Kreischmann, Fredolin 403
Krog, Arnold (1856–1931) 201
Krohn, Pietro (1840–1905) 201
Kryzinska, Marie 97
Kunisada, Utagawa (1786–1865), *Genji Monogatori* 108, *6.8*
Kupka, František (1871–1957) 367, 435

Labrouste, (Pierre-François) Henri (1801–75) 58, 221
Laforgue, Jules (1860–87) 93, 96
Lalique, René (1860–1945) 110, 228, 237–46, 292, 369, 432
 dragonflies 65, 84, 244, *4.12*
 insect based designs 65, 84, 244–8, *4.12, 15.9, 15.10, 15.11*
 materials 238–42, *15.3, 15.7*
 photography and 243
 plant based designs 240, 242–3, *6.10, 15.3, 15.7, 15.8*
 Princess Lointaine pendant *15.1*
Lamarck, Jean-Baptiste de (1744–1829) 65
Lamorvá, Milena, New Art in Prague **361–73**
Lamour, Jean (1698–1771), Place Stanislas gates 210, *2.8*
Langen, Alfred (1869–1909) 290
Laporte-Blairsy, Léo (1865–1923) 260
Larche, Raoul-François (1860–1912), Loïe Fuller lamp 261, *16.11*
Larrive, Jean-Baptiste (c.1870–1928) 259
Larsson, Carl Olaf (1853–1919) 188
Laurin, ceramics factory 196
Lauro, Agostino (1861–1924)
 furniture designs 27, 417, 421–24, *29.10*
 Gesamtkunstwerk 422
 interior design 421–2, 424, *29.9*
 palazzina 419–21, *29.8*
Lauth, ceramic glaze chemist 200
Lavirotte, Jules Marie Aimé (1864–1924) 259
Le Corbusier (1887–1965) 32, 433–4
 L'Esprit nouveau (magazine) 94, 433
Lebeau, Chris (1878–1945) 110
 silk batik screen panel 188, *11.8*
Leborgne, Lille weavers 181
Lechner, Ödön (1845–1919?) 28, 46, 50, 130, 347–51, 357
 Hungarian national style 120, 121, 347–9
 lustred ceramics 199
 Museum of Applied Arts (Budapest) 349, *24.1, 24.2*
 Postal Savings Bank (Budapest) *24.4*
Leclerc, J L, machine woven pictures 184–6
Ledru, Auguste (1860–1902) 254, *16.3*
Ledru, (Louis) Léon (1855–1926) 219
Lefébure, Charles 276
Leighton, Frederic (1830–96) 140
Leino, Kasimir 376
Lemercier, printing firm 150
Lemerre (publishers) 93
Lemmen, Georges (1865–1916) 153
Lemonnier, Camille (1844–1913) 96
Lengyel, Lörincz 352
Lenning, Henry F 73
Léonard, Agathon (1841–1923)

Jeu de l'écharpe porcelain table setting 200, *12.7*
Loïe Fuller statuette 261
Leopold II, King of Belgium 227, 240, 275
Lerche, Hans Stoltenberg (1867–1920) 215, 256
Lesbos, Adèle, stoneware 198
Lévy-Dhurmer, Lucien (1865–1953) lustre painted ceramics 199
Méduse 86, *4.21*
Liberty & Co 27, 50, 142, 180, 217 fabrics 280–2
silverware and pewter 228, 235
Turin *Esposizione* and 417
Liberty, Arthur Lasenby (1843–1917) 27, 101, 113, 142, 143, 226, 235, 429
Lindahl, Karl (1861–1895) 387
Lindgren, Armas (1874–1929) 375
Lindley, William Henry, Prague redevelopment project 361
Lion Cachet, Carel Adolph (C.A.) (1866–1945) 156, 188
Lipps, Theodore (1851–1914) 372, 434–5
Lobmeyr, J. & J., glassware 216, *13.7*
Loetz glassworks 27, 118, 213, 215–16, 218, 368
Phänomen range 215, *13.6*
Loetz-Witwe, Johann (1788–1848) *see* Loetz glassworks
Löffler, Bertold (1874–1960) 308
Logan, George (1866–1939) 320
Logan, Mary 292
Lombroso, Cesare (1835–1909) 73
Lönn, Wivi (1872–1966) 375
Lönnrot, Elias (1802–1884) *The Kalevala* 376
Loos, Adolf (1870–1933) 309, 435
Ornament and Crime 433
Loti, Pierre (1850–1923), *Les Désenchantés* 98
Louis-Philippe (1773–1850), King of France 41
Louÿs, Pierre (1870–1925)
Aphrodite 98
Les chansons de Bilitis 98
Lubicz Milosz, Oscar Vladislas de 96
Ludwig I, King of Bavaria (1786–1868) 287
Lugné-Poë, Aurélien (1869–1940), *Théâtre de l'oeuvre* 96
Lukacs, John 47
Lumière brothers, cinema and 99
Lutyens, Edwin Landseer (1869–1944) 315
Lux, Josef August 293, 301

Mabut & Rubé, enamelling 240
Macdonald, Frances (1873–1921) 292, 300, 319, 320, 321, *21.1*
posters 313
repoussèd work 227, *1.8*
sexual imagery 66, *1.8*
Autumn 1.8
Macdonald, Margaret (1864–1933) 292, 300, 311, 319, 320, 321, *21.1*
exhibitions abroad 311, 320, *21.2*
posters 313
repoussèd work 227
McIlhenny, Parker 402
Mack, Lajos (1876–1916) 352–4
McKim, Mead & White, architects 400, *28.1*
Mackintosh, Charles Rennie (1868–1928) 19, 26, 28, 52–3, 61, 109, 113, 140, 173, 292, 311, 319, 320, 321, 369, 386, 396, 435, *21.1*

architectural designs 315, 319, *21.9, 21.11*
exhibitions abroad 311, 320, *21.2*
furniture designs 165, 170, 173, 315, *2.21, 21.8*
metalwork 320, *21.13*
Miss Cranston's Tearooms 315, *21.6, 21.7, 21.8*
Oriental art collection 101
patrons 315
Secessionism and 229, 300
textile designs 180
wrought ironwork 224
The Scottish Musical Review cover 319, *21.12*
Mackmurdo, Arthur Heygate (1851–1941) 132–3, 225
furniture 134, *8.7*
Hobby Horse (magazine) 29
Wren's City Churches illustrations 134, 154, *8.8*
McNair, James Herbert (1868–1955) 319, 321, *21.1*
Secession exhibition (1900) 300
Madsen, Stephan Tschudi 37
Maeterlinck, Maurice (1862–1949) 96, 320
Pelleas et Mélisande 96
Mahler, Gustav (1860–1911) 387
Maillol, Aristide (1861–1944) 354
Maindron, Ernst, *Affiches illustrées* 154
Maison Christofle, siverware manufactory 228
Maison Vever 237, 238
brooch *1.7*
see also Vever, Henri
Majorelle, Louis (1859–1926) 27, 44, 61, 212, 234
furniture designs 165, 172, 174, *2.10, 10.10*
lamps *3.8, 3.11*
Maliutin, Sergei Vasilévich (1858–1937) 393
Mallarmé, Stéphane (1842–98) 59, 75, 88, 93, 94, 96
Aspects 97
Un Coup de dés 94, 98
Mamontov, Savva (1841–1918) circle of artists 391, 394, 396
Manés Association, Czech art 368, 371, 372
Manet, Édouard (1823–83) 94
Mann, Thomas (1875–1955) 287
Marcus & Co, jewellers 237, 242, *15.2*
Mardrus, Joseph-Charles (1868–1949), *Arabian Nights* (translation) 122
Mare, André (1887–1932) 432
Marierra, in Barcelona 339
Maróti, Géza (1875–1941), Hungarian Pavilion (Milan 1906) 354, 356
Martin brothers, ceramics 198
Martin, Camille (1861–1898), book illustrations and bindings 96, 155–6, *9.10*
Martin, Edwin (1860–1915) 198
Martinell, César (1888–1973) 336
Marx, Karl Heinrich (1818–83) 435
Marx, Roger (1859–1913) 271, 272
L'Estampe originale (magazine) 154
L'Image (magazine) 154
Les Maîtres de l'affiche (magazine) 154
Massenet, Jules (1842–1912) 96
Massier, Clément (1845–1917) 199
Massier Company 193, 199
Matsuki, Bunkio (1867–1940) 112

Maupassant, Guy de (1850–93) 98
Maus, Octave (1856–1919) 28, 227, 279
on *Le Style Anglais* 127
L'Art moderne (magazine) 27, 29, 81
Maw & Co., ceramics manufactures 193
Maximilian II (Joseph), King of Bavaria (1811–64) 287
May, Walther 65
Meier-Graefe, Julius (1867–1935) 18, 19, 27, 28, 47, 127, 170, 204, 301, 387
on Continental bookbindings 155–6
La Maison Moderne gallery 27, 166–7, 204, 207, 217, 227, 300, *10.12*
Pan (magazine) 27, 29, 74, 105, 110, 158, 159, *1.15, 19.6*
Melani, Alfredo (1860–1928), and the Turin *Esposizione* 413, 414, 415, 417
Mendes da Costa, Joseph (1863–1939) 256
Metlicovitz, Leopoldo (1868–1944) *Mostra del ciclo e dell'automobile* poster 153–4
Meunier, Constantin (1831–1905) 81, 256
Meunier, Henri (1873–1922), *Rajah* coffee poster 153, *9.6*
Michelet, Jules (1798–1874) 242, 244
Michelsen, A 228
Millais, John Everett (1829–96) 436
Minton & Co., ceramics manufactures 193
Miró, Joán (1893–1983) 435
Mohrbutter, Alfred (1867 1916) 191
Moncunill, Lluís (1868–1931) 336
Mondrian, Piet (1872–1944) 81, 367
Monet, Claude (1840–1926) 81
Montesquiou-Fézensac, Robert de, Comte de (1855–1921) 81–2, 240
Moorcroft, ceramics manufactures 193
Moore, Albert Joseph (1841–93) 139, 140
Moore, Edward C (1827–91) 116, 400, 407
Moréas, Jean (1856–1910)
Manifeste de l'École Romane 98
Symbolist manifesto (1886) 75, 93
Moreau, Gustave (1826–98) 77, 96, *7.9*
Salome painting *L'Apparition* 88, 123, *7.9*
Morel-Lacordaire, J H, on the Paris *Exposition Universelle* (1900) 269–71
Morris, Talwin (1865–1911) 315, 321, *21.10*
Morris, William (1834–96) 49, 81, 115, 128, 130–2, 138, 145, 154
decorative arts companies 132, 180
Kelmscott Press 154
political influence of 74, 132
textile designs 59, 115, 116, 132, 179, 180, *8.4*
wallpaper designs 59, 115, 116, 132
Morse, Edward (1838–1925) 106
Japanese Homes and Their Surroundings 109

illustrations 308
textile designs 308, *20.13*
Wiener Werkstätte 299, 305–9
Mourey, Gabriel 18, 184
Mucha, Alphonse (1860–1939)
commercial art work (posters) 151–3, 248, 292, 368, *9.5*
decorative and exotic women 153, 248–9, 260, *9.5, 15.13, 16.9*
Fouquet's shop design 248, 259, 369
jewellery designs 368, *15.13*
Municipal House (Prague) 369
sculptural busts 259, *3.15, 9.5, 16.9*
textile designs 184–6, 368, *11.7*
La Dame aux camélias 153
Les Documents décoratifs 153
The Four Flowers 82–4
The Four Seasons 82–4
Gismonda poster work 153
Job 107, 153, *9.5*
Médée 153
La Nature 66, *3.15*
Théâtre de la Renaissance poster work 153
Müller, Albin (1871–1941) 198, 216
Müller, Fritz von 232
Müller, Theodore 227
Munch, Edvard (1863–1944) 69, 85, 96, 157
Madonna 85, *4.17*
The Vampire 85, *4.16*
Munthe, Gerhard (1849–1929) 28
tapestry designs 188
Viking (Dragon) style 50, 52, 188, *2.17, 2.18*
C'est ainsi tapestry *11.10*
The Suitors 290
Münzberger, Bedřich (1846–1928), Central Palace pavilion (Prague 1891) 361
Murray, Gilbert 38
Muthesius, Hermann, on *Maaschinenmöbel* furniture 297
Myrbach, Felician von 300

Nabis, artists group 19, 48, 59, 75–6, 157, 188, 354, *4.1*
Nagy, Ildikó 354
Nagy, Sándor (1869–1950) 357
Napper, Harry (1860–1940) 181, *11.2*
Nash, Arthur J (1849–1934) 218, 402
Nash, Joseph (1809–1878) *Interior of the Great Exhibition* (watercolour and body colour) *8.2*
Natanson, Thadée and Alexandre, *La Revue blanche* (magazine) 157
Naylor, Gillian
Munich – Secession and Jugendstil **287–97**
Secession in Vienna **299–309**
Nazzy, Louis, on '*Le Chat Noir*' 162
Needham, Raymond 150
Newbery, Francis Harry (1855–1946) at Glasgow School of Art 319, 320, 321
Newbery, Jessie (1864–1948), embroidery designs 180–1, 321
Nichols, Maria Longworth (1849–1932) 204
Nicholson, William (1872–1949) 161
Niedermoser, Josef 179
Nietsche, Friedrich Wilhelm (1844–1900) 38, 99
The Birth of Tragedy 38
Twilight of the Idols 68

Nieuwenhuiis, Theo (1866–1951) 188
Nocq, Henri-Eugène (1868–1943) 256
Nordau, Max (1849–1923) 73
Degeneration 436
Northwood, J. & J., glassworks 218
Novák, Emanuel (1866–1918) 368
Novotný, Otakar (1880–1959) 372
Nyström, Usko (1856–1917) 387

Obrist, Hermann (1862–1927) 28, 55, 181, 230, 291, 292, 293
and the *Debschitz Schule* 293
embroideries 26, 70, 179, 181, 216–17, 292, *1.12, 11.1*
evolutionary art 70
Vereinigte Werkstätten für Kunst im Handwerk 292
Grosser Blütenbaum 181, *11.1*
Peitchenhieb (Whiplash) 179, 181, 292, *1.12*
Ohmann, Friedrich (1858–1927) 361–2, *25.3*
Ohr, George Edgar (1857–1918) 65–6, 205, *3.13*
Ojetti, Ugo art critic 387
Olbrich, Josef Maria (1867–1908) 119, 160, 299, 303, 368, 396, 415
Secession House (Vienna) 40, 223–4, 299, *20.1, 30.1*
Oliveras, Camil (1840–1898) 336
Okakura, Tenshin (1863–1913) 113
Opie, Jennifer Hawkins
ceramics **193–207**
glass **209–19**
Helsinki: Saarinen and Finnish Jugend **375–87**
Orazi, Manuel (1898–1934) Loïe Fuller poster 108
Osbert, Alphonse (1857–1939) 78, 89

Pabst, Otto, silver-chaser 232
Palissy, Bernard (1510–1590) 246
Pankok, Bernhard (1872–1943) 40, 70, 230, 291, 292, 293
furniture designs 165, 293, *3.19, 10.1*
Parry, Linda, Art Nouveau textiles **179–91**
Pater, Walter (1839–94), *The Renaissance* 138
Paul, Bruno (1874–1968) 158, 159, 297
metalwork 230, *14.8*
Kunst im Handwerk poster *19.14*
Paxton, Joseph (1801–65) 221
Crystal Palace design 58
Pèche, Dagobert (1887–1923) 308
Péladan, (Sâr) Joséphin (1859–1918) 77, 78, 94, 96, 98
Penfield, Edward (1866–1925) 161, 162
Pennell, Joseph (1857–1926) 154
Perse, Saint-John (1887–1975) 97
Pfeiffer & Löwenstein porcelain works 368
Philippe, Charles-Louis (1874–1909) *Bubu de Montparnasse* 98
Phillips, Clare, jewellery and the art of the goldsmith **237–49**
Picasso, Pablo (1881–1973), *Portrait of Guillaume Apollinaire 5.8*
Pirner, Maximilián (1854–1924) 362–4
Plumet, Charles (1861–1928) 174, 256, 271, 273, *10.14*
Poe, Edgar Allan (1809–49) 94, 159
Poelaert, Joseph (1817–79), Palais de Justice (Brussels) 38, 40

Poictevin, Francis 94
Polenova, Elena (1850–98) 160, 391, 392, *27.3*
 furniture designs 392
Polivka, Osvald (1859–1931), the Municipal House (Prague) 367, *25.7, 25.8*
Pollard, Sidney 18
Pont Aven, artists group 48, 354
Poschinger, Benedikt von (1856–1918) 216
Possémé, Evelyne 243
Pottier, Edmond 254, 256
Powell, Harry J (1853–1922) 217
Powell, James, & Sons, glassware 143, 225, *14.4*
Powolny, Michael (1871–1954) 308
Prášil, František, Central Palace pavilion (Prague 1891) 361
Prat de la Riba, Enric 335
Preisler, Jan (1872–1918) 367
Preissig, Vojte[-]k (1873–1944) 367
Previati, Gaetano (1852–1920) 81
Primavesi, Otto and Mäda 309
Privat-Livemont, T (1861–1936), *Bec Auer* poster 153, *9.7*
Proust, Marcel (1871–1922) 94, 210
 A la recherche du temps perdu 82
 Du côté de chez Swann 99
Prouvé, Victor Émile (1858–1943) 44, 96, 209–10
 Salammbô binding 155, *9.9*
Prutscher, Otto (1880–1949) 308, *20.12*
Pryde, James (1866–1941) 161
Prytz, Thorolf (1858–1938) 61
 Plique-à-Jour enamel and glass cup 217, *3.6*
Puchinger, Erwin, at the *Expositions Universelles* (1900) *1.18*
Pugin, A W N (1812–52) 46, 376
Puig i Cadafalch, Josep (1867–1956) 335, 336, 339
 Casa Ametller *23.3*
Puvis de Chavannes, Pierre (1824–98) 77

Raeburn, Agnes Middleton (1872–1955) *21.1*
Rais, Jules 259
Ramaer, carpet weaver 188
Ranson, Paul (1861–1909) 48, 75
 decorative objects and print media 157
 textile designs 184, *11.6*
 Nabic Landscape 76, *4.5*
Raphael (1483–1520) 19
Raspall, (Manuel) Joaquim (1877–1937) 336
Ravel, (Joseph) Maurice (1875–1937) 96
Read, Herbert Edward (1893–1968) 433
Redgrave, Richard (1804–88) 129
Redon, Odilon (1840–1916) 75, 77–8, 96
 Portrait of Gauguin 78, *4.7*
Redouté, P J, nature publishing 55
Reed, Ethel (1874–?) 161
Reid, Alexander (1854–1928) 312
Reijmyre glassworks 213
Reinhold Kirsch 232
Retté, Adolphe (1863–1930) 15, 17, 97
Rheims, Maurice 73
Rheinische Glashütten, metallic glass 218
Richardson, Henry Hobson (1838–86) 377, 378
Richepin, Jean (1849–1926) 94

Ricketts, Charles de Sousy (1866–1931) 116
 The Dial 29, 154
 the Vale Press 154–5, *9.8*
Riegel, Ernst (1871–1939) 232, *14.10*
Riegl, Alois (1858–1905) 434
Riemerschmid, Richard (1868–1957) 46, 158, 291, 294–5, 429, *1.19*
 carpets 294, *19.12*
 ceramics designs 198, 201, 294, *12.5*
 decorative metalwork 230–2, 294, *14.9, 19.13*
 Dresden Workshop designs 295–7
 furniture designs 165, 173, 174, 294, *10.15, 19.10, 19.11*
 glasswork designs 216, 294
 Haus Thieme designs 294, *19.10, 19.11, 19.12, 19.13*
 Jugenstil 230
 textile designs 191, 297
 Vereinigte Werkstätten für Kunst im Handwerk 292
 Garden of Eden 19.9
 Wolkengespenster (Cloud Ghosts) 294
Rigotti, Annibale (1870–1968) 414, 419
Rimbaud, Arthur (1854–91) 81, 94
 Illuminations 94, 98
 Marine 97
Rimsky-Korsakov, Nikolai (1844–1908) 391
Rindskopf, Josef & Sons Glassworks 368
Rippl-Rónai, József (1861–1927) 48, 75, 157, 354, 355
 design of furnishings 354–5
 lustred ceramic designs 199, 354
 Woman with a Bird Cage 24.7
 Illustration from *Les Vièrges 24.8*
 Woman in Red wall hanging *24.9*
Riquet, Alexandre 228
Rivière, Jacques (1886–1925) 96
Rivière, Théodore Louis Auguste (1857–1912) 261
 Carthage or *Salammbô Cez Matho* 122, 256, *7.8*
Robineau, Adelaide Alsop (1865–1929) *12.16.*204–5
 Kéramik Studio (magazine) 204
 Viking ship Vase *12.16*
Roche, Pierre (1855–1922) 256
 Loïe Fuller sculpture 261, *16.12*
Rodenbach, Georges (1855–98) 94, 96
 Bruges-la-morte 96
 Les Tombeaux 157
 Les Vierges 157, 354, 355, *24.7*
Rodin, Auguste (1840–1917) 81, 210, 256
 theme of metamorphosis 65
 and the Union Centrale 253
Roller, Alfred (1864–1935) 160
 Secession 16 Ausstellung 1903 poster 160–1, *9.18*
Rombaux, Egide (1865–1942) 227, 256, *16.8*
Rookwood Pottery 112–13, 193, 204, *4.11, 12.15*
Rops, Félicien Joseph Victor (1833–98) 81, 89–90
 The Abduction from *The Satanic Ones* 90, *4.25*
 Mors Syphilitica 85
Rörstrand ceramics company 200, 201, *12.10*
 'Fennia' earthenware range 202–4, *12.13*

Rosny, J.-H.*La Guerre du feu* 98–9
Rossetti, Dante Gabriel (1828–82) 77, 132, 139
 Beata Beatrix 8.3
Rossetti, William Michael (1829–1919) 130
Rossum, J M van 202, *12.11*
Róth, Miksa (1865–1944) 354
Rousseau, François-Eugène (1827–91) 101, 210
Rousseau, Jean-Jacques (1712–78) 48
Rousseau, Victor (1865–1954) 256
Roussel, Ker-Xavier (1867–1944) 157
Rozenburg, ceramics manufactures 193, 202
Rubió i Bellver, Joan (1871–1952) 336, 343, 345
Ruchet, Berthe 181, 292, *11.1*
Rudder, Isidore de (1855–1943) 227
Ruhlmann, Jacques-Émile (1879–1933) 432
Ruskin, John (1819–1900) 19, 46, 55, 77, 128, 145, 154, 237, 242, 323, 341, 376, 435
 the Aesthetic movement and 138
 artisanal culture and 49, 325
 Gothic ornament and 325–6, *22.3*
 on industrialisation and art 129–30
 influence on Morris and Arts and Crafts 132–3
 influence on Sullivan 325–7, *22.3*
 The Seven Lamps of Architecture 325, *22.3*
 The Stones of Venice 325

Saarinen, Eliel Gottlieb (1873–1950) 28, 46, 50, 173, 375, 377, 387, 429
 domestic architecture 384–6, *26.11, 26.12*
 furniture designs 386, *26.2, 26.15*
 see also Gesellius, Lindgren & Saarinen
Saarinen, Loja, *ryijy* rugs 386
St Louis glassworks (Lemberg) 213
Saintenoy, Paul Pierre John (1862–1952) 38, 223
Salda, František Xaver (1867–1937) 368
Salmond, Wendy, Moscow Modern **389–97**
Sandier, Alexandre 201–2
Sarazin, Pavillon Collectivité André Delieux *1.21*
Sattler, Joseph (1867–1931) 158–9, 160, *1.15*
Sauvage, Henri Frédéric (1873–1932) 272, 273
 Loïe Fuller Pavilion 32, *1.17*
 Pavillon Collectivité André Delieux *1.21*
Sayrach, Manuel 336
Scala, Arthur von 300
Scheffler, Karl 293
Schellink, Samuel (1876–1958) 202, *12.11*
Schinkel, Karl Friedrich (1781–1841) 46
Schmidt, Karl, Dresden Workshops 295–7
Schmutzler, Robert 69
Schneider, Charles (1881–1953) 213
Schopenhauer, Artur (1788–1860) 99
Schuyler, Montgomery 224
Schwabe, Carlos (1877–1926) 89

illustrations to *Le Rêve* 93, *5.1*
 Rose+Croix Salon poster 77, *4.6*
Schwaiger, Hanuš (1854–1912) 362–4
Schwob, Marcel (1867–1905), *Mimes* 98
Ségalen, Victor (1878–1919), *Stèles* 98
Segantini, Giovanni (1858–99) 300
Selmersheim, Tony (1840–1916) furniture designs 165, 174, 271, 432, *10.14*
Semper, Gottfried (1803–1879) 376
 Bekleidung theory 349
Semper, Gottfried (1803–79) 19, 58
Séon, Alexandre (1855–1917) 78, 89
Serra, in Barcelona 339
Serrurier-Bovy, Gustave (1858–1910) 27, 81, 119, 143, 275, 429
 furniture designs 165, 173, *1.13, 10.2*
 geometric metal furnishings 227
 interiors 32
 Pavillon Bleu Restaurant 32, *1.1*
 Secessionism and 230
 simplified designs 28, *1.13*
 use of English textiles 179
Sérusier, Paul (1864–1927) 48, 75
 The Talisman 75, *4.1*
Seurat, Georges (1859–91) 78–81
 Brussels exhibits 81
 Young Woman Powdering Herself 80, *4.8*
Shannon, Charles Hazelwood (1863–1937)*The Dial* 29, 154
Shaw, Richard Norman (1831–1912) 139
Shekhtel, Fyodor (1859–1926) 28, 390–1
 domestic architecture 393–4, 395–6, *27.6, 27.7*
 Iaroslavl Railway Station 392–3, *27.4*
 Moscow Art Theatre 397, *27.9*
 Riabushinsky mansion 396, *27.6, 27.7*
Sheurer Lauth & Cie, textile printing 180
Shirayamadani, Kataro (1865–1948) 112–13, 204
Sibelius, Jean (1865–1957) 376, 387
Signac, Paul (1863–1935) 81
 Portrait of Félix Fénéon 80, *4.9*
Sika, Jutta 308
Sikorski, Táde (1852–1940) Zsolnay designer *7.7*
Silver Studio designers 116, 181, *11.2*
Silverman, Debora 41, 111, 253, *2.6*
Siot-Decauville, foundryman 256
Les Six, artist's group 20, 174, 254
Skovgaard, Joakim (1856–1933), potter 197, 205
Solá-Morales, Ignasi de, Barcelona: spirituality and modernity **335–45**
Solvay family, Horta's patrons 276
Sonck, Lars (1870–1956) 375, 376, 377, 378, 387
Soulier, Gustave 375
Sparre, Count Louis (1863–1964) 204, 378, 381
Spaun, Max Ritter von (1856–1909) 215
Stanway, Richard 180
Stappen, Charles van der (1843–1910) 81, 227, 256
 Sphinx mystérieux 86, 259, *16.7*
Steer, Philip Wilson (1860–1942) 81
Steiner, F. & Co, textiles 143, 181–2
Steinlen, Théophile-Alexandre (1859–1923) 292

Cabaret du Chat Noir poster 162, *9.21*
Stephens, Frederic George (1828–1907) 130
Stevens & Williams, glassworks 219
Stoclet, Adolph 229, 307, *20.7, 20.8*
Stöhr, Ernst 301
Stoker, Bram (1847–1912), *Dracula* 73, 85
Strauss, Richard (1864–1949) 88, 96
Strauven, Gustave (1878–1919) 38, *14.3*
Strengell, Gustaf 387
Stuart-Merrill, cultural go-between 96
Stuck, Franz von (1863–1928) 88, 159, 289–90
 VII Internationale Kunstausstellung poster 289, *19.3*
 Künstleraltar 289, *19.1*
 Sin 289–90, *19.2*
Sturm, Alexander 229
Štursa, Jan (1880–1925) 372
Süe, Louis (1875–1968) 432
Sullivan, Louis H (1856–1924) 28, 46, 66–8, 130, **323–33**, 336, 378, 433
 '1884 Motif' 324, 325–6, *22.2*
 Auditorium Building (Chicago) 324, 327, 331, *22.1*
 Celtic and Gaelic imagery 50
 Chicago Style 50, 323–33
 Getty tomb door 333, *22.9*
 Gothic Revival 324, 325
 Guaranty Building (Buffalo) 224, 330–1, 333, *22.7*
 interior decoration 324, *22.1*
 National Farmers' Bank (Owatonna) 333, *22.11*
 ornamental ironwork 224, 333
 ornamental studies 326, *22.4*
 ornamented skyscrapers 323–33
 partnership with Adler 324
 Romanticism 327
 Ruskin's influence 325–7, *22.3*
 Schlesinger Meyer building (Chicago) 224, 333, *22.10*
 Scoville Building (Chicago) *22.2*
 Symbolist theories 327, 331
 Transportation Buiilding (Chicago) 31, 331–3, *22.8*
 Wainright Building (St Louis) 327, *22.5*
 Wainright tomb 333
Švabinský, Max (1873–1962) 367
Swan, John Macallan (1847–1910) 251
Swinburne, Algernon Charles (1837–1909) 96
 Poems and Ballads 138
Symons, Arthur (1865–1945) 89, 96, 145
Syrkin, Mikhail, art critic 394

Takashima, Hokkai 109
Takeda, Goichi (1872–1938) 113
Talbert, Bruce James (1838–81) 139
Talmeyr, Maurice 149
Tarjanne, Onni (1964–1946) 375
Tassel, Émile 276
Taylor, (Ernest Archibald) E.A. (1874–1951) 311, 319, 321
Terra Cotta & Ceramic Company, 'Teco' wares 204
Thesmar, André Fernand (1843–1912) 228
Thomé, Valter 387
Thonet, August (1829–1910) 170, *10.7, 10.8*
Thonet brothers 179

Thorn-Prikker, Jan (1868–1932) 188, 279

Thornycroft, (William) Hamo (1850–1926) 251

Thoroczkai, Ede Wigand (1869–1945) 359

Thovez, Enrico
and the Turin *Esposizione* 414
L'Arte Decorativa Moderna (magazine) 414

Tiepolo, Giambattista (1696–1770), Chéret's use of 149

Tiestos, iron forging 339

Tiffany, Charles Lewis (1812–1902) 400

Tiffany, L.C. & Co 116, 119, 204, 217–18, 408, *3.5, 7.2*

Tiffany, Louis Comfort (1848–1933) 26, 28, 31, 61, 116–19, 217–18, 218, 219, 237, 399, **399–411**, *7.2, 28.1*
ceramic designs 407, *28.10*
decorative silverware 232, 407
enamel work 407, *28.9*
glassware 402–7, *28.3, 28.4, 28.5, 28.6, 28.7, 28.8*
H.O.Havemeyer house 400, 407, *28.2*
influence of nature 218, 242, 399, 403–5, 407–10, *3.5*
interior designs 400
international exhibitions 400, 401, 402, 405, 407
involvement with Bing 400, 401
Japanese art collection 101, 218
jewellery designs 242, 408, *28.12, 28.13*
lamp shades and lighting 217–18, 407–8, *3.5, 28.11*
leaded glass 405, 407, 408–10, *28.7, 28.11, 28.14*
Loetz glassware 368, *13.6*
E.C.Moore and 400
at Munich Glaspalast 291
necklaces 408, *28.12, 28.13*
patrons 400
sources 399, 400, 403, 405, 407, *7.2, 13.8*

Till, Wenzell 294

Toorop, Jan (1858–1928) 66, 81, 188, 215, 300
and the *Société des Vingt* 157, *4.10*
The Three Brides 110, *4.10*

Toso, Vittorio 215

Tostrup, Jacob 217, 228

Toulouse-Lautrec, Henri de (1864–1901) 43, 162
Divan Japonais 107, 150, *9.3*

Tourette, Étienne 240

Toussaint, Fernand (1873–1955) 153

Townsend, C.H. (Charles Harrison) (1851–1928) 369

Trebilcock, Clive 18

Tschudi-Madsen, Stephan 119

Tsukamoto, Yasushi 113

Turner, Eric, modern metal **221–35**

Uiterwijk, John 188, *11.9*

Utamaro, Kitagawa (1753–1806),
Lovers Resting by a Tree 89, 105, 107, *6.5*

Uzanne, Octave (1852–1931) 73, 85, 88, 89

Valabrega, Vittorio (1861–1952) 174, 417–19, 424, *29.5*

Valeri, Salvador 336

Valéry, Paul (1871–1945) 98
Degas danse dessin 94

Vallérysthal & Portieux glassworks 213

Vallgren, Ville (1855–1940) 66, 256, *3.14*

Vallin, Eugène (1856–1922) 44, 172

Vallotton, Félix (1865–1925) 75, 157
L'Age du papier 5.7
L'Averse, woodblock print 157, *9.12*

Van Briggle, Artus (1869–1904) 65, 84, 204, *4.11*

Van Eetvelde, Edmond 275

Vanier (publishers), Naturalist Symbolist debate 93

Vanke, Francesca, Islamic influences on A N **115–25**

Vanoutryve, Lille weavers 181

Vasnetsov, Viktor (1848–1926) 391

Vaszary, János (1867–1939) *The Fair* wool tapestry *24.12*

Veblen, Thorstein Bunde (1857–1929) 435

Vedaguer i Callis 335

Velati-Bellini, Giuseppe 421

Velde, Henry van de (1863–1957) 28, 46, 81, 107, 119, 130, 153, 180, 275, 292, 433
Belgian Pavilion (Paris 1937) 432, *30.3*
bookbindings 156
ceramics designs 198, 201, 204
decorative metalwork 227, *14.5*
embroideries 183, *11.3*
furniture design 173–4, *10.12*
glasswork designs 219
interiors 32, 166–7, *10.4*
Rationalism of 431–2
socialist functionalism 69
and the *Société des Vingt* 183, *11.3*
tapestry designs 191
textiles 179, 182–3, *11.3, 11.4*
Déblaiement d'art 19, 20, 26, 431
Tropon poster 162, *9.20*
La Veillée des anges (Angels Wake) - wall hanging *11.3*

Verhaeren, Émile (1855–1916) 28, 94, 98

Verlaine, Paul (1844–96) 75, 81, 93, 94, 99, 279, 282
L'Art poétique 96
Poètes maudits 93
Sagesse 93, 98

Verneau, Charles, printing firm 150

Verneuil, Maurice Pillard (1869–1942) 202

Veth, Jan Pieter (1864–1925), adaptation of *The Claims of Decorative Art* 156, *9.11*

Vever, Henri (1854–1942)
on Fouquet 248
Japanese art collection 101, 105, 110
jewellery 240, 244, 246
on Lalique 238
views on horn 242
see also Maison Vever

Victoria, Queen of Great Britain and Ireland (1819–1901) 127

Vidal, in Barcelona 339

Vierthaler, Ludwig (1875–1967) 70, *3.18*

Vilaseca, Josepi Casanovas (1848–1910) 336

Villeroy & Boch, glassware 213

Vinck, Émile 276

Viollet-le-Duc, Eugène Emmanuel (1814–79) 19, 46, 58, 65, 221, 237, 323, 341
iron construction and rationalist architecture 223, 323, *2.13*
Entretiens sur l'architecture 223, 285, *2.13*

Vogüé, Melchior de (1850–1910) 96

Voisin-Delacroix, Alphonse 198

Vollard, Ambroise (1867–1939) 157

Voysey, Charles Francis Annesley (C F A) (1857–1941) 49, 116, 139, 142, 145, 251, 369, 384, 386
architectural and textile designs 134, 179, 180, *8.9*
carpets 180
wallpapers 59, 116, 180

Vrubel, Mikhail (1856–1910) 391

Vuillard, Édouard (1868–1940) 75, 157

Wagner, Otto (1841–1918) 299, 307, 336, 369, 415

Wagner, Richard (1813–83) 19, 96, 336

Wakai, Kenzaburo (1834–1908) 112

Walcot, William (1874–1943) 396, *27.2*

Wallace, Alfred Russell (1823–1913) 55, 62

Wallach, S. & Cie, textile printing 180

Wallander, Alf (1862–1914) 201, *12.10*

Walter, Amalric (1870–1959) 212, 213

Walton, George (1867–1933) 321
Miss Cranston's Tearooms 313, 315, *21.5*
stencilled linen frieze *21.5*

Wärndorfer, Fritz (1869–1923) 229, 307, 309, *20.9*

Wartha, Vincze 352, *24.6*

Watteau, Jean-Antoine (1684–1721), Chéret's use of 149

Watts, George Frederic (1817–1904) 77

Webb & Sons, lustred glass 216, 217–18, 402

Weingarden, Lauren S, Louis Sullivan and the Spirit of Nature **323–33**

Weisberg, Gabriel P
on A N furniture **165–77**
on Bing's gallery 256
on Paris and Hector Guimard **265–73**

Wheeler, Candace (1827–1923) 400

Whistler, James Abbott McNeill (1834–1903) 81, 101, 139–40
interior decoration 140–2
Peacock Room 140–2, *8.15*
sues Ruskin 138
Nocturne in Black and Gold: The Falling Rocket 138
Nocturne series of paintings 140, *8.14*
Ten O'Clock Lecture 59

White, Gleeson (1851–98), *The Studio* (magazine) 154

Whitefriars Glassworks 217

Whitman, Walt (1819–92) 96, 97

Wiener, René (1855–1939) 155–6

Wikström, Emil 376

Wilcox, Harriet Elizabeth *12.15*

Wilde, Oscar (1854–1900) 38, 59, 81, 90, 96, 101, 138, 139, 145, 204, *8.12*
Salome 24, 86–8, 122, 123, *1.9*
The Sphinx 122–3, 154–5, *9.8*

Wilhelm & Lind 232

Willumsen, Jens Ferdinand (1863–1958) 197

Wilson, Henry (1864–1934) 225

Wilson, Marion Henderson (1869–1956) 319

Wimmer-Wisgrill, E J (1882–1961) 309

Winssinger, Camille 276

Wittelsbach, Elisabeth von (Queen of Hungary) 352

Wolf-Ferrari, Teodor 215

Wolfers, Louis (1820–92) 227

Wolfers, Philippe (1858–1929) 227–8, 256
glasswork designs 213, 219, *13.11*
ivory carvings 227, 240
jewellery of 237, 238, 240, 242, *15.4*
Maison Wolfers 227–8
use of opal 240, *16.6*
Civilization and Barbary 62, 259, *3.9*
Coffee de Mariage 259
La Parure jewellery box 227, 240, 256, *16.6*

Wood, Ghislaine
paper and print media **149–63**
Symbolism - religious and profane **73–91**

Woolner, Thomas (1825–92) 130

Wordsworth, William (1770–1850) 48

Wornum, Ralph Nicholson (1812–1877) 57

Worringer, Wilhelm (1881–1965) 372
Abstraction and Empathy 434–5

Wright, Frank Lloyd (1867–1959) 137, 224–5

Würbel & Csokally 229

Yakunchikova-Weber, Maria 160
Mir Isskustva cover *9.17*

Yoshitoshi, Tsukioka (1839–1892)*The Ghost of Genji's Lover* 108, *6.9*

Young, Robert M 65

Zecchin, Vittorio (1878–1947) 215

Zen, Carlo (1851–1918) 424

Zeyer, Julius (1841–1901) 364

Ziegler, Jules-Claude (1804–56) 194

Zitmann, Wiesbaden glassmakers 355

Zitzmann, Friedrich (1840–1906) 216–17

Zola, Émile (1840–1902) 93, 98, 99, *5.6, 5.7*
L'Assommoir 98
L'Attaque du Moulin 96
Messidor 96
Le Rêve 93–4, *5.1*
Rougon-Macqart series 93, 98
Trois Villes (Lourdes, Rome, Paris) 99

Zsolnay ceramics manufactory 27, 118, 121, 193, 349, 352, *7.7, 24.6*

Zsolnay, Vilmos (1828–1900) 27, 28, 118, 352–4
Eozin glaze 352, *24.6*
lustred ceramics 199, 352–4, *24.6*

Zugschwert, Johann 294

Zumbusch, Ludwig von (1861–1927) 159

Subject Index

NOTE: Illustration plate numbers are in italic, and are listed after the page numbers. Page numbers in bold indicate chapters.

Abstraction
 ceramics 207
 Modernism and 434–5
 painting 367
 textile designs 191, *11.13*
Académie des Beaux-Arts (Gent) 285
Academy of Fine Art (Munich) 287
advertising 149
Aesthetic movement 59, 137–42, 145, 173, 226, 399
Alliance Provinciale de Industries d'Art 155, 213
Amsterdam 26
 Colonial and Export Industry Fair (1883) 188
anarchism 74, 81, 170, 339
androgynous imagery 90, 96
Antwerp 26
 Exposition (1894) 256
arabesques 26, 61, 88, 115, 116, 121, 123, 349
 see also line
Der Architect (magazine) 29
The Architectural Record (magazine) 29, 413
architecture 15, 24, 32, 38, 40, 74, 279, *1.1, 1.2, 1.17, 2.2, 20.1*
 Barcelona 335–45
 Brussels 107, 223, **275–85**, *1.2, 1.10, 2.2, 14.2, 18.1, 18.2, 18.3, 18.4, 18.5, 18.6, 18.7, 18.8, 18.9, 18.10*
 Chicago 50, **323–33**
 'collage' technique 343
 conservation and restoration 436
 decoration and ornamentation 323–33, 341–2, 367, 372, 421, 433–4
 design and botany 324–6
 design from nature 58, 282
 domestic 134, 342–3, 377, 378, 384–6, 384–7, 393–4, 395–6, *23.3, 23.4, 23.5, 23.6, 26.4, 26.11, 26.12, 26.13, 26.14, 27.6, 27.7*
 Dragon-style 376
 evolutionary ideas and 65
 facades 66, 107, 279, 285, 293, 342, 371, 390, 392–3, 394, *1.5, 18.9, 18.10, 23.6*
 Finland 375, 376–87, *26.1, 26.3, 26.4, 26.5, 26.10, 26.11, 26.12, 26.13, 26.14*
 in Glasgow 315, *21.9*
 Gothic Revival 46, 279, 282, 324, 325, *2.13, 23.10*
 horseshoe arch 118–19, 120, *1.1*
 influences on furniture design 118, 282, *7.4*
 interiors 121, 166, 224, 279–82, 315, 320, 324, *1.10, 1.19, 1.21, 10.4, 17.9, 21.2, 21.6, 22.1, 24.1, 24.2*
 see also interior design
 ironwork 221–5, 285, 349, 367, *23.6*
 Islamic influences 118, 119–21, 123–5, 349, *7.4, 7.6, 7.10, 7.11,*

23.3, 23.5, 23.7, 23.10, 29.2, 29.3
 Japan and 107, 113, 279
 Medievalism 384–6, *26.10, 26.13, 26.14*
 Moscow 390, 392–3, 392–4, 392–7, *27.2, 27.4, 27.6, 27.7, 27.8, 27.9*
 and natural forms 323–33
 Paris 149, 265, 265–73, *17.1, 17.2, 17.3, 17.4, 17.5, 17.8*
 the Porte Binet 123–5, *7.10, 7.11*
 Prague 361–2, 367, 369, 371–2, *25.3, 25.4, 25.5, 25.7, 25.8, 25.13, 25.14*
 Rationalism 223, 323, 327, 331, 387
 Scots baronial 37
 skyscraper construction 323–4, 327–30, 333
 Symbolism in 279, 327, 331
 Transylvanian 357
 at the Turin *Esposizione* 414–15, 421, *29.2, 29.3, 29.8*
 vernacular tradition 47, 52, 357, *2.20*
 'whiplash curves' 221, 223, 324–5, 391, 421, *22.2*
Art Deco 32, 43, 207, 431–2
L'Art décoratif (magazine) 29
Art et décoration (magazine) 29, 375
L'Art moderne (magazine) 27, 29, 74
Art Nouveau
 destructive forces 429–36
 dissemination of 29, 31
 eclecticism 430–1
 English roots of **127–45**, 251
 entrepreneurial activity 27–8
 historical sources **37–53**
 introduction and development **15–33**
 in Japan 113
 mystical aspect of 73
 opposition to 85–6, 145, 251, 429
 recovery 436
 reuniting of art and craft 110–11, 252, 253
 William Morris and 132, *8.4*
 L'Art Nouveau gallery (Bing's) 26, 94, 105, 157, 170–1, 180, 184, 204, 217, 234, 256, 269, 400, 405, *1.11, 10.9, 11.6, 17.8*
 L'Art Nouveau symposium (1903) 251
Art Worker's Guild 133, 137
L'Arte Decorativa Moderna (magazine) 414
artefacts
 biscuit tins 15, *1.3*
 candelabra 227, 230, *4.13, 14.5, 14.6, 14.8, 14.9, 16.8*
 cigarette box *2.16*
 clocks *1.13, 3.17*
 cups *3.6, 13.4*
 'grid' basket *20.10*
 Islamic 116, *7.2, 7.3*
 Japanese 106–7, 110, *6.6, 6.10, 6.11*
 jewellery box 227, *16.6*
 pre-Columbian 197
 tea-service *20.11*
 teapot and creamer 235, *14.13*
 vernacular 47, *2.14*
 see also lamps; vases

artifice, and nature in art 59–61, 80, *4.8, 4.9*
arts 19
 equality of and unity 19–20, 155, 252, 253, 259
 State support 29–31
 vernacular tradition *see* vernacular tradition
 see also painting; sculpture
Arts and Crafts Exhibition Society 133, 292
Arts and Crafts Movement 19, 48–50, 132–7, 145, 300, 320
 Cometti and 419
 communities 133–4, 359
 Lechner and 121
 metalwork 225–6
 in Munich 292–3
 and national style 50–2, 156
 Riemerschmid and 230
 Serrurier-Bovy and 119, 173
 in Vienna 300
 see also Britain
Arts and Crafts textiles 179, *8.4, 8.9*
Arts and Crafts workshop (the Hague) 188, *11.9*
L'Aurore (magazine), Zola's 'J'accuse' *5.6*
L'Avenç (magazine) 335

Barbizon painters 287
Barcelona
 architectural ironwork 224
 architecture **335–45**
 El Cercle de Sant Lluc 339
 Cerdà's *Eixample* project 335, 342
 modernista architecture 336–41
 School of Architecture 339
 Baroque 37, 40, 339, *2.3*
 in France 41, 61, 228, *3.8*
 neo-Baroque styles 32, 38, 40, 41
 batik 110, 156, 188, *11.8, 11.9*
 Bauhaus 293, 432
 Belgian Workers' Party 276
 Belgium
 architectural ironwork 223
 glassware manufacture 213, 219
 metalwork 227, *14.5*
 sculpture of A N 256–9
 see also Antwerp; Brussels
 Berlin 26, 180
 Biedermeier style 37, 40, 305, 432
 Blanc et Noir print exhibition (Paris 1892) 105
 Bohemia, glassmaking 213, 215–16
 Le Bon Marché (department store) 32
 book illustration 93, 96, 132, 134, 157, *5.1, 5.5, 5.5, 8.8, 24.8*
 see also lithography; painting; paintings
 book production, photo relief printing 151
 botany
 and architectural design 324–6
 illustration 55, *3.2*
 brassware, candelabra 230, *14.8, 14.9*
 Britain
 and European culture 127
 industrial and cultural development **127–45**
 new sculpture movement 253
 textiles 179, 180
 views of A N 251
 see also Arts and Crafts Movement

Brittany, folk culture of 48, *2.15*
Brussels 24–6, 74
 architecture 24, 38, 130, 223, **275–85**, *1.2, 1.10, 2.2, 18.1, 18.5, 18.8*
 debt to Liberty 143
 Exposition Universelle (1897) 31–2, 153, 226, 227, 256, 275, *1.16*
 Exposition Universelle (1910) 32
 sculpture 256–9
 Symbolist art 26, 81
Budapest 26
 artistic colonies 191
 ethnic styles 50, 120, 349
 fin-de-siècle **347–59**
 Lechner and 121, 347–51
 Museum of Applied Arts 121, 349, 354, 355, *24.1, 24.2*
Buddhist influences 96, 108, *6.7*

Cabaret, literary club 98
café culture 75
carpets
 by Colenbrander 188
 by Mucha 184, 368
 by Olbrich 368
 by Riemerschmid 294, *19.12*
 by Voysey 180
 Wiener Werkstätte 308
Carson-Pirie-Scott Store 224, 333, *22.10*
Castel Béranger (Paris) 165, 223, 265, 267, 272, *17.2, 17.3*
Castel Henriette (Paris) 272, 273, *17.11*
Catalonia
 Catalan nationalism 335, 336, 339
 folk art and nationalism 47, 50, 120
 provincial Baroque architecture 339
Celtic art 37, 50, 321
Century Guild 133
ceramics 143, **193–207**
 Abstraction 207
 architectural 349
 Burne-Jones and 132
 Chinese influence 110, *12.3, 12.5*
 crystalline glazes 200, *12.8*
 Czech *Moderna* designs 368
 Czech vases 364, 368
 De Morgan's influence 132, *8.5*
 decoration 193–4, 196, 198, 201
 glazes 193, 197, 198–9, 200, 204, 253, 308, *12.14*
 Iris ceramics company 27, 204, 381–3, *26.9*
 Islamic designs and influences 116, 118
 Japonism 198, 201, 210
 lustreware 121, 193, 198–9, 352–4, *8.5, 24.6*
 majolica ware 390, 391–2, 394
 Tiffany 407, *28.10*
 tiles 120, 121
 underglaze painting 201
 vernacular tradition 47, *2.14*
 at the Viennese *Werkstätte* 308
 Wiener Keramik 308
 see also earthenware; porcelain; stoneware
Champs de Mars Salon 253–6, 261
Champs Elysées Salon 256
Le Chat Noir (literary club) 75, 98, 162, *9.21*
Chicago
 architectural ironwork 224–5
 Chicago style 50, 323–33
 Columbian Worlds Fair (1893) 47, 105, 212, 402–3, 405, *22.8*

rebuilding of **323–33**
 Transportation Building 31, *22.8*
Chinese art 37, 38, 44, 110, 111, *6.12*
 carved rock-crystal and jade 110, 210, *6.12*
Chromatic Circle (Pointillist) 80–1
cinema, effect on French culture 99
Classicism
 in ceramics 193
 Gothic Revival and 46
 in Horta's architecture 279, 282
 influence on A N 37–40, 44, *2.1*
 influence on Aesthetic art and design 138
 and Rationalist geometry 431
The Climax (Beardsley) 24, *1.9*
communism 74
consciousness, altered states 88, 90, *4.23*
La Construction moderne (magazine) 223
Constructivism 432
conventionalization
 in architectural design 324, 325
 in decorative arts 57, 58–9, 143, 434, *3.4*
 in silverware 234, *14.11*
 see also symbolic conventionalization
Copenhagen 26
copperware
 jardinière *3.18*
 see also metalwork
The Craftsman (magazine) 29, 105, 399
Le Cri de Paris 5.7
Crystal Palace 31, 58, 129, *8.2*
Cubism 99, 372
culture 18, 38, 47, 96, 99
Curtis's Journal, nature publishing 55
Czech art 361–4, *25.2*

Dai Nippon Zuan Kyo[-]kai (Great Japan Design Association) 113
Darmstadt 26
 d'Aronco and 415
 artists' colony 394, 395, 415
 glassware 216
Debschitz Schule (Munich) 293
Decadence
 in art 59, 336
 bookbindings 155, *9.8*
 and ceramic art 200
 female sexual imagery 122
 in literature 59, **94–8**, 145
 Rococo designs and 45
 see also Symbolism
Le Décadent (magazine) 74, 94
Dekorative Kunst (magazine) 29, 105
Denmark
 ceramics 200
 textile sales outlets 180
department stores 29, 32, 186, 223, 224, 276–9, 313–15, 333, *22.10*
design
 commercial backing 29
 manuals 52, *8.1*
 State support 29–31, 129
Design Reform movement 129, 145, 319, 359, 417
Deutsche Kunst und Dekoration (magazine) 29, 301
Deutsche Werkstätte 309
Deutscher Werkbund (German Work Association) 297, 309
The Dial (magazine) 29, 74, 154
Divisionism 78
Dracula (Stoker) 73, 85
dragonflies
 Japanese motif 110, 244, 407, *6.11*

jewellery 65, 84, 244–6, *4.12*
 Tiffany lampshade 408, *28.11*
dreams 93, 94, 99
Dresden Workshop designs 295–7
drug addiction 88, *4.23*

earthenware 202–4
 Dutch *12.12*
 George Ohr pitcher *3.13*
 painted 195, 196, 204, 205–7, *3.7, 12.15*
 sexual imagery 84, *4.11*
 vases *3.7, 7.7, 8.5, 12.15*
 Willy Finch bowl and mug *26.9*
 see also ceramics; porcelain; stoneware
ébénisterie (cabinetmaking) 44, 48, 166
L'Echo de Paris, literary survey (1891) 93
Die Eigene (magazine) 90
Das Eigenkleid der Frau (magazine) 181
L'Élan littéraire (magazine) 94
electricity 123, 125
 glassware lamps and 217, 402
 lighting 282, 402
Elvira Studio, Munich 70, 107, 293, *1.5, 19.8*
embroidery 26, 70, 179, 180–1, 183, 186, 216–17, 320, 355, *1.12, 11.1, 11.3, 21.3, 24.9*
 Candace Wheeler and 400
 Solomenko workshops 392
 'whiplash curves' 26, 179, 181, 292, *1.12*
empathy, and creativity 434–5
Empire style 432
L'Émulation (magazine) 29
enamelling 240, 244, 246, 407
 cloisonné technique 160, 196, 215, 228
 on glass 209, 210
 plique-à-jour work 217, 228, 240, 242, 248, 405, *3.6, 15.4, 15.5*
England *see* Britain
Enlightenment, evolutionism and 65
'ensembliers' 20, 166, 269
L'Esprit nouveau (magazine) 94, 432
L'Estampe originale (magazine) 154
Ethnographic Exhibition (1895) 47
evolutionism
 in decorative arts 57, 69–71, 433–4
 nature and 22, 55, 62, 65, 434
exhibitions 26, 29, 31–2, *1.1, 1.16, 1.17, 1.18*
exoticism 115, 120, 121–3, 143

fantasy, Jugendstil and 158–9
fashion, *Wiener Werkstätte* 309
Femina (magazine) 249
Fiatalok, architects group (Budapest) 357
film stars, myth of 99
Finland
 Art Nouveau 159–60, *9.16*
 ceramics 202–4, *12.13*
 Friends of Finnish Handicrafts 386
 history and culture 375–6
 national architectural style 377, 387
 Naturalism 377
 Suomen Ka[./]sityön Ystävät (the Friends of Finnish Handicrafts) 191
 see also Helsinki
flowers
 in decorative metalwork 228
 French floralism in Prague 368
 iris emblem 110, 240, 407, *15.2, 15.3, 19.5*

Islamic patterns 116
 jewellery 110, 238, 242–4, *15.2, 15.4, 15.6, 15.7, 15.8, 19.5*
 Lauro's *palazzina* 421
 Polenova and 392
 Tiffany's glassware and 403–5, *28.4, 28.5*
folk art *see* vernacular tradition
Foulis Academy (Glasgow) 317
France
 decorative silverware 228–9
 national Baroque-Rococo style 41, 61, 228, *3.8*
 textiles 180
 see also Nancy; Paris
Freemasonry, patronage of art 74, 276
furniture design 53, 134, **165–77**, *2.21, 8.7, 10.2*
 Baroque 40, *2.3*
 Brettelstil 301
 Brussels 174, 282, *10.12*
 English 139–40, *8.13*
 Finland *26.2*
 German 165, 173, 174, 294, 297, *10.1, 10.15, 19.7, 19.10, 19.11*
 Glasgow's tearooms 315, *21.6, 21.7, 21.8*
 Hungarian 352, 354, 357, *24.5, 24.10*
 Islamic influences 118–19, *7.4*
 Japanese influences 107, 109, 118, *7.4, 21.8*
 Maschinenmöbel 297
 materials 174, 177
 metal fittings 234–5, 293, *14.12*
 metamorphosis and 66, *3.16, 4.14*
 model rooms 165, 166, 170, *1.18, 1.19, 1.21, 10.4, 10.5, 10.9*
 Nancy 172–3, *10.10*
 Naturalist 57, 134, *3.3, 8.7, 10.6*
 New York 400
 painted furniture 132, 173, *8.6*
 pantheist influences 65, 84, *3.10, 4.14*
 Paris 166–71, 174, 432, *10.6, 10.13, 30.4*
 pastel colours 167–70
 Prague 362, 371, *25.11, 25.12*
 Rococo 43, 173, *2.7, 2.10, 10.11*
 Russian 392
 sculpted furniture 65, 84, 165, 252, 256, 419, *3.10, 4.14, 10.3, 16.1, 16.5*
 Turin *Esposizione* 417–24, *29.10, 29.11, 29.12, 29.13*
 vernacular tradition 47–8, 50–2, 301, *2.15, 2.17, 2.18, 2.19*
 Vienna 170, 173, 301–7, *10.7, 20.3, 20.4, 20.5*
Futurism 99

Galerie des Artistes Modernes 254, 259
Gazette des beaux-arts (magazine) 253, 254
geometric designs 26, 61, 140, 173, 191, 202–4, 227, 300, 308–9, 319, 369, 421, *8.13, 12.13*
Germany
 ceramics 198, 200–1, *12.9*
 Secessionism 230
 textile sales outlets 180
Gesamtkunstwerk 19, 20, 76, 111, 166, 179, 229, 289, 297, 307, 308, 321, 354, 381–3, 417, 419, 422
Il Giovane Artista Moderno (magazine) 417

Glasgow **311–21**
 architectural ironwork 224, *21.11*
 artist decorators and dealers 160, 312–13
 'artistic' tearooms 313, 315, *21.6, 21.7, 21.8*
 City Art Gallery and Museum 312
 department stores 313–15
 geometric designs 26, 140, 173
 Glasgow Four 300, 319, 320, 321, *21.1*
 Glasgow Style 224, 311–13, 320, *21.3, 21.4, 21.5*
 Institute of Fine Arts 312
 interiors 224, 313, *21.6*
 International Exhibitions 311
 social tensions 320–1, *21.14*
Glasgow School of Art 180, 224, 226–7, 312, 317–20, *21.11*
Glasgow and West of Scotland Technical College (GWSTC) 317, 319
glass 143, **209–19**
 Ashbee decanter 143, 225, *14.4*
 Aurene glass 218
 blown glass 355, 402–3, 405, 407, *28.5*
 bronze glass 218
 carved *13.11, 28.3*
 'crystal' 219
 Czech designs 368, 371, *25.10*
 in decorative architecture 367
 enamel painting 209, 210
 favrile 116, 403–7, *7.2, 13.9, 28.3, 28.4, 28.5, 28.6, 28.7, 28.8, 28.14*
 flasks 116, *7.2*
 hot-worked *1.4*
 in ironwork architecture 221, 223
 Islamic influenced 116–18, 209, *7.2, 7.3*
 Japonism 210
 in jewellery 240
 lamps 116, 217–18, *3.5, 3.8, 3.11, 7.3*
 lampworking technique 216, *13.8*
 leaded 405, 407, *28.7, 28.11, 28.14*
 lustred 215–16, 217–18, 405, *13.6, 13.9, 28.6*
 metalwork mounts 217, 225, 227, 405, *14.4*
 millefiori technique 213–15, 218, *13.10*
 nature influenced 210, 218, *13.1, 13.2*
 pâte-de-verre process 209, 212
 plique-à-jour work 217, *3.6*
 Rococo *2.9*
 stained glass 132, 212, 213, 218, 282, 294, 320, 367, 381, *4.20*
 Tiffany and 400, 402–7, *28.3, 28.4, 28.5, 28.6, 28.7, 28.8*
 Wiener Werkstätte 308, *20.12*
 see also vases
Gödöllö, artistic colony 191
Golden Section 40, 53
Gothic Revival
 in architecture 46, 279, 282, 324, 325, *2.13, 23.10*
 Horta and 279, 282
 influence on A N 37, 38, 46, 50, 230, 244, *2.13, 23.10*
Gros Roman, textile printing 180, 184
Guild of Handicraft 133, 225, 229, 230, 300, *14.4*

Harper's (magazine) 162
Haslemere, Peasants Art Society and Museum 134
Helsinki
 architecture 375, 376–87, *26.1, 26.3*
 Art Nouveau 26, 28, **375–87**
 vernacular forms 50
 see also Finland
Hispano-Moresque designs
 Gaudi and 120–1
 horseshoe arch 118–19, 120, *1.1*
 at Zsolnay 121
history, as source of A N style 22, 26, 37–46, *1.6*
Hobby Horse (magazine) 29
horn, jewellery 242, *15.7*
Hungary
 admiration for Frida Hansen 191
 folk art and Islamic links 121, 349
 Hungarian Nationalism 347, 351, 352
 Magyar folk art 349, 356–7
 Transylvanian peasant art 357–9
Les Hydropathes (literary club) 75
hysteria 88–9

L'Image (magazine) 154
imperialism
 attitudes towards Orientals 111–12
 culture and 18
 influence on A N 37, 62–5, 227, 349
Impressionism 38, 59, 138, 140, 150, 196
 see also neo-Impressionism; Pointillism
individualism
 fused with nature 69
 and the spiritual 74, 81
industrialisation, effects of 18, 22, 127
Innovation (department store) 223
insects, in jewellery design 65, 84, 110, 244–8, *4.12, 6.11, 15.9, 15.10, 15.11, 15.12*
Das Interieur (magazine) 29
interior design 20, 59, 166, *1.19, 1.21, 17.9*
 Brussels 24, 32, 166–7, 279, 282, *1.10, 1.16, 10.4*
 Glasgow design 224, 313, *21.6*
 Rococo 40, 43
 Sullivan 324, *22.1*
 Tiffany 400
 Turin 421–2, 424, *29.9*
 Whistler 140–2
 see also architecture, interiors
ironwork
 architectural 221–5, 285, 349, *2.13, 14.1, 23.6, 23.8*
 by Guimard *17.6, 17.7*
 Horta's use of 223, 285
 wrought iron 210, 217, 224, 285, 349, *2.8, 14.3, 17.10*
 see also metalwork; structural steel
irony, *fin de siècle* 96–7, 99
Islamic art and design
 Aestheticism and 138
 contribution to *national* styles 120–21, 349
 enamelled glass 210
 influence on A N 37, 44, 50, **115–25**, 349
Italy
 glassmaking 213–15
 lustre glazes 199
 Stile Floreale 174
 see also Milan; Turin

ivory, in ornamental pieces 62, 227, 240–2, 256, *3.9, 4.13, 4.19, 7.8, 16.8*

jade carvings 110, 210, 228, *6.12*
Japanese art **101–13**
 aestheticism and 138
 bronzes 194, *6.1*
 designers and craftsmen in the West 112–13
 dragonfly motif 110, 244, 407, *6.11*
 and glasswork designs 210, 216
 Imari patterns 210
 influence on Western arts and crafts 37, 38, 43, 44, 52, 89, 101, 106–13, 149, 150, 159, 173, 237, 242, 259, *6.4, 6.5, 8.13, 9.3, 9.5, 9.19, 15.1, 19.5*
 influenced by that of the West 112–13
 Inro[-/] (small container) *6.11*
 in the Meiji period 112–13
 Rimpa lacquerware 106, 107, 111, *6.6*
 stoneware 194
 Tsuba (sword guard) *6.10*
 woodblock prints 105–10, *6.2, 6.3, 6.4, 6.5, 6.8, 6.9*
Le Japon artistique (magazine) 29, 101–5
Japonism 198, 201, 210, 279, 355
La Jeune Belgique (magazine) 94, 96
jewellery 110, **237–49**, 368, *4.12, 6.10, 6.11*
Le Journal de l'architecture 221
Die Jugend (magazine) 29, 74, 159, 290–1, 292, 293, 294, *19.5, 19.6*
Jugendstil 158–9, 160, 181, 230, 232, 290–7, 300, 391, *14.10*

Kalevala 47, 376
 in *Bil-Bol* poster 160, *9.16*
 Gallen-Kallela and 381
 influence on architecture 377
Karelia, influence on Finnish style 376
Keramik Studio (magazine) 204
Kunst und Handwerk (magazine) 29, 232
Kunst und Kunsthandwerk (magazine) 29
Kunstgewerbeschule (Berlin) 291
Kunstgewerbeschule (Vienna) 299, 300, 308, 352
Kunstnerkeramik (artists' ceramics group) 205

lace 186, 188, 359, *24.13*
lamps
 bronze statuettes 261, *16.10, 16.11*
 glass 116, 217–18, *3.5, 3.8, 3.11, 7.3*
 see also artefacts
laquerware, Japanese 106, *6.6*
law, intellectual discontent with 73–4
Liberalism, and A N 429
La Libre esthétique, exhibition group 27, 81, 154, 225, 227, 256, 261, 280
Liège 27, 28
 Exposition Universelle (1905) 32, *1.20*
line 26, 107
 see also arabesques
literary clubs 75, 98
literature
 Decadent movement 59, **94–8**, 145
 in the French decadent period **93–9**

Golden Age of Latin 38
Islamic influence 115
Naturalist movement **93–9**
Symbolist movement 59, **94–8**
lithography
colour 149–50, 157, *9.2*
see also book illustration; posters
Lliga Regionalista de Cataluña 335, 339
London 24
Arts and Crafts exhibition (1896) 179, 180, *1.12*
Franco-British Exhibition (1908) 32
Grafton Gallery 405
Great Exhibition (1851) 31, 41, 116, 129, 254, *8.2*
International Exhibition (1862) 101
Louis' styles 40–1, 43, 61, 432
Le Louvre (department store) 32
Lutèce, literary review 98

Magazine of Art 223, 251, 254
Magyar Iparművészet (magazine) 355
La Maison Moderne gallery 27, 166–7, 174, 204, 207, 217, 227, 300, *10.12*
Les Maîtres de l'affiche (poster magazine) 154
Mannerism 40
marine biology, illustration 55, *3.1*
Massachusetts Institute of Technology 324
Medusa 86, *4.20*
menuiserie (carpentry) 44
Le Mercure de France (magazine) 94
metalwork **221–35**
Czech 368
functional and decorative 225–35
at Glasgow School of Art 320, *21.13*
Islamic 116
peacock sconce *8.18*
repoussé 227, *1.8*
see also copperware; ironwork; silverware
metamorphosis
Carriès and 194
in decorative arts 57, 65–9, 436
depiction of women 82–5, 246
metaphysics 22, 26, *3.15*
Milan 26
Esposizione d'Arte Decorativa Moderna (1902) 120
Esposizione d'Arte Decorativa Moderna (1906) 354, 356
Symbolism and nature 26
see also Italy
Modern Art, abstraction and 434
Moderne Stickerein (magazine) 181
Der Moderne Stil (magazine) 29
Modernism 73, 191, 215, 432–6
Le Moderniste (magazine) 74
Modernity
in architecture 221, 336–45
Art Nouveau and 18–19, 22–3, 28, 37, 38–40, *2.1*
in Barcelona 336–9
cultural identity and 31
furniture design 118
and Islamic style 125
Liberty's and 142
in literature 94, 98
movement the leitmotif 149
Munich Secessionists and 290
nature and 55, 69, 323
symbols of 153–4
Toulouse-Lautrec and 150
in Vienna 299

monuments 15
Moscow 26, **389–97**, *27.1*
Cathredral of Christ the Redeemer 389, *27.1*
Exhibition of Architecture and Industrial Art in the New Style (1902) 396–7, *27.8*
Hotel Metropol 390, *27.2*
Iaroslavl Railway Station 392–3, *27.4*
modern architecture 390, 392–7, *27.2, 27.4, 27.6, 27.7, 27.8, 27.9*
Stroganov School of Technical drawing 393–4
Mulhouse, textile printing 180
Munich 28, **287–97**
Allgemeine Austellung Deutscher Industrie und Gewerbeerzeugnisse des Zollvereins 287
arts and crafts 292–3
evolutionary art 70, *3.18, 3.19*
furniture design 173
geometric designs 26
Glaspalast exhibitions 230, 287, 291–2, 294, *14.9*
glassware 216
International Electricity Exhibition, 1st 287
VII Internationale Künstausstellung 289, 291, *19.3*
Jugendstil 159, 230, 290–7
Secessionism 230, 289–92
Munich Artists' Association 287–9, 291
Munich Society of Visual Artists 289–90, 291
Munichois designs 432
Musée des Arts Décoratifs 333
Musée du Congo 275
Musée Guimet, Japanese art 106
Museum of Ornamental Art (later Victoria and Albert Museum) 129
acquisitiom of Islamic artworks 116
Indian artefacts 121, *7.6*
Oriental ceramics 199
textile acquisitions 180
museums, public 22, 29
music 19, 96
mysticism, and visual culture 73, 77
myth
as A N theme 22, 37, *2.1*
cinema and 99
the Decadent movement and 96
literary 96

Nancy 210
book production 155
École de Nancy 44, 52, 155, 172, 186, 213
École des Beaux Arts 213
fine embroidery 186
furniture design 172–3
pantheism and glass 65
Rococo designs 43–4, *2.8, 2.9, 2.10*
Symbolism and nature 26
see also France
Narcissus, in literature 96
Nationalism
Islamic art and 115
and vernacular culture 47, 49–50, 429
Naturalism
architectural ironwork and 224, *23.6, 23.8*
Art Nouveau and 57–62, 82
in ceramics 193, 201–2, 207
decorative metalwork and 226, 227–8, *14.6, 16.6*

and empathy 435
in Finland 377
in glass 210, 218, *13.1, 13.2*
Japanese 201
Lautrec and 150
in literature **93–9**
in Munich 290
in Prague 26, 367
in sculpture 256
Symbolism and 73, 81, 93–8
nature 21–2, 44, **55–71**, 434, *1.4, 1.5, 2.10*
architecture and natural forms 323–33, 434
Arts and Crafts stylization 134
in domestic furniture 167–70, *10.6*
in embroidery 179, 355, *24.9*
Horta and 282
Islamic art and 115
Japanese stylization 109–10, 115
in jewellery 237–8, 242–3
key to Gallé's glass designs 210, *13.1, 13.2*
Modernity and 55, 69, 323
natural life and 55, *3.1*
Rippl-Rónai and 355, *24.9*
William Morris and 132
as woman 82–85, 121, 123
Naturist school 99
Nemetelemer, artistic colony 191
neo-Impressionism 78
see also Impressionism
Netherlands
Arts and Crafts workshop 188, *11.9*
batik 110, 156, 188, *11.8, 11.9*
ceramics 202, *12.11*
decorative silverware 228
flat-pattern design 156
Indonesian influences 37, 110, 156–7, 188, 202, *11.8*
New York
art patrons 399–400
cultural institutions 399
Louis Comfort Tiffany and **399–11**
Nippon Zuan Kai (Japan Design Group) 113
Nordic art *see* Viking art
Nordic Exhibition (1888) 205
Norway
decorative silverware 228
Oslo 26
tapestry 188
textile sales outlets 180
Norwegian Weaving Society 188, 191

occultism, and visual culture 73, 74, 77, 78, *4.7*
Old England (department store) 223
opera 94, 96
opium addiction 88, *4.23*
Oriental art *see* Chinese art; Japanese art
ornament
attacked 433
and Design Reform 129, 433
The Grammar of Ornament (Jones) 129, *8.1*
natural forms 58, *3.4*
Ostende 275

painting and paintings 19, 43, 96, 294
Gallen-Kallela 381, *26.6, 26.7*
'Glasgow School' 160, 313, *21.4*
Islamic influence 115
nature based subjects 57
Symbolist 75–81, 86–90, 381,

4.1, 4.2, 4.3, 4.4, 4.5, 4.7, 4.8, 4.9, 4.15, 4.16, 4.21, 4.22, 4.25, 4.26
see also book illustration; prints
Palais de Trocadèro (1878) 41
Pan (magazine) 27, 29, 74, 105, 110, 158, 159, 216, 290–1, 292, 293, *1.15, 19.6*
pantheism, in decorative arts 57–8, 62–5, 84
Paris 26, 28, **265–73**
École des Beaux-Arts 105, 270, 324
École du Sacré Coeur 46, 89, *4.24*
Eiffel Tower 221, 265, *14.1*
Exposition Internationale de l'Habitation (1903) 268–9, 271–2
Exposition Universelle (1867) 101
Exposition Universelle (1878) 41, 101, 112, 194, 196
Exposition Universelle (1889) 31, 41, 82, 101, 181, 221, 252, 265
Exposition Universelle (1900) 26, 32, 41, 43, 93, 105, 113, 123–5, 127, 143, 166, 170–1, 184, 188, 191, 198, 200, 201, 212, 223, 227, 228, 237, 238, 243, 246, 248, 261, 265, **269–72**, 275, 293, 352, 354, 355, 356, 368, 375, 378, 381–3, 392, 405, 407, 410, 417, *1.1, 1.17, 1.18, 2.5, 2.7, 7.5, 10.5, 10.9, 14.1, 16.11, 17.1, 17.8, 17.9, 24.5, 26.1, 26.5, 26.8, 28.14*
Exposition Universelle (1925) 41, 431, 434, *30.2, 30.3, 30.5*
Exposition Universelle (1937) 432, *30.3*
furniture design 166–71, 174
Loïe Fuller Pavilion 32, *1.17*
'Metro' stations 32, 46, 223, 267–8, 272, *17.4, 17.5*
Opera House 40
Quartier Latin 98
rebuilding of 149, 265
Salon d'Automne (1910–1912) 432, *30.4*
sculpture 252–61
Symbolism and nature 26
see also France
Parnassians 93
parures 227, 240, 248, 256, *16.6*
pastels 43
Pavillon Bing 32, 43, 166, 171, 184, 212, 269, *2.7, 10.5, 10.9, 17.9*
Pavillon Bleu Restaurant (Serrurier-Bovy) 32, *1.1*
Pavillon Collectivité André Delieux 32, *1.21*
Persia
glass flasks 116, 118, *7.2*
textiles 115, 116, *7.1*
Le Petit Français illustré, first French cartoon (1889) 96
phallic imagery 89–90, *4.24*
Philadelphia, Centennial Exposition (1876) 101, 204
philosophy, Classicism and 37
photography
homoerotic 90
Lalique's use of 243
in Prague 361, *25.1*
source of visual reference 89, 243
use in book illustration 96
Pierrot, in literature 96, *5.5*
plant life, tropical hot houses 56
La Plume (magazine) 15, 29, 74, 75, 82, 94, 145
poetry 93, 94, 96, 97, 436
see also literature
Pointillism 78–81

see also Impressionism
politics
and A N 74, 81, 429
and evolutionism 69
Modern Art and 435
porcelain 193, 197, 200–2, *12.5, 12.7, 12.9, 12.10*
carved and decorated 205, *12.16*
Czech *Moderna* designs 368
glazes 193, 197, *24.6*
Meissen 201, 294
modelled 201
Nymphenburg 200–1, *12.9*
Rococo designs *2.12*
Sèvres 193, 196, 197, *2.12, 12.1*
vases 352, *12.1, 12.5, 12.16, 24.6*
see also ceramics; earthenware; stoneware
pornography 15, 89
post-Modernism 436
The Poster (magazine) 158
posters 15, 77, 159–61, 292, 297, 308, 381, *1.14, 4.6, 9.16, 9.19, 9.20, 9.21*
expressions of modernity 149–54
hoardings 149, *9.1*
Japanese influences 107, 149, 150, *6.4, 9.3, 9.5, 9.19*
by Stuck 289, *19.2*
Prague
Academy of Fine Art 369
architecture 361–2, 367, 369, 371–2
Art Nouveau in **361–73**
Central Railway Station 362, *25.4*
Czecho/Slav Ethnographic Exhibition (1895) 361, *25.2*
Jubilee Exhibition of the Lands of the Czech Kingdom (1891) 361
Moderna art 368, 369, 372
Naturalism 26, 367
redevelopment 361–2
School of Applied Arts 361, 368, 369
Symbolism 362–5
Pre-Raphaelitism 128, 130–2, 138, 161, 259, *16.7*
and Baroque style 40
in Prague 364–7
Rose+Croix and 77
print media
art and 149
see also book production; posters
Le Printemps (department store) 32, 186
prints 43, *3.1, 3.2*
etching 381
Japanese woodblock 105–10, *6.2, 6.3, 6.4, 6.5, 6.8, 6.9*
woodcuts 157, 159, 290, 381, *4.17, 9.12, 9.14, 19.5*
see also painting and paintings
psychology, and sexology 88–9
publications
botanical and biological 55
on design and decorative arts 129
evolutionist 65
modern art and Symbolism 74
promoting conventionalization 58–9
Purists 432, 434

Quadrastil 229, *14.7*
Die Quelle (The Source) 160, *20.13*

Rationalism
architecture and 223, 323, 327, 331, 387, 431

in Britain 127–8
and Classicism 431
and conventionalization of
 nature 58
debates with Romantics 73
visual culture and 128–9
Realism 73, 140, 150, 194
religion
 as A N theme 22, 74
 in Glasgow 321
 see also Roman Catholicism;
 Spiritualism; Theosophy
religious objects, oriental 106, *6.7*
replicas 52, *2.20*
La Revue blanche (magazine) 74, 94,
 157, *5.2*
La Revue contemporaine (magazine) 94
Revue des arts décoratifs (magazine) 29,
 105, 252, 253, 259
La Revue indépendante (magazine) 74,
 75, 94
La Revue Wagnérienne (magazine) 74,
 94
Riga 26
Rocaille forms 41
Rococo 52, 37, 40–5, 173, 210, 228,
 279, 282, *2.5, 2.6, 2.7, 2.8, 2.9,
 2.10, 2.11, 2.12, 10.11*
 decorative siverware 228, 234
 and naturalist styles 57, *3.3*
 oriental influences 101
Roman Catholicism 74, 98, 321, 336
 see also religion
Romantic movement
 debates with Rationalists 73, 128
 in France 77
 pantheism and 57
 pre-industrial communities and
 48
Romanticism
 biological 69
 in Czech art 362–4
 in the decorative arts 137
 National Romanticism 50, 429
 scientific 73
 Sullivan and 327
Rose+Croix Salon (1892–97) 76–7,
 84, 89, 90, 151
Rosicrucianism, Symbolist painting
 and 74, 76–8
rugmaking 186
 ryijy rugs 381–3, 384, 386, *26.8*
Russia
 Imperial glassworks 213, *13.5*
 neo-Russian style 391, 393, *27.5*
Russian Art Nouveau 160, **389–97**,
 9.17

Sagrada Familia, Cult of the, Gaudí
 and 74, *23.10*
St George's Guild 132
St Louis, World's Fair (1904) 32, 105,
 368, 371, 407, 408, *1.19, 25.10*
St Louis School of Ceramic Art 205
Salammbo 86, 122, 123, 125, *7.8,
 7.11*
Salome 86–8, 96, 122, 123, *7.9*
Salome prints (Beardsley) 24, 28, 88,
 123, 143, 155, *1.9*
Salon d'Automne (Paris 1912), furniture
 432, *30.4*
Salon de la Rose+Croix exhibitions
 (1892–97) 76–7, 84, 89, 90, 151
Santa Sophia (Constantinople) 120
Satanism 74, 89–90
Scherrebek, *Kunstgewerbeschule* (Arts
 and Crafts School) 191
Schlesinger Meyer (department
 store) 224, 333, *22.10*
schools, of art and design 29, 55,
 129

science 73, 74, 78, 80–1, 121
sculpture 19, **251–61**
 animalier sculptors 256, 259
 architectural 259
 Baroque 40
 Islamic influence 115, 122, *7.8*
 of metamorphosis 66, *3.15*
 nature based subjects 57, 256
 relief sculpture 259
 Rococo 40
 statuettes and figurines 40, 261,
 16.10, 16.11
 Symbolist 290, 364, *19.4, 25.6*
Secessionism 53, 113, 160–61,
 223–4, 225, *9.18*
 Lechner and 351
 in Moscow 391
 in Munich 289–92
 at the Turin *Esposizione* 415
 in Vienna 113, 160–61, 223–4,
 229, **299–309**, *9.18*
sexual imagery 65–6, 84–90, 121–3,
 434, *1.8, 4.11, 4.24*
sexuality 81–90
 Islamic art and 115, 121–2, 123
Le Sillon (magazine) 74
Silver Studio designers 116, 143,
 181, *11.2*
silverware
 American 232, 407, *14.11*
 Ashbee bowl and cover 137, *8.11*
 candelabra 227, *4.13, 14.5, 14.6,
 16.8*
 casket by Mackintosh 320, *21.13*
 cup by Hutton & Sons 143, *8.17*
 cutlery 294, 307–8, *14.14, 19.13,
 20.9*
 decorative 62, 225–35, *3.9, 14.4,
 14.5, 14.6, 14.7, 14.10, 14.11,
 14.13, 14.14*
 Epergne 40, *2.4*
 'grid' basket *20.10*
 jardinière *1.6*
 mounts for glassware 405
 see also metalwork
Simplicissimus (magazine) 29, 159,
 290, *9.15*
socialism 48–50, 74, 145
 Walter Crane and 137
 William Morris and 132
 utopian 48–50, 226, 435
Société des Artistes Décorateurs 432
Société des Artistes Français 229, 253,
 265, 405
Société des gens de lettres (Society of
 Authors) 93
Société des Indépendanres 252, 432
Société des Vingt, exhibition group 27,
 81, 157, 182, 204, 256
Société du Nouveau 272
Société Nationale des Beaux-Arts 253,
 265
La Société nouvelle (magazine) 94
Société Parisienne d'Orfèverie 228
Sphinx 86, 122, 154–5, *4.18*
spiritual world, and Art Nouveau
 73–91, 320
Spiritualism 22, 73, 74, 81, 320, 367
 see also religion
State, the, support for art 29–31,
 188, 199
De Stijl movement 81, 432
Stile Floreale 174, **413–25**
stoneware 193–7, 198, 294
 glazes 197, 198–9, 200, 204,
 253, *12.8, 12.14*
 sculptured 194, 197, 198, 253,
 12.2, 16.2
 Sèvres 199–200, *12.8*
 see also ceramics; earthenware;
 porcelain

Strasbourg, École des Arts
 Décoratifs 253
structural steel 224, 361
 see also ironwork
The Studio (magazine) 24, 28, 29,
 105, 154, 179, 180, 184, 216, 242,
 292, 294, 301, 311, 381, 414, *1.14*
'Le Style Anglais' 115, **127–45**
supernatural, the 22, 73
Suprematism 432
Surrealism 32, 73, 435–6
Sweden
 glassware 213
 Hardarbetets Vänner (Friends of
 Handicrafts) 191
 textile sales outlets 180
symbolic conventionalization 57,
 59–61
 see also conventionalization
Symbolism 19, 22, 26, 40, 48, 59,
 62, **73–91**, 93, 98, 121, 194, 435,
 1.7, 1.8, 3.15
 in architecture 279, 327, 331
 and Baroque style 40
 book illustration 157, *4.15*
 book-binding 155, *9.8*
 and ceramic art 200, 253
 in France 65, 73, 210–12, *3.12,
 13.1, 13.2*
 in Glasgow 319, 320
 Jugendstil 148–9, 290
 in literature 93–6
 in Munich 290, 294
 and Naturalism 73, 81, **93–9**
 Prague 26, 362–5
 in sculpture 256, 259
 Secessionist painting 294, 300
 sexual imagery and 82–9, 122
 and the *Société des Vingt* 157
 see also Decadence
Le Symboliste (magazine) 74, 94
Syntheticism, Gauguin and 59

tapestry weaving 186, 188–91
textile designs 143, **179–91**
 Art Nouveau style 179
 Arts and Crafts style 179
 Burne-Jones and 132
 conventionalization 59
 Exposition Universelle (Paris 1900)
 184
 folk art 47
 French textile printers 180
 Gallen-Kallela and 381–3, *26.8*
 Hoffmann and 308–9, *20.14*
 Islamic 116
 Liberty's and 142
 William Morris and 115, 116,
 132, 179, 180, *8.4*
 Moser and 160, 308, *20.13*
 'ogee' patterns 119, *7.5*
 patterns 181–3
 Rococo 43, *2.7*
 Silver Studio patterns 181, *11.2*
 Tiffany and 400
 of van de Velde 182–3, *11.3,
 11.4*
 Voysey and 134, *8.9*
 Wiener Werkstätte 308
 woven silk (Persian) 116, *7.1*
textiles
 batik 110, 156, 188, *11.8, 11.9*
 at the *Exposition Universelle* (Paris
 1900) 184, *2.7*
 silk priest's mantle (*Kesa*) 108, *6.7*
 soft furnishings 183–4
 van de Velde wall-hanging 183,
 11.3
theatre 15, 40, 82
 Salome (Wilde) 24, *1.9*
Theosophy 62, 74, 81, 320, 367

see also religion
Tokyo School of Art 113
toys 15
trade 18, 22
Truth, quest for 99
Tulipán craft association 351
Turin
 furniture designs 417–24, *29.10,
 29.11, 29.12, 29.13*
 Gesamtkunstwerk 417, 419, 422
 *Prima Esposizione d'Arte Decorativa
 Moderna* (1902) 28, 32, 105,
 118, 119–20, 143, 228, 251,
 254, 259, 311, 320, 405,
 413–24, *8.18, 21.2, 29.1, 29.2,
 29.3, 29.4*
 Stile Floreale **413–25**
 Symbolism and nature 26
 see also Italy

Ume[v]leck8 me[v]síc[v]ník (magazine)
 372
Union Centrale des Arts Décoratifs
 32, 111, 197, 252, 253, 254, 256,
 269, 271, 331–3
Union of Czech Artwork 372
universalism 74, 75, 435
utility, naturalistic art and 57–8
utopianism 74, 336, 364, 435

Vale Press 154, *9.8*
vampire imagery, women and 85,
 4.16
Vanier (publishers), Naturalist
 Symbolist debate 93
vases
 bronze *3.14, 16.3*
 Czech ceramic 364, 368
 earthenware *3.7, 7.7, 8.5, 12.15*
 glass 44, 216, *2.9, 3.12, 8.16,
 13.1, 13.2, 13.3, 13.5, 13.6,
 13.10, 13.11*
 jade *6.12*
 Japanese bronze *6.1*
 porcelain 352, *12.1, 12.5, 12.16,
 24.6*
 stoneware 198, *12.3, 12.8, 12.14*
 Zsolnay 121, *7.7*
Venice
 Biennale (1910) 215
 glassmaking 213–15
Ver Sacrum (magazine) 29, 160, 300,
 301, 308
*Vereinigte Werkstätten für Kunst im
 Handwerk* (United Workshop for Art
 in Handicraft) 159, 230, 292, 294,
 10.15, 14.9
vernacular tradition
 architecture 47, 52, 357, *2.20*
 Budapest 50, 120, 349
 ceramics 204, *12.13*
 decorative silverware 228
 embroidery and 181
 Finland 376–7
 and furniture design 173
 influence on A N 47–52, 96,
 132, 134, 429, *2.14*
 Jugenstil and 159–60
 in Moscow 160, 391, 392, 394,
 27.3
 in Prague 361, 362, 371, *25.2*
 Secessionism and 301
 textile patterns 182, 351
Victoria & Albert Museum
 acquisition of Bellery-
 Desfontaines's work 158
 see also Museum of Ornamental
 Art
Vienna 28, 40, 299
 abstract textile designs 191,
 11.13

Decorative Arts Museum 174,
 10.12
decorative metalwork 229
geometric designs 26, 140
glassware 215, 216
International Exhibition (1873)
 101
Künstlerhaus 299, 300
Secession Building 223–4, 299,
 300, *20.1, 30.1*
Secession Exhibitions 53, 223,
 229, 300, 308, *9.18*
Secessionism 113, 160–61,
 223–4, 229, **299–309**, 415,
 9.18
Wiener Kunst im Hause 300
Wiener Werkstätte 299, 301, 305–9
Viking art, Dragon style 37, 50–2,
 228, 376, *1.6, 2.17, 2.18, 2.19*
La Vogue (magazine) 74, 94

wallpaper designs
 conventionalization 59
 Walter Crane and 137, *8.10*
 William Morris and 115, 132
 Wiener Werkstätte 308
weaving
 Finnish *ryijy* rugs 381–3, 384,
 386, *26.8*
 in Hungary 357–9, *24.11, 24.12*
'whiplash curves'
 in architecture 221, 223, 324–5,
 391, 421, *22.2*
 in earthenware *7.7*
 in embroidery 26, 179, 292, *1.12*
 in glassware 116–18, *7.2*
 in Islamic art 115, 121
 jewellery reeds 243–4
women
 De Feure's images 157, *4.15*
 exotic fantasies 86, 246, 261,
 4.12, 4.18, 4.19
 feminism and suffrage 82, 293,
 300
 femme fatale 85–8, 96, 122, 290
 Femme Nouvelle 82–5
 femmes-fleurs 259, 260
 Grasset's posters of 151, *9.4*
 images of sexuality 82–9, 121–3,
 259, 260, *7.8, 16.7, 16.8, 16.9,
 16.10, 16.11*
 Lalique's images 84, 244, *4.12,
 15.11*
 Mucha's commodification of
 153, *9.5*
 as nature 82–5, 121, 123
Women's Pavilion (Paris 1900) *2.5*
World of Art (magazine) 394

Yellow Book (magazine) 74

Zurich, textile sales outlets 180